by Jesse Bryant Wilder, MA, MAT

BICENTENNIAL
1807
WILEY
2007
BICENTENNIAL

Wiley Publishing, Inc.

Art History For Dummies®

Published by
Wiley Publishing, Inc.
111 River St.
Hoboken, NJ 07030-5774
www.wiley.com

Copyright © 2007 by Wiley Publishing, Inc., Indianapolis, Indiana

Published simultaneously in Canada

WILEY

About the Author

Jesse Bryant Wilder is the publisher and editor of the NEXUS interdisciplinary texts series (www.nexusbooks.org), which includes *Romeo & Juliet & the Renaissance; Macbeth & the Dark Ages; Julius Caesar & Ancient Rome, From Republic to Empire; Antigone & the Greek World; The Lion in Winter & the Middle Ages; The Harlem Renaissance;* and *The Grapes of Wrath & the American Dream.* Each NEXUS volume connects the history, art history, art, music, and science of a major period to a literary work that reflects the period.

Jesse has garnered numerous writing awards. He has written and edited hundreds of articles on art, theater, cinema, and music for national and regional magazines and newspapers, including *American Theatre* and *Film Comment.* He is the principal writer for NEXUS.

Jesse is also the creator of the Web site Europe's Most Spectacular Festivals (www.eurofestivals.com) and the co-author of two medical books, *Thyroid Disorders* and *Stress and Your Body,* published by the Cleveland Clinic Press. He is the author of several screenplays and plays, a published poet and fiction writer, as well as a former lecturer in the Kent State University Department of English.

Dedication

I dedicate this book to my wife and best friend, Gloria Wilder, a great traveling partner, a brilliant cook, an inspirational and simply superb middle-school art teacher, and a painter, ceramist, and photographer with a very discerning eye.

Author's Acknowledgments

I would like to thank several outstanding art historians for their advice and support. Above all I am grateful to Dr. John Garton from the Cleveland Institute of Art and author of *Grace and Grandeur: The Portraiture of Paolo Veronese,* for his highly insightful and continual support throughout this project. I would also like to thank Stephen Fliegel, Assistant Curator of Early Western Art, Cleveland Museum of Art; Dr. David Bernstein, professor of History and Art History at Sarah Lawrence College; Dr. Francis V. O'Connor, editor of *Art for the Millions: Essays from the 1930s by Artists and Administrators of the WPA Federal Art Project;* and Dr. Jenifer Neils, chair of the Department of Art History and Art at Case Western Reserve University, all of whom have been a great help to me as writers and consultants for NEXUS projects. Their past support has rubbed off significantly on this book.

I am very grateful to my supportive and talented project editor, Elizabeth Kuball, and my acquisitions editor, Stacy Kennedy, under whose tutelage we developed a top-notch table of contents. I also want to thank my agent Coleen O'Shea and her colleague Marilyn Allen from the Allen O'Shea Literary Agency for offering me this project, as well as the editors of Wiley Publishing for accepting me into their stable of writers.

I want to thank my excellent technical editor, Thomas Larson, PhD, Santa Barbara City College; Wiley acquisitions director Joyce Pepple, for her tremendous support; and Michelle Hacker, Carmen Krikorian, and Erin Calligan Mooney, for helping to acquire all the images in this publication. I would also like to thank publisher Diane Steele for her support.

In addition, I am grateful to sculptor Brinsley Tyrrell for the information he provided regarding earthworks artist Robert Smithson, and to Harold B. Nelson, director of the Long Beach Museum of Art, for sharing his vast knowledge on the Golden Age of American Enameling with me. Above all I want to thank my wife, Gloria Wilder, who is my muse, editor, and all-around helper as well as my very warm-blooded arts resource.

Publisher's Acknowledgments

We're proud of this book; please send us your comments through our Dummies online registration form located at www.dummies.com/register/.

Some of the people who helped bring this book to market include the following:

Acquisitions, Editorial, and Media Development

Project Editor: Elizabeth Kuball

Acquisitions Editor: Stacy Kennedy

Copy Editor: Elizabeth Kuball

Technical Editor: Thomas Larson, PhD

Editorial Manager: Michelle Hacker

Consumer Editorial Supervisor and Reprint Editor: Carmen Krikorian

Editorial Assistants: Erin Calligan Mooney, Joe Niesen, David Lutton, and Leeann Harney

Cover Photo: © Carson Ganci

Cartoons: Rich Tennant (www.the5thwave.com)

Composition Services

Project Coordinator: Lynsey Osborn

Layout and Graphics: Carl Byers, Brooke Graczyk, Denny Hager, Joyce Haughey, Laura Pence, Heather Ryan, Alicia B. South

Anniversary Logo Design: Richard Pacifico

Proofreaders: Aptara, Todd Lothery, Susan Moritz

Indexer: Aptara

Special Help

Carmen Krikorian and Erin Calligan Mooney

Publishing and Editorial for Consumer Dummies

Diane Graves Steele, Vice President and Publisher, Consumer Dummies

Joyce Pepple, Acquisitions Director, Consumer Dummies

Kristin A. Cocks, Product Development Director, Consumer Dummies

Michael Spring, Vice President and Publisher, Travel

Kelly Regan, Editorial Director, Travel

Publishing for Technology Dummies

Andy Cummings, Vice President and Publisher, Dummies Technology/General User

Composition Services

Gerry Fahey, Vice President of Production Services

Debbie Stailey, Director of Composition Services

Contents at a Glance

Introduction ..1

Part I: Mankind in the Looking Glass: Art History 101....7
Chapter 1: Art Tour through the Ages9
Chapter 2: Why People Make Art and What It All Means15
Chapter 3: The Major Artistic Periods and Movements....................21

Part II: From Caves to Colosseum: Ancient Art33
Chapter 4: Magical Hunters and Psychedelic Cave Artists.................35
Chapter 5: Fickle Gods, Warrior Art, and the Birth of Writing:
 Mesopotamian Art ..43
Chapter 6: One Foot in the Tomb: Ancient Egyptian Art..................55
Chapter 7: Greek Art, the Olympian Ego, and
 the Inventors of the Modern World71
Chapter 8: Etruscan and Roman Art: It's All Greek to Me!89

Part III: Art after the Fall of Rome:
a.d. 500–a.d. 1760 ..103
Chapter 9: The Graven Image: Early Christian, Byzantine, and Islamic Art105
Chapter 10: Mystics, Marauders, and Manuscripts: Medieval Art..........................123
Chapter 11: Born-Again Culture: The Early and High Renaissance........................151
Chapter 12: Venetian Renaissance, Late Gothic,
 and the Renaissance in the North171
Chapter 13: Art That'll Stretch Your Neck: Mannerism189
Chapter 14: When the Renaissance Went Baroque199
Chapter 15: Going Loco with Rococo219

Part IV: The Industrial Revolution and
Artistic Devolution: 1760–1900227
Chapter 16: All Roads Lead Back to Rome and Greece: Neoclassical Art.............229
Chapter 17: Romanticism: Reaching Within and Acting Out239
Chapter 18: What You See Is What You Get: Realism..................................251
Chapter 19: First Impressions: Impressionism263
Chapter 20: Making Their Own Impression: The Post-Impressionists275

Part V: Twentieth-Century Art and Beyond289

Chapter 21: From Fauvism to Expressionism291

Chapter 22: Cubist Puzzles and Finding the Fast Lane with the Futurists.............303

Chapter 23: What You See Is What You Don't Get: From Nonobjective Art
to Abstract Expressionism313

Chapter 24: Anything-Goes Art: Fab Fifties and Psychedelic Sixties339

Chapter 25: Photography: From a Science to an Art353

Chapter 26: The New World: Postmodern Art365

Part VI: The Part of Tens381

Chapter 27: Ten Must-See Art Museums383

Chapter 28: Ten Great Books by Ten Great Artists387

Chapter 29: Ten Brushstrokes That Shook the World391

Appendix: Online Resources399

Index415

Table of Contents

Introduction ... *1*

Part 1: Mankind in the Looking Glass: Art History 101.....7

Chapter 1: Art Tour through the Ages**9**
 That's Ancient History, So Why Dig It Up?..............................10
 Did the Art World Crash When Rome Fell,
 or Did It Just Switch Directions?10
 In the Machine Age, Where Did Art Get Its Power?11
 The Modern World and the Shattered Mirror12

Chapter 2: Why People Make Art and What It All Means**15**
 Focusing on the Artist's Purpose.......................................15
 Religion, ritual, and mythology16
 Politics and propaganda..16
 When I say jump . . . : Art made for patrons17
 Personal vision ..17
 Detecting Design ...17
 Pattern ..18
 Rhythm ...18
 Balance ..18
 Contrast ...19
 Emphasis ...19
 Decoding Meaning...19
 The ABCs of visual narrative ..20
 Sorting symbols ..20

Chapter 3: The Major Artistic Periods and Movements**21**
 Understanding the Differences between a Period and a Movement21
 Art movements ..21
 Art periods ..22
 An Overview of the Major Periods...22
 Prehistoric period (30,000 b.c.–2500 b.c.)............................23
 Mesopotamian period (3500 b.c.–500 b.c.)23
 Egyptian period (3100 b.c.–332 b.c.)..................................24
 Minoan, Ancient Greek, and Hellenistic art24
 Etruscan and Roman art..25
 Byzantine and Islamic art ...25
 Medieval period (500–1400)..26
 Renaissance period ..26
 Baroque and Rococo art..27
 Neoclassicism and Romanticism..27

An Overview of the Major Movements...28
 Realism (1840s–1880s)...28
 The Pre-Raphaelite Brotherhood (1848–1890s) and
 the Arts and Crafts movement (1850s–1930s)28
 Impressionism (1869–late 1880s) ..28
 Post-Impressionism (1886–1892)...29
 Fauvism and Expressionism..29
 Cubism and Futurism...29
 Dada and Surrealism ...30
 Suprematism, Constructivism, and De Stijl: Nonobjective Art.......30
 Abstract Expressionism (1946–1950s).....................................31
 Pop Art (1960s)..31
 Conceptual art, performance art, and feminist art
 (late 1960s–1970s) ..32
 Postmodernism (1970–) ..32

Part II: From Caves to Colosseum: Ancient Art...............33

Chapter 4: Magical Hunters and Psychedelic Cave Artists35
 Cool Cave Art or Paleolithic Painting: Why Keep It a Secret?36
 Hunting on a wall...37
 Psychedelic shamans with paintbrushes................................38
 Flirting with Fertility Goddesses ...38
 Dominoes for Druids: Stonehenge, Menhirs, and Neolithic Architecture...39
 Living in the New Stone Age: Çatalhöyük and Skara Brae..............40
 Cracking the mystery of the megaliths and menhirs.......................40

Chapter 5: Fickle Gods, Warrior Art, and the Birth of Writing:
Mesopotamian Art .43
 Climbing toward the Clouds: Sumerian Architecture....................44
 Zigzagging to Heaven: Ziggurats...45
 The Tower of Babel ..46
 The Eyes Have It: Scoping Out Sumerian Sculpture46
 Worshipping graven images..46
 Staredown with God: Statuettes from Abu Temple.......................47
 Playing Puabi's Lyre..48
 Unraveling the Standard of Ur ..49
 Stalking Stone Warriors: Akkadian Art ..51
 Stamped in Stone: Hammurabi's Code ..51
 Unlocking Assyrian Art..52
 Babylon Has a Baby: New Babylon ...53

Chapter 6: One Foot in the Tomb: Ancient Egyptian Art55
 Ancient Egypt 101...56
 The Palette of Narmer and the Unification of Egypt......................57
 The Egyptian Style ...60
 Excavating Old Kingdom Architecture ...61

The In-Between Period and Middle Kingdom Realism65
New Kingdom Art ..65
 Akhenaten and Egyptian family values...................................66
 Raiding King Tut's tomb treasures ...67
 Admiring the world's most beautiful dead woman......................68
 Decoding Books of the Dead ...69
 Too-big-to-forget sculpture...70

**Chapter 7: Greek Art, the Olympian Ego, and
the Inventors of the Modern World****71**
 Mingling with the Minoans: Snake Goddesses,
 Minotaurs,and Bull Jumpers ...72
Greek Sculpture: Stark Symmetry to a Delicate Balance...................75
 Kouros to Kritios Boy ...75
 Golden Age sculptors: Polykleitos, Myron, and Phidias78
 Fourth-century sculpture ...80
Figuring Out Greek Vase Painting...81
 Cool stick figures: The geometric style82
 Black-figure and red-figure techniques82
Rummaging through Ruins: Greek Architecture83
Greece without Borders: Hellenism...86

Chapter 8: Etruscan and Roman Art: It's All Greek to Me!**89**
The Mysterious Etruscans ...89
 Temple to tomb: Greek influence ..89
 Smiles in stone: The eternally happy Etruscans90
Romping through the Roman Republic..91
 Art as mirror: Roman realism and republican sculptural portraits...92
 Realism in painting...95
 Roman mosaics..97
 Roman architecture: A marriage of Greek and Etruscan styles......98

*Part III: Art after the Fall of Rome:
A.D. 500–A.D. 1760* ..*103*

**Chapter 9: The Graven Image: Early Christian,
Byzantine, and Islamic Art****105**
The Rise of Constantinople..105
 Christianizing Rome..106
 After the fall: Divisions and schisms......................................106
Early Christian Art in the West...107
Byzantine Art Meets Imperial Splendor ...108
 Justinian and Early Byzantine architecture109
 Amazing mosaics: Puzzle art ...111
 Icons and iconoclasm ...115

Islamic Art: Architectural Pathways to God ...117
The Mosque of Córdoba ...118
The dazzling Alhambra ..120
A temple of love: The Taj Mahal ..122

Chapter 10: Mystics, Marauders, and Manuscripts: Medieval Art . . .123

Irish Light: Illuminated Manuscripts ...124
Browsing the Book of Kells, Lindisfarne
Gospels, and other manuscripts ..124
Drolleries and the fun style ..126
Charlemagne: King of His Own Renaissance126
Weaving and Unweaving the Battle of Hastings: The Bayeux Tapestry ...127
Providing a battle blueprint ...127
Portraying everyday life in medieval England and France128
Peddling political propaganda ..129
Making border crossings ..129
Romanesque Architecture: Churches That Squat130
Romanesque Sculpture ..133
Nightmares in stone: Romanesque relief133
Roman sculpture revival ..134
Relics and Reliquaries: Miraculous Leftovers135
Gothic Grandeur: Churches That Soar ...136
Bigger and brighter ..137
Making something new from old parts137
Finishing touches and voilà! ...139
Expanding the Gothic dream ...139
Stained-Glass Storytelling ...140
Gothic Sculpture ...141
Italian Gothic ...143
Gothic Painting: Cimabue, Duccio, and Giotto144
Cimabue ...144
Duccio ...146
Giotto ...147
Tracking the Lady and the Unicorn: The Mystical Tapestries of Cluny ...148

Chapter 11: Born-Again Culture: The Early and High Renaissance . . .151

The Early Renaissance in Central Italy ...152
The Great Door Contest: Brunelleschi versus Ghiberti —
And the winner is! ...152
The Duomo of Florence ...153
What's the point? The fathers of perspective153
Sandro Botticelli: A garden-variety Venus157
Donatello: Putting statues back on their feet158
The High Renaissance ...159
Leonardo da Vinci: The original Renaissance man160
Michelangelo: The main man ...165
Raphael: The prince of painters ...168

Chapter 12: Venetian Renaissance, Late Gothic,
and the Renaissance in the North .**171**
 A Gondola Ride through the Venetian Renaissance171
 First stop, Bellini ...172
 A shortcut to Mantegna and Giorgione173
 Dürer's Venice vacation ...174
 Touring the 16th century with Titian..175
 The Venice of Veronese...177
 Tintoretto and Renaissance ego...179
 Palladio: The king of classicism...179
 Late Gothic: Northern Naturalism ..180
 Jan van Eyck: The Late Gothic ace..180
 Rogier van der Weyden: Front and center....................................183
 Northern Exposure: The Renaissance in
 the Netherlands and Germany...184
 Decoding Bosch...184
 Deciphering the dark symbolism of Grünewald...........................186
 Dining with Bruegel the Elder...186

Chapter 13: Art That'll Stretch Your Neck: Mannerism**189**
 Pontormo: Front and Center..190
 Bronzino's Background Symbols and Scene Layering............................191
 Parmigianino: He's Not a Cheese!..193
 Arcimboldo: À la Carte Art...194
 El Greco: Stretched to the Limit ..195
 Finding Your Footing in Giulio Romano's Palazzo Te197

Chapter 14: When the Renaissance Went Baroque**199**
 Annibale Carracci: Heavenly Ceilings..200
 Shedding Light on the Subject: Caravaggio and His Followers.............201
 Orazio Gentileschi: Baroque's gentle side, more or less...............202
 Shadow and light dramas: Artemisia Gentileschi202
 The Ecstasy and the Ecstasy: Bernini Sculpture....................................203
 Embracing Baroque Architecture ...204
 Dutch and Flemish Realism ...207
 Rubens: Fleshy, flashy, and holy..208
 Rembrandt: Self-portraits and life in the shadows209
 Laughing with Hals ...211
 Vermeer: Musicians, maids, and girls with pearls.........................211
 French Flourish and Baroque Light Shows ..213
 Poussin the Perfect ...213
 Candlelit reverie and Georges de La Tour....................................213
 Versailles: Architecture as propaganda and the Sun King214
 In the Limelight with Caravaggio: The Spanish Golden Age.................215
 Ribera and Zurbarán: In the shadow of Caravaggio215
 Velázquez: Kings and princesses...216

Chapter 15: Going Loco with Rococo .**219**

 Breaking with the Baroque: Antoine Watteau...................................220
 Fragonard and Boucher: Lush, Lusty, and Lavish...............................221
 François Boucher ...222
 Jean-Honoré Fragonard ..222
 Flying High: Giovanni Battista Tiepolo...223
 Rococo Lite: The Movement in England ...224
 William Hogarth...224
 Thomas Gainsborough ...225
 Sir Joshua Reynolds ..225

Part IV: The Industrial Revolution and
Artistic Devolution: 1760–1900..................................**227**

Chapter 16: All Roads Lead Back to Rome and Greece:
Neoclassical Art .**229**

 Jacques-Louis David: The King of Neoclassicism231
 Grand, formal, and retro..231
 Propagandist for all sides...232
 Jean Auguste Dominique Ingres: The Prince
 of Neoclassical Portraiture...234
 Élisabeth-Louise Vigée-Le Brun: Nice and Natural............................235
 Canova and Houdon: Greek Grace and Neoclassical Sculpture.............236
 Antonio Canova: Ace 18th-century sculptor..............................237
 Jean-Antoine Houdon: In living stone237

Chapter 17: Romanticism: Reaching Within and Acting Out**239**

 Kissing Isn't Romantic, but Having a Heart Is239
 Way Out There with William Blake and Henry Fuseli:
 Mythologies of the Mind..241
 Inside Out: Caspar David Friedrich..243
 The Revolutionary French Romantics: Gericault and Delacroix............243
 Théodore Gericault ..244
 Eugène Delacroix ..245
 Francisco Goya and the Grotesque...247
 J. M. W. Turner Sets the Skies on Fire ..249

Chapter 18: What You See Is What You Get: Realism**251**

 Courbet and Daumier: Painting Peasants and Urban Blight..................252
 Gustave Courbet..253
 Honoré Daumier: Guts and grit..254
 The Barbizon School and the Great Outdoors255
 Jean-François Millet: The noble peasants255
 Jean-Baptiste-Camille Corot: From naked
 truth to dressed-up reality ...257

Keeping It Real in America..257
 Westward ho! with Albert Bierstadt................................257
 Navigating sun, storm, and sea with Winslow Homer258
 Boating through America with Thomas Eakins258
The Pre-Raphaelite Brotherhood: Medieval Visions
 and Painting Literature ...259
 Dante Gabriel Rossetti: Leader of the Pre-Raphaelites.................260
 John Everett Millais and soft-spoken symbolism261

Chapter 19: First Impressions: Impressionism**263**
M & M: Manet and Monet...264
 Édouard Manet: Breaking rules to free the artist.......................264
 Claude Monet: From patches to flecks267
Pretty Women and Painted Ladies: Renoir and Degas268
 Pretty as a picture: Pierre-Auguste Renoir...........................269
 The dancers of Edgar Degas270
Morisot and Cassatt: The Female Impressionists271
 Mary Cassatt ..272
 Berthe Morisot..272

Chapter 20: Making Their Own Impression:
The Post-Impressionists .**275**
You've Got a Point: Pointillism and Georges-Pierre Seurat.....................275
Red-Light Art: Henri de Toulouse-Lautrec277
Tracking the "Noble Savage": Paul Gauguin277
 Brittany paintings...278
 Tahiti paintings ...279
Painting Energy: Vincent van Gogh...280
Love Cast in Stone: Rodin and Claudel......................................281
 Auguste Rodin..281
 Camille Claudel ...283
The Mask behind the Face: James Ensor283
The Hills Are Alive with Geometry: Paul Cézanne284
Art Nouveau: When Art and Technology Eloped285
Fairy-Tale Fancies and the Sand-Castle Cathedral of Barcelona:
 Antoni Gaudí ..287

Part V: Twentieth-Century Art and Beyond....................**289**

Chapter 21: From Fauvism to Expressionism**291**
Fauvism: Colors Fighting like Animals......................................292
 Henri Matisse..292
 André Derain ..293
 Maurice de Vlaminck ..294

German Expressionism: Form Based on Feeling295
 Die Brücke and World War I ..295
 Der Blaue Reiter ...298
Austrian Expressionism: From Dream to Nightmare300
 Gustav Klimt and his languorous ladies301
 Egon Schiele: Turning the Self inside out302
 Oskar Kokoschka: Dark dreams and interior storms302

Chapter 22: Cubist Puzzles and Finding the Fast Lane with the Futurists303

Cubism: All Views At Once ...303
 Pablo Picasso ..304
 Analytic Cubism: Breaking things apart306
 Synthetic Cubism: Gluing things together307
 Fernand Léger: Cubism for the common man308
Futurism: Art That Broke the Speed Limit ..309
 Umberto Boccioni ...310
 Gino Severini ...311

Chapter 23: What You See Is What You Don't Get: From Nonobjective Art to Abstract Expressionism313

Suprematism: Kazimir Malevich's Reinvention of Space313
Constructivism: Showing Off Your Skeleton315
 Tatlin's Tower ..316
 A dance between time and space: Naum Gabo317
Piet Mondrian and the De Stijl Movement ...318
Dada Turns the World on Its Head ..319
 Dada, the ground floor, and Cabaret Voltaire319
 Marcel Duchamp: Urinals, hat racks, and bicycle wheels321
 Hans (Jean) Arp: In and out of Dadaland323
Surrealism and Disjointed Dreams ...324
 Max Ernst and his alter ego, Loplop ...324
 Salvador Dalí: Melting clocks, dreamscapes, and ants325
 René Magritte: Help, my head's on backwards!327
 Dissecting Frida Kahlo ..328
My House Is a Machine: Modernist Architecture330
 Frank Lloyd Wright: Bringing the outside in330
 Bauhaus boxes: Walter Gropius ...331
 Le Corbusier: Machines for living and Notre Dame du Haut333
Abstract Expressionism: Fireworks on Canvas334
 Arshile Gorky ..334
 Jackson Pollock ..335
 Willem de Kooning ...337

**Chapter 24: Anything-Goes Art: Fab Fifties
and Psychedelic Sixties** .**339**
 Artsy Cartoons: Pop Art...339
 The many faces of Andy Warhol......................................340
 Blam! Comic books on canvas: Roy Lichtenstein..........342
 Fantastic Realism ..343
 Ernst Fuchs: The father of the Fantastic Realists........343
 Hundertwasser houses ...344
 Less-Is-More Art: Rothko, Newman, Stella, and Others....345
 Color Fields of dreams: Rothko and Newman................346
 Minimalism, more or less ...347
 Photorealism..347
 Richard Estes: Always in focus...348
 Clinical close-ups: Chuck Close348
 Performance Art and Installations.......................................349
 Fluxus: Intersections of the arts......................................349
 Joseph Beuys: Fanning out from Fluxus350

Chapter 25: Photography: From a Science to an Art**353**
 The Birth of Photography ...354
 From Science to Art ...355
 Alfred Stieglitz: Reliving the Moment356
 Henri Cartier-Bresson and the "Decisive Moment"357
 Group f/64: Edward Weston and Ansel Adams.................359
 Dorothea Lange: Depression to Dust Bowl360
 Margaret Bourke-White: From Smokestacks and Steel Mills
 to Buchenwald and the Death of Gandhi........................361
 Fast-Forward: The Next Generation....................................363

Chapter 26: The New World: Postmodern Art**365**
 From Modern Pyramids to Titanium Twists:
 Postmodern Architecture..365
 Viva Las Vegas!..366
 Chestnut Hill: Case in point..367
 Philip Johnson and urban furniture.................................367
 The prismatic architecture of I. M. Pei368
 Deconstructivist architecture of Peter Eisenman,
 Frank Gehry, and Zaha Hadid.......................................369
 Making It or Faking It? Postmodern Photography and Painting372
 Cindy Sherman: Morphing herself373
 Gerhard Richter: Reading between the layers...............374
 Installation Art and Earth Art...375
 Judy Chicago: A dinner table you can't sit down at.....375
 It's a wrap: Christo and Jeanne-Claude............................376
 Robert Smithson and earth art: Can you dig it?...........377
 Glow-in-the-Dark Bunnies and Living, Genetic Art.........379

Part VI: The Part of Tens381

Chapter 27: Ten Must-See Art Museums383

The Louvre (Paris) ...383
The Uffizi (Florence) ...384
The Vatican Museums (Rome)384
The National Gallery (London)384
The Metropolitan Museum of Art (New York City)....385
The Prado (Madrid) ..385
The Hermitage (St. Petersburg)385
The Rijksmuseum (Amsterdam)386
British Museum (London)..386
The Kunsthistorisches (Vienna)386

Chapter 28: Ten Great Books by Ten Great Artists387

On Painting, by Leonardo da Vinci..........................387
Lives of the Most Eminent Painters, Sculptors,
 and Architects, by Giorgio Vasari.......................388
Complete Poems and Selected Letters of Michelangelo........388
The Journal of Eugène Delacroix..............................388
Van Gogh's Letters ...388
Rodin on Art, by Paul Gsell389
Der Blaue Reiter (The Blue Rider) Almanac, edited
 by Wassily Kandinsky and Franz Marc389
Concerning the Spiritual in Art, by Wassily Kandinsky.........389
The Diary of Frida Kahlo: An Intimate Self-Portrait............390
Hundertwasser Architecture: For a More Human Architecture
 in Harmony with Nature, by Friedensreich Hundertwasser390

Chapter 29: Ten Brushstrokes That Shook the World391

The Man Who Mainstreamed Oil Paint: Jan van Eyck...........391
What's That Smoke? Leonardo Da Vinci392
Lost and Found in Rembrandt's Shadows..................392
Does the Guy Need Glasses? Monet and Impressionism393
Pinpointing Seurat's Style393
The Frenzied Brush: Van Gogh394
Paint It Blue: Picasso ...394
Painting Musical Colors: Kandinsky395
Paint-Throwing Pollock ..395
Squeegee Painting and Richter................................396

Appendix: Online Resources399

Index...415

Introduction

● ●

My goal in writing *Art History For Dummies* was to make it as useful, fun to read, and handy as a good travel guide. This book covers a lot of art history, but not everything. I focus on the Western art tradition and cover some art and art movements that other art history books neglect.

Most art-history books these days weigh in at about 10 pounds. I made this book leaner so you could stick it in your backpack and carry it to class without feeling weighted down, or so you can take it on a long trip as a guidebook or carry it around a museum as a handy resource.

As you read *Art History For Dummies,* you'll journey around the world and travel back in time. Reading many of the chapters is like going on a vacation to an exotic land in a past life. You can hobnob with a Byzantine empress or an Egyptian pharaoh, attend the ancient Olympics (the games were often depicted on Greek vases), or stroll through the Ishtar Gate in ancient Babylon.

Why do some people study art history and others don't? Probably because high schools don't often teach art history and colleges usually offer it as an elective, unless you're an art major. But art history is the visual side of history — they're sister subjects. Studying art history and history together is like adding pictures to text. It makes the overall story clearer and more interesting. In *Art History For Dummies,* I often splice history and art history together, giving you a context for the art.

Some people believe art history is a high-brow subject. With all those Italian and French terms, it just has to be snobby, right? I disagree. I believe art history is an everyman/everywoman subject because it's about mankind's common cultural heritage. Art history mirrors human evolution. It shows mankind through the ages, from cave to castle, jungle hut to urban high-rise. Each age for the last 30,000 years has left an imprint of itself in its art.

About This Book

In this book, I'm your tour guide through the world of art history. The tour features the greatest art and architecture ever created. On the journey, I point out the key features of these works and structures; often, I suggest possible

interpretations that I hope inspire you to make your own interpretations. I also add spicy anecdotes and colorful facts to make every stop on the tour fun.

This book is a reference — it's something you can turn to again and again, dipping into it to find whatever piece of information is most critical to you at the time. You don't have to read it cover to cover. Use the table of contents and index to find the subjects that you're interested in and go from there. Of course, if you want to start with Chapter 1 and read through to the end, you can — but it isn't a requirement to understand the information in these pages.

Conventions Used in This Book

The conventions used in this book are pretty straightforward. When I introduce new terms, I put them in *italics* and define them in context. I put e-mail addresses and Web addresses in monofont so you can spot them more easily and know exactly what to type.

When this book was printed, some Web addresses may have needed to break across two lines of text. If that happened, rest assured that I haven't put in any extra characters (such as hyphens) to indicate the break. So, when using one of these Web addresses, just type in exactly what you see in this book, pretending as though the line break doesn't exist.

What You're Not to Read

Here's a novel idea: Don't read anything you're not interested in. If you think Egyptian tombs are dreary, or if Postmodernism makes you dizzy, skip those subjects. You don't have to remember everything you read, either. After all, I'm not testing you on any of this. You can also skip anything in a sidebar — a gray box of text — without missing the meat of what I'm covering. Sidebars often have interesting information, but they aren't essential to the topic at hand.

Foolish Assumptions

You don't need to have taken remedial art history or even studied high school art to understand and benefit from this book. This is Art History 101 and there are no prerequisites! I assume you've at least *heard* of Leonardo da Vinci's *Mona Lisa* and Michelangelo's *Sistine Chapel Ceiling*. But if you haven't, it's no biggie — you have now. You don't need any background in art history or art. I give you the background you need as I go along.

I also assume that anything with the word *history* attached to it may scare you. It conjures up visions of memorizing dates and isms in high school. That's okay. I give some dates and define some isms, but I don't dwell on that side of art history. I prefer to get into the fun stuff. Instead of putting dates and isms in the foreground of the subject, in this book I put the story of art front and center. Bottom line: You won't have to memorize dates. In fact, you won't have to memorize *anything!*

How This Book Is Organized

I break the chapters of *Art History For Dummies* into parts, described in the following sections.

Part I: Mankind in the Looking Glass: Art History 101

Chapter 1 helps you decide which chapters you want to read first and which chapters you may want to skip, at least for the time being. I've arranged the chapters in chronological order. But you don't have to follow that order; you can jump from Surrealism to cave art if you like, or from the Renaissance to Impressionism.

In this part, I also introduce you to the tools and art concepts that will help you navigate this book and the world of art and art history. These tools and concepts include comparing and contrasting, looking at balance and pattern, reading visual narrative, sorting out symbolism, and figuring out the artist's intention.

Finally, in Chapter 3, I give you a quick rundown of the major art periods and movements, from prehistoric art to Postmodernism and everything in between. You may want to periodically refer back to this chapter as a quick reference to see how the periods fit together and influence each other.

Part II: From Caves to Colosseum: Ancient Art

In this part, I look at Stone Age art and its roots in ritual and primitive religion. Next, I examine the religious and political art of the first civilizations in Mesopotamia and Egypt. Then I explore ancient Minoan and Greek vase and

mural painting, sculpture, and architecture and tell you how Greek culture laid the foundation for the modern world. I show you how Etruscan and Roman art are in some ways outgrowths of Greek art. In my coverage of Roman art, I explain how closely art, architecture, and politics can be interwoven.

Part III: Art after the Fall of Rome: A.D. 500–A.D. 1760

Classical art tumbled with Rome in A.D. 476. New religious-centered art styles emerged in both Europe and Asia. In this part, I examine the glittering Byzantine art of the Eastern Roman Empire (which outlived the Western Empire by about 1,000 years), early Christian art in Europe, and Islamic art. I follow the evolution of religious art in Europe during the Middle Ages, focusing on manuscript illuminations, relief sculpture, architecture, tapestries, and painting. Then I explore the rebirth of classical art during the Renaissance and the art traditions that grew out of this rebirth: Mannerism, Baroque, and Rococo.

Part IV: The Industrial Revolution and Artistic Devolution: 1760–1900

The Industrial Revolution transformed the world — and the way artists viewed and depicted it. In this part, I show you how some artists tried to rewind the clock — their art was a graceful throwback to classicism: Some grounded themselves in the glories of unsullied nature, while others soared beyond the stench of industrial mills on the wings of their imaginations. The Industrial Revolution also jumpstarted sweeping political turnovers like the American and French revolutions. I show you how Romantic and Realistic art reflected and often encouraged independence movements, democracy, and social change.

Part V: Twentieth-Century Art and Beyond

In the 20th century, art fanned out in so many directions, it can be hard to track all of them. But I do exactly that in this part. World War I, World War II, and the Vietnam War all had enormous impacts on artists who lived through those catastrophes. In this part, I show you how war spawned arts movements, the goals of which were sometimes the betterment of mankind. I also show you how artists struggled to reflect an increasingly complex world and how they used technology to give their art added horsepower. Finally, I explore early photography and identify how the pioneers of photography slowly learned to focus their art.

Part VI: The Part of Tens

The Part of Tens, a feature of every *For Dummies* book, is a place to go when you're short on time but craving information. In this part, I provide a list of ten must-see art museums. I briefly describe the museums' collections and highlight a few of the most celebrated works.

I also recommend ten great art books penned by ten great artists. I strongly recommend you pick up one of these books to discover what the artists themselves thought about their art and life in general. If you're a student, you can use any of these books to write a report on the artist-author. If you're not a student, the books will simply enrich and inspire you.

Finally, I introduce you to ten revolutions in tastes that began on the tips of paintbrushes. Some of these revolutions were short lived, like Seurat's Pointillism (painting with dots) movement; others were highly influential. I fill you in here.

Appendix

I couldn't fit in this book every piece of art that I wanted to discuss, so I've included an appendix that lists many of these pieces and the Web sites where you can go to see them. As always, Web addresses are subject to change. The addresses are current as of this writing, but if a page has moved, you can use your favorite search engine to track it down.

Icons Used in This Book

This book uses icons in the margins, designed to flag your attention for a particular reason. Here's what each icon means:

When I have a little artsy gossip to share with you, I use the Anecdote icon. Think of these as the *Art History For Dummies* version of the *E! True Hollywood Story.*

Paragraphs marked with the Contrast icon tell you to compare or contrast one piece of art with another, to reveal something interesting about both.

This icon is like a nudge in the ribs reminding you to file away information for future use.

When I give you more information than you really need, I mark it with a Technical Stuff icon. This is interesting stuff, but if you just want to know what you need to know, you can skip it.

The Technique icon lets you know that the paragraph to its right covers technique — how the artist made that piece of art.

Paragraphs marked with the Tip icon offer suggestions for unraveling complicated images and making your review of art history easier and more fun.

Where to Go from Here

You can dive into this book anywhere you like. I've organized *Art History For Dummies* so that you can read it in two ways:

- ✔ **You can take the full tour and read the book chronologically from cover to cover.** This is a great way to see how art evolved over the millennia.

- ✔ **You can jump into any chapter or section within a chapter, extract the information you need, and skip the rest.** For example, if you're planning to see an Egyptian exhibition or you're taking a test on the period, Chapter 6 will give you all the information you need to ace the test or enjoy the show.

If you don't begin at the beginning, I recommend starting with the chapter that covers the art you like best. If it's Michelangelo and Leonardo, start with Chapter 11 on the Early and High Renaissance; if it's Frida Kahlo, start with Chapter 23, which includes Surrealism and other movements. Then fan out from there. Each period or movement will lead you to the periods that it grew out of and that grew out of it, giving you a better understanding of why Leonardo da Vinci, Michelangelo, or Frida Kahlo painted as they did.

Finally, if you have questions or comments about this book, you can e-mail me at jesse_bryant_wilder@hotmail.com.

Part I
Mankind in the Looking Glass: Art History 101

MANY FAMOUS ARTISTS EXPERIMENTED IN THE STICK FIGURISM MOVEMENT IN ART

Edvard Munch

Grant Wood

Renoir

In this part . . .

In this part, I tell you what art history is, why people have made art almost nonstop throughout the ages, and how to look at art. You see why art history is worth studying (art gives you snapshots of human evolution, before and after the invention of the camera). And you see what separates art history from history — and what connects them. I end the part with brief, useful descriptions of all the art periods and movements.

Chapter 1

Art Tour through the Ages

. .

In This Chapter

▶ Understanding the difference between art history and plain, old history

▶ Recognizing the importance of art from prehistoric times to the present

. .

*W*hy study art history rather than music history, literary history, or the history of the postage stamp? Art history, which begins around 30,000 B.C. with the earliest known cave paintings (see Chapter 4), predates writing by about 26,500 years! That makes art history even older than history, which begins with the birth of script around 3500 B.C.

Along with archaeology, art history is one of our primary windows into *prehistory* (everything before 3500 B.C.). Cave paintings, prehistoric sculpture, and architecture together paint a vivid — although incomplete — picture of Stone Age and Bronze Age life. Without art history, we would know a lot less about our early ancestors.

Okay, but what do you need art history for after the historical period kicks in around 3500 B.C.? History is the *diary* of the past — ancient peoples writing about themselves combined with our interpretation of what they say. Art history is the *mirror* of the past. It shows us who we were, instead of telling us, as history does. Just as home movies document a family's history (what you wore when you were 5, how you laughed, and what you got for your birthday), art history is the "home movie" of the entire human family through the ages.

History is the study of wars and conquests, mass migrations, and political and social experiments. Art history is a portrait of man's inner life: his aspirations and inspirations, his hopes and fears, his spirituality and sense of self.

That's Ancient History, So Why Dig It Up?

If we know who we were 10,000 years ago, we have a better sense of who we are today. Even studying a few Ancient Greek vases can reveal a lot about modern society — if you know how to look at and read the vases.

Many Greek vases show us what ancient Greek theater looked like; modern theater and cinema are the direct descendants of Greek theater (see Chapter 7). Greek vases depict early musical instruments, dancers dancing, and athletes competing in the ancient Olympics, the forerunner of the modern Olympic Games. Some vases show us the role of women and men: Women carry vases called *hydrias;* men paint those vases.

Ancient art teaches us about past religions (which still affect our modern religions) and the horrors of ancient war craft. Rameses II's monument celebrating his battle against the Hittites (see Chapter 6) and Trajan's Column (see Chapter 9), which depicts the Emperor Trajan's conquest of Dacia (modern-day Romania), are enduring eyewitness accounts of ancient battles that shaped nations and determined the languages we speak today.

Art isn't just limited to paintings and sculptures. Architecture, another form of art, reveals the way men and women responded to and survived in their environment, as well as how they defined and defended themselves. Did they build impregnable walls around their cities? Did they raise monuments to their own egos like the female pharaoh Hatshepsut and the vainglorious Rameses II (see Chapter 6)? Did they erect temples to honor their gods or celebrate the glory of their civilizations like the Greeks (see Chapter 7)? Or did they show off their power through architecture to intimidate their enemies like the Romans (see Chapter 8)?

Did the Art World Crash When Rome Fell, or Did It Just Switch Directions?

Art definitely changed course with the exponential rise of Christianity during the last phase of the Roman Empire.

Throughout the Middle Ages, art and architecture had a spiritual mission: to direct man's attention toward God. Churches soared in that direction, and sculpture and paintings pointed the way to paradise. They depicted the sufferings of Christ, the Apostles, martyrs, the Last Judgment, and so on.

Man's physical features mattered less to medieval artists than his spiritual struggles and aspirations. So they tended to represent man more symbolically than realistically (see Chapter 10). In Byzantium, religious art had the double role of celebrating the Orthodox Church and the Eastern Roman Empire, which endured until 1453. The Islamic world channeled much of its creative energy into architecture and decorative splendor that has never been surpassed (see Chapter 9).

During the Renaissance, man's spiritual focus shifted again. You could say that Renaissance man had a double vision: He wore spiritual bifocals so that he could see close up (earthly things) and far away (heaven). With this double vision, Renaissance artists celebrated both man and God without short-changing either. The close-up focus allowed realism to make the come-back we call the Renaissance: man reclaiming his classical (Greek and Roman) heritage (see Chapters 11 and 12).

The Reformation split Christianity down the middle, unleashing a maelstrom of religious wars between Catholics and Protestants and nearly 200 years of intolerance. To recover what lost ground she could, the Catholic Church launched the Counter-Reformation in the middle of the 16th century. One of the weapons the Church used was religious art that reaffirmed Catholic values while rendering them more people friendly. Baroque saints shed the idealistic luster they had during the Renaissance and began to look like working-class folk — the class the Church was trying to hold on to (see Chapter 14). Baroque art and architecture are characterized by grandiose decoration, dramatic lighting, and theatrical gestures that seem to reach out to viewers, mixed with earthy realism.

In the Machine Age, Where Did Art Get Its Power?

Many 18th- and 19th-century artists rejected, criticized, or ignored the Industrial Revolution. Instead of uplifting man, industry seemed to demoralize and dehumanize him. Men, women, and children were forced to work 14 hours a day, 6 days a week in urban factories, without benefits or vacations. Factories polluted the cities, alienated man from the soil, and seemed to benefit only those who owned them. This led many artists to turn to nature or the past or to a make-believe Golden Age when life was beautiful and just. It provoked others to try to reform society through their art.

Neoclassical artists didn't paint factories or the urban poor, and they didn't celebrate the upside of the Industrial Revolution: the wider availability of products. Instead, Neoclassicism looked back to the pure air and refined

beauty of the classical era. Often, artists dressed contemporary heroes in Roman togas and posed them like Olympians. In Neoclassical art, no one sweats or strains; no one's hair is ever mussed; and everything is tame, elegant, and orderly (see Chapter 16).

The Romantics believed in individual liberty and the rights of man. They supported and actively encouraged democratic movements and social justice; they opposed slavery and the exploitation of labor in urban factories. *Freedom, liberty,* and *imagination* were their favorite words, and some were willing to die for these ideals. Many Romantics tried to reform man by emphasizing his spiritual kinship with nature. Others sought a spiritual communion with the divine through their imaginations. Romanticism is an art of intense emotions and passion that exalts individual freedom, while facing off with the infinite and even with death (see Chapter 17).

The next generation of artists, the Realists (see Chapter 18), tried to elevate middle- and upper-class consciousness regarding the struggles of the poor (factory workers and agricultural laborers) by illustrating them plainly and honestly. The invention of tin tubes for oil paint in 1841 enabled these artists to paint outdoors *(en plein air),* capturing laborers on canvas while they worked.

Impressionist painters tried to capture on canvas fleeting moments and the changing effects of light (see Chapter 19). Their rapid brushstrokes (you have to paint fast if you're going to catch a fleeting moment) give their work a fuzzy, slightly out-of-focus look. In the 1870s, people thought their paintings looked unfinished — or that the artists needed glasses. Today Impressionism is the most popular style from all of art history.

The Post-Impressionists (see Chapter 20) didn't have one guiding vision like the Impressionists. In fact, each Post-Impressionist had his own artistic philosophy. Van Gogh pursued a universal life force behind all things; Gauguin tracked primitive emotions and the "noble savage" all the way to Tahiti; Cézanne painted the geometrical building blocks of nature; and Ensor unmasked society by giving everyone a mask!

The Modern World and the Shattered Mirror

By the beginning of the 20th century, the camera seemed to have a monopoly on realism. That may be one reason painters turned increasingly toward abstraction. But it's not the only reason. Following Cézanne's example, many

artists strove to simplify form (the human body, for example) into its geometrical components; that goal was partly the impetus for Cubism (see Chapter 22). The Fauves expressed emotion with color; and the Expressionists did the same thing by distorting form (see Chapter 21 for both).

World War I slammed the door on the past for a lot of artists because the old order had caused the war — the worst in history. The so-called "anti-art" movement, Dada (see Chapter 23), was a direct reaction to World War I. If war was rational, artists would be irrational. Sigmund Freud's theories of the role of the unconscious (the home of the irrational) inspired the Surrealists (the offspring of Dada) to paint their dreams and coax the unconscious to the surface so they could channel it into their art (see Chapter 23). Einstein's theory of relativity (published in 1905) stimulated the Futurists to include the fourth dimension, time, in their work (see Chapter 22).

Horrendous acts of injustice during the global depression of the 1930s, racism, and World War II fired up many artists, especially photographers, to create activist art. New technology enabled photographers to capture people quickly and discreetly, showing life more "honestly" or more unposed than ever before. The cameras of pioneering photojournalists like Henri Cartier-Bresson, Dorothea Lange, and Margaret Bourke-White zoomed in on urban life, poverty, and war, and showed the entire world grim realities (as well as beautiful ones) that had previously been swept under the carpet (see Chapter 25).

After the Holocaust and Hiroshima, mankind seemed overdue for an appointment on the psychoanalyst's couch. That's exactly where some artists and thinkers went. Psychoanalysis inspired one postwar American artist to pioneer Abstract Expressionism (see Chapter 23), the first influential and imitated American art movement. Jackson Pollock's Abstract Expressionist works look like he dropped the big one on each of his canvases — or at least a paint bomb. Actually, he just dripped, poured, and threw paint at his canvases instead of slathering it on with a brush.

Pollock's and de Kooning's *action painting* — as dripping and throwing paint came to be called — signaled that art had moved away from craft toward pure expression and creative conceptualization. Many new forms of art grew out of the notion that process is more important than product. Craft had been the cornerstone of art for millennia. But after the war, Pollock and de Kooning seemed to drop an atom bomb on art itself, to release its pure creative energy (and shatter form to smithereens). Conceptualization began to drive the work of more and more artists. However, while this trend continued in performance art, installation art, and conceptual art, some artists backtracked to representation. The Photorealists, for example, showed that painting could reclaim realism from the camera (see Chapter 25).

Postmodernism (see Chapter 26) is an odd term. It suggests that we've hit a cultural dead end, that we've run out of ideas and can't make anything new or "modern." All that's left is to recycle the past or crab-leg it back to the cave days. Postmodern artists *do* recycle the past, usually in layers: a quart of Greece, a cup of Constructivism, a pound of Bauhaus, and a heaping table-spoon of Modernism. What's the point of that? Postmodern theorists believe that society is no longer centered. In the Middle Ages, art revolved around religion. In the 19th century, Realist art centered around social reform, and Surrealism dove into dreams and the unconscious. But since the 1970s, point of view has become fluid. Even the political left and right get mixed up some-times. To express our uncentered or ungrounded existence, artists try to show the relationships between past eras and the present. Some critics argue that Postmodernism is a spiritual short circuit, a jaded view that separates meaning from life. You be the judge.

Chapter 2

Why People Make Art and What It All Means

In This Chapter

▶ Exploring the reasons artists make art

▶ Understanding the elements of art

▶ Decrypting those deep meanings

A rt is a sometimes mysterious form of communication. What did so-and-so mean to convey when he or she carved a stone into a fat fertility goddess or a fractured geometric shape? In this chapter, I help you demystify the visual language that we call art.

Focusing on the Artist's Purpose

Why do artists make art? To celebrate god, glorify the state, overthrow governments, make people think, or to win fame and fortune? Or do they make art because, for them, creating is like breathing — they *have* to do it?

Artists create for all these reasons and more. Above all, great artists want to express something deeper than ordinary forms of communication — like talking or writing — can convey. They strive to suggest meanings that are beyond the reach of everyday vocabularies. So they invent *visual* vocabularies for people to interpret. Each person can "read" this picture language — which doesn't come with a dictionary — differently.

This difference in the way each person "reads" a piece of art is especially true of art made in the past 500 years. Ancient as well as medieval art (art made before 1400) often had a communal purpose and a common language of symbols that was widely understood; often that communal purpose was linked to religion, ritual, or mythology.

Religion, ritual, and mythology

The earliest works of art — prehistoric cave paintings from 30,000 B.C. to 10,000 B.C. (see Chapter 4) — were likely to have been a key part of a *shamanistic ritual* (a priest acting as a medium enters the spirit world during a trance). In many prehistoric cultures, people thought religion and ritual helped them to control their environment (for example, fertility rituals were linked to a god or goddess of crops, and were designed to guarantee a successful harvest) or prepare for an afterlife. Art (and often dance and music) frequently had a role in these religious rituals.

Scholars don't know much about the religion of prehistoric man (people who lived between 30,000 B.C. and 3500 B.C.). But they know a great deal about the religions of the earliest civilizations in Mesopotamia and Egypt (which began around 3500 B.C.). Some Mesopotamian art and most Ancient Egyptian art have a religious theme. Egyptian art typically focuses on the afterlife and man's relationship with the gods.

During the Roman period (476 B.C.–A.D. 500), religious art was less common than *secular art* (art about man's life on earth). But religious art dominated the Middle Ages (500–1400), lost some ground during the humanistic Renaissance (1400–1520) and Mannerist period (1520–1600), and made a comeback in the Baroque period (1600–1700) during the religious wars between Catholics and Protestants.

Politics and propaganda

The U.S. Constitution guarantees separation of church and state. But in many earlier civilizations, religion and politics were two sides of the same coin. Egyptian pharaohs, for example, viewed themselves as God's divine representatives on earth. Egyptian art was both religious and political. The notion of the *divine right of kings,* in which kings were supposedly appointed by God to rule on earth (and which continued up to the French and American revolutions in the late 1700s), is rooted in these ancient Egyptian practices.

In Ancient Greece, Pericles (the leader of Athens at its cultural and political peak) ordered and paid for the building of the Parthenon and other monuments (using money permanently borrowed from Athens's allies) to memorialize Athenian power and prestige. "These works will live forever as a testament to our greatness," he said. Art was meant to glorify the state.

Similarly the Romans erected columns, such as Trajan's Column (see Chapter 8), and triumphal arches, like the Arch of Constantine, to celebrate Roman victories and assert Roman power.

In the early 19th century, the French Romantic painter Eugène Delacroix fired up people to fight for democracy with his painting *Liberty Leading the People* (see Chapter 17).

When I say jump . . . : Art made for patrons

A lot of art was commissioned by rich and powerful patrons to serve the patrons' purposes. Some of them commissioned religious works showing themselves kneeling beside a saint, perhaps to demonstrate their religious devotion and earn brownie points from God. Others commissioned works to celebrate themselves or their families — for example, Phillip II of Spain paid Spanish painter Diego Velázquez to immortalize Phil's family during the Baroque period.

Some patrons merely wanted to fatten their art collections and enhance their prestige — like Pieter van Ruijven who commissioned works from Johannes Vermeer in 17th-century Holland. Van Ruijven (1624–1674) was one of the richest men in Delt and was Vermeer's primary patron.

Personal vision

No one paid Vincent van Gogh to paint. In fact, he only sold one painting during his lifetime. Van Gogh was the classic starving artist — but he kept painting, driven by a personal vision that his public didn't share or understand.

Many modern artists are also driven by a personal vision, a vision that offers the public a new way of looking at life. Typically, these artists have to struggle to communicate their vision and find an accepting public. Until they find that acceptance, many of them must eat and sleep in Van Gogh's shoes.

Detecting Design

Design is the arrangement of visual elements in a work of art. In this section, I show you how to recognize and interpret design elements in the art you see.

Pattern

Pattern is as important in visual art as it is in music or dance. A song is a pattern of notes; a dance is a pattern of movement; and a painting is a pattern of colors, lines, shapes, lights, and shadows. Patterns give consistency and unity to works of art. Mixing a pretty floral pattern with a checkerboard design would be as inconsistent as pasting two types of wallpaper together. The key to pattern is consistency. That said, an artist may choose to intermingle several patterns to create contrast (see "Contrast," later in this chapter).

Sometimes patterns in art are as easy to recognize as the designs in wallpaper — but more often, the patterns are complex, like musical motifs in a Beethoven symphony or the intricate design in a Persian carpet or a rose window (see the rose window of the north transept of Chartres Cathedral in the color section). Patterns may also be subtle, like the distribution of colors in Jacopo Pontormo's *The Entombment* (see the color section).

Rhythm

Visual art also has rhythm, like music. Although you can't tap your feet to it, a visual beat does make your eyes dance from hot color to cool color (as in Matisse's *The Joy of Life* in the color section), from light to shadow, or from a wide wavy line to a straight one. Without varied visual rhythms, the artwork would be static (or monotone, like wallpaper with the same visual rhythm repeated over and over), and your eyes would lock on one thing or fail to notice anything at all.

Balance

Each part of a painting or relief has visual weight. The artist carefully distributes this weight to balance the work of art. Look at the visual weight distribution in Sandro Botticelli's *Primavera* (see the color section): The two male figures on opposite ends of the painting balance it like bookends. Venus stands in the center spreading love from left to right — to the trinity of Graces (on the viewer's left) and to the goddess Flora and nymph Chloris (on the viewer's right). If Botticelli had placed Flora, Chloris, and the Graces on the same side of the painting, it would have been lopsided. Besides, Botticelli is telling two love stories in the same painting.

Usually, the more symmetrical and balanced a work of art (sometimes to the point of stiffness), the more likely it is that the piece of art depicts something godlike, important, or ideal, as in Leonardo da Vinci's *The Last Supper* (see the color section).

Contrast

The stiffness that balance can bring with it (see the preceding section) can be balance's biggest problem. For example, most Egyptian statues are *so* symmetrical that they seem rigid and unable to move. Art needs something to upset the scales a bit.

Contrast can disrupt balance while preserving it, as in Polykleitos's *Doryphoros,* or *Spearbearer* (see Chapter 7). The statue is balanced, but his limbs strain in opposite directions. The opposites — the cocked left knee and the cocked right arm — balance each other while creating contrast and tension.

Contrast has other roles in art beyond disrupting and preserving balance. It creates interest and excitement. Artists can create contrast by offsetting wavy lines with straight lines (a winding road snaking through a grid, for example) or by *juxtaposing* (placing side by side) organic shapes and geometric shapes (like planting a pear inside a pyramid). René Magritte created startling contrasts by placing a soft, curvaceous woman beside a boxy solid wall and a rock (see his *La Magie Noir,* or *Black Magic,* in the color section); the color of the wall and the woman's lower body are almost the same, but the wall is rough and rectangular and the woman is soft and curvy. That's contrast.

Emphasis

Emphasis — something that stands out from the rest of the artwork — is important, too. Artists can achieve emphasis with striking colors, contrast, or placement of a figure (at the center of a painting, for example). Like the X that marks the spot on a map, emphasis draws the viewer's attention to what's unique and most important — to the treasure in the artwork.

Sometimes artists achieve emphasis by sticking something odd or striking in the middle of a painting (like a dark figure, when the other figures are well-lit) or by painting a naked woman having a picnic with men in suits (as Édouard Manet does in his famous *Luncheon on the Grass*).

Decoding Meaning

Of course, art also conveys meaning. Sometimes it tells a story (visual narrative); sometimes it suggests meaning through symbolism and metaphor like a poem; and at other times meaning seems to swim inside the feeling you get from the art — kind of like it does in music (you have a vague sense of meaning, but the feeling overrides it).

The ABCs of visual narrative

How do you know when an artist is telling a story? To decide whether a painting is a visual narrative, you should ask yourself three questions:

- ✔ Does the artwork suggest the passage of time (as opposed to being static, like a still life)?
- ✔ Does it seem to have a beginning and an end?
- ✔ Does it hint at something that happens outside of the picture frame?

If the answer to any of these questions is "yes," then the artist is probably telling a story.

How do you read these stories? To read a narrative painting, you don't necessarily start at the left and move toward the right the way you read a book — although sometimes you do as in the Bayeux Tapestry (see Chapter 10). Instead, you begin at the *focal point* (the place where the artist leads your eye). The focal point may be the beginning of the story — but it can also be the climax.

The key is to look for relationships in the painting among people and between people and their surroundings. Is someone in love, broken-hearted, jealous, or vengeful? Is she at home in her world or alienated? Also ask yourself what happened to the person in the painting just before the moment depicted, what's happening at that moment, and what will happen next. Look for clues, like pointing figures, facial expressions, and meaningful gestures as in Caravaggio's *Calling of Saint Matthew* (see the color section). Who or what is the person in the artwork looking at? Let *his* eyes lead *your* eyes.

Sorting symbols

Symbolism is often a key part of visual narrative and even of portraits and still lifes. Understanding symbols helps you enter the world and situation of the painting. Without that understanding, you may miss much of an artist's message. For example, many observers believe that the meandering road in Leonardo da Vinci's *Mona Lisa* (see Chapter 11) symbolizes the path of life, or as the Beatles called it, "The Long and Winding Road." The skull in Frans Hals's *Young Man with a Skull* obviously symbolizes death, and the apple in Nicolas Poussin's *The Holy Family on the Steps* (see the color section) clearly suggests the Garden of Eden, even though there's no sign of Adam and Eve or the serpent.

Chapter 3

The Major Artistic Periods and Movements

In This Chapter

▶ Identifying the difference between a movement and a period

▶ Exploring the main art periods

▶ Delving into the major art movements

*A*rt history is divided into periods and movements. In this chapter, I take you chronologically through these divisions, giving you a quick-reference description of the major ones.

Understanding the Differences between a Period and a Movement

Art movements and art periods represent the art of a group of artists over a specific time period. The difference between a period and a movement has to do with duration and intention.

Art movements

An *art movement* is launched intentionally by a small group of artists who want to promote or provoke change. A movement is usually associated with an art style and often an ideology. Like the women's movement or the civil rights movement, an art movement may push for a new perspective on specific issues. For example, members of the movement may oppose war or a particular political system. Sometimes they write manifestos that spell out their goals and hold movement meetings.

Typically, the artists in a movement hang out together and show their work in group exhibitions. Their art shares stylistic features and focuses on similar subjects.

Art periods

An *art period* is usually not driven by conscious choice on the part of artists. Periods typically outlast movements and develop gradually due to widespread cultural or political pressures.

Often, an art period is based on a parallel historical era. For example, *Early Christian art* refers to art made during the early Christian era. The artists painted Christian subjects and shared a set of religious beliefs. But they didn't write manifestos or hold meetings in which they discussed ideology and stylistic guidelines. Art historians group their art together because they lived at the same time, painted similar subjects, and were driven by a similar spirit — the spirit of their religion, culture, and age.

An Overview of the Major Periods

An art period can last anywhere from 20,000 years to 50 years, depending on the rate of cultural change. Cave art began around 30,000 B.C. and ended with the Paleolithic period, or Old Stone Age, between 10,000 B.C. and 8,000 B.C., depending on where you lived with respect to the receding Ice Age. In those days, culture changed about as fast as a glacier melts — and this was before global warming. The Neoclassical period, on the other hand, only lasted about 65 years, from 1765 to 1830. The Industrial Revolution accelerated the rate of social and cultural change after the mid-18th century.

Sometimes the distinction between a period and a movement is fuzzy. The High Renaissance — which some people call a subperiod within the 150-year Renaissance, and others call a movement — only lasted from 1495 to 1520 because two of the three principal High Renaissance artists died in 1519 and 1520. (You can't have a movement — or a period! — with only one guy, even if it's Michelangelo!)

Mannerism, too, was once considered a period, but is now widely viewed as a movement that started in the mid-1520s with works by Rosso Fiorentino, Pontormo, and Parmigianino. The thing is, these artists didn't call themselves Mannerists — they thought their artfulness and style were just extensions of what Raphael and others would have done in the High Renaissance. Conscious or not, they inaugurated a "manner" of artwork, together with Michelangelo, that was stylistically different and became a movement.

Prehistoric period (30,000 B.C.– 2500 B.C.)

The prehistoric art period corresponds with the Old Stone Age and New Stone Age, when people used stone tools, survived by hunting and gathering (in the Old Stone Age) or agriculture (in the New Stone Age), and didn't know how to write.

Although they couldn't write, Old and New Stone Agers definitely knew how to paint and sculpt. In the Old Stone Age (the Paleolithic period), artists painted pictures of animals on cave walls and sculpted animal and human forms in stone. Their art seems to have been part of a magical or shamanistic ritual — an early form of visualization — to help them hunt. Even the act of painting was probably part of these rituals.

Painting went downhill during the New Stone Age (the Neolithic period), despite the fact that they had better stone tools, herds of domesticated animals, and permanent year-round settlements. But architecture really got off the ground with massive tombs like Stonehenge, temples, and the first towns.

Mesopotamian period (3500 B.C.–500 B.C.)

The Mesopotamian period covers several civilizations:

- ✔ The Sumerians, who invented writing (known as *cuneiform*) and monotheistic (one-god) religion (Abraham was a Sumerian)
- ✔ The Akkadians
- ✔ The Assyrians
- ✔ The Babylonians

Mesopotamian art is usually war art, propaganda art, or religious and tomb art. Though each civilization contributed different features to Mesopotamian culture — the warlike Assyrians developed visual narrative, for example — the art developed in the same region (the land between the Tigris and Euphrates rivers), and the different peoples who ruled the area influenced each other. Mesopotamian art is often macho, but also refined, and sometimes comic and highly imaginative.

Egyptian period (3100 B.C.–332 B.C.)

Egyptian art could be called the "art of the dead," because most Egyptian art was made for the tomb. The Egyptian style is symmetrical, rigid but elegant, for the most part unchanging, highly colorful, and symbolic. Egyptian artists also used visual narrative, but their picture stories were less dramatic and realistic than the art in Mesopotamia (see the preceding section).

Minoan, Ancient Greek, and Hellenistic art

Because of the conquests of Alexander the Great (356 B.C.–323 B.C.) and the later Roman love affair with Greek culture, the art produced in the city-states of Ancient Greece spread from to the British Isles to India, changing the world forever. The earlier Minoans influenced Greek culture, but their achievements were small in comparison.

Minoan period (1900 B.C.–1350 B.C.)

Minoan culture and art had a short life compared to Egyptian and Mesopotamian art. Minoan art is playful and focuses on life, sport, religious rituals, and daily pleasures. It is the first art to truly celebrate day-to-day life.

Ancient Greek period (c. 850 B.C.–323 B.C.)

Greek art is divided into the *archaic* (old-fashioned) and classical periods and moves increasingly toward realism. The Greeks invented techniques like red-figure painting, the *contrapposto* pose (see Chapter 7), and perspective to allow artists to represent the world realistically. But as real looking as classical Greek art is, it is also *idealized* (made to look better than real life). Greek statues don't have pot bellies, zits, or receding hairlines. Art of the classical period (when Greek art peaked) is known for its otherworldly calm and beauty.

Hellenistic period (323 B.C.–30 B.C.)

The Hellenistic period begins with Alexander the Great's death and ends with Cleopatra's snakebite suicide. It is Greek art stripped of much of its idealism (though not in all cases). Most Hellenistic statues are still physically perfect, but instead of being imperturbably serene, they can express anger, bitter sorrow, or intense fear. The Hellenistic period was the first time these emotions were dramatically and realistically portrayed in art.

Etruscan and Roman art

You could call Etruscan and Roman art copycat culture. Each borrowed extensively from the Greeks, but each contributed something of its own.

Etruscan period (8th century B.C.–4th century B.C.)

The Etruscans who lived in Etruria (modern-day Tuscany) didn't leave much architecture behind them, and the Romans who conquered them built over most of their settlements. But the Romans didn't disturb Etruscan tombs. So we know Etruscan life mainly through their tomb art, which was a surprisingly happy affair — apparently, the early Etruscans viewed death as a pleasant continuation of life.

Roman period (300 B.C.– A.D. 476)

The Romans also copied the Greeks. But art historians don't call the Roman period a Greek replay. Like the Etruscans, the Romans didn't merely imitate — they added something to the Greek style. In architecture, the Romans contributed the Roman arch, an invention that helped them to build the biggest system of roads and aqueducts the world has ever seen. In painting and sculpture, the Romans took realism even farther than the Hellenistic Greeks. The busts of senators and early emperors look middle-aged, tough, and worldly.

Byzantine and Islamic art

Byzantine art is Christian art of the Eastern Roman Empire after the fall of Rome in A.D. 476. Islamic art and architecture spread across the Near East, North Africa, and Spain following the wave of Islamic conquests between A.D. 632 and A.D. 732.

Byzantine period (A.D. 500– A.D. 1453)

Byzantine art is a marriage of late Roman splendor, Greek artistic traditions, and Christian subject matter. Byzantine art is symbolic and less naturalistic than the Greek and Roman art that inspired it. It points to the hereafter rather than the here and now.

The most popular form of painting in the Byzantine period was icon painting. *Icons* (holy images of Jesus, Mary, and the saints) were used in prayer. Byzantine artists also liked to work in *mosaic* (pictures made with tiny pieces of cut stone or glass).

Islamic period (7th century–)

Like Moses, Mohammed condemned graven images, so there aren't many representations of human beings in Islamic art. The Middle Eastern and North African countries that converted to Islam were also the guardians of the most sophisticated knowledge of mathematics and geometry. Some of this knowledge seems to have filtered into the artwork. Islamic artists often incorporate incredibly intricate and colorful patterns in carpets, manuscripts, ceramics, and architecture.

Medieval period (500–1400)

Medieval art is mostly Christian art created in Europe after the fall of Rome and before the Renaissance. Its most familiar art forms are stained-glass windows, illuminated manuscripts, silver and golden *reliquaries* (elaborate containers for holy relics — bones and other body parts of saints), architectural reliefs, and Romanesque and towering Gothic cathedrals. Medieval art is steeped in mysticism and symbolism, with a focus on the Christian afterlife.

Renaissance period

Renaissance means "rebirth." In the Renaissance period, artists returned to classical models in painting, sculpture, and architecture. Christian religious art still dominated the market, but the stories and images in the art tended to celebrate man and things of this world. The rising value of the individual led to many portrait commissions, a *genre* (class of art) that had become all but extinct in medieval art. With such a here-and-now focus, realism became as important as symbolism. To make paintings and sculptural reliefs look three-dimensional (like windows opening onto the real world), Renaissance artists worked out the mathematical laws of perspective.

High Renaissance (1495–1520)

Leonardo da Vinci, Michelangelo, and Raphael defined the movement known as the High Renaissance even though their artwork sometimes looks very different from each other's. All three strove for perfection and often found it in stable, geometrically shaped compositions.

The High Renaissance ideal is "high" because these three artists portrayed idealized subjects, even if the subject was a restless and youthful warrior like Michelangelo's immortal *David*. An aura of beauty and calm is the hallmark of High Renaissance art.

Mannerism (1530–1580)

After mastering nature, artists began to intentionally distort it. Mannerist artists elongated human figures, created contorted postures, and distorted

landscapes, which were often charged with symbolism and erotic or spiritual energy. Art was no longer a window into an idealized version of the real world, but a window into the fruitful and fanciful imaginations of artists.

Baroque and Rococo art

Baroque artists traded the geometrical composure of the Renaissance for drama that involved the viewer. Rococo art dropped the drama of Baroque art while taking its ornamental side to extremes.

Baroque period (1600–1750)

Baroque developed during the *Counter-Reformation* (the 16th-century Catholic Church reform effort) and became a propaganda weapon in the religious wars between Catholicism and Protestantism in the 16th and 17th centuries. The Catholic Church wanted art to have a direct and powerful emotional appeal that would grab the attention of ordinary people and bind them to the Catholic faith. Baroque cathedrals stuffed with dramatic sculptures and paintings filled the bill.

In Protestant lands, Baroque artists went out of their way to downplay the importance of saints, preferring more symbolic subjects for moral painting like landscapes charged with meaning, genre scenes (pictures of everyday events that read like fables), and paintings of fruit that suggest the temporariness of life on earth. Kings and princes also enlisted Baroque artists to celebrate their wealth and power.

Rococo period (1715–1760s)

Rococo is Baroque art on a binge. This was an art favored by kings, princes, and prelates who had too much money to spend. The ornamental quality of Rococo painting, relief, sculpture, and architecture is often more important than the subject matter.

Neoclassicism and Romanticism

Neoclassicism and Romanticism occurred during the Enlightenment and the American, French, and Industrial revolutions. In a sense, Neoclassicism and Romanticism were not only periods but movements. Some conscious choices were made by Neoclassical and Romantic artists: They chose their style of art usually to convey a political and/or spiritual message.

Neoclassicism (1765–1830)

Neoclassicism (*neo* means "new") is yet another return to Greco-Roman classicism. It is a dignified art that depicts men and women of the period as if they were Greek gods and heroes. Their poses and often grandiose gestures are larger than life.

Romanticism (late 1700s–early 1800s)

Romantic artists shunned the Industrial Revolution, attacked the excesses of kings, and championed the rights of the individual. Some took refuge in nature; others sought an invigorating mixture of fear and awe in sublime landscapes and seascapes. Imagination with a capital *I* and Nature with a capital *N* were the wellsprings of their unbridled creativity.

An Overview of the Major Movements

When the trend toward "movements" kicked in, periods pretty much got pushed out of the picture. Since the 19th century, the direction of art is no longer dictated by church or state, but by the artists themselves.

Realism (1840s–1880s)

Realists reasserted the integrity of the physical world by stripping it of what they viewed as Romantic dreaminess or fuzziness. They painted life with a rugged honesty — or at least they claimed to.

The Pre-Raphaelite Brotherhood (1848–1890s) and the Arts and Crafts movement (1850s–1930s)

In the mid-19th century, the Pre-Raphaelite Brotherhood in England created an art designed to counter the negative effects of the Industrial Revolution: gritty cities, poverty, and so on. They rejected the materialistic society fed by the Industrial Revolution and backpedaled to the mysticism of the Middle Ages, often depicting Arthurian romances and other medieval legends in their paintings and stained-glass windows. The Arts and Crafts movement, founded by William Morris, one of the Pre-Raphaelites, preferred the hands-on medieval workshop to the sweatshops of capitalism. They favored handmade furniture and decorative arts produced in small workshops and artist colonies.

Impressionism (1869–late 1880s)

The Impressionists painted slices of everyday life in natural light: people on a picnic, a walk in the park, an outdoor summer dance. But Impressionist art doesn't freeze life the way a classical painting does. Instead, by capturing the

subtle changes of atmosphere and shifting light, Impressionist paintings convey the fleeting quality of life.

Post-Impressionism (1886–1892)

Post-Impressionism is not a movement, per se, but a classification of a group of diverse artists like Vincent van Gogh and Henri de Toulouse-Lautrec who painted in the wake of Impressionism.

Fauvism and Expressionism

Both of these early 20th-century movements pushed art in the direction of abstraction by simplifying or distorting form and by using expressive rather than naturalistic colors.

Fauvism (1905–1908)

Fauvism was a short-lived movement headed by Henri Matisse and André Derain. The Fauves simplified form by stylizing it. They also flattened perspective, which made their paintings look less like windows into the world and more like wallpaper. The leading Fauve, Henri Matisse, believed that art should be inspiring and decorative, fun to look at. Fauve art does have a wallpaper appeal. It's art you could hang in a child's playroom — if your kid weren't clamoring for Big Bird and Elmo.

Expressionism (1905–1933)

Expressionism is two German movements: Die Brücke (The Bridge) and Der Blaue Reiter (The Blue Rider). Each of these movements had slightly different goals, but they employed similar techniques and painted similar subjects.

Expressionist artists distort the exterior of people and places to express the interior. On an Expressionist canvas, a scream distorts not just the face but the whole body. Similarly the madness inside an insane asylum twists the architecture itself so that it, too, looks "mad."

Cubism and Futurism

Both Cubism and Futurism fractured physical reality into bite-size units, but for very different reasons.

Cubism (1908–1920s)

Cubism could be called the artsy side of Einstein's theory of relativity. All is relative; what you see depends upon your point of view. Georges Braque and

Pablo Picasso invented Cubism so people could observe all views of a person or an object at once, from any angle.

Futurism (1909–1940s)

Unlike most art movements, instead of turning their backs on the machine age, the Futurists embraced technology, speed, and, unfortunately, violence and Fascism. They felt Fascism was the only type of government that could carry out the cultural housecleaning they believed that society needed. Their movement was based mostly in Italy and pre-Revolution Russia.

Dada and Surrealism

World War I caused unprecedented destruction and misery in Europe. Disillusioned artists reacted by rejecting the traditional values and art forms of the culture that they believed triggered the war.

Dada (1916–1920)

The madness of World War I spawned Dada, which started in neutral Switzerland and quickly spread across Europe. Their "art" was to mock the prevailing culture, including mainstream art, with demonstrations, "actions," and mock-art. The Dadaists assumed that rational thinking had caused the war; therefore, the antidote to war must be irrational thinking.

Surrealism (1924–1940s)

Surrealism was inspired by Dada and Freud's theories of the unconscious. Like the Dadaists, the Surrealists (many of whom had been Dadaists) hoped to fix humanity by snubbing the rational world. But instead of mocking earlier art and art traditions like the Dadaists, they sought ways to get in touch with the deeper, instinctual reality of one's unconscious. They painted their dreams, practiced free association, and mixed up the rational order of life in their art by juxtaposing objects that don't normally or rationally fit together: a vacuum cleaner plugged into a tree, a locomotive driving out of a fireplace, a melting clock hanging from a dead tree branch.

Suprematism, Constructivism, and De Stijl: Nonobjective Art

Fauvism, Cubism, Dada, and Surrealism freed artists to explore reality in nontraditional ways. The Suprematism, Constructivism, and De Stijl art movements side-stepped representational art completely, moving into the realm of pure abstraction, or nonobjective art.

Suprematism (1913–1934)

The leader of Suprematism, Kazimir Malevich, strove to free feeling from form, disassociate it from representational art. He believed that photographic realism — like you see in the *Mona Lisa* — places a wall between the observer and the essential feeling that the artist is trying to express. He believed that most people only see the picture and don't experience the "inner feeling." So he stripped away the representation or picture to liberate the feeling.

Constructivism (1914–1934)

Constructivist Russian artists refused to make art for galleries or museums. They wanted to create a practical art that ordinary workers could use and that represented the modern utopia that Socialism was supposedly creating.

De Stijl (1917–1931)

De Stijl is artistic geometry, achieved with a few shapes and the primary colors — red, blue, and yellow — along with black and white. The head of the De Stijl movement, Piet Mondrian, believed that there are two types of beauty: subjective (which he linked to the world of the senses) and objective (which he considered universal and abstract). De Stijl artists wanted to depict the objective type of beauty, so they avoided photographic representation (realism) because it awakens subjective feelings.

Abstract Expressionism (1946–1950s)

After World War II, it was as if American artists dropped a bomb on German Expressionism, splattering the representational side of it and leaving only the naked expression. In German Expressionism, emotion distorted the face of reality (the way human faces are distorted by extreme feelings, but are still recognizable). In Abstract Expressionism, emotion distorts the face of reality beyond all recognition. One of the most famous American Abstract Expressionists, Jackson Pollock, achieved this effect by throwing paint on his canvases.

Pop Art (1960s)

In the early '60s, Pop Art artists decided to co-opt the new styles of advertising, the fantasies of stardom, and the hunger for ever-new stuff that characterizes post–World War II America. Their art is sometimes hard to distinguish from the movies and ads they borrowed from.

Conceptual art, performance art, and feminist art (late 1960s–1970s)

In the late 1960s, the art world fractured into so many minor movements that tracking them all is difficult. In one of the most radical of these movements, artists believed that they didn't need to produce any artwork at all (rather like Dada) but simply generate concepts or ideas. In reality, this conceptual art, as it's known, is often a type of performance or "happening" that can be very spontaneous and audience-driven. Sometimes it's simply writing on a wall. One early conceptual artist camped out with a coyote for a week in an art gallery to get people thinking about the treatment of Native Americans. Feminist art is linked with conceptual art in that it focuses on the inequalities faced by women and tries to provoke change. The movement has no set style. It might include a painting on canvas or a group of women dressed up in gorilla costumes crashing a public event to pass out pamphlets.

Postmodernism (1970–)

Postmodern means life "after Modernism." And *Modernism* refers to art made between about 1890 and 1970. Postmodernist thinkers view contemporary society as a fragmented world that has no coherent center, no absolutes, no cultural baseline. But it is often built on the past, which has all these qualities in abundance.

How do you capture the mosaic of the mixed-up Postmodern world on canvas or in a building? Postmodernist artists and architects sometimes do it by borrowing from the past and by mixing old styles until they wind up with a new style that reflects contemporary society.

Part II
From Caves to Colosseum: Ancient Art

The 5th Wave By Rich Tennant

"Looks like the artist never quite finished this one."

In this part . . .

1 fill you in on the first art galleries, the caves of prehistoric man, and the rituals behind their art. Then I dig up the past in Ancient Egypt and Mesopotamia by excavating the meaning of tomb art and political and religious art. Next, I examine how Ancient Greece and Rome invented the modern world. (They did, you know!)

Chapter 4

Magical Hunters and Psychedelic Cave Artists

In This Chapter

▶ Deciphering the world's oldest paintings

▶ Cozying up to a Stone Age fertility symbol

▶ Grappling with New Stone Age architecture like Stonehenge

During the last great Ice Age, a vast sheet of ice buried much of the world. In about 120,000 B.C., *Homo sapiens sapiens* (the doubly wise [*sapiens* means "wise"], known today as humans) appeared on this frozen stage. They've stolen the show ever since.

Humans shared the scene with herds of woolly mammoths, woolly rhinos, *aurochs* (extinct horned oxen), saber-toothed cats, bison, horses, and deer, which roamed much of the planet. The first humans survived in this glacial land as nomadic hunter-gatherers. We don't know much about them because they left no written records, no art, and no permanent settlements.

The earliest surviving art came into the picture about 90,000 years later in the Paleolithic period, or Old Stone Age, which lasted roughly from 40,000 B.C. to 8,000 B.C. This "primitive" art was already highly developed in 30,000 B.C. — at the peak of its game, as if the prehistoric artists who made it studied their craft in some Stone Age art school. More likely, their skills were handed down from master to apprentice and honed over thousands of years. They painted their masterful depictions of wild animals in the world's first art galleries, the walls of caves primarily in southern France and northern Spain. Their pictures of woolly mammoths, wholly rhinos, and aurochs are the most accurate images we have of these extinct species.

In this chapter, I introduce you to the earliest artists — those who lived in the Stone Age and New Stone Age.

Tools and art: A critical connection

Before humans could make art, they had to be able to make tools. Apes *use* sticks as tools to knock down bananas, for example, but they don't *produce* tools (or art). Our earliest ancestors got onto their feet about 4 million years ago. We don't know what they did with their hands until 2 million years later, when the first primitive tools appeared in east-central Africa. These tools were simply stones with sharpened edges made by our ancestors *Homo habilis* (which means "handy man" or "able man"). Tools were slowly refined over the millennia from handy man's ruff-flaked stones used for cutting meat and pelts (about 2,000,000 B.C.) to the invention of the hand ax (about 1,300,000 B.C.) and the spear (about 1,000,000 B.C.). The bow and arrow were invented around 10,000 B.C. Our forebears were slowly learning to master their environment — and art was just around the corner.

Cool Cave Art or Paleolithic Painting: Why Keep It a Secret?

Prehistoric artists hid their paintings deep within the bowels of caves as if they were meant to be kept secret. The paintings are so well hidden, in fact, that the first discovery of a cave painting didn't occur until 1879 in Altamira, Spain (see Figure 4-1). The second discovery took place in 1940 in Lascaux in Dordogne, France — two little boys followed their lost dog into a hole that opened into the ancient cave.

Figure 4-1:
The superbly rendered cave paintings of prehistoric animals in Altamira, Spain, were the first to be discovered.

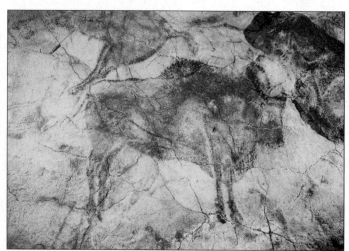

Courtesy of Spanish National Tourist Office

Hunting on a wall

Initially researchers believed cave art was connected to hunting. Hunting was primitive man's main job, and the paintings are mostly of animals — with the exception of a few human stick figures, handprints, and geometric patterns in some caves. Did primitive man believe that capturing an animal's likeness on a wall with paint made it easier to kill the animal in the wild? If so, then primitive painting was probably a type of *sympathetic magic,* kind of like voodoo. The idea is, if you paint a picture of a creature, then you have power over it. In some cave paintings, spears and arrows seem to pierce the animals (like needles sticking in a voodoo doll).

If you wanted to kill lots of bulls, you painted lots of bulls on the walls of your cave! In the Lascaux cave, the roughly 65-foot-long cave gallery known today as the Great Hall of the Bulls could be an example of a large-scale, prehistoric magic ritual. But today researchers suspect that cave art was more than just hunting magic.

Feathers, fur, and chewed sticks: Prehistoric art tools

Cave artists used feathers, fur, moss, chewed sticks, and their fingers as paintbrushes. Sometimes they incised the outlines of pictures into cave walls with sharp stones or charcoal sticks. They ground minerals like red and yellow ochre, manganese, and hematite into red, violet, yellow, brown, and black powders, which they applied directly to the damp limestone walls to create painted fur for bears and bison, and spots for leopards and hyenas. Today, 15,000 to 25,000 years later, this primitive paint still hasn't peeled! (Don't you wish you could find stuff like *that* at the local hardware store.)

Prehistoric artists also "spray-painted" their pictures to cover larger areas more efficiently by blowing colored powders through hollowed-out reeds or bones. Some of these hollow tubes have been discovered in the caves with traces of color still in them.

Cave painters sometimes used bumps and crevices on cave walls to emphasize an animal's contours: a bulge for a belly, an indentation for an eye, a bump for a hump. In the Chauvet cave in southwestern France, an artist painted a bear's paw over a knob in the wall, making it appear more threatening, as if the animal were reaching into real space to claw somebody!

Ten thousand years later, cave artists at the Altamira, Spain, cave used the same technique, painting the burly bodies of bison over swellings on the cave's ceiling, giving the herd a sculpted, three-dimensional look.

Psychedelic shamans with paintbrushes

Later researchers discovered that the animals that appeared on Old Stone Age dinner menus showed up least in cave art. Many paintings depict predators like panthers, lions, and hyenas — not typical dinner fare and not easy to hunt.

These researchers offered a new theory based on the fact that hunter-gatherer societies from Africa to Siberia and North America practiced shaman magic. Prehistoric hunter-gatherers probably did the same thing.

Hollywood portrays shamans as witchdoctors, but a tribal shaman is more than a spell-casting, dancing doctor in a Halloween costume — he's a visionary and sometimes an artist. Primitive peoples believed that the shaman could "beam up" into the spirit world to talk to the souls of beasts. They even thought he could learn from animal spirits how to fix imbalances in nature.

Some shamans appear to have used natural hallucinogens to give them a boost into the sixth dimension. Primitive peoples throughout the world often depict shaman journeys with hallucinogenic images of humans and animals entwining and even merging. Cave art might depict these journeys, too.

Are cave paintings the world's first psychedelic art? The half-human, half-animal cave paintings, such as the *Bird-Headed Man with Bison and Rhinoceros* on the wall at Lascaux suggest they are.

At first glance, *Bird-Headed Man with Bison* looks like a typical hunting scene. A hunter spears a bison in the belly. The beast's entrails spill out of him. But why does the prone man beside the animal have a bird's head? And why is a bird perched on a nearby pole like a totem? In 19th-century Siberia, shamans used a so-called "world pole" topped by a bird to launch their voyages into the underworld. The Lascaux bird-headed man and bird-topped pole may have been meant to give a prehistoric shaman a successful send-off into the spirit world.

Trainee shamans had to undergo ceremonial, fake deaths, as well as food and sleep deprivation. Maybe the prone figure is a trainee shaman, faking death after a long fast and a couple of all-nighters.

Flirting with Fertility Goddesses

Sculpture grew up alongside painting as a sister art. Most prehistoric sculptures were either small statues called *statuettes* or *reliefs*. In a relief, the sculptor outlines an image in stone or wood, and then carves out the background so that the image projects above it. The most famous early statuette is the *Woman of Willendorf,* also known as *Venus of Willendorf.*

All nude female figures found by German archaeologists in the 19th century (including *Woman of Willendorf*) were named Venus.

Woman of Willendorf is a pudgy 4½-inch-high figure carved out of limestone. She doesn't look very sexy to modern eyes, but she may have been a fertility symbol 25,000 years ago.

Does this mean that cavemen thought that *Woman of Willendorf* was hot stuff, the Marilyn Monroe of her day? Because concentric braids of hair wrapped around her head like a stocking cap conceal *Woman of Willendorf*'s face, we can surmise that her looks didn't matter. She wasn't an individual, but a type. What mattered were her sexual characteristics: huge breasts, a bulging belly (as if she were permanently pregnant), watermelon-sized buttocks, and prominent genitals. Her other features weren't given much attention by the artist. Her pudgy arms and cut-off legs seem to be an afterthought. The same female type is found in many prehistoric cultures around the world.

So what was the purpose of this type of figure and what was her appeal? Was *Woman of Willendorf* meant to turn people on? Probably not. More likely, her purpose was to promote fertility and abundance. A woman might have held the statuette in her hand before having sex so that the statuette's fertility could be magically transferred to her.

But why is *Woman of Willendorf* so fat? Her ample proportions may have been a sign of wealth. Living off nuts, berries, and wild game didn't make primitive people chubby. Many primitive people probably died of malnutrition — only a few reached the age of 30. And only a very privileged woman could afford to be this big.

Dominoes for Druids: Stonehenge, Menhirs, and Neolithic Architecture

Technological progress followed the melting glaciers. As the land warmed up, man was able to farm it, domesticate animals, improve his stone tools, and build permanent settlements. He was no longer dependent on hunting and gathering for survival. Historians call this period the Neolithic Age or New Stone Age. It began in the warm southern climes and migrated northward in the wake of the retreating glaciers. With improved technology, cave life and cave art became a thing of the past. Artistically, mankind fell into a creative slump that lasted about 6,000 years. He still made art, but it doesn't compare to the Old Stone Age cave paintings and carvings. However, during the New Stone Age, men improved as architects and built structures to last.

In this section, we check out New Stone Age architecture from Anatolia to the British Isles.

Living in the New Stone Age: Çatalhöyük and Skara Brae

One of the oldest New Stone Age settlements was at Çatalhöyük in Anatolia (modern Turkey). It thrived from around 6500 B.C. to 5650 B.C. Interestingly, the people of Çatalhöyük appear to have had no fortifications or war gods — they seem to have been a truly peaceful people. They mastered textiles, basketry, and simple pottery (the potter's wheel hadn't been invented yet), and built rectangular, mud-brick homes with doors in the roofs (they climbed into their houses from the top). Each house had two or more elevated, multipurpose platforms, one of which was always painted red. The platform served as a table, workbench, bed, and *bier* (a bed for corpses — in this case, skeletons [Çatalhöyük inhabitants let vultures eat the flesh off their dead before burying them]).

Some of the rooms in Çatalhöyük homes included paintings and sculptures. Çatalhöyük paintings frequently feature stickform men who are usually hunting; hardly any women appear in the paintings. But the female figure shows up in Çatalhöyük sculptures with *Woman of Willendorf* features and dimensions (see "Flirting with Fertility Goddesses" earlier in this chapter), apparently as a fertility symbol or earth mother.

In Skara Brae, a later Neolithic community (around 3000 B.C.) in the northerly Orkney Islands of Scotland, the homes included a fireplace, stone tanks (possibly used for storing live fish, because they were a seafaring folk), and built-in stone furniture (beds, chairs, tables, and shelves). The only art we have from Skara Brae are the simple designs carved into the stone pottery and some of the stone beds.

Cracking the mystery of the megaliths and menhirs

The most interesting examples of New Stone Age architecture are the mysterious *megaliths* (huge stones) of Brittany and England. A megalithic structure is a simple or complex arrangement of stones. Some appear to be stark, open-air temples built by mammoth-sized men. Others look like graveyards with hundreds of headstones sprouting out of the earth. In fact, some megalith structures did serve as tombs, either for one person or several people. Many megalithic tombs look like giant stone tables with two uprights supporting a massive horizontal slab laid across them. This arrangement is called a *post-and-lintel system* (the post part is made up of the uprights, and the lintel is

the horizontal slab). The post-and-lintel system is one of man's first architectural advances. Sometimes the tombs are covered with small rocks and dirt, forming a grave mound over the horizontal.

Topless megaliths — solitary upright slabs — are called *menhirs*. Prehistoric peoples scattered fields of menhirs throughout Brittany in western France between 4250 B.C. and 3750 B.C. Menhirs appear in two types of formations: circular patterns known as *cromlechs* and cemetery-like rows called *alignments*. Despite their appearance, alignments weren't graveyards. They appear to have been astronomical observatories and sites for sun worship (not the kind that requires an SPF 15). The largest alignment is in Carnac, Brittany, where 3,000 menhirs stand in 2-mile-long rows. The menhirs appear to gradually grow as you move from east to west. Stones on the eastern side are 3 feet high, while on the western end they're over 13 feet high. The alignment corresponds to the rising and setting sun. Today, no one knows how this prehistoric observatory worked.

The greatest megalithic structure is the circle of stone slabs known as Stonehenge on the Salisbury Plain of England. Stonehenge was built between 2550 B.C. and 1600 B.C. in at least four stages. It was once believed to be a Druid (Celtic priest) temple. We now think that this elaborate network of stones was used to predict solstices and eclipses, vital knowledge for people dependent on the growing season.

From a distance, Stonehenge looks like an unfinished dominoes game played by giants. On closer inspection, it consists of a series of concentric circles and circular shapes: an inner horseshoe of five sets of gray sandstone groups in a post-and-lintel arrangement, and an outer circle of 20-foot-high gray sandstones, called *sarsen stones,* topped by lintels. Each sarsen stone weighs up to 50 tons. The lintels are connected, forming a continuous circle. A roughly 1,000-foot trench and embankment encircle the megaliths. This arrangement of circles within circles still mystifies people today.

Until 1500 B.C., a circle of bluestones stood between the sarsen stones and the horseshoe. The only available bluestone comes from Wales, 150 miles away. Stonehenge builders believed that bluestone possessed special properties, probably magical ones — otherwise, they wouldn't have hauled them such a long distance. In 1500 B.C., the last generation of Stonehenge builders moved the bluestones inside the horseshoe; researchers today have no idea why.

Prehistoric builders also smoothed the inside faces of the stone posts and lintels and tapered the posts at the top so that the bellies or midsections of the posts appear to bulge. Even more impressive, they "drilled" holes in the lintels and cut cone-shaped pegs into the posts so that the posts and lintels would fit together snuggly in a mortise and tenon joint (like a set of Lincoln

Logs). The designers also curved the outer lintels so each would form an arc, enhancing the circular appearance of the outer ring.

So what's the purpose of this elaborate network of massive stones? Was it a temple, a place of human sacrifice, or a stone calendar? The function of Stonehenge is still a mystery, but recent investigations show that it could have been used to accurately predict the phases of the moon, solstices, and eclipses.

Chapter 5

Fickle Gods, Warrior Art, and the Birth of Writing: Mesopotamian Art

In This Chapter

▶ Exploring the skyscrapers of the ancient world

▶ Eyeballing Sumerian sculpture and graven images

▶ Seeing through propaganda art

▶ Reading the first visual narratives

▶ Hanging out in Babylon

> *And Terah took Abram his son . . . and they went forth . . . from Ur of the Chaldees, to go into the land of Canaan [modern Lebanon, Palestine, and Israel]. . . .*

> —Genesis 11:31

Abraham, the father of the Jewish religion, was an Iraqi — sort of. According to the Bible, he was born in Ur, one of the world's first cities, which was located in Mesopotamia, modern-day Iraq. But in those days, that part of Mesopotamia was called Sumer. So Abraham was actually a Sumerian, or more specifically an Urian (a guy from Ur). Historians don't know when Abraham left Ur, but until about 2334 B.C., Ur was an independent city-state. Sumer was not really a country, but a cluster of city-states, like Ancient Greece. Sumer included Ur, Uruk (Erech in the Bible), Eridu, Larsa, and about eight other cities in southern Mesopotamia. Although linked by culture, religion, and the fact that they shared the world's first written language, the city-states didn't unite for over a thousand years. Nevertheless, Sumerians called their patchwork "country" the "land of the civilized lords," which makes it sound

like they had some pretty "uncivilized" neighbors. They also called themselves "the black-headed people."

Sumer was a land of firsts. The Sumerian patriarch Abraham founded *monotheism* (belief in one God), and the Sumerians invented writing. They also created the first epic poem, *Gilgamesh,* and the earliest codes of laws, the most famous being the Code of Hammurabi. Archeologists even found the oldest wheel in Sumer — it's about 5,500 years old! The Sumerians seem to have made the first potter's wheel, too. What an inventive people.

Mesopotamia, which means "between rivers" in Greek, is bounded by the Tigris and Euphrates rivers, which fertilize it throughout the year. For this reason, it is also known as the Fertile Crescent. Some archeologists believe that this fertile belt of land, where fruits and grains once flourished in natural abundance, was the biblical Garden of Eden.

Geography was good to Mesopotamia's farmers, but not to its rulers. Unlike Egypt, which is surrounded by natural defenses — deserts on the east and west and the Mediterranean Sea on the north — Mesopotamia had no mountains, deserts, or oceans to protect it. It was easy to conquer and hard to hold on to. The Sumerians' "uncivilized" neighbors — desert-tough nomadic tribes — must have been irresistibly attracted to this flowering oasis. Power changed hands in Mesopotamia over and over during the 3,000 years in which the pharaohs maintained a fairly steady hold on Egypt. The art of both civilizations tells the story of their governments. Egypt was stable and so was its art, which hardly changed in 3,000 years (see Chapter 6). Mesopotamia's art changed almost as often as its rulers, each conqueror bringing new influences.

In this chapter, I examine the art and architecture of the Sumerians, the Akkadians, Assyrians, Babylonians, and New Babylonians. Although each people had a distinctive style, these styles seemed to grow out of each other like a family tree of art and architecture, and in this chapter, I lay it all out for you.

Climbing toward the Clouds: Sumerian Architecture

Each Sumerian city-state had its local god, who owned and protected the city (a bit like the Greek goddess Athena protected Athens). Priest-kings ran the city-states, acting as the gods' appointed "shepherds of the people." They managed everything from the economy and government to religious affairs. They distributed the food, too, because even people's labor was viewed as god's property.

Zigzagging to Heaven: Ziggurats

And they said, Go to, let us build a city and a tower, whose top may reach unto heaven. [Description of the building of the Tower of Babel or Tower of Babylon.]

—Genesis 11:4

The Sumerians tried to get physically close to god with their architecture. Because their gods lived in the sky, they built their temples like high-rises. (The same impulse to soar toward God seems to have motivated the architects of the Gothic cathedrals of the Middle Ages.) Sumerian architects achieved this skyscraper height with *ziggurats,* which look like tiered wedding cakes up to seven layers high. The temple sat on top, close to god. The biblical Tower of Babel (see the following section) was probably a ziggurat.

Because the Sumerians didn't have access to limestone, like the Egyptians, they built their ziggurats, temples, and palaces out of mud brick, which has a much shorter half-life than limestone or granite (the material the Egyptians used to build the pyramids). As Genesis 11:3 says, "And they had brick for stone, and slime had they for mortar."

Most Sumerian architecture has disappeared, and gauging the original grandeur of it from the ruins left behind is difficult. However, the epic *Gilgamesh* gives a brief description of the glittering beauty of a Sumerian temple in Uruk:

> He built Uruk. He built the keeping place
> Of Anu and Ishtar [Sumerian gods]. The outer wall
> shines in the sun like brightest copper; the inner
> wall is beyond the imagining of kings.
> Study the brickwork, study the fortification;
> Climb the great ancient staircase to the terrace;
> Study how it is made; from the terrace see
> The planted and fallow fields, the ponds and orchards.
> This is Uruk, the city of Gilgamesh.
>
> [Translated by David Ferry]

Ziggurats included long staircases, ascending from terrace to terrace, climbing toward heaven and the Sumerian pantheon. But only priests were allowed to use the stairs and enter the temple at the top.

All that remains of the ziggurat of King Urnammu of Ur is the first floor, but it's enough to show the impressive architectural and engineering skills of the ancient Sumerians.

The Tower of Babel

Nebuchadnezzar II, king of Babylon (605 B.C.–562 B.C.), gave ziggurats a bad rap by stealing holy objects from the temple in Jerusalem and housing them in the ziggurat of Babylon. He probably wanted to show that his gods had more power than the Hebrew god did. According to Chronicles II 36:7, "Nebuchadnezzar also carried of the vessels of the house of the Lord to Babylon, and put them in his temple at Babylon."

To the captive Jews, Babylon's mountain-high ziggurat must have symbolized Nebuchadnezzar's overweening pride. But in general, the Sumerian and Babylonian peoples built ziggurats to put them in touch with the gods, not to elevate their personal egos.

The Eyes Have It: Scoping Out Sumerian Sculpture

The Sumerians had lots of gods — a sun-god named Shamash; Enlil, the god of the wind; Anu, the king of gods; and Ishtar, the goddess of desire, to name a few. Each city also had a local god who acted as its spokesman in the assembly of the gods, kind of a like a senator in the United States. As spokesperson, the local god made sure the leading gods (like the god of the sun and the god of floods) granted special privileges to his town. People could petition their local god indirectly (sort of like writing a letter to your senator) by going through the priest-king, or they could do it more directly by commissioning a statue of themselves and placing it in the temple.

Worshipping graven images

Like most gods, Sumerian divinities lived somewhere in the sky or mountains (though of course they didn't have an exact address). They also resided inside their statues in the temples of each city-state. In Sumer, a statue of a god wasn't just a representation, as it was later on in Greece — it *was* the god. Divinities could be in more than one place at a time.

Statues could also be stand-ins for ordinary citizens. That is, if a Sumerian commissioned a statue, part of him or her took up residence *in* the statue — like a home away from home. For this reason, Sumerians placed statues of themselves in temples where they could interact with the statue of the local god.

Staredown with God: Statuettes from Abu Temple

People placed statues in temples to commune directly with god, as in the Abu Temple statuettes. Are they bug-eyed aliens or did ancient Sumerians really look like this? The statuettes (the tallest is 30 inches high) are called *votive statues,* because they represented real Sumerians who devoted themselves to, or made a vow to, their local god.

Okay, but why are they bug-eyed? In horror movies, people's eyes bulge cartoonishly when they see a ghost. The ancient Sumerians' eyes popped when they saw a god. Being bug-eyed meant you were devout; it showed that you were awestruck in god's presence and that you couldn't take your eyes off of him or her. Of course, the denizens of Tell Asmar didn't really look like this—though the clothes, beards, and hairdos are certainly on target. Tell Asmar was a small town and their sculptors weren't as polished, so to speak, as big-city artists in Ur and Uruk.

Compare the Abu Temple statuettes to the sensitively rendered mask of a god from Uruk carved approximately a thousand years earlier, about the time the Sumerians invented writing (see Figure 5-1). The mask's eyes were most likely filled with colored stones; the eyebrows and hair were probably wrought of gold or copper, which is now missing.

Figure 5-1:
The female head of a goddess from Uruk was carved between 3,500 B.C. and 3,000 B.C.

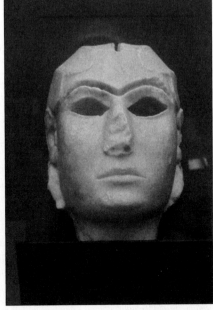

Bildarchiv Preussischer Kulturbesitz / Art Resource, NY

 Early Egyptian statues seem squared-off and rectangular (see Chapter 6), but Sumerian statues appear cylindrical. In fact, Sumerian artists based the human body on the cylinder and cone. Conelike skirts flair out on the Abu Temple statuettes, most of which are men. Their legs are cylinders, and their braids look like vacuum-cleaner hoses. Staircaselike beards distinguish most of the men.

Playing Puabi's Lyre

When a Sumerian king or queen died, he or she didn't go to the grave alone. More than 60 soldiers, attendants, and musicians accompanied King Abargi of Ur into the tomb. Some of these grave guests wore helmets and carried spears to protect the king from any afterlife dangers, others bore musical instruments (including Puabi's Lyre, shown in Figure 5-2) to perform for him, and a few drove wagons, which were pulled by teams of oxen. The oxen's remains were also found in the grave. More than 20 attendants joined Queen Puabi in her nearby tomb, including three soldiers with drawn copper daggers and ten well-dressed women buried in two rows facing each other. Whether these tomb groupies committed mass suicide or soldiers simply slew them, historians don't know. We do know that working for a Sumerian ruler was a demanding job!

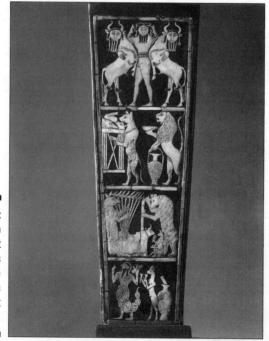

Figure 5-2:
The design on the front of Puabi's lyre illustrates four ancient fables.

Plaque from the Lyre from Ur; University of Pennsylvania Museum of Archaeology & Anthropology

The exquisite decoration that adorns Puabi's Lyre shows that Ur artists were master craftsmen. A golden bull's head protrudes from the harp, which stands in for the bull's body. His blue-tipped horns, mat of blue hair, baby blue eyes, and curlicue blue beard are made of lapis lazuli, an azure or deep-blue gemstone. The closest source of lapis was 2,000 miles away in Afghanistan. Obviously, trade flourished in third-millennium Asia! Under the bull's beard are a strip of animal fables wrought with wood and shell and inlaid in bitumen, a mineral pitch made from coal or oil.

But who is the bull with the blue-tipped horns? In the top fable, a naked macho man hugs two bulls as though they were old school chums. The bulls' faces practically mirror the man's, and their right legs and hooves wrap about his head like parentheses. This image, common in Mesopotamian art, is sometimes called the "Gilgamesh motif." In the Sumerian epic *Gilgamesh* (a story about literature's first superhero), Gilgamesh and his friend Enkidu wrestle and slay the Bull of Heaven, whose horns are also made of lapis lazuli, like the bull's head on the lyre.

The three other bands under the Gilgamesh motif tell a visual story or perhaps a series of fables invented long before Aesop. A lion, bear, wolf, deer, donkey, gazelle, and scorpion-man serve food and beverages or play instruments like the humanoid animals in Disney cartoons. Some of these scenes must have seemed comic even then, like the ass playing the lyre or the wolf and lion waiters bearing food and drink for a feast. Ironically, the wolf, who wears a knife in his belt, carries a wolf's head on a platter (it could be one of his cousins), which he apparently just dressed for dinner! We can only guess at the meaning today, ponder what appear to be ironies, and enjoy the craftsmanship of artists who lived four and half millennia before us.

Unraveling the Standard of Ur

The Standard of Ur depicts a Sumerian military victory fought in about 2,600 B.C. The artist tells the story of the battle and aftermath with inlaid images on three parallel strips on both sides of a wooden box. The front (shown in Figure 5-3) focuses on battle scenes, the back (shown in Figure 5-4) on the peaceful aftermath. The king is the big guy in the middle of the top band (on the war side), examining naked prisoners (one of whom is blindfolded) who file before him. The lower strips show the battle itself. Apparently, this visual narrative should be read from bottom to top, because the battle is in full swing in the bottom register, and the king collects prisoners in the top band.

Figure 5-3:
The Standard of Ur, measuring 8½ inches high by 19½ inches long, is a wooden box inlaid with shell, lapis lazuli, and red limestone. No one knows how it was used. This is the war side.

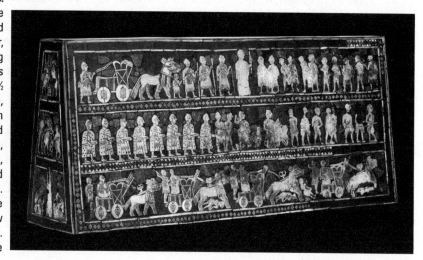

© British Museum / Art Resource, NY

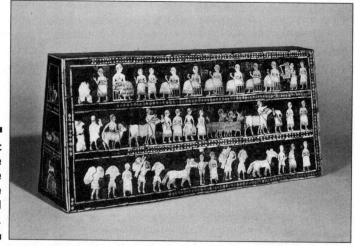

Figure 5-4:
This is the peace side of the Standard of Ur.

Erich Lessing / Art Resource, NY

Notice how the artist overlaps the wild asses (known as *onagers*) pulling the chariots in the top and bottom bands of the war side. And notice how awkwardly he illustrates the dead men trampled by the animals in the bottom strip.

The peace side (refer to Figure 5-4) depicts what must be an after-the-battle banquet. Reading again from the bottom up, men convey what may be battle

booty to the feast. In the middle band, the food-and-gift parade continues. The top strip shows the banquet, people eating and drinking before the king while an entertainer plays a lyre.

Despite all the activity, the Standard of Ur is static, frozen in time. A thousand years later, in northern Mesopotamia, the Assyrians dramatically improved visual narrative, giving it an action-movie feel (see "Unlocking Assyrian Art," later in this chapter).

Stalking Stone Warriors: Akkadian Art

In about 2334 B.C., a powerful king finally united Mesopotamia. But he wasn't Sumerian. Sargon I, an Akkadian king from an area north of Sumer, conquered Mesopotamia, northern Syria, and possibly part of Anatolia (modern-day Turkey), creating one of the first empires. Now the devout Sumerians had a new kind of leader who put politics before religion. Under Sargon, art became a propaganda tool or another gear in his war machine. He used it to promote his ambitions rather than to honor the gods. Yet Sargon and his Akkadian successors still respected the Sumer religion. Sargon's daughter even became a priestess of Nanna, the moon-god of Ur. But Sargon replaced the Sumerian language with Akkadian. Sumerian culture was on the way out, though it had a brief rebirth before finally fizzling.

An example of Sargon's new art is the Head of an Akkadian ruler from Nineveh. The king is depicted as a godlike but secular ruler (not a shepherd of the people). He appears calm but with a seething battle-ready energy behind his imposing features. The style is similar to Sumerian sculpture. The artist coifed the beard like those of the statuettes of Abu Temple, but the modeling of the face is much more realistic and brilliantly executed, especially the superb contours of the lips and slightly hooked nose.

Stamped in Stone: Hammurabi's Code

The Akkadian Empire lasted about two centuries, until tribes from the northeast overran it in 2112 B.C. Urnammu, the Sumerian king of Ur, which had remained independent, ejected them about 50 years later and reunited Mesopotamia for another century, until a new wave of conquerors swept the Sumerian kings away forever. These centuries of turmoil produced no great art. Finally, in 1792 B.C., Babylon emerged as a great political and cultural power in southern Mesopotamia, under King Hammurabi, its greatest and most famous ruler. Art and Sumerian culture resurfaced. Hammurabi respected the Sumerian gods so much that he created a code of divinely ordained laws — the first

detailed written law code in history — to help carry out their moral commands on earth. He wrote the code in *cuneiform,* the Sumerian script.

Like Moses, Hammurabi claimed to receive his law code directly from god. On the *stele* (a carved or inscribed upright stone slab used as a monument), Hammurabi meets the sun god Shamash, not on his knees like Moses, but standing, eye to eye with god. Under the image, Hammurabi writes a powerful introduction to the laws:

> Anu and Bel called by name me, Hammurabi, the exalted prince, who feared God, to bring about the rule of righteousness in the land, to destroy the wicked and the evil-doers; so that the strong should not harm the weak; so that I should rule over the black-headed people [the Sumerians] like Shamash, and enlighten the land, to further the well-being of mankind.

Hammurabi's law code prevented judges from arbitrarily handing down sentences based on personal bias. Nevertheless, many of the laws seem brutal to modern ears:

- If a son strike his father, his hands shall be hewn off.

- If any one steal cattle or sheep, or an ass, or a pig or a goat, if it belong to a god or to the court, the thief shall pay thirtyfold; if they belonged to a freed man of the king he shall pay tenfold; if the thief has nothing with which to pay he shall be put to death.

- If a man knock out the teeth of his equal, his teeth shall be knocked out [similar to the Hebrew "an eye for an eye and a tooth for a tooth" code].

In spite of its occasional severity, Hammurabi's Code was the beginning of civil rights or, as the U.S. Declaration of Independence calls them, "inalienable rights." Hammurabi must have known that writing the code in stone would make the laws seem immutable. (The expression "written in stone" derives from this practice.)

Unlocking Assyrian Art

In 1596, about a hundred years after the death of Hammurabi, the Hittites conquered Babylon. They produced no great art. Not long after, the Kassites overran Babylon. About the same time, in northern Mesopotamia, the brutal Assyrians grew from a city-state called Assur into a vast empire that lasted from about 1363 B.C. to 612 B.C., when the Persians and Scythians overran them. With their iron weapons, they terrorized their neighbors and mercilessly destroyed all challengers.

The Assyrians created a macho art that glorified their rulers and intimidated their enemies. Each Assyrian king built a bigger-than-his-predecessor's palace to flaunt his power.

Five-legged creatures called *lamassu* (half bull, half man) with mile-long beards guard the gates of the Citadel of Sargon II. The fifth leg makes the creature appear to be striding when viewed from the side, while from the front the lamassu appears to stand firm. More important, to convey their military exploits and staged hunting expeditions (the animals were released from cages and then killed), the Assyrians gave visual narrative an action-movie feel by inventing continuous visual narration. In other words, their picture stories "read" like a film strip with one event leading dramatically to the next.

To appreciate this Assyrian contribution, compare an Assyrian storytelling relief to the Standard of Ur (refer to Figure 5-3 and Figure 5-4). The victory that the Standard of Ur describes is told in chunks — discrete strips. Not only does the story get stuck at the end of each band, but the events within the band have no dramatic momentum — one action does not propel the next. The Assyrian relief of *King Ashurnasirpal II Killing Lions* (see Figure 5-5) is cinematic and roils with dynamic energy. You can feel the lion's awesome power as he leaps at the king, and you pity the dying lion under the horses' hooves who has been shot a few moments earlier. Notice that rank is no longer indicated by physical size (as in the Standard of Ur) but by action.

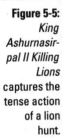

Figure 5-5:
King Ashurnasirpal II Killing Lions captures the tense action of a lion hunt.

© British Library / HIP / Art Resource, NY

Babylon Has a Baby: New Babylon

After the Persians and their allies sacked the Assyrian capital Nineveh, Babylon reemerged as the center of Mesopotamian culture. Nabopolassar, a Babylonian general who had sided with the Persians, became the first king of New Babylon. Although the kingdom only lasted for 70 years, its beauty and culture have become legendary, especially as they flowered under the reign of Nabopolassar's famous son, Nebuchadnezzar.

Nebuchadnezzar is best known for a present he supposedly gave his wife: the Hanging Gardens of Babylon, one of the original Wonders of the World. But the Hanging Gardens didn't hang. They were terraced, rooftop gardens, irrigated by water pumped from the Euphrates. To visitors, it must've seemed as though an oasis had blossomed on the rooftops of Babylon.

The kings of New Babylon returned to the Sumerian model of being "shepherds of the people." Although Nebuchadnezzar attacked Judah, the New Babylonians were much less warlike than the Assyrians. New Babylonian art reflected this quieter and gentler period; it was much less aggressive and less active than Assyrian art.

Nebuchadnezzar rebuilt Babylon into the most beautiful city on earth. One of his greatest architectural achievements is the Ishtar Gate, the gorgeous entrance to the city. The animals in the Ishtar Gate look like ornaments. On the front, against a background of glazed blue bricks, stand decorative horses, blue-horned bulls, and dragons made of gold-colored, turquoise, and blue bricks. The top of the gate is *crenellated* (notched) like a medieval castle. But instead of squares (like in a medieval castle), the crenellations rise like mini-ziggurats.

What's the difference between the Ishtar Gate and Assyrian art? In the Ishtar Gate, all the animals strike the same pose; there is no movement. But the Ishtar Gate wasn't intended to tell a story. It was meant to be beautiful and imposing, a reflection of Nebuchadnezzar's cultivated tastes. The stiffness of the animals adds to this impression. Action would take away from the solemn majesty of the goddess's gate.

Chapter 6

One Foot in the Tomb: Ancient Egyptian Art

In This Chapter

▶ Reading one of the oldest historical documents in the world

▶ Sizing up the pyramids

▶ Exploring the art of Egyptian tombs

▶ Reading a Book of the Dead

▶ Understanding why Egyptian statues are so colossal

The mountain-high pyramids and stony stare of the Great Sphinx have awed mankind for thousands of years. The ancient Greek historian Herodotus wrote, "There is no country that possesses so many wonders, nor any that has such a number of works which defy description." The Roman leaders Julius Caesar and Marc Antony were so impressed by Egyptian culture and wealth that they had to first marry Egypt (in the form of Cleopatra) and then rule it. The mystique of Ancient Egypt still captivates modern man. But today Egypt's biggest draw isn't the pyramids or Cleopatra, but Egyptian mummies, magic, and tomb art.

Mummies and the magical resurrection rituals painted on the walls of tombs and coffins have inspired witches' spells, short stories, movies, documentaries, art historians, archeologists, and even the fashion industry. The film companies of the world have unreeled more than 90 mummy movies since the dawn of cinema, from a French short in 1899 about Cleopatra's mummy to Hollywood's *The Mummy* in 1999 and the made-for-TV *The Curse of King Tut's Tomb* in 2006. The Three Stooges even got into the act with *We Want Our Mummy* (featuring King Rootin-Tootin) in 1939 and their more mature work, *Mummy's Dummies*, in 1965.

Mummies, medicine, and magic

Mummies have teased people's imaginations since at least the Middle Ages when people believed they had healing powers. Twelfth-century doctors prescribed mummy dust (made from pulverized corpses) for wounds and bruises, and until around 1500 people ingested mummy powder to relieve upset stomachs. Even in the 17th century, witches — like those depicted in Shakespeare's *Macbeth* — used mummies to help them forecast the future.

Ancient Egypt 101

The discovery of King Tut's tomb in 1922 made front-page news and spawned an Egyptian fashion craze. Women forgot their distaste for bugs and put on scarab-beetle jewelry, donned pharaoh blouses with hieroglyphic prints, and carried golden pyramid- and sphinx-shaped ladies' compacts.

Napoleon triggered the global fascination with Egypt in 1798 when he led the first major scientific expedition there, while trying to conquer Egypt and Syria. *Egyptology* (the study of Ancient Egypt) has been almost a cult science ever since.

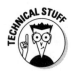

In the 3rd century B.C., an Egyptian priest named Manetho cataloged Egypt's ancient rulers into 31 dynasties. (A *dynasty* is continuous rule by members of the same family.) Today, historians still use his list, which begins in about 3100 B.C. with the unification of Upper and Lower Egypt and ends with Alexander the Great's conquest of Egypt in 332 B.C. The 4th through 20th dynasties are divided by modern historians into three kingdoms — the Old Kingdom, Middle Kingdom, and New Kingdom — each with its own distinct features, as well as two intermediate periods bracketing the Middle Kingdom. Anything between the New Stone Age and the first dynasty is called Predynastic (see Table 6-1).

Table 6-1	Ancient Egyptian Historical Periods	
Period	*Dynasty*	*Date*
Predynastic	0	4,500 B.C.–3,100 B.C.
Early Dynastic	1st–3rd	3,100 B.C.–2613 B.C.
Old Kingdom	4th–6th	2,613 B.C.–2,181 B.C.
First Intermediate	7th–10th	2,181 B.C.–2,040 B.C.

Period	Dynasty	Date
Middle Kingdom	11th–14th	2,133 B.C.–1,603 B.C.
Second Intermediate	15th–17th	1,720 B.C.–1,567 B.C.
New Kingdom	18th–20th	1,567 B.C.–1,085 B.C.

The Nile River was the lifeline of Ancient Egypt. Without it, the most durable civilization in history couldn't have survived. Herodotus said Egypt is "the gift of the river." He was right. The Nile's annual summer floods fertilize the land around it, which otherwise would be desert. Most Egyptian cities and tombs hug the banks of the Nile like children clinging to their mother. If you venture too far from the river, you end up in the desert like Moses did.

The ancient Egyptians believed the Nile's life-giving floods, which occur during the hottest and driest part of summer, were the gods' gift because they didn't appear to be caused by the weather. The rain that swells the Nile actually falls hundreds of miles away in Ethiopia in the tributary called the Blue Nile — but before the advent of the Weather Channel, the floods in Egypt appeared to arrive miraculously.

The Palette of Narmer and the Unification of Egypt

During the Predynastic period, the tribes of Lower and Upper Egypt gradually formed into two separate nations, which were united at the dawn of history in about 3100 B.C., possibly by Narmer, the first pharaoh of the first dynasty.

Mummification

Because Egyptians believed the *ka* (soul) reunited with the body in the tomb, the body had to be painstakingly preserved through mummification. Mummification consists of three basic steps:

1. **Remove the body's organs, preserving the important ones in jars.**

2. **Dry the corpse (because moisture causes decay).**

3. **Wrap the body with layers of linen bandages.**

Embalming priests extracted the organs through a slit in the stomach, dried the body for 70 days with *natron* (baking soda and salt), and then bandaged it up.

Incense, jewels, and herbs were often laid between the layers of bandages or mummy clothes.

The *Palette of Narmer* is a two-sided work of art. On one side, Narmer wears the white, bowling-pin crown of Upper Egypt (see Figure 6-1); on the other side, he wears the red, hatchet-shaped crown of Lower Egypt (see Figure 6-2). The artist made Narmer at least two times bigger than the people around him to show his superiority and divine status. Pharaohs were considered gods in Ancient Egypt. (A pyramid text says, "Pharaoh's lifetime is eternity / His limit is everlastingness.")

Figure 6-1:
The Palette of Narmer chronicles a victory of King Narmer over his enemies. Here, the pharaoh clobbers a kneeling enemy.

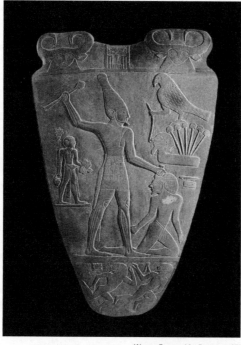

Werner Forman / Art Resource, NY

Post-unification pharaohs usually wore a double crown, combining the white crown of Upper Egypt and the red crown of Lower Egypt. The symbols of Lower Egypt are papyrus, which grows abundantly in the Nile Delta, and the cobra. Those of Upper Egypt are the lotus and the vulture.

Though it seems like backwards thinking, Upper Egypt is lower on the map than Lower Egypt — that is, Upper Egypt is geographically south of Lower Egypt. How did that happen? Unlike the Tigris, Euphrates, and Mississippi rivers, the Nile flows from south to north, which is a downhill trek from its source at Lake Victoria in Central Africa to the Mediterranean Sea.

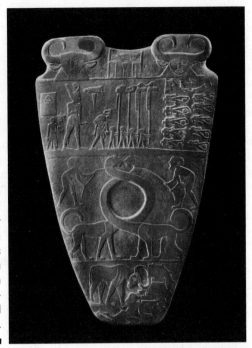

Figure 6-2: Check out the pharaoh looking at his decapitated enemies who have been stacked with their lopped heads between their legs (in the upper-right-hand corner).

Discovered in Hierakonpolis, the ancient capital of Upper Egypt, the Palette of Narmer is perhaps the world's oldest historical document, dating from around 3100 B.C. It resembles the small palettes on which Egyptians ground the pigments for their eye makeup, but seems far too big to have actually been used for that purpose. The reliefs on both sides of the green siltstone (25 inches high) tell the story of the unification of Upper and Lower Egypt in horizontal bands, kind of like a comic strip. There's even some helpful text (comic-book text bubbles) in hieroglyphics, the picture language of Ancient Egypt. We can't read every part of the palette, but we can interpret a lot of it.

The hieroglyph for Narmer's name — a catfish perched on a chisel — appears at the top on both sides. Clearly Narmer, the big guy on the palette, is the main character in the story. Notice that a pair of cow heads in the top strip set off Narmer's hieroglyph — like bookends. Hathor, the motherly cow goddess, is often viewed as the mother of pharaohs. Placing Narmer's name between images of Hathor suggests his divine origin.

On one side (see Figure 6-1), the pharaoh clobbers a kneeling enemy. The victim resembles the two sprawling, naked guys in the bottom band. Apparently, they've already been clobbered and are now worm's meat.

When Moses meets god in the Old Testament, the first thing God tells him to do is take off his shoes. (Exodus 3:5 says, "Put off thy shoes from off they feet, for the place whereon thou standest is holy ground.") Here, Narmer is also shoeless. A servant behind Narmer carries the pharaoh's sandals. Is there a connection? Why does Narmer have to remove his shoes to clobber somebody? Perhaps because slaughtering defeated enemies was viewed as a religious ritual because the divine pharaoh was always right. (People always find ways to justify their brutalities.) Also, like Moses, Pharaoh is in the company of a god — in this case, Horus, the hawk-god hovering over him.

Horus, the god of war and light, is sometimes depicted as a man with a hawk's head and other times simply as a hawk. Here he is represented as a hawk with one claw and one human arm with which he de-brains an enemy who is attached to a bouquet of papyrus plants. (In the process of mummification, the embalmer drained the dead person's brain through the nose, which is what Horus seems to be doing to the head.) The fact that the hawk stands atop papyrus plants, the symbol of Lower Egypt, shows that Lower Egypt has been subdued. Also, Horus's action parallels the pharaoh's and indicates that Narmer's deeds are in harmony with the gods'.

On the flipside of the Palette of Narmer (refer to Figure 6-2), Narmer, identified by his size and by the hieroglyphic nametag next to his head, is shoeless again. So he's probably performing another religious act, inspecting decapitated enemies who have been stacked with their lopped heads between their legs. A priest and pharaoh's standard bearers march before him. Their respective heights suggest their rank.

On the next lower strip, two snake-necked lionesses face off. Their entwined necks and perfect symmetry may suggest the unification of Upper and Lower Egypt, and that both halves of Egypt are equal. Note that two of the pharaoh's men restrain the lionesses, implying that the two Egypts need to be governed by a strong hand, Narmer's.

In the bottom band, a bull (possibly the Apis Bull, which was a god) tromps Egypt's enemies, while knocking down a fortress with his tusks. Bulls were often used to depict the might of pharaoh.

Both sides of the palette paint a picture of Egypt's strength and unity under the divine rule of Narmer.

The Egyptian Style

Though it's a very early work, the Palette of Narmer (see the preceding section) is representative of all later Egyptian art. The Egyptian style, once established, hardly ever changed. Notice that part of the pharaoh is shown in profile, while the rest of him is represented in frontal view. In 3,000 years of

Egyptian art, the pharaoh never changes his pose (in side-view reliefs and paintings). The pharaoh's legs are always shown in profile, with the flat left foot planted in front of the right. The chest and shoulders are in frontal view, while the face is in profile (except for the right eye, which you see head-on, so to speak).

Egyptian artists were ultra-conservative, probably because the main purpose of art was religious, and the Egyptian religion didn't change much — not until the reign of Akhenaten in the New Kingdom (see "New Kingdom Art," later in this chapter). All artists followed a *canon of proportions* when representing the human figure, sizing a man with an 18-unit grid. The unit could be based on a man's shoe size or his fist. The knees, belly button, elbows, and shoulders had to be a specified number of units from the feet. This is why Egyptian royals look so much alike. The pharaoh was considered perfect and unchanging, like a god; therefore, his proportions had to be unchanging in art, regardless of the king's actual dimensions. Only the lower ranks could be shown in more realistic poses, like the men harnessing the lionesses in the *Palette of Narmer,* whom you see from strict profile (except for their eyes) in more naturalistic positions.

Artists used the same canon of proportions to sculpt statues, but the figure was depicted frontally rather than in partial profile. Also, the left leg of the statue steps forward, more so in men than women (the more testosterone, the bigger the step), as in the statues of King Menkaura and his queen from the 4th dynasty. Despite their stoic faces, notice the intimacy and sculptural harmony of the pair. They look like they were *made* for each other. King Menkaura and his queen, who seem as durable as the pyramids, represent the stability of the Old Kingdom.

Excavating Old Kingdom Architecture

Old Kingdom pharaohs ruled Egypt liked gods on earth. Their power and financial resources must have seemed limitless and are best represented by the Great Pyramids and mighty Sphinx of Giza, who has the body of a lion and the head of Khafre, the fourth pharaoh of the 4th dynasty. Even after four and a half millennia of dust storms, the majestic 65-foot-high sphinx still stares boldly at the world (though its eyes are eroded).

The pyramids grew in steps, literally. They began with small mastabas, which seemed to grow with the prestige of the pharaohs during the 1st and 2nd dynasties. A *mastaba* is a mud-brick rectangular slab with doors and windows. It included a mourning room for visiting relatives and a sealed chamber for the deceased person's soul. The mastaba was attached to an underground tomb by a long shaft cut into rock.

During the 3rd dynasty, stone stairways to heaven called *step pyramids* were erected over the mastabas to ensure their permanence and give kingly tombs

a grander appearance. The greatest is the Step Pyramid of King Djoser (2667 B.C.–2648 B.C.), the second king of the 3rd dynasty.

Until about 2690 B.C., Egyptians used primarily mud brick, wood, and reeds to build mastabas and temples. The first totally stone structure was King Djoser's Step Pyramid, which was raised in the *necropolis* (city of the dead) at Saqqara, just south of modern-day Cairo.

Erecting the first all-stone structure took an innovative mind, someone with the vision to break with tradition and think outside the box — or, in this case, mud-brick mastaba. Imhotep, whose name appears at the base of a tomb statue of Djoser in the Step Pyramid, was just that. He is the first known artist and architect in history and was referred to as the "Chancellor of the King of Lower Egypt, the first after the King of Upper Egypt, Administrator of the Great Palace, Hereditary Lord, the High Priest of Heliopolis, Imhotep, the builder, the sculptor, woodcarver" (try fitting *that* on a nametag). He was also a famous physician and magician. (Medicine and magic were the same thing in those days.) In late Egypt, Imhotep was viewed as the god of medicine and healing and had shrines in parts of Egypt and Nubia. (Boris Karloff plays Imhotep in the 1932 film *The Mummy*. Arnold Vosloo plays him in the 1999 *The Mummy* and the 2001 film *The Mummy Returns*.)

Imhotep's Step Pyramid is similar to a Mesopotamian ziggurat (see Chapter 5). It seems to be a spiritual launch pad, designed to give the pharaoh's soul a boost into heaven, one step at a time.

In the 4th dynasty, the Step Pyramid evolved into the familiar four-sided pyramid like the Great Pyramids at Giza.

The oldest and biggest of the Great Pyramids, completed in about 2560 B.C., was erected by Khufu (a.k.a. Cheops) who ruled Egypt between about 2589 B.C. and 2566 B.C. Khufu's pyramid took roughly 20 years to build, stands 450 feet high, and is built on a 13-acre square base! Originally the pyramid stood at 481 feet, but its polished limestone veneer, which added about 30 feet to its height, has deteriorated. The sides of the pyramid are equilateral triangles that face due north, south, east, and west. They are aligned perfectly to one tenth of a degree to the cardinal points on a compass.

The pyramid is part of a vast funerary complex that includes two mortuary temples, three smaller pyramids for Khufu's wives, another small pyramid for Khufu's mother, a causeway, and mastabas for nobles linked to the pharaoh.

The pyramid shape duplicates the sun's rays streaming through an opening in a cloud. Because Egyptians believed that a deceased pharaoh rode to heaven on the sun god's rays, the perfect pyramid may have been designed to facilitate his skyward ascent in a more refined fashion than the Step Pyramid.

The Rosetta Stone

In 1799, one of Napoleon's officers, Captain Pierre-François Bouchard, discovered the Rosetta Stone, which was dated 196 B.C., in the port city of Rosetta (present-day Rashid). An important decree was inscribed on the stone in two languages — Egyptian and Greek — so everybody would understand it, like Canadian road signs that are written in both French and English.

One of the languages, Egyptian, was expressed in two different scripts. One of the scripts, *hieroglyphics,* was the sacred writing that Egyptian priests used. The other, *demotic,* was the common people's script starting in the 8th century B.C. Greek was the language of the foreigners who ran the country.

The key was to find common ground between the three scripts. About 20 years after the Rosetta Stone was discovered, Thomas Young, an Englishman whose hobby was studying Ancient Egypt, matched a couple names in hieroglyphs on the top third of the Rosetta Stone with the Greek equivalents in the bottom register. In 1822, Jean-François Champollion, a French Egyptologist and the founder of scientific Egyptology, continued Young's work, matching the hieroglyphic symbols of the names with phonetic sounds in a related ancient language that Champollion spoke, called Coptic. (Coptic is sort of an in-between language, halfway between Greek and Egyptian.) Soon Champollion figured out the whole alphabet. And the rest is art history.

The second largest pyramid is Khafre's at 446 feet. The base covers 11 acres. It is accompanied by the Great Sphinx and a temple complex similar to Khufu's.

Menkaure's pyramid, the third of the three Great Pyramids, is much smaller than the other two, standing at about 203 feet.

Although pharaohs continued building pyramids until the New Kingdom, the great age of pyramid building ended with the Old Kingdom. Middle Kingdom pyramids are much less grand.

The pharaoh spent much of his life preparing for death. A new pharaoh built his own tomb — which was considered his second or eternal home — as soon as possible. (Who knew when he'd have to move in?) He stocked the tomb with provisions that he would need in the hereafter, including clothes, toiletries, jewelry, beds, stools, fans, weapons, and even chariots. King Tut was entombed with four golden chariots! After his death, the immense task of managing a pharaoh's tomb was given to an entire town.

During the Middle and New Kingdoms, rich and middle-class Egyptians also built elaborate tombs. After their death, a family member known as "the priest of the double" managed the tomb and fed the dead relation from a sort of mummy menu, which included bread, fruit, meat, wine, and beer. For

insurance, pictures of food were painted on the walls in case a descendant stopped supplying meals. The pictures, combined with the right spells uttered by the deceased's spirit, would magically zap the food onto the table.

The tomb housed not only the mummy, but also the deceased's *ka,* or soul, which was represented by a statue housed in a sealed-off part of the mastaba. The ka statue was a backup in case the mummy disintegrated or was stolen. The statue had to look like the dead person in order for its magic to work. The words *carved from life* are inscribed on many ka statues.

Compare the realistic facial features of the life-sized ka statues of Prince Rahotep (son of King Sneferu, the founder of the 4th dynasty) and his wife Nofret in Figure 6-3 to the generic faces of King Menkaura and his queen (see *Menkaure and His Wife* in the appendix). This realism wasn't intended to impress anybody. When the pharaoh died, the statue was sealed up with him. No one ever saw it again.

The Egyptians also preserved and mummified internal organs that the dead would need in the hereafter like the stomach for digesting delicacies on the mummy menu. The organs were stored in four canopic jars, which were usually capped by the animal heads of the four sons of Horus.

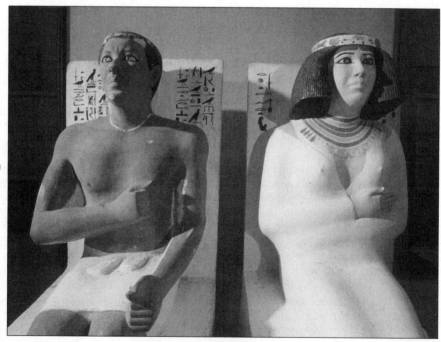

Figure 6-3:
Ka statues, like those of Prince Rahotep and his wife, had to be realistic to perform their magic.

Werner Forman / Art Resource, NY

The In-Between Period and Middle Kingdom Realism

In 2258 B.C., Egypt fractured into constellations of competing states. During this period, Egyptian people modified their view of the afterlife. Now petty princes and the rich who supported them could also have tombs to guarantee them a place among the stars. Instead of building pyramids (which would have been too showy), wealthy Egyptians carved their tombs in rock cliffs. Soon the pharaohs began to imitate them.

Trade expanded during the Middle Kingdom, especially during the 12th dynasty, creating a middle class who demanded rights, including admission to the afterlife. The demand for tomb and coffin paintings rose dramatically.

With these liberal trends, the rules for artists were relaxed somewhat. More naturalism was permitted.

The bust of Senusret III, a 12th-dynasty pharaoh, shows that the new realism applied to all ranks. His slightly downcast, heavy eyes and sensitive mouth show that he feels the burden of his rule. Senusret is represented more as a man than a god.

New Kingdom Art

The Middle Kingdom ended when the Hyksos, an Asian people, conquered most of Lower Egypt in 1720 B.C. The arts declined during this intermediate period, even though the Hyksos tended to respect Egyptian traditions. The decline ended in 1567 when Ahmose I, the founder of the 18th dynasty, reunited Egypt, ushering in the New Kingdom. Egypt expanded into Nubia and Libya during this period, becoming an empire. This expansion spread the influence of Egyptian art far beyond its borders and also brought foreign influences into Egypt.

Pharaohs stopped building pyramids and began to be buried in the Valley of the Kings in rock-hewn tombs on the West Bank of the Nile near Thebes (modern-day Luxor). The trend toward naturalism continued in the New Kingdom, especially during the reigns of Hatshepsut and Ahkenaten.

The 18th-dynasty female pharaoh Hatshepsut ruled from 1473 B.C. to 1458 B.C. She was the queen of her half-brother Thutmose II before becoming regent for her stepson Thutmose III and finally pharaoh after her husband's death. During her 21-year reign, Hatshepsut cultivated peace instead of war, commissioned

great building projects, and restored monuments destroyed by the Hyksos. She completed the tombs of her father (Thutmose I) and husband (Thutmose II), and built an even more magnificent funerary temple for herself at Deir el-Bahri. Her tomb complex consists of tiered *colonnades* (rows of columns) and two long, sloping causeways (one formerly lined with sphinxes), which may have suggested her spiritual ascent after death. At the ends of the second colonnade, she built shrines to Anubis, the god of the underworld, and Hathor. Behind the upper colonnade were temples to Hatshepsut herself and her father as well as to the chief gods Amun, the king of the gods, and Re, the god of the solar disk. These two eventually merged into one god, Amun-Re or Amun-Ra.

Hatshepsut was called "his majesty" and commissioned male-like images of herself like the Sphinx in the Metropolitan Museum of Art in New York City. By most counts, Egypt had only four queens in its 3,000-year history, so perhaps Hatshepsut needed such images simply to survive in a man's world. She was buried in the Valley of the Kings.

Akhenaten and Egyptian family values

The 18th-dynasty pharaoh Amenhotep IV (1352 B.C.–1355 B.C.) launched a new monotheistic religion in Egypt, built around the sun god Aten (a variation of the sun god Re).

Amenhotep IV shut down the temples of competing gods, especially Amun, whose priests were powerful and tried to prevent the new religion from taking root. The pharaoh changed his name from Amenhotep, which means "Amun is satisfied," to Akhenaten, meaning "It pleases Aten." Then he moved the capital from Thebes, where the cult of Amun was strongest, to a new location that he dubbed Akhetaten. (The modern name of the city is Amarna.) The artists and architects that Akhenaten hired to honor his new religion created a new style of art, which is called the Amarna style by art historians.

Akhenaten ordered that open-air temples be built to celebrate the light and love of the sun god in a more natural, open setting. Honesty was of central importance in the new religion, so artists had to depict people, including the pharaoh, more truthfully — in other words, in everyday situations, blemishes and all. The statue of Akhenaten in the Egyptian Museum in Cairo, for example, exposes his pot belly!

One of the best examples of the Amarna style is the family portrait of Akhenaten, his queen Nefertiti, and their three young daughters (see Figure 6-4). The youngest princess, who is still an infant, plays with her mother's earring. Akhenaten tousles the hair of the princess in his arms while she points to the *ankh* (symbol of life) at the tip of a sun ray. The other princess holds Nefertiti's hand and points toward her father, which helps to interlink the family. Intimacy between parents and children was new in Egyptian art. In this case, belief in one god seems to have encouraged more humanity.

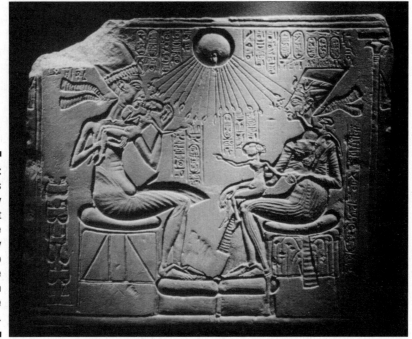

Figure 6-4: Akhenaten's family portrait brings the royal family down to earth while linking them to the god Aten.

Vanni / Art Resource, NY

The sun disk (representing Aten) in the relief spreads its rays equally on the king and queen, suggesting that they are co-rulers governing a balanced kingdom under one god.

This is a *sunken relief*. The artist incises the image into the stone rather than cutting out the background, as in raised relief.

The painted bust of Akhenaten's queen Nefertiti is the most famous female bust in Egyptian art. Her magnificent jewelry (typical of the Amarna period, in which exquisite jewelry flourished) echoes the color pattern of the band in her headdress. The queen is both idealized (the epitome of grace and elegance) and realistic. Her rounded shoulders and forward-leaning neck highlight her perfection and humanity. Her name means "the beauty that has come."

Raiding King Tut's tomb treasures

Akhenaten's monotheistic experiment (only one god — Aten!) didn't take root. It died with him.

When the new 9-year-old pharaoh Tutankhaten (which means "living image of Aten") came to the throne, his *vizier* (chief minister) Ay, an old-school Amun

priest, forced him to change his name to Tutankhamun, which means "living image of Amun." The old religion was now back on track. Tutankhamun moved the capital back to Thebes and ordered many of Akhenaten's outdoor temples and other innovations to be destroyed. Tutankhamun's own death mask, made only nine years later (see the color section), shows that most of the old formality and rigidity made a comeback after Akhenaten's death.

Tutankhamun, by the way, is the only pharaoh with a nickname. He has been popularly known as King Tut ever since Howard Carter discovered his intact tomb in 1922. His was the only king's tomb that hadn't been ransacked by grave robbers. It revealed the full cornucopia of Egyptian wealth and splendor and included a golden throne, four golden chariots, precious jewels, a casket of pure gold, statues of gold and ebony, and on and on. You can see why grave robbing was big business in Ancient Egypt!

Admiring the world's most beautiful dead woman

Tombs weren't simply covered with hieroglyphic spells. They were also elaborately painted, some with depictions of daily life that the dead could observe, but no longer participate in. The most common images were those of gods protecting the deceased. The most elaborate surviving tomb is that of Nefertari, Rameses II's favorite wife (he had half a dozen wives, as well as countless concubines) in the Valley of the Queens. In vibrant colors, Gods escort the lovely Nefertari on her journey through the afterlife. The tomb also features a creation myth and stories of resurrection (see the color section).

Mummy slaves

Pharaohs were also buried with mummy slaves called *ushabtis,* which were simply statuettes. Their job was to perform work details such as brewing beer or baking bread so that the pharaoh could lead an afterlife of leisure. The ushabtis even had a script: "If the deceased is summoned to do forced labor, 'I will do it, here am I!'"

Mummy armies also accompanied New Kingdom pharaohs in case they ran into any underworld enemies in the hereafter. (These mummy armies were probably the inspiration for the powerful skeletal soldiers in the recent mummy movies *The Mummy* and *The Mummy Returns.*)

Decoding Books of the Dead

In the Old Kingdom, pyramid texts — which included resurrection spells, charms, passwords, and prayers — were inscribed on pyramid walls. They were used to resurrect pharaohs. During the New Kingdom, similar spells were published in papyrus scrolls called Books of the Dead, which were readily available. Now anyone who could read could be resurrected.

But New Kingdom resurrection came with a hitch. The books weren't cheap, and you had to be good to be resurrectable.

Although books of the dead were individualized for the owner, they all include a goodness test called the weighing of the heart (see Hu-Nefer's Book of the Dead in Figure 6-5 — Hu-Nefer is an otherwise unknown man who lived during the 18th dynasty).

Figure 6-5:
This narrative scene from the Book of the Dead illustrates the weighing-of-the-heart ritual, the Egyptian version of the Last Judgment.

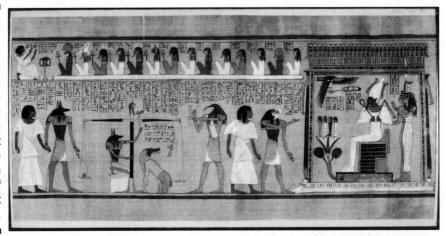

© British Library / HIP / Art Resource, NY

Anubis, the jackal-headed god of the underworld, leads Hu-Nefer's *ka* (soul) to the judgment scales. In his right hand, Anubis holds an ankh, the symbol of life. Things look hopeful for Hu-Nefer. At the scales, Anubis shows up again, this time to weigh the heart, which is contained in a jar on the left scale. The feather of truth (symbol of Maat, the goddess of truth) rests lightly on the right-hand scale. The heart had to be very light not to outweigh a feather! The court reporter, ibis-headed Thoth, records the weight while a monster named Ammit watches greedily. If the heart is heavy, Ammit gets to eat it. But on this occasion, Ammit goes hungry. Hu-Nefer moves on to the next stage.

The hawk-headed Horus leads Hu-Nefer's ka to the temple of Osiris to face a second test. To be admitted into paradise, Hu-Nefer must recite secret prayers to Osiris that he memorized while alive — or he could have had the prayers inscribed on his coffin lid if his memory wasn't up to snuff. Inside Osiris's temple, Hu-Nefer encounters the four miniature sons of Horus standing on a lotus blossom, a symbol of resurrection. (**Remember:** These are the guys whose heads cap the jars that contain the deceased's organs.) Maat, the goddess of truth, soars overhead, guaranteeing that Hu-Nefer's heart is light. Behind Osiris are his wife, Isis, the goddess of life, and sister-in-law Nephthys, goddess of decay.

Too-big-to-forget sculpture

Rameses II, who ruled Egypt for 67 years and supposedly sired 100 children, had a pharaoh-sized ego. This 19th-dynasty pharaoh (1304 B.C.–1237 B.C.) wanted to be remembered — maybe he feared he'd get a bad rap from the Bible, if indeed he was the "Pharaoh" of *Exodus*. In any case, Rameses erected colossal monuments to himself throughout Egypt, especially at Abu Simbel, Karnac, and Luxor, the temple districts near Thebes. Four 65-foot statues of Rameses guard the entrance to his massive temple in Abu Simbel where he could be worshipped as a god. Smaller statues of family members and his chief queen, Nefertari, hover around his knees.

Rameses II also used art as political propaganda. He barely survived the Battle of Kadesh against the Hittites, yet he touted it as a great victory on a war monument.

Though they are monumental, Rameses's temples are not always great art. The execution seems coarse when compared to earlier temples. Maybe Rameses was in a hurry and forced his artists to streamline their work, leaving out details, so they could move on to their next project — another monument to him.

Chapter 7

Greek Art, the Olympian Ego, and the Inventors of the Modern World

In This Chapter

▶ Jumping the bulls with the Minoans

▶ Understanding Greek sculpture

▶ Interpreting Greek vase painting

▶ Touring Greek ruins

▶ Tracking Hellenism

> *Everything that grows great also decays. But the memory of our greatness will be bequeathed to posterity forever . . . the admiration of the present and succeeding ages will be ours, since we have not left our power without witness, but have shown it by mighty proofs . . . we have forced every sea and land to be the highway of our daring, and everywhere . . . have left imperishable monuments behind us.*
>
> —Pericles (Athenian statesman, 5th century B.C.)

*P*ericles was right. The world he helped create did decay. But its memory and influence have lasted for nearly 2,500 years, reaching across the ages into our day-to-day lives.

Whether you're watching a play or movie; cheering your country at the Olympics; debating an ethical question; visiting the Lincoln Memorial in Washington, D.C.; wrestling with an abstract math problem; or voting for your local mayor, your actions are rooted in Ancient Greece. The Greeks wrote the blueprint for the modern world. They invented democracy, logic, ethics, drama, the Olympics, the study of history, theoretical math, and rational inquiry (the precursor of modern science); laid the foundations of Western art; and developed architectural styles that we still mimic today.

The Greeks knew what they were talking about

The Greeks handed down to us a treasure trove of art and literature on government, education, drama, day-to-day life, economics, and even love. Here are just a few of their famous words:

- ✔ "Our constitution does not copy the laws of neighboring states, we are rather a pattern to others than imitators ourselves. Its administration favors the many instead of the few; this is why it is called democracy. If we look to the laws, they afford equal justice to all in their private differences." —Pericles

- ✔ "Good people do not need laws to tell them to act responsibly, while bad people will find a way around the laws." —Plato

- ✔ "We cannot learn without pain." —Aristotle

- ✔ "The most important part of education is proper training in the nursery." —Plato

- ✔ "Love is a serious mental disease." —Plato (a diehard bachelor)

- ✔ "There is only one good, knowledge, and one evil, ignorance." —Socrates

We owe our Western heritage to all of Ancient Greece, but especially to Athens (located on the coast of the Aegean Sea), which may be the most creative city in history. (Florence, Italy, runs a close second — see Chapter 12.)

How did a tiny city-state the size of Toledo, Ohio, launch the modern world two and a half millennia ago? Read on.

Mingling with the Minoans: Snake Goddesses, Minotaurs, and Bull Jumpers

Aegean culture (civilization around the Aegean Sea) didn't begin with the Greeks — it began with the Minoans in the late 3rd millennium B.C. The Minoans lived on the island of Crete (south of what became the Greek mainland), which is about 150 miles long and 36 miles wide (at its widest). Though they traded with the Egyptians and Mesopotamians, the Minoans lived in relative isolation and developed a unique culture. Their art focused not on death and war like the Egyptians and Mesopotamians, but on life, beauty, and having fun!

The Minoans are named after the mythical King Minos who supposedly ruled Crete and owned a half-man, half-bull "pet" called the minotaur. The pet's name is a variant of the king's, because the minotaur was also his stepson. Minos's wife cheated on him with a bull! (And you thought *Desperate Housewives* was

salacious.) Minos penned up his monstrous stepson in a labyrinth and sacrificed young Athenian men and women to him until the mythical Athenian hero Theseus slew the beast.

Actually, the Minoans were a peaceful people. They made more tools than weapons, and their chief god was not a thunderbolt-wielding macho man like Zeus, but a sexy-looking snake-goddess. Her *cult animals* (animals associated with worship) included the dove, snake, and bull. The minotaur myth probably evolved from the Minoans' infamous religious sport, bull jumping, in which young men and women somersaulted off the backs of wild bulls.

The Minoans built palaces (though much less impressive than Egyptian and Mesopotamian palaces), which they decorated with elaborate murals. In fact, mural paintings were their greatest cultural achievement. *The Toreador Fresco* (circa 1500 B.C.), which features the bull-jumping event, is the most dramatic example (see Figure 7-1).

Figure 7-1: The Minoans didn't run with the bulls like they do in Pamplona; they somersaulted off their backs as shown in *The Toreador Fresco* from Knossos, Crete.

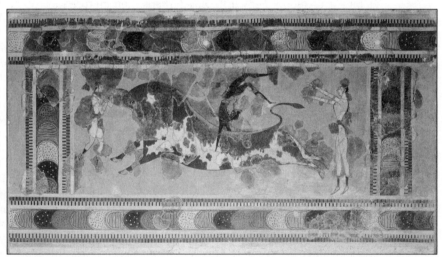

Scala / Art Resource, NY

Notice that the women vaulters (in front of and behind the bull) are white-skinned, suggesting that they spent more time indoors than the dark-skinned male jumper. Yet we see total sexual equality here for the first time in art. Man and woman are equal partners in this dangerous but playful religious sport. In fact, the women outnumber the men.

The streamlined bodies in *The Toreador Fresco* brim with exuberant life. Even the bull's S-shaped tail looks like a wisp of playful energy. The wavelike shapes of bull and jumper harmonize, suggesting that man and nature are one in Crete. The next-in-line jumper stands anxiously on her tiptoes, ready to vault off the bull's back, while an earlier jumper holds the bull's horns. (Obviously, there was some fictionalizing here!) The positions of the three jumpers suggest the sequence of actions involved in bull jumping.

Compare the graceful Minoan shapes that seem to flow like waves with the sturdy-as-a-mountain forms of Egyptian art (see Chapter 6) and Mesopotamian art (see Chapter 5). The latter two were both river-based cultures, hemmed in by deserts. The Minoans were the first civilization to be surrounded by sea. The tides of the Aegean seem to wash refreshingly through the Minoans' art and culture.

If art reflects the people who make it, the Minoans must've been a fun-loving folk. Their murals feature diving dolphins, creepy-crawly octopi, lively floral landscapes, and wavelike patterns inspired by the sea. A Minoan palace looked a bit like an indoor SeaWorld. But perhaps their culture was too fun loving and easygoing to survive in a brutal world.

In about 1500 B.C., aggressive Greek tribes invaded Crete and established the first Greek culture. Gradually, the Greeks fanned out over the Peloponnesus peninsula and Aegean Islands.

But the conquered Minoans didn't disappear completely. They merged with the Greeks, creating what we call Mycenaean culture. The Mycenaens invented the colorful Greek myths that have been handed down to us and launched the Trojan War, which is recounted in the greatest epic poem ever written, *The Iliad.*

After the Trojan War, Mycenaean culture collapsed, falling to another wave of invading Greek tribes called the Dorians, who settled in Sparta and the Peloponnesus peninsula. The Ionian Greeks, who'd migrated centuries earlier, remained entrenched in Athens and surrounding Attica, where they had resided since the era of the mythical Theseus and the Minoans.

After the fall of Mycenae, several centuries of squabbling passed before Greece settled into what became classical Greece, a constellation of far-flung city-states from Asia Minor and the Greek mainland to Sicily and the Mediterranean coast of France. Although a common language and culture united the Greek states, they were often at war with each other. For about 400 years after the conquest of Mycenae, the Greeks produced no significant art; they were too busy fighting for power and wealth. In the calmer 8th century B.C., the earliest manifestations of Greek culture emerged in the visual arts and literature. *The Iliad* and *The Odyssey* were written in the 8th and 7th centuries B.C., respectively.

Greek Sculpture: Stark Symmetry to a Delicate Balance

The Greeks absorbed the rigidness of the Egyptians, with whom they traded, and the fluid forms of the Minoans. They gradually combined the two into an idealized but naturalistic art that many people consider the greatest art of the ancient world.

Kouros to Kritios Boy

The evolution of Greek sculpture from the rigid *kouros* statues of the 7th and 6th centuries B.C. to the naturalistic *Kritios Boy* (circa 480 B.C.) correspond with a seismic political change in Athens that spread to many other city-states. *Despotism* (rule by one) was replaced by *democracy* (rule by all male citizens) in 508 B.C. *Kouros* ("youthful boy") statues represented the old order and the aristocracy — rigid, powerful, proud. The more naturalistic *Kritios Boy* represents democracy — relaxed, graceful, and realistic. *Kritios Boy* looked like an idealized version of the man in the streets, as opposed to a stiff superhero like *kouros*.

The Archaic period

Eventually, the Greeks put their own stamp on all cultural imports. But in the 7th and 6th centuries B.C., during the Archaic period (650 B.C.–480 B.C.), Greek sculptures look like hand-me-down Egyptian tomb statues. The artists obviously spent time in Egypt or studied the imports closely.

Compare the archaic Greek statue of a *kouros* at the Metropolitan Museum of Art (c. 600 B.C.) with the Egyptian statues of King Menkaura and his queen (sculpted in roughly 2515 B.C.). Almost everything about the archaic Greek statue says, "I'm Egyptian." The *kouros* is as symmetrical and rigid as the pharaoh's statue, though the Menkaura sculpture is more refined. Both the *kouros* and King Menkaura have squared shoulders; straight, rigid arms and legs; and clenched fists held firmly at their sides. Both step slightly forward with the left foot. Both have pronounced, geometric kneecaps, and the same angular calves, as if they'd been shaped with an old-fashioned wood shaver. But there are differences. The *kouros* is completely naked. Pharaohs were never represented nude; in fact, only Egyptian children were routinely shown in the buff.

The female version of the archaic statue is called a *kore,* which means "maiden." *Kores* are never nude. Only Greek men were allowed to prance around town in the altogether. Greek women usually stayed indoors to do the sewing and cooking (except in Sparta). When they went out to collect water, for example, they wore long gowns.

The Greeks gradually shed strict Egyptian symmetry for a more subtle form of balance. The *kouros* in Figure 7-2, sculpted circa 525 B.C., 75 years after the *kouros* at the Metropolitan Museum of Art (see *Kouros* in the appendix), is much more realistic, though he's still stuck in the same Egyptian pose.

Notice how much more lifelike the finely modeled curves of the shoulders, arms, and thighs are than in the earlier version. The older statue looks like a stone man. The later one is nearly a flesh-and-blood athlete; he's almost ready to learn to walk.

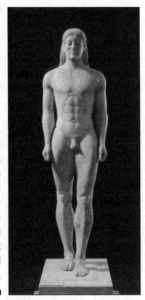

Figure 7-2: Although still at attention like a frozen soldier, this later *kouros,* called *Kroisos,* shows the Greek progression toward more naturalistic sculpture (making stone look like real flesh).

Nimatallah / Art Resource, NY

But giving statues the semblance of motion took another hundred years. First, sculptors had to learn to depict the body in a relaxed rather than rigid posture.

The Classical period

In the Classical period (480 B.C.–400 B.C.), *Kritios Boy* (named after the artist who probably sculpted him) has learned to take it easy (see Figure 7-3). The artist has redistributed his weight. The left hip is now slightly higher than the right, and *Kritios Boy*'s bulk rests comfortably on his left foot instead of both feet as in the *kouros* (see the preceding section). The contours of the graceful thighs are utterly lifelike, as is the gentle swelling of the belly. The face, too, is more human than *kouros* faces; its still mask-like appearance is due to the holes where inlaid eyes used to be.

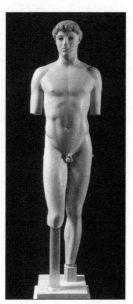

Figure 7-3:
Greek
statues
begin to get
comfortable
around 480
B.C. *Kritios
Boy* is the
turning
point. The
sculptor has
learned to
turn the
body just
enough to
give him
a more
relaxed look.

Nimatallah / Art Resource, NY

Notice the tension in the knees: The left is tight, the right relaxed, showing the distribution of weight. The sculptor has learned to represent a symmetrical young man's body in an asymmetrical stance. The next step was to make the statue walk, run, jump, and throw — or at least appear to!

The bronze *Charioteer* from Delphi (circa 470 B.C.; see Figure 7-4) is stiffer than *Kritios Boy,* but his upright posture would have helped him to be seen standing in a chariot atop a tall monument. The concentrated look in the charioteer's face and the elegant, naturalistic folds of his robe are characteristic of early 5th-century Greek realism, also known as the *severe style.* The statue was commissioned to celebrate an athletic victory, a chariot race. Sports events were a big deal in Greece. During the Olympics, all warfare ceased so the Greeks could compete for laurel leaves instead of fighting for money and power.

The fact that the athlete was cast in bronze shows how highly the Greeks regarded sports heroes. They had godlike status, especially in their hometowns, where they were given a pension and free meals for the rest of their lives.

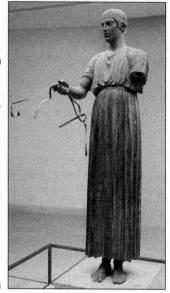

Figure 7-4:
The
Charioteer's
noble
expression
and proud
posture
indicate the
respect that
sports
heroes
commanded
in Greek
society.

John Garton

Golden Age sculptors: Polykleitos, Myron, and Phidias

The high classical style began in about 450 B.C., when Greek sculptors learned to invest statues with the appearance of motion. Myron involved the entire body of *Diskobolus* ("Disk Thrower") in a single, compressed action. The statue appears wound up, his energy ready to burst forth. Yet his classically serene face and the faraway look in his eyes contrast with the action of his body, giving the athlete a timeless quality, as if he were throwing his discus into eternity.

Polykleitos created a feeling of balance with contrasting tensions that also suggest motion. The off-center pose that gives this relaxed-but-balanced look is called *contrapposto*. You can see this effect in a Roman copy of Polykleitos's *Doryphoros* ("Spear Bearer"; see Figure 7-5). The cocked left arm contrasts with the straight or engaged right leg, while the straight right arm offsets the bent left leg. The left leg seems to propel the figure forward. Opposite forces preserve the feeling of balance while imparting a sense of tension and action. The Greek philosopher Heraclitus (circa 535 B.C.–475 B.C.) summed up the concept: "Opposition brings concord."

Polykleitos wrote a book of rules of proportion called the *Canon;* it was followed by succeeding generations of Greek and Roman sculptors. He cast his original *Doryphoros* in bronze to illustrate the principles of the *Canon*. The many surviving marble copies of *Doryphoros* attest to its popularity and to the respect that Roman copyists had for the *Canon* of Polykleitos.

Figure 7-5:
This Roman copy of Polykleitos's *Doryphoros* is at ease and tense at the same time. Almost 2,500 years after he was carved, he still has the glow of Greece's Golden Age (circa 450 B.C.– 440 B.C.).

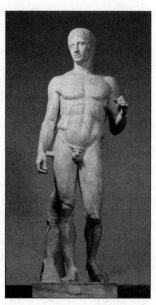

Scala / Art Resource, NY

The Greek term *canon* means "rule" or "standard." Today, when someone speaks of the canon of art history, she's referring to the masterpieces that "measure up" or meet a set of artistic standards, allowing them to be classed with the greatest works of all ages.

In order for Greek culture to survive, the disjointed city-states had to be able to defend themselves against outside aggressors like the Persians. In 480 B.C., the Athenians foiled a Persian invasion by outwitting their powerful enemy. Their 380-ship navy outmaneuvered and crushed a much larger Persian fleet of 1,207 ships at Salamis. This gave Athens great prestige in the Greek world and put her at the center of a defensive alliance called the Delian League. All member states contributed money to pay for the navy, which Athens controlled. Eventually, Pericles, Athens's greatest leader, skimmed from the defense funds to give Athens a facelift, making it one of the most glorious cities of the ancient world. This gave the city-state even more prestige, but awakened the jealousy and fear of rivals like Sparta and Corinth, and naturally angered Athens's allies. The rivalry escalated and finally erupted into the Peloponnesian War in 431 B.C. The war ended in 404 B.C. with Athens's definitive defeat. The Golden Age of Greece was over. But the age of Alexander the Great and Hellenism, which would spread Greek culture across most of the civilized world, was about to dawn.

If the proverbial "glory of Greece" rested on two men's shoulders, it would be Pericles and Phidias. Phidias was the most celebrated Greek sculptor and the overseer of the sculptural work for Pericles's building projects on the Athenian Acropolis (downtown Athens).

One of Phidias's greatest sculptures was the 40-foot-high, gold-and-ivory statue of Athena, which once stood in the Parthenon. It and most of Phidias's works are lost. His only surviving sculpture (or perhaps it's the work of his workshop — see the following paragraph) are the friezes and pediment statues of the Parthenon, many of which are now in the British Museum. But these and the praise of ancient writers are enough to ensure the sculptor's immortality. The ancients called Phidias's works sublime and timeless.

From ancient times through the 18th century, artists often worked in workshops under a master sculptor or painter like Phidias. In such cases, the apprentice artists might do the actual carving of the master artist's design. Often, the master fine-tuned his apprentices' work.

The surviving Parthenon statues (many in fragments) have these same qualities that ancient writers described. The figures seem to be watching themselves as they participate in the action, as if they were of this world and yet beyond it, part of the Greek heaven, Olympus. Even though the heads of the *Three Goddesses* (which is now in the British Museum) are missing, the superbly rendered fabrics (which have the wet or clingy look pioneered by Phidias) speak for them, revealing the moods, spirit, and down-to-earth sensuality of the flesh-and-blood women behind the clothes. What are the three goddesses doing? Watching the birth of Athena, the goddess of wisdom, springing full-grown from the brow of her father Zeus. The 1st-century Greek writer Plutarch, who saw the Parthenon and Phidias's work five centuries after they were executed, wrote:

> There is a sort of bloom of newness upon those works of his, preserving them from the touch of time, as if they had some perennial spirit and undying vitality mingled in the composition of them.

Today, even though they are in ruins, this "vitality" endures.

Fourth-century sculpture

After the fall of Athens in 404 B.C., the city-state gradually got on its feet again, though it never rose to its former glory. Nevertheless, Greek philosophy peaked in the 4th century B.C. (Maybe Athens's defeat made all Athenians more philosophical.) Plato taught at his famous Athenian Academy from about 387 B.C. to 347 B.C., and Aristotle, his greatest student, taught at the Lyceum in Athens from 335 B.C. to 322 B.C., after educating Alexander the Great in Pella, Macedonia.

The 4th century also produced three great sculptors: Praxiteles, Skopas, and Lysippos (the private sculptor of Alexander the Great). In 4th-century sculpture, the wet look got even wetter, but the timelessness associated with Phidias and Polykleitos gave way to an everyday or down-to-earth quality. For example, Praxiteles depicts his *Knidian Aphrodite* preparing to take a bath, while his *Hermes* (see Figure 7-6) looks fondly on the playful infant Dionysos cradled in his arm.

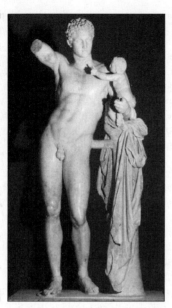

Figure 7-6: Praxiteles had a knack for giving statues a soft, sensual look, as you can see in this Hellenistic or Roman copy of his *Hermes and the Infant Dionysus* (circa 320 B.C.– 310 B.C.).

Scala / Art Resource, NY

Fourth-century statues also often have a down-to-earth sensuality lacking in 5th-century sculpture; compare Polykleitos's *Doryphoros* in Figure 7-5 to Praxiteles's *Hermes* in Figure 7-6.

The 4th century also produced the first free-standing female nudes. Praxiteles stripped Aphrodite, the goddess of love, to reveal all her delicate beauty and grace. Naked Aphrodite was a hit; many copies followed. Praxiteles was a master at depicting delicate curves and making marble look like soft, supple flesh. The original *Knidian Aphrodite,* like nearly all great Greek statues, has been lost and is only known through Roman imitations and writers' descriptions. Praxiteles's statue of *Hermes and the Infant Dionysos* (refer to Figure 7-6) is nearly as famous as his *Aphrodite* — and just as beautiful. The softness and classical serenity of the facial features and delicate grace of Hermes's body are hallmarks of Praxiteles's style. The *Hermes,* once believed to be an original, is now considered to be a superb copy, closer to the spirit of the original than the copy of *Knidian Aphrodite.*

Figuring Out Greek Vase Painting

Greek vase painting progressed from the somewhat primitive Geometric style (10th through 8th centuries B.C., in which people and animals look like stick figures) to the highly realistic Early Classical style in the early 5th century B.C. Greece also had a brief flirtation with an Oriental style influenced by trade with Mesopotamia.

Cool stick figures: The geometric style

At first glance, the paintings on vases from the 10th through 8th centuries B.C. look like the stick-figure doodlings of a child. Closer inspection reveals a complex network of geometric patterns: wraparound chains of Greek frets and *chevrons* (similar to a private's stripes), squares, dots, and squiggly lines, along with stick figures of people and animals. Geometric vases could also tell stories. The *Dipylon Krater* at the Metropolitan Museum of Art shows stick figures pulling their hair out in mourning at the funeral pyre of a Greek warrior.

In the next century, the more realistic Oriental style, which made a brief appearance, allowed for clearer visual narrative. The neck of the Oriental-style amphora (used for storing and pouring wine or olive oil) *The Blinding of Polyphemus and Gorgons* depicts a scene from *The Odyssey,* in which Odysseus and his companions burn out the eye of the one-eyed giant Cyclops (Polyphemus). Odysseus pulls off this stunt by first getting the giant drunk. The wine cup in the Cyclops's hand suggests this earlier episode.

The Mesopotamian influence is confined to the figures. Odysseus and his men look like Mesopotamians, especially the upper part of the scorpion-man in the bottom band of the *Puabi Lyre* (see Chapter 5). The animals in the middle band and the gorgons (sisters of the snake-haired Medusa) on the belly of the vase also have a Near Eastern flavor. But the Greeks added their own playful charm to the monsters. If you look closely, you can see that the bug-eyed gorgons show off their sexy left legs like can-can dancers.

The belts of interlaced wavy lines (like basket weaving) at the top, bottom, and neck are leftovers from the Geometric period.

Black-figure and red-figure techniques

The Oriental style gave way in the 6th century B.C. to the even more realistic archaic style. Archaic-style painters employed one of two techniques, either the black-figure technique, which began in the early 7th century B.C., or the red-figure technique, which was invented around 530 B.C.

In black-figure painting, the artist first sketched his figures with a lead or charcoal stick on the red clay vase, and then filled in the figures with *slip* (a wet clay mixture). When fired, the slip turned black, and the unpainted part of the vase remained red. Details were often added with purple- or red-dyed slip, as in *Hercules Slaying the Nemean Lion with Aiolos and Athena* (see the color section), an amphora by Psiax. In this vase scene, Hercules, guarded

by Athena (on the viewer's right), overcomes the Nemean Lion, one of his famous 12 labors.

Gradually, black figure was replaced by a reverse process known as the red-figure technique, which allowed the artist to create more detailed renderings of figures.

In the red-figure technique, the artist sketched the figures, and then incised a ³⁄₁₆-inch border around them. Next he painted in details with slip (historians aren't sure how — probably with a fine-haired brush or sharp tool). Finally, he painted the background with slip (which blackened in the kiln) right up to the incised border around the figure.

Notice the fine detailed work in the *Medea Krater* (see the color section). This much detail could not have been achieved in the black-figure technique. The *Medea Krater,* which was painted about 30 years after Euripides's famous tragedy *Medea* premiered in Athens, depicts the play's climax: The witch Medea has just murdered her sons to get revenge on her unfaithful husband Jason (of *Jason and the Argonauts* fame). With sword raised, she makes her getaway in a dragon-drawn chariot, a loan from her grandfather Helios, the god of the sun. The defeated Jason looks up helplessly at her, his weapon dangling uselessly at his side. The winged women flanking Medea, the daughters of the night, will fight for him. They are furies whose job is to avenge within-the-family murders. But they'll have a tough time getting past the sunburst of Helios.

Rummaging through Ruins: Greek Architecture

Greek architectural styles are perennially popular. The Romans imitated them for centuries. Europeans imitated them from the Renaissance through the 19th century, and 19th-century Americans recycled Greek styles in home building (because they had a democratic look) in an architectural movement called Greek Revival. You can find Greek columns, cornices, and pediments in practically every corner of the United States.

The Greeks invented three *orders,* or architectural formulas: Doric, Ionic, and Corinthian (see Figure 7-7). Each order is based on precise numerical relationships so that all the architectural elements in a structure harmonize; like musical notes, they must be in the same architectural key or they will seem out of tune.

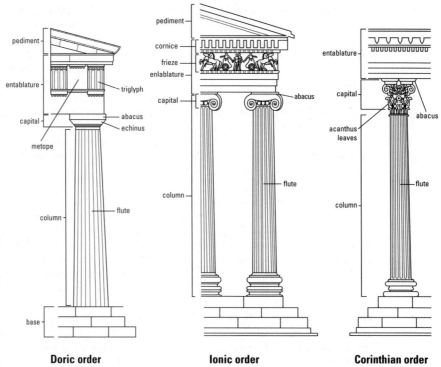

Figure 7-7:
The Doric,
Ionic, and
Corinthian
orders were
invented by
the Greeks.

Doric order **Ionic order** **Corinthian order**

In the Doric order (refer to Figure 7-7) every pair of columns is topped by
three *triglyphs*. A triglyph looks like a set of mini columns. A *metope* is the
space between the triglyphs, on which sculptors sometimes carved reliefs.
The entire horizontal section, between the columns and triangular *pediment*
(which is also often carved with relief), is called the *entablature*.

Pediment reliefs are notoriously difficult to carve because the artist must fit
the visual narrative inside the triangle without making the heights of the fig-
ures, which must shrink as you move away from the center, seem unnatural.
If you were depicting a battle between Amazons and Pygmies, the fit would
be easy. You'd stick the Amazons in the center and the Pygmies in the cor-
ners. Typically, pediment battle scenes feature standing warriors in the
center with leaning warriors beside them, then crouching archers, and finally
dead men lying in the corners as in the Doric Temple of Aphaia in Aegina.

In the Doric order, the columns stand on a three-step base. The columns
themselves are fluted (refer to Figure 7-7) like all Greek columns, with 20
grooves each; the columns taper toward the top. The crown of the Doric
column — the *capital* — is made of two hats: The bottom one (the *echinus*) is
curved like a bowl, and the top one (the *abacus*) is rectangular. Doric temples

were constructed of stone blocks, which were connected without mortar so they had to be cut perfectly to give a snug fit and elegant look.

The Parthenon (a Doric temple — see Figure 7-8) was built between 447 B.C. and 438 B.C. under Pericles, supervised by Phidias, and designed by two architects, Iktinos and Kallikrates. At 8 columns wide and 17 columns long, it is bigger than the Doric Temple of Hera in Paestum built 100 years earlier, yet the Parthenon seems lighter and more graceful. The architects managed this effect by tweaking the proportions (in other words, by breaking the rules). The legs or columns of the Parthenon are thinner than the bulky ones at Paestum. The tapering (or thinning) of the legs toward the top is more subtle. The entablature and platform are not purely rectangular; they curve upward toward the center, giving the structure a feeling of upward lift. All the *capitals* (tops of the columns) were adjusted to support this slight curving. The columns also lean imperceptibly toward the center, heightening the upward feeling. Because of this fine-tuning, the weight-bearing columns of the Parthenon don't seem to have to work as hard as those of Paestum. The Paestum temple is oppressive — you can feel its weight bearing down on you. But the Parthenon uplifts you as if it had magically overcome gravity.

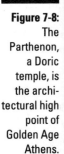

Figure 7-8: The Parthenon, a Doric temple, is the architectural high point of Golden Age Athens.

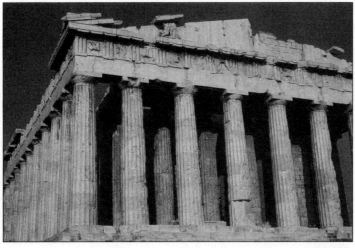

Gloria Wilder

The Ionic order (refer to Figure 7-7) is more elaborate than the Doric. The main difference is that the columns are elongated, the capital (top of the column) is capped by a scroll, and the entablature features a continuous frieze or sculpted band. There are no metopes or triglyphs as in the Doric order.

The most elaborate order is the Corinthian (refer to Figure 7-7), which has slender columns capped by overlapping acanthus leaves.

Greece without Borders: Hellenism

[Alexander the Great's father] sent for Aristotle, the most learned and most celebrated philosopher of his time, and rewarded him with a munificence proportionable to and becoming the care he took to instruct his son.

—Plutarch, *Life of Alexander*

Alexander the Great (356 B.C.–323 B.C.) was Macedonian, but he learned to think and feel like a Greek from the greatest Greek of the era, Aristotle. After the death of his father in 331 B.C., Alexander became king. In the next eight years, he overran and Hellenized (made Greek-like) most of the known world, planting Greek libraries and Greek city-states in every vanquished kingdom. But when Alexander conquered, he didn't try to shut down the native culture; instead, he fused it with Greek models. He himself married, among several other women, a princess from Bactria (a country near modern-day Afghanistan) and ordered his officers to take Persian wives to unify the diverse cultures.

After his early death, Alexander's generals divided his empire three ways:

✔ Seleucus I Nicator ruled Persia, Mesopotamia, and Anatolia.

✔ Ptolemy I Soter governed Egypt.

✔ Antigonus I Monophthalmus controlled Macedonia and Greece.

All these regions eventually fell to the new power rising on the Italian peninsula, the Romans. The last holdout was Egypt, which collapsed in 31 B.C. when Queen Cleopatra took her own life after Augustus Caesar defeated her and Marc Antony in the Battle of Actium. The Hellenistic period died with Cleopatra.

The greatest achievements of Hellenistic culture were in sculpture. Hellenistic sculptors replaced the serene beauty of classical sculpture with powerful emotionalism and sometimes brutal realism. The *Nike of Samothrace* (see Figure 7-9), a Hellenistic victory statue, looks like she's just landed with her Air Jordans on the prow of a ship, the wind still gusting in her wings and gown. You can feel victory in the folds of her garment and uplifted wings. Also the sculptor has learned to create art that charges the atmosphere around it. Instead of being self-contained, the statue radiates energy beyond itself into the surrounding space.

Hellenistic sculptors also probed the depths of human suffering for the first time in the history of art. The agony of death was never before so vividly portrayed as it is in *The Dying Trumpeter,* carved in the 3rd century B.C. in Pergamon (in modern-day Turkey), and in *Laocoön and His Sons* (see Figure 7-10), a Hellenistic sculpture from Rhodes. *The Dying Trumpeter* is a moving depiction of an enemy Celt warrior wounded in a battle with the Greeks who colonized Asia Minor. The statue is carved in a way that enables the viewer to feel the death pains that the man faces with quiet dignity.

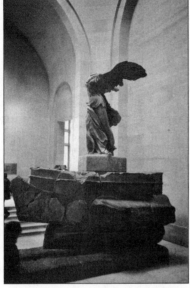

Figure 7-9:
Nike of Samothrace is often attributed to Pythokritos, the great sculptor of the Greek island of Rhodes (2nd century B.C.).

John Garton

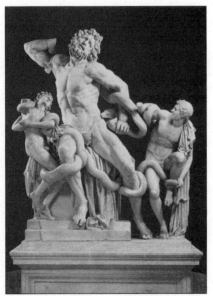

Figure 7-10:
Laocoön and His Sons may have been carved by three sculptors from the Greek island of Rhodes — Agesander, Athenodoros, and Polydoros — all highly skilled copyists.

Scala / Art Resource, NY

Laocoön and His Sons captures the mythical life-and-death struggle between a father, his boys, and two vicious sea serpents. (Laocoön was punished by the goddess Athena for trying to expose the Trojan Horse as a fraud to the Trojans who viewed it as a gift and sign that the Greeks had quit their siege of Troy.

Actually the horse concealed a bevy of Greek kings waiting to pounce on the Trojans when they dragged the giant wooden horse into their unsuspecting city.) This 1st-century B.C. statue was discovered in 1506 in the ruins of the Emperor Nero's famed "Golden House" in Rome.

Part of the intense expressiveness you see in *The Dying Trumpeter* and *Laocoön and His Sons* was no doubt due to the assimilation of so many foreign cultures, and part of it to a new worldview. The self-confidence of classical Greece had proved to be self-delusion. Life was gritty and unpredictable, not serene, changeless, and other-worldly.

But the serene beauty of Greek classicism didn't fade away completely. The *Venus de Milo* (or *Venus of Melos*), shown in Figure 7-11, is a throwback to 4th-century Athens. With her unflappable calm, she could have been sculpted by Praxiteles. The fact that her clothes seem to be slipping off enhances the goddess's potent sexuality. Yet her musing gaze takes the viewer beyond her sensuality to a place of mystery.

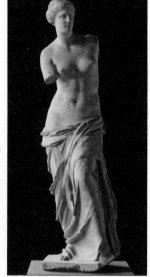

Figure 7-11:
Venus de Milo is one of the most celebrated Hellenistic statues.

Erich Lessing / Art Resource, NY

Chapter 8

Etruscan and Roman Art: It's All Greek to Me!

In This Chapter

▶ Figuring out why the Etruscans smiled at death

▶ Analyzing Roman realism

▶ Interpreting propaganda art

▶ Touring Roman ruins

*T*he amazing culture of the Greeks had a profound influence on their neighbors. The Etruscans and Romans, in particular, borrowed liberally from Greek culture. However, both peoples took Greek art in new directions that reflect their own unique civilizations.

The Mysterious Etruscans

The Etruscans appeared in central Italy in the 8th century B.C., about the same time that the Greeks founded colonies in southern Italy and Sicily. Because they didn't have their own script, the Etruscans adopted and adapted the Greek alphabet. They also borrowed Greek art styles and techniques and incorporated a handful of Greek gods into their religion. Like the Greeks, the Etruscans were a confederation of city-states; they never united into a nation or empire. Nevertheless, by the 6th century B.C., they dominated most of Italy and even ruled Rome from 616 B.C. to 509 B.C. In that year, Brutus (possibly an ancestor of the Brutus who helped murder Julius Caesar 450 years later) and others overthrew Rome's last king, the Etruscan Tarquinius Superbus, and set up a republic.

Temple to tomb: Greek influence

Almost nothing remains of Etruscan architecture. But the 1st century B.C. Roman architect and writer Vitruvius, who saw some of it firsthand, describes

Etruscan temples. According to Vitruvius, they were almost square, with an equal amount of space between the porch and the interior of the temple. Built of mud bricks, these Etruscan temples featured simple columns, topped with an entablature and pediment similar to Greek Doric temples. (See Chapter 7 for more detail on entablatures and pediments.) Another difference between Etruscan and Greek temples is that Etruscan temples have a main entrance in the front (instead of having all-around access like Greek temples) and their proportions are squatty, with heavier rooflines than their Greek neighbors.

Smiles in stone: The eternally happy Etruscans

Not much is known about the Etruscans because, beginning in the late 5th century B.C., the Romans conquered Etruria city by city, erasing their above-ground culture. By the 1st century B.C., all that was left were their tombs. So to decipher Etruscan life, you have to go inside the houses of their dead, which were often built like houses for the living. In fact, some Etruscan cemeteries were designed like underground towns and even had streets connecting the tombs, presumably so the dead could visit each other.

The Etruscans were the first ancient civilization to look death in the eye with a smile — at least their tomb statues smile. That's no surprise because early Etruscan tomb decoration didn't feature death's dark side (whatever that may be), but echoed life's joys. Birds flit across tomb walls, dolphins swim through painted seas, half-naked dancers gyrate joyously and erotically, banqueters feast, fishermen fish, and hunters pursue their prey. The early Etruscans seemed to view death as part picnic, part safari, and part all-night party. No wonder the statues are smiling: They're surrounded by a panorama of life's pleasures.

Most scholars believe that the early Etruscans viewed death as a continuation of life. Another reason Etruscan statues smile is because Greek archaic statues (*kouros* and *kore;* see Chapter 7) usually smile, and the Etruscans copied them. The Archaic smile on Greek statues had a smile-for-the-camera appeal. There never seems to be a reason for the smile; it was just a convention, like saying "cheese" for a photographer.

But in later Etruscan tombs, death is less attractive. The tombs are grim and some of the murals feature demons. Clearly, the Greeks infected the later Etruscans with their dark view of death in Hades, which the Greek poet Homer called the "joyless kingdom of the dead" (*The Odyssey,* Book 11). One late Etruscan tomb mural includes an image of the three-headed Greek hell hound Cerberus, who stands sentinel at the gates of Hades, making sure no one ever leaves.

Romping through the Roman Republic

Rome began as a city-state ruled by kings in the 7th century B.C. After the overthrow of King Tarquinius in 509 B.C., the Romans instituted a republic, which was governed by two consuls, the senate, two assemblies, and later a group of ten tribunes. The consuls were elected annually and served one-year terms. The Roman Senate was made up of wealthy, upper-class Romans (similar to the British House of Lords) who were known as *patricians.* The two assemblies, the *comitia curiata* and the *comitia centuriata,* consisted of *plebeians* (commoners) — *plebes* for short.

In practice, patricians controlled both assemblies. In fact, they pretty much ran the show in the early republic. Why? For one reason, republican Rome didn't pay its elected officials, so only the rich could afford to serve. Of the republic's 108 consuls, 100 came from the patrician class. This imbalance provoked several civil wars, which were usually followed by bloody "reigns of terror" called *proscriptions.* In a proscription, the winners of the civil war murdered their political enemies by the hundreds and even thousands. Many committed suicide to avoid being butchered.

After each civil war, power was redistributed a little more fairly, but never enough to satisfy the plebeians. In 494 B.C., the government invented another class of government officials called *tribunes* to appease the plebes. The tribunes were elected to promote plebeian interests and had extraordinary veto powers, but in practice they were often manipulated by wealthy patricians.

Later, ambitious men like Julius Caesar used the power struggles to leverage themselves to the top of Roman political life. Such opportunism and the upper class's refusal to share power with the plebes weakened the government, and after centuries of conquest, perhaps greater Rome (which included North Africa, Spain, and Gaul) had grown too large for republican rule. Civil wars and bloody proscriptions stained the last century of the republic. And even before Augustus Caesar founded the empire in 27 B.C., Rome flirted twice with one-man rule:

- ✔ In 82 B.C., the Roman Senate appointed the celebrity General Lucius Cornelius Sulla as dictator for life. After strengthening the conservative Senate and weakening the power of the tribunes, Sulla resigned in 80 B.C.

- ✔ In 48 B.C., after Julius Caesar defeated Pompey the Great in a civil war, the Senate elevated Caesar to dictator for life. Caesar was the only winner of a Roman civil war who didn't proscribe or massacre his political enemies after the war. He forgave them and offered many of them, including Brutus and Cassius, posts in his government. Four years later, in 44 B.C., Brutus, Cassius, and other pro-republic conspirators assassinated Caesar on the Ides of March (March 15).

The two civil wars that followed Caesar's murder ended the Republic forever. The victor, Caesar's heir and grand-nephew Octavian (later called Augustus), became Rome's first emperor.

Roots of realism: A family affair

The Romans practiced *ancestor worship*, praying to the spirits of their forefathers and foremothers, which were known as *manes* (good ghosts). Wax versions of ancestors, called *lares,* stood guard over the family hearth. On feast days, the *lares* got to wear garlands. On the holiday *Parentales* (ancestors days held from February 13 through February 21), family members wore wax or terracotta masks *(imagines)* of their dead relatives in memorial processions. Gradually these masks became more and more realistic, paving the way for Roman realism in sculptural portraiture, which sprang up suddenly around 100 B.C. Roman realism is called the *veristic* (truth) style.

At its largest, the Roman Empire included most of Western Europe (all the territory around the Mediterranean), modern-day Turkey, Syria, Egypt, Macedonia, Greece, the former Yugoslavia, Romania, North Africa, as well as much of modern Great Britain. The Romans planted monuments and built towns, roads, aqueducts, and baths across these diverse lands. They left their mark everywhere — but was it their mark?

In most cases, early Roman artists and architects weren't Roman. They were Greek or Hellenized Etruscans. So early Roman art looked like Greek or Etruscan art. Unfortunately, little of it survives.

During the late Republic and the Imperial period, "Roman" master artists were still mostly Greek. No wonder many people have called Rome a copycat culture. Yet Rome was more than that. The Romans added on to their Greek and Etruscan cultural foundation. Perhaps their greatest contribution was an in-your-face realism in portraiture and mural painting and their massive and sometimes majestic architecture, much of it still standing.

Art as mirror: Roman realism and republican sculptural portraits

The Romans were practical people; they looked life squarely in the eye. In art, their pragmatism translated into unflinching realism. When viewing their sculptural portraits (busts and statues), you feel as though you're face to face with real Romans. The artists showed their wrinkles, receding hairlines, sagging jowls, and paunches — and they usually captured the disposition of the model.

When Julius Caesar's great-nephew Octavian took over the government, not everyone was ready for one-man rule. So Octavian eased them into it. After two civil wars in a row, the Senate was docile and content to simply pretend

to be a republic. They did what Octavian said, granting him even more power than they'd yielded to Julius Caesar, while preserving the forms of republican government. Augustus refused to call himself king or emperor — it was bad PR. But he did allow the senate to grant him the title *princeps,* or "first citizen," and to give him a new name, Augustus (which means "venerable").

Roman realism took an idealistic turn when Augustus Caesar launched the Roman Empire in 27 B.C. The new "emperor" had to train the Romans to accept one-man rule; so he spruced up his image and idealized it, making himself appear godlike and superworthy of his job.

Idealism in Roman art is a kind of red flag — it usually means that the art is propaganda.

The statue *Augustus of Primaporta* (shown in Figure 8-1) depicts the youthful Augustus as a general of generals, pointing the way to Rome's imperial future. Specifically, the statue celebrates Augustus's recovery of Roman military standards lost to the Parthians (early Iranians) in 53 B.C. when they defeated the legions of Crassus (a member of the first Triumvirate with Julius Caesar and Pompey the Great). The Parthians were Rome's most resilient enemy. The fact that Augustus could beat them elevated his status as commander-in-chief enormously.

Figure 8-1:
Augustus of Primaporta is the most copied statue of Augustus Caesar (a.k.a. Octavian), Rome's first emperor.

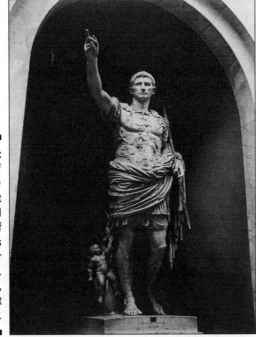

Erich Lessing / Art Resource, NY

The contrast between the statue's metal breastplate and the crumpled toga around his waist has at least two purposes:

- The softness of the fabric underscores the hardness of the armor and vice versa.

- Augustus's outfit shows his dual nature: The armor represents his military side as a great general, the toga his administrative side as the first citizen, or *princeps,* of Rome.

Augustus of Primaporta is the embodiment of Roman virtues: youthful vigor, moral rectitude, and unflappable confidence. It also expresses Rome's and Augustus's imperial dignity. Even the boy-god Cupid, straddling a dolphin at Augustus's side, looks up in awe at the godlike Augustus. Cupid's presence is also an allusion to the Caesar clan's supposed descent from the goddess Venus (Cupid's mom). Julius Caesar often claimed descent from Venus — that's how he justified his political dominance of Rome.

Augustus's propaganda was a big hit. The statue was so popular that it was copied at least 148 times.

Though this form of propagandistic idealism is very Roman, the sculptor modeled *Augustus of Primaporta* on two famous Greek statues. The pose is almost identical to Polykleitos's *Doryphoros* (see Chapter 7). Compare the stances and the position of the feet and left arms. But instead of throwing a spear, Augustus hurls his imperial message. He also looks straight ahead, boldly confronting the world, while Doryphoros turns his head to the right. The pose of the mini-Cupid beside Augustus is modeled on that of the infant Bacchus in Praxiteles's *Hermes and Bacchus*. In a way, *Augustus of Primaporta* is a Greek statue inside a Roman one.

But most Roman statues and busts, even of emperors, are not idealized. We see only naked realism in the bust of Vespasian, the ninth Roman emperor and builder of the Colosseum. Vespasian was no country-club king. He was a tough, blunt, down-to-earth general who fought his way to the top. He never pretended to be a god. In fact, he shocked Rome by dressing himself, putting on his own shoes, and deflating show-offs. According to Suetonius, a Roman historian, "when a young man, reeking of perfume, came to thank him for a commission . . . he'd obtained, Vespasian turned his head away in disgust," cancelled the guy's commission, and said he would have preferred that the man stunk of garlic.

Vespasian mocked the Roman tradition of deifying dead emperors. On his deathbed, the emperor, who was known for his locker-room sense of humor, cracked his last joke: "Dear me, it seems I am about to become a god."

Roman reliefs are more worldly than their Greek counterparts, whose scenes were often set in the clouds of Olympus. Some Roman reliefs were more or less newspaper stories carved in stone. They recounted current events that

the emperors didn't want the world to forget. Many of these news reports were carved into Roman triumphal arches, to broadcast the irresistible might of Rome.

After winning wars, the Senate usually permitted Roman generals to build triumphal arches and other monuments to commemorate their victories. One of the most famous is Trajan's Column (see Figure 8-2), a 98-foot-high commemoration of the Emperor Trajan's conquest of Dacia (modern Romania). Trajan defeated the Dacians in a two-part war; the first phase was from A.D. 101 to A.D. 102, the second from A.D. 105 to A.D. 106.

Figure 8-2:
Trajan's
Column
recounts the
two-part
Dacian War
fought at the
beginning
of the 2nd
century A.D.

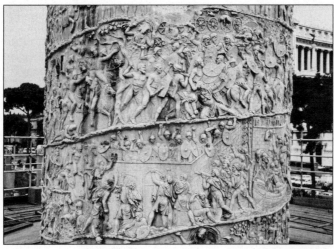

Scala / Art Resource, NY

The sculptor recounts the marches and battles on a scroll that winds around the column like a filmstrip. (Of course, no one — except the gods — can read the episodes at the top without binoculars.) The first campaign is told on the lower half of the column, the second campaign on the upper half. The sculptor scrunches in as many details as he can, often sacrificing aesthetics and creating mixed-up perspectives — you can see a march or battle from above, below, left, or right as if viewing it through multiple camera lenses, which isn't necessarily bad. The column scenes tell a great deal about Roman weapons and war craft.

Realism in painting

Roman mural painting, which appeared suddenly in the second half of the first century B.C., surpassed all earlier painting in depicting life realistically. Because virtually no earlier Roman paintings have survived, historians don't know how the tradition evolved. It seems to have simply appeared as a fully

mature style — which is impossible, because every style starts from somewhere and evolves. Undoubtedly the Romans learned how to paint realistically from Hellenistic models, but almost none of the Hellenistic models have survived either, so historians can't be sure.

The Romans, like the Greeks, used intuitive perspective to create the illusion of three-dimensionality on flat surfaces. They didn't have a system for creating perspective — they simply had a feel for it. (Compare intuitive perspective to scientific perspective, discussed in Chapter 12.)

Roman murals sometimes depict Roman versions of Greek myths, like the fresco of the *Marriage of Venus and Mars* (see Figure 8-3) found in the House of Fronto in Pompeii. Compare the use of perspective in this fresco to flat Greek vase painting (see the color section). The Romans took realism to a much higher level. Notice the three-dimensionality of the furniture (viewer's left) and the shading in Venus's face (viewer's left). Also notice that the head of the woman standing in the doorway is slightly smaller than the other heads (the figures appear to shrink in the distance).

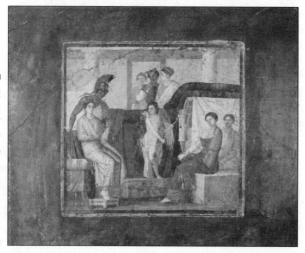

Figure 8-3:
The
*Marriage of
Venus and
Mars*
illustrates
Roman
artists' use
of intuitive
perspective.

Alinari / Art Resource, NY

The *Flora* fresco (see the color section) from ancient Stabiae, 4½ miles south of Pompeii, is perhaps the most poetic of all Roman paintings. Because Flora, the goddess of flowers, gently turns her face from the viewer, you can only imagine her beauty or feel it reflected in the landscape that she beautifies. Flora is credited with bringing color into the world by planting flowers everywhere.

The Roman poet Ovid says Flora "warns us to use life's beauty as it blooms" — to pluck it, just as she picks fresh flowers in the fresco and collects them in her basket. Little happens in this poetic painting; little *needs* to happen. The

soft, caressing beauty of the landscape, the hinted-at loveliness of the bare-foot goddess in her windswept gown, and her delicate gesture are enough. The fresco is as beautiful and moving today as it ever was, even in its damaged condition. For all its might and imperial majesty, Rome definitely had a soft side.

Roman mosaics

When Roman artists wanted an image to last, they used mosaics. Roman mosaics are made with small colored stones, pebbles, or pieces of glass cemented together to form highly realistic pictures like the *Scene from New Comedy* from Pompeii. Notice the comic facial expressions and the realistically ruffled fabrics of the actors in the mosaic. The figures even cast shadows! All this was achieved with tiny pieces of colored stone.

The small town of Vienne, France, which the Roman historian Tacitus described as an "historic and imposing city," has more than 250 superbly preserved floor and wall mosaics. The *Hylas Mosaic* (see Figure 8-4) from Vienne shows the mythical hero Hylas being seduced by two nymphs while he tries to fill his water pitcher at a spring. The decorative border frames the central scene with simple but stylishly effective shell and floral patterns.

Figure 8-4:
The *Hylas Mosaic* illustrates the brief but often-represented myth of Hylas and the nymphs. Hylas, who was Hercules's lover, disappeared after trekking to a spring to fetch water.

Gloria Wilder

After the fall of the Western Empire in A.D. 476, the mosaic tradition continued to flourish in the Eastern Empire and in the Italian city-state of Ravenna (see Chapter 9).

Roman architecture: A marriage of Greek and Etruscan styles

Architecture, like the Ionic Temple of Apollo in Pompeii, built in about 120 B.C., is the best-preserved art form of the republican period. This temple is so Greek in style that it looks like it was shipped from Greece piece by piece.

Temple of Portunus

Later temples, like the Temple of Portunus, built in the 1st century B.C., look a little more homegrown. Although at first glance the structure (also known as the Temple of Fortune Virilis) appears to be a miniature Greek temple with graceful Ionic columns and an unadorned entablature and pediments, there are some subtle differences. Instead of the all-around three-step platform used in Greek temples as a base for the columns and a staircase (see the Parthenon in Chapter 7), the Romans added a flight of steps in front of the temple. In other words, they built a main entrance. (Greek temples can be entered from all sides.)

Also, while Greek temples are oriented toward the rising and setting sun for religious reasons, Roman temples can face any direction. Their position was determined by practical rather than religious reasons: the proximity of other buildings and Roman laws, which ensured that each building and house had its daily quota of sun rays. Solar heating was mandated by law in ancient Rome. No one was allowed to erect a new building that blocked an older building's access to the sun. The Roman architect Vitruvius made sun-facing windows part of his housing designs.

Maison Carrée

About a century after the Temple of Portunus was built, a similar but larger temple called the Maison Carrée ("Square House"; see Figure 8-5) was erected in Nimes, a wealthy Roman city in Gaul. Whereas the older Temple of Portunus uses the simpler Ionic columns, the larger and more elaborate Maison Carrée employs Corinthian columns. The Maison Carrée is the best-preserved Roman temple in the world.

Roman aqueducts

A few miles from Nimes stands one of the most famous Roman structures, the Pont du Gard, a sprawling 900-foot-long aqueduct. Pont du Gard was once part of a 31-mile aqueduct that carried 44 million gallons of water a day from the Eure River in Uzès to Nimes. The Pont du Gard was built in the middle of the 1st century A.D., probably by Augustus Caesar's son-in-law Marcus Vipsanius Agrippa.

Is the Roman arch Roman?

Whereas most Roman temples look Greek or Greek-like, many other Roman structures actually look Roman. Majestic triumphal arches; massive, sprawling aqueducts; and the Colosseum have a distinctly Roman appearance. All these structures have rounded arches — in fact, the arch is their main architectural feature.

Roman triumphal arches appear throughout the former empire. The Triumphal Arch of Orange (see the nearby figure) was built by Julius Caesar in 49 B.C. in Orange, France, to commemorate his first victories over the Celts of Gaul. A Roman arch is part gateway — a road usually passes through an arch — and part memorial. The first arches were built of brick and stone. Later architects employed marble to make the memorials endure. Some triumphal arches have ornamental columns and most are decorated with commemorative reliefs that recount military victories.

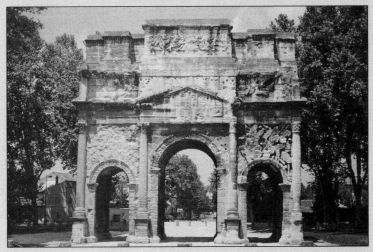

Gloria Wilder

The Roman arch is proverbial. When the arch made a comeback in medieval churches, centuries after the fall of Rome, the buildings were called Romanesque. But the Romans didn't invent the arch or the *barrel vault* (a round arch extended into space). These architectural forms appear in earlier Egyptian, Mesopotamian, and Greek structures, but not very often. The Romans gave the arch and barrel vault worldwide currency. That's why we associate the arch with Roman architecture. They made it popular.

A barrel-vaulted ceiling looks like the inside of a barrel that's been sawed in half. The Romans used the barrel vault in triumphal arches and in their arenas. They also employed the *groin vault*, two intersecting barrel vaults meeting at right angles.

Figure 8-5:
The Maison Carrée, in Nimes, France — which was erected around 19 B.C. to 16 B.C. and dedicated to heirs of Augustus — inspired the Virginia state capitol designed by Thomas Jefferson and completed in 1788.

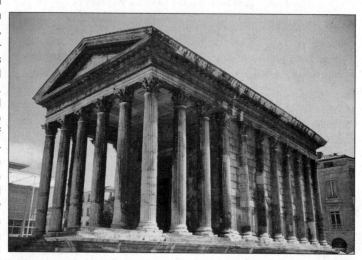

Gloria Wilder

Roman engineering skills were unsurpassed in the ancient world. Although some of the aqueduct's limestone blocks weigh up to 6 tons, no mortar was used to hold them together. Yet the structure has held together for 2,000 years. How? Roman engineers linked the stones with sturdy iron clamps that are still holding today.

The Colosseum

Rome's showcase building is the Colosseum, a 6-acre sports arena where gladiators fought each other to the death. The Colosseum also featured fierce wild-animal hunts, mock naval battles (for which the bottom of the Colosseum was flooded), and public executions in which starved, man-eating animals mauled criminals tied to stakes. The arena also had warm-up circus acts like wrestling alligators, tight-rope-walking elephants (as well as an elephant that could write in Latin with his trunk!), and human acrobats. On several occasions, Roman emperors fought in the arena (but these battles were rigged to guarantee the emperor's safety, unlike the duel between the Emperor Commodus and General Maximus in the Russell Crowe film *The Gladiator*).

The Emperor Vespasian began building the Colosseum in A.D. 72. His son Titus completed the amphitheater in A.D. 80 and inaugurated it with 100 days of games one year later.

The Colosseum design was based on linking two theaters together, which is why the structure is called an *amphitheater* (literally, "round theater").

Seventy-six entrance gates and barrel-vaulted corridors efficiently lead to three levels of tiered stone seats, allowing crowds of more than 50,000 people to enter and exit easily. The Colosseum also had a system of canvas awnings that was so complex that an entire naval unit was needed to operate it.

The Romans didn't try to disguise the structural features of the Colosseum. Instead, they gave them a pleasing appearance. The three-level, circular arcade of arches looks like windows inviting passersby into the arena. The faux columns between the arches are basic Doric on the first level, Ionic on the second, and Corinthian on the third. As your eye travels up the building, the orders of architecture (style of columns and *capitals,* or column tops — see Chapter 7) become more elegant and refined.

The Pantheon

The Pantheon (see Figure 8-6), the temple of all the Roman gods, is Rome's most perfect building. It is topped by a gloriously constructed dome with a 143-foot diameter. The distance from the dome's peak to the floor is also 143 feet. When you enter the Pantheon, you have the sense of being inside a globe under the dome of an Olympian sky. The 29-foot-wide *oculus* (opening) at the top enhances this feeling, allowing natural light to stream into the temple during the day and the stars and moon to peer through in the night.

Figure 8-6:
The Pantheon, built between A.D. 125 and A.D. 128, is Rome's supreme architectural structure, a wonder of the Roman world.

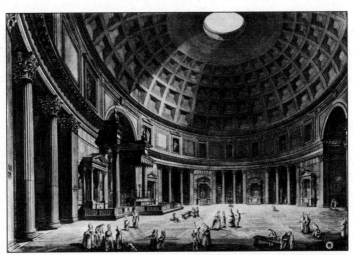

Alinari / Art Resource, NY

In the Pantheon, aesthetic considerations have priority over practical ones. A mask of marble hides the massive supporting brick arches and concrete walls. A spacious, circular colonnade of graceful Corinthian columns appears to support the dome effortlessly. Everything in the temple rises toward the oculus, making visitors feel as though they're transcending gravity and floating into the company of the gods.

Rome's fall

Why did Rome fall? Maybe the empire got too big for its britches and had too much frontier to defend. In the late 3rd century A.D., the Emperor Diocletian decided that the empire was too vast for one man to rule, so he split it into two halves, each with its own emperor and sub-emperor. This form of government is called a *tetrarchy* (rule by four leaders). Maybe Christianity, which became the state religion in A.D. 380. during the reign of Theodosius I, gradually changed the fabric of Roman society and the empire model no longer fit.

Some have accused 4th- and 5th-century Romans of getting lazy and soft. They hired mercenaries — Vandals, Huns, Visigoths, Ostrogoths, and Burgundians — to fight for them and allowed these tribes to settle in Roman provinces as *federates*. By the middle of the 5th century A.D., the Visigoths and Burgundians occupied most of southern Gaul. Many of the federates frequently turned on Rome. In A.D. 476, a coalition of Germanic tribes overran the city of Rome and ejected Romulus Augustus, the last Roman emperor, replacing him with their leader, Odoacer.

With the fall of Rome, culture declined, too. Government commissions to construct new buildings and design reliefs, statues, and mosaics dropped off. Art and culture retreated to Christian monasteries. Many of the techniques of making art were forgotten or lost. Besides, a Christianized Europe rejected or transformed the pagan, worldly art of the Roman Empire. They preferred art that turned man's gaze to heaven or art that terrified him into behaving.

But only half of the Roman Empire fell in A.D. 476. The Eastern or Byzantine Empire, the capital of which was Constantinople (named after Constantine the Great), endured for another thousand years, though often on shaky legs. The Byzantine Empire preserved Roman art traditions, in a modified form. Oriental influences from Byzantium's neighbors mingled with traditional Roman art styles to create a uniquely Byzantine style (see Chapter 9).

Part III

Art after the Fall of Rome: A.D. 500–A.D. 1760

The 5th Wave By Rich Tennant

EARLY CHRISTIAN WALL MOSAICS

"We'd like some scenes from Genesis over here, followed by David composing the Psalms over there, and at the end, let's have Abraham pointing the way to the coat room."

In this part . . .

You see how the crash of Rome and the rise of Christianity and Islam changed everything in Europe, North Africa, and the Near and Middle East. I examine the new art forms that Eastern and Western Christian artists and Islamic artists invented to express the new religions, and how these art forms evolved or stayed the same over the next dozen centuries. You also see that, although when Rome fell its art styles stumbled, they eventually got back on their feet and are still with us today.

Chapter 9

The Graven Image: Early Christian, Byzantine, and Islamic Art

In This Chapter

▶ Understanding the development of early Christian art

▶ Exploring Byzantine architecture

▶ Reading mosaics

▶ Understanding icons and the iconoclasm controversy

▶ Touring Islamic architecture

*I*n this chapter, I cover the art and architecture of three cultures and two great religions. Each culture developed a unique form of art and architecture to promote its faith, and each responded strongly and somewhat differently to the Second Commandment (the one about graven images).

The Rise of Constantinople

In A.D. 324, Constantine the Great (who ruled from 306 to 337) decided to pack up and move the capital of the Roman Empire to Byzantium (modern-day Istanbul), which was soon renamed in his honor, Constantinople.

Transplanting Rome's capital was a stroke of genius. Byzantium was the center of the known world, the fulcrum on which Constantine would balance the needs of East and West. The city sentinels the Bosporus Strait where the busy waters of the Black Sea and Sea of Marmara intermingle. Europe and Asia eyeball each other across the strait, which at its narrowest is less than a half-mile wide. In those days, the world's wealth flowed through the Bosporus and into the pockets of Constantinople's entrepreneurs. From his new capital, the emperor could control all imperial trade and marshal his forces to defend both halves of the Roman Empire much more efficiently than he could from Rome.

Christianizing Rome

Constantine, the first Christian emperor, elevated Christianity to one of the official religions of Rome in 313 (in the Edict of Milan), ending his predecessor Diocletian's persecution of the sect. (Constantine converted to Christianity in 313, but wasn't actually baptized until he lay on his deathbed 24 years later.) Although Christianity didn't become Rome's state religion until the reign of Theodosius in A.D. 380, Constantine virtually united church and state, possibly to solidify his own power (after defeating all rivals to the imperial crown). After all, Christianity was on the rise. Now he was the official head of state and the unofficial head of the Christian church. It was Constantine who called the First Council of Nicaea (a universal council of bishops) in 325 to determine the exact relationship between Jesus Christ and God. It was Constantine who swayed the council's 318 bishops, who were strongly divided on the issue of whether Jesus was less than or equal to God, to almost unanimously accept *his* view — that Father and Son are one. The two dissenting bishops were excommunicated and exiled.

After the fall: Divisions and schisms

The new life Constantine breathed into the Roman Empire helped it survive through the 4th and most of the 5th centuries. When Rome finally fell in A.D. 476, its artistic traditions splintered. In the Eastern Empire, classical Roman art blended with oriental styles into Byzantine art, which had both an imperial and an Orthodox Christian focus. In the west, classical styles helped launch a new style, Early Christian art. But once western Christian art got off the ground, classical styles went into hibernation for centuries.

Besides a political and cultural breach between east and west, there was also a religious breakup. The Eastern and Western Christian churches gradually drifted apart after the fall of Rome. Differing religious customs and beliefs, a communication gap (the Western Church spoke Latin; the Eastern, Greek), and a centuries-old power struggle between the popes and patriarchs caused the final rupture known as the Great Schism in 1054. The crusades, in part, were the papacy's attempt to reunite the Eastern and Western churches. In the 13th and 15th centuries, popes and patriarchs came close to healing the rift, but they were ultimately unsuccessful. The schism continues to this day.

After Rome's fall, the Eastern Empire stayed on its feet for another 1,100 years, except when it nose-dived briefly in the 13th century (the knights of the Fourth Crusade sacked Constantinople in 1204). But the empire bounced back 57 years later, surviving on somewhat shaky legs for almost two more centuries until the Ottoman Turks finally overran it in 1453.

Early Christian Art in the West

Before Constantine and even after, paganism and Christianity competed for the hearts and minds of people living in the empire. The Persian religion Mithraism (which shared some key features with Christianity, including a savior, baptism rite, moral code, and last judgment) was Christianity's chief rival. Mithraism was so widespread that apparently the Emperor Diocletian (who ruled from 284 to 305) proclaimed the god Mithra the "protector of the empire" in the early 4th century while his anti-Christian persecution was in full swing.

Religious rivalry drove many Christians to reject anything that reeked of paganism, including art styles. For example, early Christian artists never sculpted life-size, free-standing nudes like Polykleitos's *Doryphoros* or *Spearbearer* (see Chapter 7) and Praxiteles's *Hermes and Dionysos* (see Chapter 7) not only because the statues are naked, but also because they were too realistic. It was thought that they could be confused with what they represent. Living in the wake of idol worship, early Christians didn't want to replace the old idols with new ones. Christianity suppressed virtually all life-size, free-standing sculpture for a thousand years.

But Christians still needed sacred images to remind them of their faith. So early Christian artists struggled to create an acceptable visual language to broadcast their religious ideals. At first they borrowed from classical painting and relief, adapting the visual vocabulary of pagan art (things like shading and perspective) to express Christian beliefs. Almost nothing survives from the first three centuries, when Christianity was still an underground religion.

The earliest Christian art works are 4th-century catacomb paintings like the ceiling mural in the Catacomb of Sts. Pietro and Marcellino in Rome — the images are Christian, but the look is Roman. Due to centuries of deterioration, the mural is hard to make out. Thanks to extensive restoration, the early 5th-century mosaic, *Christ Enthroned and the Apostles in the Heavenly Jerusalem* in the 4th-century church Santa Pudenziana in Rome, is in excellent condition and illustrates the Roman influence even better (see Figure 9-1).

The use of perspective and shading, and the naturalistic gestures and folds in the garments are typically classical. The Roman illusionism (three-dimensionality) is especially striking given that the mosaic was executed on the curved wall of an apse! The Roman influence isn't only apparent in the artist's technique. The New Jerusalem behind Christ is a Roman-style city. Notice the Roman arches of some of the buildings. Also, Christ sits in a throne like a Roman Emperor, and the apostles flanking him are arrayed in togas like Roman senators. Notice that each Apostle has individualistic features. These are not mere symbols, they are realistic depictions of men. Peter, who sits on

Jesus's right, is being crowned by a woman who represents the Jewish people he converted. Paul, on the left, is crowned by a woman who symbolizes the gentiles (Romans and other non-Jews) that he converted. The point: The New Jerusalem includes both Jews and gentiles.

Figure 9-1:
Christ Enthroned and the Apostles in the Heavenly Jerusalem shows that Roman illusionism was still alive and well in early Christian art.

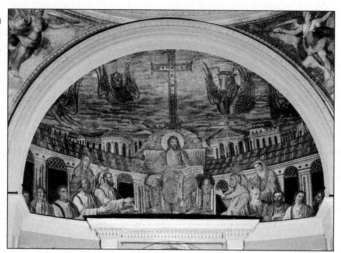

Scala / Art Resource, NY

This mosaic is one of the earliest images in which Christ appears with the cross. But instead of being crucified on it, here the bejeweled cross is depicted above Jesus's head to symbolize his heavenly glory.

Also, it may be the first time that the traditional emblems of the evangelists (authors of the Gospels) are shown in art: St. Matthew, a winged human being; St. Mark, a lion; St. Luke, an ox; St. John, an eagle. The winged creatures have a dual role here. They were first described in the 6th century B.C. by the Old Testament prophet Ezekiel: "As for the likeness of their faces, they four had the face of a man, and the face of a lion, on the right side: and they four had the face of an ox on the left side; they four also had the face of an eagle" (Ezekiel 1:10). Here Ezekiel reveals his vision of the approach of God's winged attendants before describing the New Jerusalem later in the book. The positions of the winged creatures shows that the artist intended to illustrate Ezekiel's vision of the New Jerusalem. (Because of the curved surface you can't see the eagle or winged man in the figure.)

Byzantine Art Meets Imperial Splendor

When most people think Byzantine, they think of painted icons, glimmering mosaics, and multidomed cathedrals. The style started in the 5th century A.D. in Constantinople and has never gone out of fashion. Modern icons and icon

screens still beautify Orthodox churches around the world. Originally, Byzantine art celebrated both church and state; today, it is strictly religious art for Eastern Orthodox churches, many of which now also exist in the West.

The eastern influence of Bzyantine art derived from Greece and, to a lesser extent, Egypt and Syria, which remained part of greater Byzantium until the Arab Empire absorbed them in the 7th century.

In the 11 centuries of its existence, Byzantium spread its glittering art traditions through North Africa, the Balkans, Russia, Italy, Sicily, Egypt, and Syria. Byzantine culture also influenced medieval and Renaissance art through trade and contact with the crusading forces of the 11th through 13th centuries. In the West, the greatest Byzantine works are in Venice and Ravenna, Italy, as well as in Sicily.

Byzantine art is usually divided into three periods: early Byzantine (5th century–726), middle Byzantine (843–1204), and late Byzantine (1261–1453). The *Iconoclasm Controversy,* which separates the early and middle periods, shut down most art production for over a hundred years, after Emperor Leo III declared war on religious art in A.D. 726. *Iconoclasm* means "image breaking."

Justinian and Early Byzantine architecture

Justinian ascended to the Byzantine throne in 527, 51 years after the fall of Rome. He thought his first job was to restore the entire Roman Empire — and he came pretty close. Justinian recaptured North Africa from the Vandals, Italy from the Ostrogoths, and southeastern Spain from the Visigoths, as well as Sicily, Sardinia, and Corsica. But he never made it to France (Gaul) or Britain. At the same time, his armies held the Persian Empire at bay in the East. But his conquests were short lived. What endures from Justinian's reign are his civil code of laws *(corpus juris civilis)* and the art and architecture that Justinian and his queen, Theodora, commissioned.

Corpus juris civilis (body of civil law) is a collection of all Roman law from the time of Emperor Hadrian (who ruled from A.D. 117 to A.D. 138) through the reign of Justinian. Justinian's law code became the basis for Western European law during the Middle Ages. It also influenced Eastern European and Russian law codes.

The greatest architectural triumph of Justinian's reign (from 527 to 565) is Hagia Sophia (the Church of Holy Wisdom) in Constantinople. Fire destroyed two earlier versions of Hagia Sophia. Justinian began rebuilding the church immediately after the last of the two fires, in 532, and finished it five years later. The new Hagia Sophia was a sensation, the greatest church to date. It is sometimes called the Eighth Wonder of the World.

Justinian chose Isidore of Miletus (a physics teacher in Alexandria and an expert on vaulting) and Anthemius of Tralles (an engineer and a geometry whiz) to design Hagia Sophia. The result seemed like architectural magic to contemporaries. The interior evokes a feeling of transcendence (see Figure 9-2). The windows, walls, and arches lift your eyes and spirit toward the central dome, which appears to hover on a crown of light — a ring of 40 tightly spaced, arched windows. The ceiling of Hagia Sophia looks like nothing less than the vault of heaven. Two tiers of arched windows below the crown contribute to the feeling that you're being uplifted as you enter this church, ascending on a ladder of light toward God.

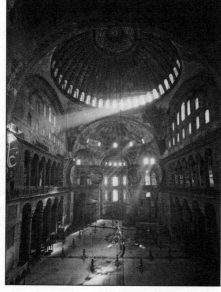

Figure 9-2:
The interior of Hagia Sophia is celebrated for its mystical lighting.

Erich Lessing / Art Resource, NY

The dome soars 184 feet from the floor and has a 335-foot base. To set the dome on what looks like a flimsy collar of window supports, the architects had to reduce its weight. They achieved this by constructing the dome from a thin shell of brickwork. In addition, two half domes on either side of the main dome and external buttresses counter the dome's thrust — that is, they do most of the work holding it up. Yet these supports are so integrated into the overall structure that they don't seem to be supporting anything. They look ornamental rather than functional. The entire structure appears to transcend gravity, making it feel like a truly otherworldly place.

The architects' greatest challenge was to solve a geometry problem. How to set a round dome on a square base? The solution: *pendentives,* rounded triangular groins or legs fanning out from the four *piers* (rectangular columns).

Pendentives are curved legs made by cutting four semicircular scallops from a dome (like boring crisscrossing tunnels through a dome). I'll call this Dome A. The architect sets the four pendentives of Dome A securely on the four supporting columns of the square base. Then he slices off the top of Dome A and sets the circular base of a smaller Dome B snugly on top of it. In other words, the architect secures a round dome on a square base by inserting an intermediate dome that's round on top and square on the bottom between them.

Amazing mosaics: Puzzle art

Byzantine artists tried to depict heaven in their art. (They also exalted their emperors in a similar idealized manner.) To achieve their goals, Byzantine artists needed a new medium that would suggest divine and imperial splendor. They chose wall mosaic, which was later dubbed "painting for eternity," probably by the Renaissance artist Domenico Ghirlandaio (Michelangelo's teacher).

Mosaic "painting" was not new. Centuries earlier, the Romans created elaborate mosaic floors that often looked like paintings (see Chapter 8). Because people walked on these "paintings," they needed to be made from durable material. Roman artists chose natural-colored marble that allowed them to "paint" fine gradations of color with which they achieved illusionistic effects like perspective and shading, as in the *Scene from New Comedy* Pompeii mural.

Roman mosaic floors are gorgeous, but the colors are dull compared to Byzantine mosaics, which shimmer like holiday tinsel. To produce this glittering effect, Byzantine artists used colored glass (not something you can walk on!) instead of marble. The palette of colors included emerald greens, Mediterranean blues, royal purples and reds, glittering golds, and clear glass laid on a gold or silver backing called *foil*. Also the glass was cut at various angles, which makes light reflect off the surface in multiple directions. Byzantine mosaics seem to radiate light rather than reflect it.

The downside of using colored glass is that it doesn't offer the variety that natural marbles do. You can't create the subtle color gradations needed for shading and illusionistic effects. But Byzantine artists weren't after realism. They wanted their mosaics to suggest visions of heaven.

Few early mosaics survive in Constantinople from Justinian's period. The most sublime early mosaics are in Ravenna, Italy, and Salonika, Greece. In this section, I focus on the ones in Ravenna.

San Vitale: Justinian and Theodora mosaics

The greatest wall mosaics in Ravenna are at the Church of San Vitale and the Basilica of Sant'Apollinare Nuovo in Classe, the port of Ravenna on the Adriatic coast (6 miles from the city). In this section, I examine the San Vitale mosaics.

In 527, Ecclesius, the Bishop of Ravenna, began building San Vitale. It took 20 years to complete, and Ecclesius didn't live to see the final product. Bishop Maximianus completed the job in 548. Both bishops are depicted in wall mosaics in the church.

Entering San Vitale is like walking into a jewelry box. Gorgeous mosaics of saints, angels, Christ and his apostles, and Old Testament figures surround you as if you've stumbled into heaven. Glittering gardens, populated by exotic birds, wildflowers, fruit, and stars, are interwoven with the holy figures.

Jesus appears at the summit of the chancel vault, wearing imperial purple and sitting on a blue globe. He passes a crown to the man on his right, the martyr San Vitale. On the other side of him, Bishop Ecclesius offers Jesus a replica of the church, indicating that the Church of San Vitale is dedicated to both Christ and St. Vitale.

At first glance, the design seems simple. The cross section looks like a short-stemmed flower planted in an octagonal flower bed. Each flower petal (semi-circular bay), budding from the circular nave in the center, corresponds to one side of the octagon. The *ambulatory* (walk-around area) separates the octagon from the ring of flower petals. The stem of the flower extends just outside the octagonal frame into the apse. Inside the church, you encounter a mesmerizing interplay of spaces that reveal the genius of the architect. Giant two-story archways with half-dome caps meet at sometimes surprising angles, making the space seem bigger than it is.

Side chapels flanking the apse are a typical feature of Byzantine churches.

Colored glass cubes cover every inch of the walls and vaults of the chancel. Medallions of Christ and his apostles emblazon the triumphal arch that leads into it, while the sacrificial Lamb of God stands at the center of the vault directly above the altar, signifying both Christ's sacrifice and Holy Communion.

Although Justinian and Theodora may never have visited Ravenna, they are depicted on the apse wall mosaics as if they had attended the church's consecration in 547 (a year before Theodora's death). The north and south walls show Justinian and his retinue (north wall) and Theodora and her attendants (south wall) participating with bishop Maximianus in the church's consecration.

Each group stands in a row facing you like actors on a stage (see Figure 9-3).

The Theodora mosaic: The south wall of the apse

Despite their flatness, the faces express individuality, especially Theodora's and the two women on her left, who may be her closest friend Antonina (the wife of Justinian's top general Belisarius) and her lovely daughter Joannina.

Figure 9-3: The San Vitale mosaic of Empress Theodora and her attendants (on the south wall of the apse) offers a glimpse into the royal fashion of the period.

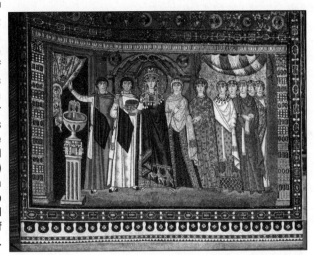

Cameraphoto Arte, Venice / Art Resource, NY

Theodora is displayed in San Vitale as Justinian's equal — and she was. Procopius, the imperial biographer said, "They did nothing whatever separately in the course of their life together." In one of his laws, Justinian called her "Our most reverend partner granted Us by God." She helped write some, if not most, of the laws. Theodora influenced policy more than any other empress while the emperor was still alive. She encouraged him to write laws to benefit the underprivileged and women, especially prostitutes (some of whom she frequently invited to the palace for talks and tea — or whatever beverage they consumed). Together she and Justinian built a refuge for the most downtrodden prostitutes. The refuge was actually a convent where the ex-prostitutes were required to live like nuns.

The Justinian mosaic: The north wall of the apse

The Justinian mosaic, on the opposite side of the apse from the Theodora mosaic, is less colorful, though still highly impressive. He holds a gold *paten* (a container for communion bread), while Theodora on the opposite wall bears the chalice for the communion wine. This suggests that they were co-rulers even in spiritual matters. The emperor is flanked by the two aspects of his power — the secular (praetorian guards on the far left) and the spiritual (bishops and clergymen on both sides of him). Bishop Maximianus, who completed and consecrated the church, stands on Justinian's left. Maximianus's name appears above him, not only to identify him, but also to serve as his signature on the work.

Notice that both Justinian and Theodora have halos, putting them on the level of the saints, martyrs, and apostles.

The mosaics of Saint Mark's Basilica, Venice, Italy (Middle Byzantine)

Constantinople also left its imprint on Venice, which it dominated in the 8th and 9th centuries. The domed Basilica di San Marco (Saint Mark's Basilica) is Byzantine to the bone. The first St. Mark's was built in 829 to preserve the hijacked bones of St. Mark the Apostle. The building of the current structure began in the middle of the 11th century.

After the collapse of Rome, the early Venetians picked St. Theodore as their patron, a minor saint for a minor city. But by the 9th century, Venice was on the rise and was determined to bolster its prestige by adopting a famous patron saint. So in 828 Venice sent two sailors to Alexandria to hoist the bones of St. Mark the Evangelist — the guy who wrote the Gospel of St. Mark. This gave Venice the spiritual leverage it needed to become a great city-state. The Venetians began building a grand church to house the body of St. Mark in 829. St. Mark's symbol, the winged lion, became the symbol of Venice.

The original wooden-framed St. Mark's burned down during a revolt in 976. Work began on the present basilica in about 1063. The five-domed structure is partly modeled on Hagia Sophia (refer to Figure 9-2) and the Church of the Apostles in Constantinople, originally built by Constantine in the 4th century and then rebuilt in the 6th century, possibly by Theodora.

St. Mark's is based on the *Greek cross* (a cross with equilateral arms). Three of the five domes rest on one arm of the cross; and the remaining two domes rise above the other arm. Barrel vaults connect the series of domes. Mosaics on a splendorous field of gold encrust the entire surface of vaults, domes, and cupolas.

Entering the church, you're greeted by the Creation mosaics (1215–1289), 26 episodes from Genesis, including

✔ God separating light from darkness

✔ God creating the plants, and then the animals

✔ Adam and Eve meeting and falling for each other

✔ God banning the sinful couple from the Garden of Eden

The mosaics highlight many of the most famous Bible stories.

After the Creation series in the atrium, you enter the church itself where the entire New Testament spreads before you in an opulent visual display. It took over 700 years to complete these mosaics, which cover more than 26,000 square feet!

The basilica served as the personal chapel of the *doge* (the leader of the Venetian Republic) until 1807, when it became everybody's chapel.

Icons and iconoclasm

Thou shalt not make unto thee any graven image, or any likeness of any thing that is in heaven above, or that is in the earth beneath, or that is in the water under the earth.

—Exodus 20:4

In 726, Emperor Leo III, who took the Second Commandment literally, issued a proclamation: Destroy all religious images. Only abstract design was permitted. *Iconoclasts* (literally, "image breakers") marched into churches destroying icons and mosaics of Christ, Mary, and the saints. Most monasteries, however, didn't support the edict — icons attracted pilgrims and donations! — so they hid as many icons as they could. Icon lovers were dubbed *Iconodules*. Leo ordered that anyone caught hiding an icon be flogged and, in extreme cases (when caught hiding lots of icons), blinded or mutilated. When Leo's offspring became emperors, they continued his policy. One hundred and seventeen years later, the last Iconoclast emperor Theophilus died, and his wife, the Empress Theodora, an Iconodule, ended Iconoclasm once and for all.

Iconoclasm didn't take root in Italy. The popes opposed it — which may be why the great mosaics of San Vitale survive today, while very little 5th-, 6th-, and 7th-century art exists in Constantinople.

An *icon* is meant to be a window to heaven, not a window to the world. For this reason an icon represents Jesus's or Mary's heavenly features, not their earthly looks. Because of this, icons don't have shading or highlights. The light on an icon's face arises from within, like his spirituality. This is one reason why mosaics were a mainstay of Byzantine art: They look like they radiate light, and they don't allow for much earthly realism.

When you look at icons, you may notice that they are very similar. Orthodox Christians believe that St. Luke the Evangelist (author of the Gospel of St. Luke) painted the first images of Jesus and Mary, and he knew what they looked like. So later artists simply made copies of those pictures, preserving the "true" features.

Also, Byzantine artists used symbolism instead of facial expression to communicate spirituality. They thought that facial expressions were too worldly and that spiritual beings have more subtle ways to speak to us. Gestures, objects in the hands, even the colors of a saint's clothes all have symbolic meaning.

For symbols to communicate ideas, everyone must agree on their meaning. Therefore, the symbols must never change. Icon painters follow strict formulas that govern everything from the shapes of noses (long and lean) to the colors of clothing. The mouths, noses, and eyes of icons no longer have worldly functions (eating, smelling, or gawking). They have spiritual functions instead, and

their stylized shapes reflect these new functions. The mouths are usually closed, small, and pinched because heavenly beings don't eat much, and they don't chatter. Jesus and Mary usually wear red and blue. Red represents divinity and blue symbolizes humanity, so Jesus typically wears red against his flesh and blue as an outer garment, which indicates that his divine inner nature (red) is encased in a human form (blue). Mary's colors are reversed (with blue closest to her body) because she is a human being who becomes divine (red on the outside). However some artists don't follow this color-coding.

Westerners look for originality in an artwork; Byzantines look for consistency. For this reason, an icon painting in the 12th century, the 15th century (see Andrei Rublev's *The Old Testament Trinity* in the color section), and the 21st century (see Figure 9-4) all look pretty much alike.

Byzantines also believed that three-dimensional figures (especially statues) were too much like sensual pagan art, which glorified the flesh. So they created a flat style, embroidered with symbolism.

The 12th-century *Virgin of Vladimir* was probably painted in Constantinople. The cheek-to-cheek pose of Mary and Child and the harmonious relationship of their bodies is typical, one of several formulaic poses of Mary and baby Jesus intended to show Mary's compassion. This icon type is known as *Umilenie* (Our Lady of Tenderness). The *Virgin of Vladimir* was eventually exported to Russia, which converted to Orthodox Christianity in the 9th and 10th centuries.

Christianity became the official Russian religion in 988. Russian artists learned icon painting by copying icons from Constantinople like the *Virgin of Vladimir*. Afterward, icon painting was practically the only art form in Russia until the end of the 17th century. The greatest Russian icon painter is Andrei Rublev (c. 1370–c. 1430), who was a monk as well as an artist.

Rublev followed the formulas of icon painting but still managed to be original. He gave his icons a unique and extraordinary sensitivity. In his masterpiece *The Old Testament Trinity* (see the color section), which was painted for a monastery near Moscow, the angels still have generic icon looks (they could pass for triplets!): long, lean noses; tiny mouths that look like they could barely swallow a peanut; almond-shaped eyes; identical hairdos that modestly frame their faces; and garments that hang in exactly the same way.

Yet each angel quietly exudes his own personality. Rublev's paintings convey tenderness and a gentle poetry that other icons lack. Each angel's body bends a little differently; their postures express unique spiritual and poetic emotions. The combination of the harmonious gestures and forms and the luminescent colors give the painting a rhythmic, lyrical quality.

The *Dormition Shroud* (see Figure 9-4) is a modern Orthodox icon painted by Christine Uveges and the Eikona Workshop in 2004. The expressions, pose,

gestures, and the flatness of the composition show that icon painting has hardly changed in a thousand years.

Figure 9-4:
The
*Dormition
Shroud* icon
at the
National
Shrine,
painted in
2004 by
Christine
Uveges,
shows that
icon tradi-
tions haven't
changed in
more than
1,000 years.

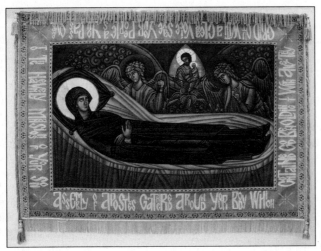

Courtesy of Eikona Studios

Ironically, the *Dormition Shroud,* which represents a uniquely Orthodox point of view regarding the Virgin Mary's last day on earth, is owned (and was displayed) by the National Shrine of the Roman Catholic Church, which maintains a very different view on Mary's final hours. The Metropolitan (head) of the Ukrainian Catholic Church of America commissioned the shroud as a gift for the National Shrine of Roman Catholicism in Washington, D.C. The purpose of the gift and of representing an Orthodox tradition in the National Shrine of Catholicism was to help heal the schism between the Eastern and Western churches, which began in 1054 (see "After the fall: Divisions and schisms," earlier in this chapter).

Islamic Art: Architectural Pathways to God

In A.D. 610, a merchant named Muhammad took refuge in a cave near Mecca. According to Muhammad, during the night, the Archangel Gabriel appeared and revealed to him truths that became the basis for a new religion, Islam. Throughout Muhammad's life, Gabriel enlightened him with revelations that

Muhammad's followers recorded in the Muslim holy book, the Koran. Muhammad didn't reject the two other great monotheistic religions, Judaism and Christianity, but he said God commanded him to complete and perfect them. The Koran honors the Hebrew prophets, as well as Jesus.

Muhammad, who was both a religious and political leader, converted and united the tribes of Arabia before his death in 632. Within 100 years of his death, Muhammad's successors, the Caliphs, spread Islam by conquering Palestine, Syria, Egypt, and the rest of North Africa and seizing them from the Byzantine Empire. They also conquered Spain and penetrated into France. But Charles Martel (the grandfather of Charlemagne) turned back the Muslims at the Battle of Poitiers in 732.

The new religion appealed to millions of people. Most of the conquered countries had been Christianized for centuries. But the majority of inhabitants switched to Islam. Those who didn't were usually permitted to practice their faith, without persecution.

Like Moses, Muhammad banned graven images and anything that resembled idolatry. Therefore, Islamic countries produced very little figurative art (people pictures) and sculpture. But they excelled in architecture and in the decorative arts.

At first, the Caliphs made makeshift mosques (houses of prayer) — a fenced-in field, an ex-Christian church, a Persian hall — for the converts to Islam. But after the Muslims settled into their new lands, they began to build permanent, huge, elaborate mosques. Having no art traditions of their own, they borrowed from the people they conquered — and because they'd conquered so many different lands, the influx of influences was broad. Many early mosques had Byzantine and Persian elements, depending on their location. The huge Mosque of Mutawakkil in Samarra, Iraq, built between 848 and 852, which occupies almost 10 acres, resembles a Tower of Babel ziggurat (an ancient Mesopotamian temple — see Chapter 5). Obviously, the architect was inspired by ancient Mesopotamian structures.

But the Muslims soon developed a uniquely Islamic style. In the following sections, I cover some of the finest examples of Islamic architecture.

The Mosque of Córdoba

The Mosque of Córdoba was begun in A.D. 786. Córdoba, the capital of Islamic Spain, and Baghdad were the two greatest centers of Islamic culture in the 8th through 11th centuries. The Caliphs expanded the Mosque of Córdoba in the middle and late 10th century.

Inside, nearly a thousand double-arched pillars support the mosque's massive roof. An upper tier of arches straddles the lower arches. Though the pillars are arranged in rows, they look like a vast stone forest fanning out in all directions. The complex vistas appear to interweave as you walk through the structure, making the mosque seem infinite.

The architecture gives you the sense of journeying toward God (see Figure 9-5). The maze of aisles all lead to the *qibla* (praying area), which faces Mecca. The fact that so many aisles lead to the same place suggests that there are many pathways to prayer, many roads to the divine. Each worshipper must find his own path. This is quite different from Christian churches, where a single, center aisle leads to the altar, implying that there is only one path to God.

Figure 9-5: The tunnels of arches in the Great Mosque of Córdoba pull visitors forward toward the *qibla*, or praying area.

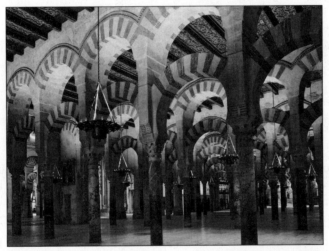

Courtesy of Spanish National Tourist Office

Every mosque also has a *mihrab* (prayer niche) that faces Mecca. The entrance to the *mihrab* is usually elaborately decorated because it's a symbolic gateway to the holy city. The *mihrab* of the Mosque of Córdoba, a domed chamber, is the architectural climax of the structure (see Figure 9-6). The intricate carvings (known as *Arabesque,* meaning Arab-like) on the scalloped entrance arches look like a cross between script and ornament. This feature is typical, a reflection of the fact that Arabs were masters of calligraphy. The center of the *mihrab* dome is a stylized sculpted shell encrusted with a mosaic of blue, green, and reddish leaves and flowers on a golden background. The shell is encased in an eight-sided star, slashed by broad arcs that carry the dome's weight to the supports.

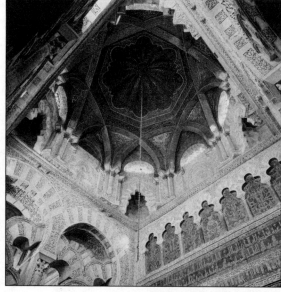

Figure 9-6:
The magnificent *mihrab* dome of the Mosque of Córdoba was built in 965.

The dazzling Alhambra

It's difficult to imagine anything more impressive than the Mosque of Córdoba, until you enter Granada's extraordinary palace and mosque, the Alhambra. The Alhambra was built between 1248 and 1354, when most of Spain had been retaken by the Christian forces of the Reconquista. Granada, the last Moorish holdout in Spain, capitulated to Ferdinand and Isabella in 1492.

The most exquisite part of the Alhambra is the Muqarnas dome in the Court of Lions, a rectangular courtyard with a pool surrounded by 12 white marble lions (see Figure 9-7). (It's said that the circle of lions once functioned as a clock; each beast spewed a stream of water on the hour.)

The cap of the elaborate dome rests on a glowing, star-shaped base made of 16 windows (see Alhambra Muqarnas in the appendix). The eight-pointed, star-shaped cutout looks like it unfolded or blossomed to allow light to stream into the mosque. The dome cap and square ceiling that encases the star are lavishly embellished with stalactite-like ornaments that look like drippings from a melted candle.

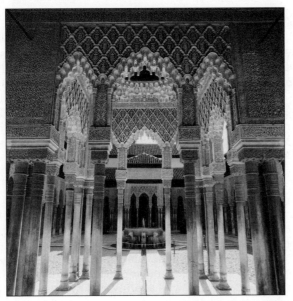

Figure 9-7:
The elegant, filigree-walled pavilion of the Alhambra's Court of the Lions is a fitting setting for the spectacular dome called the Muqarnas.

Courtesy of Spanish National Tourist Office

On closer inspection, these drippings reveal elaborate carvings of detailed geometric patterns. Where did this style come from? There's nothing like it in the countries the Arabs conquered. Perhaps because Islamic artists weren't allowed to represent the human figure, they packed all their creativity into linear designs. Many Arab scholars were devoted to the study of geometry and various types of arithmetic. Algebra derives from the Arabic *al-jabr* and trigonometry was devised by Islamic mathematicians. Maybe these mathematical preoccupations are rooted in this style of artwork. Whatever the reason, Islamic artists created some of the most complex and beautiful ornamentation in the history of art.

Equally elaborate, calligraphic designs appear in Islamic manuscripts, like the cover of a 14th-century copy of the Koran from Cairo, Egypt, and a 13th-century Islamic textile from southern Spain called the *Banner of Las Navas de Tolosa*. The star within a star on the manuscript page is reminiscent of the star shapes in the *mihrab* of the Great Mosque of Cordorba (refer to Figure 9-6) and the dome in the Alhambra (refer to Figure 9-7). The top and bottom border designs of the banner resemble Arabic script. Notice the eight-pointed star in the center of the banner.

A temple of love: The Taj Mahal

When Shah Jahan's favorite wife, Mumtaz, died in childbirth, the number of white hairs in his beard more than tripled. At least that's what the court chronicler claimed. The remaining wives of the Muslim Mughal Emperor of Southern India couldn't console him. So Shah Jahan commissioned the most beautiful mausoleum in the world for her, a testament to his love. The result: the Taj Mahal in Agra, India, which took 23 years to complete (1631–1654). Today, the Taj Mahal, which seems to gaze at itself in the long pool that stretches from its entrance, is considered one of the Wonders of the World.

The building is a marriage of Islamic, Indian, Persian, and Mughal styles. None of the styles dominates; it's a harmonious marriage. In fact, the Taj Mahal is very musical architecture, using geometric theme and variation patterns. The 213-foot-high central onion dome is poised gracefully between two smaller domes. The dome motif is obviously the major theme of the architecture. Smaller variations of the domes cap the minarets that frame the building. The *finial* (spike) protruding from the main dome appears on all the other domes, as does the beanie cap decorated with a lotus-petal design. These variations of the main visual theme contrast strikingly with the varied rectangular shapes and arches on the middle and lowest level. (Architecture needs contrast just like music does — loud and soft, fast and slow, and so on.)

The pointed archway of the grand entrance is echoed by smaller, but identically shaped, windows on the building's flanks. The arch is the second visual motif. The lateral domes and minaret domes sit on arched arcades, which continue the arch theme, while adding variation. Instead of being hoop-shaped, the arcade arches are petaled in typical Islamic fashion. The intricate design work in the door frame is repeated in the window frames.

To appreciate the magnificence of this building (without seeing it in person), try to actually think of it as visual music. Imagine the domes are a great booming musical motif, a powerful melody line that sets off a train of echoes — the minaret domes. The rectangles and arched openings below the domes are the varied baseline that supports the melody. Arabesques carved into the rectangles are analogous to the trills and other musical ornaments in a Baroque cantata; they delight the eye with exotic surprises amidst the swelling shapes of the domes and grand, inviting doorways and windows.

It's hard to believe that such a magnificent building is merely a mausoleum. In any case, it's one of the most visited sites in India.

Chapter 10

Mystics, Marauders, and Manuscripts: Medieval Art

In This Chapter

▶ Tracing the squigglies in illuminated manuscripts

▶ Reading a tapestry that *isn't* a tapestry

▶ Tracking medieval developments in architecture

▶ Peering into the medieval world of painting and sculpture

▶ Reading a tapestry that *is* a tapestry

*W*hen Rome fell, western civilization's lights went out — sort of. The Western Empire's collapse unleashed political chaos and caused a cultural blackout throughout Western Europe. The barbarian tribes that broke the back of the empire — including the Vandals, Visigoths, Franks, and Lombards — now fought each other, grabbing land on one frontier while losing it on another. With so much warfare, who had time for art, architecture, or theater? The Middle Ages began with the fall of Rome and continued until the Renaissance or cultural rebirth in 1400 — approximately a 1,000-year stretch.

For centuries, scholars called the entire period the *Dark Ages,* meaning the light of knowledge that was the hallmark of classical Greek and Roman culture had been doused. But as 19th-century researchers learned more and more about the second half of the Middle Ages, they realized that it wasn't as dark as they'd once thought. The 12th century, for example, had a kind of mini-Renaissance, an appetizer for what was to come in the 15th century.

So scholars scaled back the Dark Ages by about 400 years, dubbing the brighter part (A.D. 1000– A.D. 1400) the Middle Ages, while stigmatizing the earlier era (A.D. 500– A.D. 1000) as the Dark Ages.

Today, scholars recognize that the scaled-down version of the Dark Ages has some bright spots, too. So they call the entire 1,000-year era the Middle Ages or the Medieval period, while quietly acknowledging that the first part is

"dimmer" than the second. Bottom line: It was harder to get an education, see a play, or get your teeth fixed in the 8th century than it was in the 13th.

In this chapter, I shed some light on the entire era, from manuscripts to tapestries and Gothic architecture, sculpture, and painting.

Irish Light: Illuminated Manuscripts

The knowledge accumulated over 1,300 years (from 800 B.C. to A.D. 500) in Greece, Alexander's Hellenistic empire, and Rome didn't suddenly disappear with Rome's demise — it went into hiding in monasteries scattered across Europe. The light of learning burned brightest in the hushed and secluded monasteries of Ireland.

St. Patrick converted the Irish to Christianity in the first half of the 5th century A.D. — just a couple decades before the fall of Rome. Because Ireland had never been absorbed into the Roman Empire, it remained almost completely independent of Roman traditions, including Roman religious and art traditions. The Irish Celts developed their own breed of Christianity and their own style of religious art. The popes didn't have much say in Ireland until the 12th century when England conquered it and imposed both English and papal law on Irish kings and bishops.

After Ireland's conversion, the Irish didn't build lots of churches as other Christian countries did. They erected lots of monasteries instead, which evolved into great centers of learning. In monastery workshops called *scriptoria,* Irish monks copied all the manuscripts they could lay their hands on — including Latin versions of the Bible, writings of the Church Fathers, and classical texts.

Between about 600 and 900, the monks distributed these books throughout Europe as part of their mission to Christianize the world. This network of monks spread knowledge around like a traveling university, founding branch schools in Britain, France, Switzerland, Germany, Austria, Italy, and even Iceland.

In the following sections, we exam early Irish and Hiberno-Saxon illuminated manuscripts.

Browsing the Book of Kells, Lindisfarne Gospels, and other manuscripts

The Irish monks developed a unique style of manuscript illumination, freely borrowing elements from their pagan past, like entwined animals and knotted lace patterns. The new style that they developed is called *Hiberno-Saxon.*

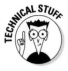

The Romans called the Irish "Hiberni." The "Saxon" part of the term refers to the English contributions to the new style. These contributions were made after the Irish established monasteries in England and began rubbing creative elbows with local populations.

The greatest example of the mixed Irish and English style is the *Lindisfarne Gospels* (see the color section). Notice how the detailed interlacing is similar to the *Book of Kells,* a purely Irish illuminated manuscript.

The greatest two illuminated manuscripts that are strictly Irish in style are the *Book of Durrow* (c. 700) and the *Book of Kells* (early 9th century). The *Book of Kells* was probably created between 803 and 805, primarily in an Irish monastery on the tiny island of Iona off the coast of Scotland. Vikings attacked the island first in 795, then in 802, and again in 805. The surviving monks fled, taking the unfinished *Book of Kells* with them to the town of Kells, 39 miles outside of Dublin.

The image of the *Lindisfarne Gospels* in the color section and the *Book of Kells* image referred to in the appendix show the opening page of the *Gospel of Matthew.* The large stylized initials, *XPI,* are the first three letters of Christ's name in Greek — *chi, rho,* and *iota.* This trinity of letters was often used in the Middle Ages as a monogram to represent Christ. The rest of the text is in Latin.

The three stylized letters on the *Book of Kells* page (and to a lesser extent in the Lindisfarne example) partially frame large decorative wheels, which in turn frame smaller wheels that circumscribe even smaller wheels. The whole design has the feel of a system of intermeshing gears made out of pinwheels. The curved and angular shapes meld to form a perfect visual harmony. The overall impression is both wild and controlled. As you lose yourself in the interwoven patterns of the design maze, figures jump out at you: The head of a man grows out of the curling stem of the letter *P;* three golden-winged angels peer at you from the left edge of the *X;* and a pair of cats crouch on the bottom-right scroll of the same initial, eying two mice who heretically nibble a communion host. Two "big mice" ride the cats' backs, teasing them.

Book curses

Before copyright laws, monks used book curses to protect books, not from potential plagiarists but from book bandits. The gold used in illuminations and the rarity of books made them a great temptation to thieves. The scribe usually wrote his curse in the *colophon* (the author's inscription on the back page of the book). Here's a typical medieval book curse:

This book belongs to the Abbey of St. Mary in Arnstein, which, if anyone should take away, may he die surely by being cooked in a pan, have the falling sickness and fevers draw near him; may he be hung up and twisted around. Amen.

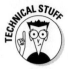

The pre-Christian Celts believed in the interconnectedness of all things. They illustrated their belief by interweaving images of plants, animals, and spirits into complex lacy patterns (like the *Book of Kells* designs) on their jewelry, weapons, and monuments. After they became Christians, they didn't renounce their earlier beliefs — instead, they merged them with Christian doctrine. In the *Book of Kells,* they symbolically harness their old belief system to the opening initials of Christ's name (thereby linking all the interconnected patterns to him). In this way, they show that the "old ways" have been absorbed by the Christian God, not nullified by him.

Drolleries and the fun style

In the 12th and 13th centuries, the first European universities emerged in Bologna and Padua, in Italy; in Paris and Montpellier, in France; in Oxford and Cambridge, in England; in Salamanca, Spain; and in Lisbon, Portugal. Students needed books, and monasteries couldn't meet the demand. So bookmakers called *stationers* sprang up in university towns. To satisfy an increasingly *secular* (nonreligious) market, stationers produced new types of books:

- **Herbals:** Books about plants and their medicinal uses
- **Bestiaries:** Collections of *fables,* stories in which animals act like people
- **Books of Hours:** Devotional books for everyday people
- **Books of Secrets:** Volumes of love potions, remedies, and even spells to prevent people from talking behind your back

With a widening public, books had to entertain, too. In about 1240, a new "fun" style emerged in Paris and soon spread across France and England. It featured whimsical, hybrid creations called *drolleries* or *grotesqueries:* a nun with the body of a platypus, a mole-headed priest, a pigeon-footed knight with insect wings and a serpent's tail. These grotesqueries sometimes peek over the borders of the page to eavesdrop on your reading.

Creative book illuminators also braided flowers and foliage with the writhing tails of dragons and serpents or the tendril-like necks of exotic birds. Drolleries were the rage for about 250 years.

Charlemagne: King of His Own Renaissance

On Christmas Day in the year 800, the Roman Empire made a comeback — or so people thought. Pope Leo III crowned Charlemagne Holy Roman Emperor before cheering crowds shouting "Emperor!" and "Augustus!" Between 768

and 800, Charlemagne had conquered almost all of Western and Central Europe. It seemed he'd resurrected the Roman Empire.

Charlemagne wasn't content just resurrecting the political and geographical side of the Western Empire — he wanted to launch a classical-culture rebirth, too. The rebirth he fostered is called the *Carolingian Renaissance* (A.D. 775–A.D. 875); it was another mini-Renaissance before the big one in the 15th century. Charlemagne encouraged monasteries and churches to operate schools, copy manuscripts, and develop a universal calligraphic script. To that end, he invited scholars from Ireland, England, Spain, Italy, and Gaul (France) to his capital in Aachen. One of the scholars, Alcuin, invented a new easier-to-read script called the *Carolingian script,* which soon became the universal standard in Europe.

Weaving and Unweaving the Battle of Hastings: The Bayeux Tapestry

In 1066, William the Bastard, the duke of Normandy, got a new name: William the Conqueror. All he had to do to shed his nasty nickname was conquer England. After overrunning the Saxons at the Battle of Hastings, no one called William "the bastard" again. His new name concealed his illegitimacy. (William's mother was a commoner's daughter whom his father, Duke Robert I of Normandy, never married.)

After Will grabbed the English throne, his half-brother Bishop Odo commissioned a Saxon artist to celebrate William the Conqueror's victory on cloth. The result is the 231-foot-long Bayeux Tapestry, which chronicles the Battle of Hastings and events leading up to it from a Norman point of view.

Providing a battle blueprint

At the Battle of Hastings, William and his forces faced the newly crowned English King Harold and his veteran Saxon troops called *housecarls.* Harold had been *underking* of England for 13 years, second only to King Edward the Confessor. When Edward died, several men contended for the English throne, including his Norman cousin William the Bastard and Harold Godwinson, the underking. Edward the Confessor is said to have thrown his support to Harold on his deathbed. The English barons proclaimed Harold king. But William the Bastard insisted that the king had promised *him* the throne several years earlier. The tapestry illustrates why William believed he was the legitimate heir, and how William's Norman cavalry (supported by knights from throughout Europe) defeated Harold's army in a vicious ten-hour battle that changed English and world history forever.

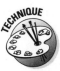

The Bayeux Tapestry isn't really a tapestry or weaving, but an embroidery. The story of the Norman Conquest is stitched on linen cloth using two techniques that can be compared to crayoning in a child's coloring book. The *stem* or *outline* stitch is used to "draw" the contours of shapes and to write text. The *laid-and-couched* method is used for filling or coloring in areas within the outlines: people's clothes and hair, buildings, trees, shields, the flesh of horses, and so on. The actual stitching was done by highly skilled Saxon women.

Portraying everyday life in medieval England and France

The Bayeux Tapestry is one of the only surviving secular artworks of the period. As such, it offers a wealth of details about medieval life in England and France. It reveals medieval customs, armor, weaponry, and war craft; it also tells us what people ate, and how they dressed and wore their hair (see Figure 10-1). Turns out, the Normans shaved the backs of their heads and the Saxons had early Beatles-style haircuts and handlebar mustaches. In Figure 10-1, the Normans feast before going into battle. Notice the men on the left use arrows to skewer cooked chickens. Another man blows the dinner horn in the ear of the man on his left. To the right, dinner has ended and William, his half-brother Bishop Odo, and his brother Robert plan the battle (illustrated in the next scene in the tapestry).

Figure 10-1:
The scene from the Bayeux Tapestry depicts the feast before the battle.

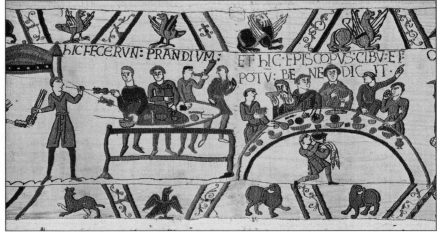

Erich Lessing / Art Resource, NY

Peddling political propaganda

Art is sometimes used as propaganda, and the Bayeux Tapestry appears to be an example of this. The Bayeux Tapestry may be Norman propaganda, designed to justify a foreign duke's conquest of England. One episode in the tapestry shows Harold's coronation. At the left of the newly crowned king stands Stigand, the archbishop of Canterbury, to anoint the king and legitimize the proceedings. But Archbishop Stigand wasn't legitimate himself — he'd been excommunicated by Pope Nicholas II, but he still had his job. He refused to resign. According to Saxon sources, Stigand didn't even *attend* Harold's coronation — Harold wasn't about to let an excommunicated archbishop crown him. Instead, the Archbishop of York performed the ceremony, but he doesn't appear anywhere in the tapestry's coronation scene. The reliable English monk and chronicler Florence of Worcester (1030–1118) wrote:

> When [King Edward the Confessor] was entombed, the underking, Harold, son of Earl Godwin, whom the king had chosen before his demise as successor to the kingdom, was elected by the primates of all England to the dignity of kingship, and was consecrated king with due ceremony by Ealdred, archbishop of York, on the same day.

Including the excommunicated bishop in the tapestry was a vital piece of propaganda for William. It helped him justify his claim and won him papal support before the conquest. In fact, Pope Alexander II gave William the papal banner to carry into battle and a ring containing a relic of St. Peter. This recast William's war of aggression into a holy crusade in the eyes of many contemporaries. William won the PR war before the battle even started.

Making border crossings

Some scholars believe the borders of the Bayeux Tapestry are merely a decorative frame, like the margins of an illuminated manuscript. Others think they tell the losers' side of the story in code — after all, a Norman (Bishop Odo, the half-brother of William the Conqueror) commissioned the design. But most scholars believe an Anglo-Saxon artist designed it and Anglo-Saxon needleworkers carried out the work. Obviously, the designer had to report the story that Bishop Odo recounted in the main sections of the tapestry. But he appears to have had a free hand in the borders. Did he sneak in Anglo-Saxon propaganda to counter the Norman view of history? If so, he had to be secretive about it. William didn't like negative publicity.

Some of the border areas contain Latin fables — animal stories with morals — by the 1st-century writer Phaedrus. The bad behavior of the animals in these

"cartoons" may mirror the actions of some of the Normans in the main body of the tapestry; they may hint at an alternative interpretation of events. Scholars are still trying to extract the meanings of the border designs.

Romanesque Architecture: Churches That Squat

Viking raids petered out in the mid-11th century, probably because most Scandinavian states had been Christianized. Europe was safer than it had been in centuries. Trade picked up and the standard of living rose throughout Europe.

During this relatively peaceful period, towns and cities groomed themselves, launching ambitious building projects on a scale Europe hadn't seen since the fall of Rome. Naturally, they turned to Rome for inspiration. They didn't have to look far. The Roman Empire left its stamp everywhere. Aqueducts, triumphal arches, and other Roman structures peppered the continent. The inventors of the new style borrowed the Roman arch, barrel-vaulted and groin-vaulted ceilings (see Chapter 8), and the solid masonry walls and ceilings you can see in Roman arenas (amphitheaters). Before this time, medieval church roofs were constructed of wood, but they caught fire easily in the candlelit world of the Middle Ages. The new style with vaulted stone roofs is fittingly called *Romanesque*. (The inventors of the new style didn't make up this name — art historians did, in the 19th century.)

The Romanesque rage was also inspired by religion. The 10th through 12th centuries were the great age of pilgrimages to Jerusalem, Rome, and Santiago de Compostela in northwestern Spain. The many arteries to Santiago naturally passed through France. Hundreds of thousands of pilgrims traveled these roads annually on their way to Santiago. Traditional churches were too small to hold them. To meet the growing tourist traffic, large "pilgrimage churches" were built on the roads to Santiago. But the style spread beyond the Santiago route into Germany, Italy, and England. The French monk-chronicler Raoul Glaber (c. 985–1047) said, "It was as if the whole earth . . . were clothing itself in a white robe of churches."

St. Sernin

One of the grandest Romanesque cathedrals is the pilgrimage church of St. Sernin in Toulouse, which honors the first bishop of Toulouse, Sernin, who was martyred on the spot. According to local tradition, Sernin was tied to the tail of a wild bull and dragged to his death. The name of the street in front of the church is Rue du Taur, which means "Street of the Bull." Built between 1060 and 1118 on the Road of St. James, St. Sernin is the largest Romanesque cathedral in Europe. This roomy structure was made to handle crowds.

Like most Romanesque churches, St. Sernin has a *cruciform* or cross-shaped structure (see Figure 10-2). The tower that rises from the center or heart of the cross suggests Christ's resurrection. Small semicircular chapels bud out of the *apse* (east end) of the cathedral and serve as repositories for holy relics. The biggest change from earlier church designs is the addition of an extra aisle wrapping around the nave and altar. This *ambulatory* (walk-around) allowed pilgrims access to the relics without disturbing mass (held in the nave). The church became a round-the-clock pilgrimage destination while still holding masses, weddings, funerals, and other services.

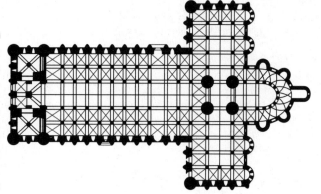

Figure 10-2: The *cruciform,* or cross-form, is the traditional shape of medieval cathedrals.

St. Sernin's most impressive feature is its tunnel-like *nave* (see Figure 10-3), the area that begins on the west end of the cruciform church. The two-story-high nave is topped by a barrel-vaulted ceiling whose weight is transferred from the arches to the piers or square pillars, which have to be very thick to hold it up. The two levels of arches on the sides help open up the space, while harmonizing with the tunnel of *ribs* (ceiling arches) at right angles to them. The long barrel vault has an Emerald City, Wizard-straight-ahead feel, and leads you irresistibly toward the altar.

Because of the enormous weight of the stone ceiling, the cathedral walls had to be thick. Large windows reduce the wall area, and wall area is needed for support, so Romanesque cathedrals had to have small windows.

Durham Cathedral

William the Conqueror brought the new Romanesque style to England. He'd promised Pope Alexander II that he would reform the Anglo-Saxon church of England along papal lines (and eliminate Irish Celtic influences) if he defeated Harold. Building new churches was part of his reform package. The huge and impressive structures showed the Saxon majority that their church had been Romanized and was now under the authority of the pope. The building projects continued after his death in 1087. Durham Cathedral, the masterpiece of

Norman architecture, was built in 1093, during the reign of William the Conqueror's son, William II, on the contentious border between England and Scotland. It took only 40 years to complete the gigantic structure, which was breakneck speed in those days. The constant threat of Scottish invasions must have inspired the builders to work fast.

Figure 10-3:
The nave or parishioner area of St. Sernin had to be large to accommodate the endless stream of medieval pilgrims on their way to the shrine of St. James in Santiago de Compostela, Spain.

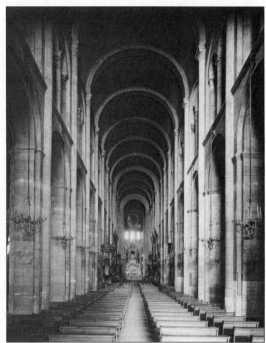

Scala / Art Resource, NY

Durham's basic structure is similar to St. Sernin's (see the preceding section). But it also has some new architectural elements. Whereas St. Sernin's nave is two stories high, Durham's is three. Large windows let light stream in from the top level. The nave is wider, and the larger nave arches open up the space even more than St. Sernin.

The contrasting pillars — compound *piers* (clusters of columns) and cylindrical columns — add variety and interest. The biggest difference is the ceiling, which features a new vaulting system called a *ribbed groin vault* with pointed instead of round vaults. Two modified barrel vaults are spliced together at right angels in this ceiling. Another way to look at it is that the ceiling is comprised of two overlapping barrel vaults, neither of them centered. This structure allowed builders to use thinner materials to make the sections of ceiling between the ribs. With a lighter ceiling, the architect was able to cut larger holes in the walls for windows. Durham helped pave the way for the innovative arches and vaults of Gothic architecture.

Romanesque churches had a dark side, literally. The windows were too small to let in much light. This and the massiveness of the churches made them oppressive rather than uplifting. Some are so gloomy that being in them feels like a penance. The Gothic style fixed that (see "Gothic Grandeur: Churches That Soar," later in this chapter).

Romanesque Sculpture

Instead of a welcome mat, reliefs of the Last Judgment grimly greet visitors to Autun Cathedral and the Basilica of Ste-Madeleine Cathedral of Vezelay (see Figure 10-4). Most churches displayed scenes of the Last Judgment on the interior back wall of the nave (above the exit) so that, on their way out, people would be reminded of the price for committing sin. Why these two pilgrim churches on the Road of St. James chose to put such a menacing story at their *entrances* remains a mystery.

Figure 10-4:
The tympanum over the entrance doors of the Basilica of Ste-Madeleine, a pilgrimage church in Vezelay, depicts a medieval vision of the Last Judgment.

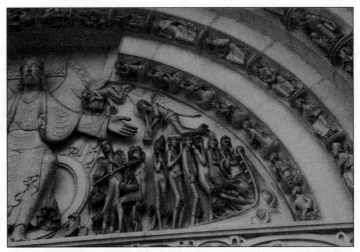

Jesse Bryant Wilder

Nightmares in stone: Romanesque relief

The front-door Last Judgment relief at the Basilica of Ste-Madeleine appears on the *tympanum* (the half-moon-shaped stone above the door also known as a *lunette,* from the word *lunar*).

Christ dominates the scene by his placement and exaggerated size (with respect to the other figures). His stylized expression of openness invites everyone to come to him and to enter the church.

However, on the sides of the top and middle registers, four angels blow the trumpets of the Last Judgment. The top register represents heaven, the middle represents life on earth, and the bottom level is reserved for the dead.

Notice that the angels on the top level sound their trumpets to those on earth, while the angels on the middle band blow their horns to waken the dead. On Jesus's left (the viewer's right), an Angel and devil operate the judgment scales (compare this to the Egyptian "weighing of the heart" in Hu-Nefer's Book of the Dead in Chapter 6). On the viewer's far right, a demon, representing the mouth of hell, swallows the damned. Just below the scales, a devil lifts one of the dead up to be weighed. On the other side of the bottom band, children cling to an angel, hoping to enter heaven. Above them in the land of the living, a similar scene plays out. Some people poke their heads out of their windows to check out Judgment Day.

Such scenes must have encouraged many people to mend their ways.

Roman sculpture revival

Since the fall of the Roman Empire, sculptors had virtually stopped making large-scale sculpture in the round. Romanesque artists revived the tradition, but in their own way. The earliest examples of large-scale sculpture appear on the Road to Santiago in southwestern France and northern Spain. Perhaps they were inspired by ruins of free-standing Roman sculptures. *The Apostle*, carved in about 1090 for the pilgrim church of St. Sernin in Toulouse, is reminiscent of Roman statues, even though he's stuck in a niche (not free-standing). The solidness of the statue, the cut of and folds in his garment, and his expression and stance look like a simplification of a Roman statue like the *Augustus Primaporta* (see Chapter 8).

Crusades: A Middle Ages crisis

The first three Crusades (1095, 1147, and 1189) were organized to "rescue" Jerusalem from its Muslim conquerors, guarantee the safety of Christian pilgrims journeying to the Holy Land, provide land and booty to landless second sons of nobles (and third sons), unite Christendom under the pope's authority, defend the Byzantine (Orthodox Christian) Empire from Muslim incursions, and end the *schism* (separation) between the Eastern and Western churches.

None of these goals was achieved over the long term. The First Crusade did reach and conquer Jerusalem in 1099, mercilessly massacring the Muslim and Jewish residents, and even the women and children. Crusader states (also called Latin states) were established in Jerusalem, Antioch, Tripoli, and Edessa. But within 88 years, the Muslims reconquered Edessa, Tripoli, and Jerusalem. Antioch fell in 1268.

The great wave of Arabic contributions to Western culture

The Crusades and *Reconquista* (Spanish wars to eject the Islamic Moors from Spain) brought Western Europeans in contact with the far more advanced cultures of the East (Byzantium and the Islamic world). This contact changed the West forever. It led to increased trade with the East, stimulating European economies and the development of money and banking. It breathed new life into art, literature, music, and architecture and spawned a new inquisitiveness about the natural sciences.

Islamic translators in Baghdad, Iraq, and Córdoba, Spain, translated into Arabic all the surviving works of classical Greece, as well as works of Indian literature written in Sanskrit. Later these works were translated, often directly from the Arabic, into Latin, helping to keep the flame of classical knowledge alive. Without the Arabic translations, some Greek masterpieces would have been lost forever.

The influence of the two greatest medieval Arab thinkers, Avicenna (981–1037) and Averroes (1128–1198), was enormous. Avicenna's *Canon of Medicine,* which was taught in European universities for about 500 years, is the foundation for western medicine. Books by Averroes, who argued that reason was more important than faith in the quest for truth, were taught in Europe until the 17th century. His famous commentaries on Aristotle influenced the leading medieval philosophers, including Albertus Magnus and St. Thomas Aquinas. Dante and Chaucer praise both men in the *Divine Comedy* and *Canterbury Tales,* respectively.

Relics and Reliquaries: Miraculous Leftovers

As modern rock fans might trek to Graceland to tour Elvis's home or see one of his Vegas jumpsuits, medieval Christians journeyed hundreds and even thousands of miles to be close to the bones or belongings of saints. They believed some of a saint's virtue remained in his bones or clothes after death. This leftover virtue was supposedly powerful enough to produce miracles. The most potent *relics* (the bones and clothes) could purportedly protect entire kingdoms.

To protect relics, Romanesque-era artists preserved them in sealed, often silver-gilt reliquaries that resembled the relic: arm reliquaries for arm bones, foot reliquaries for feet, even head reliquaries for heads. In this way, pilgrims knew what body part they were worshipping without actually seeing it. In later centuries, peepholes were added so pilgrims could glimpse the bone or body part. After walking hundreds of miles, most people wanted to see more than a pretty reliquary.

Late Gothic reliquaries make it even easier to see the relic, often by placing it in a carved rock-quartz casing.

Gothic Grandeur: Churches That Soar

Abbot Suger is credited with being the inventor of Gothic architecture (which in the Middle Ages was known as "the French Style" or the "Modern Style"). Yet he wasn't even an architect. How did he do it?

To answer that question, you need to know a little bit about feudalism. *Feudalism* is a sociopolitical system in which a powerful man like a king (a *lord*) grants land (a *fief*) and his protection to a less powerful man (a *vassal*). In exchange, the vassal pledges his loyalty and military service to his lord. A lord might have 100 or 200 vassals (dukes, counts, viscounts, barons), who in turn have their own network of vassals. At the bottom of this social scale were *serfs,* peasants who were attached to the land as if they were part of the property.

Feudalism peaked in the 11th and 12th centuries. During the first half of the 12th century, the king of France ruled only the area around Paris, which is called the Île-de-France. King Louis VII was weaker than many of his vassals. To help Louis strengthen his hand and knit the rest of France to the crown, his advisor, Abbot Suger, recommended a church-and-state alliance, which would compel the counts, dukes, and bishops to submit to both God and king, at least in theory. The glue of this alliance was an architecture project, the rebuilding of the Royal Abbey Church of St. Denis, which is just north of Paris.

St. Denis (3rd century) is the patron saint of France. According to legend, he chose the site for the Royal Abbey of St. Denis himself — after being decapitated. The trunk of St. Denis supposedly stooped down to retrieve his head, and then carried it 7 miles, from Montmartre (a district in modern Paris) to the town known today as St. Denis. When he arrived, he deposited the head on the spot where he wanted his church built. Then he collapsed and died. A few centuries later the first church was built on that location, or so the legend goes. St. Denis's relics are in residence in the church to this day.

St. Denis is the resting place of many of France's early kings. Charles Martel, Pepin the Short, and Charles the Bold are interred there; Charlemagne and Pepin the Short were anointed kings at St. Denis. In the 12th century, the Royal Abbey Church of St. Denis symbolized France (even more than the Eiffel Tower does today). But it didn't look the part. Abbot Suger felt it needed a facelift, something that would announce to everyone that France was about to be reborn.

Bigger and brighter

Suger wanted the abbey church to mirror the glory of the monarchy and God. But the church was too small to reflect such a grand vision. In his book *Ordinator,* Suger describes "the unruly crowds of visiting pilgrims" who poured into the church on holy days to be near the relics of St. Denis or visit the tombs of France's early kings. "You could see how people grievously trod down one another. How . . . eager little women struggled to advance toward the altar marching upon the heads of the men as upon a pavement."

The Abbey Church's other shortcoming was that it was too dark. Basically, Suger wanted bigger, brighter churches. He believed that God is light, so churches should be filled with radiance, not Romanesque gloom. He believed that the colored light that filters through stained glass or reflects off the gems in chalices and monstrances transports people into a mystical world of the spirit. For Suger, beautiful art was a "materialistic" highway into the spiritual world, a pathway to god.

Making something new from old parts

How big and bright could Suger make the Abbey Church of St. Denis, given its Romanesque frame? If he enlarged the windows too much, the roof would cave in. To solve the problem, Suger invited many of the best architects in Europe to Paris. Their mutual solution (Suger helped to find it, too) was to cobble together innovations from Romanesque churches like pointed arches, ribbed-groin vaults, and flying buttresses, and merge them into a single structure. No Romanesque church included all these elements.

Before enlarging the windows, the designers had to redistribute the church's weight. This was achieved with ribbed-groin vaults and flying buttresses placed against the outside walls of the church (see Figure 10-5). To understand how flying buttresses work, picture a row of strong guys or gals, each straight-arming the church, as if to hold it up. Their arms are the "semi-arches" or butts of the buttresses, and their bodies are the buttress verticals.

How does ribbed vaulting work? The ribs of each vault, which look like a rib cage or the inside spokes of an umbrella (see Figure 10-6), channel the weight from the *vault* (roof) to the walls, where the flying buttresses counter or neutralize it.

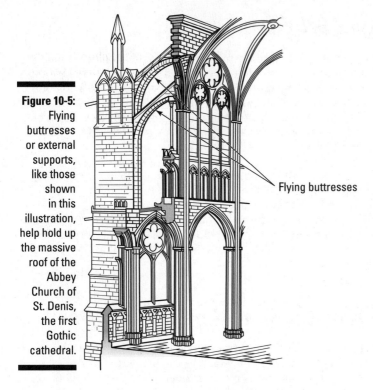

Figure 10-5:
Flying buttresses or external supports, like those shown in this illustration, help hold up the massive roof of the Abbey Church of St. Denis, the first Gothic cathedral.

Flying buttresses

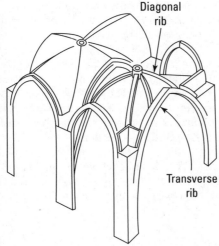

Figure 10-6:
St. Denis's ribbed vaulting, like that shown in this illustration, transfers the weight of the roof to the external flying buttresses.

Diagonal rib

Transverse rib

Because the flying buttresses do much of the wall's work, the walls can be opened up with large windows. For the first time in history, a monumentally large, closed building could be flooded with natural light! Suger's achievement must have seemed miraculous.

Finishing touches and voilà!

Suger added a necklace of chapels around the east end of the church so "the wonderful and uninterrupted light of most luminous windows [could] pervade the interior beauty" of the choir and altar. (The east end of the Romanesque cathedral of St. Sernin is similarly circuited by a ring of small chapels.) Abbot Suger rededicated the Royal Abbey Church of St. Denis on June 11, 1144 in the presence of King Louis VII and his queen, Eleanor of Aquitaine.

Expanding the Gothic dream

The Gothic style spread from St. Denis to the rest of France. In 1163, construction began on Notre Dame (see Figure 10-7). Between 1170 and 1270, the French erected more than 500 Gothic churches. Among the greatest are Chartres (1194), Reims (1210), Amiens (1247), and St. Chapelle (1243–1248). During this period, architects became more daring — building taller cathedrals, streamlining the stone piers and buttresses to maximize efficiency, and reducing the walls to expanses of stained glass (see the following section, "Stained-Glass Storytelling"). The buildings become more skeletal and gravity-defying. By 1243 (when St. Chapelle was built), the walls had all but disappeared and had been replaced by acres of stained glass.

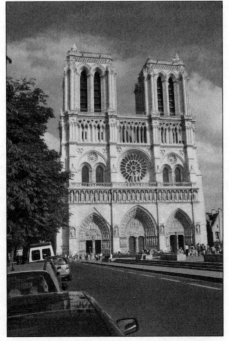

Figure 10-7: Notre Dame in Paris is the most famous Gothic cathedral in the world.

Jesse Bryant Wilder

During the next 200 years, the Gothic style spread across all Europe and beyond. Like Romanesque, it was an international style born in France. Some of the most outstanding Gothic cathedrals are Salisbury Cathedral in Salisbury, England (1220); Cologne Cathedral in Cologne, France (1248); St. Stephens in Vienna, Austria (1304); St. Vitus in Prague, Czech Republic (1344). The French style stayed largely intact in most countries, with some regional variations. But in Italy, Byzantine and Roman influences greatly modified the style.

Stained-Glass Storytelling

In 1194, the city of Chartres and its Romanesque cathedral burned. The townspeople were crushed. Not only had they lost their homes and church, but more importantly, they lost their prize relic, the *Sancta Camisia* (the veil Mary is said to have worn when she gave birth to Jesus). Three days later, the relic turned up, undamaged. It seemed like a miracle, but in fact, when the fire started, a resourceful priest hid it in the cathedral crypt. A visiting cardinal, addressing the relieved citizens, said the recovery of the relic was a sign from Mary: She wanted a bigger church! The crowd erupted with enthusiasm. Donations soon poured in for the new cathedral. Although he was at war with France (as usual), Richard the Lionheart, king of England, let English priests collect money for the reconstruction. Not to be outdone, the French king, Phillip August, paid for the cathedral's elaborate North Porch.

Because the cathedral was to be built in the new Gothic style, many people donated stained-glass windows. French guild workers donated 43 stained-glass windows, each guild "signing" its work with an image depicting its trade. Nobles often "signed" the windows they donated with their coats of arms. The *blazonry* (coat of arms) of France — the *fleur de lis* — is part of the elaborate pattern of the north rose window of Chartres (see the color section), donated about 40 years later by the new French queen, Blanche of Castille, the granddaughter of Eleanor of Aquitaine and the mother of St. Louis.

The kaleidoscope patterns of the rose window are an exercise in theme and variation of shape, symbol, and color. Each of the clocklike, concentric rings is comprised of 12 repeated shapes. The outer semicircles feature 12 Hebrew prophets. The postage-stamp figures in the middle ring are 12 kings of Judah. Mary and the Christ child sit in the center. Beneath the rose, five *lancet* (tall and narrow) windows frame Hebrew, Babylonian, and Egyptian kings, from Nebuchadnezzar to King Solomon.

Other windows and external relief sculpture tell the stories of the Bible from Genesis to the Apocalypse. In those days, the only way most people could "read" the Bible was through stained-glass storytelling and narrative relief.

Thanks to Abbot Suger, windows and churches could now be built large enough to recount the entire Bible.

Most of France's Gothic stained-glass windows were smashed during the French Revolution. The only church with most of its original stained glass is the Cathedral of Chartres; 152 of the original 186 windows survive.

Gothic Sculpture

Gothic sculpture was inspired by Abbot Suger's innovations at St. Denis (see "Gothic Grandeur: Churches That Soar," earlier in this chapter). Unfortunately, much of the St. Denis sculpture has been damaged. But the statues on the west portal (front doors) of Chartres were carved just one year after Suger completed St. Denis and reflect a similar style (see Figure 10-8). The statues are much more realistic than the relief carvings on the tympanum of Vezelay Cathedral (refer to Figure 10-4), even though those were carved only 10 to 15 years earlier (a decade before Suger launched the Gothic style!).

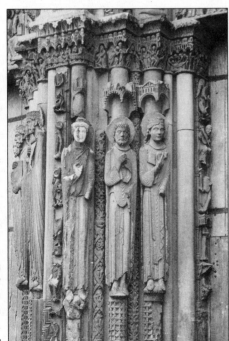

Figure 10-8: The jamb statues on the west portal (entrance doors) of the Cathedral of Chartres stand in a pose that is determined by the column, as if they were an extension of it.

Gloria Wilder

The cigar-shaped statues (*jamb* or column statues) that sentinel each of the three doors were made to fit the columns, which almost appear to be their backbones (refer to Figure 10-8). Their long legs still have a Romanesque rigidity, but the clothing and faces are much more realistic. Instead of the wild, nightmarish look of the Vezelay tympanum (in Figure 10-4), these statues have a quiet dignity that befits their stature as Old Testament kings, queens, and prophets (the ones without crowns are the prophets). The west doors are also known as the *royal portal*.

Forty years later, during the church's reconstruction after the 1194 fire, the Gothic style had moved even closer to Realism. The statues on the south transept doors, or south portal (see Figure 10-9), look like people you might meet on the streets of Paris or Chartres if you could beam back in time. The figures are still dignified like those on the royal portal, but their dignity no longer conceals their individuality. These figures are much nearer to being free-standing statues than their royal portal counterparts. The column supports seem like crutches that the statues could walk away from to share a draught of mead with you in a local café. The statue of St. Theodore dressed as a contemporary crusader on the left (these were carved 10 to 20 years after the Fourth Crusade in 1204) is the most naturalistic. Notice the round contours of the flesh under his left arm and the naturalistic manner in which he grips his lance.

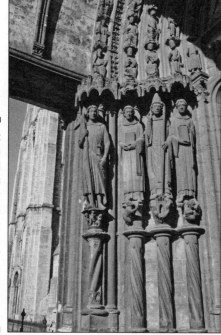

Figure 10-9:
The south portal statues have a much more realistic look than the older jamb statues on the royal, or west, portal.

John Garton

Italian Gothic

In Italy, the transplanted Gothic or French style took on a distinctly Italian flavor. Italian Gothic cathedrals look nothing like French cathedrals. There is more than a hint of Byzantine splendor and Italian love of color in Siena Cathedral, which may be the most sumptuous church in Europe — from its inlaid marble floors, which Giorgio Vasari (the great Renaissance biographer) called "the most beautiful . . . great and magnificent pavement ever made" to the stellar beauty of its star-spangled, rib-vaulted ceiling, created to suggest heaven.

Siena Cathedral took several centuries to complete. I focus here on the Gothic part, which was built in the 13th and 14th centuries, beginning in 1215.

Like many Italian churches, Siena Cathedral has a dome and bell tower *(campanile),* but it lacks the soaring spires associated with the French style. What it fails to achieve in height, it makes up for in decoration. Giovanni Pisano designed the bottom half of the dazzling facade and sculpted its superb statues between 1284 and 1296 (the originals are now in the Cathedral Museum). Giovanni Pisano had assisted his famous father, Nicola Pisano, 20 years earlier in creating the cathedral's magnificent Carrara marble pulpit. At the time, Giovanni was in his early 20s. (The top half of the facade was designed by Giovanni di Cecco, beginning in 1376.)

Pisano framed the three front doors with elaborate polychrome marbles, some of which are striped like candy canes. The columns have Corinthian-style capitals and appear to arc into the lunettes above them. The pediments above the lunettes each enclose a from-torso-to-head bust. Just above the outside pediments, Pisano sculpted the four evangelists of the gospels in pairs — Mark and Luke to the viewer's left, Matthew and John to the right. Each apostle stands next to his animal symbol; each, except John, holds the gospel he wrote.

The interior of Siena Cathedral is a visual feast. There's almost too much to look at. But in spite of the abundance of decoration and sculpture, it has an overarching unity. The rib-vaulted ceiling and the colonnades of arches dividing the nave from the aisles are influenced by French Gothic. Together they create a glorious architectural harmony. The inlays on the inside of the arches, the black-and-white marble piers, and the 36 busts of Christian emperors beneath the two imposing rows of 176 popes are all uniquely Italian features.

The rose window on the opposite end of the cathedral was based on a design by Duccio (see the following section).

Gothic Painting: Cimabue, Duccio, and Giotto

The knights of the Fourth Crusade (1201–1204) never reached their destination: Egypt. They got sidetracked into attacking Constantinople — their ally! The crusaders crushed the Eastern Roman Empire, which, until then, seemed eternal (though it did get back on its feet about 60 years later, and stayed on them for almost 200 more).

The one positive result of the crusaders' occupation of Constantinople was that many Byzantine artists fled the city and emigrated to Italy, bringing Eastern cultural influences with them. Italians called this influence the *Greek manner.* The Greek manner mixed with the relatively new Gothic style that seeped into Italy from the north. The melding of the two gave birth to a revolutionary style of painting that paved the way for the Renaissance. This style was more than the sum of its parts. Although the component parts were French Gothic and Byzantine or Greek, the new style had a decidedly Italian flair. The three greatest masters of this new style are Cimabue, Duccio, and Giotto.

Cimabue

Madonna Enthroned by Cimabue (c. 1240–c. 1302) has many of the same generic features that Byzantine icons have. (Refer to the *Virgin of Vladimir* [see the appendix] and Andrei Rublev's *The Old Testament Trinity* in the color section.) These features include

- Standardized folds in the garments, as if they'd all been pressed by the same drycleaner
- Gold, plate-size halos
- Identical poses and gestures
- Clone-like angels
- A flat, decorative background (hammered gold leaf)

In other words, *Madonna Enthroned* has the same hand-me-down composition. But there *are* subtle differences. Cimabue's faces, especially those in the bottom register, are fuller, fleshier, and much more expressive.

These differences are more pronounced in Cimabue's *Madonna in Majesty* fresco (see Figure 10-10), painted for the Basilica of St. Francis in Assisi about 50 years after St. Francis's death:

- **The *Madonna in Majesty* has an intimacy that Byzantine icons lack.** Icon paintings are meant to be aloof, because they depict divine beings

(saints, apostles, Christ) who might raise a hand in the viewer's direction and make eye contact, but who remain from another world.

✔ **The flesh of the figures is fleshy.** They're more realistic than Byzantine icons.

✔ **The painting has a gentle sadness about it that the blues and greens and Mary's angelic prettiness sweeten.** All the faces in the fresco seem to reinforce this emotion as if they had the same reaction to something that's not visually stated in the painting. Expressive emotion is one of the unique characteristics of the new style of Italian painting (13th and early 14th centuries).

Figure 10-10: Cimabue's serene but damaged *Madonna in Majesty* adorns the Basilica of St. Francis in Assisi. The fresco has undergone several major restorations.

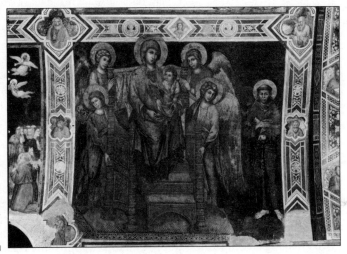

Scala / Art Resource, NY

On the right side of the painting stands a barefoot St. Francis. He is easy to identify because he bears the *stigmata* (wounds of Christ) on his hands and feet. Like the angels beside him, Francis looks at the viewer, almost as if he were posing for a photograph. None of them seems to notice the others.

Sameness in Byzantine painting is a good thing. Icons are not supposed to change, because the figures they represent are believed to be eternal and unchanging. Byzantines believed that the first icons of Christ and the Virgin Mary were painted by St. Luke, so later artists, in a sense, copy from those originals. Also, Byzantine art is meant to depict the spiritual side of the figure, not the sensual side; so fleshiness or three-dimensionality was off-limits to Byzantine artists (see Chapter 9 for more on Byzantine icons).

Thirty years after Cimabue painted the fresco, part of it was destroyed. St. Antony formerly stood on the left side of the painting, balancing the image of St. Francis.

Cennino Cennini's craftsman's handbook

In the late 1390s, a Florentine painter named Cennino Cennini wrote a guidebook that gave instructions in medieval painting techniques. Cennini wasn't the greatest painter of his day, but his *Handbook* records time-tested methods of art making from the medieval period.

The book reveals that wood panels (oak in the northern countries, poplar in Italy) had to be installed in elaborately carved and decorated frames before the painter got a crack at them. (Duccio used frames like this to paint altarpieces.) Then a craftsman brushed the panel surface with *gesso* (a mixture of rabbit-skin glue and chalk) many times and afterward sanded it smooth. Next, he mixed a red earth pigment, called *bole,* with the glue and brushed it onto the areas where gold leaf would be applied

(think extremely light, gold foil). If the craftsman placed the gold leaf directly on the tan gesso, it would look greenish and sickly; whereas, with the reddish underlayer, it glowed with a golden warmth. Next he sketched in the contours of the figures and then stamped ornate halo designs onto the gold background with special tools. Finally, he cracked a few eggs, extracted the yolks, and mixed them with tempera pigment to create the paints. Because egg tempera dries quickly, most medieval artists mixed their colors as they worked by painting tiny strokes of one color next to the dry strokes of a neighboring color, hoping that, from a distance, they would appear to mix to the desired hue of the saint's robe or whatever they were painting.

Cimabue painted *Madonna in Majesty* between 1278 and 1280. St. Francis died in 1226. According to local Assisi tradition, Cimabue captured the true likeness of St. Francis in this painting, even though he never saw the saint. Like a police artist making a composite sketch, Cimabue supposedly reconstructed St. Francis's face by gathering accounts of his appearance from people who knew him.

Duccio

At first glance, *Madonna Enthroned* by Duccio (c. 1255–c. 1319; see the color section) also mimics Byzantine icon painting — "the Greek manner." But on closer inspection, you can see a three-dimensionality that's missing from icon paintings. The faces have contours, angles, areas of shadow and light, and a hint of personality. Notice that Mary's right hand is more natural looking here than it is in Cimabue's *Madonna Enthroned.* The two pairs of bare feet on the right and left sides of the painting are also fleshed out and real: They don't wear the same size shoes.

The cloaks on the figures fall more fluidly. The contours of Mary's right knee and leg press naturalistically through the fabric. You can see the same naturalism in

the Gothic statue of St. Theodore on the south portal of Chartres (refer to Figure 10-9). These differences reflect the French-Gothic side of Duccio. In this painting, Duccio seems to have found a perfect balance between Gothic elegance and Byzantine formality. But in Italy, the scales soon tipped toward naturalism and a revival of Western Empire classicism.

Giotto

According to Renaissance biographer Giorgio Vasari, Giotto (c. 1266–1337) became Cimabue's pupil after the older artist saw the boy sketching some grazing sheep. He recognized the 10-year-old's talent at once. In 1550, Vasari wrote, "The child not only equalled the manner of his master, but became so good an imitator of nature that he banished completely that rude Greek manner and revived the modern and good art of painting."

Like Cimabue, Giotto was practically a Florentine. (Both were born in the suburbs, but scholars usually label them as Florentines.) Although Giotto appears to have been Cimabue's student (Vasari isn't always reliable), he was a much greater or at least more original artist than his master. Apparently, Cimabue liked sticking to the Byzantine tradition as long as he could mix it with a little Gothic realism. What made Giotto unique was that he didn't copy from others — he copied from nature.

Giotto was a great observer. He noticed life's details and included them in his art. His religious paintings give the impression that you're watching the actual events through a hidden camera. Some figures in his paintings turn their backs on you, as they might in real life. Others stand in front of the people around them, blocking their faces or part of their bodies from view. Byzantine artists would never do this; the formulas for icon paintings wouldn't allow it.

Giotto's ability to capture feeling in a multitude of situations makes his work revolutionary and refreshing. There is an emotional intensity in his frescoes that hadn't been seen before, not only in the expressiveness of the faces, but in the dramatic lighting that bathes the figures. In *The Kiss of Judas* (see Figure 10-11), Giotto creates an electrifying drama, heightened by the thicket of spears, torches, and shepherd staffs, wielded by the combatants. All the explosive tension in the painting converges on the kiss, as Jesus and Judas square off.

Giotto's paintings have a cinematic quality, especially the Arena Chapel fresco series in Padua, which is considered to be his greatest work. Instead of posing for the viewer, as if someone were about to snap their picture (as in the Cimabue and Duccio examples above), the people in the frescos look at each other directly or out of the corners of their eyes. They interact and communicate with one another instead of posing.

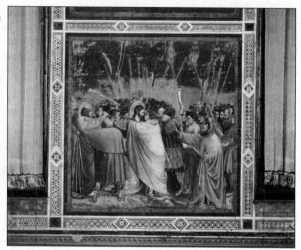

Figure 10-11: In *The Kiss of Judas,* Giotto dramatizes Christ's betrayal by depicting the clash between Jesus's supporters and enemies.

Scala / Art Resource, NY

In *The Flight into Egypt,* notice how the Virgin Mary and the woman leading the donkey study Joseph as he guides them through the desert. The Christ child observes a woman behind the donkey who is talking to her companion. Everyone has his or her eyes on someone. The interplay of glances tells a very human story. True, the background trees look like magazine cutouts pasted onto the mountains (which also look like cutouts), but Giotto was interested in people. His painting revolution took place in the foreground, not the background.

Giotto's people inhabit not only the same scene, like the figures in Cimabue's and Duccio's works, but they occupy the same psychological space. This is the first time in art that people in a painting ignore the viewer and focus on each other.

Tracking the Lady and the Unicorn: The Mystical Tapestries of Cluny

Tapestries woven of wool and silk threads and gold and silver wires were very fashionable among the rich in the 14th and 15th centuries. They hindered drafts and beautified drab castle walls. The reason so few exist today is that, in later centuries, people burned them to extract the gold and silver wires. Medieval tapestries usually recounted *allegorical stories* (stories in which the characters represent virtues or vices) meant to illustrate courtly love, chivalry, or religious themes.

Perhaps the most famous tapestries are the six *Lady and the Unicorn* tapestries, created for Jean Le Viste in the late 15th century. The tapestries now hang in the Musée de Cluny (also known as the Musée National du Moyen-Age) in Paris. The *Lady and the Unicorn* cycle is done in the popular *millefleur* (thousand flowers) style, in which hundreds of floating flowers sift through the tapestry background like confetti. The background is intended to represent a field of flowers, often populated by playful animals, but the ground is so steeply pitched that both the flowers and the animals appear to be levitating.

At first glance, *The Lady and the Unicorn* doesn't seem to have a courtly love theme. There are no men in any of the six tapestries. But a male presence is implied; the Lady seems to be wistfully thinking of an absent lover. Perhaps the unicorn is a kind of stand-in for him.

Five of the *Lady and the Unicorn* tapestries represent the senses. Today we refer to them as "Touch," "Taste," "Sight," "Hearing," and "Smell." The sixth and most mysterious tapestry seems to be about love and desire — yielding to it or renouncing it. The words *A Mon Seul Désir* (To My Only Desire) are emblazoned on the canopy of the blue tent in the center of the tapestry. In the other tapestries, the Lady wears a richly jeweled necklace, possibly a gift from a lover. In *A Mon Seul Désir*, she either returns or takes the necklace from her jewelry box. Is she renouncing love (putting the necklace back) or getting ready for a date (putting it on)?

In the tapestries of the senses, the Lady tames or seduces a wild unicorn. In pre-Christian legends, only a virgin can tame the erotic beast by resting its phallic horn between her breasts. This racy tale was edited in the Middle Ages. In the Christian period, only a virgin could catch and tame a unicorn (which may be why their "appearances" were so rare). Christians also believed that the animal's horn would purify whatever it touched — dipping a unicorn horn into a polluted stream could clean the water. They further updated the legend by linking the unicorn to the Virgin Mary. In medieval art, often a unicorn is shown resting its head on the Virgin's lap or touching her lap with its hoof, as it does in the "Sight" tapestry, shown in the color section. The infant Jesus also sat in Mary's lap and purified whatever he touched, so unicorns became symbols of Christ's incarnation as well.

Is the Lady who tames the unicorn a substitute for the Virgin Mary? Is she a virgin who wants to be something else or a virgin who wants to transcend the world of the senses forever? Or is she an experienced woman who wishes she could have her innocence back? Or do the tapestries represent the seasons of a woman's life?

These are questions no one can answer, which is one reason why the tapestries still intrigue people after 500 years. Many people believe the *Lady and the Unicorn* tapestries are about a woman renouncing the sensual world for a

contemplative or spiritual life. This was not uncommon in the Middle Ages. Many women and men retired from the world of the senses to join one of the many religious orders: Franciscans, Poor Clares, Dominicans, Carthusians.

In "Touch," the Lady holds the unicorn gently by the horn, suggesting that she has tamed him. But there may be another level of meaning. Does holding the unicorn's horn mean the Lady has mastered her desire or been mastered by it? Is she renouncing the sense of touch, or yielding to it? Maybe the answer is in her faraway eyes, which suggest she longs for something she can no longer have.

All the animals in the tapestry, except the monkey on the upper left, seem to serve or be controlled by the Lady. Notice that the monkey (a symbol of unruliness) is chained up. There's no place for monkey business in the "Touch" tapestry. But in the other tapestries, he's unleashed and sometimes behaves mischievously — sniffing a rose or chomping on a nut or morsel of candy the Lady drops.

Chapter 11

Born-Again Culture: The Early and High Renaissance

In This Chapter

▶ Exploring Renaissance ideals

▶ Making sense of rationalist architecture

▶ Tracking vanishing points and reading narrative paintings

▶ Decrypting the visual poetry of Botticelli

▶ Standing up with Donatello

▶ Soaring into the High Renaissance with Leonardo, Michelangelo, and Raphael

*T*he Renaissance is the "rebirth" or reawakening of Greek and Roman culture, which in 1400 had been dozing for almost a thousand years. What sent classical culture into hibernation? When Rome fell, many Christians turned their backs on classical culture, which they associated with paganism. For the next 1,000 years, artists focused on God and the afterlife (or depicted the horrors of hell to scare people into behaving), instead of celebrating the sensual earthly life as the Romans and Greeks had.

But the past wasn't completely forgotten. Poets like Dante and Chaucer mentioned Greek myths on occasion, and Romanesque architecture (see Chapter 10) revived elements of Roman architecture in the 11th and early 12th centuries.

During the Renaissance, classical culture made nearly a complete comeback. Artists resurrected realism in painting and sculpture; and classical literature, history, and philosophy inspired writers from Niccolò Machiavelli to William Shakespeare and Jean Racine. Even the Greco-Roman gods reappeared, showing up in art nearly as often as Christian saints. That doesn't mean artists converted to paganism (though some were accused of it). They became down-to-earth Christians, focusing on the here and now as much as the hereafter.

The Early Renaissance in Central Italy

Most historians believe that the city of Florence gave birth to the Renaissance in the 15th century (also known as the *quattrocento,* or 1400s). But the new movement had its roots in the *preceding* century, especially in the art of the Florentine Giotto (see Chapter 10), who had given flesh a three-dimensional look for the first time since the fall of Rome. However Giotto's perspective was intuitive and imprecise, not mathematical; consequently, his paintings have a shallow depth of field; the figures tend to hover in the foreground.

Building on Giotto's achievements, artists of the Early Renaissance (1400–1495) invented a precise science of perspective to give their artwork infinite depth. During the Renaissance, looking at a painting was like peering through a window at the real world, with some objects close and others far.

The Great Door Contest: Brunelleschi versus Ghiberti — And the winner is!

In a way, a door-making contest launched the Renaissance in 1401. Florence was about to be gobbled up by Milan. The power-hungry Duke of Milan had already conquered Siena (in 1399) and Perugia (in 1400). Florence was next on his hit list. The duke intended to rule all of Italy, which was a fractured "country" of independent city-states. Despite the impending danger, Florence's leaders decided to sponsor a door-making contest instead of investing all their civic energy into strengthening their defenses.

The doors of the Florentine *baptistery* (the place where all citizens were baptized) were very important to Florence. Seventy years earlier, the sculptor Andrea Pisano had cast two of the baptistery doors in gilded bronze with scenes from the life of St. John the Baptist, the city's patron saint. Now city leaders wanted two more bronze doors.

The year 1402 turned out to be a good one for Florence and the Renaissance. The Duke of Milan died of the plague, and Florence was saved. Also, the winner of the door contest was announced: Lorenzo Ghiberti. The Renaissance was under way. Three of the other seven contestants also became pioneers of the Renaissance, spreading it in other directions: Donatello, Jacopo della Quercia, and Filippo Brunelleschi.

Ghiberti's bronze doors so dazzled Florentines that the city invited him to make two more doors. He did. The second set perfectly illustrated scientific perspective (which Brunelleschi invented) and so impressed the young Michelangelo that he dubbed them the "Gates of Paradise" (see the color section).

After failing to win the door contest, Brunelleschi gave up sculpture and became an architect. He probably made a trip to Rome not long after the contest with his friend the sculptor Donatello to study Roman architecture. Using classical models like the Pantheon and Colosseum, Brunelleschi invented Renaissance architecture, a geometrical style of grace, harmony, and openness.

The Duomo of Florence

Sixteen years after the door contest, Brunelleschi competed against Ghiberti again to design a dome for the Duomo (cathedral) of Florence. This time he won. The Duomo had a wooden roof, it needed a stone one. But the massive Gothic structure seemed too huge to cap with a stone dome. Instead of constructing a single solid mass, which would have been too heavy, Brunelleschi solved the problem by designing a double masonry shell, each reinforcing the other. (The total dome weight is over 40,000 tons!) The double shell rested on a massive drum, rather than the roof. Thanks to this ingenious method, Brunelleschi was able to construct the world's biggest and one of its most majestic domes. The Duomo dome soars 375 feet.

Other projects soon came Brunelleschi's way. One of his greatest achievements was his design for the ruling Medici family's church, San Lorenzo. With its Corinthian columns, Roman arches, and classical harmony, San Lorenzo feels as much like a pagan temple as a Christian church. Because Brunelleschi used proportional ratios (possibly derived from musical ratios) and geometric shapes, the building conveys a sense of rational order, grace, and serenity.

Gothic cathedrals soar toward heaven and seem to lift visitors beyond themselves. But the cubical interior of San Lorenzo with its flat, coffered ceiling doesn't draw anyone skyward. The space feels self-contained, but at the same time open, not boxy. The relationships of arches at different angles and levels and *roundels* (round windows) in a rectangular space creates an architectural harmony.

Above all, the space conveys a sense of rational order rather than religious ecstasy, inspiring visitors to think about God rather than swoon over him.

What's the point? The fathers of perspective

Things appear to shrink as they recede into the distance. Watch someone walking down a straight road, and eventually, she'll disappear. But at what rate does she shrink? At a hundred yards away, how much shorter is she than she was when she was standing next to you?

Artists had to guess until Brunelleschi invented *linear perspective,* which his friend Leone Battista Alberti described in his book *De Pictura* (On Painting) in 1435. The main feature of linear perspective is the vanishing point. You know railroad tracks are parallel, yet they appear to converge as they recede into the distance. In *one-point perspective* (which means perspective with one vanishing point), the lines on each side of a painting gradually converge like railroad tracks. By drawing railroad tracks from the tops and bottoms of rectangular buildings on the left and right sides of a painting or drawing, you can determine the correct height of any object between the foreground plane of the painting (the surface of the canvas) and the vanishing point (see Figure 11-1).

In the following sections, we examine the art and architecture of major Early Renaissance and High Renaissance artists and architects.

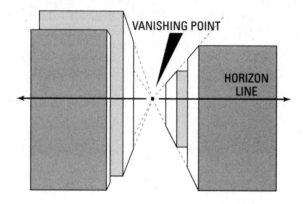

VANISHING POINT

HORIZON LINE

Figure 11-1: Linear perspective is an exact science; an object's location determines its size.

VANISHING POINT

HORIZON LINE

Masaccio: Right from the fish's mouth

Masaccio (1401–1428), one the greatest painters of the Early Renaissance, was the first to apply Brunelleschi's system of perspective to painting. At the age of 21, he was already a master. Unfortunately, he only lived six more years.

Masaccio's greatest works may be his frescoes of the life of St. Peter in the Brancacci Chapel in St. Maria del Carmine in Florence. The painting *The Tribute Money* is a visual narrative with three episodes that begin in the center, move to the left, and then backtrack to the right. Only one character, St. Peter, appears in all three scenes, dressed in an orange cloak over a blue undergarment. His clothes help the viewer track his movements.

Peter's concern about paying *tribute money* (taxes) prompts Jesus to say, "Go thou to the sea, and cast an hook, and take up the fish that first cometh up; and when thou hast opened his mouth, thou shalt find a piece of money: that take, and give unto them for me and thee [pay the taxes with it]."

The baffled looks on the faces of the apostles (each dumbfounded in his own way) shows the Renaissance shift in focus from God to man. Although the painting illustrates a biblical passage, Masaccio draws the viewer's attention to the apostles' human reaction to Jesus's strange prediction. Pointing fingers, gestures, and stunned expressions tell the rest of the story.

Masaccio's handling of perspective is masterful. Though the figures cluster together in the center of the painting, the ones in the rear of the group shrink convincingly, according to the laws of linear perspective. The background of gloomy gray mountains and sky, though simple, gives the painting a profound sense of depth. Your eyes can wander into the distance in his painting.

After Masaccio's early death, painting languished in Florence.

Andrea del Castagno: Another Last Supper

For a while, it seemed Andrea del Castagno (c. 1423–1457) might fill Masaccio's shoes as the next great Renaissance painter. But like Masaccio, he died young, at the age of 34, from the plague.

Castagno's career started when he was a teenager. At 17, the Medici family commissioned him to paint the corpses of rebels hanged for conspiring against Medici rule. The painting has long been lost.

One of Castagno's greatest paintings is *The Last Supper* on the dining hall of the convent of St. Apollonia in Florence. The Apostles have even more personality in this fresco than they do in Masaccio's *The Tribute Money*. But they barely communicate; they seem to be in their own world.

Fra Angelico: He's not a liqueur!

Fra Angelico's real name was Guido di Pietro. His nickname, which is what most people know him by, means "Angelic Brother." He carried the Renaissance spirit quietly and subtly into the Florentine Monastery of San Marco where he lived as a Dominican monk. With a team of assistants, Fra Angelico covered the walls of the monastery over a ten-year period (1435–1445) with frescoes of quiet beauty.

The paintings of Fra Angelico (c. 1400–1455) are prayers. They have a serene intensity — perfect for spiritual contemplation.

Even his fresco *The Mocking of Christ* (see Figure 11-2), in which disembodied hands harass Jesus, is as calm and peaceful as meditation. You feel as though you're out of reach of the violence, even as it occurs. It can't disrupt the contemplative quiet of the painting or the monastery. Although a man spits at Jesus, the spray never reaches him. Jesus sits erect and calm on a throne that looks almost like a stage for a theater piece, further distancing him (and the viewer) from his suffering. At the foot of the platform, St. Dominic thumbs through a book and the Virgin Mary wistfully muses, suggesting that the event is happening in memory rather than the present.

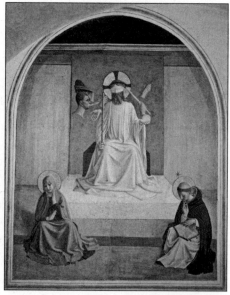

Figure 11-2: The floating body parts in *The Mocking of Christ* make it seem almost like a surreal painting.

Scala / Art Resource, NY

Filippo Lippi: The wayward monk

Although he was a monk, too, Fra Filippo Lippi (c. 1406–1492) was much less devout than Fra Angelico (see the preceding section). Lippi lived a wild life and cavorted with nuns. His masterpiece, *Madonna and Child with the Birth of*

the Virgin (see the color section), though delicate and beautiful, is stuffed with the details of day-to-day life. Instead of transcending the world, like Fra Angelico's art, Fra Lippi shows the viewer the texture of everyday life: someone running up the steps, tired women carrying baskets to and fro, a child pulling on his mother's gown.

Whereas Masaccio's narrative *The Tribute Money,* combines several instances into rapid succession in one frame, the episodes in Fra Lippi's painting occur many years apart. Yet these events exist simultaneously on different levels, showing their interconnectedness: Jesus's birth is possible only because of Mary's birth, which occurs supernaturally to a barren woman, St. Anne, and is depicted just behind the adult Mary in the foreground. At the top of the stairs, you can see St. Anne nine months prior to the Virgin's birth, getting the good news. Time moves in a circle in this painting — like a clock, leading the viewer from birth to birth, beginning to beginning.

The color red helps you navigate the painting, leading your eyes around the circle as they leap from Mary's red garment, to St. Anne's bedspread, to the drapery above her, to the red shirt of St. Anne's husband bounding up the stairs. Red also helps to balance this complex composition, as does Lippi's subtle use of perspective.

The delicacy that Lippi brings to Renaissance painting; Mary's pale, luminous skin; her transparent veils; and her pretty grace, appear again in the paintings of Lippi's famous student Botticelli (see the following section) and in the paintings of his son Filippino Lippi (whom Botticelli taught).

Sandro Botticelli: A garden-variety Venus

Sandro Botticelli (c. 1444–1510) is the most poetic painter of the Early Renaissance. His masterpieces, *The Birth of Venus* and *Primavera* (see the color section), are painted poems, the visual language of which has intrigued and mystified people for centuries. Both works seem to be painted in a kind of code based on the philosophy of Neo-Platonism. *Neo-Platonism* (new Platonism) was more than a philosophical fashion in the 15th century. It was the spiritual side of the Renaissance. Its core belief is that man's origin is divine and his soul is immortal.

Marcilio Ficino, a humble but inspiring genius, who woke with the sun every morning, abstained from sex, practiced vegetarianism, and eventually became a priest, was the father of the Neo-Platonic movement in Florence. He headed an updated Platonic Academy just outside Florence (modeled on the ancient one in Athens). Lorenzo de' Medici, Leone Battista Alberti, Sandro Botticelli, and Michelangelo all basked in Ficino's spiritual glow, carrying it into their work. Through Ficino's correspondence with philosophers, church leaders, statesmen, and kings from Hungary to England, Ficino spread Neo-Platonic ideas and the Renaissance across Europe.

Botticelli's *Primavera* (see the color section), which may have been commissioned for a wedding, was supposedly based on Neo-Platonic stories recounted by Lorenzo de' Medici and turned into a poem by the Renaissance poet Poliziano. In the painting, Venus, the goddess of love, presides over the garden and is the focus of the work. Her son Cupid, flying over her head, aims a fiery arrow at one of the three Graces (the lithe ladies in see-through gowns on the left). Blind as he is, Cupid never misses. Notice how one of the Graces eyes the god Mercury, who's too busy chasing clouds to notice her. Has she been wounded before Cupid shoots his arrow? Is Botticelli playing Neo-Platonic tricks with time and simultaneous narrative?

On the right, another love story unfolds — not one step at a time, but all at once. Puffy cheeked Zephyr, the sky-colored wind god, thrusts himself into the painting to rape the nymph Chloris. During the encounter, Chloris begins to turn into somebody else: Flora, the goddess of flowers who is standing at her right. The flowers sprouting from her mouth signal the transformation.

After the rape, Chloris/Flora marries Zephyr and scatters flowers about the earth. As the blossoms touch the ground, they instantly take root. Venus's love garden exists in an eternal springtime, where youth is recycled over and over. Notice that this springtime also enjoys the benefits of fall: blossoming and ripening occur simultaneously. The trees live in two seasons at once, bearing September fruit and April blossoms. Another time trick? Maybe in Venus's mythical garden love transcends time, and we can experience all seasons at once.

Donatello: Putting statues back on their feet

Donatello (1386–1466) helped birth the Renaissance with his friend Brunelleschi. Like him, Donatello championed a return to classical models in sculpture and architecture. His study of classical sculpture paid off. Acclaimed as the greatest sculptor of the 15th century, Donatello's achievements in sculpture equaled the Greeks. His bronze *David* (see Figure 11-3) was the first free-standing, life-size nude in a thousand years. Before *David*, he'd sculpted superlative three-dimensional niche statues for the walls of Florence's Orsanmichele that seemed poised to march off their pedestals into the streets of the city.

With *David*, Donatello took a bolder step and freed his statues completely from the restrictions of the Middle Ages. He literally put statues back on their feet. They were no longer glued and subordinate to architecture (like the jamb statues of Chartres in Chapter 10). Not only did Donatello free statues from their niches, but he broke another taboo by depicting David naked. The statue's unabashed, sensual nudity would have been X-rated in the Middle Ages.

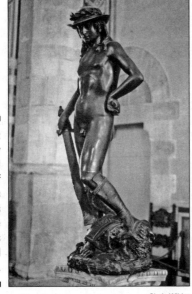

Figure 11-3:
The highly polished bronze of Donatello's *David* helps to give the statue its sensual appeal.

Gloria Wilder

The bronze warrior helmet of Goliath, under David's foot, and David's shepherd's hat emphasize that a gentle shepherd boy has overcome a brutish, gigantic warrior. David's flower-wreathed hat is still on his head. Goliath's helmet and head lie on the ground. A gentle, beautiful boy (a poet and singer) has overpowered a gargantuan bully, yet David doesn't gloat. He regards the fallen Goliath not triumphantly but wistfully, as if he might shed a tear for him.

With *David,* Donatello made a political statement, too. Milan was threatening Florence once again. His statue suggests that David-like Florence, a city of refinement, art, and beauty, is mightier than the brutish, Goliath-like dukes of Milan, who were bullying northern Italy.

The High Renaissance

In the Middle Ages, men *made* things, they didn't *create* them. Medieval man believed only God could create. But around 1500, people began to view painters, sculptors, and architects as creators, too. Michelangelo was sometimes called the "divine" during his lifetime, a reflection of society's changing attitudes. Almost overnight, art makers evolved from artisans into artists, super geniuses who created works of wonder that seemed to rival nature like Leonardo da Vinci's *The Last Supper,* Raphael's *The School of Athens,* and Michelangelo's Sistine Chapel Ceiling.

It was as if, during the Renaissance, man overcame a 1,000-year-old inferiority complex. In the Middle Ages, people knew their place; they were born into it and couldn't change it. If your father was a peasant, you were stuck being one, too. All you could do was hope for a better situation in the next life. Aiming too high in *this* life was a sin. If a medieval artist claimed to *create* something, he would have been viewed as trespassing on God's domain.

During the Renaissance, men and women gained a new self-respect and learned to value life on earth as more than a pit stop on the road to the afterlife. Artists began to celebrate not only God, but man.

Armed with supreme self-confidence, Renaissance artists dared to do what men had never before dared. The three super heroes of the High Renaissance (1495–1520) are Leonardo da Vinci, Michelangelo, and Raphael (now you know where three of the Teenage Mutant Ninja Turtles got their names — we discuss the namesake of the fourth turtle, Donatello, earlier in this chapter). These High Renaissance geniuses broke through medieval limitations and elevated man with their paintbrushes, pens, and chisels.

In *The Creation of Adam* Michelangelo painted Adam almost on the same level as God. The creator and his creation practically touch fingertips as the electric charge of life passes from God to man. No medieval artist ever depicted human beings on such a high level.

Similarly, Leonardo elevated man; most famously when he attempted to lift man to the level that earlier generations had assigned to the angels. He gave man wings — or tried to. In 1505, he designed a flying machine, 400 years before the Wright brothers launched their airplane at Kitty Hawk. Despite his ingenious work, Leonardo's flying machine never got off the page. But his Olympian effort to give man wings was more than High Renaissance ego — it was part of the new vision of man as a co-creator, nearly equal to God.

Raphael elevated man in a quieter way. He brought the Holy Family down to earth, emphasizing Jesus's humanity even more than his divinity. In his paintings, the Holy Family look like ordinary people. Unlike medieval artists, Raphael, Michelangelo, and Leonardo almost always abandoned the *halo* (the golden ring that crowns the heads of holy people in medieval art).

Leonardo da Vinci: The original Renaissance man

Leonardo da Vinci (1452–1519) had a buffet-style brain — every specialty imaginable was on his mental menu. He was the ultimate Renaissance man, not just a super painter and sculptor (though none of his sculptures survive),

but an anatomist, biologist, botanist, engineer, inventor, meteorologist, musician, physicist, and writer. He was the almost-discoverer of hundreds of inventions. But because he wrote backwards, no one understood his writings for centuries, and his discoveries went largely unnoticed. (To decode his manuscripts, you need to read them in a mirror and, of course, understand Italian; the man knew how to keep a secret.)

Leonardo's techniques

The techniques Leonardo employed — including aerial perspective, sfumato, and chiaroscuro — made figures and landscapes appear more realistic. This realism, more than anything else, is what distinguishes Renaissance art from Medieval art (see Chapter 10).

Aerial perspective

Leonardo invented the term for a kind of perspective based on his optical studies that he called *aerial perspective*. (The ancient Romans were aware of this kind of perspective and van Eyck and other 15th-century Flemish painters used it intuitively.) As Leonardo put it:

> Aerial perspective depends on the differences in the thickness of the air. If you want to place a number of buildings behind a wall, some more distant than others, you must suppose that the air between the more distant buildings and the eye is thicker. Seen through such thick air any object will appear bluish. . . . If one building is five times farther back from the wall, it must be five times more blue.

One of the early paintings in which Leonardo used aerial perspective is *The Virgin of the Rocks* (see the color section). This masterpiece depicts (from right to left) John the Baptist, the Virgin Mary, Jesus, and an angel inside a secluded grotto that opens onto a scene of mystic mountains and a sunken river. You can almost feel the air getting thicker as your eye recedes into the painting.

Sfumato

In *The Virgin of the Rocks* (see the color section), the pale-as-mist blues and soft grays that delicately veil the landscape are Renaissance special effects called *sfumato,* which means "smoky" in Italian. Leonardo invented sfumato so he could capture subtle atmospheric changes with his brush and blend the outlines of figures into the environment. Now instead of seeming superimposed on the background like a kid's cutouts, the figures look like they belong there.

Sfumato is not dependent on distance like aerial perspective, where far-off mountains appear blue. In fact the "color" of sfumato is more smoky gray than blue. Using sfumato, Leonardo blurred the edges of side-by-side objects just enough so that they seemed part of the same atmosphere.

Chiaroscuro

Leonardo also used *chiaroscuro,* a painting technique invented by the Ancient Greeks, but largely forgotten after the fall of Ancient Rome in A.D. 476 until it was reintroduced to painting by Masaccio in the early 15th century. *Chiaroscuro* means "light-dark" in Italian. The shifts from light to dark in figures painted with this technique give the flesh a 3-D feel. Notice how the shading and light in the Virgin's face in *The Virgin of the Rocks* help give depth to her features, bringing out the contours.

This three-dimensional effect that is so prominent in Leonardo's paintings is very different from the work of his predecessors, such as Botticelli (see "Sandro Botticelli [c. 1444–1510]: A garden-variety Venus," earlier in this chapter). As beautiful as Botticelli faces are, they seem flat compared to Leonardo's. Later artists, like Caravaggio (see Chapter 14) and Rembrandt (see Chapter 14), used chiaroscuro even more dramatically than Leonardo.

Leonardo's greatest works

In the following sections, I take a closer look at two of Leonardo's most famous paintings: *Mona Lisa* and *The Last Supper.*

Behind Lady Lisa's smile

Leonardo da Vinci's *Mona Lisa* (see Figure 11-4) is the most famous painting in the world. The model for the *Mona Lisa* was Lisa Gherardini del Giocondo, which is why the painting is also called *La Gioconda,* which means "the smiling one."

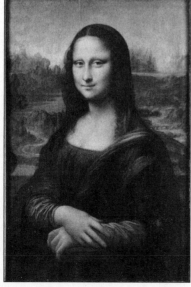

Figure 11-4: Among other things, the *Mona Lisa* is celebrated for its use of sfumato and aerial perspective.

Réunion des Musées Nationaux / Art Resource, NY

Some say the reason for the *Mona Lisa*'s celebrity is that her eyes follow the viewer; others think it's her understated smile that captivates people. I think it's more than that: Although she was painted 500 years ago, *Mona Lisa* seems to *know* her viewers. Her eyes and smile fascinate and disturb because they suggest that she sees through people's disguises, forcing them to see through their disguises, too. *Mona Lisa* is a kind of psychological mirror. The longer you gaze, the more you see yourself — through her eyes. She is the perfect icon of the Renaissance: a reflection of man and woman learning to know themselves.

Check out the sfumato in the *Mona Lisa* and the use of aerial perspective. The background seems as sober, timeless, and wise as Lisa herself.

Decoding The Last Supper

Though badly damaged, *The Last Supper* (see the color section) is still one of the greatest masterpieces in the history of art for many reasons, both historical and technical. For one thing, the painting is a spectrum of human emotions — the first of its kind — captured during an intensely dramatic moment. Previous paintings of the Last Supper focus on the breaking of bread and Jesus saying, "This is my body. Eat this in remembrance of me." The apostles and Jesus pretty much all share the same somber mood during the ritual. Leonardo chose to focus on a much more dramatic moment: Jesus telling his closest circle of friends that one of them will betray him. This causes an uproar among the apostles, which Leonardo captures, showing each of their reactions. Yet despite the chaos, the painting is orderly and finely balanced, like all great Renaissance art. Jesus's calm solitude, which contrasts with the animation of the groups of upset apostles, helps to give the painting its sense of order.

Leonardo painted *The Last Supper* in a *refectory* (dining room), located in the Santa Maria delle Grazie monastery in Milan, Italy. The table at which Jesus and his apostles sit is very much like the ones originally in the monks' dining room. The windows in the painting duplicate the real dining hall windows, and the illuminated wall appears to be lit by the real windows of the room, adding to the Renaissance realism of the mural. By doing this, Leonardo shifted this long-ago supper into the present tense. The Last Supper appears to reoccur every time the monks sit down to dinner.

Earlier artists isolated Judas by making him sit by himself on one side of the table — as if he were already being punished. Leonardo seats him in High Renaissance fashion — in other words, naturalistically with the others, who are arranged in four groups of three around Jesus. (Three is considered to be a mystical or holy number — for example, the Trinity: Father, Son, and Holy Spirit.) The other apostles — except for the one on Jesus's right — argue about Jesus's revelation: "One of you will betray me." The painting's shadows fall on the guilty one. Judas's silence and the purse clutched in his hand give him away, too. Again, naturalism rather than the heavy symbolism used by medieval artists broadcasts the message: This guy's guilty.

Did Leonardo da Vinci code his painting?

Judas and Jesus are not the only silent ones in *The Last Supper.* The apostle on Jesus's right is also mute. Usually, this disciple is identified as the young St. John the Evangelist, the guy who wrote the book of Revelation. In his bestseller *The Da Vinci Code,* Dan Brown identifies this figure as Mary Magdalene. The apostle does look like a woman or an effeminate man. (The youthful St. John is often depicted as a pretty boy in art.)

Many brush off Dan Brown's interpretation for religious reasons. But Leonardo obviously intended this apostle to stand out from the rest. In other Last Supper paintings, the young John leans against Jesus or sleeps on his shoulder. In Leonardo's version, the apostle leans away from Jesus and his fate. Also, this apostle is dressed like Christ in reverse. Whereas Jesus wears a blue undergarment and a red robe, this figure wears a red undergarment and a blue robe. And as Dan Brown points out, together the two figures create a V shape, which Brown says is the symbol of femininity (for obvious reasons). As a great artist who used metaphors and double meanings in all his paintings, it's possible that Leonardo intentionally included this gender bender here: Is the silent apostle a sad, effeminate John or a broken-hearted Mary Magdalene? Or both?

If you compare this figure to other Leonardo women, the face is clearly similar to theirs, especially Mary in *The Virgin of the Rocks* and *The Annunciation.* In both Virgin paintings, Mary leans to one side in a gesture of feminine tenderness, as the apostle does in *The Last Supper.* If you superimpose the silent apostle's face with that of Mary in *The Virgin of the Rocks,* the similarity is striking. They have the same feminine roundness in the forehead; the same cheek bones and chin; the same downcast, modest eyes; the same eyebrow line; an identical part in the hair; and the same graceful neck (very unlike the muscular necks of all the other apostles). It's as if the same model posed for both pictures — a woman. Nevertheless, many Renaissance artists, including Leonardo, sometimes gave young male saints feminine features.

Considering the religious views at the time, including Mary in *The Last Supper* would have been viewed as heresy. If Leonardo were painting in code, as Brown suggests, he would probably have disguised her, given that, in those days, heretics were cooked on open fires. And who better to hide her behind than the effeminate face of John? The real Mary Magdalene may well have attended the historical Last Supper, so why not suggest her presence? The painting is rich enough to include this possibility. Is the apostle a woman, Jesus's other half? Mary is probably at least an implied presence in *The Last Supper,* if not a dinner guest.

Remember: Art is about suggestions, not answers. When you have an answer, if you're like most people, you tend to stop looking. With great art, you *never* stop looking.

When Leonardo includes symbolism, as he typically does, it appears as a natural element within the scene. Instead of a painted halo around Christ's head, as in medieval works of art, Leonardo painted a sunset and overcast sky directly behind Jesus, which form a natural halo around him. But his sky is more than a substitute halo. The setting sun foreshadows Jesus's approaching death, and the overcast atmosphere suggests his mood: sad yet serene.

In *The Last Supper,* Leonardo used one-point perspective (see "What's the point? The fathers of perspective," earlier in this chapter) in a similar way. It's not just technique — it suggests meaning and the passage of time in a naturalistic way. Christ is the center of attention because of his position, pose, and silence, and because the center window and the arch on the back wall focus the painting's light on him. But, surprisingly, the painting's lines don't converge on Jesus. The vanishing point is behind him, implying that Jesus is about to "vanish." All the lines in the painting, from those in the coffered ceiling, on the walls, and on the sides of the table, point to the place where Jesus is going. The vanishing point suggests the future, the next step, taking viewers beyond the painting into another world that they can't see. The scene has a cinematic feel. It's anything but static like Castagno's *The Last Supper.*

Michelangelo: The main man

Whereas Leonardo da Vinci created sensitive, intellectual paintings made to be contemplated in drawing rooms, Michelangelo (1475–1564) produced a muscular, heroic art to cover vaulted ceilings, the walls of churches, and large public spaces. His sculptures and paintings seethe with energy and raw emotional power. Even his women are muscle-bound.

Michelangelo's technique and style

In painting the Sistine Chapel Ceiling, Michelangelo used the *buon fresco* technique, which dates back to around 1500 B.C. One of the earliest *buon frescoes* is the *The Toreador* on the island of Crete (see Chapter 7). In *buon fresco,* the artist paints on wet plaster without using a binder to make the paint stick. The plaster absorbs the pigment which dries with it in 10 to 12 hours. After the plaster dries, the paint is set and can't be changed. Therefore Michelangelo had to paint quickly and know in advance exactly what he was going to paint that day. The only way to fix a mistake was to pry off the plaster with a crowbar after it dried.

Many of Michelangelo's statues seem to be in tug-of-war with themselves. Their minds pull one way, their bodies another. Part of this may be due to the fact that Michelangelo was equally inspired by Lorenzo de' Medici (in whose home he lived during part of his youth and training period) and the fiery evangelist Girolamo Savonarola, whom he befriended as a young man. Michelangelo loved to represent opposite forces in his art: spirit and flesh, night and day, freedom and slavery, peace and violence. In electricity, opposite charges cause current to flow. In Michelangelo's sculptures, the tension between opposites charges the statues with spiritual force.

Michelangelo's greatest works

In the following sections, I cover three of Michelangelo's most celebrated works: the *Pieta, David,* and the Sistine Chapel Ceiling.

The Pietà

Michelangelo used tension in his early masterpiece the *Pietà*, begun when he was just 23 years old. In the *Pietà*, the dead Christ's muscles still show the strain from his recent agony on the cross, yet his face radiates perfect peace and glows with an otherworldly light. Michelangelo polished Christ's marble features so that they would reflect light as if it were radiating from within, suggesting Christ's transcendence of death. The relationship between Mary and Jesus in the *Pietà* also brims with tension. Mary cradles the dead Christ as she once cradled the infant Jesus. Her womb has become a tomb; death and life merge in her arms. Michelangelo's *Pietà* is a marriage of earthly suffering and heavenly beauty, the contrast between them making each spiritual state more intense, more electrifying.

David

The tension in Michelangelo's *David* (see Figure 11-5) is just as potent as in the *Pieta* (see the preceding section). *David* appears calm and confident, yet tense and poised for action like a taut bow. You can see the approaching battle in his eyes. He has the grace and physical harmony of a classical Greek statue (see *Doryphoros* in Chapter 7), but the emotional intensity and titanic self-confidence of a Renaissance man.

From a historical perspective, *David* was meant to be a symbol of Florence, small but tough. He was a warning to any wannabe Goliaths (like Rome or Milan) who might try to conquer Florence.

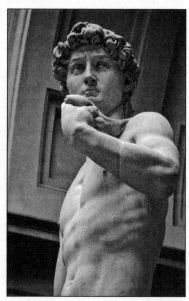

Figure 11-5: In Michelangelo's version of the biblical story of David and Goliath, you see only the young challenger David. But you can sense Goliath's presence in David's focused and fearless eyes.

Gloria Wilder

Sistine Chapel Ceiling

Painting the Sistine Chapel Ceiling was a four-year backache Michelangelo didn't want. But there was no arguing with Julius II, the impatient pope who commissioned the work. In a poem written at the time, Michelangelo complained about his job: "My loins have moved into my guts/As counterweight, I stick my bum out like a horse's rump . . . I bend backward like a Syrian bow. . . ." Michelangelo's grand struggle to paint a 68-foot-high ceiling the size of a basketball court is the most famous example in the history of art of an artist suffering for his work.

The ceiling recounts Genesis and other Old Testament stories. The visual narrative begins with God separating light from darkness above the altar and ends with the story of Noah's drunkenness over the entrance. The creation of Eve is told in the middle of the ceiling.

All the panels are framed by what looks like the classical architecture of an ancient temple. This faux sculpture is known as *trompe l'oeil* (literally "trick the eye"). Inside the giant *spandrels* (triangular areas), Michelangelo painted the Old Testament stories; in the *lunettes* (crescent-shaped panels), he painted the ancestors of Jesus.

In the most famous panel, *The Creation of Adam* (see Figure 11-6), Michelangelo captures the first moment of human consciousness with his brush. Adam has an adult body, but his face is filled with childlike wonder as he looks at God out of newly created eyes. His body and pose also suggest the innocence of this brand-new being. Adam looks freshly minted, as peaceful and content as a newborn when he first meets his mother's eyes. In typical Renaissance fashion, the emphasis here is on man, on Adam's reaction to being created, more than on God — even in this traditional Bible story.

Figure 11-6:
Notice that in *The Creation of Adam,* man is physically almost on the same level as God.

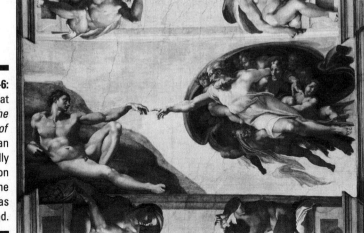

Erich Lessing / Art Resource, NY

Raphael: The prince of painters

High Renaissance art is often known for its grace, balance, and harmony. No painter better depicted these qualities than Raphael (1483–1520). Unfortunately, after a stunning outpouring of masterpieces, he died at 37.

You can think of Raphael as the spiritual son of both Leonardo and Michelangelo. He learned from both of them, and then created his own style. He borrowed tenderness from Leonardo's paintings and muscular energy from Michelangelo. In Raphael's years in Florence, he painted the most motherly Madonnas of all time. Many of them appear on holiday postage stamps and Christmas cards today. Raphael's angels are popular, too — they're practically Valentine's Day icons. His Madonna and Child paintings are often based on the pyramid and include John the Baptist. They're always perfectly balanced, to illustrate ideal Renaissance order and perfect human harmony in relationships (the kind of relationships we all wish we had!), as you can see in his *Madonna with the Goldfinch* (see the appendix).

Raphael's techniques

Raphael is known as the painter's painter. He was the ideal to which other painters aspired for nearly 400 years.

What's so special about Raphael? For one thing, he built his paintings on geometrical grids, so the proportions and spacing between figures would appear as formal and perfect as a cube or triangle. For example, he often built his Holy Family paintings on a pyramid structure. Yet his paintings don't look like a math problem — they seem completely natural.

Raphael united the perfect harmony of classical art (in which proportions are as balanced as a set of scales in equilibrium — see Chapter 7) with naturalism and idealism. By *idealism,* I mean that his paintings transport you to a place of perfect peace and beauty.

Raphael's greatest work

Raphael's greatest masterpiece is *The School of Athens* (see Figure 11-7), a fresco in the Stanza della Segnatura of the Vatican. The walls of the Stanza weren't blank when Pope Julius II ordered Raphael to paint them — they were decorated with frescoes by other great artists, including Raphael's teacher Pietro Perugino and his friend Il Sodoma. The pope commanded Raphael to cover their work with plaster and then paint over it.

The School of Athens is really two schools: the old school of Athens and the new school of Florence. Many old-school characters — including Plato, Euclid, and Heraclitus — are represented by new-school artists. Plato has the face of the aging Leonardo da Vinci. Donato Bramante, the architect who got Raphael his job at the Vatican, represents Euclid studying a diagram.

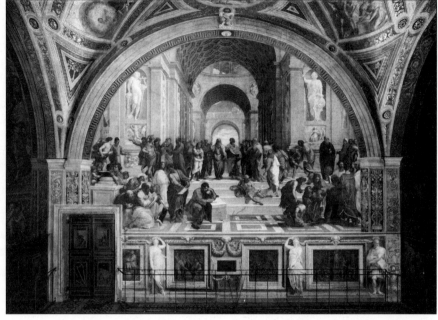

Figure 11-7:
Notice how
Raphael
divided *The
School of
Athens* into
two
balanced
halves.

Scala / Art Resource, NY

Raphael's point was to suggest that Florence is the home of the rebirth of Greek culture and learning. Seventy years earlier, Cosimo de' Medici had gathered Florentine thinkers and artists into an academy in Florence based on Plato's ancient school.

But if that's the case, where's Michelangelo? Raphael stuck him in later, either as an afterthought or because he had sneaked a peak at the antisocial master while he was frescoing the Sistine Chapel Ceiling next door. Raphael made Michelangelo the hermit-like Heraclitus in the foreground, the Greek philosopher who loved contradictions.

Raphael even included himself in the lower-right corner of the painting as a student. Note that Raphael is the only one in *The School of Athens* who is aware of the world outside the school (beyond the fresco). He looks directly at the viewer, perhaps to invite the viewer in. To make amends for covering up his art with plaster, Raphael placed his friend Il Sodoma beside him as a fellow student in the elite School of Athens.

The School of Athens is a masterpiece of perspective, composition, and balance. The spatial balance, which is easy to see, suggests other kinds of balance. Raphael divided the painting into two halves: The Platonic idealists are on the left; the Aristotelian realists are on the right. Plato (left) and Aristotle (right) stand side by side at the focal point under the last arch. Plato, the idealist, points skyward; Aristotle, the realist, points straight ahead and down at

the physical world. Raphael put these two opposing schools of philosophy under one roof so that they could balance each other. In front of the dueling philosophers, Heraclitus (Michelangelo) ponders the union of opposites.

Western philosophy and science aren't the entire curriculum in *The School of Athens*. A dose of Eastern philosophy, represented by the great Persian mystic Zoroaster (a contemporary of Heraclitus) and the 12th-century Arab wunderkind Averroes, brings additional balance to the school. (Averroes's translations of Aristotle helped revive Aristotelian philosophy in the West.)

The arches within arches that frame the school don't shut it off from the rest of the world. Instead, they open it up, allowing knowledge to breathe and expand into the universe beyond the school's walls.

Chapter 12

Venetian Renaissance, Late Gothic, and the Renaissance in the North

In This Chapter

▶ Homing in on the Venetian Renaissance

▶ Understanding Late Gothic painting

▶ Tracking the Renaissance to the Low Countries

In this chapter, I trace the spread of the Renaissance northward, first to Venice, then to Germany and the Low Countries. I also examine the Late Gothic style in Flanders.

A Gondola Ride through the Venetian Renaissance

With almost a quarter million residents, Venice was a Renaissance boomtown and one of Europe's greatest cities. Population-wise, it dwarfed Rome. Almost all of Europe's trade with the Near East and Far East filtered through Venice. In fact, Venice was the greatest port town in Europe. The city teemed with exotic goods and merchants from all over the known world.

Europeans venturing south over the Alps, on pilgrimages or business trips, typically stopped to "refuel" in Venice before journeying to other Italian destinations. Those travelers sometimes hauled artworks across the Alps with them. Great Venetian families often collected the latest in Dutch, French, and German styles.

Venice was an artistic melting pot. This meant that a Venetian artist like Giovanni Bellini could learn of the oil-painting innovations of a Flemish artist like Jan van Eyck simply by checking out the paintings trickling in on the art market or by observing visiting artists who had mastered northern techniques. Venetian artists had the world at their brush tips, and they wound up surpassing other nations and Italian city-states in oil painting and the use of rich colors.

Venice offered another advantage for artists: It was politically stable for more than a thousand years — so stable, in fact, that most official documents referred to the city as the "Most Serene Republic." Today, few people realize that Venice had the longest-running *republican* (representative) form of democracy, uninterrupted from around 750 to 1797 when Napoleon Bonaparte marched in and squelched everything. It was hardly a perfect democracy; only the 1,400 or so people of noble bloodline could vote. But Thomas Jefferson and other Founding Fathers of the United States studied Venice closely as a model for representative democracy. In Renaissance times, this form of government meant that, although the rest of Italy was a bloody battleground for competing dukes, princes, and foreign kings, an artist or cutting-edge author could generally find safe haven and a good market in Venice.

In the following sections, I explore the art of Giovanni Bellini, Andrea Mantegna, Giorgione, Titian, Paolo Veronese, and Tintoretto, as well as the architecture of Andrea Palladio.

First stop, Bellini

If you order a Bellini in a bar, the bartender will serve you a drink made from white peaches and Italian champagne. The mixture has a distinct pink glow. It's the same beautiful shade of pink that Giovanni Bellini once mixed on his palette and applied to such masterpieces as his *San Zaccaria Altarpiece* in Venice. What better compliment for a Renaissance painter than to have the colors he mixed 500 years ago continue to inspire revelers today!

Although Renaissance artists got to mix their own colors on their palettes, it was usually some underling in the studio who had to grind the pigments in a pestle and mortar so that they could be mixed with oil or egg tempera. In the Renaissance, artist's workshops were often like mini-corporations. Besides the immediate family members, the shop included numerous nonfamily apprentices and journeymen performing different tasks and assisting in the production of art. The young folks had the laborious jobs of sanding wood, grinding pigment, cleaning the studio, and running errands. The older apprentices sometimes painted parts of a picture — filling in the drapery, painting the backgrounds, and so on. The goal was to imitate the master's style.

Giovanni Bellini (c. 1430–1516) grew up in a family of artists, so he had a privileged spot in the studio. His father, Jacopo (c. 1400–c. 1470), kept splendid sketchbooks of drawings that were really corporate trade secrets. (These drawings are now in the Louvre and the British Museum.) The sketchbooks showed novices how to make good animals, interesting scenes, and convincing perspective.

The pressure was on Giovanni, because his older brother, Gentile (c. 1429–1507), had already proven to be an outstanding painter.

Fortunately for Giovanni — and for us — he surpassed all expectations. His Virgin and Child images are some of the most lifelike and intimate in all of art history. Bellini's Madonnas often pop up on Christmas cards and stamps. His paintings glitter with the rich Byzantine colors he grew up seeing in Venice's great churches (see Chapter 9).

Though Bellini started painting in egg tempera, he found it too dry and the colors too flat. He soon switched to the new oil-painting technique used by artists in the Low Countries (modern-day Belgium, Luxembourg, and the Netherlands), and introduced it to Venice in the 1470s. This technique allowed him to softly model his figures, mix and remix his colors, and create glowing effects of light and dark.

In Bellini's *Feast of the Gods,* the gleaming effects mentioned earlier are set against the dark backdrop of a secluded wood. The theme is taken from Ovid's ancient book, *The Feasts,* which describes the origins of Roman festivals. Bellini illustrated a feast hosted by Bacchus, the God of Wine. At the party, the beautiful nymph Lotis, shown at the far right on Bellini's canvas, falls asleep after consuming too much wine. The figure shown lifting her skirt is Priapus, the lustful God of Virility. In Ovid's humorous account, Priapus's attempt is foiled by a braying donkey. Lotis wakes up and repels the God of Virility.

Bellini animated the staged scene by organizing the figures along a slightly wavy compositional line. The viewer feels the drunken sway of this pastoral fantasy.

A shortcut to Mantegna and Giorgione

Giovanni Bellini's sister, Nicolosia, married the artist Andrea Mantegna (c. 1431–1506), further expanding the Bellini art business. But whereas Giovanni's art explored color and soft contour, Mantegna picked up on Jacopo Bellini's (his father-in-law's) interests in line and perspective. For Mantegna, color takes a back seat to drawing.

Mantegna had a knack for creating elaborate stage sets of ancient architecture that seemed to tunnel back in space. He painted a portrait of the Gonzaga family in Mantua in what appears to be an open-air pavilion. The illusion of depth is so convincing that the actual walls of the Gonzaga bedroom where the frescoes are painted seem not to exist. In other works, his crumbling Roman capitals and broken arches make for some of the most imaginative architecture ever painted.

Mantegna also liked to show the human figure in perspective, sometimes dramatically *foreshortened* (made to look as though either receding in space or projecting out of the picture plane, through the use of perspective). His *Dead Christ* depicts Jesus stretched out on his back like a corpse in a morgue. The

figure is so foreshortened that the viewer gets a close-up view of Christ's punctured feet, which seem to project out of the painting. Regardless of your religious beliefs, the picture is painful — and Mantegna's precise lines don't soften the gruesome image.

Giovanni Bellini's pupil, Giorgione (c. 1477–1510), on the other hand, was all *about* softness. He took Venetian painting in the direction it would follow for centuries. Leonardo da Vinci's *sfumato* technique (that smokiness around the contours of people and objects; see Chapter 11) is also used by Giorgione. The warm light and glowing presence of Giorgione's figures make them seem a natural part of the rustic landscapes they frequently inhabit.

One of Giorgione's greatest works, *The Tempest,* shows a nude woman suckling a child while sitting on a hill near a stream. She gazes wistfully into the distance, seemingly unaware of the child. On the other side of the bank, a young man holding a staff and dressed as if he were from another world stops to watch her. In the background, a storm gathers and lightning flashes in the sky. But neither the impending storm nor the woman's faraway gaze can dispel the serenity of this poetic and mysterious painting. It haunts the viewer without letting him into its secrets.

Many books have been written in an attempt to explain this puzzling picture, but nobody has figured it out. Even Giorgio Vasari, writing just 50 years after Giorgione's death, had to admit that the meanings of some of the artist's works had been lost. Vasari also said that Giorgione was soon eclipsed by the fame of his star pupil, Titian. Apparently, the older artist overheard people praising a part of his work but then became unnerved when he realized that it was the portion he had delegated to Titian.

Dürer's Venice vacation

When the great German draftsman and printmaker, Albrecht Dürer (1471–1528) first visited Venice in 1494, he couldn't stop drawing and painting watercolors. As he approached Italy, he made watercolors of the Alps from his carriage window. The drawings started when he reached Venice. German artists at the time didn't usually draw or paint from nude models — but Italians did. When Dürer met Italian artists who were working directly from live models, he started drawing nudes as well. He also made quick sketches of the fashionable dresses that the beautiful Venetian women wore, drawing them in the streets.

Dürer had such a good time on his first trip that he returned to Venice in 1506. Dürer's most famous work from this second journey is the *Madonna (or Feast) of the Rose Garlands;* it owes a lot to the example of Bellini. Commissioned for the Venetian charterhouse of German merchants, this altarpiece depicts graceful figures flanking the Virgin. All the subjects are rendered in rich, warm colors and painted in a carefully blended technique reminiscent of Bellini's.

The trips to Italy reshaped Dürer's style of art and even his style of dress. His *Self-Portrait at Age 26* (see Figure 12-1), which he made after his first trip, shows an increasingly confident artist decked out like an Italian dandy. Behind him, the window reveals a view of the Alps separating Germany and Italy. The portrait shows off Dürer's newly acquired rank as *Ehrbaren,* a member of Nuremberg's merchant class, even as it reminds everyone that he has traveled widely. Everything about the picture says, "I have come into my own." Yet, when the artist returned to self-portraiture two years later, in 1500, he made his image resemble Christ's. That painting, now in Munich, may have been inspired by a comment jotted down in the artist's own notes, "the more we know, the more we resemble the likeness of Christ who truly knows all things."

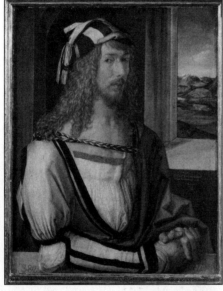

Figure 12-1:
Albrecht Dürer's *Self-Portrait at Age 26* shows the young artist as a rising star.

Erich Lessing / Art Resource, NY

Many people in Dürer's day believed that 1500 would be the year of the Apocalypse or Judgment Day. (The Y2K fears of crashing computers and food and water shortages were echoes of that type of thinking.) In that climate of fear, the savvy Dürer illustrated a book on the Apocalypse in 1496 and published it in Latin and German editions. It became a best-seller. The woodcuts from this book secured his status as one of Europe's best printmakers.

Touring the 16th century with Titian

The beautiful Venetian women that caught Dürer's eye are best captured on canvas by the painter Tiziano Vecellio da Cadore, better known as Titian (c. 1488–1576). When he was alive, Venetians called him "the sun amidst

small stars." Today Titian is regarded as Venice's most famous, and possibly greatest, painter. His rich, earthy palette can include fiery colors, as well as blues of the coolest sapphire. His portraits are so psychologically powerful that each of them seems like a page lifted out of Shakespeare. A portrait of the Holy Roman Emperor earned the artist a knighthood, and Titian was subsequently presented with a huge, golden chain that he wore in all his self-portraits. Spanish royalty avidly collected his works, and later Baroque artists from Diego Velázquez to Peter Paul Rubens copied his paintings.

Titian painted the largest altarpiece Venice had ever seen, *The Assumption of the Virgin,* which still stands in the church of the Santa Maria Gloriosa dei Frari. But the work for which Titian is best known today, the painting whose sexiness inspired the humorist Mark Twain to write *A Tramp Abroad,* is the reclining nude *Venus of Urbino* (see Figure 12-2).

Figure 12-2:
Venus of Urbino is Titian's most sensual masterpiece.

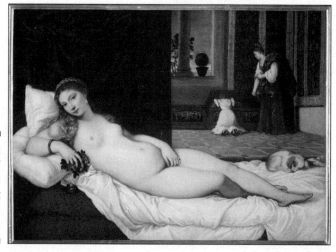

Scala / Art Resource, NY

Mark Twain, the great American satirist, jokingly recorded how, upon entering the Uffizi in Florence, you proceed to that most-visited little gallery in the world — the Tribune — and there, against the wall, without obstructing rag or leaf, you many look upon the foulest, the vilest, the obscenest picture the world possesses — Titian's *Venus.* It isn't that she is naked and stretched out on a bed — no, it is the attitude of one of her arms and hand. If I ventured to describe that attitude, there would be a fine howl — but there the Venus lies, for anybody to gloat over that wants to — and there she has a right to lie, for she is a work of art, and Art has its privileges.

Her left hand *does* seem to be preoccupied. Perhaps Titian intended to create a fertility symbol of that hand — along with other elements in the painting. You can puzzle those out for yourself.

This version of the Goddess of Love hails from Urbino, Italy, because Guidobaldo II della Rovere, the son of the duke of Urbino, commissioned the picture.

The *Venus of Urbino* is inspired by a much earlier sleeping Venus in a landscape painted by Giorgione and finished by Titian. But in Titian's solo effort, the goddess is indoors and a lapdog curls at her feet as a symbol of fidelity. Two servant women pull out one of the goddess's elegant dresses from a wedding chest along the back wall. The lollipop-shaped bush in the pot on the back ledge is a myrtle, a shrub sacred to Venus in ancient times.

Titian is now held to be one of the best painters to ever wield a brush — and he wielded many brushes of radically different sizes. His early works are more linearly precise and painted with small to medium-size brushes. But by the time Titian was an old man, Vasari jokingly described Titian's large, fat brushes as "brooms." For late Titian paintings, even the strongest eyeglass prescription won't bring the canvases into focus. The artist was so obsessed with painterly effects and heavy surface *impasto* (paint buildup) that the lines of his subjects all but disappear.

The Venice of Veronese

By the mid-16th century, Martin Luther's Protestant Reformation had spread over large parts of Europe. Its followers railed against the excesses of the Catholic Church and the selling of indulgences. They encouraged people to read the Bible for themselves, instead of accepting the Church's interpretation without question.

Such protests were really getting under the Vatican's skin. In 1545, Pope Paul III called Catholic bishops from all over Europe to attend a series of meetings in northern Italy. At these meetings, known as the Council of Trent, Catholics passed reforms for the Church and tried to suppress the heretical offshoots of Luther, Calvin, and the rest.

The Council of Trent took place intermittently from 1545 to 1563 in Trent, Italy, and established the Counter-Reformation, or Catholic Reformation. The Council passed tougher codes of conduct to reform the priests. They also declared the importance of religious images, because the Protestants were destroying the images of saints that once decorated churches. The Council stated that artists should pursue more dramatic and sober scenes in art to better instill a sense of piety in their audience.

Trent was practically in Venice's backyard, and it wasn't long before a series of political alliances brought the Inquisition to Venice to stamp out heresy. The Inquisition soon got wind that a Last Supper painted by Paolo Veronese (1528–1588) for a monastery didn't portray the Christian story with the seriousness and solemnity advised in the edicts of the Council of Trent. (Check

out the painting for yourself in Figure 12-3.) Just who complained about the canvas is unclear, because the monks loved having it in their dining hall. Nonetheless, when Veronese was hauled before the tribunal, they asked him to explain the eccentricities of his painting and what various figures in the painting were supposed to be doing.

The inquisitors were especially peeved that the artist showed two German guards at the far right taking bread and wine, as if the Protestants were administering their own Communion. Paolo Veronese was ordered to correct his Last Supper. The tribunal even wanted the dog in front of the table, who sits splayed out (as dogs often do), taken out of the composition. The artist tried to point out that the dog, the dwarf, the man with the nosebleed (holding the handkerchief at the left of the picture), and the two German guards are all in the foreground of the picture — in other words, in the *viewer's* space, not in Christ's space. Christ and his disciples are under the colonnade on a stage removed from the raucous elements of the scene.

But the Inquisitors wanted it repainted. Fortunately for the friars who loved the painting and for the Venetians who resented Rome trying to control their art, the artist came up with a clever compromise. Veronese simply painted in a few inscriptions referencing the fifth chapter of Luke on the railings of the stairs. Luke 5 describes the supper in the house of Levi in which Christ dined with "publicans and sinners." By *renaming* the painting *Feast in the House of Levi,* it was suddenly okay to have all sorts of riff-raff sharing a table with Christ — in fact, the story required it! The Roman inquisitors could do nothing, the Venetians got the picture they wanted, and we all inherited a colorful masterpiece that celebrates the splendor of Venice's Golden Age.

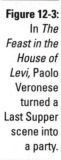

Figure 12-3:
In *The Feast in the House of Levi,* Paolo Veronese turned a Last Supper scene into a party.

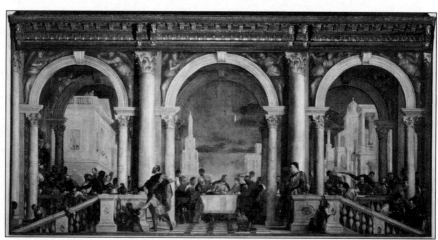

Scala / Art Resource, NY

Tintoretto and Renaissance ego

Jacopo Robusti, called Tintoretto (1518–1594), was Veronese's main rival. Tintoretto claimed that his art combined "the drawing of Michelangelo and the color of Titian." Whether he reached the perfection of either is still up for debate, but no one can deny that Tintoretto was one of the stars of the Venetian Renaissance — and an aggressive self-promoter.

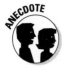

Tintoretto's dedication and his marketing skills became apparent to everyone during the 1565 competition for a painting to hang in the Confraternity of San Rocco in Venice. Five artists submitted small oil sketches of their designs. Tintoretto arrived with his full-scale ceiling painting *San Rocco in Glory* already finished! Before anyone could protest, Tintoretto announced that he was *donating* the painting to the organization. So, how could the artist hope to survive by giving away his art? Well, the San Rocco patrons were so impressed that they awarded Tintoretto a commission to decorate the entire interior of their meeting hall from floor to ceiling. This well-paid job lasted 22 years! The cycle of paintings still hangs in its original location in the Scuola di San Rocco, the best place in Venice to see Tintoretto's work.

Tintoretto's *Saint George and the Dragon* displays the artist's energetic story-telling style. St. George was a 3rd-century saint who supposedly rescued a Libyan princess from a ferocious dragon. After George killed the beast, the king and all the townspeople converted to Christianity. Tintoretto's altarpiece is a dramatic vertical composition that pulls you in different directions as you try to keep up with the action. In the foreground, the beautiful princess runs toward you, faintly looking over her shoulder. You look over her shoulder, too, and you see George on his white charger spearing the dragon into the sea. Between the damsel and the chivalrous knight lies the corpse of one of the dragon's victims. His body seems to be stretched between the two events. This corpse mimics the pose of Christ's crucifixion. The light source for the painting is God, sending out oval rays in an extraterrestrial light show. This little altarpiece is a high-octane representation of a chivalric Christian legend. Today we have Schwarzenegger on DVD; Renaissance Venice had the action-packed paintings of Tintoretto.

Palladio: The king of classicism

The most influential High Renaissance architect was Andrea Palladio (1508–1580). Palladio's style, which is called *Palladian* or *classicism,* is based on the writings of the ancient Roman architect Vitruvius (c. 70 B.C.–c. 25 B.C.), Roman ruins, Renaissance ideals, and his experience as a stonecutter and mason. Palladio's style is formal, elegant, and clean (without much ornament). His hands-on experience as a mason helped him to put Vitruvius's theory into practice with impressive results.

Typically, Palladio's buildings have a Roman temple front or facade like the Maison Carrée (see Chapter 8). Most of his work is in Venice and the Veneto (the region around Venice) where he grew up. One of Palladio's greatest achievements is San Giorgio Maggiore, a Benedictine Abbey and church in Venice, begun in 1565. Palladio chose to build the abbey/church as a basilica and then impose a classical temple front on the Christian basilica. To make the basilica and classical facade harmonize, he created an interlinked double temple front — a tall one based on the height of the basilica's nave, and a wide one, conforming to the lower height of the side aisles. He interlocked the two fronts into a single tiered facade with four huge columns.

Many buildings have been influenced by Palladio's style, especially in England, Ireland, and North America, including the facade of Buckingham Palace, the White House, and the Jefferson Memorial.

Late Gothic: Northern Naturalism

Late Gothic art, which developed in Flanders around 1420, was a long way from the elongated, Gothic figures on Chartres Cathedral, built between 1194 and 1220 (see Chapter 10). *Late Gothic* refers to the new naturalism in Flemish art and had a lot in common with the Early Italian Renaissance (see Chapter 11). Both strove to depict life realistically, to make people look like people. The main difference between Late Gothic and Renaissance art is that Late Gothic artists weren't trying to resurrect Greco-Roman culture as Renaissance artists were.

Jan van Eyck: The Late Gothic ace

Jan van Eyck (c. 1395–1441; pronounced yawn van ike) is sometimes called the "Inventor of Oil Paint." But scholars now know that oil paint had been used with little success over a hundred years before his birth. He is more accurately called the "Father of Oil-Painting Technique," because he mastered the medium better than anyone before him (but "Father of Oil-Painting Technique" just doesn't roll of the tongue as well). Using walnut and other oils as his medium, and setting his panels aside to dry after each coat, he built up his illusionist pictures with dozens of *glazes* (thin layers of paint). (For more on van Eyck's technique, see Chapter 29.) With van Eyck's paintings, for the first time in the history of art, you really did have to reach your hand out to make sure the image was flat and not three-dimensional.

Van Eyck came from a family of artists, and his earliest dated work is the *Ghent Altarpiece (or Adoration of the Mystic Lamb)* which he and his brother

Hubert painted for the Cathedral of Saint Bavo in Ghent, Belgium, in 1432. Standing almost 12 feet high, and opening to 15 feet wide, the 12-panel *Ghent Altarpiece* pulled out all the stops. The images burst from the wood panels like peals from a pipe organ. Throngs of saints adore the sacrificial lamb; choirs sing; a beautifully dressed woman plays an organ in the painting; Mary, Christ, and John the Baptist preside over the altar like kings and queens; even Adam and Eve join in naked from the sidelines! After this giant outpouring, van Eyck preferred to work small — virtually every other work of art he did was on a modest, intimate scale. His pictures got more lifelike and detailed, but it was as though you were looking through a little window to witness their magic.

One such "window" onto a domestic scene is Jan van Eyck's *The Arnolfini Wedding (or Portrait of Giovanni Arnolfini and His Wife)* (see Figure 12-4). The double portrait is a reminder of how much people traveled at the time: The man is Giovanni Arnolfini, an Italian merchant from Lucca who lived most of his life in Bruges, Belgium. He and his wife are dressed stylishly in fur-lined garments, but not so lavishly as to be mistaken for royalty. The greeting chamber in which they are shown has an expensive bed (as was the Flemish custom), but the walls are not covered in expensive tapestries and the floor is bare wood. Besides trading in silks, merchants from Lucca often imported oranges and lemons from Spain, which sold at a premium. An orange appears on the window ledge and three more are casually spread on the wooden chest to suggest the wealth of the couple and perhaps the forbidden fruit of the Garden of Eden. In fact, every object in the painting has a literal and a symbolic meaning or meanings. Freighting objects with meaning was the norm in Netherlandish art. The cute dog between the couple, for example, is a standard symbol of fidelity. But he's also an expensive breed, an affenpinscher, suggestive of the pair's wealth.

Burgundian and Dutch women wore their dresses with the train gathered in front, making them look pregnant whether they were or not. Though many have speculated that the woman is pregnant, it wasn't customary to depict pregnant women in 15th-century art. Nevertheless, the carving on the left post of the chair beside the bed is of St. Margaret, the patron saint of childbirth.

Some art historians believe that the painting depicts an actual wedding and have dubbed the painting *The Arnolfini Marriage.* One scholar has argued that the couple have kicked off their shoes to show that they're standing on the holy ground of matrimony. A solitary marriage candle burns overhead, and Giovanni raises his right hand as if to take his vows. The convex mirror on the back wall shows the reflection of two figures, perhaps witnesses to the marriage, and the signature on the back wall declares: "Jan van Eyck has been here, 1434,"as if he were one of the witnesses, possibly the one with the red turban in the mirror.

Figure 12-4:
Jan van Eyck's *The Arnolfini Wedding (or Portrait of Giovanni Arnolfini and His Wife)* is poorly named. Scholars aren't sure whether the couple is already married, in the process of marrying, or only engaged.

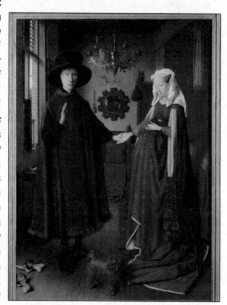

Erich Lessing / Art Resource, NY

Although many scholars still accept the wedding interpretation, there are some major weaknesses in the argument. Giovanni di Arrigo and Jeanne did not marry until 1447, 13 years after van Eyck did the painting. Lorne Campbell has suggested a cousin, Giovanni di Nicolao Arnolfini is a better candidate, and that this is a portrait with his second wife. As to the holy ground of matrimony, the couple have only removed their overshoes; Giovanni still wears black boots. No evidence has been found that lighting a single candle was a marriage tradition of the time, and most couples joined their right hands during their marriage ceremony. If Jan van Eyck were actually witnessing the event — in the way a wedding photographer might document the occasion today — it's strange that he didn't give the exact date. Several of his other portraits give the exact day they were finished. Some scholars have suggested that the couple is already married, and others propose that they're betrothed but have not yet tied the knot. Whatever the state of their wedlock, the relationship between the couple is intriguing. Their hands are joined, yet each stares solemnly into his or her own world.

Rogier van der Weyden: Front and center

Jan van Eyck didn't have the corner on the realist market; another artist called the Master of Flémalle (c. 1406–1444), now generally identified as Robert Campin, also painted realistic images in oil. He was especially good at lifelike portraits and small devotional altarpieces, like the *Merode Altarpiece*.

However, Campin's achievements were overshadowed by his pupil, Rogier van der Weyden (c. 1399–1464), whose large and dramatic altarpieces introduced a new and often painful emotionalism in northern religious art. The earlier Gothic art was dramatic and emotional too, but because it's less realistic, its emotionalism doesn't penetrate the viewer as deeply. Van der Weyden figures aren't symbols — they're real people in despair or some other powerful emotional state. He dramatizes emotion by placing his figures front and center. Sometimes he includes a background landscape.

Rogier van der Weyden's *Deposition* (see the color section) is carefully choreographed to play upon the viewer's feelings. The figures are so realistically modeled that they appear to be actually standing in front of the stone wall behind them. They look like characters in a *Passion play* (a theatrical re-enactment of Christ's final hours) performing on the edge of a stage. Notice that Mary's drooping body echoes the body of Christ; this implies that her love for her son is so intense that she feels what he feels, and part of her dies with him.

The cross-shaped composition reinforces the theme of the painting, while giving van der Weyden a perfect frame in which to set up his symmetrical arrangements of people. Two weeping women with similar poses and white head wraps stand on either end of the horizontal axis of the painting. A pair of people on the left tend to the fallen Mary and hold up her arms. A pair on the right tend to Jesus, one of them (probably Nicodemus, the Jewish leader who followed Christ) supports his legs. Joseph of Arimathea, in the center, and the man on the ladder form the vertical or *y*-axis. The descending arrangement of these men helps the viewer to feel the weight of Christ's body as it sinks toward the ground. Their bowed heads, Jesus's dangling arm and drooping form, and the man descending the ladder, all contribute to the painting's downward pull.

Notice that van der Weyden used contrasts to break up the symmetry while preserving the painting's overall balance. The triads of people on either side of the horizontal or *x*-axis balance and contrast with each other. The positions of the heads of the middle figures contrast; one is lower than his two neighbors' heads, and the other is a bit higher. On the vertical or *y*-axis, Joseph of Arimathea stands on the left side of the cross, while the man on the ladder stands on the right. The balanced arrangement of the mourners helps to make their collective sorrow converge on the dead Christ in the center of the painting.

Northern Exposure: The Renaissance in the Netherlands and Germany

Trade with Venice, Florence, Rome, and other Italian city-states exposed northern countries like France, Germany, and the Netherlands to Italian art, igniting a Renaissance in the North. Italian Renaissance artists such as Leonardo da Vinci and Benvenuto Cellini who moved to France to work for King Francis I, and northern artists like Dürer and Bruegel, who studied in Italy, also helped transport the Renaissance spirit and style northward. Like the Italian Renaissance, the rebirth in the northern countries inspired artists to depict earthly life naturalistically and imaginatively.

In the following sections, I focus on the paintings of the Netherlands and Germany where the new emphasis on Renaissance *humanism* (an outlook stressing individual worth and human values) created a demand for portraiture and genre scenes, and where religious fervor sparked some of the most visceral and violent Christian art.

Decoding Bosch

The Dutch painter Hieronymus Bosch (1450–1516) painted some of the darkest images of humanity ever created. His most famous work is a *triptych* (a work of art with three hinged panels that you can close like a book) called *The Garden of Earthly Delights* (see the color section). One look at this painting is enough to convince you that Bosch was as pessimistic as he was devout. In his painting, the whole world seems stuck on the sensual life and bound for hell. Apparently, to Bosch, even listening to music was a sin. As gruesome as his depiction of hell is (the right panel), it may be the most creative vision of the Inferno ever conceived.

On the left panel, Christ introduces the newly created Eve to Adam in an Eden inhabited by peacefully grazing animals (some of which are quite bizarre). In the large middle panel, which represents life after the Fall of Adam and Eve, naked people cavort, flirt, and ride horses and pigs in what looks like a sexual funhouse. Although the earthly-delights panel is intended to warn man to forsake his pleasure quest and turn to God, it seems designed to turn people on rather than off. The right panel shows the price man pays for a life devoted to satisfying the senses.

The Garden of Earthly Delights is stuffed with images. There are probably as many interpretations of it as there are image combinations. To read this painting it's helpful to look for patterns, parallels, and inversions between the three worlds: Eden, earth, and hell. Notice that the clear sky and the green hilly landscape of Eden continue into the middle panel, Earth. There are geographical correspondences in hell, too. Each panel includes a cut-out oval pond

(in hell it's a cesspool). Even in paradise, the pond is inhabited by grotesque, hybrid creatures: a black unicorn, a flying fish, a ducklike creature perusing a book — man's future looks gloomy already. Each landscape also has a lake. In Eden, ducks cruise the clear waters; on earth, naked folks frolic in what looks like a water theme park; and in hell, people boil in an infernal soup.

Notice that in the left and middle panels ominous owls eyeball mankind like an all-seeing conscience or to foreshadow his doom.

Birds flit through each section: In Eden, they fly blissfully through blue sky. On Earth they morph into giant fowl, cutting through the air with winged people and flying fish and griffins — perversions of nature. In medieval lore, witches were believed to corrupt nature by stealing eggs and sperm from humans and other species and mixing them to create hybrids. Their goal: to replace God's and nature's harmony with discord. In hell, tiny black birds take off from the rectum of a man who's being swallowed by a giant bird. (Bosch's hybrids may have been inspired by medieval manuscript drolleries — see Chapter 10 — but he's taken drolleries to a new level of weirdness.)

Edenic fruit reappears in the fallen world as an apple orchard from which people freely pluck and eat. Giant strawberries, blueberries, and cherries are conspicuous features of the middle panel, suggesting that mankind lives only for his pleasures, which loom larger than everything else. Notice that people and birds offer each other fruit as the serpent did in Eden. Future hybrids are suggested by interracial mingling and by a man cozying up to an owl — although the owl appears indifferent to his advances.

In hell, pleasure is transformed into pain. The fiery pit is divided into different torture arenas for each pleasure: the gaming arena, the music "room," the toilet bowl — a hole in hell into which one man vomits, another excretes gold coins (obviously he horded too much money in life), and a man-eating bird defecates undigested people. In other arenas, animals maul and bag the hunters who preyed upon them, and beastly "personifications" of lust fondle gluttons and lechers.

In the music "room" musicians and music appreciators get punished for pleasing their aural sense rather than praying. Their lutes and flutes become instruments of a torture: One man is crucified on a harp, another is racked on the strings of a lute, while another is impaled by a hunchback as he incessantly grinds out tunes on an oversized hurdy-gurdy.

The gaming section of hell features fallen cards, dice left forever on a table, and a spilled pitcher (there are no refills in hell). A die tottering on a woman's head suggests that gambling was how she balanced her books in life. A naked man is sandwiched between a gaming table (to which he's pinned), a ravenous beast, and an impaled hand with a die perched on its fingertips. The latter image implies that even without a body or head to direct it, the hand is still banking on a lucky roll. In Bosch's hell, people don't give up their pleasures — they're tormented by them.

Deciphering the dark symbolism of Grünewald

The German painter Matthias Grünewald (1470–1528) took Gothic drama even further than Rogier van der Weyden. He depicted intense, often violent emotion more effectively than any other Renaissance artist. His grim paintings of the Crucifixion depict the horrors of Christ's gruesome death with vivid realism.

Grünewald's most powerful rendering of the *Passion* (the sufferings of Jesus up to and through his crucifixion, as in Mel Gibson's *The Passion of the Christ*) is in the *Isenheim Altarpiece,* painted for the Abbey of St. Anthony in Isenheim, Alsace, between 1510 and 1515. The left panel shows an impassive St. Sebastian impaled by arrows; the right panel depicts the mild St. Anthony; in the bottom, Christ is in his tomb, mourned by the two Marys and Joseph of Arimathea.

But it's the dramatic center panel that grabs the viewer's attention and won't let go. Christ's battered body hangs so heavily that it bows the horizontal arm of the cross. His outstretched fingers scratch at the sky, and his muscles strain with anguish. The bright red cloaks of John the Baptist on the right and the Apostle John on the left echo the color of the blood flowing from the wound in Christ's chest. Grünewald expresses the intensity of Jesus's last moment on earth as viscerally as Mel Gibson does in *The Passion of the Christ.* Rigor mortis has already set in, freezing Jesus's final agony, which Grünewald depicts with brutal realism.

Grünewald's most terrifying work is *The Temptation of St. Anthony,* painted from 1510 to 1515. According to St. Athanasius, who wrote *The Life of St. Anthony,* when Anthony retreated to the desert to live an *ascetic* life (contemplation and self-denial — in other words, the opposite of the modern American way), the devil fought with Anthony on several occasions, surrounding him with temptations and vicious demons. In *The Temptation of St. Anthony,* Grünewald depicted a bevy of strange beasts persecuting the saint. The vivid primary colors that Grünewald uses help to dramatize the scene.

Dining with Bruegel the Elder

The Flemish painter Pieter Bruegel the Elder (c. 1525–1569) specialized in landscapes and scenes of common people working in the fields, eating, hunting, and skating, as well as flirting, drinking, and raising Cain in bars. His depictions of peasant life are full of rough-hewn people and rustic charm. Paintings like *The Peasant Dance* and *The Wedding Dance* are magnificent windows into 16th-century peasant life.

According to Bruegel's first biographer, Carel van Mander (writing 35 years after the artist's death), Bruegel enjoyed crashing weddings and village fairs with a buddy. "Wearing peasant garb . . . they came to the wedding bearing gifts like everyone else and claiming to be members of the family of the bride or groom. Bruegel took pleasure in studying the appearance of the peasants. . . . He also knew how to represent these peasant men and women most exactly."

Bruegel is famous for his partying peasant scenes like *Peasant Dance* and *Wedding Dance.* In the animated *Wedding Dance,* red pants, shirts, and skirts, interspersed over the canvas among greens, browns, and white hats, pants, and aprons, create a visual dance rhythm for the eyes. You feel as though you're gyrating through the space with the dancers.

Not only did Bruegel capture the essential character of peasant life, but he used landscape to evoke moods, as in his *The Hunters in the Snow* (also known as *Return of the Hunters*), which depicts peasants hunting, working, and ice-skating and fishing on a frozen lake in a winter landscape. The painting was part of a series of works representing the months of the year. *The Hunters in the Snow* represents January and February. The figures are shown from a distance or with their backs turned to the viewer; the composition and frigid landscape, bleak sky, and distant alpine peaks — not the people — communicate the paintings' moods and messages.

Of course, there are no mountains in Antwerp or Brussels where Bruegel made most of his work. So how did he paint such convincing glacial peaks? In about 1552, Bruegel, like many northern artists, journeyed to Italy to study the masters of the Italian Renaissance. He was above all impressed by Michelangelo; by Venetian landscapes and people-scapes probably by artists like Titian, Giorgione, and Vittore Carpaccio; and by the majestic Alps. He filled notebooks of sketches of the Alps, which he later used in his paintings in Antwerp and Brussels. His biographer said Bruegel swallowed the mountains on his Italian trip so he could spit them out later in his studio. He spit them out for the rest of his life.

But Bruegel had a darker side, too. Like Bosch, who was one of Bruegel's greatest influences, and Grünewald, he sometimes ventured into the world of the macabre — for example, in his *Dulle Giet (Mad Meg)* (1562) a chaotic landscape inhabited by giant demons and ranting people, and in *The Fall of the Rebel Angels* (1562) and the *Triumph of Death* (c. 1562). The first two works look like Bosch could have painted them. In fact, as a young artist, Bruegel was paid to imitate Bosch, whose popularity soared after his death.

In *The Triumph of Death,* an army of skeletons (some carrying cross-marked coffins like body shields) massacre humanity in countless gruesome scenes. The invading armies of death look like endless streams of Grim Reaper clones and remind viewers of the Black Death, which decimated Europe in the mid-14th century, wiping out roughly half the population.

Chapter 13

Art That'll Stretch Your Neck: Mannerism

In This Chapter

▶ Stretching the rules

▶ Re-viewing perspective

▶ Adjusting to Mannerist architecture

*T*he High Renaissance (see Chapter 11) elevated artists from *makers* of art to *creators* of art. In the wake of this "promotion," artists began to assert their individuality. After the students of Raphael and Andrea del Sarto mastered all the High Renaissance rules like scientific perspective and orderly, geometric compositions, they began breaking the rules to make art that was more stylish and expressive. Scholars generally call this style *Mannerism,* but they don't agree on which artists should be labeled Mannerist or even how long the style lasted. Most scholars believe that Mannerism extends from 1520 to 1600.

The term *Mannerism* comes from the Italian *maniera,* a word that artist and biographer Giorgio Vasari used in the 16th century to signal the high intellect and refined skill of Michelangelo's style after about 1520. Vasari wrote that, when the Mannerist style first appeared in Michelangelo's Medici Chapel, it "broke the fetters and chains that had earlier confined [artists] to the creation of traditional forms." Maybe it's like learning to ride a bike: After you master the basics, you want to start doing tricks, things the bicycle wasn't designed to do.

What does Mannerism look like? When you celebrate the artificial over the natural by exaggerating proportions, distorting perspective, or even shaping a backyard hedge into an arched entrance, you're being a Mannerist.

If the great Mannerist artists were alive today, many of them would probably be hanging around the fashion shows of Paris or Milan. Artists such as Francesco Primaticcio or Parmigianino would be quite at home sketching the lanky runway models, with their collagen-enhanced features and extravagant clothing. Mannerist Madonnas have a stylish artificiality all their own, and

sometimes the clothing worn by attendant figures is as form-fitting as Calvin Klein underwear (check out the men in Pontormo's *Deposition* [see the color insert] for an example). The angular features and sulky expressions of Mannerist faces seem to communicate haughty refinement even as they beg for your emotional empathy.

Part of the reason that Mannerism seems like such an aristocratic art is because it served the tastes of the Medici family in Florence, the French kings at Fontainebleau, and Emperor Rudolf II in Prague. The pictures commissioned by these patrons often have veiled erotic symbolism that only a select few were ever meant to understand (see the figure in "Bronzino's Background Symbols and Scene Layering," later in this chapter).

Even Mannerist gardens require the visitor to be reasonably well educated and art savvy in order to appreciate the various orders of architecture and how they've been playfully adapted. The Orsini garden at Bomarzo, Italy, for example, displays an assortment of jests, tricks, and architectural styles, including a so-called "leaning house" (like the ones you find in amusement parks today), trick fountains, and seductive sirens and ancient gods carved into the large outcroppings of lava rock. Patrons of Mannerism had a good sense of humor and liked the type of beauty that surprises with its strangeness.

In Italy, at the end of the High Renaissance, Michelangelo's style moved toward Mannerism. The elongated forms in his *Pietà Rondanini* (1556–1564) are classic examples of his late Mannerist style.

In this chapter, I examine paintings in which limbs are elongated, emotions intensified, and backgrounds transformed into symbolic or visionary landscapes. Then I show you how Mannerism stretched architecture to its limits.

Pontormo: Front and Center

Jacopo da Pontormo (1494–1557) was one of the first Mannerist painters. He may have studied under Leonardo da Vinci. Scholars know for sure that in 1512, Pontormo became an assistant of Andrea del Sarto, from whom he learned to master the High Renaissance style. Five years later, Pontormo broke ranks and helped launch Mannerism.

Pontormo's *Descent from the Cross* (1525–1528) is one of the earliest Mannerist masterpieces (see the color section). It shows two young men carrying Christ's body in the company of mourning women. Pontormo virtually eliminated depth from the painting, moving almost all the figures into the foreground and stacking them on top of each other like a Cirque du Soleil pyramid. Instead of depth, the painting has height. Moving the action into the foreground enabled Pontormo to intensify the emotion. It gives the viewer a close-up of everybody's feelings.

He further removed the event from ordinary reality by dressing the figures in baby blues, soft pinks, and olive greens — not exactly the colors of tragedy. Some of the cast wear pink-and-blue, skin-tight clothing that shows off their expressive postures and their bodies. The artificial colors and mannered perspective make the painting poetic rather than dramatic. Pontormo softened tragedy into visual lyricism (a poetic quality accompanied by graceful lines). The whole scene rests delicately in space and, like the cloud in the background, seems as if it might float away.

Bronzino's Background Symbols and Scene Layering

Pontormo's adopted son and student, Agnolo Bronzino (1503–1572), became one of the greatest Mannerist painters. From 1539 to 1560, Bronzino served as court painter to Cosimo I de' Medici, Duke of Florence. Bronzino's paintings are rich with symbolism, which isn't much of a surprise considering that Bronzino was also a poet.

The name Bronzino means "copper-colored" or "nicely tanned."

Cosimo commissioned a painting from Bronzino that he intended to present as a gift to Francis I, the king of France. The painting turned out to be one of Bronzino's greatest works, *Allegory of the Triumph of Venus* (see Figure 13-1).

The central figures in the painting are Venus and her son Cupid. Venus swipes Cupid's arrow and points it at him. He responds by making love to his own mother. (And you thought that only happened on modern-day soap operas. . . .) The other figures react with a mixture of shock and glee.

The leering old, bald man in the upper right with an hourglass sitting on his back represents Time. The identities of the rest of the cast (with the exception of Venus and Cupid) are hotly contested by scholars. It's possible that even the Medici family wanted the painting's meaning to be open-ended so the French court could debate it. Old-man Time and the masklike figure in the left corner raise a blue curtain to reveal this behind-the-scenes affair.

The two masks on the floor suggest that the whole "scene" is just a theater piece. In the Renaissance, aristocrats often staged mythical love affairs at their private parties. The discarded masks may also suggest that two of the characters in the painting are in the process of revealing their true natures.

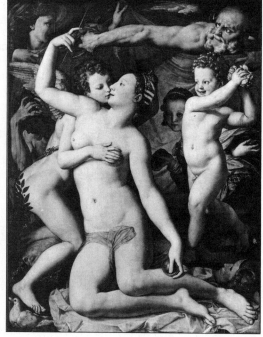

Figure 13-1:
Agnolo Bronzino's *Allegory of the Triumph of Venus* is one of the most enigmatic paintings of the 16th century.

The blithe child on the right, who may represent Folly, playfully pelts the lovers with pink roses (one of Venus's symbols) to encourage them. The mysterious little girl who offers Venus a honeycomb has been identified as Fraud because her body morphs into a monster with clawed feet and a scorpion tail. A dove (traditionally one of Venus's assistants) roosts in the left corner next to Cupid's right foot.

The painting includes an even more discordant image than the little girl: a tormented crone (or hag) wails behind the beautiful bodies of Cupid and his mother. We have no idea what's causing the crone's anguish or who invited her to the party. She is frequently identified as Jealousy or Despair. Her darkened skin and bad teeth have led some scholars to assume that she represents syphilis, a venereal disease from which the French king suffered.

The crone's hideous appearance makes a nice foil for Venus, who holds the golden apple that she won in the beauty contest judged by Paris, which triggered the Trojan War. The golden apple indicates that Venus is the most desirable of all creatures. It also shows that her vanity has no limits; she clenches it while seducing her own son. Of course, spreading love is the job description of both Venus and Cupid. Bronzino has simply taken this fact to its logical, albeit extreme, conclusion. In other words, the painting is a Mannerist pose that goes beyond the bounds of Renaissance order and propriety.

What else makes this painting a Mannerist work? The *arcane* (tricky) symbolism, the crushed perspective (the background figures are practically on top of the foreground figures), and the cluttered composition (compare it to the formal balance of da Vinci's *The Last Supper* or Raphael's *The School of Athens* in Chapter 11). But also the painting is about vanity — and not just Venus's vanity: Bronzino is showing off, too. He gives a dazzling display of technical bravura in his smooth, polished brushwork, designed to flatter the refined tastes of his highly educated audience. He titillates them while simultaneously offering a contradictory moral message: Keep a leash on your passions.

Parmigianino: He's Not a Cheese!

Parmigianino (1503–1540) might sound like a tasty cheese, but it's actually the name of a tasteful painter whom Pope Clement VII called "Raphael reborn."

One of his masterpieces, *Self-Portrait in a Convex Mirror,* showcases both the artist's good looks (even a funhouse mirror can't distort his handsome face) and his Mannerist style. In this work, Parmigianino demonstrated that he could maintain classical proportions in a distorting mirror! At the same time, he celebrated vanity — his own. Also, notice that the artist's brush hand presses against the mirror as if it wants to break the barrier between the viewer and the painting. (In addition, it illustrates the distorting action of the convex mirror.)

Disrupting traditional Renaissance perspective and playing games with point of view are hallmarks of Mannerist art.

Parmigianino's most celebrated work is *Madonna with the Long Neck* (see Figure 13-2). The woman's long and large body contrasts surprisingly with her small shoulders, little head, and long neck. Nevertheless, these distortions don't diminish her beauty. Instead, they expand it into rarified elegance.

In Mannerist art, artificial beauty trumps nature. The strange perspective in *Madonna with the Long Neck* is another Mannerist feature. The background with the miniature man, white columns, and hazy mountains has a surreal quality like a Salvador Dalí dreamscape (see Chapter 23). It's as if two paintings had been superimposed. The small background man displays a scroll while turning away from it, suggesting that pure display takes precedence over function.

In Mannerist art, showiness and artifice always take the front seat.

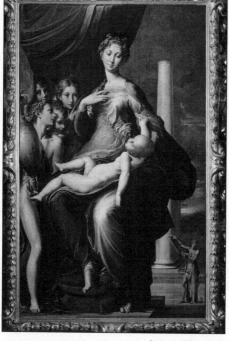

Figure 13-2:
*Madonna
with the
Long Neck*
(c. 1535) is
Parmigian-
ino's most
celebrated
work.

Scala / Art Resource, NY

Arcimboldo: À la Carte Art

The most mannered of the Mannerists is the Milanese painter Giuseppe
Arcimboldo (1527–1593). Arcimboldo, who began as a religious fresco painter
and a tapestry designer, also painted conventional portraits, but these works
aren't well known. In 1562, Habsburg Emperor Ferdinand I hired him as an
imperial portrait painter in Vienna and Prague. Not long after, Arcimboldo
invented "edible portraiture." (What that says about Viennese cooking we
can only guess.) Although you can't actually *eat* Arcimboldo's art, it *looks*
like you can.

His first foray into this genre was a series based on the seasons, painted in
1563. The paintings were an instant hit, and many artists began to imitate
Arcimboldo. In his portrait of *Summer* (see the color section), Arcimboldo
created a personification of this season wearing a coat woven of wheat stalks
with an artichoke boutonniere planted in his chest. A golden pear forms the
man's chin; his cheeks are ruddy apples; a protruding pickle represents his
nose; and his lips and teeth are made from a split peapod. Of course, apples
and pears aren't summer produce. Nonetheless, the man's horn-of-plenty
looks convey a sense of summertime abundance with the promise of a
healthy harvest.

Arcimboldo painted composite portraits made from a cornucopia of fruit, vegetables, fish, meat, even tree roots. For example, he constructed a fruit-basket lady, a man out of cooked chicken parts, and the bust of a librarian from a shelf of books (see *The Librarian* in the appendix).

He even re-created the faces of Adam and Eve out of naked babies — yet Adam and Eve are both dressed in 16th-century attire! (See *Adam and Eve* in the appendix.) The infants twist and turn in a variety of cute, sometimes surprising positions to represent Adam and Eve's features: An arched back signifies Eve's ear, a baby's bottom forms the tip of Adam's nose, and a tiny foot delineates each of their upper lips. Eve holds in her hand the apple that led to the duo's expulsion from Eden, while Adam flourishes a scroll with one hand and supports an open book with the other. Why is Adam reading? It illustrates the upside of the Fall. Adam is no longer ignorant; thanks to the apple, he can read.

Sometimes Arcimboldo actually captured his sitters' looks with his meat-and-fruit-salad caricatures. He concocted a lawyer out of broiled chicken and fish that many of his contemporaries immediately recognized as the emperor's financial administrator — although others argued that it was John Calvin, the Protestant reformist. (Calvin was also an attorney.) The barrister's neck is a ream of legal forms and his belly is made from law books (see *The Lawyer* in the appendix).

El Greco: Stretched to the Limit

The real name of the artist known as El Greco is Doménicos Theotokópoulos (1541–1614). But who wants to say all that? Most people simply know him as El Greco ("the Greek"). Doménicos Theotokópoulos was born on the Greek island of Crete, then part of the Republic of Venice. As a youth, he learned Greek Orthodox icon painting (see Chapter 9), which influenced his later work. In the late 1560s, El Greco moved to Venice to study painting with the aging Titian. El Greco's early works show that he thoroughly absorbed the style and techniques of Titian and Tintoretto. In 1570, he relocated to Rome, hoping for papal commissions, but he enjoyed only modest success. In 1577, he moved to Toledo, Spain, where he developed his distinctive Mannerist style.

In Spain, El Greco began to elongate his forms. Many of them looked like they'd been stretched on a torture-chamber rack. Also, the sun stopped shining in his paintings. Dark, stormy skies became his signature look. The looming, black clouds in El Greco paintings promise more than bad weather — they have an end-of-the-world gloom. He said he wanted to "mirror the Incarnation by spiritualizing nature." Despite that, there's not a lot of "nature" in his art. He usually painted people-scapes. When El Greco included landscapes and cities, they seemed to be infected by his apocalyptic skies. In his

The Burial of Count Orgaz (1586), heaven — the upper part of the painting — is a swirling realm of spiritual energies. By contrast, the funeral in the bottom third is orderly and stiff; it seems almost dreamlike by comparison.

The Counter-Reformation mysticism of St. John of the Cross (1542–1591) and Theresa of Ávila (1515–1582; see Bernini's *Ecstasy of St. Theresa* in Chapter 14) strongly influenced El Greco's work. His art seems to be a painterly transcription of their spirituality. The arrest and imprisonment of the Andalusian cleric later canonized as St. John of the Cross in Toledo the year El Greco arrived must have made a great impression on the newcomer. St. John of the Cross, who'd been imprisoned for trying to reform the local Carmelite order, was publicly lashed once a week for nine months!

In El Greco's *Fifth Seal of the Apocalypse (Vision of St. John),* the apocalypse that many of his works foreshadow arrives. Revelations 6:9 says: "And when he had opened the fifth seal, I saw under the altar the souls of them that were slain for the word of God, and for the testimony which they held." In the painting, the ghostly white male and female martyrs rise up and raise their arms longingly toward descending *cherubs* (baby angels). The two lower cherubs look like dive-bombers dropping yellow and green mantles (cloaks of salvation) over the nudes.

Notice that the right-hand martyr grasps a white blanket unfurled by the angel above him. The blanket links heaven and earth, which was El Greco's main preoccupation: "on earth as it is in heaven."

After his death, El Greco's popularity plummeted. Critics around the world ridiculed him for centuries as "extravagant," "queer," and "ridiculous." Some accused him of madness. In the early 20th century, scholars took a more scientific view. They attributed his twisted, elongated limbs to an *astigmatism* (a vision defect caused by an irregular cornea)! But the Expressionists revered him and considered his work a forerunner of their own. They realized that he used distortion to express extreme emotional and spiritual states. Expressionism may have taught the rest of the world how to read his paintings. Today, El Greco is probably the most popular Mannerist artist.

Just how unappreciated was El Greco?

In 1899, a convent in the province of Toledo, Spain, owned El Greco's *Holy Family with Mary Magdalen* and used it as a patch over a broken window to keep out the rain. When the town mayor learned that the nuns couldn't afford to fix their window, he paid four pesetas (about 80¢) to replace it. In gratitude, the head nun gave him the painting. Shortly thereafter, the mayor sold it for 200 pesetas (roughly $40). Eventually *Holy Family with Mary Magdalen* found its way to the Cleveland Museum of Art. It needed a facelift before it could be displayed.

Finding Your Footing in Giulio Romano's Palazzo Te

Mantua isn't usually on tourists' lists of don't-miss sights in Italy — but it *should* be. Between Andrea Mantegna's dazzling frescoes in the Ducal Palace and Giulio Romano's Palazzo Te, Mantua is one of Italy's cultural meccas.

Like their painter colleagues, Mannerist architects bent the rules. And no one did it more playfully than Giulio Romano (c. 1499–1546), Raphael's top student and adopted son. After Raphael's premature death in 1520, Romano became the head of Raphael's workshop and completed his most important commissions, such as the Sala di Costantino ("Room of Emperor Constantine") in Rome. Even before Raphael's death, the High Renaissance master entrusted Romano to complete some of his works, including *Joanna of Aragon* and *Saint Margaret* (both in the Louvre).

After Raphael's death, Romano's fame gradually spread across Europe. He was so well known in the century after his own death that Shakespeare mentioned him in *The Winter's Tale,* calling him that "rare Italian master, Julio Romano, who, had he himself eternity and could put breath into his work, would beguile nature of her custom, so perfectly he is her ape" (5.2).

In 1524, the marquis of Mantua, Federico II Gonzaga, invited Romano to become his court painter and architect. Of Romano's numerous achievements in Mantua, the Palazzo Te is the most outstanding. Romano transformed the Gonzaga stables (Gonzaga racing horses were the most famous in Europe) into a palace, modeled on an ancient Roman villa. The stables were located on the Island of Te just outside the southern walls of the city. The palace consists of four blocks of apartments that alternate with four loggias wrapped around a square courtyard.

As a Mannerist, Romano disrupted pure classicism by throwing some architectural surprises and jokes into his design of Palazzo Te. For example, between the columns on the east and west courtyard facades, every third triglyph has slipped out of alignment, as if the palace had been shaken by a selective earthquake on just two sides of the building.

A *triglyph* is a triple scalloped architectural element on an entablature (see Chapter 7 for more information).

In addition, giant-sized keystones protrude into the *pediments* (triangular spaces) above the arches, as if they'd slipped upward. A *keystone* is the wedge-shaped stone in the center of an arch that locks the other stones in place. This innovation disrupts the classical order and suggests that the building is unstable — its big keystones can't even hold it together.

Michelangelo learns to be mannered

While Romano was playing architectural games in Mantua, Michelangelo experimented with Mannerism in Florence. His emerging Mannerist style is evident in the vestibule of the Laurentian Library. Instead of a rectangular, classically cut stairway, the library steps flow like descending wavelets in a manmade waterfall. You don't *walk* down these steps — you surf. Also, the powerful, double columns that punctuate the neighboring walls are merely decorative. This contradicts the classical ideal that form and function should play equal roles in architecture. Classical columns are beautiful, but they also hold up the roof. Here, decoration tends to conceal function.

Also, Romano gave the palace a motley stonework surface. He combined fat stones with skinny and medium-size ones; some smooth and others *rusticated* (rough and beveled); some protruding and others flush. This variety in the stonework gives the palace an agitated Mannerist feel rather than a classical calm as in Palladio's High Renaissance buildings (see Chapter 12).

On the inside, Palazzo Te is even more impressive. Nearly every room is a masterpiece of design. The most outstanding is Sala dei Giganti ("Room of the Giants"). In Greek mythology, after the Olympians (Zeus and his buddies) defeated and replaced the Titans (old gods), the Giants tried to overthrow the Olympians. Romano shows Zeus turning back their assault and hurling the defeated Big Guys to Earth. As you enter this room, you feel you've walked into a horrific fray spilling from heaven and engulfing the whole Earth. The room itself seems to be caving in. Giants and broken columns tumble down the walls to the floor. Romano even painted toppling brickwork over one of the entrances so that the doorway looks like it's being crushed. He enhanced these effects with *trompe d'oeil* (literally, "tricks of the eye"), which makes the figures and architecture look sculptural. Even modern cinema, with its arsenal of special effects, can't create a more convincing upheaval.

Romano passed his Mannerist style on to his students, especially Francesco Primaticcio, who carried Mannerism to Fontainebleau, where he worked for King Francis I, France's great Renaissance king. From France, Mannerism spread to northern Europe.

Chapter 14

When the Renaissance Went Baroque

In This Chapter

▶ Defining Baroque art

▶ Tracing Caravaggio's influence

▶ Exploring Bernini's sculpture and architecture

▶ Basking in Baroque light

▶ Examining Spanish Baroque

*A*fter 150 years, the Renaissance ran out of "rebirth." Mannerism came and went like a fashion (1550–1600), and a new 100-year period, the Baroque, took root in the psyches of artists, patrons, and the European public. The Baroque is the artistic side of Catholicism's comeback during the Counter-Reformation. The Catholic Church enlisted Baroque art and architecture as weapons in the cultural wars with the Protestants. But Protestant countries adopted the Baroque style, too, adapting it to their own needs. In the Catholic nations, the Baroque tended to serve religion, attracting people to the Church with sumptuous or dramatic art and architecture, while Protestant states used the Baroque to create stately, elegant architecture often to advertise their worldly power or strikingly realistic landscape, still life, and everyday or *genre* scenes in painting.

The Reformation, ignited by Martin Luther in 1517, knocked the wind out of the Catholic Church. Half of Europe turned its back on the pope: Northern Germany, Scandinavia, England, and part of the Low Countries all converted to Protestantism.

To hold on to its shrinking flock, the Church launched the Counter-Reformation, which officially began at the Council of Trent (1545–1563), even though it had unofficially started earlier. The Counter-Reformation cleaned up the Church's act, chastising wayward priests and power-hungry bishops, requiring all clergy to be educated, and founding the Society of Jesus (the Jesuits). The Jesuits, who underwent a highly rigorous classical training, submitted to the pope absolutely, founded religious schools throughout Europe,

and converted non-Christians. Though the Council of Trent confirmed most Church doctrines, the Council upheld one of Martin Luther's chief complaints: It condemned the selling of *indulgences* (forgiveness for sins), which had been widespread for centuries.

In addition, the Council of Trent gave Catholicism a Baroque facelift, starting in about 1600. That may have been its most potent reform, because it's what people saw first.

What did the facelift look like? Unlike Renaissance art, which inspires quiet contemplation, Baroque art reaches out to people and provokes action. Baroque paintings are filled with dramatic movement (saints in ecstasy or pain, charging horses, turbulent skies), striking contrasts of light and dark, vivid colors, and earthy realism. Often, Baroque artists depicted the heroic acts of martyrs and saints to inspire the lower classes to accept their own suffering and not lose faith. Baroque architecture (in Catholic countries) reached out to Catholics, welcoming them into churches. Inside, the splendor of sumptuous Baroque relief and sculpture exalted the congregation, inspiring them to participate fervently in their faith.

Annibale Carracci: Heavenly Ceilings

Illusionistic ceiling frescoes were fashionable in the Baroque period. Annibale Carracci, born in Bologna in 1560, helped develop the style when he moved to Rome in 1595. Two years later, Cardinal Odarico Farnese commissioned Carracci to fresco the Palazzo Farnese ceiling to celebrate a wedding in his family. The Farnese frescoes became almost as famous as Michelangelo's Sistine Chapel Ceiling, which was one of Carracci's inspirations. Carracci divided the barrel vault of the Farnese central hall into rectangular compartments to frame his animated pictures of mythological love scenes. The lovers in these episodes seem to swarm over the expanse of ceiling, which looks like an upside-down art gallery. *Trompe l'oeil* statues of slumbering *ignudi* (nude youths) and bronze medallions separate the scenes.

Before painting the Farnese ceiling, Carracci and his cousin Ludovico founded a highly influential art school (the Accademia degli Incamminati) in Bologna, where students studied Renaissance and classical art and nature. The students spread the Carracci style throughout Italy. Among the most famous were Giovanni Lanfranco (1582–1647); Domenico Zampieri, known as Domenichino (1581–1641); Guido Reni (1575–1642); and Giovanni Francesco Barbieri, known as Guercino (1591–1666). Lanfranco combined Carracci's revived classicism with Caravaggio's dramatic intensity (see the following section). Guercino expanded upon Carracci's sense of space in the Farnese ceiling. In his fresco *Aurora* (1621–1622), painted in the Villa Ludovisi in Rome, the ceiling appears to open up into infinity. Painted architectural forms soar above into a heavenly space where the horses of Aurora charge through the clouds, bringing on the dawn.

Shedding Light on the Subject: Caravaggio and His Followers

Michelangelo Merisi da Caravaggio, known more simply as Caravaggio (1571–1610), was the greatest and most influential painter of the Baroque style. He was also a quick-tempered Bohemian who was often jailed for brawling. In 1606, he knifed a man to death while arguing with him over a tennis match and had to flee Rome. In absentia, a Roman court condemned Caravaggio to death (though he was pardoned toward the end of his life). The fugitive artist settled in Naples a few months later, but had to flee within a year for brawling. From there he journeyed to Malta, where in 1608 he was imprisoned following a quarrel with a powerful knight. He escaped to Sicily, making still more enemies. Eventually, he worked his way back to Naples where he was stabbed in the face, probably by allies of the Maltese knight. The artist survived the wound and continued painting and fighting. The fact that Caravaggio was often on the run helped to spread his extraordinary style, which was soon imitated across Europe.

Caravaggio infused his work with more gritty naturalism than any previous artist, hiring common people as models for saints and apostles, which shocked many of his contemporaries. He dramatized his religious scenes by throwing a diagonal light across his subjects, highlighting some of their features (to emphasize certain emotions and actions) and leaving the rest in shadow. Caravaggio's lighting technique is called *tenebrism,* from the Italian word *tenebroso* which means "gloomy" or "murky." His paintings recount climactic moments while powerfully suggesting the events that precede and follow them.

Caravaggio created his dramatic lighting effects by letting natural light stream through a high window or with a highly placed lamp that threw a beam down onto his subjects. This technique, known as *cellar lighting,* yields dramatic effects if the artist positions his models well.

In *Calling of Saint Matthew* (1599–1600), the cellar light slashes across the back wall and illuminates the faces of some of the men crowded around a wooden table where Matthew counts his money (see the color section). Three of Matthew's companions regard Jesus, who has just entered and stands in the shadows. The cellar lighting streaming through the window almost traces the line of Jesus's index finger, which points at the tax collector Matthew, who's about to change jobs. But the future apostle resists, avoiding Jesus's eyes and staring stubbornly at the stack of coins on the table. The painting illustrates the tug-of-war going on inside Matthew. The tension between light and dark, between pointing fingers and gazing eyes staring in opposite directions, heightens the drama to the breaking point.

Notice that despite Matthew's reluctance to sign on, Jesus's feet are already turned toward the exit and the future. Caravaggio was the first to depict a single tense moment and let the tension stretch the moment backward and forward in time.

To help break the barrier between a painting and the viewer, Caravaggio and other Baroque painters placed highly illusionistic objects — a bed, a copper bowl, someone's foot — at the bottom edge of their paintings so that the objects appear to project into the viewer's space. You feel that you can touch these objects, so you become more involved in the painting.

In the following sections, I examine the work of artists who were influenced by Caravaggio.

Orazio Gentileschi: Baroque's gentle side, more or less

Orazio Gentileschi (1563–1639) was the first of Caravaggio's many followers. Gentileschi emphasized realism like Caravaggio, and placed his subjects close to the viewer in a stop-action moment as in his *The Lute Player* (1610). In this sensitively rendered painting, a female lute player, illuminated by Caravaggio's cellar-lighting, gently strums her instrument. It's a fine work, but there's no tension and no stirring sensuality as in Caravaggio's *The Musicians* (1595–1596) and *The Lute Player* (1595–1596). The stop-action in the Gentileschi painting is truly stopped. The frozen moment doesn't pull us in multiple directions as in a Caravaggio painting. One of Gentileschi's most moving works is his *Madonna with Child* in the Gallery Borghese in Rome. The tender warmth in the mother's face as she gazes at her child is magnified by the lighting.

Perhaps the reason *Madonna with Child* is so convincing is because Gentileschi injected his feelings for his own daughter, Artemisia, into the painting. Gentileschi was very close to his daughter, whom he taught to paint. He taught her so well that by the time Artemisia was 17, she had already surpassed him (see the following section).

Shadow and light dramas: Artemisia Gentileschi

Artemisia Gentileschi (1593–c. 1652) wasn't the only female artist in the Baroque period. But she is one of the few to paint historical and religious paintings. Most other female artists were pigeonholed into portrait, still-life, and devotional paintings.

Among Artemisia's greatest works are *Susanna and the Elders* (1610), *Judith Slays Holofernes* (1620), and *Lucretia* (1621). Like the heroines in *Lucretia* and *Susanna and the Elders,* Artemisia was raped. Her personal experience resonates in these works. Like her father and Caravaggio, Artemisia placed her figures intimately close to the viewer. The extremely dark background in *Lucretia* thrusts the sharply lit woman still farther into the viewer's space, while highlighting Lucretia's psychological isolation after her rape. Lucretia squeezes her left breast while clutching a dagger to indicate what's going to happen next.

The Ecstasy and the Ecstasy: Bernini Sculpture

The statues of Gian Lorenzo Bernini (1598–1680), the greatest Baroque sculptor, seem like living stone. They convey both powerful emotion and a lively sense of motion. The feeling of movement is often driven by a wound-up tension as in his remarkable *David* (1623).

Michelangelo's *David* (see Chapter 11) is a resurrection and extension of classical sculpture. The tension in his *David* is powerful but passive. It stays inside David's mind and muscles. Bernini's *David,* on the other hand, is active. He is just half of a violent equation; the unseen Goliath is the other part. You don't see the giant, but you feel his presence and can gauge his distance by David's reaction to him. Baroque tension is not merely internal; it interacts with the space around it, charging it with energy. Bernini's *David* doesn't seem stuck on his pedestal like Michelangelo's statue. He's ready to fire his sling, and then leap off his platform to finish the job. Active sculpture like this was intended to animate Catholics with religious fervor.

Bernini's most compelling work is his *Ecstasy of Saint Theresa* (see Figure 14-1), which he sculpted for the Cornaro family chapel in the Church of Santa Maria della Vittoria in Rome. Because the chapel is dedicated to St. Theresa of Avila, Bernini sculpted a statue based on her life. St. Theresa suffered from severe pain (possibly caused by malaria). Eventually, she mystically transmuted the pain into ecstasy. She perceived this transmutation as a vision in which an angel repeatedly drove a fiery lance into her heart. The pain was "so sweet that I screamed aloud," she explained, "but at the same time I felt such infinite sweetness that I wished the pain to last forever."

Bernini captures the saint's experience of sweet pain perfectly. You see and feel it in her eyes and mouth, in the limp hand and dangling foot, which link her to the earth, and in her open posture, which invites the pain to stay. The pure joy on the angel's face contrasts strikingly with Theresa's mixed expression of anguish and bliss — especially because the angel is about to pierce Theresa's heart again. (The sculpture suggests that, on earth, we can never experience the unmixed joy the angels feel.) The contrast establishes a force field between the saint and angel that gives the sculpture its Baroque dynamism.

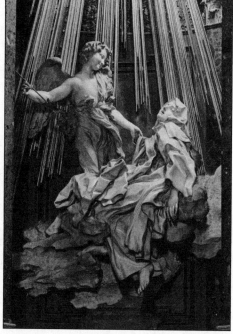

Figure 14-1:
Bernini's
*Ecstasy of
Saint
Theresa* is
the *Pietà*
(see
Chapter 12)
of Baroque
sculpture.

Embracing Baroque Architecture

Baroque architects in Catholic countries strove to make buildings active, inviting, and dramatic. Baroque architecture is driven by a directional point of view that coaxes visitors into the church and draws them through a sequence of increasingly sumptuous forms toward a visual and emotional climax, an explosion of Baroque splendor above the altar. The artwork over the altar usually consists of exquisite relief with playful *putti* (cherubs) peaking down from clouds surmounted by Christ in his glory framed by a golden sunburst.

To achieve these architectural crescendos, designers often decrease the spacing between columns as they get closer to the altar or make columns and pilasters gradually grow, visually leading the congregation forward and upward.

Carlo Maderno (1556–1629) launched the Baroque movement in architecture when he designed the facade for the Roman church Sta. Susanna in 1597. During most of the 16th century, Roman church facades were clean-cut, geometrical Renaissance structures or intentionally disjointed Mannerist buildings. Maderno replaced the static look of Renaissance architecture with dynamism and harmony. The large pediment capping the second level of the church echoes the smaller pediment over the entrance. The second-floor central window frame mirrors the first-floor door frame. The round ground-level

columns are replaced by rectangular pilasters on the second level. And elegant scrolls (which would become characteristic Baroque ornaments) bracket the entire second-floor level, giving the facade an upward, sweeping momentum.

Sta. Susanna was the launch pad for a style of sumptuous grandeur that would soon make Sta. Susanna look bland and uninspired. In 1607, Pope Paul V commissioned Maderno to design a long nave for St. Peter's (in the Vatican) and to redo the facade.

When Maderno died in 1629, Pope Urban VIII replaced him with Gian Lorenzo Bernini who was also a brilliant architect. His first task was to design a *baldachino* (canopy) over the altar, which would be the focal point of the most important Catholic church in the world. Like many Baroque artists, Bernini often sought to unite painting, sculpture, and architecture in a common front to win back the Church's lost flock.

By unifying sculpture, relief, and architecture, Bernini made St. Peter's Basilica one of the most uplifting churches in the world. The massive bronze canopy he designed rests on twisted columns that soar about 80 feet high. The canopy is topped by an ornate crown. A golden orb (representing the earth) surmounted by a golden cross sits on the crown.

While continuing work on the interior, the pope commissioned Bernini to transform the vast piazza in front of St. Peter's into a welcoming space. He achieved this by designing curved *porticoes* (roofed colonnades) around the piazza, which are connected to two straight porticoes that attach to the sides of St. Peter's. The curved porticoes reach out to embrace the world like wide-open arms, while the straight porticoes draw people into the church. Bernini built the colonnade from simple Tuscan rather than showy Corinthian columns, which would tend to intimidate rather than welcome ordinary people. (Tuscan columns resemble Doric columns, but the former have a profiled base and are usually unfluted.)

Baroque buildings were designed to invite crowds to gather around them and to interact with neighboring structures, usually by dominating them. By contrast, Renaissance churches and buildings tend to be more flat and reserved.

The Baroque style migrated north as the Renaissance style had in the 16th century. Protestant countries absorbed and modified the style because it was intended to serve different ends. In Holland, for example, the Mauritshuis (in the Hague) is a building of stately grandeur, but with decidedly less splash than its Catholic counterparts. The overall impression of Protestant Baroque is one of controlled elegance.

Powerful princes and dukes erected palaces in the Baroque style to celebrate their power and awe their subjects. In France, the Palace of Versailles, built in the late 17th century (see "Versailles: Architecture as propaganda and the Sun King"), was designed by the architects of Louis XIV to show the unruly French nobility that an absolute monarch was now in charge.

In the Catholic Habsburg Monarchy (or Austrian Empire), the Baroque style served to glorify both church and state. Austrian architects began building in the Baroque style after 1690. Two of the greatest structures are Johann Bernhard Fischer von Erlach's Karlskirche (St. Charles Church) in Vienna, and Jakob Prandtauer's Monastery of Melk, which perches on a hilltop above the Danube River. Both buildings look as ornate and appetizing as Vienna's famous desserts.

Karlskirche (see Figure 14-2), designed by Johann Bernhard Fischer von Erlach (1656–1723) in 1716, is the greatest Baroque church north of Italy. (Fischer von Erlach also designed the Schönbrunn, the Habsburg Monarchy's answer to Versailles.) When a plague hit Vienna in 1713, Holy Roman Emperor Charles VI vowed to build a church to honor St. Charles Borromeo, the patron saint of plagues and his namesake, when the pestilence ended. The Baroque masterpiece Karlskirche is the result.

Figure 14-2:
St. Charles or Karlskirche, designed by Johann Bernhard Fisher von Erlach, is the architectural crown of the former Austrian Empire.

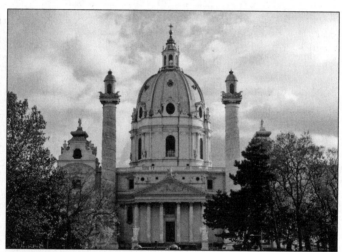

Andreas Ceska

Fischer von Erlach used a hybrid style, harmonizing elements from Italian Baroque, Ancient Rome, and modern Rome. The two gateway-tower pavilions behind the columns were influenced by Italian Baroque designs of Francesco Borromini and Bernini. The green elliptical dome rises over a Corinthian portico modeled after the Roman Pantheon (see Chapter 8) and the Maison Carrée (see Chapter 8). A statue of St. Charles Borromeo crowns the pediment. The flanking columns, which are carved with reliefs recounting St. Charles's life, were inspired by Trajan's Column in Rome (see Chapter 8).

But there's more to these columns than that. With the death of Charles II, the last Habsburg ruler of Spain, the Iberian Peninsula and its vast New World colonies were lost to the Holy Roman Empire centered in Vienna. The columns of Karlskirche represent the Pillars of Hercules (doorway to the

Atlantic at the Strait of Gibraltar) at the southern frontier of Spain. With the columns, Charles VI marked his claim for the last time to a nation that had been part of the Habsburg Monarchy for two centuries.

Dutch and Flemish Realism

Spain ruled the Low Countries, also known as the Netherlands, until the northern part (Holland) won its independence in 1609 and officially became Protestant. (The Dutch independence movement was dictated by religion as much as politics and money.) But Spain held on to the southern Netherlands, Flanders, which remained staunchly Catholic.

Protestant Baroque painting was less exuberant than Catholic Baroque painting. In Holland, it was intended to mirror ordinary life. Sometimes the ordinary scenes had moral messages, but they were not religious subjects. During the Reformation, Protestants had rebelled against the use of images of saints and martyrs in Catholicism. In Holland, religious paintings were banned by the Calvinist government.

But in Catholic Flanders, which remained under Spanish control until 1798, artists like Peter Paul Rubens, a devout Catholic, frequently painted religious themes. Nevertheless, Flemish art is less transcendental than its Italian counterpart. The Flemish and Dutch had always been a practical people. Their art reflects that national trait. The Dutch, in particular, loved material goods and were fond of paintings that had a shop-window appeal, displaying lifelike objects that you could almost sink your teeth into.

The Dutch had a love affair with art, including the still life, which they transformed from a backwater to a mainstream painting genre. Dutch people were proud of their hard-won independence and their thriving mercantilism (think Dutch East India Company), and they liked to see Dutch life celebrated in painting. Holland produced a lot of painters to satisfy that love — so many, in fact, that Dutch painters *had* to specialize (because art was traded on a open-market system rather than by commission). Some artists just painted flowers; others specialized in food or poultry. There were even expert bug painters.

This specialization led to collaborative painting. Many artists pooled their talents and made composite canvases. You need a chicken, call so and so — he'll paint you the best fowl in Holland. Want some bugs on your rose petals? Send for Mr. van Bloom or whomever.

The Dutch and Flemish also loved to read into paintings for double meanings. So Dutch artists filled their canvases with visual double-entendres and symbolism. Who knows what that bumblebee hovering over a rose or that cooked chicken thigh really represents?

In the following sections, I cover the art of the greatest Dutch and Flemish masters, Rubens, Rembrandt, Hals, and Vermeer.

Rubens: Fleshy, flashy, and holy

The Flemish artist Peter Paul Rubens (1577–1640) was a master painter, drawer, sculptor, architect, engraver, businessman, and diplomat. He also spoke seven languages (very useful for a diplomat). In 1600, he moved to Italy to study the Italian masters. Shortly after his arrival, he landed the perfect job to realize his goal. The duke of Mantua, Vincenzo I Gonzaga, hired Rubens as a copyist. His job description: Copy the great Italian painters so the duke could have facsimiles of their masterpieces in his private gallery. What a break! It was like being paid to go to graduate school — the best graduate school in the world! Rubens was also required to paint some of the most beautiful noble women in Italy (such as his *Portrait of Marchesa Brigida Spinola Doria*) for the duke's beauty-queen museum. Rubens remained with the duke for eight years, painting babes and copying masterpieces.

In 1601, Gonzaga sent him to Rome to copy masters like Raphael and Michelangelo. While in the Eternal City, Rubens watched Annibale Carracci's highly disciplined team painting the Farnese Gallery. Rubens later applied Carracci's team approach in his own painting workshop in Antwerp. Before leaving Italy in 1608, Rubens had already evolved his famous Rubenesque style — richly colored, crowded, yet perfectly composed canvases that erupt with boundless vitality. His *Fall of Phaeton* (1604–1606) and especially *St. George and the Dragon* (1606–1607) both roil with characteristic Rubenesque energy. St. George and his horse practically charge off the canvas. In spite of Rubens's stellar talent, Gonzaga never purchased a single Rubens original. Talk about not seeing the talent right under your nose!

Rubens's fortes were agitated movement, dramatic lighting, and illusionistic figures that plunge or fall into the viewer's space. Often, his paintings have an upward thrust. *Christ Risen* (1616) illustrates this tendency (see Figure 14-3). Of course, the upward thrust in this painting is symbolic. The angels' drapery and Christ's shroud rise toward heaven as Jesus lifts himself up from his tomb. The illusionism Rubens used to create Christ's left foot — which appears to be perpendicular to the picture plane — makes it look like Jesus is stepping out of the painting. The resurrection appears to occur right in front of the viewer. Never has Christ seemed so earthbound before, even as he rises from the dead. He is both weightless (floating upward into the clouds) and as solid as a body builder rising from his workout bench. The *putti* and angel that assist Christ look on in amazement. Only Jesus is unsurprised by his casual yet glorious resurrection.

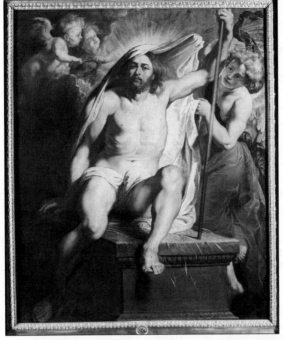

Figure 14-3:
Peter Paul
Rubens's
Christ Risen
(1617) brims
with
Baroque
power and
drama.

Scala / Art Resource, NY

In some ways, *Christ Risen* is atypical. Rubens's paintings are usually crowded with active people; beefy men and fleshy women sprawl across his canvases; *putti* tumble from the clouds. In his masterful *Raising of the Cross,* the muscular mass of figures is depicted at a 45-degree angle and seems to spill from an invisible cornucopia into the viewer's space. Jesus and the men crucifying him are a river of flesh flowing toward you. Yet the men are raising Christ's cross. This two-directional motion charges the painting with tension.

Rembrandt: Self-portraits and life in the shadows

Following Caravaggio's lead, Rembrandt (1606–1669) was a master of *chiaroscuro* (see Chapter 11) and dramatic lighting. He learned to manipulate light and dark for dramatic effect probably from the Utrecht School in Holland, which was influenced by Caravaggio, but also from his teacher Pieter Lastman. Lastman was influenced by Tintoretto's unique use of chiaroscuro.

In Rembrandt's *The Blinding of Samson,* instead of light streaming from above (in so-called "cellar lighting"), it pours in from an open tent to expose the cruel blinding of the Old Testament strong man. Delilah, holding the scissors with which she cropped Samson's hair and virility, looks back aghast, yet without pity. Like many of Caravaggio's paintings, *The Blinding of Samson* is rife with action moving in opposite directions. Delilah scuttles away to the left while a Philistine soldier thrusts his spear toward the prone Samson at the right. But in his later work, the light is less like Caravaggio and more like Tintoretto, mysterious and emotive. It suffuses his canvases with a spiritual light. Rembrandt went beyond either of his predecessors in interpreting human nature. His penetrating portraits and many religious paintings of Old Testament stories reveal the inner world of the characters he so brilliantly depicts. Rembrandt also plumbed the depths of his own character in a life-long series of self-portraits; over 60 survive.

Compare Rembrandt's *Philosopher in Meditation* (see Figure 14-4) to Caravaggio's *Calling of Saint Matthew* (see the color section). Caravaggio spotlights dramatic moments and uses light symbolically. Rembrandt employs a softer, warmer radiance to probe character.

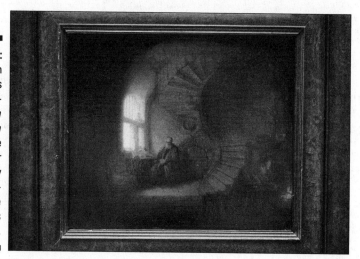

Figure 14-4:
In Rembrandt's *Philosopher in Meditation* (1632), the old thinker quietly contemplates the mysteries of life.

Philosopher in Meditation illustrates how Rembrandt used light and shadow to suggest meaning through contrast. The steps, winding around a cavern of darkness, symbolize the philosopher's meditative journey into the unknown. The room looks almost like a convex mirror with the coiling stairs and the top of the window arcing into the curve of the upper part of the staircase. The golden light, pouring richly through the window, casts an aura of warm radiance around the philosopher as if he were a cerebral saint. On the opposite side of the room, a woman (perhaps the philosopher's wife) stokes the fire, taking care of the practical side of life that he probably neglects.

For more on Rembrandt's technique, in particular his unique brushwork, see Chapter 29.

Laughing with Hals

Frans Hals (c. 1582–1666) painted no religious scenes or historical paintings, no landscapes or still lifes. His focus was the face, mostly merry ones with wine-red cheeks, either solo or in groups. He had a gift for capturing any fleeting expression that passed over the features of his sitters: an impish smile, a man grinning greedily as he pours his beer *(Young Man with a Jug of Beer)*, a buxom girl giving a man the eye *(Gypsy Girl)*.

Hals is famous for his robust paintings, which look like a cross between a Christmas card and a beer ad, though he illustrated the sober sides of life, too. For example, Hals's *Lady Governors of the Old Men's Home at Haarlem* depicts the staid and pragmatic directors of the Haarlem Old Men's Home. At first, the elderly women's faces seem solemn, even forbidding. But if you look long enough, a warm humanity begins to glow inside each face, especially in their eyes. Caring for the old men isn't just a job for these women; it's a labor of love. Besides the hints of humanity, a lifetime of experience is etched on each careworn face.

In spite of his great talent, Hals was only moderately successful, partly because people took his light and loose brushstroke for laziness. Impressionism has since taught people the expressive power of light and loose application of paint. But in those days, who knew? *Young Man with a Skull (Vanitas)* is one of Hals's most remarkable works. Sensuality and symbolism fight it out in this painting. The boy's confident charm and infatuation with someone outside the frame is undimmed by the gruesome skull in his hand. With the exotic, almost erotic orange feather sprouting from his hat, his dashing good looks, and his unflappable faith in tomorrow, the youth represents *vanitas* (vanity). He *is* the joy of life holding death in the palm of his hand. But the ominous skull, which is his future (and all our futures), can't touch him. He's too brimful of life to notice death.

Vermeer: Musicians, maids, and girls with pearls

In his short life, Johannes Vermeer (1632–1675) only created 34 paintings. He painted slowly, fine tuning his work again and again before releasing it to the buyer, usually Pieter van Ruijven. Vermeer's works are not typically Baroque. He didn't use flamboyant colors like Rubens. Nothing jumps off the canvas at the viewer. In fact, his paintings are rather spare and soft spoken. He usually

illustrates a domestic scene with one or two characters in a room containing only a few objects: a piano, a table, a pitcher of water. Everything is still like a stopped clock. And yet there's an inner tension — psychological or spiritual. His subjects are firmly grounded in everyday life — a maid pours milk, a girl strums a guitar, a man turns a globe — yet they are somehow outside the actions they perform. A quiet mystery hangs over Vermeer's paintings like a diaphanous mist you sense but can't see.

Vermeer is celebrated for his extremely subtle and sensual use of light, which can be warm and cool in the same painting. The light is often a mélange of warm yellow and cool blue filtering in through an open window. The soft, cool radiance makes his paintings seem intimate and aloof at the same time. Vermeer almost always painted the same room (his studio with its checkered tiled floor and paneled window). He knew all the room's moods and learned to let them speak on his canvases when the noise of the world was momentarily silenced. Maybe that's why he wouldn't let his wife and 11 children enter his studio. (Or maybe he just wanted some peace and quiet!)

Vermeer's *Girl with a Pearl Earring* (see the color section) is sometimes called the "Mona Lisa of the North." Yet in 1881, *Girl with a Pearl Earring* sold for just two guilders (about US$2) — Vermeer's popularity had sunk that low. Today he is considered one of the greatest 17th-century painters and *Girl with a Pearl Earring* is priceless.

What's so special about the "Mona Lisa of the North" other than that she's more fetching than the *Mona Lisa* of the South? Perhaps it's the fact that she is seductive and innocent at the same time. She is the crossroads where innocence and experience meet up and get to know each other. Also, the contrast between her maid's garb and that thumb-size pearl dangling from her ear is shocking and yet appropriate. How did a maid afford such a large, perfect pearl? Or what did she have to do to get it? But her innocence eliminates the possibility of anything untoward. What's most impressive about *Girl with a Pearl Earring* isn't the woman's striking looks, but *how* she looks at the viewer. She is so fascinated by the viewer that she makes *you* feel special. The black background intensifies this feeling by extracting *Girl with a Pearl Earring* from her own world, allowing her to enter the viewer's space — in a very Baroque way!

If you're unable to go to the Mauritshuis museum in The Hague to see this painting, you can get the next best thing by watching the film version of Tracy Chevalier's book *Girl with a Pearl Earring* (starring Colin Firth as Johannes Vermeer and Scarlett Johansson as the subject of the painting). Many of the scenes in this poetic, beautifully shot film look like Vermeer canvases brought to life.

French Flourish and Baroque Light Shows

France's Baroque style had an Italian side and a French side. The Italian part is represented by the émigré painters Nicolas Poussin and Claude Lorraine, who spent much of their careers in Rome. The home-turf artists and architects include Georges de La Tour (though he admired Caravaggio) and Jules Hardouin-Mansart (one of the designers of the Palace of Versailles).

Poussin the Perfect

Nicolas Poussin (1594–1665) moved to Rome in 1624 and spent most of his life there. Titian was a major influence on him (an exhibit of the Venetian master's work took place in Rome in the mid 1620s), but Poussin, who hitched the Baroque style to Greek and Roman art, was more interested in classical forms and harmony than Titian was.

Yet his classical settings serve Christian ends. The rectilinear steps of the classical temple in his *The Holy Family on the Steps* lead not only into the sky but also to heaven (see the color section). The top step simply dead-ends in the clouds. The Holy Family sits on the stairs (Mary with perfect posture), like friendly but vigilant sentinels, or maybe guides. Yet the stairs invite the viewer to climb more than the holy guides who seem unaware of the viewer. Like other Baroque artists, Poussin places objects at the bottom of the *tableau* (picture) where they are most accessible to the viewer — where he feels as though he can reach them. The viewer is almost *tempted* to pick an apple from the fruit basket on the ledge.

Notice that John the Baptist has already yielded to the temptation and hands an apple to baby Jesus. Jesus with an apple is a traditional motif, suggesting that he will undo Adam and Eve's sin. Thanks to him, the apple won't lead to a second fall but to an ascent up the stairway to heaven.

Candlelit reverie and Georges de La Tour

Caravaggio also influenced Georges de La Tour (1593–1652), but La Tour wasn't a mere follower. Instead of grand religious dramas like the Italian master, La Tour created intimate, candlelit settings for his religious and secular paintings. In La Tour's paintings, you feel as though you're in the same room with Mary Magdalene or Jesus. His source of illumination is often a solitary candle on a table or in someone's hand rather than an on-high, Caravaggio light. He placed divinity (light) within reach, instead of somewhere beyond the window.

In La Tour's *Joseph the Carpenter* (c. 1645), the young Jesus holds a glowing taper to help Joseph cut wood in a very dark room. The candlelight radiates on Christ's face as if it were rising from within him. The light merely glances off the bald head and arms of Joseph. Like Caravaggio, La Tour's light strikes his subjects from an angle, dramatically highlighting some features while leaving other parts in shadow. Although La Tour lived in the small town of Lorraine, his work came to the attention of King Louis XIII, who in 1638 elevated La Tour to "Painter to the King." Despite the royal favor, after La Tour's death, he was largely forgotten until the 20th century.

Versailles: Architecture as propaganda and the Sun King

To weaken the French nobility, King Louis XIV (*Le Roi Soleil,* or the Sun King) simply moved away from them. It was a smarter ploy than it appears. The powerful nobles of France had revolted violently during Louis's *minority* (when he was too young to rule — Louis was crowned shortly before his 5th birthday in 1643). The experience soured him on nobles, and he never fully trusted them again.

When Louis XIV assumed full power in 1661, he transplanted the royal residence from unruly Paris to rural Versailles, 11 miles away. This forced the French nobility to meet him on his own terms. At first, he ordered the 5,000 most defiant nobles to live with him at Versailles so he could prevent them from brewing revolutions behind his back. A palace that could accommodate 5,000 nobles and their retinues and families had to be enormous. So Louis transformed his father Louis XIII's somewhat modest hunting lodge into the greatest palace the world had ever known, built on 2,000 acres of land.

To achieve his vision of architectural splendor, Louis XIV hired Louis Le Vau (who died shortly afterward) and then Jules Hardouin-Mansart. Hardouin-Mansart's most famous design is the Hall of Mirrors (357 mirrors framed by 17 arches), where the Treaty of Versailles was signed, ending World War I. Louis commissioned André Le Nôtre to design the vast formal gardens and fabulous fountains, which are arranged symmetrically about a vertical axis that begins at the backdoors of the palace and extends through the Grand Canal. The king hired Charles Le Brun to design the interior frescoes, relief, and sculpture, all of which he did in a highly sumptuous Baroque style.

The grandiose Palace of Versailles was designed to be the visible symbol of the Sun King's absolute power. Like many other monarchs, Louis viewed himself as God's representative on Earth. The power of church and state were united in him. *L'Etat, c'est moi* (I am the state) is one of his most characteristic statements.

In the Limelight with Caravaggio: The Spanish Golden Age

Spain produced no homegrown artists in the 16th century. The Spanish court preferred imports like El Greco and especially Italian artists such as Titian. After Columbus's discovery of the New World, Spain acquired a vast empire. In addition, the Spanish crown had to govern Europe's most multicultural population and was at continual war with its neighbors.

The Spanish kings didn't have the time or inclination to nurture homegrown art. But after the defeat of the Spanish Armada in 1588, Spain's power declined and the royal attitude toward Spanish art changed. King Philip IV, a poet and art fan, nurtured all the arts, sponsored a painting competition, and hired Diego Velàzquez to be his principal court painter. Seventeenth-century Spain produced a slew of great painters such as Velázquez, José Ribera, Francisco Zurbarán, and Bartolomé Estéban Murillo, and brilliant novelists, poets, and dramatists, like Miguel de Cervantes, Lope de Vega, and Pedro Calderón de la Bsarca. The era became known as Spain's Golden Age.

Ribera and Zurbarán: In the shadow of Caravaggio

Like so many other artists of the time, Jusepe (or José) de Ribera (1591–1652) went to Rome, the art capital of the western world, to study painting in about 1613. Later, he moved to Naples where he remained for the rest of his life.

In Rome, Ribera became an ardent disciple of Caravaggio. Like Caravaggio, Ribera used striking contrasts between light and dark and chiaroscuro to heighten the drama in his paintings.

Counter-Reformation clergy and political leaders often commissioned paintings of martyrs to inspire Catholics not to lose their faith and to attract Protestants back to the Catholic fold. Like Caravaggio, Ribera typically used street people as models for his martyrs, giving his religious paintings an earthy look. Ribera's *St. Jerome* (the 4th- to 5th-century author of the Latin or Vulgate Bible) has an emaciated, been-through-it-all body. Similarly, in his *The Martyrdom of St. Bartholomew* (the 1634 version in the National Gallery of Art in Washington, D.C.), he depicts a careworn, rustic-looking saint confronted by a coarse executioner who looks like a Mafia hit man. Like Caravaggio, Ribera dramatizes the events he paints, in this case, by having the saint spread his old but muscular arms heroically to accept the blade of his brutal executioner. St. Bartholomew was flayed alive.

Francisco de Zurbarán (1598–1664) also studied in Rome and adopted many of Caravaggio's techniques. In fact, he was dubbed by his countrymen the "Spanish Caravaggio." But the figures in his religious paintings are less rugged than Caravaggio's. In fact, they tend to look like middle-class sitters rather than laborers and street people. For example, the model in his *Ecstasy of St. Francis* looks as well educated and middle class as the real St. Francis, whose father was a wealthy cloth merchant.

Zurbarán was commissioned to paint many religious paintings for King Philip IV who supported artists who shared his Counter-Reformation ideals. Zurbarán's paintings so impressed Philip IV that he granted the artist the title "Painter to the King."

Velázquez: Kings and princesses

Like Ribera and Zurbarán, Diego de Velázquez (1599–1660) also traveled to Rome to study, first from 1629 to 1631, and then between 1649 and 1651. In 1623, King Philip IV, one of Velázquez's biggest fans, appointed him to be his principal court painter. He remained the king's court painter for the rest of his life.

Velázquez developed a very free and loose brushstroke (which at times appears almost impressionistic) so that, up close, his canvases look like a jumble of crisscrossing brushstrokes. But when you step back, those loose strokes tighten into a sharp image. To achieve this effect, Velázquez used long-handled brushes so he could see the effect of his strokes from a distance.

Many of Velázquez's early works show a strong Caravaggio influence. But later on, the Caravaggio elements become simply a handful of the many ingredients in Velázquez's unique style. *Los Borrachos (The Drunkards)* (c. 1629) and *Joseph's Bloody Coat Brought to Jacob* (1630) are among Velázquez's most Caravaggio-like paintings. He painted *Los Borrachos* just before going to Italy. But Caravaggio's style had infiltrated Spain a few years earlier through intercourse with Dutch and Flemish artists. Also, Rubens traveled to Spain in 1628 and spent a lot of time with Velázquez, whom he persuaded to travel to Italy.

Velázquez's greatest work, *Las Meninas (The Maids of Honor)* (see Figure 14-5), is really two paintings, and possibly more. The viewer sees one of the paintings in the mirror. Velázquez is in the process of painting either the picture you see in Figure 14-5 or a portrait of King Philip IV and his queen Marie-Anne of Austria, whose reflections appear in the mirror. Velázquez stares at them like models while painting. At the same time, the artist gazes at the viewer, because the viewer stands in the same spot (out of the picture frame) as the king and queen. The *infanta* ("princess") Margarite and one of the

maids of honor also focus on the royal couple. Interestingly, the principal figures in *Las Meninas* aren't posing! They are simply being themselves, caught off guard like actors between scenes. Some people believe the princess got dolled-up to be painted; after all, she is the subject, isn't she? Is she about to join her parents on the viewer's side of the picture frame so she can pose for the king's greatest painter? Or have the king and queen walked in to check the progress of the princess's portrait and Velázquez has momentarily looked up from his task?

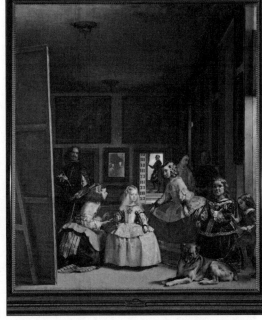

Figure 14-5:
Las Meninas (The Maids of Honor) is Velàzquez's most intriguing work.

Erich Lessing / Art Resource, NY

Chapter 15

Going Loco with Rococo

In This Chapter

▶ Reeling in the Rococo

▶ Scoping out sexy French art

▶ Checking in with the Brits

*T*hink of Rococo art and architecture as over-the-top Baroque or Baroque on a binge. In the early 18th century, the upper classes — first in France, then all over Europe — rejected Baroque sobriety and got drunk on ornamentation: swirling, fanciful curves; bright pastel colors; dripping gold filigree; and sensuous scenery.

Unlike robust, regal, and dramatic Baroque, Rococo is light, delicate, and playful. Baroque, which was at the service of the Church, lifted people to heaven; Rococo brought people fluttering back to Earth. Sublime spirituality was swapped for elegant sensuality. At the time, the new style was called *genre pittoresque* ("picturesque style"). The term *Rococo* didn't come into vogue until the end of the 18th century, when the style was already passé.

Instead of ecstatic saints in candlelit settings, portraits of imperious kings, and heroic scenes, Rococo artists favored sunbathed, idyllic landscapes inhabited by pleasure-seeking aristocrats like François Boucher's *Lovers in a Park* and Jean-Honoré Fragonard's *Blindman's Bluff.* They also delighted in painting mythological escapades with naked nymphs frolicking in pastoral settings, such as Boucher's *Diana Leaving Her Bath* and *Hercules and Omphale.*

Gilded Rococo palace ceilings, like the Kaisersaal in Würzburg, Germany (a confection of French, Italian, and German Rococo styles), often feature chubby cherubs eavesdropping from puffy clouds on the party below. Such paintings imply that even angels (at least baby ones) approved of the 18th-century jet-set lifestyle. But to the poor, who paid for the party (because they were the only taxed segment of French society), the whole period had a let-them-eat-cake feel and helped ignite the French Revolution of 1789.

The celebration started when King Louis XIV died in 1715. French aristocrats felt liberated after 72 years under Louis's autocratic rule. While the new ruler

Louis XV, who was only 5, was growing up, the aristocrats partied. The party didn't stop when Louis matured. French architecture appeared to celebrate with them. Rococo architects transformed palaces into playgrounds. Chateau walls and furnishings, Parisian apartments and salons dripped with flamboyant ornamentation; gilding spread across palace ceilings in webs of gold and silver filigree. The nobility and the new king commissioned artists like Antoine Watteau, Boucher, and Fragonard to decorate their chateaux with paintings that depicted the aristocratic life as a nonstop pageant of pleasures.

Rococo design was contagious and spread like wildfire across Europe. It seemed everybody wanted to lighten up, although in southern Germany and Austria, Rococo was harnessed by the Catholic Church. But the flamboyant style didn't transplant well in sober England. Instead, English artists like William Hogarth, Thomas Gainsborough, and Sir Joshua Reynolds, as well as the architect Sir Christopher Wren, developed a formal variant of Baroque, geared to English tastes.

Breaking with the Baroque: Antoine Watteau

It took the party a while to heat up. The first great artist of the Rococo, Antoine Watteau (1684–1721), was tame compared to those who appeared later. He depicted scenes of earthly paradise in which elegant aristocrats quietly cavort, watch actors, or listen to musicians. The all-powerful French Royal Academy created a new genre — *fêtes galantes* ("elegant parties") — to classify Watteau's paintings. Watteau's landscapes are usually dressed in mist, which blends trees, hills, seas, and sky into a poetic space where only beautiful, graceful things can happen. The mistiness also helps to distance the scenes from the real world; any flaws are hidden in these fuzzy, faraway Arcadias.

Watteau often mixed theater and real life in his paintings, which are like plays on canvas. (His teacher, Claude Gillot, was a professional stage scenery painter.) Many of them feature actors from the Italian Commedia dell'arte, a 16th- to 18th-century improvisational theater played by comic stock characters like Harlequin, Columbina, and Pulcinella. In Watteau's painting *Love in the Italian Theater,* Harlequin strums his guitar around a glowing torch, while other actors and aristocrats look on in quiet amusement. This painting was actually a little radical for its day, because Commedia dell'arte (which was often risqué) was banned in France during the last years of Louis XIV's reign (from 1697 to 1716).

Watteau's *Gilles and Four Other Characters from the Commedia dell'Arte* (see Figure 15-1) shows a sadder side of the period. Pierrot (a.k.a. Gilles) stands alone on stage to face the viewer, his only audience. He seems to be waiting for applause that he knows will never come. The sad-faced, white-on-white clown has been left out of his companions' revels. With his traditional over-sized clothes, it seems he'll never fit in.

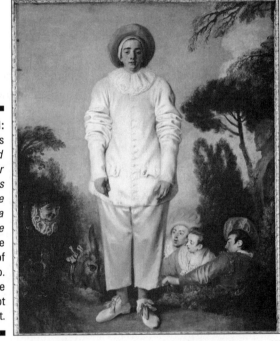

Figure 15-1:
Watteau's *Gilles and Four Other Characters from the Commedia dell'Arte* shows the dark side of the Rococo. Some people got left out.

Erich Lessing / Art Resource, NY

Fragonard and Boucher: Lush, Lusty, and Lavish

François Boucher and Jean-Honoré Fragonard revved up the party. Although they depicted the exhibitionist variety of sex from a sanitized distance in their mythological paintings, they also strongly hinted at it in their painterly transcriptions of day-to-day aristocratic life. Couching sexuality in elegant surroundings made it palatable to the tastes of the day.

François Boucher

The paintings of François Boucher (1703–1770) are so sexy, at least by 18th-century standards, that many of his contemporaries, including Denis Diderot (see Chapter 16), condemned some of them as pornographic. But Louis XV's influential, art-loving mistress, Madame de Pompadour, adored Boucher and his work, so he got away with it.

Boucher's paintings have the look of a rich woman's boudoir, so soft and sensual, they seem to exhale French perfume. In his *Cupid a Captive,* he gently mocks the boy god of love, Cupid, who gets caught in his own snare. Instead of Cupid wounding hearts with his famous flaming arrows, now he's the prisoner of several women in a pleasure garden. His chains are their arms and legs. One of the nymphs has snatched his arrows, rendering him defenseless.

Jean-Honoré Fragonard

Jean-Honoré Fragonard (1732–1806) was Boucher's student, and Boucher's influence shows in some of Fragonard's paintings, including *The Bathers,* which may be even more orgiastic than his teacher's works. But Fragonard also painted sun-suffused landscapes inhabited by powdered nobles, reminiscent of Watteau's work. But even in these paintings, there are erotic undercurrents.

At first glance, *The Swing* (see Figure 15-2) depicts a pleasant afternoon outing: A man pushes a lovely woman on a swing, and a handsome young man sitting in front of her innocently watches. Nearby shadowy *putti statues* (naked, winged infant boys) observe the entertainment as if they were alive and might join in. But the viewer tends not to notice them immediately. The woman's luminous pink dress holds the viewer's attention as she flies through the air, suspended in her pleasure. Closer inspection reveals that one of her shoes has flown off. The wide-eyed man in front of her is dazzled, not because her shoe is flying through the air, but because he can see up her dress. But then again maybe he isn't gawking. This maybe-he-is/maybe-he-isn't tension made the painting both titillating and acceptable. It tightrope-walked the line of 18th-century morality.

Though the intended subtext of the painting is certainly erotic, the unintended subtext is that the rich lived in blissful isolation, cushioned by their pleasures from the tribulations of the poor struggling all around them.

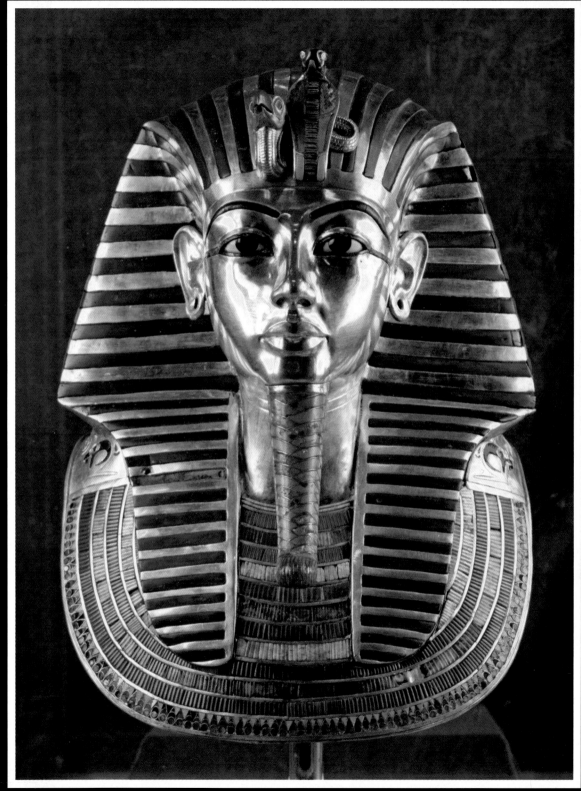

The awe-inspiring funerary mask of Tutankhamun is made of gold inlaid with semiprecious stones and glass.

This detail from Queen Nefertari's tomb in the Valley of the Queens shows the falcon-headed god Horus leading Rameses II's favorite wife on her journey through the afterlife. The seated divinity on the right is Re-Harakhty, a combination of the sun god Re and Horus.

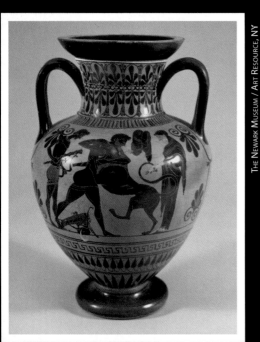

In a life-and-death struggle, Hercules tangles with the Nemean lion (one of his 12 labors) on this black-figure amphora called *Hercules Slaying the Nemean Lion with Aiolos and Athena* (c. 530 B.C.).

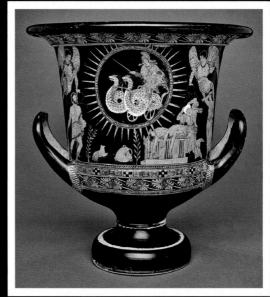

The red-figure *Medea Krater* illustrates the climax of the Euripides tragedy *Medea:* The witch makes her getaway after slaying her sons.

The *Flora* fresco from ancient Stabiae (4¹/₂ miles south of Pompeii) was buried for nearly 1,700 years by ash from the eruption of Mount Vesuvius in A.D. 79. It was recovered during the excavations carried out between 1749 and 1754.

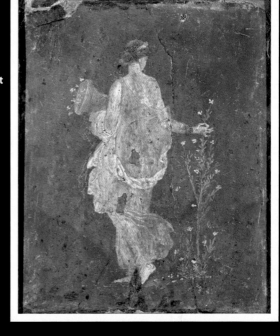

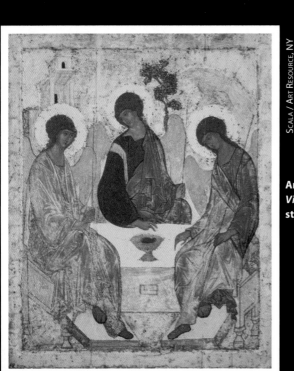

Andrei Rublev's *The Old Testament Trinity (Three Angels Visiting Abraham)* follows the formulas of icon painting but still manages to express an individual style.

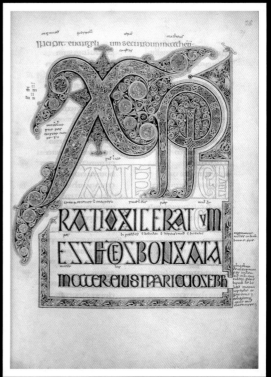

The first page of the Gospel of St. Matthew from the famous Lindisfarne Gospels illustrates the interlaced first three letters of Christ's name in Greek.

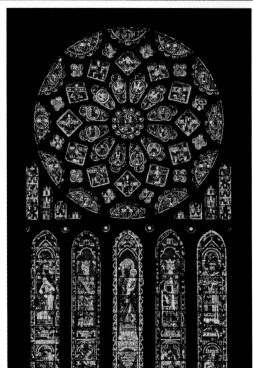

The North Rose window of Chartres Cathedral is a kaleidoscope pattern of religious icons and royal symbols.

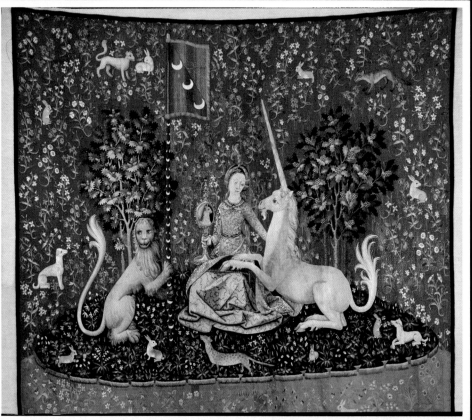

In the "Sight" tapestry of *The Lady and the Unicorn*, the Lady appears to renounce vanities like grooming in front of a mirror.

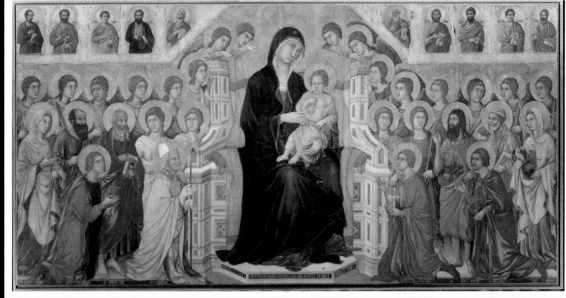

Duccio's *Madonna Enthroned* — the main panel of the Maestà Altarpiece from Siena Cathedral — is a marriage of Byzantine and Northern Gothic influences.

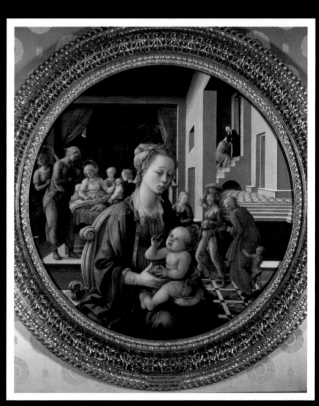

The Madonna and Child with the Birth of the Virgin, by Fra Filippo Lippi, interweaves three stories on one canvas.

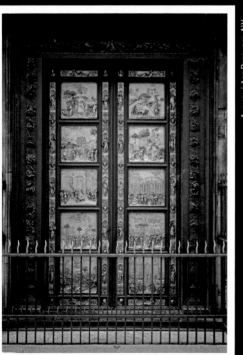

Notice the brilliant use of perspective in Ghiberti's bronze *Gates of Paradise* and how deep the pictorial space is.

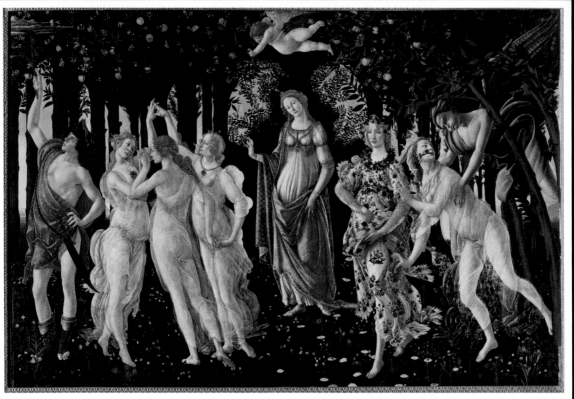

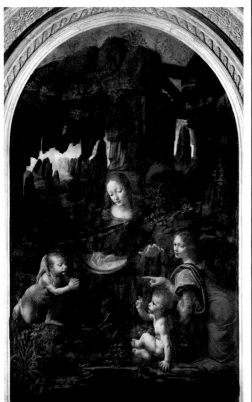

Primavera was supposedly based on Neo-Platonic stories recounted by Lorenzo de' Medici and turned into a poem by the Renaissance poet Politian.

Which baby is Jesus in the Louvre version of *The Virgin of the Rocks?* It's not easy to tell. Jesus raises a finger like a guide, while his cousin John the Baptist prays, worshipping Christ.

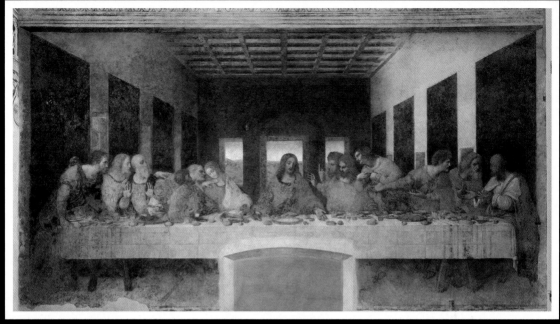

Notice the orderly yet realistic arrangement of the figures in Leonardo da Vinci's *The Last Supper;* this is a typical feature of Renaissance art. Also observe how Jesus's calm solitude contrasts with the animation of the groups of upset apostles.

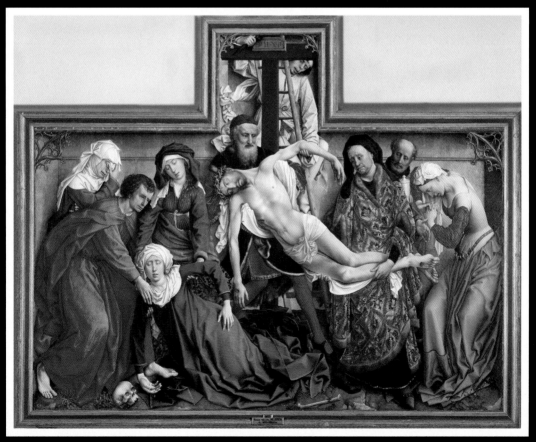

Rogier van der Weyden moves the action to the front of his canvas in his early Late Gothic masterpiece *Deposition (also known as Descent from the Cross),* painted in about 1436.

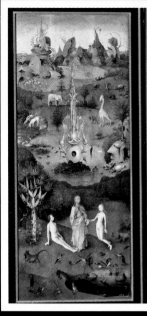

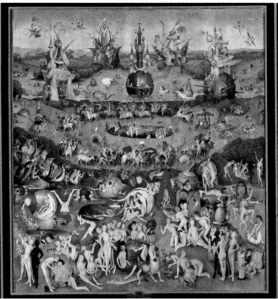

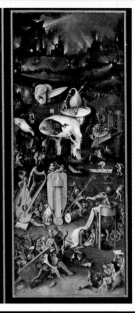

Hieronymus Bosch's *The Garden of Earthly Delights* contrasts the Garden of Eden with a garden of earthly pleasure and an extraordinary vision of hell, where men and women are punished by their pleasures.

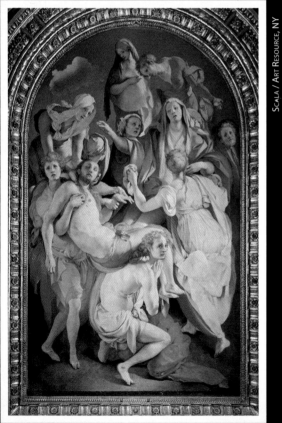

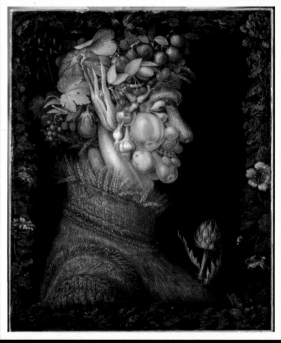

The soft pinks and blues and flowing lines of Pontormo's *Descent from the Cross* (also known as *Deposition*) give the painting a poetic lyricism and otherworldly beauty.

Arcimboldo's portrait of *Summer*, along with his other seasonal busts, launched his career as a Mannerist painter.

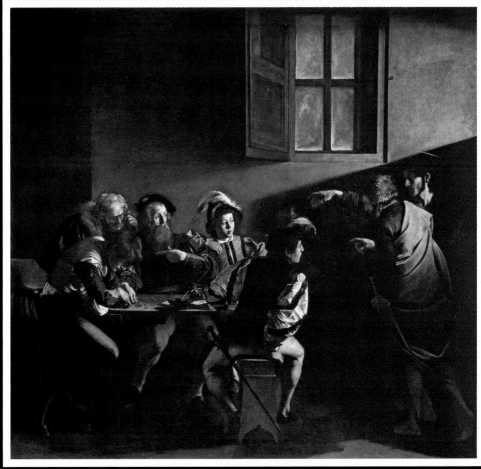

In Caravaggio's *Calling of Saint Matthew,*
Christ enlists the reluctant Matthew as an
apostle. Caravaggio dramatizes the scene
with gestures and slashing lighting that is
both natural and spiritual.

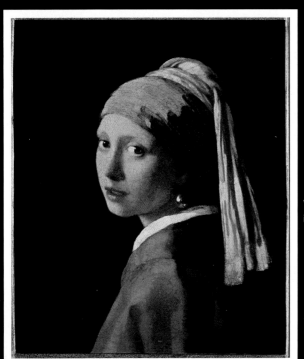

Vermeer's most famous painting, *Girl with a Pearl Earring,*
is often called the "Mona Lisa of the North."

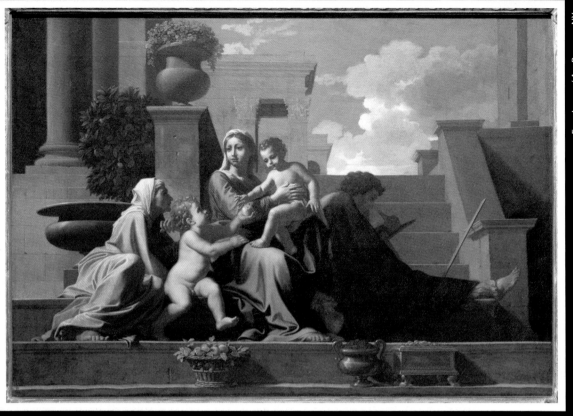

Geometrical precision and serene beauty characterize Nicolas Poussin's masterpiece *The Holy Family on the Steps.*

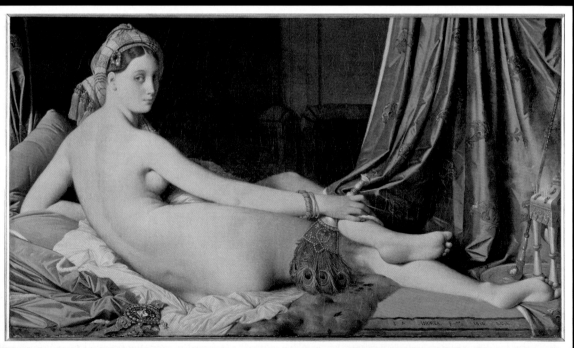

Ingres's *Odalisque* has Mannerist proportions and Neoclassical elegance.

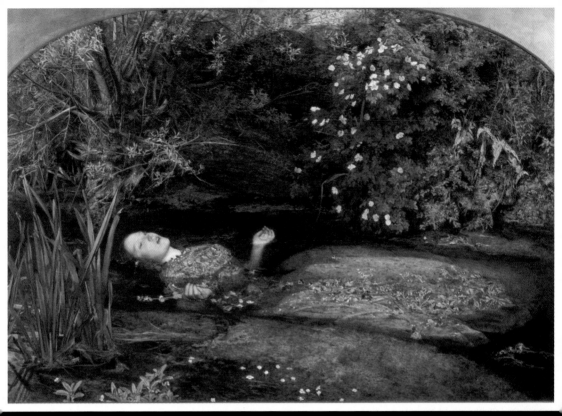

In *Ophelia*, Millais depicts the suicide of the tragic heroine as described by Shakespeare in *Hamlet*.

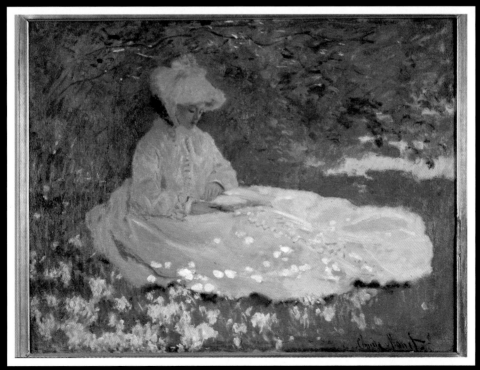

In *The Reader* (also known as *Springtime*), Monet captures a poetic slice of life and the

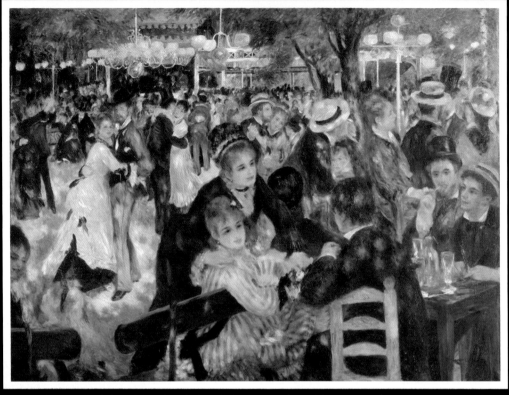

Scala / Art Resource, NY

In Renoir's *Moulin de la Galette,* dappled sunlight dresses the swirling scene of gay dancers at a Paris dance hall on a bright Sunday afternoon.

Degas's *Blue Dancers* is visual music. The colors and forms harmonize like the parts of a song.

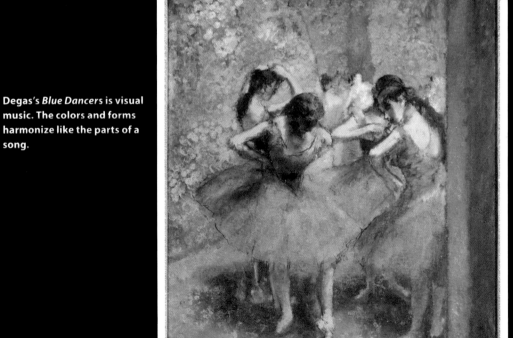

Reunion des Musees Nationaux / Art Resource, NY

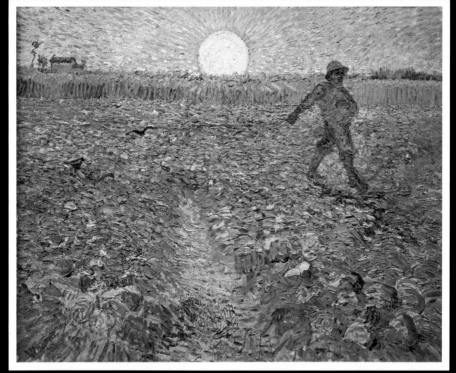

Van Gogh glorifies field work by planting the laborer in a radiant landscape in *The Sower*.

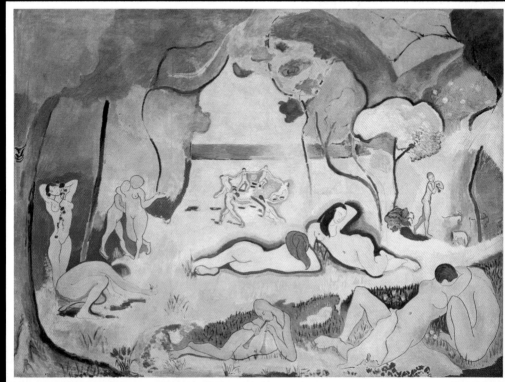

Matisse's Fauve masterpiece, *The Joy of Life*, celebrates life's sensual pleasures in a stylized idyllic landscape. He used garish colors, fluid lines, and gestures to express earthly bliss.

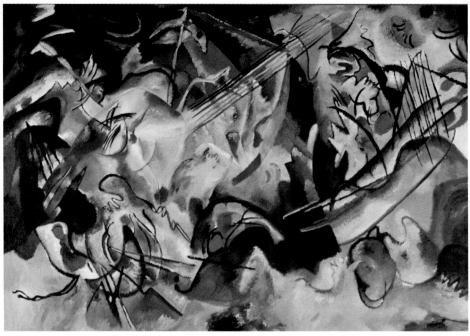

The cymbal crash of colors in *Composition Number VI* is typical of Wassily Kandinsky's nonobjective art. Kandinsky treated color like musical notes in a visual symphony.

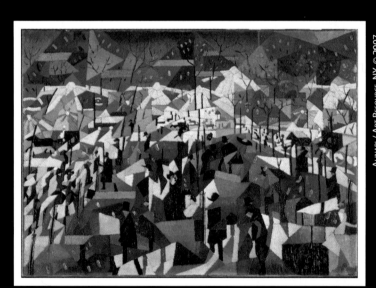

In Gino Severini's Futurist work *The Boulevard,* the crowd of forms (people, buildings, and so on) interpenetrate one another, suggesting the hyperactivity of the modern cityscape.

Gustav Klimt's *Watersnakes* depicts the lithe, golden shapes of women entwined in a sensual, underwater dream.

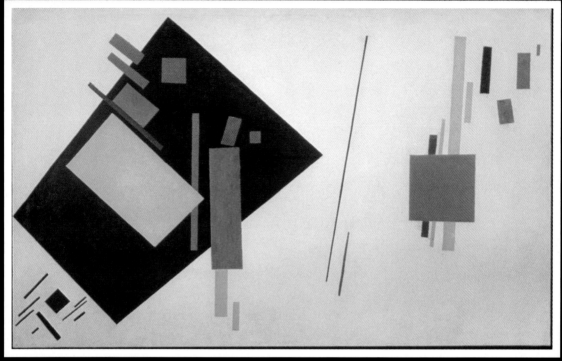

In Kazimir Malevich's *Suprematist Painting, 1915,* squares, rectangles , and quadrangles seem to float in an antigravity chamber.

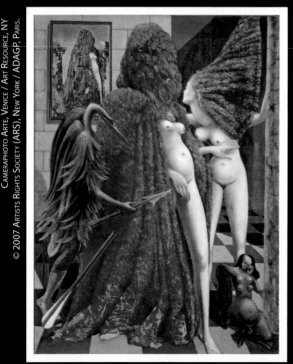

Max Ernst's *The Robing of the Bride* is a confrontation between unconscious dreams and fears in a prewedding ritual.

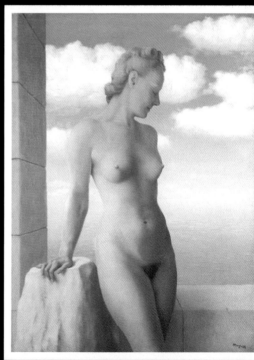

Inviting open windows and intruding skies, as in *Black Magic,* are typical of the Surrealist art of René Magritte, who is famous for his mystifying visual metaphors.

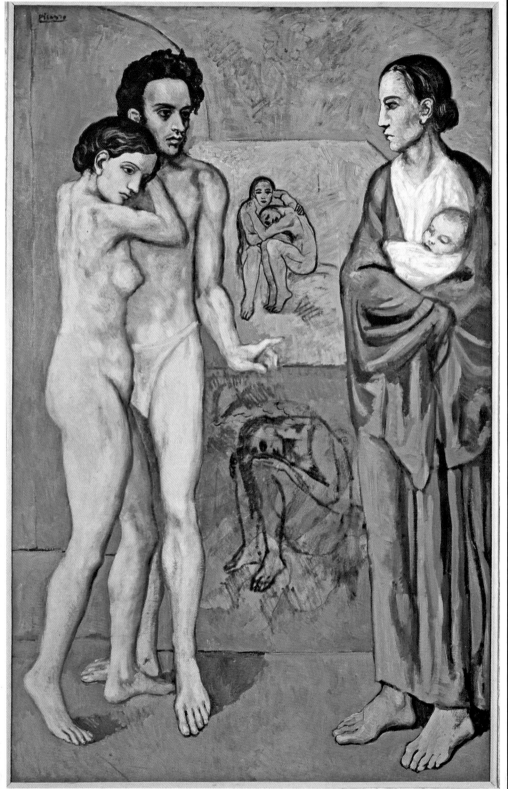

La Vie is one of Picasso's greatest and most enigmatic Blue Period paintings.

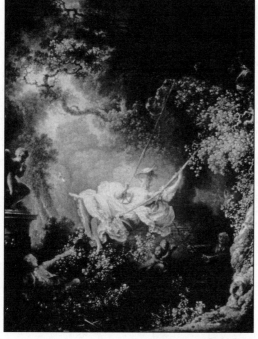

Figure 15-2:
Fragonard's
The Swing
touts
sexuality
behind a
guise of
innocence.

Art Resource, NY

Twenty-two years after Fragonard painted *The Swing*, the French Revolution unleashed the pent-up resentment of the underclasses. By that time, sensual Rococo paintings had fallen out of favor and Fragonard was living in poverty.

Flying High: Giovanni Battista Tiepolo

Giovanni Battista Tiepolo (1696–1770) injected religion back into 18th-century art. He painted many altarpieces for Italian churches in Venice, Milan, Bergamo, and Padua. He is best known for his *frescoes* (painting on wet or dry plaster), which won him international fame.

He painted sumptuous celestial ceilings in palaces and churches all over Europe, including the Kaisersaal in Würzburg, Germany, mentioned at the beginning of this chapter. The main characters in his frescoes are usually pale-colored saints and angels; mythological figures in diaphanous, windswept gowns; or historical figures. Typically, they recline on sun-drenched clouds that float like islands through heaven or Olympus. By the middle of the century, Tiepolo was the most sought-after painter in Europe.

Rococo Lite: The Movement in England

Although Rococo never got a foothold on British soil, English artists still felt its influence like a fresh breeze from across the English Channel. Without becoming flamboyant, a new, lighter look infused English art. The two leading British painters of the period, Thomas Gainsborough and Joshua Reynolds, were both influenced by Watteau, as well as Italian Renaissance and Baroque artists and Dutch and Flemish painting. The third great 18th-century British painter was William Hogarth.

England hadn't had a major painter in 200 years (since Nicolas Hilliard [1547–1619]). In the 18th century, England produced three. Sir Joshua Reynolds, the first president of Britain's Royal Academy of Arts, acknowledged this fact while praising his rival Thomas Gainsborough: "If ever this nation should produce genius sufficient to acquire to us the honorable distinction of an English School [of painting], the name of Gainsborough will be transmitted to posterity, in the history of Art, among the very first of that rising name."

William Hogarth

The woodblock prints of William Hogarth (1697–1764) caricature upper-class Englishmen. Hogarth was one of the few artists of the period who used his talent to critique and mock the upper classes: their excesses, extravagance, and moral depravity. He had trained to become an engraver and later switched to painting. But the engraver in him never died. In fact, he made engravings of some of his paintings so he could sell multiple copies of them. Smart guy.

Like Watteau's work, Hogarth's paintings look like theater pieces — in this case, comedies of manners. He created series of paintings that tell stories like cartoon strips. Each painting is a chapter in the story. His first moral painting series is called *A Harlot's Progress*. It was a sensation. The series chronicles the conversion of a country bumpkin into a city prostitute and follows her gradual decline. Hogarth even depicts the woman's horrid death and funeral — as a moral lesson.

He followed this series with a second hit, *The Rake's Progress*. This painted story follows the moral collapse of Tom Rakewell. In one of the episodes, *The Orgy,* Tom drinks himself into a stupor at a brothel. Though a prostitute caresses his chest, he looks too nauseated to notice. In the dark background, a servant holding out a candle looks on aghast at the scene. Clothes lie about in disarray. Some of the women brazenly hold flasks of rum or whiskey; one threatens another with a knife. Beside them, a client chokes a woman who's flirting with him. The final painting in the series finds Tom Rakewell in a lunatic asylum.

Although Hogarth's paintings and engravings are intended to be moral lessons, his art never feels preachy. Each painting brims with entertaining and often humorous details.

Thomas Gainsborough

The paintings of Thomas Gainsborough (1727–1788) have perfect manners. Everything and everyone is in its proper place. His specialty was portraits of English gentry and aristocrats and wholesome English landscapes.

He began as a landscape painter but found that painting portraits was more profitable. Even so, Gainsborough never abandoned landscape painting. He often placed his country ladies and gents in the sedate English countryside. For example, in his great portrait *Mr. and Mrs. Andrews,* Gainsborough poses the elegantly dressed Andrews couple in a beautiful late-day, countryscape. Mrs. Andrews, attired in a blue taffeta dress and pointed, pink velvet slippers, looks like she's ready to go to the opera, yet she's at ease in her rural surroundings. Mr. Andrews, with his trusty English Whippet at his side, appears ready for a foxhunt. But his elegant white jacket and white hose aren't up for a rustic jaunt. As rural gentry, they're very much in their element. Yet they've obviously never lifted a hoe. They own the land, but they don't work it. In fact, the landscape looks like it's been tamed by his gun and her dress. To facilitate their comfort, Gainsborough planted an ornate wrought-iron bench in the midst of the meadow. The bench on which the lady perches and on which the man leans further separates them from the landscape that they dominate.

The British Empire was on the rise during this period. One hundred and fifty years later, Great Britain ruled a quarter of the world's people. Paintings showing upper-class Englishmen mastering the land were very popular in the mid-18th century.

Sir Joshua Reynolds

Sir Joshua Reynolds (1723–1792) brought Italy to England. He'd studied in Rome from 1750 to 1752 and then taken the Grand Tour of Italy. Highly influenced by Michelangelo, Raphael, Titian, and the Mannerist Giulio Romano, he imported what he called the "great style" to England. As the first president of the Royal Academy of Art, Reynolds helped shape artistic tastes throughout Great Britain.

Near the end of Reynolds's career, he told his students in one of his famous *Discourses,* "I should desire that the last words which I should pronounce in this Academy, and from this place, might be the name of — Michel Angelo."

Reynolds hoped to bring Italian subject matter to England, too — in particular, mythological and historical painting. But British tastes inclined toward portraiture; 16th- and 17th-century foreign painters who'd worked in England, like Hans Holbein and Anthony van Dyck, focused on portraits, helping foster a taste for that kind of painting.

So like his rival Thomas Gainsborough, Reynolds painted portraits. The most striking difference in their styles is in how they posed their models and embedded them in their surroundings. Gainsborough's models sit like they're posing for their picture between sips of tea; the background is just that — background. The sitters don't interact with it. The figures in Reynolds's portraits are almost always active and dramatically or poetically wedded to the landscape.

Reynolds incorporated the landscapes he found in Italian art into his portraits of English lords and ladies, especially after 1760. Often, he placed English women in Italianesque settings accented with a Greek column or bust or a Roman arch or relief. Frequently, the ladies wear flowing Roman gowns and make grand or poetic gestures. Reynolds was so inspired by Romano that he actually borrowed poses and even figures from his paintings. He said, "Genius . . . is the child of imitation."

In *Lady Sarah Bunbury Sacrificing to the Graces,* he transforms Lady Bunbury into a Roman priestess of the Patrician class. Any flaws in the actual woman's features have been corrected. She is as idealized as a Raphael Madonna.

The settings for Reynolds's portraits of men are usually heroic. For example, he depicted the British admiral Augustus Keppel, who fought in the Seven Years' War and the American Revolution, walking boldly along a darkened stone path backed by Gothic scenery and a tempestuous sea.

Hogarth, Gainsborough, and Reynolds did create a world-class English School of painting as Reynolds had hoped. The next great school of English artists, the Pre-Raphaelite Brotherhood, built on their achievements, primarily by rebelling against the aesthetics of Reynolds.

Part IV
The Industrial Revolution and Artistic Devolution: 1760–1900

The 5th Wave By Rich Tennant

"...and so my summer fling with a Dutch painter came to an end. But not before receiving this lovely memento from Vincent himself."

In this part . . .

The Industrial Revolution changed a lot of people's jobs, the way cities looked and smelled, and the way artists made art. All these transformations are interconnected. In this part, you see how art mirrors those changes and how many artists tried to stimulate or provoke improvements in society, some by retreating to the past (the pre-pollution days), some by rechanneling the Industrial Revolution in a more humane and artsy direction, and others by trying to inspire democratic and social revolutions.

Chapter 16

All Roads Lead Back to Rome and Greece: Neoclassical Art

. .

In This Chapter

▶ Seeing how the Enlightenment affected art

▶ Connecting painting and politics

▶ Reading between the brushstrokes

. .

*T*he 18th-century Enlightenment philosophers thought they'd found the light that went out when ancient Rome fell. Reason, not faith, was their torch. It would illuminate man's path to political and social reform, reveal nature's secrets, and elucidate God's plan — if he has one. Enlightenment thinkers advocated natural science and natural religion, all subject to reasonable laws that can be deduced using rational inquiry and the scientific method pioneered by Galileo and René Descartes in the 17th century.

Enlightenment philosophers viewed with horror the faith-driven wars of the Reformation (in the 16th and 17th centuries), which devastated Europe. They witnessed irrational emotionalism and prejudice in their own day that led to religious intolerance, poverty, injustice, and censorship of new ideas in most countries and households. It was time for the pendulum to swing from the heart to the head, from faith to reason.

The German Enlightenment philosopher Immanuel Kant said:

> Enlightenment is man's emergence from his self-imposed immaturity. Immaturity is the inability to use one's understanding without guidance from another. This immaturity is self-imposed when it comes not from lack of understanding, but from lack of determination and courage to use [one's intelligence] without outside guidance. *Sapere Aude!* [Dare to know!] — that is the motto of the Enlightenment.

One hundred and fifty years earlier Galileo Galilei said practically the same thing:

> I do not feel obliged to believe that the same God who endowed us with sense, reason, and intellect intended us to forgo their use. . . .

The Holy Inquisition put Galileo under house arrest for the last nine years of his life for using his reason to contradict the Church's faith-driven geocentric view of the universe ("geocentric" means the sun, planets, moon, and stars revolve around the Earth). Enlightenment thinkers were an optimistic bunch. Despite what happened to Galileo and the fact that many of them were censored, exiled, and imprisoned, most were convinced that man could solve his own problems through calm reason. Today when you tell someone "Calm down and think" or "Look before you leap," you're subscribing to an Enlightenment attitude — whether you realize it or not. Among the greatest and most influential Enlightenment thinkers were John Locke, Voltaire, Jean-Jacques Rousseau, Denis Diderot, Montesquieu, Benjamin Franklin, Thomas Paine, Mary Wollstonecraft, Immanuel Kant, and David Hume. Many of these figures were influenced by the great 17th-century rationalists René Descartes and Sir Isaac Newton.

Voltaire preached freedom of religion and separation of church and state, the right to a fair trial, and civil liberties. John Locke said a "government is legitimate only if it has the consent of the governed" and only if it guarantees the "natural liberties of life, liberty, and estate." Montesquieu advocated separation of powers into three independent but interlinked branches of government. These and other Enlightenment thinkers inspired the American and French Revolutions, the U.S. Bill of Rights, and the French Rights of Man, as well as the U.S. and French constitutions. They inspired democratic and independence movements from Venezuela to Greece, and they turned on "Enlightened monarchs" like Catherine the Great and Holy Roman Emperor Joseph II, who instituted humanistic reforms like abolishing serfdom and building public schools (enlightenment for everybody).

Rousseau called for *didactic art* (art that teaches enlightened ideals) and a return to high-minded *classicism* (beautiful, idealized art that elevates people). He condemned what he considered the frivolous art of the Rococo, especially the playfully erotic paintings of François Boucher.

Enlightenment ideals birthed the Neoclassical art style, which was originally called the "true style," to contrast it with the artificiality of Rococo art, which was fashionable until around 1760 (see Chapter 15).

Johann Joachim Winckelmann, the German art historian and founder of the Greek Revival in art, said the "true style" should have a "noble simplicity and

calm grandeur." Although he wanted to revive Greek art, he rejected carbon copies of it. Instead, he encouraged a recharging of the ancient spirit. He believed this would produce an updated version of Greek art, a marriage of the classical style with Enlightenment thinking — Neoclassicism.

In this chapter, we examine 18th-century art that reflected Enlightenment ideals.

Jacques-Louis David: The King of Neoclassicism

Jacques-Louis David (1748–1825), the greatest Neoclassical painter, was highly influenced by Winckelmann. David's first masterpiece, *The Oath of the Horatii,* exemplified the "noble simplicity and calm grandeur" that Winckelmann advocated.

Grand, formal, and retro

Louis XVI (whose death warrant Jacques-Louis David would later sign during the Revolution) gave David his first big job as a painter. Actually, the king's director of arts and buildings, Count d'Angivillier, presented David the commission on the king's authority. Count d'Angivillier decided that France needed historical paintings with high-minded themes that would inspire patriotism. (The tremors of the coming revolution could already be felt.) The count hired David to paint a historical canvas (the artist got to choose the subject) that would promote unwavering patriotism as the threat of revolution loomed.

David chose to illustrate a fanciful story about an ancient war between Rome and a rival city-state, Alba. Instead of clashing armies, the "war" was simply a showdown between two groups of brothers: the three Horatii boys, who lived in Rome, and their Curiatii cousins who resided in Alba — kind of like an early version of a mob war. He called the painting *The Oath of the Horatii.* In the painting, the father of the Horatii brothers hands them their swords. The weeping women on the right have ties to both bands of young men — the ones we see and the off-canvas Curiatii. One of the women is a Horatii who's engaged to a Curiatii. Another is a Curiatii who's married to a Horatii. It's like two *Romeo and Juliet* stories rolled into one — complete with rhymes! But the moral isn't that love conquers all; it's that patriotism overrides love.

The Oath of the Horatii expresses a rational, geometric sense of order and total commitment to the state, without messy emotion to distort the classical proportions of the figures or the background.

The three classical arches resting on Greek Doric columns frame the action. Nothing spills over the edges of this perfectly composed painting. That would be emotional, sloppy, and anticlassical. David does include some sentiment, but it's reserved feeling — a classical grief, so softened and restrained that it doesn't distort the women's beauty.

Notice that the soft, pliant forms of the weeping women contrast with the three shining swords and the steely men, balancing the painting pictorially and emotionally. Compare David's *Horatii* to Myron's classical *Diskobolus*. Though the discus thrower is performing a strenuous feat, there's no sign of strain on his face, no distortion anywhere to mar the harmony of his perfect form. This comparison should help you recognize the classical look of David's *The Oath of the Horatii*.

David painted the anatomies of the figures in *The Oath of the Horatii* with near scientific precision. It's reported that to get the father's foot right, he redid it more than 20 times!

In his *Essay on Painting* (1765), Diderot said, "There are sublime gestures that all the eloquence of oratory will never express." He recommended that painters include "sublime gestures" in their work that teach moral messages. In *The Oath of the Horatii,* David achieved Diderot's goal. He expressed the "sublime" with an economical Neoclassical body language of gestures. The "oath" itself is the most potent gesture in the painting. The unyielding Horatii practically Nazi-salute their father to indicate that patriotism takes precedence over personal feelings.

In fact, the men appear to have no feelings *other* than patriotism, while the women look as though they're on sedatives.

Propagandist for all sides

During the French Revolution, David quit painting what amounted to propaganda pictures for King Louis XVI and joined the radical Jacobins who overthrew the king. David idolized the Jacobin leader Maximilien Robespierre, the architect of the Reign of Terror. David also signed the king's death warrant in 1792 with most of the Jacobins.

The Reign of Terror was the 11-month purge of so-called counter-revolutionaries during the French Revolution. During this period, between 18,000 and 40,000 people were beheaded or beaten to death by mobs.

One of David's most famous paintings is of his friend and fellow Jacobin, Jean-Paul Marat, who was murdered in his bathtub by the political moderate Charlotte Corday (see Figure 16-1). Corday connived her way into Marat's bathroom by posing as an informant. She claimed that she had a list of luke-warm revolutionaries (moderates like herself), the kind of people Marat routinely carted off to the guillotine. As he scribbled down the names, she pulled out a knife and stabbed him. In David's painting, Marat still holds Corday's letter is his left hand; he grips the pen in his right. The bloody knife lies inches from his body, a more potent weapon than Marat's "bloody" pen, which had sent so many to the guillotine.

The bold inscriptions on the painting read "A Marat [to Marat], David," suggesting that the painting was a tribute to his friend. But the inscription was written as one might sign a letter, so the letter motif comes 'round full circle: Corday delivered a letter (her name is written on it), Marat began copying it and was stabbed, and David turned the whole painting into a farewell letter to his friend.

Notice that the white handle of the knife links it visually to the white feathers of Marat's two quills. The pens are stained with ink; the knife, with blood.

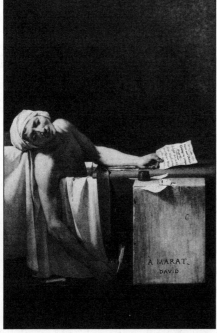

Figure 16-1: David's *The Death of Marat,* painted in 1793, is both a memorial to a friend and propaganda.

Gloria Wilder

The light falling on Marat through the window behind him makes him seem divine, like a martyred saint. He was called one of the three gods of the French Revolution. When Robespierre unleashed the revolution's iconoclastic phase against the Catholic churches, Marat's bust was often put in place of images of Christ.

In the last years of his life, when Marat wasn't sending "enemies of the Republic" to the guillotine, he was soaking in a tub to relieve the symptoms of a terrible skin disease he had probably contracted while hiding from royalists in the sewers of Paris. Perhaps the interminable itch helped to fuel his wrath-of-the-people image.

After Robespierre's fall and execution, David was imprisoned briefly. But he survived to change sides again. The former radical Republican became an avid Napoleon Bonaparte supporter, even after Bonaparte crowned himself emperor. David seemed to gravitate to wherever the power was. He once raved that Napoleon Bonaparte "is a man to whom altars would have been raised in ancient times."

Jean Auguste Dominique Ingres: The Prince of Neoclassical Portraiture

Jean Auguste Dominique Ingres (1780–1867) was David's greatest student. He tried to follow in his teacher's footsteps as a history painter but couldn't cut it. He excelled at intimate, sensual close-up paintings, not sweeping documentary scenes. Ingres was a brilliant, sensitive portraitist, although his greatest works are usually considered to be his female nudes in exotic settings.

When he first exhibited *The Great Odalisque* (which means "female harem slave"; see the color section) in 1819, critics and the public verbally attacked it. But after the initial shock, the painting grew on them. Ten years later, it was a triumph. But in the meantime, Ingres left France to study and paint in Rome, where he did portraits for a living. Business was so good that he refused to paint anyone he didn't like. Later, he moved to Florence, where he received few commissions and lived on the edge of poverty with his wife. Returning to France in 1826, Ingres discovered he was famous.

Although the painting is a Neoclassical masterpiece, *The Great Odalisque* isn't an example of classical perfection. She has mannerist proportions: Her hips are too large; her neck and shoulder line, too long. Her proportions were among the things viewers initially criticized. But the exaggeration is intentional; it makes *The Great Odalisque* seem even more luxurious and languorous. The figure's nearly classical beauty is mixed with a cool, listless sensuality that classical art never had and marks this painting as Neoclassical.

Ingres puts *The Great Odalisque* on display, invites the viewer's eyes to wander over her flesh. Yet her own eyes keep the viewer at a distance. She is a voyeur, too — watching not the viewer, but her master.

The soft pillows and crumpled sheet on the couch are an invitation to plea-sure, yet the slave resists in a soft-spoken way. She modestly covers her bare calf with the drape, as if she would like to cover more. She turns her body away from, and her face toward, her master. The cool blue colors of the drapes and couch, which contrast sharply with her ivory skin, emphasize her lackadaisical sexuality.

Élisabeth-Louise Vigée-Le Brun: Nice and Natural

Instead of participating in or being inspired by the French Revolution, Élisabeth-Louise Vigée-Le Brun (1755–1842) fled from it. She was an excep-tionally talented painter, one of the few women accepted in the French Royal Academy and the personal portraitist of Marie Antoinette, whom she painted about 30 times.

Female artists were expected to paint only women, children, and flowers. Most of Vigée-Le Brun's paintings were of women, though she also did about 200 landscapes. But her portraits are not merely pretty — they capture the characters of her sitters. Her self-portrait with her young daughter shows the tender, close relationship between mother and child, while revealing aspects of each of their characters (see Figure 16-2). The little girl, Julie, is shy, yet innocently intrigued by what she doesn't understand. Vigée-Le Brun's expres-sion is more complex. She didn't like being pregnant because it interrupted her painting. Even on the last day of her pregnancy, she'd hurry back to her canvas and continue working between contractions, which she found "irritating." She seems to recall this in the portrait and appears surprised by the delight that motherhood now gives her, despite the interruptions. The Madonna-and-child pose adds another level of charm, especially because this child is a girl.

Vigée-Le Brun's paintings are windows into the fashions of the period. She tended to dress up her models to suit her taste and usually asked them not to wear powder. She preferred to paint natural skin tones. But even when she was able to persuade the queen to shed her powder, she struggled with the queen's complexion. She noted:

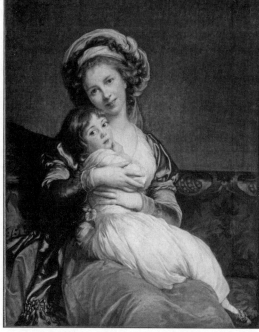

Figure 16-2:
Vigée-Le
Brun's
self-portrait
with her
daughter
captures
the sweet
charm of
an adoring
mother
and her
daughter.

Réunion des Musées Nationaux / Art Resource, NY

The most remarkable thing about [the queen's] face was the splendor of her complexion. I never have seen one so brilliant, and brilliant is the word, for her skin was so transparent that it bore no umber in the painting. Neither could I render the real effect of it as I wished. I had no colors to paint such freshness, such delicate tints, which were hers alone, and which I had never seen in any other woman.

The last painting Marie Antoinette commissioned from Vigée-Le Brun was of her surrounded by her four children. When Louis XVI saw it, he told the artist, "I know nothing about painting, but you make me like it." The French Revolution erupted a year later.

Canova and Houdon: Greek Grace and Neoclassical Sculpture

In many cases, Neoclassical statues look a lot more Greek than Neoclassical paintings. Many of them, especially Canova's, have classical composure, proportions, and grace. And yet Neoclassical statues look newly minted, even today.

Antonio Canova: Ace 18th-century sculptor

Antonio Canova (1757–1822) was the greatest Neoclassical sculptor and the greatest sculptor of the 18th century. Although he was born in Venice, he developed his style in Rome, by studying and copying Ancient Roman statues and reliefs. He also came under the influence of Johann Joachim Winckelmann in Rome (see the introduction to this chapter).

Canova's Roman copies were so impressive that Roman city officials offered him a long-term, well-paid job making copies. Even though he was only 20, Canova refused, saying if he always made copies, he would never learn to become a great artist in his own right.

Instead, he absorbed and then expanded the Ancient Greek style. For example, Canova gave the bodies of *Cupid and Psyche* perfect classical proportions. But their tender, passionate gestures would be out of place on the Parthenon or in a Roman temple. Romans and Greeks kept that emotional display behind closed doors; showing too much feeling was a sign of weakness or craziness.

Diderot recommended that Neoclassical artists use gestures, like actors on the stage, to mime moral truths. *Cupid and Psyche* mime a moral message: Love can overcome death. Cupid revives the dying Psyche with a kiss.

Jean-Antoine Houdon: In living stone

Jean-Antoine Houdon (1741–1828), like Canova, was inspired by Winckelmann and made a trip to Italy to study ancient sculpture. He specialized in sculptural portraits, which have never been surpassed. His statues are so realistic that they look like they might start delivering speeches or writing new laws. He combined a sharply observed realism with an elevated, Neoclassical restraint. He made busts of many heroes of the Enlightenment, including Voltaire, Rousseau, Diderot, the Marquis de Lafayette, Benjamin Franklin, George Washington, and Thomas Jefferson. The sculptures preserve not only their features but also their personalities for posterity.

Sometimes Houdon dressed his figures like Roman senators or consuls. He draped Voltaire, who posed for him just a few weeks before his death in 1781, in a toga. Houdon dropped the classical attire for his statue of Washington and his bust of Jefferson, which he sculpted a little later — Washington between 1785 and 1788 and Jefferson in 1789. Both Americans wear elegant period clothing — the Armani suits of the day. Their poses are presidential and enlightened.

Realism mattered so much to Houdon that he hopped on a boat for the United States to do in-person studies of Washington and Jefferson. Similarly, when he heard that Rousseau had died, he rushed to his wake and made a cast of the dead man's face. Shortly after, he sculpted a lifelike bust of Rousseau from the cast.

Chapter 17

Romanticism: Reaching Within and Acting Out

In This Chapter

▶ Defining Romanticism

▶ Probing within

▶ Understanding the cult of caring

▶ Discovering what Romanticism and revolution have in common

▶ Tracking where Romanticism and democracy cross paths

Many art historians will tell you that Romanticism slips through your fingers when you try to define it. That's partly because Romantic artists didn't have one style like the Impressionists or Expressionists. The movement was about intense personal expression, so artists could focus on whatever turned them on. In addition, the movement wasn't grounded in France or Italy. It spread across most of Europe and later to the United States. Romanticism wasn't merely a visual-arts movement — it included poetry, fiction, and music. There were even Romantic philosophers! The fact that Romanticism was so widespread and diverse makes it hard to squeeze it into one definition.

In this chapter, I define Romanticism partly by telling you what it isn't, and then by exploring the art of the most important Romantics in France, England, and Germany.

Kissing Isn't Romantic, but Having a Heart Is

Romanticism doesn't mean lying dreamy-eyed on a patch of clover, or gazing wistfully into your lover's eyes. It doesn't refer to romance at all. It means being a staunch individualist, believing in the rights of other individuals, and expressing deep, intense, and often uplifting emotions — like Beethoven (he's called a "classical" composer, but his spirit was Romantic to the core). Often,

but not always, it means having a deep, spiritual relationship with nature. "Nature never did betray the heart that loved her," wrote the British Romantic poet William Wordsworth in *Tintern Abbey.*

The most famous Romantic works of art are not paintings, poems, or symphonies, but three novels: *The Hunchback of Notre-Dame* and *Les Misérables,* both by the French writer Victor Hugo, and *Frankenstein,* by 18-year-old British writer Mary Shelley. All three works are outcries against man's inhumanity to man. To drive home the point, the writers magnify the inhumanity so we can see it better. They do this by directing it against outcasts: a hunchback, an ex-convict, and a manmade monster. The more of an outsider someone is, the more people abuse that person.

The Romantic period was the first time in history that art focused on teaching people to care about each other. In this sense, Romanticism was "art with a heart." Romantic artists were also concerned with promoting individual liberty, ending slavery, and supporting democratic and independence movements, like the Greek war for independence from Turkey and the nationalism movement in Italy. To promote democracy in England, the Romantic poet Percy Bysshe Shelley (husband of Mary) said to his countrymen in "Song to the Men of England":

> Men of England, wherefore plough
> For the lords who lay ye low?
> Wherefore weave with toil and care
> The rich robes your tyrants wear?

The French painter Delacroix used his paintbrush to win support for the Greek struggle for independence against the Turkish Empire. His painting *The Massacre at Chios* broadcast the terrible price the Greeks were paying in their struggle for liberty (in 1822 the Turks massacred 42,000 inhabitants of the island of Chios and sold about 50,000 as slaves in North Africa), moving many Europeans to sympathize with the Greek cause. The British Romantic poet Lord Byron put down his pen to help out. He died in Greece from a fever in 1824. Today, Byron is a Greek national hero.

Besides trying to improve social and political conditions, many Romantics went on inward quests to find and express a higher, truer reality than the one that confronts us day to day. These painters and poets became prophets of a new Romantic spirituality. In "A Defense of Poetry," Shelley wrote:

> The great secret of morals is Love; or a going out of our own nature. . . . A man, to be greatly good . . . must put himself in the place of another and of many others; the pains and pleasures of the species must become his own.

Many Romantics believed that there was a basic goodness in man buried under layers of socialization. The idea was largely born in the brain of Jean-Jacques Rousseau. In his influential book *The Social Contract,* he wrote, "Man is born free, and everywhere he is in chains."

Rousseau said man was naturally good and honest (innocent as a babe) and that society made him bad. His *Social Contract* started a "back-to-Eden" movement, and a lot of the Romantics got onboard. Rousseau's ideas spurred the cult of the *noble savage* (Tarzan is an early 20th-century example), the natural man, born in the wild and unpolluted by socialization. The noble savage was natural, good, honest, and free — just like Tarzan and Mowgli in *The Jungle Book.*

Originally, *Romantic* also meant the opposite of classical. Classical is calm, orderly, even serene like the *Venus de Milo* (see Chapter 7). Romantic is wild — a painting or poem bursting at the seams with energy, meaning, and often intimations of something spiritual.

Neoclassical artists like Jacques-Louis David and Jean Auguste Dominique Ingres felt that excessive emotion undermined the classical cool of Greek art. They preferred artwork that kept its composure (as opposed to wild, Romantic paintings that seemed to muss up your hair when you looked at them). The Neoclassical painter and president of the conservative London Royal Academy Sir Joshua Reynolds said, "If you mean to preserve the most perfect beauty in its most perfect state, you cannot express the passions, all of which produce distortion and deformity, more or less, in the most beautiful faces."

Way Out There with William Blake and Henry Fuseli: Mythologies of the Mind

William Blake (1757–1827) was a Romantic poet-painter. His artworks are both paintings and poems; the images help carry the poem's meaning and vice versa. Nevertheless, many people view the literature and paintings separately, but this is not what Blake intended. For him, art was a form of prayer. The paintings were the right hand in his prayer; the poetry the left. Blake also printed his work himself (partly to keep editors from altering his work) with an engraving method he developed and called *illuminated printing.*

Conventional religion split body from soul, designating one evil and the other good; while the priests of the Enlightenment separated emotion from reason, viewing reason as good and emotion as bad. For Blake that was tantamount to shutting down one half of the brain to make a decision (though people didn't think in terms of the right and left sides of the brain in those days). In his complex mythology, Blake reconciled the world of the spirit and senses, and of emotion and reason. His was a personal cult of the unified and universal human being.

To Blake, Sir Isaac Newton's celebrated rationalism was the epitome of half-headed thinking. So he painted a nude of Newton that shows the rationalist at war with himself (see Figure 17-1). Using his rationalist's "weapon," a compass, Newton divided and compartmentalized life (where Blake would unify it).

Figure 17-1: Blake painted Sir Isaac Newton with pen, ink, and watercolor in 1795. He made Newton resemble an Ancient Greek, like Euclid or Archimedes.

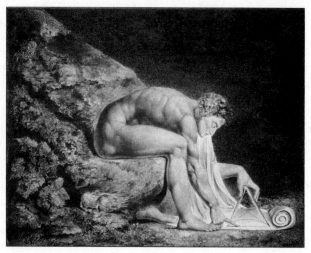

Tate Gallery, London / Art Resource, NY

But Newton's muscular body (Blake was inspired by Michelangelo's Mr. Universe nudes on the Sistine Chapel Ceiling) wants to flex and burst out of the restrictions of rational thinking that Newton places on himself and nature. At the same time, Newton's body sides with his reasonable mind. It mimics the compass's triangular shape and rigidity. The right thigh, knee, and calf form a triangle; the forearm, wrist, and thumb form another triangle (one that's awkward to imitate, though Newton's hand looks accustomed to the strain). The fingers form a triangle with one leg of the compass, and so on. The composition itself is divided into two roughly triangular shapes of dark and light.

Blake's friend, John Henry Fuseli (1741–1825) liked to probe all aspects of the human psyche, too. But he seemed most comfortable with the dark side of the imagination. His painting *The Nightmare* appalled many British Royal Academy artists, but the public loved it.

The dreaming woman's white nightgown and light skin sharply contrast with the black monsters that invade her dreams, suggesting a battle between purity and evil. But is the evil in the woman's mind or on her chest? Her body participates in the sensuality with the masked demon or Incubus squatting on her chest and pawing her breast. Yet her face registers terror. The terror and title suggest that the demons are only in her mind. On the other hand, some critics believe the leering, phantasmal horse represents the artist, and the nightmare may be Fuseli's. His girlfriend rejected him and married another man about a year before Fuseli painted the first version of *The Nightmare*. He did four; it seems he couldn't get her or the nightmare out of his head!

Fuseli used both Romanticism and Symbolism to probe the darkest dungeons of the mind. Later in this chapter, I show you how Goya did the same.

Inside Out: Caspar David Friedrich

The German Romantic painter Caspar David Friedrich (1774–1840) used to stand in front of a blank canvas and wait for the painting to appear in his mind. He told a fellow artist and friend, "Close your bodily eye, so that you may see your picture first with the spiritual eye. Then bring to the light of day that which you have seen in the darkness so that it may react upon others from the outside inwards."

Friedrich's landscapes are visionary bridges between the internal and external. There's a dramatic tension between these worlds. But in spite of the drama, nothing ever happens in the paintings — there's no physical action. In *The Wanderer Above the Mists,* a lone figure takes a tentative step toward a windswept, snowy landscape that somehow seems to mirror his soul. It's as if he were about to walk into himself, his spiritual self, but he hesitates. He's attracted to the frigid landscape, but the attraction isn't powerful enough to incite him to take the fateful step. The wanderer seems to confront a spiritual frontier that is frigid and desolate as death.

In *Monk by the Sea,* Friedrich depicts a similar theme. A lone monk stands contemplatively on a beach gazing at a night-blackened sea. A curtain of dark mist hangs ominously over the water. Like the figure in *The Wanderer Above the Mists,* the monk turns his back on the viewer to absorb and be absorbed by a sublime yet inhospitable vista. The bleak beauty attracts him and seems to foreshadow death, perhaps his own.

Friedrich suffered a string of heart-rending tragedies in his youth. His mother died when he was 7 years old. Six years later, his older brother drowned trying to rescue Friedrich, who had fallen through the ice while skating. One of his sisters died of typhus four years after that, and another passed away a few years later. Death closed in on Friedrich at a young age, and it haunts all his art.

The Revolutionary French Romantics: Gericault and Delacroix

The powerful and majestic paintings of Théodore Gericault and Eugène Delacroix, two of the greatest Romantic artists, are associated with revolutionary fervor. Gericault is the father of French Romanticism, while Delacroix is its greatest practitioner.

Théodore Gericault

Théodore Gericault (1791–1824) was the first of the great French Romantic painters. He painted his most celebrated work *Raft of the Medusa* (see Figure 17-2) in 1819, when the second generation of British Romantic poets (Byron, Shelley, and Keats) was writing its most celebrated works. Like them, he was born between 1788 and 1795, and like them, he died young.

Raft of the Medusa is a kind of documentary of the aftermath of a shipwreck, with all the drama compressed into one scene. The French ship *Medusa* sank off the coast of Senegal on June 17, 1816. The captain and officers took the ship's six lifeboats for themselves and strapped together a raft made of masts for the crew and passengers. The lifeboats towed the raft for a while, but it slowed them up so much that they cut it loose. Though the raft was only 4 miles offshore, a rescue ship didn't reach it for 13 days! By that time, only 15 out of 130 men were still alive. Some had resorted to cannibalism to survive.

The ship captain was a royalist of the restored Bourbon monarchy (1815–1830). To many French people, his neglect of the passengers seemed like a throwback to the "let them eat cake" attitude of the pre-Revolution aristocracy. Gericault's painting seemed to incite revolution because it illustrated the heroics of the suffering lower classes in the face of aristocratic injustice and death.

Although pain wracks the faces and bodies of the men on the raft, Gericault mixes their agony with a muscular hope. A romantic light gilds their sprawling bodies and turns the distant sky gold. The black man on top (Jean Charles) desperately signals the far-off ship through the storm. Gericault makes him the hero. Though he comes from the lower strata of society, he has the highest place in the picture. He is the ideal Romantic hero, breaking free from the chains of class to rescue his brothers. Jean Charles died a few days after being rescued.

Figure 17-2:
Raft of the Medusa, one of the most imposing master-pieces of French Romantic painting, is Gericault's most ambitious painting.

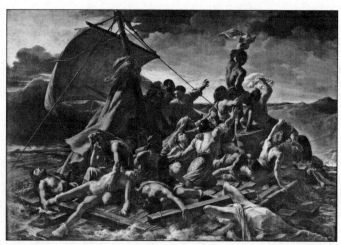

Scala / Art Resource, NY

The massive 23-foot-long painting shocked many people. Its biggest critic was the Neoclassical painter Jean Auguste Dominique Ingres (see Chapter 16). Ingres demanded that the painting be taken down from the walls of the Louvre so that it wouldn't "corrupt the taste of the public which must only be conditioned to the Beautiful. . . . Art must be nothing but Beauty and teach us nothing but Beauty." Ingres's dislike for Gericault's masterpiece mushroomed into a general dislike for Romantic painting and triggered an art war between the Neoclassicists and Romantics. After Gericault's premature death at 32, Ingres focused his attacks on Gericault's successor, Eugène Delacroix.

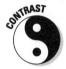

Compare the classical composure of Ingres's *The Great Odalisque* (see the color section) and David's *Oath of the Horatii* with Gericault's *Raft of the Medusa* (refer to Figure 17-2). David's painting expresses a rational, geometric sense of order. In the Gericault canvas, chaos reigns. The frame can't hold back the explosive energy; it spills beyond it and seems to engulf the entire world.

Eugène Delacroix

Five years after painting *Raft of The Medusa,* Eugène Gericault (1798–1863) died following a riding accident. He was 32. Delacroix, who had idolized him, became the new leader of French Romanticism. Delacroix actually posed for Gericault's *Raft of the Medusa* — he's the dead guy lying face down front and center.

Two of Delacroix's early masterpieces, *Death of Sardanapalus* and *Liberty Leading the People* (see Figure 17-3), took the art world by storm and showed that a new light had dawned in European art.

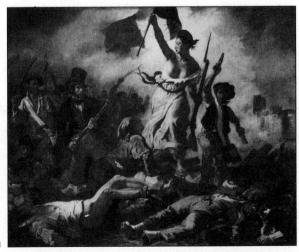

Figure 17-3: Delacroix's *Liberty Leading the People* is an icon of the French spirit.

The French flags

After the 1830 Revolution, the tricolor flag replaced the white flag of the Bourbon dynasty as the official flag of France. It had been the French flag from 1794 until the death of Louis XVIII in 1824. But Louis's undemocratic brother and successor, Charles X, restored an absolute monarchy and replaced the tricolor flag with the traditional white flag of French kings. Delacroix's painting *Liberty Leading the People* celebrates the return of the tricolor flag, which represents the return of the liberties won during the revolution of 1789. But the revolution of 1830 didn't bring as much change as people had hoped. After the smoke settled, voting privileges were extended merely to the top layer of society — only the 200,000 wealthiest male citizens could vote. France was a constitutional monarchy again. Universal male suffrage came with the next revolution, in 1848.

In *Liberty Leading the People,* a female personification of Liberty rallies the common people to fight for justice in the three-day revolution of 1830. Delacroix painted *Liberty* a few months after the July Revolution against the restored Bourbon monarchy. While working on it, he told his brother in a letter, "If I haven't fought for my country, at least I will paint for her."

Lady Liberty in the painting makes non-French people think of a topless Joan of Arc fearlessly raising the French tricolor flag to rescue her nation from tyranny. To the French, she is Marianne, the symbol of French liberty.

Although Delacroix was a well-known colorist, the tones of the painting are dull and flat, making it look like it's covered by the dust and smoke of battle. Compare the dusky colors of *Liberty Leading the People* to the glowing flesh tones and the rich oranges and reds in *Death of Sardanapalus.* But the brown hues are perfect for *Liberty.* They're the colors of the common people. Almost all the color in the painting seems to be sucked up into the flag and the red lips of Liberty/Marianne.

Liberty Leading the People has become a French icon and symbol of French liberty — like the Statue of Liberty in the United States, which was a gift from the French. The painting was so inflammatory in the revolution-ridden 19th century that it was hung up and taken down more than once. It wasn't placed on permanent display in the Louvre until 1874. By then, the dust of the French revolutions had finally settled.

Delacroix's *Death of Sardanapalus* was based loosely on *The Tragedy of Sardanapalus,* a play by Lord Byron, whom Delacroix adored. In Delacroix's version, the Assyrian King Sardanapalus, realizing that defeat and death are imminent during a siege by the Persians, decides to massacre his attendants and concubines before the Persians do, and then commit suicide. In the play,

Byron depicts Sardanapalus as a lazy, luxury-loving effeminate king whom he calls "the Man-Queen." But the king doesn't order the slaughter of his attendants in the play; he frees them. The lusty massacre is Delacroix's invention. Romantics didn't copy — they used literary sources and historical events as launch pads for a personal vision.

In the painting, Sardanapalus watches the massacre as if he were looking at a painting of it: an erotic harem scene turned into an orgy of violence. Of course, he knows he's next. Although the painting has some of the tumultuous energy of a grand Rubens canvas (Delacroix was inspired by Rubens — see Chapter 14), the swirling symphony of intense, conflicting emotions is Romantic. The women's sensuous, naked bodies emphasize their vulnerability, as well as the brutality of this "merciful" act of the king's. The besiegers would have presumably been even more violent. The ferocious and dynamic energy of the painting is powered by the red bedspread that flows like a river of blood from the head of the bed at the top left — where the king props himself on a pillow to watch the massacre — to the naked maiden being slaughtered at the foot of the bed on the bottom right.

Delacroix's attraction to exotic, Oriental themes (which at first derived from literature) was further fueled by a visit to North Africa and Spain in 1832. His trip influenced his brushwork and colors, too, which became more expressive and intense, as in *Combat of the Giaour and the Pasha*. Gradually, painting emotion took precedence over delineating precise form (as in Expressionism, which Delacroix influenced — see Chapter 21). Delacroix began to blur the edges between figures and their surroundings so that their emotions appear to spill from them into the atmosphere and landscape. He achieved this effect with highly energetic brushstrokes, each a transcription of pure feeling. He no longer relied entirely on composition and color to create a sense of turbulence (as in *Death of Sardanapalus*); now his brushwork unleashed energy, too, as in *The Lion Hunt* and the 1846 version of *The Abduction of Rebecca*. In *The Abduction of Rebecca* (based on a scene from Sir Walter Scott's Romantic novel *Ivanhoe*), all the colors, action, and intense emotion seem caught in a whirlwind spun by his agitated brushstrokes, which also influenced the Impressionists (see Chapter 19).

Francisco Goya and the Grotesque

Francisco Goya (1746–1828), the greatest Spanish painter since Diego Velázquez, came of age during the reign of Charles III (1759–1788). Charles III was one of the so-called "Enlightened monarchs," who passed reforms to improve conditions for the common people. He also suppressed the excesses of the Spanish Inquisition. Goya grew up absorbing Enlightenment ideals that filtered from France and England into Spain. When Charles III died, his unenlightened son, Charles IV, nixed most of the reforms.

Actually, Charles IV didn't nix the reforms. The nixing was simply done in his name. Charles preferred hunting to politics. His domineering queen and her lover ran the show. They also banned French books and reignited the fires of the Inquisition.

Goya, by then a fully ripened liberal, attacked the new regime and the highly sensitive Inquisition with a series of 80 etchings that he called *The Caprices*. The etchings include images of people being tortured by the Inquisition with sarcastic captions explaining the victims' petty crimes: "For having been born a Jew," "For speaking a foreign language," "Because she was too sensitive."

The most famous of *The Caprices* — *The Sleep of Reason Produces Monsters* — shows what happens when the Enlightenment ideal of reason passes out or is suppressed. Ghoulish, big-eyed owls crouch over the image of dozing Reason, while bats hover above him like winged omens of evil. In spite of the etchings, the queen gave Goya a job as court painter the same year he published *The Caprices* (1799).

In 1792, Goya fell gravely ill with a fever that left him deaf for the rest of his life. The deafness isolated the artist, perhaps causing him to retreat more and more into the darker side of his imagination.

When Napoleon pounced on Spain in 1808, Goya and many other liberals celebrated, believing that Napoleon's troops carried the ideals of the French Revolution in their gun barrels. To an extent, they did. Napoleon put his big brother, Joseph, on the throne. Joseph gave the Spanish a new constitution and suppressed the Inquisition's Reign of Terror. But soon a rumor circulated that the French were planning to kill the royal family (as they had in France). The rumor sparked an insurrection that the French troops brutally suppressed with their gun barrels.

Goya never forgot the punitive massacres of Spanish citizens. Six years later, after the Spanish restoration, Goya painted two documentary oil paintings to commemorate the Spanish resistance during the uprising: *Second of May, 1808* and *Third of May, 1808* (see Figure 17-4). On the night of May 3, the French soldiers rounded up Spanish insurrectionists and locked them in a convent. Early the next morning, they dragged them out and executed them. The grim painting depicts the firing squad as a faceless machine of brutality, systematically massacring group after group. The frightened yet defiant victims fight back the only way they can, with their eyes. Their humanity glares down the barrels of the guns, teaching the firing squad what liberty really means. But, of course, a machine can't learn. When asked why he painted such a brutal work, Goya replied: "To warn men never to do it again."

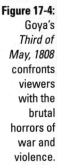

Figure 17-4:
Goya's
*Third of
May, 1808*
confronts
viewers
with the
brutal
horrors of
war and
violence.

Scala / Art Resource, NY

In 1815, the Inquisition summoned Goya about a nude painting he'd done 18 years earlier, *The Nude Maja*. Apparently, they'd been waiting to get at Goya. The Inquisition released him, but Goya grew bitter and lost faith in his fellow man's ability to change. Revolutions and Enlightenment didn't seem to work. He retired to a country house outside Madrid in 1819. A year later, he decorated the walls with his nightmares, his so-called "Black Paintings." The owls and bats in *Sleep of Reason Produces Monsters* had crawled out of the background of his imagination into the foreground. He no longer depicted Reason as napping in his paintings — it had fled the world.

J. M. W. Turner Sets the Skies on Fire

Catastrophes inspired J. M. W. Turner (1775–1851). When he heard that the London Parliament was on fire, he rushed to the scene armed with his watercolors to capture the chaos on paper. He also liked to paint whipped up seas, turbulent clouds, and fiery sunsets.

Atmosphere and light were Turner's specialties, especially when riled by storms and raging winds. Academic British painters criticized him for over-dramatizing natural scenes rather than calmly capturing the solid reality of forms. Only the English critic John Ruskin truly appreciated Turner's genius. He said his paintings either evoked "the poetry of silence and calmness" or "turbulence and wrath." Very rarely was there anything in between.

Turner's painting *The Slave Ship,* painted in 1840, six years after Parliament abolished slavery in all British colonies, reveals his "turbulence and wrath" side. The sinking sun appears to have set the sky on fire (which apparently burned more beautifully than the London Parliament). The sky's dazzling beauty overwhelms the viewer. The russet and black clouds on the left seem to be the smoke from this celestial fire. The sea is coppery gold. The painting's beauty draws the viewer into it. Then a gruesome reality comes into focus: helpless hands wave at the viewer through the waves. The ship's captain ordered his crew to toss sick slaves into the boiling sea! Now the blood-red sky, instead of being beautiful, looks like nature's reaction to the brutality. (The painting was based on an article Turner read about a slave trader throwing sick slaves into the sea so they'd be covered by his insurance policy. Slaves killed by disease weren't insured.)

Notice that the white light near the center looks vaguely like a radiant angel walking from the horizon onto the sea. This hint of transcendental beauty attracts the viewer to look at the painting again and again, forcing him to revisit the horrific event.

The critic John Ruskin bought *The Slave Ship* and hung it in his house for years, until he could no longer bear the horror and took it down.

Chapter 18

What You See Is What You Get: Realism

In This Chapter

▶ Facing life without rose-colored glasses

▶ Grasping the revolutionary nature of realism

▶ Finding majesty in the mundane

▶ Interpreting Pre-Raphaelite symbolism

"**K**eep it real" is a modern expression, but not a modern idea. People have felt the need to deflate exaggeration and filter out bias since, well, probably the cave days when some braggart returned from a hunt claiming he'd bagged 50 bison by himself.

In the mid-19th century, artists in France began to feel that Romanticism and Neoclassicism had stretched the truth or overlooked it. The French artists felt that the Romantics distorted reality by projecting their sublime emotions onto landscapes and people, or that they painted exotic locales instead of their own backyards (for example, Delacroix's *Death of Sardanapalus* is set in ancient Babylon).

The leader of the Realist movement, Gustave Courbet, said, "I cannot paint an angel because I have never seen one." He'd never seen Babylon either and wasn't about to paint it. The Realists grounded themselves in the ordinary, capturing day-to-day life on their canvases: laborers breaking up rocks, peasants hoeing a field, a baker lounging on a sack of flour.

Realists also rebelled against Neoclassicism and its idealized forms and subjects. They weren't about to dress farmers in togas or soften emotion, for fear of distorting the harmony of the human form! They painted straining muscles and weathered, impoverished faces — as well as pretty ones. In other words, they kept it real.

Revolutions of 1848

The year 1848 was a year of revolutions. They detonated all across Europe in Paris, Berlin, Budapest, Vienna, Milan, Venice, and Prague. Many of the revolts occurred just a few days apart.

Who lit the match that ignited all these uprisings? Europe suffered from economic depression and crop failures in the 1840s. Sparse harvests made food prices skyrocket, and people starved. Dreadful working conditions prevailed in factories, and Socialism offered a hopeful solution with its slogan "Workers Unite." The combination of these forces lit the first explosion and the rest went off in a chain reaction.

Most of the revolutions flopped. But they set the tone for change, which progressed at a snail's pace over the next few decades. The French Revolution of 1848 was somewhat successful. All men over 21 could finally vote, and they replaced their king with an elected president, Louis-Napoleon. France was a republic again. But four years later, Louis-Napoleon overthrew his own government and became Emperor Napoleon III.

On the other hand, like the Romantics, many French Realists were driven by the desire to reform society, to make life fairer for the little guy, especially the peasant and factory worker. In 1848, another revolution erupted in Paris, overthrowing France's last king, Louis-Phillipe, the so-called "Citizen King." This was a revolt of the working class. They won the revolution, got the vote, and elected a president, but working conditions stayed the same.

In France, the revolution of 1848 fired up Realist painters like Gustave Courbet, Honoré Daumier, Jean-Baptiste-Camille Corot, and Jean-François Millet. They continued the fight with their paintbrushes, democratizing art by painting the poor and mixing social classes on their canvases. That was a provocative thing to do considering that, in 1832, Daumier was thrown in prison for six months for a caricature of the king. The cartoon shows a gargantuan version of King Louis-Phillipe with a 40-foot plank extending from his open mouth like an elongated tongue. Emaciated workers load carts of materials which are wheeled up the plank, suggesting that the king stuffs himself with the produce of the working class while they starve.

In this chapter, I explore works by the leading Realist painters, including the Barbizon school and Hudson River school, as well as the British Pre-Raphaelites, and see how prevailing social conditions affected their work.

Courbet and Daumier: Painting Peasants and Urban Blight

Gustave Courbet and Honoré Daumier were the most political of the Realists. Courbet told a newspaper after the Revolution of 1848, "I'm not only a Socialist, but a Democrat and a Republican . . . a supporter of the whole Revolution!"

Gustave Courbet

In 1847, Gustave Courbet (1819–1877) visited Holland. The paintings of every-day people by Frans Hals, Rembrandt, and Jan Steen inspired him. Courbet wanted to do the same kinds of paintings in France.

One day, Courbet noticed two men hacking up rocks on a dirt road. He sketched them on-site and invited them to his studio to pose so he could turn his sketch into a painting. Apparently, they brought along their lunches to pose, too: a soup pot, a loaf of bread, and a spoon. Instead of Romantic vistas of nature like in J. M. W. Turner's *The Slave Ship* or Caspar David Friedrich's *The Wanderer Above the Mists* (see Chapter 17), Courbet relegates nature — a shady hill, a patch of wheat, and a couple bushes — to the background. The focus is on hard work. Even the laborers' personalities don't matter. The young man's face turns away from the viewer; a hat hides the older man's shadowed features. They are simply generic workers.

When he showed *The Stone Breakers* (see Figure 18-1), Parisian society found it crude, as some people today might be turned off by a painting of a road crew drilling pavement with jackhammers. In those days, upper- and middle-class people preferred to avert their eyes from the gritty side of daily life, not see paintings of it in galleries. *The Stone Breakers* reminded them of the recent working-class revolution. Harmless as it looks to us, the painting was perceived as a threat — and Courbet probably meant it to be. In a letter to a friend, written in 1850, he said, "In our very civilized society, it is necessary for me to live the life of a savage. I must be free even of governments. The people have my sympathies. I must address myself to them directly."

In addition to painting ordinary people and nature scenes, Courbet gave his works a rough finish so they'd look grittier, like real life. No glazed veneer, no makeup — just the naked truth.

Figure 18-1:
Courbet's
*The Stone
Breakers*
captures on
canvas the
gritty side of
everyday
life.

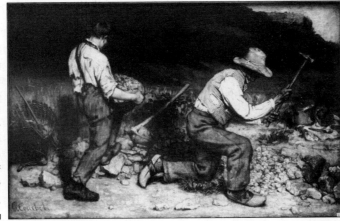

Foto Marburg / Art Resource, NY

Official art

The governments of most European countries sponsored official academy exhibitions throughout the 18th and 19th centuries. These exhibitions were usually the only venues in which artists could show their work. The exhibitions typically showcased art that followed the rules, not art that broke new ground. In France, the official exhibition was called the Salon of Paris and was held in the Louvre. If you couldn't get into the Salon, most likely no one would see your work.

At first, the exhibitions were held annually, then biannually. In 1863, the Salon rejected the work of so many artists, including famous ones, that Napoleon III established the Salon des Refusé (Gallery of the Refused) for artists whom the Salon rejected. The Salon des Refusé was held periodically over the next 20 years.

Honoré Daumier: Guts and grit

Honoré Daumier (1808–1879) shared Courbet's views, but instead of painting country scenes, he focused on city life. His brand of Realism tends to be expressionistic. Capturing mood and character was more important to him than detailed realism. Blurry backgrounds and heavy shadows are typical features of Daumier's work. His painting *The Third-Class Carriage* almost seems like a sketch. Daumier shows us the care-worn faces of the poor, including that of a small boy. Years of hardship are etched on the old woman's face. The basket on her lap and her central position suggest that she is the bread-winner of this small family. Perhaps the breast-feeding mother isn't married. The background characters don't need to be sharply focused in order for the viewer to understand how they feel in this crowded, claustrophobic carriage. The brown tones, dirty yellow light, and sketchy look of the painting allow you to feel the texture of poverty and travel back in time to a typical urban scene in mid-19th-century France.

In his lifetime, Daumier was known for his caricatures much more than his paintings. Lithography was invented just in the nick of time — ten years before Daumier's birth. He mastered the medium and became one of France's greatest lithographers and caricaturists. Most of his caricatures mocked government officials, autocratic laws, and middle-class mores. As mentioned in the first section of this chapter, one of them got him thrown in jail for six months. A few years later, Daumier created a lithograph depicting the government's violent suppression of a strike. In response, the king ordered all copies of the image to be destroyed.

Experimental Communism: The Paris Commune

In 1870, Napoleon III declared war on Prussia, and the Franco-Prussian War erupted. Within a year, France lost and Napoleon's government fell. For 72 days after the signing of the peace treaty, a Socialist government called the Paris Commune ruled the capital. Gustave Courbet was one of the Commune's 92 leaders. Courbet's most remembered action as a Commune member was to recommend that the Communards knock down the Vendôme column, because it had been built to memorialize Napoleon I's military victories in Italy. Courbet said:

> In as much as the Vendôme column is a monument devoid of all artistic value, tending to perpetuate by its expression the ideas of war and conquest of the past imperial dynasty, which are reproved by a republican nation's sentiment, citizen Courbet expresses the wish that the National Defense government will authorize him to disassemble this column.

Eventually the French army besieged Paris and retook it. Thousands of Communards were lined up against walls and massacred. The new government imprisoned Courbet for six months and fined him 500 francs — about $100 (or over $1,300 in today's dollars). While he was incarcerated, Courbet did a chalk drawing depicting prison conditions. The drawing, called *Young Communards in Prison,* shows some of the young children who were imprisoned for helping the Commune.

In 1873, the new Republican government of France decided to rebuild the Vendôme column destroyed by Courbet's order. They demanded that Courbet pay for part of it — 10,000 francs a year for 33 years. He fled to Switzerland and died the day before the first payment was due!

The Barbizon School and the Great Outdoors

A year after the Revolution of 1848, the artist Jean-François Millet left Paris nearly broke. Millet joined another starving artist, Théodore Rousseau, in Barbizon, a tiny village about 30 miles southeast of Paris, on an edge of the Forest of Fontainebleau. Together with two other painters, Jean-Baptiste-Camille Corot and Charles-François Daubigny, they headed the Barbizon school of artists. They had all gone to Barbizon to paint natural scenes *en pleine air* (in the open air, or outside).

Jean-François Millet: The noble peasants

Whereas Rousseau communed with nature, mesmerized by the "voice of the trees," Millet (1814–1875) painted peasants working the land. This wasn't new stuff for Millet; he'd grown up tilling the earth in rural Normandy. His love for

the rustic life shows. He projected it in his landscapes like a Romantic painter. A soft poetry suffuses most of his paintings. The pastoral scenes of workers sowing, harvesting, and tilling fields are so beautiful that you want to pick up a hoe and join in.

But not everyone felt that way when Millet exhibited his work at the Salon of 1850. Critics attacked Millet's *The Sower* and *The Binders* and accused him of being a Socialist. That sounds absurd today, but in 1850, middle- and upper-class Europeans were hypersensitive about anything that had the scent of Socialism. Karl Marx's *Communist Manifesto,* published two years earlier, in 1848, called for the overthrow of capitalism and a classless society. A painting showing peasants as equals and manual labor as ennobling and beautiful scared a lot of people. The shadowy, energetic peasant (in *The Sower*) might be sowing the seeds of revolution. *The Gleaners* (see Figure 18-2), shown in the 1857 Salon, riled up Millet's critics again, for similar reasons — it seemed like he was advocating workers' rights. The painting depicts three impoverished women gleaning what's left of a wheat crop that's already been harvested. In spite of the poverty, Millet's painting dignifies the laborers' work by bathing the scene with a nostalgic light.

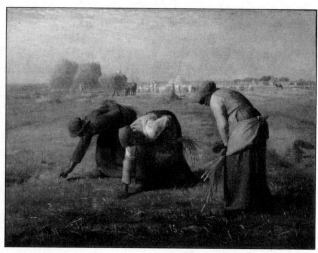

Figure 18-2: Millet's *The Gleaners* documents a rural way of life that was beginning to be displaced by the Industrial Revolution.

Réunion des Musées Nationaux / Art Resource, NY

Despite the criticism (or maybe because of it), Millet's paintings sold and the Barbizon school's influence spread far beyond France's borders (for example, the Dutch artist Vincent van Gogh painted numerous copies of Millet's works in the 1880s).

Jean-Baptiste-Camille Corot: From naked truth to dressed-up reality

Jean-Baptiste-Camille Corot (1796–1875) is probably the greatest artist from the Barbizon school. The Impressionist Claude Monet said of him, "There is only one master here — Corot. We are nothing compared to him, nothing."

Corot's early paintings like *Chartres Cathedral* (1830) and the *View of Volterre* (1838) were as naturalistic as Gustave Courbet's; every object sharply defined; the background, middle and foreground distinct from one another. But around 1850, Corot changed: His paintings became poetic. He suffused them with a soft radiance, like sunlight muted by mist. These paintings appealed to and inspired Impressionists like Monet a generation later.

Morning: Dance of the Nymphs (1850) is veiled with silvery summer light. The background begins in the middleground, the two zones blending mystically together. The leaves on some of the mid-ground trees blur and blend into the background like puffy green clouds. Even the bare-breasted nymphs frolicking in the foreground seem on the verge of dissolving into the haze. Corot has made near and far seem equally distant from the viewer, which gives the painting its poetic, almost magical power.

Corot's art earned him a lot of money, money that he liked to share. He financed a day-care center in Paris to assist working parents. When his friend Millet died, he gave 10,000 francs to Millet's widow. He also helped Daumier, who went blind late in life. Unable to work, Daumier became homeless. Corot purchased a cottage for him.

Keeping It Real in America

Some Americans followed traditions developed in Europe. Others preferred homegrown styles. Realism was a natural for pragmatic Americans, especially when it celebrated majestic natural scenery or rural pleasures like boating and fishing or paintings of the sea.

Westward ho! with Albert Bierstadt

Albert Bierstadt (1830–1902) was born in Solingen, Germany; grew up in New Bedford, Massachusetts; returned to Germany for four years to study painting; and came back to the United States to paint. Bierstadt's specialty was

spectacular mountain scenery. He made sketches and took photos of the scene, often in treacherous and dangerous locations; from these photos, he painted his awe-inspiring landscapes. For example, he headed west with an expeditionary party in 1859 and, in the summer of 1861, sketched in Eastern Shoshone country in the Wind River region of Wyoming.

In *The Rocky Mountains, Lander's Peak* he works the natural sunlight to highlight pieces of the landscape as if he were shining spotlights on them. Although Native Americans and animals populate the foreground and middle ground of the painting, they don't project any personality — they're simply local color and ambience. It's the light in the painting that has personality. (See the nearby sidebar "Let there be light: The Hudson River school" for more.)

Bierstadt always went for the long, wide shot, so to speak, and never the intimate close-up.

Navigating sun, storm, and sea with Winslow Homer

The earliest paintings of Winslow Homer (1836–1910) are of the Civil War, which he covered as a pictorial reporter (sketcher) for *Harper's Weekly* in 1862. After the war, he studied in Paris for a year (in 1867), but it doesn't appear that he absorbed much from the French Impressionist movement, which was coming into its own at that time. In fact, after he returned to the United States, Homer painted mostly realistic scenes of happy rural life, many of them of pastoral figures in sun-drenched landscapes. He began experimenting with watercolors and soon mastered the medium to become one of the greatest watercolor artists in history.

Homer's best paintings are watercolor seascapes done primarily in the 1880s in Maine. Man against nature is the "Maine" theme that runs through most of his sea paintings. In Homer's *Summer Night,* silhouetted figures ensconced on black rocks gaze at a glassy sea. Two women in evening gowns — one with a wistful expression — dance solemnly on the shore as if to the music of the crashing waves, but the other figures take no notice of them. The glorious scene entrances them.

Boating through America with Thomas Eakins

Like Winslow Homer, Thomas Eakins (1844–1916) studied in Paris in the 1860s. But he stayed much longer than Homer and appears to have absorbed more art styles.

Let there be light: The Hudson River school

Luminous light was the hallmark of the Hudson River school artists (sometimes called Luminists), a loosely linked group that included Bierstadt, Frederic Edwin Church, Martin Johnson Heade, and others. Focusing on the Hudson River Valley and the mountain ranges in New York, Vermont, and New Hampshire, their goal was to glorify American scenery and life. Their romanticized landscapes imply that man and nature live in perfect harmony. The Hudson River school didn't usually paint *en pleine air,* but in studios where they could "dress up" their paintings to reflect an idealized vision of the United States.

His most famous paintings are of boat racers. In *The Biglin Brothers Racing,* he captures a sense of cinematic action. You feel the effort of the rowers, yet the scene is peaceful. The tension between rowing and the surrounding serenity of nature gives the painting its power and interest.

But Eakins was more than a boat painter. He was a very versatile master of many genres. His *Agnew Clinic,* a painting of a surgical operation performed on a woman before an auditorium of medical students (reminiscent of Rembrandt's famed *Anatomy Lesson*), is a probing study of character. He examines the personalities of the medical students as carefully as the surgeons examine the body on the operating table.

The Pre-Raphaelite Brotherhood: Medieval Visions and Painting Literature

Three British art students — Dante Gabriel Rossetti, John Everett Millais, and William Holman Hunt — launched the Pre-Raphaelite Brotherhood in 1848. In school, they avoided the splashy techniques and stylized subjects of Royal Academy of Arts instructors. The Pre-Raphaelites chose their name out of respect for the perfect naturalism of Raphael, and as a reminder of how all of Raphael's followers got art wrong by making it too stylized and artificial. Like the French Realists, they chose to paint nature as she is, with an almost photographic realism. Yet the Pre-Raphaelites weren't Realists. They didn't paint peasants working in the fields (as Courbet and Millet had) or England's urban poor. They looked to medieval art and literature for models.

They painted fictional rather than true stories drawn from medieval romances, Dante Alighieri, William Shakespeare, Alfred Tennyson, and Romantic poets. The Pre-Raphaelites were particularly fond of Arthurian romances (the stories of King Arthur and his court). They also painted pictures with stained glass.

Like the French Realists, the Pre-Raphaelites hoped to reform society. They rejected middle-class materialism and were opposed to mass production because it turned workers into robots and churned out functional products without aesthetic value. They also objected to middle-class art buyers. In England, the middle class bought art that reflected their values and glorified the Industrial Revolution that had leveraged their social rise. They had a tendency to buy art that looked like the Industrial Revolution, preferring murky colors and brown tints that made the paintings look as though they'd been colored by the breath of London's textile factories. (A Titian painting reportedly fetched a higher value in 19th-century England after a brown wash made of bitumen was painted over it.)

To counter this penchant for brown, the Pre-Raphaelites used dazzling colors that had just been invented. To intensify these colors even more, they first painted their canvases with a bright white layer. This makes the colors stand up and shout, "I'm red; I'm blue!"

Dante Gabriel Rossetti: Leader of the Pre-Raphaelites

Dante Gabriel Rossetti (1828–1882), the leader of the Pre-Raphaelites, was both a poet and a painter. He sometimes wrote poems to accompany his paintings, which he called "double works." The often brilliant poems elaborate on the paintings' meanings.

Rossetti was the most mystical member of the Pre-Raphaelite Brotherhood. His *Beata Beatrix* follows the poet Dante's muse Beatrice to heaven. Rossetti's own wife, Elizabeth Siddal, had died, possibly by committing suicide, the same year (1862). Rossetti links her to Beatrice in the painting. With closed eyes, Beatrice/Elizabeth peers across the gulf of death and sees a faded Dante/Rossetti trying to reach her from the other world (the other figure is Love). A gilded sundial next to Beatrice/Elizabeth's shoulder marks both terrestrial time and the hours of eternity. A haloed bird sets a poppy on Beatrice/Elizabeth's lap, a symbol of remembrance. In this case, it's more than a symbol: Elizabeth Siddal overdosed on laudanum, a poppy derivative.

The Pre-Raphaelites tried to embed symbols naturalistically into their paintings instead of superimposing them. In this way, *Beata Beatrix* could be both naturalistic and symbolic. For a mystic like Rossetti, this was hard to do. The more-grounded Millais was better at achieving a natural-looking symbolism in his paintings.

John Everett Millais and soft-spoken symbolism

In his painting *Christ in the House of His Parents,* John Everett Millais (1829–1896) depicts Jesus at the age of 8 or 9 in his father's carpenter shop. Millais embeds naturalistic symbols of Christ's crucifixion in the scene. The nails on the table are something you'd find on a carpenter's bench, but they also suggest the crucifixion. Joseph holds a spike right next to Jesus's open hand, suggesting that Jesus accepts his fate, even as a child. The young John the Baptist, on the right, carries a bowl of liquid (representing blood), while eyeing Jesus. A dove perches on a ladder, symbolizing the Holy Spirit descending from heaven; and a flock of sheep peek in the room as if looking for their shepherd.

All the symbols fit naturalistically into the scene. The painting offers both the realism of a snapshot and the symbolism of poetry.

Millais's most famous painting is *Ophelia* (see the color section). In this work Millais depicts the suicide of Ophelia in Shakespeare's *Hamlet,* described by Hamlet's mother Gertrude (4.7):

> There is a willow grows aslant the brook,
> That shows his hoar leaves in the glassy stream;
> Therewith fantastic garlands did she make
> Of crowflowers, nettles, daisies, and long purples,
> That liberal shepherds give a grosser name,
> But our cold maids do dead men's fingers call them.
> There on the pendent boughs her coronet weeds
> Clamb'ring to hang, an envious sliver broke,
> When down her weedy trophies and herself
> Fell in the weeping brook. Her clothes spread wide,
> And mermaidlike awhile they bore her up,
> Which time she chanted snatches of old lauds,
> * * *
> But long it could not be
> Till that her garments, heavy with their drink,
> Pulled the poor wretch from her melodious lay
> To muddy death.

Millais captures the scene with great poetic power, combining botanical realism with a brutally beautiful depiction of a suicide provoked by what Ophelia wrongly believed was unrequited love. Ophelia accepts death with upturned hands as she sinks into an environment with which she perfectly harmonizes. Her open mouth, half-shut eyes, and already deathly pale skin enhance the poignancy of Millais's painting.

The Arts and Crafts movement: Adding form to function

The Pre-Raphaelite Brotherhood, which expanded to seven members, broke up after a couple years. After the dissolution of the group, one of the members, William Morris, launched the highly influential Arts and Crafts movement (1880–1910).

Morris's goal was to replace generic, mass-produced items like furniture with beautiful, handcrafted objects. Why did a chair have to be merely functional? Couldn't it be beautiful, too? Morris hoped his handcrafted products industry would grow large enough to provide creative alternative employment opportunities for factory workers. He also hoped the products would be as affordable as mass-produced commodities.

However, Morris proved a better craftsman than an economist: His Arts and Crafts movement never panned out financially, remaining a luxury for the rich while the masses embraced machined furniture made cheaply in large factories. However, his totalizing approach to interior design, taking a hand in crafting everything from the curtains to the light fixtures to the tea set, inspired many artists and architects of the late 19th and early 20th centuries.

To paint *Ophelia,* Millais had his model (Elizabeth Siddal, Rossetti's wife) lie in a bathtub for hours during the winter. He heated the tub by placing lamps under it. But one day the lamps burned out. He was too absorbed in his work too notice. But Siddal never complained. She nearly died afterward and never recovered completely.

Chapter 19

First Impressions: Impressionism

. .

In This Chapter

▶ Breaking up light

▶ Catching up with the high-speed brushstroke

▶ Examining the evolution of Impressionism

. .

*P*aintings by Monet, Renoir, and Degas brighten people's homes, dress up their offices, cheer them in hospitals, and inspire vacations to France. Postcard copies of their paintings occasionally greet people in their mailboxes. You can even find Renoir wrapping paper and Degas paper plates!

Impressionism is the most popular art movement of all time. Collectors will pay $50 million to own an original Monet or Renoir, yet when their paintings first came on the market in 1874, most people wouldn't pay $10 for one.

Why is Impressionism such a hit more than a century after the style exhausted itself in France? Partly because Impressionism's rapid stroke, feathery style, and bright-as-spring colors make most of the paintings as refreshing and invigorating as a pleasant May day. Entering an Impressionist gallery in a museum is like walking into an eternal spring.

Despite all these positives, the term *Impressionist* was originally intended as an insult. It meant that the paintings looked unfinished and that the artists were too lazy to refine their brushstrokes. Colors dissolve into each other in Impressionist art, and images blur a bit like an action shot in photography. But there's a point to the soft focus. Impressionist artists were interested in the interplay of colors and light more than the precise contours of people and things. They wanted to capture the fleeting quality of life: impressions, glances, gestures, a pleasant stroll in the sun. The soft focus gives people the sense of a lovely impression caught before it slips away.

As the heirs of Realists like Gustave Courbet and Jean-Baptiste-Camille Corot, most Impressionists preferred to paint from real life *en plein air* (in the open air, or outside). The invention of the tin paint tube in 1841 made oil paint available to artists in easy-to-use tubes, which made outdoor painting more convenient. To capture fleeting moments on canvas, the Impressionists had to paint fast and use loose or sketchy brushstrokes. They needed to make

each dab of paint work double-time and suggest more than it portrayed. They succeeded. You can practically feel the sunlight radiating from their canvases and the breezes whispering through the scenery.

Often, people see Impressionist works as merely pretty, but early paintings by Manet and some other Impressionists had shock value — both in how they were painted and what they occasionally portrayed (train stations, night clubs, entertainers). Manet and Degas painted numerous images of people who seem to be alienated and depressed by the so-called "progress" of capitalism.

Monet, Renoir, and Pissarro, on the other hand, were more interested in capturing beautiful moments and in the changing effects of light on landscapes than in reforming society. All of them were children during the revolution of 1848. During the Franco-Prussian War (1870–1871) and the Paris Commune (1871), Monet and Pissarro fled to England, Degas joined the National Guard, and Renoir served in the Tenth Calvary Regiment of the French Army. If they had a message, it was that life is beautiful, every fleeting second of it.

In this chapter, I examine the art and painting techniques of the greatest Impressionist painters: Édouard Manet, Claude Monet, Pierre-Auguste Renoir, Edgar Degas, Mary Cassatt, and Berthe Morisot.

M & M: Manet and Monet

Impressionism began to take shape in the 1860s on the canvases of Édouard Manet, Claude Monet, and Pierre-Auguste Renoir. But the actual birth, if a delivery date can be pinpointed, was probably the summer of 1869 when Monet and Renoir painted views of a swimming resort at La Grenouillère on the Seine. That summer, they learned to catch the transitory moods of nature with quick, suggestive brushstrokes. It was here that the broken-brushstroke style (painting in flecks of color) became a standard characteristic of Impressionist art. The movement didn't yet have a name — that came five years later when a critic attacked one of Monet's early paintings: *Impression — Sunrise*.

Monet and Renoir pioneered this new art style by borrowing and adapting techniques that Manet had developed a few years earlier. In the following sections, I fill you in on Manet and Monet; I cover Renoir later in this chapter.

Édouard Manet: Breaking rules to free the artist

The classically trained Édouard Manet (1832–1883) straddled Realism and Impressionism. He influenced the Impressionists and was, in turn, influenced by them. In the 1860s, the Impressionists began meeting near Manet's studio

at Café Guerbois (not far from the famed Bohemian hangout Montmartre). He was the unofficial head of the twice-weekly meetings, which included Monet, Renoir, Degas, Alfred Sisley, Émile Zola, and sometimes Paul Cézanne, Camille Pissarro, and others.

What was the bridge between Realism and Impressionism? It was Manet's new approach to painting, his innovations with color and brushwork.

Earlier artists began painting their canvases with a layer of dark, usually brown, paint and then built layers of paint on top of it. Of course, they had to wait for each layer to dry before adding the next one. Finally, they glazed the painting to give the surface a smooth finish. This process could take weeks or months. The advantage of painting in layers is that you can home in on the right color, gradually refining, layer after layer, until it's perfect. Obviously, the models couldn't pose all that time. So painters frequently added layers without the model being present.

As a Realist, Manet preferred to paint from life, in other words with his model in front of him. He did this by completing his paintings in one sitting. How did he achieve this high-speed efficiency? By not painting in layers and not glazing the final product. That meant he had to choose the perfect color right off the bat because there were no layers to fall back on. His first draft was his final draft; there was no opportunity for editing — at least in theory. However, radiographs of his paintings show that he did do *some* editing — when he made a mistake, he scraped off the paint, down to the bare canvas, and then repainted that area.

The Impressionists, most of whom worked outdoors from life, adopted Manet's *alla prima* ("at once") technique. Without it, they couldn't have painted fast enough to capture the shifting effects of light.

Manet didn't invent *alla prima* painting. Many of the old masters, such as Matthias Grünewald, Caravaggio, and Frans Hals, used it in conjunction with other techniques. Manet's innovation was to use it *exclusively,* eliminating the need for the slow buildup of layers of paint.

Manet also painted in patches of color, cutting out in-between *values* (shades of color) to make sharper contrasts. So instead of painting a range of progressively lighter or darker shades of orange to indicate how close an orange dress is to a light source, he would simply slap on a patch of bright orange. This technique is called *Tachism.* (*Tache* means "spot" or "blot" in French.) This spotting technique made Manet's paintings look flat. The leading French Realist, Courbet, said that Manet's paintings are as flat as playing cards. This flatness gives his art an in-your-face immediacy. The Impressionists modified this technique by breaking up Manet's color patches into much tinier patches, flecks, and dabs of color.

Compare the skin of Manet's *Olympia* in Figure 19-1 to the finely graded skin tones of Vermeer's *Girl with a Pearl Earring* in the color section.

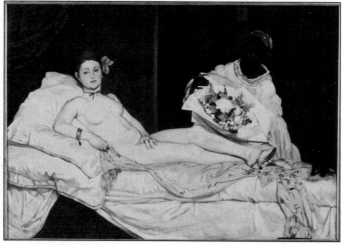

Figure 19-1:
Manet's
Olympia is a
mid-19th-
century
example of
shock art.

Réunion des Musées Nationaux / Art Resource, NY

Manet was a great innovator. Even when he painted conventional subjects, like a picnic or a female nude, he did it unconventionally. The Impressionists appreciated his fresh approach; the public didn't. Manet's *Luncheon on the Grass,* which depicts a midday picnic with two conservatively dressed men sitting beside a stark-naked woman, outraged and alienated the public. Although there's no erotic behavior, the woman's casual, public nudity shocked people. One critic called it "a shameful, open sore." Critics also attacked Manet's brushwork, his color-patch technique. The Salon of 1863 rejected the painting, but it was included in the Salon des Refusé exhibition (see Chapter 18), held the same year for works that the Salon rejected.

The Salon of 1865 accepted Manet's *Olympia,* which caused an even bigger scandal than *Luncheon on the Grass.* Manet obviously intended the painting to shock. Everything about it is a radical break from the norms of European art. He chose to call the painting *Olympia* because it resembles the names adopted by Parisian brothel prostitutes who liked to use exotic pseudonyms. Concubines had been painted elegantly before — Jean Auguste Dominique Ingres's *The Great Odalisque* (see the color section) is an example — but Manet's painting made people feel as though they'd been dragged into a brothel. It was as if a prostitute were advertising herself on his canvas. The painting was too real.

But there's much more to *Olympia* than that. When Manet was 20, he visited Florence and copied Titian's masterpiece *The Venus of Urbino* (see Chapter 12). *Olympia* pays homage to Titian's painting and serves as a potent parody of it. Titian's nude is curvaceous, soft, and sensual; Olympia is angular, naked rather than nude, and she has her shoes on. In *The Venus of Urbino,* a cuddly dog curls up beside the goddess. Instead of a dog, Manet paints a black cat

with an erect tale on the edge of Olympia's bed. Whereas Venus's face is alluring and tender, Olympia looks like a naked businesswoman. Titian shows off the Renaissance rediscovery of perspective in his work. Manet's painting is intentionally flat, which puts Olympia even closer to the viewer, like a window display.

Claude Monet: From patches to flecks

The new style of Claude Monet (1840–1926) came from a shift in focus. He looked at the colors of objects instead of the objects themselves. He advised another painter:

> When you go out to paint, try to forget what objects you have before you — a tree, a house, a field. . . . Merely think, here is a little square of blue, here an oblong of pink, here a streak of yellow, and paint it just as it looks to you, the exact color and shape.

He believed that people should always judge based on first impressions, before getting to know something or someone. Becoming familiar with an object or a face falsifies it. You get the gist of what you see — a blue car, a red house, or a man's double chin — so your eyes don't search out details. You settle for an approximation. But the first time you encounter a face or place, you examine it thoroughly. "Ah, her eyes are green with flecks of blue; the window has a Z-shaped crack in it." To notice the color components of an object, Monet had to stop seeing the object and focus on the color.

In the second half of his long career, Monet painted series of the same scene captured at different times of day. Some of these paintings are like pictorial clocks, especially the haystack series. You can tell the time by the light and shadow on the hay bundles (as in *Haystack, End of Summer, Morning* and *Haystack at Sunset, Near Giverny*).

Most of the Impressionists bypassed the juried Salon exhibitions and held their own unjuried exhibitions (in which all entries are accepted), which gradually eroded the Salon's control of taste. The first independent (Impressionist) exhibition was in 1874. Among other works, Monet showed *Impression: Sunrise.* The name inspired one critic to condemn all the paintings in the show for being "impressionistic" or incomplete. Although it was intended as an insult, most of the artists liked the label, so it stuck.

Monet invented a new style of painting based on capturing the subtleties of color and light rather than perfect lines and shapes: color over contour. He experimented with effects of light and atmosphere throughout his career. Often, he painted slashes of contrasting colors like red and green side by side, without in-between values. This causes your eye to bounce rapidly from color to color, giving his paintings their shimmering effect. (For more on Monet's revolutionary painting technique, see Chapter 29.)

Springtime (a.k.a. *The Reader;* see the color section) is a painting of Monet's wife Camille reading a book in a meadow. Camille's softened beauty blends gently with the landscape so that she seems to be one with her surroundings. Other than that, the painting has no obvious symbolism or message. But it leaves a lasting poetic impression, which may be more enduring than any message. The painting is simply a lovely moment captured on canvas before it fades forever. Camille died at the age of 32, seven years after Monet painted *Springtime*.

In *Springtime,* Camille is reminiscent of Flora, the Roman goddess of flowers (see *Flora* in the color section). The dappled sun on her dress resembles the smudges of white flowers beside her, connecting her to the landscape like a goddess of nature. In any case, she creates an otherworldly impression and seems to float on the feathery lawn like a sun-streaked cloud. If you focus closely on the lawn, you can see how color was more important than shape to Monet. One brushstroke signifies a clump of grass. He painted the color of an area of grass, not the shapes of individual grass blades or grass clumps.

Look closely at how Monet constructs Camille's dress and bonnet from masses of pinks, grays, and white that merge into the flowing shape of the fabric. You may suspect that Monet drifted from his ideal of ignoring the object and focusing on its colors while painting Camille's face. Compare the flurry of brushstrokes in the upper-right quarter of *Springtime* with the brush-work on his wife's face. Up close, the frenzied strokes of the upper-right quadrant look like a whirlwind of leaves, while the paint on Camille's face is laid down delicately and slowly. In fact, you can barely see the strokes. Also the brushwork on the dress differs from that of the rest of the painting. Monet uses caressing sweeps of color to delineate the fabric as if his brush were guided by his tender feelings for his wife.

In 1883, Monet rented a house at Giverny, about 50 miles west of Paris, near the Normandy border. By the 1890s, he was wealthy enough to buy the house and 5 acres of land around it, which he transformed into gorgeous gardens. Some of Monet's most celebrated paintings are of these gardens and the lily pads on the property pond. Monet did 250 versions of water lilies on huge canvases. His greatest water lily paintings hang in oval-shaped rooms in the Musée de l'Orangerie in Paris.

Pretty Women and Painted Ladies: Renoir and Degas

In this section, I examine the paintings of Pierre-Auguste Renoir and Edgar Degas, both of whom focused largely, although not exclusively, on the female.

Pretty as a picture: Pierre-Auguste Renoir

Pierre-Auguste Renoir (1841–1919) painted happy people in pretty places. He said, "For me a picture should be a pleasant thing, joyful and pretty — yes, pretty! There are quite enough unpleasant things in life without the need for us to manufacture more." His fortes were lovely female faces and forms; sunlit meadows; gardens; and summery, open-air cafés.

Early Renoir

The early work of Renoir (from 1860 to 1868), like his *At the Inn of Mother Anthony,* shows the influence of Gustave Courbet (see Chapter 18). But Renoir soon abandoned the natural browns and tans of Courbet's earthy style and developed his bright and happy "rainbow palette." In 1869, while painting with Monet at La Grenouillère, Renoir invented the dappled-light effect that he used so effectively throughout his career.

Dance at the Moulin de la Galette (see the color section), which was exhibited in the Third Impressionist Exhibition in 1877, is one of Renoir's most celebrated masterpieces. The Moulin de la Galette was a Parisian dance hall in Montmartre, which was still a rural district in the 19th century. The Moulin's specialty was pancakes *(galettes)* — thus, its name. Working-class people and artists mingled there at Sunday afternoon dances, one of which Renoir captured on his 1876 canvas. Several of Renoir's regular models appear in the painting, and some of his close friends are seated at the table in the foreground. Sunlight filtering through the surrounding trees bathes the gay company in dappled light, lending a breezy look to the scene, which gives it both immediacy and the feeling of an unending summer.

What makes *Dance at the Moulin de la Galette* an Impressionist painting, besides the fact that Renoir painted it? It has a snapshot feel — a slice of life has been captured on canvas before the scene shifts. The dappled light on the faces and clothes, and the quick brushstrokes and sketchiness of the painting give *Moulin de la Galette* its distinctive Impressionistic look.

Impressionism's midlife crisis: It may have hit Renoir hardest

Between 1881 and 1885, the whole Impressionist movement had a midlife crisis (art historians call it the "crisis of Impressionism"). Most of the artists felt that their early works were superficial — they had captured life's glimmering surface but hadn't probed its depths. The artists began to develop their styles independently of one another. Monet continued in the same direction, probing the nature of light and going deeper into mist and color. Pissarro moved away from intuitive Impressionism toward the scientific study of light with Seurat (see Chapter 20). Degas zoomed in on his subjects, making more intimate portraits, and showing less blurry Impressionistic backgrounds (see the following section). Manet, on the other hand, became more Impressionistic.

Initially, Renoir was pleased that Impressionism freed painting from meaning. He said, "I am at liberty to paint flowers and call them simply flowers." But by 1881, he felt boxed in by the movement that had freed his brush. He said he'd "wrung it dry." Like the other members of the group, Renoir wanted his art to grow up. Instead of focusing on fleeting moments, he wanted to make a lasting impression. So he went to Rome to absorb Renaissance and ancient Roman painting — art that had endured for centuries. He was particularly influenced by Raphael. Afterward, his figures became much more solid. But his backgrounds remained Impressionistic. Some critics have said his mature paintings look like Raphael's work in Impressionist settings. The contrast between solid figures and soft, feathery backgrounds is the trademark of Renoir's mature style.

The influence of Raphael (see *Madonna with a Goldfinch* in the appendix) is evident in Renoir's *The Bathers,* painted between 1885 and 1887, and in *Dance at Bougival,* painted in 1883. The latter work shows the kind of cafés Renoir had always loved to paint, brimming with *joi de vivre,* but now the foreground dancers are sharply defined. The background, however, is still a poetic, Impressionist blur.

The dancers of Edgar Degas

Unlike Monet and Renoir, Edgar Degas (1834–1917) was classically trained, studying under a pupil of Ingres. His early works were historical paintings, inspired by the Romantic painter Eugène Delacroix (see Chapter 17).

After meeting the Impressionists in the late 1860s, Degas turned his attention to painting first horseracing events, then ballet and theater scenes. His most famous works are of ballerinas rehearsing, stretching, scratching, and occasionally dancing. Although he participated in all the Impressionistic Exhibitions between 1874 and 1880 and used many Impressionistic painting techniques, he rarely painted *en plein air* like his colleagues; Degas preferred the artificial light of the theater to natural lighting. But, like other Impressionists, his paintings look like snapshots of life's passing moments.

But Degas's snapshots aren't as spontaneous as they appear. He made many preparatory sketches, testing different angles and ways of framing his subjects, before creating a painting. He said, "No art is less spontaneous than mine."

Like a classical painter, Degas usually defined his figures with clear outlines. He was an excellent draftsman, and his drawing was an integral part of his composition. The other Impressionists didn't do this. Nevertheless, Degas's art has a feeling of energy and delicacy.

After the crisis of Impressionism in the early 1880s, Degas's style changed. He continued painting the same subjects, but he caught them in intimate close-ups and seemingly off-guard. He cut out most of the background to focus on the subject. Furthermore, he frames the women at odd angles, which makes the scenes seem a little wobbly, like an off-balance ballerina. Viewing the dancers from oblique angles gives the viewer the impression that he's sneaking a peek at them around a corner. Degas said he wanted to depict "a human creature preoccupied with herself. . . . It's as if you looked [at them] through a keyhole."

Degas also began painting female nudes bathing, wringing out a sponge in a tub, drying off, and so on. Again, he uses the peering-through-a-keyhole approach. The bathers' positions are completely naturalistic, as if the women didn't know they were being painted. Often, the viewer can't see their faces (see *The Tub* in the appendix).

In *Blue Dancers* (see the color section), Degas blends the background into a mosaic of soft colors: blues mingling with purples, glittering greens that look like sun-dappled leaves, rougelike pinks, and glowing golds. The dancers' identities don't matter. Their faces are either turned away from us or in shadow. This is a painting about interacting colors and forms. The subject of the painting (the dancers), though not secondary, is so interfused with the qualities of color and form that it can't be separated from them. Like Monet and Cézanne (see Chapter 20), at this point of his career Degas was moving toward abstraction.

Morisot and Cassatt: The Female Impressionists

Painting was still a man's world in the late 19th century. Even women of talent were discouraged from becoming artists. Those who did often put away their brushes after marriage to raise families. The French painter Berthe Morisot (1841–1895), who married Manet's brother Eugéne in 1874, and the American Mary Cassatt (1844–1926) were exceptions. Berthe Morisot's sister, Edma, was also a talented painter, but she quit art after marrying. Even Mary Cassatt temporarily gave up painting to take care of her ill sister. Morisot, on the other hand, had children but never stopped painting.

Cassatt, the daughter of a wealthy American businessman (who discouraged her from painting and refused to pay for her art supplies), helped introduce the United States to Impressionism. U.S. museums were the first to add Impressionist paintings to their collections. Also, Cassatt's wealthy friends purchased Monets, Manets, Cézannes, and Cassatts for their private collections. Although the French public slowly learned to appreciate Impressionism, with Americans it was love at first sight.

Mary Cassatt

At the age of 16, Mary Cassatt began studying painting at the Pennsylvania Academy of Fine Arts. Unhappy with her chauvinistic professors, she set off for Paris after the Civil War to teach herself in the museums of Europe. In 1872, she met Camille Pissarro, who taught her Impressionism. Cassatt said Pissarro was such a great teacher that "he could have taught stones to draw correctly." Cassatt is best known for her sensitive paintings of mothers and children, but she painted other subjects, too.

Cassatt fled France for the duration of the Franco-Prussian War and painted at home. One of the greatest paintings she did at this juncture is the unfinished *Portrait of Mrs. Currey: Sketch of Mr. Cassatt.* Mrs. Currey was the Cassatt family's mulatto servant. The painting is a powerful character study and, whether intentional or not, a compelling portrait of late 19th-century society in the United States. The image of the warm, vivacious, and mysterious servant rises out of a sketchy, upside-down portrait of Cassatt's father (he kept snoozing while posing for his portrait). The fact that the servant and master are connected at the neck adds a symbolist or surreal dimension to the painting. Each face seems to be a dream or nightmare of the other. The servant is higher on the social scale of the painting than the rich, but ghostly, businessman. When Mary Cassatt returned to France after what she considered a dreary sojourn in the States, she gave the unfinished painting to the servant rather than to her father.

Although *Portrait of Mrs. Currey: Sketch of Mr. Cassatt* is not one of Cassatt's Impressionist works, the painting suggests that she was moving in an Impressionist direction before she began studying with Pissarro in 1872.

Berthe Morisot

Like Cassatt, Berthe Morisot's main subjects were other women and sometimes children. Morisot added a feminine softness and a brooding sadness to the Impressionist *oeuvre.* Her paintings are as pretty as Renoir's, but hardly as happy. There are no bustling cafés or summer dances. The women are often alone, their features more indistinct than in most other Impressionist paintings. Often, the viewer seems to be peering at the women through translucent glass. Most of the women seem weighed down by silent burdens. Their melancholy contrasts with the sun-drenched landscapes that Morisot often places them in. This contrast is evident even in some of her brightest canvases, such as *Chasing Butterflies,* in which a woman carrying a butterfly net searches wearily for a butterfly. Morisot paints a fine film of nostalgia or sadness over these scenes of innocence. Perhaps that fine film was Morisot's own sadness.

Morisot takes the viewer to a dance in *At the Ball* (see Figure 19-2), but she doesn't show us anyone dancing. Instead, she focuses on a lovely young woman holding a gorgeous fan and waiting to be invited onto the floor. The woman can't do the asking — women, regardless of social class, had to play the role men assigned to them. Fortunately, Morisot was an exception and carved her own destiny.

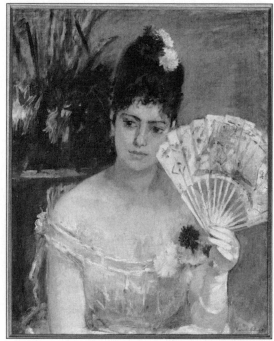

Figure 19-2:
At the Ball
paints a
poignant
picture of
womanhood
in the 19th
century.

Erich Lessing / Art Resource, NY

Chapter 20

Making Their Own Impression: The Post-Impressionists

In This Chapter

▶ Understanding Post-Impressionism

▶ Reading between the brushstrokes

▶ Scoping out Symbolist sculpture

*I*mpressionism's loose approach freed the next generation of artists to be even more experimental with color, form, and subject matter. The Post-Impressionists didn't rebel against Impressionism as the Realists had rebelled against Romanticism and Neoclassicism. They simply extended Impressionism in new directions.

You've Got a Point: Pointillism and Georges-Pierre Seurat

Georges-Pierre Seurat (1859–1891) felt that Impressionism was too intuitive. He wanted to explore the nature of color and light scientifically and apply it to his art. Through his studies, he developed the style of Pointillism (a.k.a. Neo-Impressionism or Divisionism), constructing a painting out of dots of color. I discuss Seurat's technique and the color theory behind it in Chapter 29, but the basic idea is that a grid of closely spaced colored dots expands into a fuller bouquet of hues when seen by the eye.

Seurat's scientific system of painting attracted other artists, including the Impressionist Camille Pissarro, as well as Paul Signac, Henri-Edmond Cross, and Maximilien Luce.

One of Seurat's greatest paintings is *The Circus* (see Figure 20-1), painted the year he died. The dots give it an airy lightness, but also a static feel (perhaps because the grid of dots has a vague resemblance to television noise). Seurat said his goal was to "Make modern people . . . move about as if on friezes, and place them on canvases organized by harmonies of color, by directions of the tones in harmony with the lines, and by the directions of the lines."

The limited color palette — red, brown, yellow, blue, and white — distributed evenly in *The Circus* enhances the feeling of rigidness. But the leaping acrobats and arabesque shapes energize the painting. Surprisingly, the animation and rigidity don't neutralize each other — instead, they reinforce one another. The painting has a stop-action feel, like a carrousel frozen in the middle of a spin. Critics had claimed that early Impressionism amounted to a "tyranny of the eye," in which artists stopped arranging and making choices, and just recorded as fast as possible the impression they saw. Seurat and other Pointillists protected themselves from this charge by using geometric shapes and stylish lines to highlight the artificiality of their scenes. In *The Circus,* the clown's sweeping cape seems to set off all the other curves and swoops that give the scene a swirling sense of energy. The application of color also shows great planning and thought. The broken brushstrokes of Monet and Renoir give way to countless dots of brilliant color painstakingly organized into a harmonious whole.

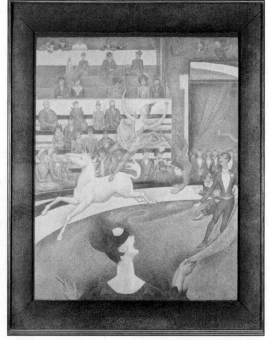

Figure 20-1:
The Circus
is an
example of
Seurat's
scientific
approach to
painting:
Pointillism.

Erich Lessing / Art Resource, NY

Red-Light Art: Henri de Toulouse-Lautrec

Henri de Toulouse-Lautrec (1864–1901) was a master at delineating character in nightlife scenes: cabarets, circuses, bars, and brothels. Artificial lights gleam revealingly on the faces and bodies of the characters he paints, exposing lines and details that sunlight would hide.

Toulouse-Lautrec was also a highly gifted caricaturist and lithographer. The stylized posters he made for cabarets are works of high art themselves. Everything Toulouse-Lautrec touched turned to art. His stunted legs, which made him look dwarflike, kept much of life out of his reach. Art brought the world to him. Even when he was drinking at a cabaret (one of his favorite pastimes), he sketched the people with whom he chatted and laughed. The next morning, he'd transform the best sketches into paintings.

Many of his paintings could be called high-end caricatures. But instead of looking like caricatures drawn by an artist, the people in the paintings make caricatures of themselves. Often they appear to be wearing a mask. Or perhaps their faces are masks, figuratively speaking. He spotlights some of the characters in *At the Moulin Rouge* to suggest that they're always on stage, that their lives are an act.

At the Moulin Rouge depicts Montmartre nightlife in the 1890s as an ongoing cabaret. First, you notice the flaming-red lipstick and pasty faces. Then you notice the top-hatted men surrounding a hard-faced procuress and an orange-haired prostitute. As your eyes sink into the picture, you see that even the background figures are more than local color. Each person has a distinct personality. Toulouse-Lautrec was a Montmartre fixture, so he included himself in the painting; he's the little guy in the bowler hat standing beside the tallest man in the bar.

Toulouse-Lautrec liked to place his subjects in environments that made them uncomfortable (perhaps that's why he placed himself next to the tall guy). Their awkwardness helped to unmask them. In such settings, the artist could sum up any character with a few well-chosen lines.

Tracking the "Noble Savage": Paul Gauguin

Paul Gauguin (1848–1903) was inspired by Jean-Jacques Rousseau's back-to-Eden philosophy: "Man was born free, and he is everywhere in chains. Those who think themselves the masters of others are indeed greater slaves than they."

Gauguin tried to return to a primitive state through art and to find the prover-bial "noble savage" or natural person. He said everything in Europe is "artificial and conventional. . . . In order to do something new we must go back to the source, to humanity in its infancy." Eventually, his quest to shed civilization and become a noble savage took him to Tahiti. But first he sought primitivism in rural France.

The concept of the noble savage, man living in harmony with nature, was popularized in the 18th century. It refers to an individual uncorrupted by civilization. Jean-Jacques Rousseau helped spread the idea, though he never actually used the term. In *Emile,* he wrote: "Everything is good in leaving the hands of the creator of things; everything degenerates in the hands of man."

Brittany paintings

In 1886, Gauguin moved to Pont-Aven, Brittany, hoping to find primitivism among the ancestors of the ancient Celts (the Bretons). Instead, he found that even the rural Bretons were socialized.

Gauguin, who had studied under Pissarro and began his painting career as an Impressionist, abandoned Impressionism in Brittany. He created a new movement called Synthetism (also known as Symbolism) by building on Cloisonnism, a style invented by his friend Émile Bernard and Louis Anquetin in about 1887. In Cloisonnism, large patches of vivid color are painted on the canvas and then bordered by thick, black lines like in stained-glass windows, except each patch is one color, with a minimum of shading.

The term *Cloisonnism* comes from an enameling process called cloisonné. In cloisonné enameling, colored enamels are poured into metal chambers *(cloisonnes)* that outline figures and objects.

Gauguin used Cloisonnism in his turning-point painting *The Vision after the Sermon (Jacob Wrestling with the Angel).* In this mystical work, praying Breton women, some with eyes shut, envision the holy wrestling match between Jacob and the angel, which their priest has just described to them in church. The battle takes places on an otherworldly red carpet spread over the land-scape (in one large color patch), around which the women gather like sports spectators. The color units that make up this painting are as separate as puzzle pieces or the patches of a quilt.

The psychological side of the painting is even more revolutionary than the technique. Gauguin weds two worlds in one work: the physical reality (the women in their Breton dresses) and the psychological reality (a picture of the

women's collective vision). In a letter to Vincent van Gogh, Gauguin said, "I believe I have achieved in these figures a great rustic and superstitious simplicity." He had, in fact, discovered a way to reveal the inmost, unfiltered thoughts of people. By using flattened perspective and Cloisonnism, he was able to harmoniously splice people's inner visions with the world around them. Gauguin took his discovery even further in Tahiti, for which he set sail in 1891, having sold most of his paintings to fund the trip.

Tahiti paintings

Tahiti didn't fulfill Gauguin's dream of finding the "noble savage." When he arrived, he discovered that thousands of European expatriates had already turned the island into an extension of Europe.

But in his work, Gauguin was able to use the contrast between what he'd hoped for and what he found. He juxtaposed the two realities, making them confront each other on adjacent picture planes. Often, he placed a primitive scene in the foreground and images or symbols of the civilized world in the background, and then flattened the painting (eliminating perspective and most shading) so the background would encroach on the foreground, peer over its shoulder, and infect it.

Sometimes these back-to-back planes contrast primitive innocence and jaded civilization, as in *Savage Tales* (1902), which exudes mystery, suspense, and exotic danger. Two seated, nearly naked Tahitian girls dominate the foreground. They look about suspiciously, but in the wrong direction. Behind them (in the claustrophobic, looking-over-your-shoulder background), a demonic, green-eyed man in a blue gown contemplates the girls. Gauguin gave this demon hot-red hair, cloven feet, and the face of his friend Meijer de Haan. Perhaps Meijer de Haan is Gauguin's alter ego, at least in the painting. Ironically, Gauguin felt that plunging into the savage side of man's nature (acting like the demonic man) was a way of purging the degenerative effects of civilization. He said, "To me barbarism is a rejuvenation."

Gauguin's manipulation of traditional perspective and his expressive use of color had a major influence on late-19th- and early-20th-century art movements, especially Fauvism and Expressionism (see Chapter 21) and the Nabis (Pierre Bonnard, Édouard Vuillard, and Paul Sérusier, who called Gauguin their spiritual father). Also, in 1901, Picasso encountered several Gauguin paintings at a friend's house, and they inspired him to launch into his Blue Period (see Chapter 21).

The Fauves (see Chapter 21) were influenced by Gauguin's loud colors and shocking color contrasts: chartreuse next to blues, hot reds, oranges, and yellows that often seem to burn each other.

Painting Energy: Vincent van Gogh

The Dutch artist Vincent van Gogh (1853–1890) only painted for ten years, from 1880 until his death in 1890. But in that time, he produced over a thousand paintings, 70 of them in the last 70 days of his life. (Feeling like a slacker in comparison? Me, too.) Van Gogh was driven by a spiritual quest to create art. Even though he is said to have only sold one painting in his lifetime — and that one was sold toward the end of his life — nothing could douse the fire of his drive.

He trained to be a preacher, but his superiors fired him for being too committed. His empathy for the poor miners in his parish (he provided them with blankets and cared for them when they were ill, for example) was viewed as too unconventional. In despair, van Gogh turned to art, channeling the same commitment into teaching himself to draw and paint. Within a year, he wrote joyfully to his brother Theo, telling him that he'd at last found a vocation in which he could do his fellow man some good.

Some of van Gogh's early paintings are of Belgium coal miners from the region where he had preached. *The Potato Eaters* shows a humble mining family eating their spare diet of potatoes. The shacks that mining families lived in were often supplied by the mining companies that exploited their labor. This painting inspired the Expressionist painters of the early decades of the 20th century because form (the miners' faces and bodies) takes a backseat to expression. The miners' feelings are so strong that they distort their careworn faces and speak through their exhausted bodies. In a letter about the painting to Theo, Vincent van Gogh said, "If a peasant painting smells of bacon, smoke, potato steam, fine — that's not unhealthy . . . a painting of peasant life should not be perfumed."

In his early career, van Gogh copied paintings by the French Realist painter Jean-François Millet, a member of the Barbizon school (see Chapter 18). Van Gogh believed that Millet had come closer to capturing the spiritual essence of landscapes than the Impressionists.

But van Gogh read into the landscapes that he painted even more than Millet had. For van Gogh, nature brims with a turbulent, underlying spiritual force. Sometimes in his eagerness to get at this force (or free it from the material forms that restrain it), van Gogh made the scenery swirl and rage like a

stormy sea. At other times, perhaps when van Gogh's mind was more at peace, he produced paintings filled with a religious light that appears to radiate out of the landscape, as in *The Sower* (see the color section). In this painting, the sun rays are as richly textured as the golden wheat field that it sinks into. They seem part and parcel of the same elemental glory, as does the laborer who is haloed by the radiant landscape. In van Gogh's view, the humble sower gives life by feeding us. For more on van Gogh's style, see Chapter 29.

In the last year of his life, van Gogh's work began to win some recognition. Les XX invited him to participate in one of their international exhibitions, and Monet praised his work. (See "The Mask behind the Face: James Ensor [1860–1949]" for more on Les XX.) But van Gogh's stress, loneliness, depression, and turbulent mind gradually incapacitated him, making it almost impossible for him to paint. And if he couldn't paint, he didn't want to live. On July 27, 1890, van Gogh committed suicide by shooting himself.

Love Cast in Stone: Rodin and Claudel

Auguste Rodin (1840–1917) is often said to be the greatest sculptor since Michelangelo and is often called his equal. Like Michelangelo, Rodin made every part of the body speak in his sculptures. Other people think that Rodin couldn't have achieved the level of fame he did without his assistant and lover, Camille Claudel (1864–1943). They contend that he not only found inspiration in Claudel's muse-like support and love, but also assimilated or stole many of her ideas and that she carved parts of his sculptures. It's possible.

Rodin and Claudel's collaboration lasted 15 years, and Claudel, who began as Rodin's student, became a great sculptor in her own right. Comparison of their independent and collaborative work indicates that they did swap creative ideas — and maybe more. After Rodin rejected her in 1898, Claudel pursued an independent career — but it was a career cut short by madness and a growing sense of persecution, possibly triggered by Rodin's rejection.

Auguste Rodin

Both Rodin and Claudel are sometimes classified as Symbolists, though Rodin didn't like the label. Rodin's most famous works are *The Thinker* (see Figure 20-2), *The Kiss, The Monument to the Burghers of Calais, The Monument*

to Balzac, *The Age of Bronze,* and the unfinished *The Gates of Hell. The Thinker* was originally intended to be a small statue made to fit at the top of the doorframe of *The Gates of Hell.* Rodin decided to take *The Thinker* out of Hell (after all, the Inferno is no place for contemplation) and make him a full-size statue and a man of this world.

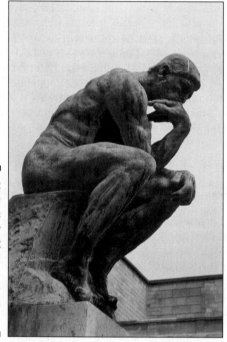

Figure 20-2:
Rodin's *The Thinker* is probably the most celebrated statue since Michel-angelo's *David.*

Vanni / Art Resource, NY

The Thinker became so down-to-earth that he showed up in American living rooms once a week during the late 1950s and early 1960s. The popular TV sitcom *The Many Loves of Doby Gillis* opened with Doby ruminating beside *The Thinker.* Doby always adopted *The Thinker's* pose. But Doby was a comic — *The Thinker* isn't. In fact, the figure looks stressed. Rodin understood the relationship between mental stress and the body long before the adverse affects of stress on the body were discovered in the 1920s. Rodin's *Thinker* thinks with his whole body. You can see his thoughts in his muscles and tendons. Rodin, who said "Every part of the human figure is expressive," made *The Thinker's* mind as naked as his flesh.

But who is *The Thinker,* and what's he thinking so hard about? *The Thinker* represents everyone, pondering the meaning of life or how we're going to pay a bill or meet a deadline. Maybe he's wondering what he's going to have for lunch. In any case, his whole body is wondering with him.

The Kiss also grew out of *The Gates of Hell.* Perhaps Rodin decided that the couple's kiss was too tender for hell — better to let them smooch above-ground. Rodin anchors their bodies to a hard rock which helps to soften their smooth marble flesh by contrast. The fact that the couple is glued to the stone, unable to progress to the next stage of passion, makes *The Kiss* even more poignant. The lovers can never achieve complete fulfillment. Their yearning is eternal (which may be why Rodin originally planned to stick them in hell). Today the statue has become a universal symbol for sensual love. Rodin completed *The Kiss* the year he broke up with Camille Claudel.

Camille Claudel

Claudel's *Vertumnus and Pomona,* carved in 1905, is based on the Roman myth of the wood nymph Pomona, who was immune to love. (The poet Ovid recounts the story in his *Metamorphosis.*) Pomona only loved her job, pruning fruit trees and grafting new branches on old trees. In the sculpture, she's surely a stand-in for Claudel — Pomona's pruning knife representing Claudel's sculpting tools (chisels and rasps). With her knife, Pomona helps trees grow and bear fruit; with her chisel, Claudel brings stone to life.

Vertumnus (who represents Rodin), the god of orchards, seasons, and changes, falls in love with Pomona. At first she's cold, so Vertumnus works on her. As the god of changes, he's a master of disguises. He sneaks into her presence by posing as a fellow tree pruner, and then as an old woman. The old woman teaches the virginal Pomona that men and women must graft together like the trees to produce fruit. At that moment, the old woman transforms into Vertumnus, and Pomona melts with desire. In Claudel's stone version of the myth, the slender lovers embrace and Pomona leans her cheek on Vertumnus as if grafting herself onto him. This poignant portrait of love, carved eight years after their breakup, suggests that Claudel's love for Rodin never waned. She had grafted herself onto him and couldn't live sanely without him.

The Mask behind the Face: James Ensor

The Belgian artist James Ensor (1860–1949) is one of the founders of Les XX (The Twenty), a Belgium-based international movement that linked all the arts to create a united front against bourgeois values. The group staged

international exhibitions that featured not only their own works but paintings by the American painters John Singer Sargent and James McNeill Whistler, French artists Claude Monet and Paul Cézanne, and many others. Les XX also hosted readings by great Symbolist poets like Stéphane Mallarmé and Paul Verlaine, as well as musical performances to celebrate composers they felt in tune with like Claude Debussy and Gabriel Fauré.

One of Ensor's most famous and challenging paintings is *Christ's Entry into Brussels in 1889*. He painted the work in 1888; it was intended to be a mock prophecy, a schedule for the Second Coming. The thick crowd of the faithful carries Jesus through the streets like a trophy. In medieval religious processions, people shouldered images of Jesus or saints through densely crowded streets, but in a spirit of reverence. Here the entire mob is dressed for a masquerade. But the masks appear to be their real faces. Perhaps it's their faith that's a masquerade. The red banner over the crowd states "Vive La Sociale," which translates to "Long live the welfare state." On the right, someone holds up a red sign that translates, "Long live Jesus, king of Brussels."

The Hills Are Alive with Geometry: Paul Cézanne

Like Gauguin, Cézanne (1839–1906) began as an Impressionist, or maybe a pseudo-Impressionist. He exhibited in the first and third Independent Exhibitions of Impressionist Painters (see Chapter 19), but early on he believed that Impressionist paintings were too airy and superficial. He said, "I wanted to make of Impressionism something solid and enduring, like the art in museums." Pierre-Auguste Renoir and Edgar Degas developed the same view after the Impressionist "Crisis" in the 1880s (see Chapter 19). Instead of fleeting, light-as-air impressions, Cézanne chose to make forms look solid; he did this by rendering them with thick slabs of color instead of flecks of paint. Also, he wasn't interesting in chasing motion with quick flicks of his brush, but in painting solid things anchored firmly to the ground.

Cézanne's solidness was based on geometry. He believed that everything is built on fundamental geometric forms: cylinders, cubes, cones. His goal was to break down objects and people into their underlying geometry (a goal that Picasso would share a few years later).

Although Cézanne gave *Mont Sainte-Victoire (1902–04)* a pale, watercolor appearance, it still has a solid feel. The color patches on the ground in front of the mountain look like small cubes of color. The mountain, too, appears to

be comprised of blue and green crystal cubes. Cézanne repeated the color palette of the mountain in the sky, but with bigger color slabs. By repeating and interweaving yellows and greens (analogous colors) on the ground and blues and purples in the mountain and sky, Cézanne created color harmonies that seem like the visual equivalent of music. Speaking of repetition, Cézanne painted Mont Sainte-Victoire more than 60 times between 1870 and 1906, the year of his death. *Mont Sainte-Victoire (1902–04)* (shown in Figure 20-3) is one of the last versions of the mountain he painted.

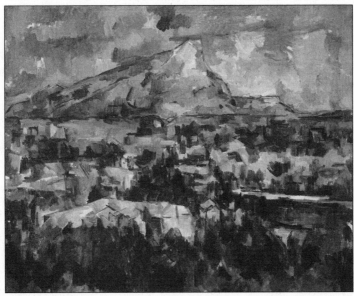

Figure 20-3:
Cézanne's favorite model was a mountain called Mont Sainte-Victoire, located near Aix-en-Provence where the artist was born and died.

The Philadelphia Museum of Art / Art Resource, NY

Art Nouveau: When Art and Technology Eloped

Art Nouveau (New Art) grew out of a combination of influences:

- ✔ William Morris's Arts and Crafts Movement (see Chapter 18)
- ✔ Flat, colorful, and stylized Japanese prints that appeared in Europe in the mid-19th century
- ✔ Symbolism

The first to use the term *Art Nouveau* were Les XX in 1884. In an arts magazine, they announced, "We believe in Art Nouveau." But the style itself didn't develop until about ten years later.

The biggest names in Art Nouveau were

- **Henry Van de Velde,** a Belgian architect
- **Victor Horta,** a Belgian architect
- **Hector Guimard,** a French architect and furniture designer
- **Émile Gallé,** a French glassmaker and cabinetmaker
- **Louis Comfort Tiffany,** an American stained-glass maker

Van de Velde and Horta seem to have invented Art Nouveau, which was originally called *le style Belge* (the Belgian style).

Art Nouveau wasn't a painting style, but a decorative-arts, architecture, and graphic-arts (poster) style. From Belgium, it spread like a fashion craze across Europe and the United States in the 1890s. The movement endured until about 1915.

The Nouveau look is a confection of exotic yet natural curves: graceful arabesques; undulating, organic lines; twisting tendrils and flowers; and curvaceous female forms. Symmetry is an Art Nouveau no-no. Art Nouveau artists always take their designs from nature and then stylize them. The left and right sides of a design shouldn't match, but they should blend as gracefully as climbing ivy.

The products that modern technology churned out in the 1890s worked well, but they weren't pretty. The goal of Art Nouveau was to prettify them, transform blasé functional products — from staircases to teacups — into high art. These objects didn't merely get facelifts. Industrial Age products were *naturalized* (that is, they were given flowing, organic shapes).

Nouveau artists also strived to raise the status of the decorative arts. "Decorative art should be everywhere" was the movement's guiding principle. This Art Nouveau agenda was carried out with mind-boggling efficiency all across Europe, transforming everything it touched. It spread from Horta and Van de Velde's architecture in Belgium to the Paris subway stations (Hector Guimard made some Métro entrances into Art Nouveau monuments) and Jugendstil (Art Nouveau) public toilets in Vienna (see Figure 20-4). The whole world was becoming beautiful.

Figure 20-4:
Wilhelm
Beetz
designed the
Jugendstil
underground
toilet in
Vienna's first
district.

Andreas Ceska

Fairy-Tale Fancies and the Sand-Castle Cathedral of Barcelona: Antoni Gaudí

Whether the playfully organic style of Catalan architect Antoni Gaudí (1852–1926) is Art Nouveau or not is debatable. Gaudi is hard to fit in one art-history box; part of him always slips out. In any case, Gaudí's aversion to squares and symmetry and his love for the fanciful and organic is apparent in all his architecture, from Casa Milà and Casa Batlló (see Figure 20-5) in downtown Barcelona to his unfinished cathedral La Sagrada de Familia, which looks like a melting sand castle with soaring Neo-Gothic spires capped by colorful treetop ornaments.

The moment you enter Casa Batlló you can see why many people call Gaudí's idiosyncratic style Art Nouveau. Your eyes are greeted by stairwells that look like wooden waves rolling down the steps, doors with curved windows and panels cut into them, and sculpted bulges that make the woodwork appear to be breathing. The off-white, wave-shaped domed ceilings look like the inside of mushrooms. But Art Nouveau is a surface art — it doesn't penetrate to architectural structures. With Gaudí, on the other hand, organic lines and shapes are more than window dressing — they're the essence of his structures that seem to grow artfully out of the landscape. As you wander through Casa Batlló or Casa Milà, the spaces around you seem to flow with you.

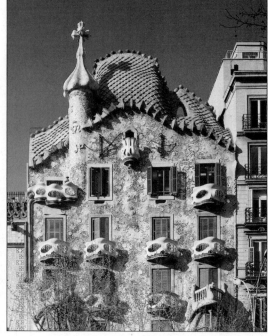

Figure 20-5:
Gaudí's
Casa Batlló
is a five-
story
archi-
tectural
wonderland.

Courtesy of Spanish National Tourist Office

Throughout most of his professional life, Gaudí also worked on the cathedral La Sagrada Familia, the splendor and spiritual heart of Barcelona. The structure was incomplete at the time of his death in 1926.

Gaudí was run down by a tram but survived the accident. No cab driver would pick him up because he was wearing ragged clothes and they thought he wouldn't be able to pay the fare. When he finally received treatment at a hospital for the poor, it was too late to save him. He died two days after the accident.

Part V
Twentieth-Century Art and Beyond

"I think we're close to the village Picasso grew up in."

In this part . . .

The 20th century sped up everything. Art and architecture had to catch up and keep up with technology — and they have. In this part, I show you how they did it and continue to do it. You also see how the world wars that scarred the 20th century affected artists and architects and their work. Many tried to fix society; others turned to art for art's sake. I also give you a "tour" of the art galleries and studios of the last 20 years to zero in on the latest trends in art and architecture. I stop where art history butts up against the present.

Chapter 21

From Fauvism to Expressionism

In This Chapter

▶ Seeing how the Post-Impressionists influenced the next generation of artists

▶ Understanding flattening perspective

▶ Decoding color theory

▶ Straightening out distortion

Fauvism and Expressionism — the first art movements of the 20th century — set the tone for modern art. Both groups inherited many characteristics from the Post-Impressionists, especially Paul Gauguin, Vincent van Gogh, and Paul Cézanne. Between 1901 and 1906, the Post-Impressionists enjoyed a surge in popularity. Major exhibitions of their paintings opened in France and Germany, introducing the new generation of artists to their work. In many ways, the Fauves and Expressionists picked up where the Post-Impressionists left off.

What was it about van Gogh, Gauguin, and Cézanne that turned on the Fauves and Expressionists? Van Gogh's expressive use of color and line (each of his brushstrokes sings or shouts) and Gauguin's clashing color patches and flattening of space appealed to both groups. Cézanne's method of reducing nature into its geometric components (cylinder, cone, and cube) was also highly influential. Beyond their innovative techniques, all three artists expressed their own feelings on canvas instead of painting traditional historical and religious art for public spaces. Similarly, the Expressionists and Fauves believed that they should express their personal visions in their art rather than cater to public taste.

Besides Gauguin, van Gogh, and Cézanne, the German Expressionists were strongly influenced by Norwegian Symbolist painter Edvard Munch (who painted *The Scream*) and the Belgian James Ensor (see Chapter 20).

In this chapter, I examine the work of the leading Fauves — Henri Matisse, André Derain, and Maurice de Vlaminck. Then I delve into Expressionism, exploring the Die Brücke and Der Blaue Reiter movements in Germany, and Austrian Expressionism.

Fauvism: Colors Fighting like Animals

The Fauves — Henri Matisse, André Derain, Maurice de Vlaminck, Georges Rouault, and others — exhibited for the first time at the 1905 Autumn Salon in Paris. Although their work was accepted in the show, it wasn't appreciated by most critics. The curator grouped their paintings together in one room, as if to say, "Here's all the weird stuff." But he also exhibited a classical looking bust in the same room — maybe he had no place else to put it. One offended critic wrote that the bust looked like a *"Donatello parmi les fauves"* (a Donatello among the wild animals). (Donatello was the greatest sculptor of the early Renaissance — see Chapter 11.)

The critic obviously preferred the traditional bust to the garishly colored canvases. But the artists liked his insult and adopted the name. To them, being called "wild beasts" was a compliment. Their colors were *meant* to attack, to assault the eye. So what if conservative critics fled from their colors? The critics had condemned van Gogh and Gauguin at first, too. As the Expressionist painter Franz Marc wrote, "New ideas are hard to understand only because they are unfamiliar. How often must this sentence be repeated before even one in a hundred will draw the most obvious conclusions from it?"

The Fauves didn't have a political or social agenda — which may be why the movement only lasted three years — but they shared similar views about technique and the importance of individual expression. All of them used loud colors and flat surfaces; all of them were young talented painters who wanted to experiment. Eventually, the Fauves' work won acceptance. In fact, most of the Fauves became famous in their lifetimes.

In 1906, two more artists, Raoul Dufy and Georges Braque, joined their group. Braque became one of the founders of Cubism (see Chapter 22) just a few years later.

Henri Matisse

Henri Matisse (1869–1954), the leader of the Fauves, adopted Gauguin's flat surfaces, use of visual symbols, and clashing colors. But he didn't use a garish palette to probe the primitive and instinctual side of man as Gauguin did. He preferred playful, happy hues. "What I dream of," he wrote, "is an art . . . devoid of troubling or depressing subject matter . . . [art that is like] a good armchair in which to rest."

Matisse's early masterpiece *The Joy of Life* (see the color section) is just such an armchair. Instead of attacking, these colors want to play. In the painting, Matisse spreads an imaginary pastoral landscape before the viewer. Blithe nudes lounge about, dancing, playing instruments, picking flowers, and making love. It could almost be a Rococo pleasure garden painted by Boucher (see Chapter 15). But

the bodies aren't pink and fleshy like Boucher's. Instead, they're stylized, rendered with a few fluid lines. Also, instead of using traditional perspective like the Rococo painter, Matisse's paradise is as flat as wallpaper — well, almost. There's a hint of depth: The background dancers are smaller than the foreground lay-abouts.

The nudes have almost no *modeling* (degrees of light and shade that give a three-dimensional look). They're just pink or pale blue, two-dimensional figures. And these aren't the only novelties. Matisse's islands of color were revolutionary. True, Gauguin used color patches to suggest primeval emotion and psychological states. But Matisse's colors are more than mood indicators. They're geographical locations, places to hang out. The background women dance on a color (bright yellow) rather than a field; lovers walk through colors (red and yellow) instead of groves or parks. Also, the colors are alternately hot and cool, harmonious and discordant, which keeps your eyes moving quickly over the canvas — as if you were being playfully chased by "wild beasts." This enhances the joy-of-life feel of the painting.

Like Gauguin, Matisse placed his figures in nature where they could act out their passions without inhibitions. But these are bright passions, not dark ones like in Gauguin's *Savage Tales*. Instead of probing man's primordial nature, Matisse's colors dance on the surface of life. The painting is what its title says it is, *The Joy of Life*. Who needs anything more?

Matisse simplified even more than Gauguin. One curving line of blue-green paint signifies a tree trunk (though some look like wavering kite strings). One sweeping line suggests a hip, thigh, or arm, as well as the emotions that determine the posture. He said, "Drawing is like making an expressive gesture with the advantage of permanence."

Matisse's command of anatomy enabled him to reduce shapes to their most basic contours. But *The Joy of Life* is more than an exercise in reduction. Matisse discovered how to transcribe human emotion with a single line or series of lines. Together, the flowing lines of bodies and trees create a current of happiness that streams through the painting. The scene implies that life doesn't have to be complex. It can be reduced to fundamental lines, uncomplicated colors, and simple pleasures.

Instead of using color to mirror real life, Matisse laid down colors musically, creating visual harmonies. He wrote, "I cannot copy nature in a servile way, I must interpret nature and submit it to the spirit of the picture — when I have found the relationship of all the tones the result must be a living harmony of tones, a harmony not unlike that of a musical composition."

André Derain

André Derain (1880–1954) and Matisse founded Fauvism in 1905 while painting together in the seaside town of Collioure in southwestern France. Derain's

painting *Mountains at Collioure* is one of his best works from that trip. No visual landmarks in the painting identify the place (which became a hangout for the Fauves and other artists, including Picasso). In fact, the landscape looks Provençal, probably because van Gogh and Cézanne, both of whom painted in Provence, inspired Derain. Derain's slab-dab, van Gogh–like brushstrokes — which look like streaks of energy spraying through the canvas — make the landscape look like it's charged with electricity. Like van Gogh's countrysides, the undulating fields and mountains seem to breathe. The geometric shapes with which he composes the mountains show the Cézanne influence. But the shrill, complementary colors and flatness are pure Fauve.

At a glance, the painting does look like something a creative 10-year-old might bring home from school. But that's not a bad thing; it gives the painting its freshness. Like Matisse, Derain arranges his colors and lines to create harmonies and discords. The mountains and trees are painted with fighting, complementary colors (the mountains with oranges and blues, and the trees with oranges and greens). But he also combines friendly, analogous colors — greens and yellows — to give the viewer's eyes a pleasant break from the stress of the harsh hues.

Maurice de Vlaminck

Maurice de Vlaminck (1876–1958), along with Matisse and Derain, was one of the original Fauves. He was also a talented violinist, cycling pro, and writer. Vlaminck's favorite model was France itself — its landscapes and small towns; the sites a cyclist might encounter on an outing. Like Matisse, Vlaminck arranged colors musically. In *Flowers (Symphony of Colors),* he masses colors with crescendos of intensity, while juxtaposing fighting colors to create the Fauve look: a blue notch in an orange tree, green shutters on a bright red house.

Vlaminck was highly influenced by van Gogh. Like van Gogh, Vlaminck laid on the paint thickly — so thickly that sometimes it looks like icing on a cake. To intensify his colors, he squeezed paint directly from the tube onto his canvases.

Vlaminck never flattened scenes like Matisse, but he used traditional perspective. Also, he never gave the viewer close-ups of houses and buildings. Instead, he showed the viewer the towns from a cyclist's point of view, as if the towns have just come into sight as you peddle around a bend on the Tour de France. Ironically, the houses, trees, and streets in Vlaminck's paintings abound with exuberant life and mystery, but the streets are always empty. The life force in his paintings comes from the architecture, not the inhabitants.

Vlaminck's style changed dramatically after he saw a Cézanne exhibit in 1907. His *Landscape Near Martigues,* for example, which is composed of geometrical blocks of pale color, looks as though Cézanne could have painted it.

Friendly versus fighting colors

Think of colors that live next door to each other on the color wheel — yellows and oranges, greens and blues, and so on — as friendly or neighborly colors. They get along because they have something in common. Green is made of yellow and blue; therefore, it blends harmoniously with both of them. Technically, these are called *analogous* colors, because they have something in common. (*Analogy* means "correspondence between dissimilar things.")

Fighting colors live on opposite sides of the color wheel and have nothing in common. There's no red in green, no yellow in purple. When you juxtapose these colors, they clash, each bringing out the other's personality. The sense of being the other's opposite, or *complement*, is why they are referred to as *complementary* colors.

German Expressionism: Form Based on Feeling

Expressionism sprang up in Germany at the same time the Fauves staged their first exhibition in France. Technically, the two movements have a lot in common: Expression dominates form; perspective is often flattened; and both use in-your-face, garish colors. But whereas the Fauves were a light-hearted bunch, the German Expressionists had a penchant for brooding.

There are two German Expressionist groups, *Die Brücke* (The Bridge) and *Der Blaue Reiter* (The Blue Rider). Die Brücke was the gloomier of the two.

Die Brücke and World War 1

In 1905, tensions that had been building for centuries in Europe were on the verge of rupturing. A worldwide conflict seemed inevitable to many people. The 1905 war between Japan and Russia was viewed by many as a tremor before an earthquake. The old order was cracking at the seams. Avant-garde artists wanted it to crack. Many hoped for a complete collapse so they could rebuild society on the ruins of the past. When war came in 1914, many of the German Expressionists, led by visions of reforming the world, enlisted. Some never returned or, if they did, they came back mad. But I'm jumping ahead of myself.

Ernst Ludwig Kirchner, Erich Heckel, Karl Schmidt-Rottluff, Fritz Bleyl, and other like-minded artists founded Die Brücke in 1905 in Dresden. Kirchner, the leader of the movement, wrote in a 1906 woodcut (a favored media of Die Brücke, because it was cheap and quick):

We believe in development and in a generation of people who are both creative and appreciative; we call together all young people, and — as young people who bear the future — we want to acquire freedom for our hands and lives, against the well-established older forces. Everyone belongs to us who renders in an immediate and unfalsified way everything that compels him to be creative.

Like Gauguin, their revolt was a return to primitivism. This is one reason they liked to paint nudes: Nudes have been stripped of social conventions.

Like the Impressionists, Die Brücke artists painted from life, *en plein air.* Therefore, they had to be fast. But to express their heavier, darker feelings, they slapped more paint on the canvas than the light-as-air Impressionists, which slowed them until they learned to thin out the paint by mixing in petroleum. Like the Fauves, Die Brücke artists preferred to use clashing, complementary colors. They especially felt a kinship with Gauguin, whose paintings probed the underbelly of life. To express man's instinctual side was viewed as spiritually purifying — no matter how impure the art might look to others. The Expressionists were proud that they faced the dark side of human nature in their art, instead of shoving it under the carpet.

The members of Die Brücke drew and painted together, developing a common style and a shared visual vocabulary. Their focus was the human form, which they regarded as the ultimate vehicle for expression. A twisted expression on someone's face, a contorted posture, became the language with which they communicated their own feelings. Like Gauguin, they used unnatural colors to convey inner tensions.

For Die Brücke artists, the old forms of art weren't suitable vehicles. They refused to paint pretty portraits or lush landscapes. Their own feelings were the subjects of their art. Kirchner wrote, "He who renders his inner convictions as he knows he must, and does so with spontaneity and sincerity, is one of us." Van Gogh's tumultuous landscapes, deranged architecture, and explosive colors inspired them because his emotions live on inside his paintings. They, too, wanted to express their feelings so strongly that the landscapes or cityscapes in their paintings were reshaped by them. Buildings grimace and slouch according to the painter's mood. Arms and faces are contorted to express the artist's angst.

Think of classical art as a beautiful gilded box. Die Brücke Expressionists didn't want to eliminate the box (though they could do without the gilding). They wanted to bend it and bash it in so the box revealed the emotional battles raging inside of it. The perfect exterior of the classical box (a Gainsborough portrait of a composed aristocrat, for example, who never cries too hard or smiles too much) hid the interior warfare that goes on in every individual.

Ernst Ludwig Kirchner

In 1911, Ernst Ludwig Kirchner (1880–1938) moved to Berlin. The other members filtered into the German capital over the next couple years. Many of Kirchner's greatest paintings are portraits of seamy Berlin street life. In these works, you feel as though you're viewing life through a fisheye lens or in a hall of mirrors. The men, dressed exactly the same, seem like clones of each other, which contributes to the hall-of-mirrors impression. Kirchner usually separates the sexes — boys on the right, girls on the left — which intensifies the sexual charge coursing between them.

In *Street, Berlin* (see Figure 21-1), Kirchner's color palette is like a woman's makeup kit: limited and flashy. Light blue buildings and windows border a hot pink street. A mauve fur-collared coat and a blackened-blue one clash and harmonize simultaneously, partly because the bodies of the women wearing them conform to each other like overlapping waves. Men in dark blue and black trench coats hover around these chic, high-end prostitutes, pretending to shop for something other than the women. The angular cityscape framing the crowd conforms to their shapes.

Figure 21-1: Kirchner stretched the figures in *Street, Berlin,* perhaps because the Berlin denizens strut down the avenue like peacocks; or maybe because their tall hats and feathered headdresses suggest that they want to add several inches to their stature.

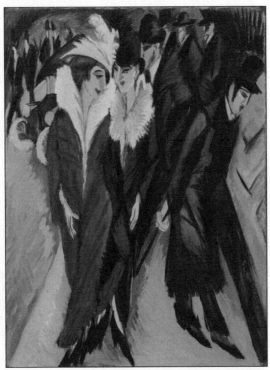

Street, Berlin, 1913. Ernst Ludwig Kirchner (1880-1938)
© Copyright. Location: The Museum of Modern Art,
New York, NY. Digital Image © The Museum of Modern Art /
Licensed by SCALA / Art Resource, NY.

Erich Heckel

Erich Heckel (1883–1970) was the chief organizer for Die Brücke and the glue that kept the group together during tough times. Without his efforts, Die Brücke wouldn't have received the recognition they did; he arranged most of the exhibitions. Like the other members, Heckel's paintings have a murky look, flattened perspective, and simplified forms.

Although Die Brücke didn't paint antiwar or prowar paintings, the threat of war infects their art because it's inside the artists. In Heckel's 1908 painting *Red Houses,* the landscape and houses appear to feel the approach of an imminent catastrophe or apocalyptic storm like wild animals sense a fire or hurricane. As the war got closer, Heckel's colors became murkier. After World War I (WWI) broke out in 1914, Heckel enlisted and became a medic in Belgium. While there, he painted *Corpus Christi in Bruges.* The ominous clouds in the painting look like mammoth mountains heaved up by the convulsions of the earth. The architecture is warped and frightened, and the handful of people roaming the yellow-green streets look as though they're walking through a hallucination.

In the late Middle Ages, Corpus Christi (a celebration of the Eucharist) was a bigger holiday than Christmas. In Heckel's painting, the only signs of celebration are the limp flags and the religious window display (blurred and indistinct like the pedestrians).

Der Blaue Reiter

Der Blaue Reiter, which began in 1911 in Munich, is the spiritual and bright side of Expressionism. The movement's leaders, Russian-born Wassily Kandinsky and Franz Marc, sought to elevate mankind spiritually through a visual art that was allied to music. They believed man had sunken into a mire of materialism. For art to extract him from his materialistic rut, it must first shed its own materialism — in other words, the use of naturalistic forms. Der Blaue Reiter artists believed that, because naturalistic forms mirror the material world, they reinforce materialism rather than free people from it. In other words, a painting of a palace makes people want to live in it; a sculpture of a beautiful body stimulates thoughts of sex, not spirituality.

To achieve his spiritual goals, Kandinsky created a nonobjective or non-representational art. His subjects were his own inner tensions and emotions rather than landscapes or human models. He said, "The more obvious is the separation from nature, the more likely is the inner meaning to be pure and unhampered."

Die Brücke artists didn't have a lot to say about their movement. But the members of Der Blaue Reiter recorded their ideas in two books: the *Blaue Reiter Almanac* (see Chapter 28) and Kandinsky's solo effort *Concerning the Spiritual in Art.*

Wassily Kandinsky: Symphonies of color

Wassily Kandinsky (1866–1944) believed that spiritual communication required a new language, so he invented a language of color. Paintings have always used color, but until the 20th century, color was subservient to form. For color to communicate effectively, Kandinsky believed it had to be freed from form in nonobjective art. His predecessors van Gogh, Gauguin, and the Fauves had moved in that direction. But they didn't go far enough — they left color still locked inside representational forms.

In *Concerning the Spiritual in Art,* Kandinsky claims that the arts are gradually converging: "There has never been a time when the arts approached each other more nearly than they do today, in this later phase of spiritual development." He said all the arts tended to borrow from music:

> A painter, who finds no satisfaction in mere representation . . . in his longing to express his inner life, cannot but envy the ease with which music, the most non-material of the arts today, achieves this end. He naturally seeks to apply the methods of music to his own art. And from this results that modern desire for rhythm in painting, for mathematical, abstract construction, for repeated notes of color. . . .

In his painting *Composition Number VI* (see the color section), Kandinsky puts these ideas into practice. Instead of combining mostly garish colors like the Die Brücke artists and the Fauves, he juxtaposes friendly colors (greens and blues) to create harmonious blends mixed with clashing colors (vivid reds and toned-down yellows), which create discords that suggest frenzied motion. *Composition Number VI* feels like the climax of a jazz jam with cymbal crashes, rousing rhythms, and blaring horns. It's an exploding concert of colors that soothes and stirs you up simultaneously. The impression of organized chaos conveys Kandinsky's message of freedom from form. Yet if you look hard enough, the painting begins to resemble natural scenery — perhaps a Bavarian mountainscape during a riotous Mardi Gras. Despite its freeform feel, *Composition Number VI* (one of a series of compositions that Kandinsky painted) is not randomly composed; each color is as carefully chosen as the notes in a Mozart symphony.

Franz Marc: Horses that harmonize with the landscape

At first, Franz Marc (1880–1916) was less abstract than his fellow Der Blaue Reiter member Kandinsky. He felt true spirituality could be achieved by returning to nature, to the primitive. So he painted animals because, to him, they represent purity untainted by society. In a letter to his wife, Marc wrote:

> Instinct has never failed to guide me . . . especially the instinct which led me away from man's awareness of life and towards that of a pure animal. The ungodly people who surrounded me (especially the male variety) did not inspire me very much, whereas an animal's unadulterated awareness of life made me respond with everything that was good in me.

The color combinations of the Fauves, especially Derain and Vlaminck, showed Marc that color can be freed from the object. In other words, an artist didn't have to use naturalistic colors. Marc began to paint his famous blue horses, a purple fox, and a bright yellow cow. However, from 1913 until his death in WWI, Marc moved toward pure abstraction (nonobjective art).

Horse Dreaming, painted in 1913, is a bridge between his more realistic work like *The Yellow Cow* and *The Little Blue Horses,* and his later abstract work. In *Horse Dreaming,* the representational (realistic) elements are not more or less important than the abstract ones. Marc perfectly balances the two. To harmonize the representational horses with the abstract circles, cylinders, and triangles that surround them, he simplified the horses into geometric units. Both the abstract and representational elements look like geometry problems. But these problems can only be solved through the imagination. For example, abstract green and red shards pierce the large blue horse without wounding it. Are the shards merely the "stuff that dreams are made on"? The mysteriousness of the painting draws you into the horse's dream so that it becomes your own.

Austrian Expressionism: From Dream to Nightmare

In Austria, Expressionism grew out of Art Nouveau (see Chapter 20). The leader of Austrian Expressionism, Gustav Klimt, launched a reformist art movement in 1897 called the Secession or the Vienna Secession. The goal of the Secession was to secede from the restrictive academic art world in Vienna and create what they wanted to create. Their motto: "To the times its art; to the art its freedom." This goal didn't change when the Secession evolved from an Art Nouveau (Jugendstil) movement into the Austrian Expressionist movement.

The Secession raked in enough money from its first Exhibition (staged in a building of the horticultural society) to buy their own building. They used it to showcase all the arts, which they believed were allies. Like Les XX in Belgium (see Chapter 20), the Secession hosted literary readings and concerts of Arnold Schoenberg and other contemporary composers' music. They also published a monthly magazine *Ver Sacrum* (Sacred Spring), which included articles about art and architecture as well as drawings and poetry by great poets of the period, including Rainer Maria Rilke. Also, like Les XX, they held international exhibitions featuring works by Édouard Manet, Claude Monet, Pierre-Auguste Renoir, Paul Cézanne, Vincent van Gogh, Auguste Rodin, Paul Signac, and others.

Gustav Klimt and his languorous ladies

Sigmund Freud wrote, "The interpretation of dreams is the royal road to a knowledge of the unconscious activities of life." His Viennese contemporary, Gustav Klimt (1862–1918), explored people's dreams, too, but with a paintbrush.

Watersnakes (see the color section) appears to be a decorative, sensual dream of two female lovers. The painting has an underwater feel, which makes it even dreamier, emphasized by the fluid forms of the women or watersnakes, the white and gold flowerets swaying like seaweed in unseen currents, and the passerby whale oozing into the picture on the lower right.

In this and other paintings, Klimt glorified female sexuality by embedding it in a gorgeous ornamental background like an exotic jewel set in gold filigree. But the background of swirls and circles of gold isn't merely decorative; it is also subtly symbolic. For example, the small circular shapes in the painting (white, gold, and black) are actually ova raining through the lovers' dream like pollen.

The painting is done in Klimt's famous gold style, which he developed after visiting Venice and Ravenna in 1903. The gold-encrusted ceiling of St. Mark's in Venice, the glittering Justinian and the Theodora mosaics (see Chapter 9) in Ravenna, and Byzantine icons in general deeply inspired him. Klimt mixed the Byzantine style with his other influences, in particular Art Nouveau (and the drawings of Aubrey Beardsley) and Symbolism, creating a new, jewel-like manner of painting. He transformed the classic Byzantine icon into icons of sensuality. He didn't merely wrap his figures in a golden aura like Byzantine artists did; instead, he blended them into his shimmering background with decorative motifs.

In one of his greatest gold-style paintings, *Adele Bloch-Bauer I,* Klimt flattened the woman's dress so that it shares the same picture plane as the background. Then he blended them together by merging the decorative dress with an equally decorative background. Yet the dress is still distinguishable from the background. Actually, the painting has two backgrounds: a flat gold wall, and a golden membrane or ornamental cocoon wrapped around Ms. Bloch-Bauer. Sinuous lines, swirls, and large and tiny squares distinguish the membrane from the dress, which is comprised of silver arrowheads, and gold pyramids with eyes in them. The latter give the impression that the dress is watching us. But the woman's face, neckline, hands, and forearms are classically modeled, so that she emerges from the background and her own flattened body as a three-dimensional woman.

Egon Schiele: Turning the Self inside out

The early canvases of Egon Schiele (1890–1918) show the influence of Klimt, who was a father figure to the younger artist. (Schiele's own father died of syphilis when Egon was 15.) But Schiele soon shed the Klimt glitter and dreaminess to express his own brilliant but dark visions and anguished eroticism.

Self-Portrait Pulling Cheek shows the artist's characteristic expressive swirling brushstrokes painted with thinned out watercolor (or oil). This technique exposed some of the paper underneath. Schiele's art is an art of exposure. He exposed his model's and his own innermost tensions and anxieties, probing sexual obsessions like an angst-ridden version of Freud. He used hard-edged contours and murky colors to reveal the anxieties, fear, and depression of his model-patients, who usually looked starved.

The viewer feels that Schiele has turned eroticism and his own mind inside out, exposing everything. Sex in Schiele's paintings is an act of desperation between beings so knotted up that entwining with another person can't relieve the tension of either lover.

Schiele and his wife and unborn child died in 1918 from the Spanish flu, which swept away over 20 million lives that year.

Oskar Kokoschka: Dark dreams and interior storms

Oskar Kokoschka (1886–1980), another great Austrian Expressionist, explored the dark side of human nature like Schiele. He held a profound admiration for Klimt, and the older artist's influence is apparent in his early work. Kokoschka's *Bride of the Wind,* painted at the outbreak of WWI, looks like a golden Klimt dream turned into a black nightmare. Instead of being sweetly entwined, the bodies of the nude man (the Wind) and bride cocoon desperately together. The painting is a metaphor for Kokoschka's intense love affair with Alma Schindler, the widow of composer Gustav Mahler and future wife of Walter Gropius, founder of the Bauhaus (see Chapter 23). She ended their affair and aborted their child. A year later, Alma learned Kokoschka had been mortally wounded in WWI. But he recovered in 1916 and returned to find her married to Gropius. His love for her became an obsession; he had a doll made of her, which he lugged around Vienna and used as a model for some of his paintings (the story is recounted in the 2001 film *Bride of the Wind*).

Chapter 22

Cubist Puzzles and Finding the Fast Lane with the Futurists

In This Chapter

▶ Sorting out Cubism

▶ Keeping up with Futurism

▶ Checking to see if Futurism was a dead end

Cubism and Futurism (founded in 1908 and 1909, respectively) revolutionized art by showing multiple views of a subject simultaneously — something no artist had ever done before, with the exception of Cézanne to a limited extent. If you've ever caught a glimpse of yourself in a dressing-room mirror and been disoriented by the split, multifaceted images of yourself, then you're on the right track for deciphering the flat canvases of the Cubists; they depicted objects from all angles. The Futurists, who were addicted to speed (painting quickly, not the drug!), compressed a series of movements into a single gesture, or a time sequence into an instant.

Both groups believed that earlier artists had painted false pictures of life by depicting it from only one angle, either head-on or in profile. The notion that no single viewpoint has a monopoly on truth was in the air. In 1905, Albert Einstein published his special theory of relativity, stating that space and time frames fluctuate, depending on the observer's position or point of view. Einstein also proved that energy and matter are essentially the same thing. The Futurists capitalized on this idea by merging motion (energy) and matter in their art or by transforming matter into action.

Cubism: All Views At Once

What is Cubism? Crack an egg and then reassemble its fragments on a flat surface. Voila, you've made a kind of Cubist construction. You can see all sides of the egg at once, and yet it's hard to recognize the egg.

Cubist artists moved art toward abstraction by breaking down physical reality into geometric shapes, usually cubes, and then rearranging the cubes — often independently of what they represent — on a flat surface with little or no perspective. A Cubist painting allows you to see a physical object from multiple viewpoints simultaneously (all sides of the egg), although you might not recognize the object.

Cubists didn't just fragment the *main* subject of their paintings (the egg) — they also shattered the background (the frying pan, refrigerator, or kitchen). When they reconstructed the fragments, they often mixed the subject and background so that these physical realities interpenetrate one another. In other words, if you shattered both the egg and the frying pan, when you reconstructed them, you might put the frying pan in the egg instead of the egg in the frying pan.

The founders of Cubism were Georges Braque and Pablo Picasso. The first fully Cubist painting is Braque's *Houses at L'Estaque.* The cluster of cubelike houses in the painting looks like a rockslide on a steep slope. The painting has almost no depth; the background houses are simply the top of the rockslide.

Pablo Picasso

The art of Pablo Picasso (1881–1973) dominates much of the 20th century, probably because it kept pace with progress — or stayed a few steps ahead of it. His art passed through many phases after he began hanging out in Paris in the late 1890s. As a teenager, he immersed himself in the latest Parisian art trends. By his 20s, he was *setting* the trends. His first major phase was his Blue Period (1901–1904), which was followed by his Rose Period (1905–1908), his Analytic Cubist Period (1908–1912), and his Synthetic Cubist Period (1912–1919). After that, Picasso stopped having periods — but his art kept evolving.

Picasso's first period is called the Blue Period because he used various shades of blue and depicted unhappy or "blue" people. It's said that Picasso himself was "blue" at this time, deeply depressed because a close friend of his, Carlos Casagemas, had committed suicide in 1901. The two young men had moved to Paris together in 1900. Not long after, Casagemas shot himself in a Parisian café when the woman he loved spurned him. Picasso painted several tributes to his friend, including *Death of Casagemas* and *Evocation: The Burial of Casagemas,* and then launched into his Blue Period.

One of Picasso's noteworthy Blue Period paintings is *Life,* or *La Vie* (see the color section), painted in 1903. It depicts a pair of gaunt young lovers (the woman nude, the man nearly nude) who face off with a stern elderly woman cradling an infant. The elderly woman looks at them; they don't look at her. Perhaps the child is theirs, or maybe it represents the child they want to have. The couple and woman confront each other through a space neither seems able to penetrate. The couple's nakedness shows their vulnerability.

The woman's clothes suggest her strength. In the background, two equally vulnerable nude women crouch in fetal positions within picture frames. A naked man tries unsuccessfully to comfort one of them. The only content person in the painting is the infant, sleeping in the elder woman's cloak, which she has gathered around the child like a womb. The repeated fetal positions, with their suggestion of vulnerability, and stages of life represented by the infant, young couple, and elder woman, suggest the cycle of life *(La Vie)* and perhaps a need to return to the comfort of the womb.

Picasso gave the young man the face of his friend Casagemas, which adds another level of meaning to the work. Perhaps the reason why the old woman sees the young couple and they don't notice her is because they're not in the same space: She is recalling her past, before Casagemas killed himself. The paintings behind them may be snapshots of her memories before and after Casagemas's death.

Radiographs of *La Vie* show the underlayers of the painting. Picasso made several changes before settling on the picture seen today. The X-ray reveals that, in an earlier version, Casagemas's young woman was pregnant. Perhaps this alludes to a real or desired pregnancy that caused their split. Who can say? Even stranger is the fact that Picasso originally painted his own face in the place of Casagemas. Perhaps some artists' secrets are better off left buried beneath the layers of paint!

The bridge between Picasso's realistic paintings and Cubism is *Les Demoiselles d'Avignon* (see Figure 22-1), painted from 1908 to 1909. In this painting, Avignon is not the French city but a street in Barcelona's red-light district. The demoiselles are prostitutes who confront the viewer like a potential customer. (Ironically, *demoiselle* means "gentlewoman," "bachelorette," "virgin," or "spinster.") Picasso unmasks and strips these women, showing us both their inner natures and the geometric structures under their flesh.

In 1906 and 1907, Picasso discovered primitive Iberian art, Gauguin's primitivism (his Tahiti paintings — see *Savage Tales* in the appendix), and African art, which sailors brought to Paris from France's African colonies. All these influences helped shape Picasso's new style, Cubism. African art influenced many other Paris-based artists as well. The art critic and poet Guillaume Apollinaire (1880–1918) said that the Fauve painters André Derain and Maurice de Vlaminck (see Chapter 21) were deeply impressed by African art because it "succeeded in reproducing the human figure without using any of the elements of direct visual perception."

In other words, African artists reduced the human figure to semi-abstract forms that conveyed the most essential details about the body and character. Picasso, who had said that "Art is the elimination of the unnecessary," was equally impressed by this aspect of African art. He learned a new visual language from it, which he adapted and used for the rest of his life.

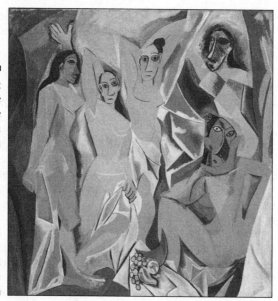

Figure 22-1:
Les Demoiselles d'Avignon is Picasso's Crossing-of-the-Rubicon painting. It both announced and triggered the abstract art revolution.

Notice how the faces (or heads) of the two figures on the right of *Les Demoiselles d'Avignon* are more reductive and aggressive looking — in other words, more like African masks. This suggests that, with these two, Picasso has gotten closer to the instinctual ground floor of human nature. One of their heads is on backwards (swiveled around like Regan in *The Exorcist*).

Cézanne was a major influence on Picasso's Cubist style. Compare Picasso's *Les Demoiselles d'Avignon* with Cézannes's *Mont Sainte-Victoire* in Chapter 20. Notice how both artists have broken down their work into geometric blocks. Obviously, Picasso took this approach much further than Cézanne did.

Analytic Cubism: Breaking things apart

Georges Braque (1882–1963) and Picasso invented Analytic Cubism in 1908. In Analytic Cubism, the artist presents objects in a prismatic fashion so that the viewer can see all sides at once. As in a prism, some planes intersect, some overlap, and others appear to interpenetrate. To achieve this affect, the artist breaks objects and figures down into geometric units, usually two or three shapes. Then he flattens all the surfaces into a single plane. Finally, he dramatically reduces his color palette to several shades of one or two colors. Looked at another way, the artist drains color and perspective from natural forms so the viewer can focus on multifaceted forms — see all views from a single viewpoint (and not be distracted by color).

The face in Picasso's *Portrait of Ambroise Vollard* looks like shattered brown glass. The man's body is in fragments, though most of his fractured face is recognizable.

The viewer's job is to pick up the pieces and reconstruct them in his imagination. But you take one look at the fragmented form of the man, and you realize all the king's horses and all the king's men couldn't put Ambroise Vollard back together again. In fact, he's more interesting in this state. Picasso and Braque soon eliminated representation completely in Analytic Cubism. Braque said, "There is only one valuable thing in art: the thing you cannot explain."

What may be the downside of Analytic Cubism is that the artist has drastically limited his tools of expression (color, form, perspective) to zero in on one aspect of reality that, until that time, had been largely ignored.

Because Braque and Picasso were working with such a limited toolbox of expressive media, much of their work during this period is indistinguishable. Without a signature, it's hard to tell what is Braque's and what is Picasso's.

Compare Picasso's limited use of form and line in *Portrait of Ambroise Vollard* to Matisse's expressive use of line, form, and color in *The Joy of Life* (see the color section) from a few years earlier. Matisse conveys joy and uninhibited sensuality with his sinuous lines. Picasso reveals the many physical facets of a man, but little if anything of his inner nature.

Synthetic Cubism: Gluing things together

Braque and Picasso created a new version of Cubism, called Synthetic Cubism, in 1912. Instead of breaking objects down, they pasted things together to create a semi-representational whole.

The new style of Cubism began with Picasso's invention of the collage. In his first collage, *Still Life with Chair Caning,* he pasted bits of paper (with Cubist shapes drawn on them) onto an oilcloth that is printed with the pattern of chair caning. The picture frame is a piece of rope wrapped around the canvas. Inspired by this work, Braque invented a variant called *papier collé,* in which the flat object or material stuck into the collage is usually cut to represent an object in the artwork. For example, if one of the elements were a comb used to represent a man's hair, it might still look like a comb even though cut into the shape of hair. In other words, it would participate in the artistic illusion created by the collage, while retaining its reality as a comb.

Both Picasso and Braque expanded their color palettes and their range of forms during this phase of Cubism. They also continued to manipulate perspective. By overlaying objects, they gave their works a sculptural sense of depth. But instead of your eyes sinking into the canvas toward a vanishing point, like in a traditional painting, the three-dimensionality rises out of the

work toward the viewer. Sometimes they made the real three-dimensionality of the work seem to contradict the representational by adding shadows going in different directions with pencil or charcoal.

Comparing Picasso's Cubist paintings with *Life,* or *La Vie* (see the color section), reveals a surprising similarity. In *La Vie,* Picasso is already playing games with point of view, but on an emotional level. The points of view of the elder woman, the young man, and the young woman don't quite gel. No one connects, yet their viewpoints intersect at surprising angles like the planes in his Cubist works. Also, the paintings within the painting seem like Cubist fragments of the whole. You can see that they fit, but like the pieces in a Cubist puzzle, you're not quite sure how. Although *La Vie* is a representational work, some of the ingredients of Cubism are nascent in its composition.

Fernand Léger: Cubism for the common man

Fernand Léger (1881–1955), a painter, printmaker, filmmaker, ceramist, and set designer for theater, broadened Cubism's color palette (as did Juan Gris), expanding its expressive possibilities. In 1911, Léger joined Marcel Duchamp, Guillaume Apollinaire, Robert Delaunay, Francis Picabia, and others to form an offshoot Cubist movement called the Puteaux Group (sometimes called Orphism), named after a Parisian suburb where the group met.

Léger's form of Cubism differed greatly from Picasso's and Braque's. Not only did he use more colors, but he included curves and three-dimensional forms such as cylinders. He especially liked jarring primary colors, which he used to emphasize the startling incongruities of daily life. He said, "Pictorial contrasts used in their purest sense are . . . the structural basis of modern pictures."

During World War I, Léger's style evolved. He was drafted into the army where he said he learned to appreciate "the people." While recovering from being gassed, he drew and painted what he saw around him (he also illustrated trench warfare while on active duty). Léger felt that art had sidestepped ordinary people and only appealed to intellectuals. So he created Cubism for everyday folks, Cubism that mirrored real life while glorifying the machine age, which he hoped would improve conditions for the working class. Léger's observations of World War I soldiers playing cards to pass the time inspired his *The Card Players.* The soldiers in the painting look like disassembled robots playing cards inside a machine. This is intended as a compliment, suggesting that the men are as efficient as machines.

Léger employed a fascinating interplay of angles in the painting while contrasting cylindrical limbs with a factory-like background comprised of red and yellow square shapes. He used green highlights to harmonize with the

yellow and fight with the red. Despite its robotic appearance, Léger's painting doesn't banish emotion. These mechanical men have personalities. You can see the "poker face" of the player on the right: He adopts a confident but bored look by resting his chin on his left hand (a cigarette between his fingers), while displaying what he believes is his winning hand. His opponent stiffens and scans his cards to see if he can still pull off a win.

Futurism: Art That Broke the Speed Limit

The Futurists introduced a couple new features into art: compression of movement and greater interpenetration of subjects and backgrounds. Even though earlier photographers like Eadweard Muybridge had shot series of photos of people or animals moving, the Futurists depicted moving figures and machines at multiple moments of time all in *one* image. You could say they took a cinematic sequence and compressed it into a single shot.

In the first *Futurist Manifesto* (published in the Paris newspaper *Le Figaro* on February 20, 1909), the group's founder, Italian poet Filippo Tommaso Marinetti (1876–1944), said, "We declare that the splendor of the world has been enriched by a new beauty: the beauty of speed. . . . All subjects previously used [in art] must be swept aside in order to express our whirling life of steel, of pride, of fever and of speed."

The first Futurist Manifesto was little more than raving — a loud shout that announced that the old guard must yield to the avant-garde. The Futurists declared,

> We want to demolish museums and libraries. . . . Museums, cemeteries! Truly identical in their sinister juxtaposition of bodies that do not know each other. . . . To make a visit once a year, as one goes to see the graves of our dead once a year, that we could allow! We can even imagine placing flowers once a year at the feet of the Gioconda [the *Mona Lisa*]!

Marinetti soon attracted others to the movement: Umberto Boccioni (painter and sculptor), Gino Severini (painter), Giacomo Balla (painter), Luigi Russolo (painter and composer), and Carlo Carrà (painter and writer). In 1910, the Futurists published the *Technical Manifesto of Futurist Painting* (their third publication), which offers some visionary ideas for a more active form of art:

> All things are rapidly changing. A profile is never motionless before our eyes, but it constantly appears and disappears. On account of the persistency of an image upon the retina, moving objects constantly multiply themselves. . . . Thus a running horse has not four legs, but twenty.

Not only did the Futurists compress a series of movements into a single frame, but they also illustrated the interaction between man and his environment by blending him into his surroundings and vice versa:

> Our bodies penetrate the sofas upon which we sit, and the sofas penetrate our bodies. The motor bus rushes into the houses which it passes, and in their turn the houses throw themselves upon the motor bus and are blended with it.

With this system of interaction and interpenetration, the borders that separate human beings from their surroundings break down. Geography becomes part of identity. If someone says proudly, "I'm from New York," then the Empire State Building and Chrysler Building pierce through his head and subways race through his body.

In addition, the Futurists wanted their public to be active participants in their collages of life, to sit inside their paintings rather than view them from the outside like tourists in a museum:

> The construction of pictures has hitherto been foolishly traditional. Painters have shown us the objects and the people placed before us. We shall henceforward put the spectator in the center of the picture.

To cleanse the world of what they consider the dinosaurs of old art and culture, the Futurists advocated war. "We want to glorify war," wrote Marinetti, "the only cure for the world." In 1918, Marinetti founded a Futurist political party, which merged with Mussolini's Fascist Party in 1919.

In the following sections, I examine the work of two of the greatest Futurists, Umberto Boccioni and Gino Severini.

Umberto Boccioni

Umberto Boccioni (1882–1916), both a painter and sculptor, is considered the best artist of the Futurists. One of his works that illustrates the Futurist idea of blending man into his surroundings is *La Strada Entra Nella Casa (The Street Enters the House)*, painted in 1911. In this work, a woman peering over a balcony at a hyperactive street scene absorbs the action that she sees: The street below scales the balcony and cuts through her; the reddish horses galloping on the road charge through her consciousness and her body. Neighboring apartment buildings infiltrate the woman's flat. Buildings farther down the street lean on each other, sharing walls. The whirling energy of city life infects everyone and everything.

One of Boccioni's most celebrated works is the sculpture *Unique Forms of Continuity in Space* (see Figure 22-2). The bronze statue of a robotic running man is the Futurist ideal: a human with the dynamism and speed of a machine. The figure looks like a hybrid of Darth Vader and Nike of Samothrace: power and action in a single form. Ironically, in the original *Futurist Manifesto,* Marinetti declared that "A screaming automobile that seems to run like a machine-gun is more beautiful than the Nike of Samothrace" (see Chapter 7).

Figure 22-2:
Boccioni's
Unique
Forms of
Continuity in
Space
illustrates
the Futurist
concept of
simultaneity:
multiple
moments
suggested
by a single
image.

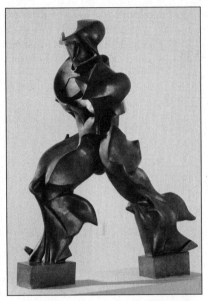

Scala / Art Resource, NY

The statue is also reminiscent of the liquid metal policeman in *Terminator II* (1990) during one of his meltdowns. The man liquefies, re-forms, and moves swiftly into the next moment all at the same time. *Unique Forms of Continuity in Space* is as futuristic today as it was in 1913 when Boccioni created it.

Transferring the ideas of Futurist painting to sculpture, Boccioni wrote in his 1912 *Technical Manifesto of Futurist Sculpture,* "Let us tear the body open and let us enclose the environment in it."

Gino Severini

Gino Severini (1883–1966) was among the most original Futurist artists. Strongly influenced by Cubism, his geometric canvases are typically crowded with interlaced activity that seems to expose life from every angle. He tended

to use analogous colors to blend his diverse forms, and complementary colors to suggest dramatic actions. For example, in his *Red Cross Train Passing a Village,* the stylized French Red Cross locomotive roars past houses and hillsides. The landscape of triangular-cut hills, stylized trees, and rectilinear buildings appears just as streamlined as the train, as if it were designed to accommodate speed.

In *The Boulevard* (see the color section) Severini blends pedestrians into the cityscape they navigate, while preserving something of the pedestrians' rather generic individualities. This pretty scene looks like a semi-abstract quilt of an alpine ski resort. But like other Futurist work, the overall impression is that the artist has captured a human being's fragmented consciousness of his surroundings. Some of Severini's work could be called Cubist Futurism.

Chapter 23

What You See Is What You Don't Get: From Nonobjective Art to Abstract Expressionism

In This Chapter

▶ Surveying the Russian avant-garde

▶ Probing Dada, Surrealism, and the unconscious

▶ Sizing up Modernist architecture

▶ Sorting out Abstract Expressionism

By the turn of the 20th century, the camera had the objective world well in focus. Partly to counter the camera and partly to explore new visions of reality inspired by the Machine Age, by Albert Einstein's theory of relativity, and by Sigmund Freud's and Carl Jung's explorations of man's unconscious, many artists turned to abstract, nonobjective art, and Surrealism, creating new visual languages to express the complexities of the modern world.

In this chapter, I fill you in on the basics of these languages. I explore the Suprematism, Constructivism, De Stijl, Dada, and Surrealism movements in Russia, Holland, and France. Then I cover the modernist architectural languages of Frank Lloyd Wright, Walter Gropius and the Bauhaus, and Le Corbusier. Finally, I explore Abstract Expressionism, the first art movement launched in the United States that gained international attention.

Suprematism: Kazimir Malevich's Reinvention of Space

Suprematism means "the supremacy of pure feeling in art." So what's "pure feeling" in art — or anywhere, for that matter? Try to imagine a mental anti-gravity chamber in which your emotions float around unattached to earthly

things. If you can't imagine that, then check out a Suprematist painting by Kazimir Malevich (1878–1935) and see where his images take you.

Kazimir Malevich's ideas about art were as revolutionary as, well, the Russian Revolution. Two years before the Russian Revolution, he founded Suprematism, which he believed surpassed all other forms of painting. In his 1915 manifesto *From Cubism and Futurism to Suprematism,* Malevich said: "All past and recent painting before Suprematism . . . has been subjugated by the shapes of nature [and is] waiting to be liberated, to speak its own language." He believed that geometric shapes arranged in patterns that don't reflect the natural world can communicate pure feeling — like an abstract mobile suspended over an infant's crib that soothes and transfixes the child when he's stressed. For Malevich, pure feeling recaptures a newborn's first look at the world; it has no memories attached to it, no preconceptions.

Malevich started as an Impressionist and converted to Cubism. But neither of these styles communicated his spiritual goals. He said that Cubism, despite its abstract appearance, is still grounded in physical reality and "does not convey even an inkling of the presence of universal space." (To Malevich, *universal space* means both spiritual space and outer space.) He said that Suprematism "does not belong exclusively to the earth . . . in fact, in man . . . there is a striving towards space, a yearning to 'take off from the earth.'" Malevich tried to capture this yearning on canvas.

Think of traditional painting as being governed by man's ordinary conception of space, which includes the force of gravity. Human beings don't float or fly around on the naturalistic canvases of Gustave Courbet (see Chapter 18) or in a Pierre-Auguste Renoir (see Chapter 19) café scene. Their figures and objects are grounded. If you flip a Renoir café scene upside-down, it mars your appreciation of the painting.

By contrast, you can turn a Malevich painting in any direction and it's just as effective. Similarly, in outer space, nothing is right side up or upside-down. The moon isn't really above the Earth; it revolves around it. Malevich simulated this effect in his art.

The vocabulary of Malevich's new pictorial language consisted primarily of squares and rectangles, which he considered to be free of everyday associations. He said, "The square is a vivid and majestic newborn, the first step of pure creation in art."

Malevich didn't merely want to reinvent pictorial space; his goal was to reinvent the world (like the Russian revolutionists). He wrote, "Suprematism is the beginning of a new civilization." To help him build this revitalized world, he founded the Suprematist group, which included painters Olga Rozanova, Aleksandra Ekster, Lyubov Popova, and others. His paintings of squares were meant to be intuitive bridges to a higher reality, as well as illustrations of it. In Malevich's *Red Square: Painterly Realism of a Peasant Woman in Two*

Dimensions, there's no sign of the peasant woman. All you see is a red square, slightly askew, on a white background. So what's the point?

Colors had meaning for Malevich. White signified motion, black suggested unlimited potential, and red meant revolution. Perhaps Malevich foresaw that the Russian Revolution would free the peasants of Russia from the social system that held them down for centuries. Before he invented Suprematism, he often painted peasants working the fields. In *Red Square,* he painted the spirit of a peasant woman in a revolutionary space — a red square — free from gravity. The fact that he called the work "painterly realism" indicates that he painted a new reality.

In one of his busier compositions, *Suprematist Painting, 1915* (see the color section), rectangles, lines, quadrangles, and squares are suspended in free space. The forms have no associations with ordinary life, but they have relationships to one another: Shapes and colors are repeated and patterns varied. The little black lines and boxes in the lower left seem to shoot out of or into the pattern of larger rectangles above it. The green diagonal line divides the painting into two zones. Each side has a different weight, and this imbalance creates movement as if the objects were falling, flying, or rotating — like a child's mobile in an antigravity chamber.

Constructivism: Showing Off Your Skeleton

Constructivism, another Russian avant-garde art movement, began two years before Suprematism. The Constructivists believed that art should be useful, not just hung on a wall. The leaders of Constructivism were Vladimir Tatlin (1885–1953), El Lissitzky (1890–1941), Naum Gabo (1890–1977), and Aleksander Rodchenko (1891–1941).

Like Malevich and the Cubists, the Constructivists stripped away the extras from art, but for different reasons. It wasn't that the extras hid reality (although that mattered to some Constructivists) but that they got in the way of practical concerns. The American writer Max Eastman said that for an object to be considered art, it must be so beautiful that people don't want to use it — like a Greek amphora that people display but never drink from. The Constructivists held the opposite opinion: Art must be useful, and aesthetic frills should be eliminated because they hamper use. Furthermore, they believed art should help reform society along Marxist lines. Despite their differences from other arts movements, Constructivist artists borrowed liberally from Cubism, Futurism (see Chapter 22), and Suprematism. El Lissitzky's paintings, which look like futuristic architectural designs, show the influence of Malevich, with whom he worked at the Vitebsk School of Fine Arts (see *Proun 99* in the appendix). Lissitzky called his paintings "Prouns," which he

defined as "stations for changing from architecture to painting." His art wedded the practical and the abstract.

The goal of most Constructivists was to take art to the people, in the factory and on the collective farms. Their for-the-people philosophy soon led Rodchenko to abandon the "high art" of painting (even though he too was a brilliant painter, greatly influenced by Malevich) and concentrate on posters, theater sets, and photography — art that could reach the worker on a daily basis. He employed catchy colors with mass appeal, Suprematist shapes, and startling lettering, designed to penetrate the viewer's psyche. His photography is equally startling, typically shot from disorientating angles that force viewers to adjust their perspective and think. In the wake of the revolution, thinking was popular in Russia. But in 1921 when Lenin launched his New Economic Policy, artists were no longer treated like cabinet members and were held on a much tighter thought-leash. Many, like Lissitzky and Naum Gabo (see "A dance between time and space: Naum Gabo [1890–1977]," later in this chapter), fled to the West, exporting Constructivist ideas to Germany, France, England, and eventually the United States.

Constructivist architects like Tatlin celebrated the Machine Age, in part, by exposing the skeletons of the structures they designed. They wanted their architecture to look machine-like — in other words, like the Eiffel Tower (which was an influence), with no concrete cover-up to hide the bones of their buildings (or the effort of the worker). Typically, Constructivist buildings look like a child's Erector Set structures — but more elaborate and artsy, often employing geometrical arrangements inspired by Suprematism. Tatlin's architectural designs were an extension of his earlier three-dimensional collages or constructions, which were influenced by Picasso's Cubist collages (see Chapter 22). In his constructions he treated positive and negative space as equal partners — the empty space between parts was as crucial to the construction as the sculpted portions. Ultimately, his constructions were intended to be four-dimensional, suggesting both time and motion.

Tatlin's Tower

The most influential Constructivist building is the Monument to the Third International, also known as Tatlin's Tower, because Vladimir Tatlin designed it. The tower was intended to be the Russian center for promoting global Communism, but the Soviet government never had the funds to build it. The model of this amazing structure looks like a cross between the Eiffel Tower (you can see the metallic skeleton), the Leaning Tower of Pisa, and a spring or helix. In fact, it's a twin-helix design and looks like it would make a very cool ride at Disneyland.

The tower was to include three rotating building-size units, each with a Suprematist shape: a cube on the bottom floor, then a cone, and finally a cylinder. Each unit was designed to rotate at a different rate. The cube (for conferences and the Party Congress) was to revolve once a year. The cone, which would serve as the executive headquarters, would rotate monthly. The cylinder room, which was to be used for communications, media, and propaganda, had the fastest "spin": once per day. Tatlin also planned to mount a huge projector inside the cylinder that would beam messages into the sky, with the clouds serving as projector screens. The entire quarter-mile-high tower was to thrust daringly skyward, suggesting the relentless progress of the international Communist revolution.

A dance between time and space: Naum Gabo

Like Kandinsky, Mondrian, Malevich, and others, Naum Gabo (1890–1977) believed that art should open up the spiritual world to the viewer. For Gabo, sculpture could do this if the sculptor represented volume without mass. In other words, the space that a statue occupies can be suggested or created without filling the space with the statue. Think of it as shadow space or negative space. (If you cut a snowman from a piece of paper, the snowman-shaped hole is called negative space or a negative snowman.) Gabo believed that negative space could be made active, enlivened by what's around it. His sculptures are called *kinetic art* because they suggest motion and therefore the passage of time. In some cases, he used moving parts so that his sculptures actually were kinetic.

In his *Realistic Manifesto,* Gabo wrote:

> We do not measure our work by the yardstick of beauty, we do not weigh it on the scales of tenderness and feeling. The plumb line in hand, the look accurate as a ruler, the mind rigid as a compass; we are building our works as the universe builds. . . . This is why, when we represent objects, we are tearing up the labels their owners gave them, everything that is accidental and local, leaving them with just their essence and their permanence, to bring out the rhythm of the forces that hide in them.

The interplay of curves in Gabo's sculpture creates a sense of dynamic motion and energy. His *Constructivist Head No. 1* (1915) is a female bust made from intermeshing planes and negative space. (Yes, the negative space is part of the composition!) The woman's arcing shoulders and long, streamlined neck create a sense of dynamism as they interact with each other and the spaces they cut out.

In his later work, Gabo takes this dynamism much further. In his *Construction Through a Plane* (1937), energy seems to spring out of the curvilinear shapes that elegantly slice through each other and wrap around a curved black square, which, in turn, frames a circular opening (negative space). For Gabo, negative space was a dance hall or playing field in which sweeping and slashing lines intersect and release their energy.

Like other Constructivists, Gabo used Machine Age materials like steel, tin, wood, glass, plaster, and plastic to bridge the great divide between art and industry. *Constructivist Head No. 1* is made of plywood, and *Construction Through a Plane* is constructed with Perspex, a form of plastic invented in 1928 and made available for commercial use in 1933.

The purpose of art, says Gabo, is "to accompany man everywhere where his tireless life takes place . . . work days and holidays, at home and on the road, so that the flame of life does not go out in man."

Piet Mondrian and the De Stijl Movement

The Dutch artist Piet Mondrian (1872–1944) began as an Expressionist. But after encountering Analytic Cubism, he turned his back on Expressionism and nature and developed a new, nonrepresentational style that he called Neo-Plasticism. Mondrian's abstract designs do not resemble anything in the real world except perhaps the pictures in a geometry book. He felt that naturalistic forms and colors disguise ultimate spiritual reality because they trigger worldly associations that obscure the spirit (a view similar to Malevich's, discussed earlier in this chapter). For example, if you see an Expressionist painting of Berlin street life or an Impressionist canvas of a Paris café, it may stimulate various physical desires in you. Mondrian's goal was to eliminate the baggage of associations that color and form usually have. Instead, he used simple forms, usually the rectangle and square, and primary colors that could interact on their own terms without reminding people of ordinary life.

Also, like the Cubists, Mondrian broke down physical reality into fundamental forms, which he believed were closer to an ultimate, unchanging reality (like breaking physical reality into its molecular components). This is another reason he chose primary colors — all other colors resolve into red, blue, and yellow.

The movement he founded with Theo van Doesburg is called De Stijl (Dutch for "The Style"). Mondrian and other De Stijl artists strove to create offsetting tensions, as Mondrian said, "through the balance of unequal but equivalent oppositions." Many of Mondrian's paintings, for example *Composition with Large Blue Plane, Red, Black, Yellow and Gray* (1921), look like game-board grids or street maps enlivened with blocks of bold color. His late work, *Broadway Boogie Woogie* (1942–1943), a grid of tiny yellow, red, white, and blue squares, looks like a jazzy circuit board.

Dada Turns the World on Its Head

Dada sounds like baby talk or, at best, an art movement that never grew up. Perhaps Dada artists wanted to regress to the playfulness of childhood, while the adult world was busy destroying itself in World War I (WWI).

The Dada movement specialized in anti-art pranks:

- ✔ Noise concerts
- ✔ Mock art like Marcel Duchamp's *Mona Lisa* with a mustache
- ✔ Poet Hugo Ball delivering a gibberish poem ("gadji beri bimba glandridi laula lonni cadori") while dressed in blue cardboard tubes and periodically flapping his cardboard wings
- ✔ A three-way portrait of Cézanne, Renoir, and Rembrandt, using the same wind-up monkey to portray all of them
- ✔ The art lecture in New York that Arthur Craven turned into a striptease before an audience of high-society ladies (He was arrested before he could shed his underwear.)

According to Hans Richter, one of the original Dadaists, the movement was designed to be misunderstood: "Dada invited, or rather defied, the world to misunderstand it, and fostered every kind of confusion." But the confusion was a put-on:

> Our provocations . . . were only a means of arousing the bourgeoisie to rage, and through rage to a shamefaced self-awareness. . . . Dada was a storm that broke over the world of art as the war did over the nations. . . . It was an artistic revolt against art.

It was a revolt against everything that seemed to have paved the way to the war. The Dadaists were young and perhaps naïvely believed they could change the world by mocking it. (WWI certainly proved that the world needed a shakeup.) But Dada's naïveté and its stagy anti-art antics were refreshing. Like a storm, they helped clear the air of stale ideas, making room for new ones.

Dada, the ground floor, and Cabaret Voltaire

When madness engulfed much of the world in war, many artists fled to neutral Switzerland. In 1916, the poet Hugo Ball persuaded a Zurich bar owner to let him transform his sluggish establishment into a literary café called the Cabaret Voltaire. Ball promised he could increase the owner's beer and

sausage sales. He did — dramatically. Soon most of the foreign and local artists in Zurich gravitated to Cabaret Voltaire, and a constellation of independent, like-minded thinkers formed. The constellation was Dada.

In the first Dada publication, in May 1916, Hugo Ball wrote: "The present booklet . . . is intended to present to the Public the activities and interests of the Cabaret Voltaire, which has as its sole purpose to draw attention, across the barriers of war and nationalism, to the few independent spirits who live for other ideals." Suggesting that war is a mainstream "ideal" was of course a jab in the mainstream's collective ribs.

Cabaret Voltaire was an all-in-one gallery, concert hall, and stage for poetry readings. The main figures in this first phase of the movement were Hugo Ball; the Romanian poet Tristan Tzara, who eventually became the Dada leader; the painters Max Ernst, Hans (Jean) Arp, Marcel Janco, and Hans Richter; the singer Emmy Hennings; Richard Huelsenbeck, a German drummer, poet, and writer; and Walter Serner, a German writer who died in a concentration camp during World War II (WWII).

More people joined the movement later, including Marcel Duchamp, Francis Picabia, André Breton, and Man Ray. Some, like Kurt Schwitters, lived and created on the Dada fringes but never became full members. A quieter version of the movement sprang up almost simultaneously in New York. After the war, Dada spread to Berlin, Cologne, Hanover, Paris, and Barcelona.

Some features of Dada were inspired by Futurism: noise music, rejection of past art, and jumbled type (see Chapter 22). But the Futurists had a mission and a program. Dada's only program, according to Richter, "was to have no programs . . . and, at that moment in history, it was just this that gave the movement its explosive power to unfold in all directions."

Art had become an industry and, therefore, a buttress for the social system that ignited WWI. Dada anti-art attempted to free art from the yoke of commercialization and from old rules and values. Each Dadaist was like a young Oedipus, ready to kill his cultural fathers — or at least disarm them. Ball said, "Art is for us an occasion for social criticism." Their pens and paintbrushes were weapons in their war against tradition. But they were still pens and paintbrushes. Despite its anti-art pose, Dada paintings, poems, and actions are art, but an art that wants to provoke change rather than sit on a wall or pedestal.

One of the most important features of Dada is chance. Chance became another tool in the Dadaists' anti-art arsenal. They believed that if art reflects life, everything in a composition shouldn't be composed. Chance events occur in life; they should occur in art, too. Besides, chance behaviors, gestures, and phrases like Freudian slips may not be as accidental as they seem. The Dadaists thought that chance might be an outlet for their unconscious minds, which they wanted to express in their art. For example, Tzara would cut out single words from a newspaper, toss them in a bag, shake the bag, and then spill the words into a poem.

Marcel Duchamp: Urinals, hat racks, and bicycle wheels

When Marcel Duchamp (1887–1968) moved to New York in 1915 to escape the war, he was already a celebrity.

Two years earlier, Americans had been introduced to his *Nude Descending a Staircase No. 2* (see Figure 23-1) in the groundbreaking Armory Show in New York. The Armory Show was the first major exhibit of modern European art in the Western Hemisphere. Americans, bred on realism, were shocked by what avant-garde European artists had been doing for the last 13 years. But 100,000 people attended the show anyway. After seeing the exhibition, President Theodore Roosevelt declared, "That's not art!" The most controversial piece was Duchamp's "nude," which one critic said looked like "an explosion in a shingle factory" — which isn't a bad description.

Figure 23-1:
Marcel Duchamp's *Nude Descending a Staircase No. 2* scandalized viewers not because she's naked — but because she's an unattractive abstraction of nudity.

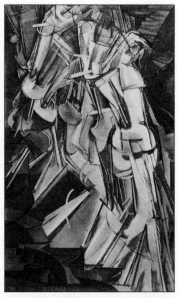

Digital Image © The Museum of Modern Art / Licensed by SCALA / Art Resource, NY. © 2007 Artists Rights Society (ARS), New York / ADAGP, Paris / Succession Marcel Duchamp.

Duchamp, inspired by the Futurists' goal of illustrating the passage of time, depicted a nude woman tromping down the steps over several seconds. He painted her in accordion layers to show the successive stages of her descent.

Duchamp, a member of the Puteaux Group of Cubists (see Chapter 22), dissected the woman into Cubist units that do look a bit like shingles. Calling her a "nude" is a joke. It's impossible to know whether the "shingles" are

clothed or not. It was Duchamp's way of mocking the tradition of painting female nudes. That's what shocked people.

When Duchamp first tried to exhibit *Nude Descending a Staircase No. 2* at a Cubist exhibition in Paris, the curator asked him to change the title. (Apparently, he was scandalized, too.) Duchamp refused and withdrew from the show.

In the summer of 1915, Duchamp met up with his friend and fellow artist Francis Picabia in New York. A year later, Duchamp, Picabia, and the American photographer Man Ray launched the tamer New York Dada movement from the studio of pioneering photographer Alfred Stieglitz (see Chapter 25). Stieglitz supported the New York Dadaists and published their articles in his magazine, *Camera Work,* although he never became a Dadaist himself.

Before leaving Europe, Duchamp began creating what he called "readymades" — an aggressive protest against traditional art. A *readymade* is an object from everyday life transformed into art by the will rather than the craft of the artist. Duchamp didn't do anything to the readymades other than give them titles and sign and date them; he simply said, "It's art," and — *voilà!* — a snow shovel or hat rack turned into a museum piece, or a bottle rack was transformed into a sculpture.

While mocking the stuffy side of the art world, Duchamp's readymades also raised interesting questions about the difference between art and non-art. His readymades suggest that if you strip the utilitarian function from an object, tack on an artsy title (he called the snow shovel "In Advance of the Broken Arm"), and stick the thing in a gallery, it becomes art. After all, art is about perception — isn't it? If we view a snow shovel as merely useful, we will probably never recognize its aesthetic qualities. On the other hand, a snow shovel displayed in an art gallery still reminds me of shoveling the drive.

Duchamp's first readymade was a bicycle wheel mounted on a kitchen stool. In 1917, he entered a porcelain urinal in the Society of Independent Artists exhibition and called it *Fountain,* by R. Mutt. (J. L. Mott Iron Works manufactured the urinal.) As a founding member of the association, Duchamp seemed to be testing the nerve of his colleagues. How avant-garde were they? Most of the other members rejected *Fountain,* even though the exhibition was unjuried (all entries were supposed to be accepted). Duchamp resigned immediately in protest (or perhaps as yet another Dada prank).

In 1920, Duchamp and Man Ray produced one issue of a magazine called *New York Dada.* Shortly after, Man Ray declared, "Dada cannot live in New York. All New York is Dada, and will not tolerate a rival." Duchamp apparently agreed. In 1923, he gave up not only Dada, but painting, too. He said he preferred playing chess (a game for which he had an extraordinary talent).

Hans (Jean) Arp: In and out of Dadaland

Jean Arp (1886–1966), better known as Hans Arp, described the goals of Dada in his book *Dadaland:*

> Revolted by the butchery of the 1914 World War, we in Zurich devoted ourselves to the arts. While the guns rumbled in the distance, we sang, painted, made collages and wrote poems with all our might. We were seeking an art based on fundamentals, to cure the madness of the age, and find a new order of things that would restore the balance between heaven and hell. We had a dim premonition that power-mad gangsters would one day use art itself as a way of deadening men's minds.

Arp's art looks like an illustration of a secret law of biology: natural things flow into each other and blend if the viewer lets them (something the "power-mad gangsters" don't seem to get). For Arp, Dada was a "moral revolution" and would help plug man back into his roots — nature, where everything harmonizes. To advance this peaceful revolution, he copied shapes from nature that he found by chance (for example, debris such as sticks and leaves that washed up on the shore of Lake Maggiore in southern Switzerland) and merged them fluidly with biomorphic — softly, rounded organic — forms in his art. These biomorphic forms were often inspired by the human body.

His painted construction *Untitled (Forest),* made in 1917 while WWI was still raging, depicts a playful setting that resembles a wooden puzzle made of biomorphic colored pieces: pink, mauve, black, yellow, brown, and olive green. Despite their differences, the puzzle pieces fit on top of or inside one another into a harmonious three-dimensional whole (like a map of countries that get along). The top piece, a bright pink leaf (perhaps based on a leaf that washed up on the Lake Maggiore shore), informs the viewer that he is in a forest of interconnected organic shapes.

Arp's art, in some ways, is an antidote to war. It demonstrates that diverse forms and objects can remain themselves and still blend. His revolutionary paintings and sculpture convey a comforting sense of harmony; you feel like you're flowing into them, without losing your identity.

After WWI, Arp and Max Ernst founded a Dada group in Cologne, Germany. Arp also helped spread Dada to Berlin and Paris. A few years later, both Arp and Ernst joined André Breton's new Surrealist movement. Although Arp's art evolved, the importance of chance remained central to his work throughout his life. It would become an ingredient of Surrealism, too.

Surrealism and Disjointed Dreams

Surrealism is Dada with a program. André Breton, one of the founders of Surrealism, joined the Paris Dada movement briefly, but decided it was a dead end. It was time to expand Dada's goals and make serious art. The Surrealists imported from Dada the idea that chance should play a role in art. They used chance as a tool to probe the unconscious.

In the first *Surrealist Manifesto* (1924), Breton said that civilization has buried the instinctual side of human nature, which lives in the unconscious. He argued that civilized man's obsession with rationalism causes him to banish intuition and imagination, to condemn everything that bubbles up from the unconscious as irrational. Breton and the other Surrealists believed that the instinctual side of man was healthier than the civilized side, which sanctioned things like war and the class system. Breton claimed that tapping into the unconscious (dreams and instincts) would help "civilized" man clean up his act. Sigmund Freud's discovery of unconscious motivations proved that man's instinctual side influences his behavior and erupts into consciousness when he least expects it — as Freudian slips, for example (when you express secret desires or feelings without intending to). The Surrealists viewed these eruptions as salutary and tried to provoke them to occur and then capture them in their art.

The challenge for Surrealist artists was to wake up the unconscious and make it speak on their canvases. They devised several ingenious ways to do this. One of them was to turn off the will power, ignore moral codes, and become a receptacle of life. In this state, the unconscious begins to communicate and an attentive artist can transcribe its "voice," either as a writer or visual artist. This form of writing is called *automatic writing*.

Philippe Soupault (1897–1990), a poetic novelist and the co-founder of Surrealism with Breton, used the automatic-writing technique to write an entire novel, *The Magnetic Fields*.

Max Ernst and his alter ego, Loplop

Max Ernst (1891–1976) tried automatic drawing, but it didn't yield very useful results. So he developed alternative methods to release his unconscious feelings and capture them on canvas. He called these methods *frottage* and *grattage:*

- ✔ **Frottage:** In frottage, the artist places a sheet of paper on a textured surface — such as a wooden floor, a bed of leaves, or dried flowers — and then draws the shapes he discovers. This is similar to taking a rubbing from a relief or headstone, except that you don't know what you're going to wind up with in advance. Ernst believed that the discoveries one makes through frottage are made by the unconscious rather than the conscious mind (presumably intuition guides your hand as you draw these shapes).

- ✔ **Grattage:** Later, Ernst developed grattage, a method similar to frottage, in which he scraped layers of paint off a dry canvas to create or discover patterns, some of which he then incorporated into his paintings.

Ernst was attracted to birds and created a bird-version of himself (a bit like a pagan shaman figure) that he named Loplop. Loplop was, more or less, a messenger from Ernst's unconscious. Ernst said: "I was visited nearly every day by the Bird Superior, named Loplop, an extraordinary phantom of model fidelity who attached himself to my person. He presented me with a heart in a cage, two petals, three leaves, a flower and a young girl." This mysterious alter ego found its way into many of Ernst's paintings.

Ernst's *The Robing of the Bride* (see the color section) is both an exotic dream and a nightmare. Loplop shows up in this dream as a green bird wearing tights. The nude bride, who is being robed in red and has the head of an owl, may represent the English Surrealist artist Leonora Carrington, one of Ernst's four wives. He left Carrington (his second wife) during WWII for Peggy Guggenheim, who became his third wife. The Peggy Guggenheim Museum in Venice houses many of Ernst's works, including *The Robing of the Bride*.

Notice that Loplop stares at the broken spear in his hand. The broken spear and other objects in the painting should be interpreted as symbols in a dream. It appears that Loplop is afraid that he won't be able to satisfy his larger-than-life bride. The messages from Ernst's unconscious are never clear but always intriguing.

Salvador Dalí: Melting clocks, dreamscapes, and ants

André Breton welcomed Salvador Dalí (1904–1989) with open arms into the Surrealist movement in 1929. "It is perhaps with Dalí that for the first time the windows of the mind are opened fully wide," Breton effused. Many of Dalí's phobias — like his fear of ants — creep through these open windows into his paintings. In fact, they show up so often that they are like road signs helping the viewer to navigate and interpret Dalí's dreams on canvas.

As a child, Dalí kept a pet bat. One day he discovered ants devouring its dead body; ants in his paintings usually signify decay. Other symbols include

- **Eggs:** Symbols of fertility and hope
- **Crutches:** Symbols of needing or receiving support or of being grounded in the real world
- **Teeth:** Symbols of sexuality
- **Drawers:** Symbols of secrets and sexuality
- **Grasshoppers:** Symbols of waste and fear

Dalí invented what he called the *paranoiac-critical method.* He induced a paranoid state without losing self-control. He said, "The only difference between me and a madman is that I am not mad." To trigger this state, Dalí sometimes stood on his head for prolonged periods. The result: Paranoia sharpened his inner vision so he could see beyond ordinary perception. This method helped him create hallucinatory scenes.

Persistence of Memory (see Figure 23-2) is Dalí's most famous painting. Instead of signaling the hour, the clocks in the painting stop time. The title suggests that time gets recycled in memory. Yet the painting itself shows time melting and decaying. Ants (Dalí's symbol of decay) eat one of the clocks. Maybe time dies so that memory can "persist" outside of it, so that the past will become eternal and the present and future melt away like the clocks in the painting. A person who recycles the past might feel perfectly at home in this dreary dreamscape.

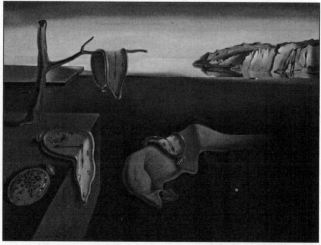

Figure 23-2:
Persistence of Memory, by Salvador Dalí, depicts a nightmare vision, in which time stops so that memory can endure.

Digital Image © The Museum of Modern Art/Licensed by SCALA / Art Resource, NY. © 2007
Salvador Dali, Gala-Salvador Dali Foundation / Artists Rights Society (ARS), New York.

Dalí called his paintings "the hand-colored photographs" of his delirium. This suggests that he was taking pictorial dictation from his unconscious while he painted. He claimed to paint while wearing a necklace with a folded fork for a pendant, so that as he nodded off at his easel the fork would poke his chin, waking him up so that he could record his dreams on canvas.

René Magritte: Help, my head's on backwards!

René Magritte (1898–1967) reshuffled reality in his art: painting a window within a window, a sky on both sides of a doorway, or a train roaring through a fireplace. He created a disorienting world built from contradictory connections. Things almost make sense in his paintings, but not quite.

In Magritte's *Black Magic* (see the color section), the soft curvaceous contours of the woman's lower body contrast strikingly with the hard, rectilinear wall that frames her and the white, rough stone beside it. But the earthy texture and the weight of the solid, lower part of her body, the stone, and the wall anchor this half of the painting in the physical world. Sensual life happens here. But from the waist up, the "black magic" woman is attuned to spirituality. Her upper half seems on the verge of dissolving into the sky. But the window space that frames her also contains her and prevents her divided self from flying apart. The title, *Black Magic,* implies that something evil is transpiring in the painting. Yet there is nothing "black" about the scene — in fact, it's blissfully blue. The dark side may simply be that your mind and body pull you in opposite directions.

Magritte said he discovered his style in a dream.

> One night . . . I awoke in a room in which a cage and the bird sleeping in it had been placed. A magnificent error caused me to see an egg in the cage instead of a bird. I then grasped a new and astonishing poetic secret, because the shock I experienced had been provoked precisely by the affinity of the two objects, the cage and the egg, whereas I used to provoke this shock by causing the encounter of unrelated objects.

In other words, instead of making a typical outlandish surrealistic link — connecting a lawnmower to the kitchen sink, for example — Magritte discovered that he could shock and suggest more by juxtaposing related objects in surprising ways: the fleshy lower half of a nude woman's body with an earth-tone stone wall, for example.

The egg in Magritte's dream is associated with the cage through the bird, so linking them together makes sense — sort of. Yet locking up an egg in a cage is disorienting because it's redundant. The egg is already a cage; it prevents the unhatched bird from taking off. Also, the notion of being born free is undermined by caging up an egg.

Dissecting Frida Kahlo

Frida Kahlo (1907–1954) built a personal Surrealist vocabulary around her troubled relationship with her husband, the Mexican muralist Diego Rivera, and the extreme physical suffering that plagued much of her life. At 18, Kahlo was in a bus accident that shattered her body, causing permanent damage to her foot, back, and pelvis. She had recurring episodes of unbearable pain throughout her life, multiple surgeries, and three miscarriages — and she documents much of this in her art.

Most of Kahlo's paintings are like pages in a visual diary (she wrote a poetic diary as well — see Chapter 28). They chronicle her lifelong wrestling match with pain, her heartbreaks and love affairs, her Communist activism, and the psychological and cultural contradictions that split her sense of self. Fifty-five of her 143 paintings are self-portraits or diary paintings.

In 1938, André Breton visited Mexico and met Diego Rivera and Frida Kahlo. He said,

> My surprise and joy was unbounded when I discovered, on my arrival in Mexico, that her work has blossomed forth, in her latest paintings, into pure surreality, despite the fact that it had been conceived without any prior knowledge whatsoever of the ideas motivating the activities of my friends and myself.

He invited her to exhibit with the Surrealists and set up a solo show for her in Paris. Kahlo gladly accepted Breton's invitation, but said, "I never painted dreams. I painted my own reality." She didn't think of herself as a Surrealist. Nevertheless, her reality paintings have a powerful dreamlike or hallucinatory quality and a symbolist vocabulary similar to Surrealism.

Like the other Surrealists, Kahlo juxtaposed unlikely images, stretching meaning to its limits and then some.

In *What the Water Gave Me* (see the Appendix), Kahlo grabs the viewer's attention with a shocking array of images as nightmarish as those in a Hieronymus Bosch painting (see Chapter 12).

Kahlo seduces you to peer through her eyes as she gazes at her body and personal history floating on the surface of a bath. The viewer's eyes are exactly where Kahlo's are in the painting as she soaks in her tub. Tight-rope-walking insects and a topless ballerina share a high wire made of a rope. The same rope strangles another woman lying naked near Kahlo's left knee. On the right, the Empire State Building erupts from a volcano like an all-American

phallic symbol. A Day-of-the-Dead skeleton sits at the foot of the volcanic mountain, which has turned a tropical island into a wasteland (note the dead bird in the tree). Two women make love on a sponge, and a masked man eyes Kahlo and us while controlling the tension in the rope.

This vision depicts the ongoing battle between the conflicting sides of Kahlo's personality — her Mexican versus her European identity, and her independent female artist persona versus her traditional woman side. The feet poking out of the water — one healthy, one bleeding — announce that you are looking at a split nature. (The right foot, which caused Kahlo pain for years, was amputated in 1953.)

Kahlo connects her personas with a rope that either supports or strangles her identity, and with vines and tendrils that tie her to her cultural roots — plants with her parents' faces. Kahlo's cultural schizophrenia began with her parents. Her father was a light-skinned German immigrant and her mother a dark-skinned native Mexican. Their skin-tone difference is reflected in the light- and dark-skinned women on the sponge, for whom cultural differences evidently don't matter.

In many of her paintings (see *My Dress Hangs There* and *The Two Fridas* in the appendix), Kahlo represents her Mexican side with a traditional Tijuana dress. In *What the Water Gave Me,* her Tijuana dress floats like the husk of a dead self beside the nude corpse (another Kahlo persona).

The man holding the rope that strangles her Mexican persona wears a Chak-Mool mask. A Chak-Mool is a reclining Pre-Columbian stone statue, which may have been used for human sacrifices. Here a white man poses as a Chak-Mool. Who is he? Maybe he is Kahlo's husband, Diego Rivera (although he's a lot thinner than Diego), a great Mexican artist who was as culturally divided as Frida. His art was influenced by both European modernism, especially Picasso, and native Mexican art. Also Rivera was an avid collector of Pre-Columbian art, and may have owned a Chak-Mool. In any case, while the Chak-Mool kills one of Kahlo's personas, he monitors and supports the other's performance on the high wire of the modern art world. (Maybe the insects are competing artists.)

The tension in the rope that strangles the Frida corpse enables the ballerina to foot it on the hire wire, suggesting that Kahlo's motherhood-potential has been sacrificed to Chak-Mool so the artist can perform.

Notice that in the lower right, the two Fridas are alive and in bed with each other, the dark-skinned woman supporting the light-skinned woman. The fair Frida represents Kahlo's European roots, and the dark Frida her native Mexican side. Kahlo painted this same scenario again a year later in *Earth Herself.*

My House Is a Machine: Modernist Architecture

The very nature and look of the American household was changing rapidly in the early 20th century. Traditional styles of houses were giving way to a radically "modern look." A lot of early- and mid-20th-century architects weren't interested in designing pretty buildings. Their primary goals were to create highly functional architecture that reflects the smooth performance of machinery, and to improve man's quality of life by designing structures to meet his needs.

Frank Lloyd Wright: Bringing the outside in

Frank Lloyd Wright (1867–1959), America's most famous and perhaps greatest architect, ushered in modern architecture in the United States. Instead of imposing the latest architectural fashion on every kind of landscape, Wright believed that manmade structures should be tailored to blend into their surroundings. To achieve this goal, he often used materials from the area and mimicked features of the landscape in his homes and buildings.

The organic home

Wright's earliest projects, primarily built in the Midwest, are called Prairie Homes. Instead of towering over their surroundings (to show man's domination of nature), Wright gave his Prairie Homes low, long, and gently sloping roofs (and stumpy chimneys) like the Robie House in Chicago, built in 1909. These flat houses harmonize with the flat prairies of the Midwest. Wright called his style "organic architecture," in spite of the fact that the houses are built with geometric shapes.

Inviting the outdoors in

Wright also believed homes should be built around the people who live in them — not merely their needs, but also their personalities. He custom-designed furniture, cabinets, and kitchen cupboards specifically to meet the needs and reflect the personalities of the residents.

As his approach to residential architecture developed, especially after 1930, he explored new ways to open up the architecture to the surrounding environment. Falling Water at Bear Run, near Pittsburgh, Pennsylvania, illustrates this daring harmony between family dwelling and nature (see Figure 23-3). The home, which was built between 1935 and 1939, is called Falling Water

because a waterfall flows under it — and seems to flow through it. Wright designed the flagstone floors in the house like streambeds to create a feeling of water flowing through the house. In addition, the sound of the waterfall permeates the structure. To further enhance this feeling, Wright made the wood grain of the moldings look like it participates in the same current. Finally, Wright cantilevered the structure like a staircase with jutting terraces. These terraces reflect the rock formations of the surrounding landscape and look like the descent of a waterfall.

You don't walk or stroll through Falling Water, you flow through the house and all the spaces seem to flow with you. Wright manipulated space in almost miraculous ways. For example, windows open like invitations, welcoming the outside world into the house. In subtle and surprising ways, Wright erases the borders between inside and out.

Figure 23-3:
At Falling Water, Frank Lloyd Wright harmonizes the architecture with its natural surroundings.

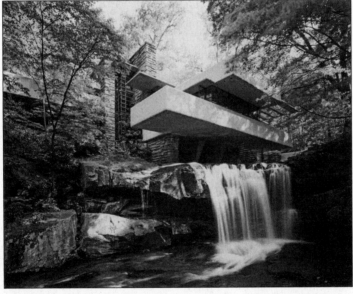

Art Resource, NY. © 2007 Frank Lloyd Wright Foundation, Scottsdale, AZ/ Artists Rights Society (ARS), New York.

Bauhaus boxes: Walter Gropius

The primary goal of Walter Gropius (1883–1969), an idealistic Socialist, was to build functional buildings that serve the needs of working-class people and improve the quality of their lives. He felt that the most efficient way to accomplish this goal was to unite architects, artists, and designers into collaborative teams.

But first architects, artists, and designers had to thoroughly understand each other's roles; then they had to learn to work together. To that end, in 1919 he created an interdisciplinary school by combining the Weimar School of Arts and Crafts and the Weimar Academy of Fine Arts. He called the combined school the Bauhaus. Gropius wrote, "The ultimate goal of the Bauhaus is the collective work of art in which no barriers exist between the structural and decorative arts." Bauhaus teachers included Wassily Kandinsky, Josef Albers, Paul Klee, and, later, Naum Gabo.

With proper interdisciplinary training, artists and designers would work together in harmony like a finely tuned machine. Initially, Bauhaus students study all disciplines — pottery, textiles, industrial design — until they find their niche.

In 1925, Gropius was forced to move the Bauhaus from conservative Weimar, Germany, to more liberal Dessau. He designed the rectilinear new school in Dessau himself, which is called the Shop Block Bauhaus. This building set the standard for functional, Modernist architecture. After designing the school, Gropius went into private practice and Hannes Meyer became director from 1928 to 1930. Meyer was replaced by Mies van der Rohe who directed the Bauhaus from 1930 until 1933. In 1932, the school was moved again, this time to Berlin. A year later, Hitler closed the Bauhaus, which he viewed as a nest of leftists.

Some of the Bauhaus teachers fled to the United States. Gropius was hired to teach at the Harvard School of Design; Joseph Albers at Black Mountain College; and Mies van der Rohe at the Illinois Institute of Technology. Lászlo Moholy-Nagy opened the New Bauhaus in Chicago (1937–1938). Together, these men sowed the Bauhaus ideals and style across the United States.

Gropius trained his students to design quality, functional materials, from ceramics to furniture, that could be mass-produced cheaply so that the working class could easily afford to buy them. At the same time, he and teachers like painter Johannes Itten taught the students to express themselves in their designs while still serving the functional needs of the working class. In Bauhaus design, above all, form must serve function. That meant no ornamentation, no decorative lines. There was a preference for basic geometric forms like the cube, the rectangle, and the circle. The modernist Bauhaus building is a clean-cut structure, with simple lines and easy-to-navigate, comfortable spaces.

Le Corbusier: Machines for living and Notre Dame du Haut

Le Corbusier (1887–1965) is one of the greatest architects of the International style or Modernism. His primary goal was to improve living conditions for city dwellers.

Le Corbusier invented a style that he called *Purism,* which was partly inspired by the work of the painter Fernand Léger. Léger glorified the Machine Age and so did Le Corbusier; the latter designed homes that he called *machines à habiter* (machines for living). These dwellings were built on five design principles:

✔ Each house was supported on stilts.

✔ Because the house was supported on stilts, the walls were freed up so they didn't have to carry any significant weight and the architect could design them to serve other functions.

✔ Because the floor plan was no longer limited by weight-bearing walls, the architect could spread the floor out as he liked.

✔ A ramp connected the floors, to reduce crowd conditions.

✔ The house had a large yard, to give every homeowner privacy.

Le Corbusier's Savoy House in Poissy-sur-Seine (1928–1929), just outside Paris, is a perfect example of these principles. It is an unornamented rectangular structure supported by 16 stilts *(pilotis).* The top layer consists of cylindrical silos and a triangle staircase (a ramp) linking the levels. Simple, streamlined, and boxy, this is a house whose architectural spaces relate to one another as efficiently as the gears of a machine.

Le Corbusier's style got curvier and more organic as he aged. His most innovative work is the boatlike church, Notre Dame du Haut in Ronchamp, France (see Figure 23-4). For this magnificent structure, he discarded geometrical shapes almost completely. Notre Dame du Haut is a curved triangle topped by what looks like the split hull of a boat. The boat is a symbol for the ship of the church, poised to set sail on a spiritual voyage each time a parishioner enters the building. The gently swelling hills around Notre Dame du Haut look like the waves on which the boat will sail. Two ends of the structure are bracketed by silo-shaped towers.

Inside, the church is even more impressive. The ceiling curves resemble the belly of a boat, and the walls curl like incoming waves. Le Corbusier also carefully controls how and where light enters the church. Two levels of rectangular windows divided by white, angled planks allow light to enter in bands on two sides of the building. Unseen openings in the silos permit light to stream mysteriously down the inner silo walls, creating an otherworldly effect because you can't see the source of the light.

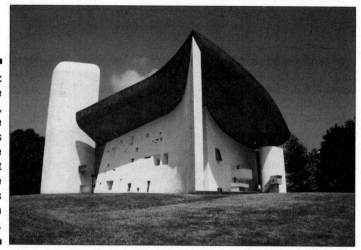

Figure 23-4: Notre Dame du Haut, by Le Corbusier, is one of the most innovative structures of the 20th century.

Many of the windows are tiny slits filled with one color of stained glass. These windows cast mystic shafts of violet, blue, and red throughout the church. Finally, Le Corbusier hand-painted the glass entrance door with playful abstractions. Some art historians believe these abstractions provide clues to unlock the mysteries of the architecture.

Abstract Expressionism: Fireworks on Canvas

After WWII, the center of power shifted from Europe to the United States and the U.S.S.R. The Soviets suppressed all art except Socialist Realism, so the avant-garde moved to the United States where freedom of expression was mandated by law and where the economy was booming. Refugee artists like Naum Gabo, Marc Chagall, Max Ernst, Fernand Léger, Piet Mondrian, Salvador Dalí, and André Breton sowed the seeds of modern art in America even more than the Armory Show of 1913. After the war, their work inspired the first American art movement to gain international recognition, Abstract Expressionism.

Arshile Gorky

The Armenian-born Arshile Gorky (1904–1948) is the bridge between Surrealism and Abstract Expressionism. He escaped the Armenian genocide as a boy, fleeing to Russian-controlled territory with his mother and sisters. After a grueling 120-mile trek, his starving mother died in his arms. He fled to

Russia and eventually to the United States. He was 16 when he arrived with one of his sisters in New York City.

Gorky studied art in Boston, where he was introduced to the Impressionists. After painting in the Impressionist style, he fell under the spell of Paul Cézanne, and then began experimenting with Cubism and Surrealism. From 1935 to 1943, Gorky worked for the Works Progress Administration (WPA), creating ten magnificent abstract murals related to aviation for the Newark airport. Unfortunately most of them were destroyed. Only two survive — they were discovered in 1972 under 12 coats of paint!

Describing his work at the Newark airport, Gorky said that in the fourth panel he reduced an airplane into its fundamental shapes so they would suggest flight without literally showing it. He also used bright hues like "children use in coloring their kites" to give the plane a playful appeal.

Like Hans Arp and Joan Miró, Gorky used *biomorphic forms* (organic blobs) to convey primordial feelings that link all human beings together. He said "I do not paint in front of nature, but from within nature." His painting *The Liver Is the Cock's Comb* illustrates this approach. The painting pulls the viewer inside of it and surrounds him with color and transmutating forms. Looking at *The Liver Is the Cock's Comb* is a bit like being on the other side of a biology experiment.

Jackson Pollock

Jackson Pollock (1912–1956), the man who created masterpieces by throwing paint at his canvases, started out as a traditionalist. In the early 1930s, he was a student of Thomas Hart Benton, one of the fathers of American Regionalist painting (a tradition of realistic painting that documents the life in the rural Midwest). The basic belief of Regionalism is that you should find subject matter in your own background.

In 1935, Pollock joined the Federal Art Project division of the WPA, where he came under the influence of the Mexican muralists José Clemente Orozco and David Alfaro Siqueiros. Next, Pollock caught the Surrealism bug, which, in conjunction with his alcoholism, led him to probe the unconscious through psychology. In 1938, he began receiving psychiatric treatment.

Most American Abstract Expressionists preferred Carl Jung to Sigmund Freud (the favorite of the Surrealists). Jung postulated a collective unconscious that all men and women share. According to Jung, the collective unconscious is a cache of common symbols, a universal language that everyone understands on an unconscious level. Pollock tried to discover these symbols through psychotherapy and incorporate them into his art.

Pollock wasn't much of a talker, not even in therapy, so he exposed his unconscious to his doctor through his paintings. He stopped treatment in 1941 and four years later discovered that he could express his unconscious best by dripping, pouring, and splashing paint on his canvases. This method of painting is called the *drip technique* (see Chapter 29).

As Pollock dripped the paint, he moved or danced rapidly around the canvas, which became known as *action painting*. An action painting captures the activity of the painting process. The artist leaves his footprints, so to speak, on the canvas. It's the opposite end of the spectrum from the delicate, invisible brushstrokes of Jan van Eyck (see Chapter 29). With van Eyck the artist disappears — you can't see his effort, you only see the painting. With Pollock, every step of his effort is visible. The process is as important as the product.

The purpose of Abstract Expressionism is to probe the unconscious, to allow it to speak its own symbolic language. But the pools and splashes of black and the pattern of streams connecting them in *Untitled* (see Figure 23-5) indicate some conscious control in the midst of the chaos. The large black figures (that look like bugs or aliens) appear to hold hands and whirl around the large central figure in a wild pagan rite. Is this the map of Pollock's own dance around the canvas, or is it a picture of his unconscious? Pollock said: "When I am in my painting, I'm not aware of what I'm doing. It is only after a sort of 'get acquainted' period that I see what I have been about." His method enabled him to create exhilarating explosions of energy on his canvases — visual fireworks.

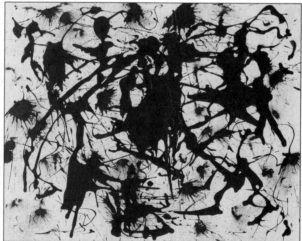

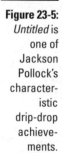

Figure 23-5:
Untitled is one of Jackson Pollock's characteristic drip-drop achievements.

Pollock preferred large canvases that he could dance around, spilling paint from all angles. When you confront one of Pollock's canvases — or it confronts you — you feel like you're being swallowed by it, sucked into a chaotic yet beautiful universe, a celebration of unbridled energy, atomic fission on canvas.

Willem de Kooning

Willem de Kooning (1904–1997) was born in Holland. At the age of 21, he stowed away on a ship to the United States. And in the mid-1930s, like Arshile Gorky and Jackson Pollock, he painted for WPA in the easel and mural divisions. He was "fired" in 1937 because he wasn't an American citizen. He later said that his years working for the WPA gave him his first opportunity to paint full-time.

De Kooning was highly influenced by Gorky, the Mexican muralists, Paris art movements like Surrealism, Pablo Picasso, and Joan Miro. He was also heavily influenced by his rival, Pollock.

De Kooning's action paintings may be his best works. His *Gotham News* is perfectly coordinated chaos, a brash jazzy display of slashing colors that look as though they were spread on the canvas by competing windshield wipers.

In the late 1940s, de Kooning's Expressionism became figurative (or representational). His angst-ridden canvas *Woman I* (like his follow-up paintings *Woman II* through *Woman VI*) seems like a portrait not of a woman but of a neurotic world leering at itself in a mirror. He depicts the "woman" with massive almost militant breasts and a greedy, toothy, bug-eyed face. She exudes the vilest aspects of human nature. The slashed-up landscape around her is as gruesome as she is, suggesting that her powerful personality has overflowed into the environment and corrupted it.

Chapter 24

Anything-Goes Art: Fab Fifties and Psychedelic Sixties

In This Chapter

▶ Tuning in to 1950s art

▶ Turning on to 1960s Pop Art and Minimalism

▶ Focusing on Photorealism

▶ Discovering performance art

After World War II, the in-your-face prospect of nuclear annihilation gave new meaning to the expression *carpe diem* ("seize the day"). Affluent Americans invented a throwaway culture that spread across the planet like both a fad and an epidemic. In the '50s and '60s, some artists reacted to the throwaway society, the Cold War, and Abstract Expressionism by reviving Realism, perhaps as a return to stability. Some blended the arts, as if one art form wasn't enough to express the chaotic variety of modern life; others turned to here-today-gone-tomorrow pop culture — movies, comic books, detective novels, and rock-'n'-roll — for inspiration.

In this chapter, I cover Pop Art, Color Field Art and Minimalism, Fantastic Realism, Photorealism, and performance art. I also give you a brief look at decorative arts that evolved into high arts.

Artsy Cartoons: Pop Art

Traditionally, popular culture and high culture didn't dine in the same restaurants, attend the same concerts, or look at the same art. Pop Art changed that by blurring the cultural divide between the classes.

The Pop Art movement began in England. But it was always about the United States, where egalitarianism had the deepest roots and where throwaway culture came of age first.

The first Pop Art picture (a collage), Richard Hamilton's *Just What Is It That Makes Today's Home So Different, So Appealing?* (1956), celebrates and parodies the U.S. cultural invasion of the U.K. Even the title mimics an American advertisement. The "appealing" home is stocked with the latest American conveniences — a reel-to-reel tape recorder, canned ham, a Ford Motors lampshade, a cartoon-strip poster, a tacky orange couch, a TV featuring an attractive woman on the telephone, and a portable vacuum cleaner with a superlong attachment hose. Its length is noted, as it would be in an ad, with a black pointer midway up the steps: "Ordinary cleaners reach only this far." (To exaggerate its length, the staircase has its own vanishing point, which the hose practically reaches.) The main attractions are the nearly naked beefcake man, posing next to the reel-to-reel, and the cheesecake woman perched on the couch as if for a *Playboy* camera. Outside the apartment window, the Warner Theater advertises an American movie, a rerun of Al Jolson's *The Jazz Singer,* the first *talkie* (movie with sound). The only remnant of British culture in the home is the black-and-white Victorian portrait above the television.

In the following sections, I cover the art of two of the most influential Pop artists, Andy Warhol and Roy Lichtenstein.

The many faces of Andy Warhol

You could say that Andy Warhol (1928–1987) looked at life backwards, and that his art tempts viewers to do the same. In his book *The Philosophy of Andy Warhol,* he wrote:

> People sometimes say that the way things happen in the movies is unreal, but actually it's the way things happen to you in life that's unreal. The movies make emotions look so strong and real, whereas when things really do happen to you, it's like watching television — you don't feel anything.

Warhol's paintings give the viewer an inside-out picture of popular culture by elevating the mundane (a soup can, a box of Brillo pads) into art. With his first Pop Art experiments — paintings of Campbell's soup cans, Brillo pads, and Coca-Cola bottles — Warhol practically transplanted supermarket shelves into art galleries. The paintings look like advertisements for the products they depict. Warhol's *brand* of art raises an obvious question: Is Pop Art "high art" in the same way that the Sistine Chapel Ceiling is? Warhol offered an ironic answer that has nothing to do with elevation:

> Business Art is a much better thing to make than Art Art, because Art Art doesn't support the space it takes up, whereas Business Art does. (If Business Art doesn't support its own space it goes out-of-business.)

Warhol's savvy blend of business and art grew out of his early success as a graphic artist/commercial illustrator in New York. His floating shoes and

flashy, stylized flowers were the rage in fashion magazines long before he started cloning commodities for art galleries.

One thing is certain: Growing up as a poor kid in Pittsburg, Warhol was obsessed with money. He was fascinated by how people crave all those glitzy objects in storefront windows. He commoditized his own painted products by generating series of them. Now you could purchase a single canvas and get from six to a hundred cans of soup!

He took up the commercial silk-screen process of printing because it had an assembly-line efficiency, enabling him to manufacture art like any other commodity (even though no two images are exactly alike). To better market his work, he founded an art "factory," further highlighting the relationship between art and business.

Celebrities are the commodities of Hollywood, and Warhol soon began silk-screening photographs of Elizabeth Taylor, Marilyn Monroe (see Figure 24-1), Elvis Presley, and other stars. He packaged them as Pop cultural icons, similar to Byzantine icons (see Chapter 9).

By depicting movie stars in a Byzantine-icon format, Warhol shows us our rather upside-down view of modern life. We put stars on pedestals so we can worship them as saints or gods. Ironically, even though Warhol seems to mock this modern-day mania, he was as star-struck by Marilyn and Elvis as anybody else.

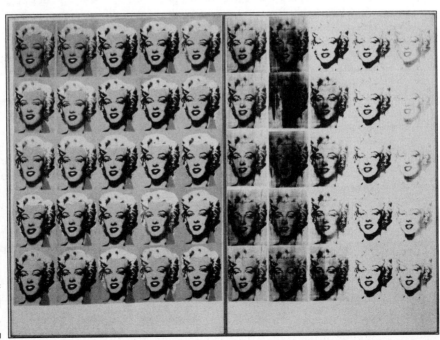

Figure 24-1:
Andy Warhol silk-screened his *Marilyn Diptych* in 1962 shortly after Monroe's death. Shocking, neonlike colors lend the star a kind of artificial immortality.

Blam! Comic books on canvas: Roy Lichtenstein

If Warhol could paint soup-can labels and call it art, Roy Lichtenstein (1923–1997) would make comic strips museum worthy. Maybe he could draw funny-paper readers into galleries by speaking to them in their own language. Although there are differences between Lichtenstein comics and the ones you find in the Sunday newspaper, the similarities are what strike you first. As in typical comic strips, Lichtenstein avoided shading, employed primary colors and thick black outlines, and used Benday dots to simulate high-speed newspaper color printing. The comic-strip look is perfect.

Benday dots is a printing process in which tightly or loosely spaced dots are used to create color tones and shading.

One difference between Lichtenstein's paintings and the Sunday comics is that Lichtenstein focused on tense moments, ignoring what leads up to them and what follows. It appears as though he extracted the climactic episodes from comic strips and suspended them, leaving the outcome forever in the balance. In *The Kiss,* a weeping blonde embraces a debonair man who seems to return her love. But is it a reunion or farewell? Lichtenstein lets the viewer write the ending — and the beginning, for that matter.

In *Foot and Hand,* two extremities fight it out over a pistol, but no personalities are attached to the hand or the cowboy-booted foot. The color contrasts — red, yellow, pink, black, and white — and the graphic starkness in the painting heighten the tension. You can't determine who the good guy is or if they're both bad. And you don't know why the hand and foot are fighting or who will win. But the list of possible outcomes is quite short, because the scene is lifted from a cliché comic-book Western. Lichtenstein said, "I'm interested in what would normally be considered the worst aspects of commercial art. I think it's the tension between what seems to be so rigid and clichéd and the fact that art really can't be this way."

Another difference between Lichtenstein's work and traditional comic strips is in Lichtenstein's attitude. Pop artists felt that Abstract Expressionists inserted themselves too much in their art — that they were overly expressive. Lichtenstein wanted to withdraw from his paintings (or appear to step back) and let the work's formal qualities and tensions speak for themselves. He said that he aimed for "the impersonal look. . . . What interests me is to paint the kind of antisensitivity that impregnates modern civilization."

Fantastic Realism

The Fantastic Realists were inspired by the Vienna Secession movement (see Chapter 21), by Surrealism, and by their teacher Albert Paris von Gütersloh at the Vienna Academy of Fine Arts. Ernst Fuchs, Erich Brauer, Wolfgang Hutter, and Anton Lehmden launched the movement just after World War II.

At first, Fantastic Realism appeared to be an offshoot of Surrealism, with its emphasis on dreamlike, highly imaginative imagery and unconscious symbolism. But Fuchs and the others soon concluded that they weren't Surrealists. They were interested in how the conscious mind interprets unconscious activity, not in letting the unconscious dictate their choice of imagery as the Surrealists did (see Chapter 23). Fuchs said:

> I have always practiced a kind of art which depicts things that, otherwise, man only sees in his dreams or hallucinations. For me, the threshold has to be crossed from inner images to their expression in wakeful being.

In the following sections, I explore the Fantastic Realist paintings by Ernst Fuchs and the art and architecture of Friedensreich Hundertwasser.

Ernst Fuchs: The father of the Fantastic Realists

Ernst Fuchs (1930–) combines fantastic imagery and symbolism with sharply defined realistic depictions. His paintings look like a marriage of Surrealism and Symbolism.

After his conversion to Catholicism in 1956, Fuchs depicted religious themes in Fantastic Realist environments. In his 1957 drawing *Christ Before Pilate,* Fuchs recounts several episodes of Christ's *Passion* (the final hours of Christ's life) simultaneously, suggesting that the mind condenses related events into a single image and moment. On the left, Pontius Pilate, who wears a skirt, breast plate, and bishop's miter, interrogates Jesus. In the center, the figure of Death gallops toward Christ on the back of a grisly faced unicorn. A miniature German soldier toting a Luger pistol has hitched a ride. Fuchs employs traditional perspective in this part of the drawing. But on the right, an empty Last Supper table (with a crucifix growing out of it) recedes toward its own vanishing point, implying that another related spiritual event occurs simultaneously within its own system of linear perspective. The walls flanking the table encase bizarre figures from yet another dimension: a howling phantom with an Asian face in his belly; a lion-headed, lanky man; and an elongated skeleton with an old man's mug.

Hundertwasser houses

The straight line is something cowardly drawn with a rule, without thought or feeling; it is a line which does not exist in nature.

—Friedensreich Hundertwasser

Friedensreich Hundertwasser (1928–2000), painter and architectural philosopher, declared war on the straight line, the square, and other forms not readily found in nature. Hundertwasser believed that blocks reflect uniformity and have a heavy, static feel, while fluid, organic shapes suggest the change and infinite variety of nature.

He also felt that uniform environments — in particular, the grid apartment complex — mold people into uniform lifestyles. In a Hundertwasser building, each apartment is unique, to encourage individuality.

Hundertwasser also banned the traditional rectangular window from his architecture. "The repetition of identical windows next to each other and above each other as in a grid system is a characteristic of concentration camps," he wrote in his essay, "Window Dictatorship and Window Right." In one of his designs, the *Eye-Slit-House,* a home built into a hillside has a single window that peeks out of the grassy slope like an ever-alert eye.

Hundertwasser not only used organic shapes and lines, but also incorporated pieces of nature into his structures. His designs typically call for rooftop gardens and, in one case, grazing cows. He insisted that apartment buildings set aside space for "tree tenants." He explained tree tenants this way:

> The tree tenant symbolizes a turn in human history because he regains his rank as an important partner of man. . . . Only if you love the tree like yourself will you survive. We are suffocating in our cities from poison and lack of oxygen. We systematically destroy the vegetation which gives us life and lets us breathe.

He said that rooftop trees and lawns provide oxygen and serve as air filters, hold heat in the building in the winter and cool it down during the summer, thereby reducing fuel costs.

Several of Hundertwasser's structures have been erected in and around Vienna. His most famous, the Hundertwasser Haus (see Figure 24-2), includes rooftop tree parks on multiple levels. He diverges from the traditional grid structure by giving each apartment a unique organic shape and painting the stone facade in lively pastel colors.

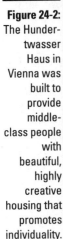

Figure 24-2:
The Hundertwasser Haus in Vienna was built to provide middle-class people with beautiful, highly creative housing that promotes individuality.

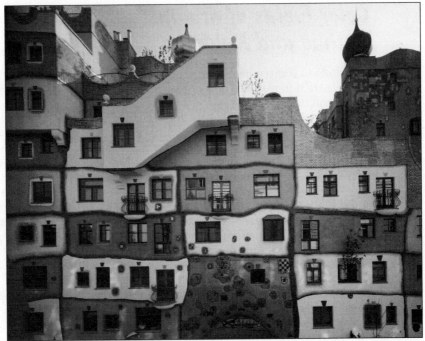

Erich Lessing / Art Resource, NY

Hundertwasser is also one of the top post-WWII Austrian painters. His art tends to reflect his architectural theories. People, buildings, and landscapes overlap and sometimes blend on his canvases. In *The 30-Day Fax Painting,* a bright red street winds through people's heads, faces become windows in buses and buildings, a statuesque traffic cop with a face for every intersection grows out of a building, and a gigantic man has contiguous blue-eye slits, multiple sets of blue lips, and about 20 bright yellow boats gliding across his wavy, sea-blue chest. Hundertwasser uses the bright, unmixed colors of a child's palette in most of his paintings, and contour lines that flow through faces, buildings, streets, cars, and buses, blending everything in candy-colored streams.

Less-Is-More Art: Rothko, Newman, Stella, and Others

Mark Rothko (1903–1970) and Barnett Newman (1905–1970) steered Abstract Expressionism in a very different direction. You could say they boxed it up. Instead of splattering colors over their canvases like crazed kids with finger paints, they painted one color or a few colors in clearly defined rectangles. Because they painted broad areas of one color, they are called Color Field painters.

Color Fields of dreams: Rothko and Newman

Mark Rothko wanted his boxes of color to fight and be friends at the same time. He tried to wed two contrasting forms of creativity — the orderly kind (form) and the wild side (expression) — inside his paintings. His boxes are meant to represent both aspects in a variety of relationships.

The German philosopher Friedrich Nietzsche identified these creative modes in his work *The Birth of Tragedy,* calling the orderly side Apollonian (after the God Apollo, god of the sun) and the wild side Dionysiac (after Dionysus, the god of wine and ecstasy). Dionysus breaks down barriers so that the energies and essences of things can merge. Apollo erects barriers that contain and restrain energy. Nietzsche contended that great art must be a balance of both: "Art owes its continuous evolution to the Apollonian-Dionysiac duality, even as the propagation of the species depends on the duality of the sexes, their constant conflicts and periodic acts of reconciliation."

In some art, one god may appear to have the upper hand. At first look, you'd think that Jackson Pollock had kicked Apollo off his canvases; Dionysus is clearly in charge of the fireworks. But even Pollock has an Apollonian side, a sense of orderly composition.

The Color Field painters, on the other hand, seem to have evicted Dionysus. How can a rectangle express anything? But Rothko's boxes argue with each other and vibrate around their edges. Sometimes he butts complementary color fields against each other, creating color wars. More often, Rothko paints harmonious (analogous) color fields close to each other, as in *Untitled (Violet, Black, Orange, Yellow on White and Red).* Because the colors are harmonious, they want to blend, but Rothko won't let them. This creates tension and establishes the visual equivalent of a magnetic pull between color fields. Barnette Newman's boxes are even more reductive than Rothko's. Frequently he used only one color to represent the human condition. But he divided his monochromatic squares and rectangles with vertical (and occasionally horizontal) lines that he called "zips." Zips can serve as abstract stand-ins for human beings who split space yet remain part of it. Newman said he hoped viewers of his work would experience an "awareness of being alive in the sensation of complete space."

Newman's *Dionysius* is a large green rectangle with two horizontal zips. Does the canvas embody the Dionysic experience described earlier — uninhibited wildness — with only two Apollonian interruptions (the zips)? It does encourage the mind to wander freely in all directions over its vast (67-x-49-inch) green expanse.

Minimalism, more or less

Frank Stella (1936–) founded the Minimalist movement in the late 1950s and was soon joined by artists such as Richard Serra (1939–), Agnes Martin (1912–2004), and Robert Ryman (1930–). Stella's goal was to tone down the visual explosions of the Abstract Expressionists. Like so many artists since Post-Impressionism, he believed that art was a process of reduction: Life should be broken down into its fundamental forms.

The Minimalists took this concept farther than anyone had before. They threw out almost all expressive forms: organic shapes, visual metaphor, symbolism, emotions, and often color or shades of color. With this very limited arsenal of expressive tools, they created highly formal compositions.

In Frank Stella's *Avicenna*, a white rectangle cut from the center of the composition is surrounded by a grid of radiating, crenellated lines. Ironically, Avicenna was one of the world's greatest and most versatile scholars. The painting may suggest the scholar's formalism, but it doesn't reflect his versatility. Repetition and contrast are the only elements of design that Stella used. To further depersonalize his work and give it a made-to-last look, Stella used industrial paint (in this case, aluminum paint).

Minimalist sculptor Donald Judd (1928–1994), who believed art shouldn't represent anything, often repeated identical units of quadrangles with little or no variation. Although these sculptures strike many people as monotonous, reducing the artwork to such sparse extremes can make the viewer sensitive to surface, volume, and the space around the object. Judd's *Untitled* (1969) is a stack of what appear to be blue shelves projecting from a wall. The piece is reminiscent of an open filing cabinet in a high school, but its rigid, formal elegance would prevent most people from storing their files there.

The next step in Minimalism is probably the dead end. At a certain point, reduction leads to nothingness. Most Minimalists changed directions before reaching that point. In the 1970s and 1980s, Stella rejected minimalism and dramatically expanded his visual vocabulary. Colors explode from his Post-Minimalist canvases in expressive writhing shapes that look like scrap metal and fractured engines.

Photorealism

Like Pop Art, Photorealism (primarily an American movement) signaled a return to representational art. The realism in Photorealistic art is so striking and yet so painterly that you're taken in by the illusion and aware of the artist's process at the same time.

Photorealists like Richard Estes (1936–), Chuck Close (1940–), Audrey Flack (1931–), Don Eddy (1944–), and Philip Pearlstein (1924–) use photographs as their models. But they don't simply transcribe photos. The goal of Photorealists is to detach themselves from their subjects, to present an objective impression of ordinary life, the way an alien might view humans. For example, Philip Pearlstein might begin a painting with a foot and work his way up the body until the canvas prevents him from including an arm or the head. Pearlstein says he prefers leaving off the head — it helps depersonalize his nudes.

In the following sections, I examine the work of Richard Estes and Chuck Close.

Richard Estes: Always in focus

Looking at a Richard Estes painting makes you feel as though your vision has improved. He turns up the intensity on reality.

Estes achieves this effect by building his paintings from multiple photographs. Using many photos of the same subject allows him to sharpen the subject's focus by eliminating the blurriness resulting from depth-of-field effects. In one photo, the entrance of a building may be sharply focused while everything else is blurry. In a different photo, the door will be blurry but another part of the structure sharp. Estes only uses the focused sections of his photos to build his painting.

He also highlights a building's geometric patterns and emphasizes color relationships by manipulating his photos as he did in *Seagram Building,* from the series *Urban Landscapes 1* (1972). Estes is a master at depicting reflections. The reflective effects in his paintings evoke a sense of super-reality because you see the reflections sharply from all angles at once — impossible to do with the naked eye, even if you *have* had LASIK eye surgery.

Light reflects at the angle it strikes a surface (the angle of incidence equals the angle of reflection). That means your eye can only take in part of a reflection because light strikes a surface from multiple angles.

Clinical close-ups: Chuck Close

After a short stint as an abstract painter, Chuck Close became a Photorealist, painting black-and-white paintings from color photographs, then color paintings from black-and-white photographs. Typically, he works in large scale to force the viewer to see his portraits in pieces, to explore a face like geographical terrain. His 1960s works are precise renderings of photos; sometimes the paintings are indistinguishable from the photographs (except for the enlarged scale). In the mid-1970s, Close's style evolved into a probing portraiture that gives the viewer macroscopic and microscopic views of the human face at

the same time. Since the late 1970s, he has broken up his portraits into the painterly equivalent of pixels. From up close (in his color portraits), these "pixels" look like small pieces of *millefiori glass* (colorful glass filled with circles of variegated colors). Close sometimes includes a third layer by breaking up the face into larger rectilinear units that contain the pixels, as in his portrait *James*. In this way, you see the face as three superimposed levels — a conventional photographic image, a dot-image impression, and a rectilinear image — each layer depicted with quasi-photographic precision.

To create his color portraits, Close builds his images from the primary colors used in professional printing: cyan, magenta, and yellow. The point of doing this is to enhance the mechanistic look of the portrait and to heighten the depersonalization.

Performance Art and Installations

Who said visual art has to be stuck on a canvas or pedestal? Imagine if all the characters in a crowded, rambunctious Rubens canvas jumped out of the painting and stormed the museum. Would it still be art? Or would it be theater? Or a combination of both? Performance artists raised these questions and tested them in front of live audiences in the 1960s. Like Dadaists, they preferred active art that challenged traditional views of life and art. Some performance artists tried to re-create an atmosphere similar to primitive ritual, involving audiences as much as the artist in a transformative experience.

In the following sections, I check out the performance art of Fluxus and Joseph Beuys.

Fluxus: Intersections of the arts

Interdisciplinary and international, Fluxus artists — Joseph Beuys (1921–1986), Yoko Ono (1933–), Dick Higgins (1938–1998), George Brecht (1924–), Al Hansen (1927–1995), and Nam June Paik (1932–2006) — blended poetry, painting, music, and theater into multimedia performances. The Dada movement and especially Marcel Duchamp were major influences. Founder George Maciunas said Fluxus was a "Neo-Dada" group (see Chapter 23) with an anti-commercial art focus.

Often, performance artists used readymade materials to register their disapproval of commercial art. Fluxus typically employed boxes that had to be opened to reveal one or more secrets. The artists stuffed the boxes with cards, notes, letters, and games, and later exposed the contents, sometimes while playing musical tracks. The idea was to treat ordinary things contained in the box as if they were as worthy of musical accompaniment as the entrance of a king.

In 1966, Yoko Ono installed her *Yes Painting* in the Indica Gallery in London. Ono rigged up a white ladder with a spyglass attached to the top, which was aimed at a tiny canvas suspended just below the ceiling. Fluxus typically invited audience participation. John Lennon, who attended one of the exhibitions and scaled the ladder, was so thrilled by what the spyglass revealed that he started dating Ono and later married her. As Lennon peered through the glass, he saw that the suspended, mini canvas contained only one written word: "Yes."

Joseph Beuys: Fanning out from Fluxus

Joseph Beuys, a German performance artist, activist, sculptor, and teacher, believed the world is in a spiritual crisis that art can help heal. He also believed all the arts should be merged into a single ritualistic force. To that end, in 1974 he founded the Free International University for Creativity and Interdisciplinary Research.

Beuys felt there was a breakdown between scientific and spiritual thinking and attempted to close the gap through shamanistic or ritualistic performances. He believed in the universal power of creativity and that, through a kind of resonance, one person's creativity can awaken another's.

More importantly Beuys felt that life is a social sculpture that everyone helps to shape. His performances, which he called *Actionen,* were intended to inspire conscious and positive shaping.

The Golden Age of American enameling

Until about 1935, most Americans viewed enameling as merely ornamental, good for decorating jewelry boxes or cigarette cases, but that was about it. However, in Europe, especially France, enameling has a long history as a high art form, particularly in Limoges where enamel paintings have been created since the 16th century.

An American enamel awakening began in the 1930s thanks largely to the work of three innovative enamel artists — Kenneth Bates (1904–1994), Edward Winter (1908–1976), and Karl Drerup

(1904–2000). The next generation of enamelists, many of them Bates's students, built upon their work, taking enameling in still more innovative directions.

Kenneth Bates, known as the Dean of American Enamelists, more than anyone spread enameling as an art form across the United States through his work and his teaching. In one of his best pieces, *Argument in Limoges Market Place,* Bates incorporates Cubist and Futurist designs into his semi-abstract representation of

women arguing at a market in the great French enameling center, Limoges. The Cubist angularity and patterns and the Futurist fusion of images increases the tension of the argument. Even the houses seem to be squabbling. At the same time Bates dilutes the tension with his playful color palette of light blues and mauves, dark greens, browns, and reds.

Edward Winter, who studied enameling under Bates and in Vienna at the Viennese Workshop *(Wienerwerkstette),* brought purely abstract European enameling styles to the States. His elegant abstractions typically feature subtle grades of color that suggest layers and transcendental perspectives. In *Textures in Pink and Brown,* an abstract staircase unfolds inside a network of angular ridges of color intersected by wavelets and graceful floral shapes. The multiple angles don't quite harmonize with one another, but create subtle active tensions between the layers that keep the eyes swimming from shape to shape, level to level.

Like Edward Winter, James Melvin Someroski (1932–1995) studied under Kenneth Bates and took enameling in still other directions, including activist art. Someroski's *Children of War* series of 12 *plique à jours* — which look like miniature stained-glass windows — illustrate scenes from German concentration camps based on actual photos. In *Never Again,* an infant in a fetal position and two older children's ghostly bodies rise from a crematorium smoke stack into a fiery sunset of intersecting waves of orange, yellow, and white light. The heavens are so enflamed and yet so glorious that it's impossible to tell if the Nazis or God has set the sky on fire. Someroski said of these children: "I try to lift them out of the photos, lift them out of the crowds, the mass graves . . . resurrect them, wrap them in fine silver and gold, try to breathe life into them again. . . . In the chamber of an enamel kiln, in a new fire restore them."

Art Estate of the late James M. (Mel) Someroski

In 1965, after leaving Fluxus, Beuys performed *How to Explain Pictures to a Dead Hare* in the Galerie Schmela in Düsseldorf. He smeared his head with honey and stuck gold leaf to it, then cradled a dead hare in his arms while sitting in a corner of the gallery. Suddenly he rose and toured the gallery, explaining the pictures to the dead animal. Periodically, he interrupted himself to walk over a dead pine tree. (Hares, honey, and pine trees have spiritual and mythical meanings for Beuys and others.) Beuys later explained that his performance was a "Complex tableau about the problems of language, and about the problems of thought, of human consciousness and of the consciousness of animals." He also said that a dead hare would grasp his explanations about art better than many people with "their stubborn rationalism."

Beuys further tested the boundaries of art and rationality as a founder of the Conceptual Art movement of the late 1960s and early 1970s, pointing out some of the contradictions in how words and images communicate. However, not everyone was eager for art to surrender its materials and craft at the altar of performance and conceptual art. Some artists working in the decorative arts (also known as Arts and Crafts) were not only unwilling to abandon their crafts, they were determined to prove that painting, sculpture, and performance and conceptual art didn't have a monopoly on high art. Glass artists like Harvey Littleton and Dale Chihuly, pioneering fiber artist Lenore Tawney, and enamelists such as Kenneth Bates demonstrated that the decorative arts can be more than just decoration. (See the nearby sidebar, "The Golden Age of American enameling" for more on the emergence of a decorative art as high art.)

Chapter 25

Photography: From a Science to an Art

In This Chapter

▶ Developing photography into an art

▶ Focusing on photojournalism

▶ Editing society with a camera

▶ Zooming in on everyday life

*W*hat does a photograph have that a painting doesn't? That's not what most pioneering photographers asked themselves in the 19th century. They wanted to know how photography could *mimic* painting. It was natural for early photographers to imitate an older, established form of image making, just as a couple generations later it was natural for the first film-makers to copy theater. Early photographers posed their models like a painter does. They photographed still lifes and built up composite pictures in the tradition of historical painting.

Early photographers had something to prove: In the 19th and early 20th centuries, many people considered photography a science rather than an art. To gain recognition for photography as an art form, photographers had to show that they could compete with painting. After they achieved this goal (in the first two decades of the 20th century), photography began to develop its own identity.

In this chapter, I examine the birth of the science of photography and photography's development into high art.

The Birth of Photography

In 1824, Joseph Nicéphore Niépce (1765–1833), a French inventor, developed a process that he called *heliography* ("sun writing"). Using heliography, he made the first photograph in 1826. He captured this image by treating a metal plate with *bitumen* (a black, sticky substance) and exposing it to sunlight for about eight hours. The sunlight eventually hardened the bitumen so that it held the image.

In 1827, unable to market his miraculous invention, Nicéphore Niépce partnered with the business-savvy Louis Daguerre (1787–1851) in England. Nicéphore Niépce taught Daguerre his process and recommended ways to perfect it. After Niépce died in 1833, Daguerre improved Niépce's method and patented it in 1839. He called the process the *daguerreotype*. The French government acquired Daguerre's patent and generously made the process available to everyone in the world.

A daguerreotype image is captured by iodizing a silver-coated copper plate, and then exposing it to light for a few minutes. Next, the plate is heated in a mercury vapor until the image appears. Finally, the image is *fixed* (made permanent) by immersing the plate in a saline solution. The result is a mirrorlike surface that holds a "reflection" indefinitely. The drawbacks of the daguerreotype are that you can't make copies and the image must be viewed at an angle, because the surface reflects light like a mirror.

Around 1834 to 1835, the Englishman William Fox Talbot (1800–1877) learned to capture the "shadow" of a leaf or other object on paper coated with silver and table salt. In 1839, he figured out how to create a negative photographic image from which he could produce countless positive images. He called his discovery the Talbotype (a.k.a. *calotype*), and he patented it in 1841. Although Talbot's images were not as sharp as daguerreotypes, they were reproducible.

In 1851, Frederick Scott Archer developed the wet-collodion process, which dramatically sharpened the negative image. The downside of the wet process was that photos had to be developed before the emulsion solution on the plate dried. So photographers had to shoot their subjects in studios or lug their darkrooms around with them. This is what the first photojournalists did during the American Civil War and Crimean War — carried their darkrooms onto the battlefield.

In 1878, the American George Eastman (1854–1932) pioneered the dry-plate development process (which meant photojournalists could now leave their darkrooms at home). In 1885, Eastman invented roll film, which he perfected and marketed four years later. Not only did roll film make photography available to everyone, but it also paved the way for movies.

From Science to Art

Most early photographers explored the documentary capabilities of the camera rather than its artistic potential. But there were exceptions. Scottish painter David Octavius Hill (1802–1870) and the Scottish photographer Robert Adamson (1821–1848) teamed up to create the first series of artistic portraits between 1843 and 1847. Among their finest work are their *Portraits of Distinguished Scotsmen* and *The Fishermen and Women of the Firth of Forth*. Their collaboration was cut short by Adamson's untimely death at the age of 27.

The greatest French photographer of the 19th century, Gustave Le Gray (1820–1884), was a major force in helping to elevate photography's status as an art. He wrote a treatise on photography called *Traité pratique de photographie sur papier et sur verre (Practical Treatise of Photography on Paper and Glass)* in which he stated, "It is my deepest wish that photography, instead of falling within the domain of industry, of commerce, will be included among the arts. That is its sole, true place, and it is in that direction that I shall always endeavor to guide it." Le Gray, who began his career as a painter, switched to photography in 1847.

To make his photographs more painterly, Le Gray invented the wax-paper negative, which produced softer images than the earlier glass negatives. (Wax-paper negatives were also more portable.) With wax-paper negatives, Le Gray captured radiant scenes of the forest of Fontainebleau in the style of the Barbizon painter Jean-Baptiste-Camille Corot (see Chapter 18) and poetic, luminescent shots of the Normandy coast.

Not only did many connoisseurs view Le Gray's work as high art, but his Normandy and Fontainebleau photographs inspired the father of Impressionism, Claude Monet, who painted similar scenes in both locations in the 1860s to 1880s.

Compare Monet's 1865 painting *The Road to Chailly, Fontainebleau* to Le Gray's "Road of Chailly, Fontainebleau" photographed in 1853. Also compare Le Gray's "Etude de chêne (Study of Oak), Fontainebleau" shot in 1852 to Monet's *The Bodmer Oak, Fontainebleau* painted in 1865.

Despite his success, the mainstream art world wasn't prepared to accept Le Gray's work as art. When he entered eight photos in a Paris arts competition in 1850, the jury accepted all eight images — because they mistook them for *lithographs* (prints made with a stone or metal plate). When the jury realized they were photographs, they rejected them.

From the 1840s to the 1890s, the majority of photographers either focused on the science of photography, like the members of the Royal Photographic Society in England, or on documentary photography (recording life).

Photographers, such as Mathew Brady (c. 1823–1896) and Timothy O'Sullivan (c. 1840–1882), both of whom shot the American Civil War, were regarded as pictorial journalists, not artists. Nevertheless, their documentary photographs brought home the horrors of war for the first time in history. O'Sullivan's powerful photographs of the Battle of Gettysburg, including his most famous photo, "The Harvest of Death," inspired President Abraham Lincoln's *Gettysburg Address*.

Alfred Stieglitz: Reliving the Moment

More than anyone else, Alfred Stieglitz (1864–1946) elevated photography to an art form in the United States. He didn't do it alone, but he was the driving force. Stieglitz achieved his goal through his own artful photo compositions and by co-founding the Photo-Secession movement with another pioneering photographer, the 21-year-old Edward Steichen (1879–1973), in 1902.

The Photo-Secession movement was modeled on similar groups in Europe. The movement held exhibitions of members' photographs and promoted photography as high art. To win recognition, the Photo-Secessionists imitated painting, especially Romantic, Realist, and Impressionist art. In 1910, they held an exhibition featuring 500 photographs at the Albright Art Gallery in Buffalo, New York. Their goal was to influence American museums to begin purchasing photographs for their collections. They were successful; the Albright Art Gallery became the first American museum to buy photography and display it as a high art.

This practice of imitating paintings in photographs is called *Pictorialism*. Basically, it means that photographs should be picturesque like Impressionist paintings. Pictorialism was an international movement and included the Brotherhood of the Linked Ring in Great Britain; the Vienna Camera Club in Austria; the Photo-Club de Paris in France; Das Praesidium in Hamburg, Germany; and other groups. In 1901, the Brotherhood of the Linked Ring, which held annual exhibitions called the Photographic Salon, noted, "Through the Salon the Linked Ring has clearly demonstrated that pictorial photography is able to stand alone and that it has a future quite apart from that which is purely mechanical." Led by the influential photographer Henry Peach Robinson along with George Davison, the Linked Ring group had broken off from the Royal Photographic Society in 1892 because they felt it was wedded to the mechanical or scientific side of photography.

Photographers used a variety of techniques to dress up their photographs so they resembled paintings, including soft-focus lenses, filters, and lens coatings to create an Impressionist look, as well as darkroom image manipulation. To get a wide range of tones, they employed platinum printing on textured papers. With the right technique, photographs could mimic charcoal drawings, watercolors, and various painting styles.

The main purpose of the Photo-Secession movement was to prove that photography is an art not a science.

An example of Pictorialism is Stieglitz's "Spring Shower." The distinct, black lines of the young tree in the foreground contrast dramatically with the gray misty rain that softly erases much of the cityscape. Stieglitz captured effects of the atmosphere like a Monet with a camera. This very painterly photograph — with its simple lines, poetic mistiness, and spell of stillness — is reminiscent of a meditative Japanese composition.

To further the goals of the Photo-Secession movement, Stieglitz launched a magazine called *Camera Work* in 1903 (see Chapter 23). During its 14-year life, *Camera Work* featured the best of American photography, modern poetry, articles on photography, modern art, and literature. In 1905, Stieglitz opened his famous Photo-Secession Gallery at 291 Fifth Avenue in New York City. Known simply as "291," the gallery not only exhibited photography, but also introduced the United States to Auguste Rodin, Paul Cézanne, Henri de Toulouse-Lautrec, and Henri Matisse before the famous Armory Show of 1913 (see Chapter 23). Ironically, while promoting realistic photography, Stieglitz strongly supported the antirealistic European avant-garde.

A few years after the 291 exhibitions and the Armory Show, the influence of European Modernism caused American photographers to do an about-face and abandon Pictorialism. Photography had proven it could compete with painting. Now it was time for it to find its own voice.

The next generation of photographers — those shooting in the 1920s and 1930s (and after), like Henri Cartier-Bresson, Edward Weston, Ansel Adams, Margaret Bourke-White, and Dorothea Lange — evolved their own personal photographic styles, and in so doing, helped photography learn to be itself.

Henri Cartier-Bresson and the "Decisive Moment"

The photographs of Frenchman Henri Cartier-Bresson (1908–2004) don't look like black-and-white paintings — they look like photographs. "Photography is not like painting," he said. "There is a creative fraction of a second when you are taking a picture. Your eye must see a composition or an expression that life itself offers you, and you must know with intuition when to click the camera. That is the moment the photographer is creative." Yet, Cartier-Bresson learned a lot about taking pictures from studying painting.

As a teenager and young man, Cartier-Bresson trained to be a painter. His out-standing teacher, André l'Hote, tried to wed Cubism to classical French painting, in particular the formal and somewhat geometric compositions of Jacques-Louis David and Nicolas Poussin. What Cartier-Bresson learned from l'Hote about composition influenced not only his paintings but his photography. It gave him his amazing skill to recognize poetic or surreal arrangements of forms, repeated lines, shadows, and highlights in the blink of an eye. He said that in a fraction of a second, a photojournalist must be able to recognize simultaneously "the significance of an event" and "a precise organization of forms."

Cartier-Bresson eventually abandoned his teacher's style and turned to Surrealism. He'd begun hanging out with the Parisian Surrealists and bought into their ideas about capturing the unconscious on canvas. He tried to do the same in his own paintings but was dissatisfied with the results and destroyed most of his work.

He switched from painting to photography in 1931 after seeing a photograph by Martin Munkácsi of three naked boys running joyously into a lake ("Three Boys at Lake Tanganyika"). The photograph convinced him that the camera could capture uninhibited life as the Surrealists tried to do with their brushes. He gave up painting and devoted himself to photography, scouting the streets of Paris to capture people in unguarded moments.

The invention of the compact Leica camera in Germany in 1924 or 1925 made photographers' jobs much easier. It meant they no longer had to drag a tripod around. Most importantly, it enabled them to shoot inconspicuously, to become the proverbial fly on the wall. In his book *The Decisive Moment*, Cartier-Bresson wrote, "It is essential . . . to approach the subject on tiptoe." This is why he didn't use a flash.

Cartier-Bresson's fly-on-the-wall style and his sensitive eye enabled him to become one of the world's greatest photojournalists. His photos, which chronicle many of the major events of the 20th century, appeared in magazines such as *Paris Match, Life, Look, Du, Epoca,* and *Harper's Bazaar.*

His photograph "Mexico" shows his mastery of poetic, geometrical composition. At a glance, the picture looks like a shadow painting. Two female figures — what appear to be the shadow of a classical nude statue and the silhouette of a real woman — stand in a stairwell slashed by shadows and angular bands of light. You see both women in profile, each facing the opposite direction. The shadowy statue appears poised to descend the stairs, while the silhouette leans against a column waiting for life to happen. The photograph brims with mystery and otherworldly beauty.

In "Berlin Wall," Cartier-Bresson again captured a remarkably suggestive moment packed with tension. Three suited people (you only see their backs) take in the bleak cityscape on the eastern side of the wall. The dreary

architecture seems infected by the repressive political climate of Communist East Berlin. Stark, brutal shapes comprise the lower section of the Berlin Wall, which strangely harmonizes with the desolate-looking apartment buildings flanking it. Not a flower pot, window decoration, or piece of curtain relieves the barrenness of the view. The wall and street it slices in half are the front lines in the Cold War. There's no destruction, but there's no sign of life either. Beauty and color seem to have gone into hiding.

Group f/64: Edward Weston and Ansel Adams

Like Cartier-Bresson, American photographers such as Edward Weston (1886–1958) and Ansel Adams (1902–1984) rejected Pictorialism in the 1920s and 1930s for "straight photography" — pure realism with little or no darkroom manipulation. Instead of imitating painting, Weston and Adams chose to let the camera be itself — its artful self.

To help them achieve their goals, Weston, Adams, Imogen Cunningham, and others founded Group f/64 in San Francisco in 1932. The group took its name from the fact that its members used the smallest *aperture* (the camera opening that lets in light) on a large-format camera to get as much *depth of field* (the in-focus area between the foreground and background) as possible. A miniscule aperture permits only a tiny bit of light to enter the camera, so the camera's *shutter speed* (the length of time the aperture stays open) must be increased, often to more than a minute so there's enough light to expose the film. That meant the photographers could only shoot still lifes and scenery, not moving objects, which require quick shutter speeds to stop the action.

The small-aperture approach enabled Edward Weston to shoot his favorite subjects — nudes, vegetables, seashells, and landscapes — with incredible intimacy. His camera closed in on the subject, intensifying every detail so that textures seem touchable. In his photograph "Pepper," strong highlights, together with the sharp depth of field, emphasize the pepper's organic undulations, giving it a rich tactile appeal that makes it seem more like a female nude than a vegetable.

Adams, whose specialty was majestic western scenery, transformed distant mountains, valleys, rock formations, and trees into transcendental landscapes, the background and foreground both in sharp focus as if illuminated by a mystic light (see "Winter Sunrise from Lone Pine" in the appendix). Adams also achieved razor-edged contrasts between light and dark by developing a "zone system," in which he divided gradations of light into ten zones from very light to very dark. He measured these zones with a light meter and was thereby able to exercise strict control over the lights and darks in his photographs.

Dorothea Lange: Depression to Dust Bowl

The American photojournalist Dorothea Lange (1895–1965) is famous for her photographs of migrant workers, California migrant labor camps, and destitute men in bread lines (such as "White Angel Breadline, San Francisco"). Her photos still define the Great Depression for most Americans.

Working under Roy Stryker in the History Division of the Resettlement Administration, along with other top photographers like Walker Evans, Arthur Rothstein, and Ben Shahn, Lange's job was to document the plight of migrant workers who'd fled from the Dust Bowl disaster in Oklahoma and Texas to seek work in the orange groves and corporate farms of California.

For Lange, documenting this catastrophe was more than a job. As a reformist, she photographed the harsh conditions in the migrant-labor camps to provoke change and government intervention. Lange captured the human suffering in unsentimental yet powerful ways. In a letter to Stryker, she said, "I saw conditions over which I am still speechless."

Because Resettlement Administration images were available to all American newspapers, Lange's photographs made a dramatic impact on public opinion and caused the administration of Franklin Delano Roosevelt to authorize the creation of government camps in California for migrant workers. Lange's most famous Depression-era photograph is "Migrant Mother, Nipomo, California" (see Figure 25-1), shot on a rainy March day in 1936 at the Pea-Pickers Camp. Lange spent about ten minutes taking six shots (one of which she kept for herself). She recalled the experience in a 1960 *Popular Photography* article "The Assignment I'll Never Forget: Migrant Mother":

> I saw and approached the hungry and desperate mother, as if drawn by a magnet. I do not remember how I explained my presence or my camera to her, but I do remember she asked me no questions. I made five exposures, working closer and closer from the same direction. I did not ask her name or her history. She told me her age, that she was thirty-two. She said that they had been living on frozen vegetables from the surrounding fields, and birds that the children killed. She had just sold the tires from her car to buy food.

After the bombing of Pearl Harbor, Lange documented the forced relocation of Japanese Americans into concentration camps for the War Relocation Authority. In one of the most poignant images, "Salute of Innocence," dozens of young Japanese girls standing in front of the American flag ardently recite the Pledge of Allegiance before being locked up in relocation camps. Fearing a public backlash over the provocative images, the U.S. Army impounded all of Lange's roughly 800 photographs of the "relocation" of Japanese Americans.

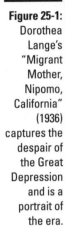

Figure 25-1: Dorothea Lange's "Migrant Mother, Nipomo, California" (1936) captures the despair of the Great Depression and is a portrait of the era.

Dorothea Lange, American, 1895–1965, Migrant Mother, Nipomo, California, 1936. The Dorothea Lange Collection, Oakland Museum of California, Gift of Paul S. Taylor. Digital Image © The Museum of Modern Art / Licensed by SCALA / Art Resource, NY.

Margaret Bourke-White: From Smokestacks and Steel Mills to Buchenwald and the Death of Gandhi

Like many other early 20th-century artists, Margaret Bourke-White (1904–1971) viewed the Machine Age as mankind's salvation. Capturing the imposing geometric forms of steel mills, skyscrapers, and dams was one of her fortes. She said, "To me these industrial forms were all the more beautiful because they were never designed to be beautiful. They had a simplicity of line that came from their direct application to a purpose. Industry, I felt, had evolved an unconscious beauty — often a hidden beauty that was waiting to be discovered."

Bourke-White began as an industrial photographer in Cleveland, Ohio, for the Otis Steel Company. Impressed by her photographs of Cleveland steel mills, Henry Luce (founder of Time, Inc.) hired her as the first photographer of his new magazine *Fortune* in 1929.

Six years after Bourke-White joined *Fortune,* Luce launched *Life* magazine and hired her as one of the magazine's first four photographers. The inaugural issue of *Life* (November 23, 1936) featured Bourke-White's famous shot of the Fort Peck Dam in Montana. The mammoth structure (250 feet high and over 4 miles long) was built as an FDR New Deal project in the mid-1930s. The angle at which Bourke-White shot the awesome construction (incomplete at the time), and the stark contrasts of light and shadow, make it look like a Machine Age version of a colossal Egyptian temple.

As a *Life* photographer, Bourke-White was able to go places no female photographer and few male photographers had been before. She was the first female war correspondent and the first Western photojournalist permitted to photograph in the Soviet Union. She shot the Nazi invasion of Russia, the Allies' Italian campaign, General Patton's march across Germany, and the Buchenwald concentration camp. After the war, she photographed the birth pangs of India and Pakistan and the death of Gandhi.

Before she could shoot her celebrated portrait of Mahatma Gandhi at his spinning wheel a year before his death, Bourke-White had to learn to spin herself. In her autobiography *Portrait of Myself,* she writes that when she asked for permission to photograph Gandhi spinning, his chief secretary asked, "Do you know how to spin?"

She replied, "Oh, I didn't come to spin with the Mahatma. I came to photograph the Mahatma spinning."

The secretary responded firmly: "How can you possibly understand the symbolism of Gandhi at his spinning wheel? How can you comprehend the inner meaning of the wheel, the charka, unless you first master the principles of spinning?"

So Bourke-White took an on-the-spot course, and learned the basics of spinning — then she got her famous shot, which suggests the symbolism of Gandhi's spinning wheel. The charka was central to his peaceful revolution; if Indians spun their own clothes, he said, they could boycott British textiles.

A year later on January 1, 1948, Bourke-White photographed Mahatma Gandhi for the last time, four weeks before his assassination. (This photo shoot is re-enacted in the 1982 film *Gandhi.*) Henri Cartier-Bresson photographed Gandhi at the same photo session. In fact, both photographers shot almost the same picture of him seated on a bed beside his two nieces, Abha and Manu (who were known as his walking sticks because they escorted him everywhere). In both photos, Abha is shown writing in a book, while Manu hands Gandhi a book to write in. Two smiling older women look on placidly. Both photographers captured the tender intimacy of this family portrait. But in Bourke-White's photo (see Figure 25-2), the subtle mingling of light and shadow and the fact that the light seems to arise as much from within Gandhi as from an external source give her portrait a quiet mysticism

and a timeless appeal. Bourke-White also included the tiny "hear-no-evil, see-no-evil, speak-no-evil" monkey who eyes Gandhi from a table in front of the bed; Cartier-Bresson left it out. (To see the Cartier-Bresson photograph, refer to the appendix.)

On January 30, 1948, an assassin gunned down Gandhi while he was walking to a prayer meeting, supported by his nieces Abha and Manu.

Figure 25-2: Margaret Bourke-White's "Gandhi with His Nieces" is one of the last photographs taken of the great Indian spiritual leader.

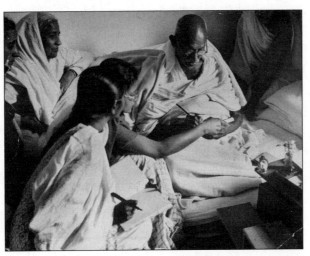

Margaret Bourke-White / Time & Life Pictures / Getty Images

Fast-Forward: The Next Generation

The influence of *Life* magazine's first photographers — Margaret Bourke-White, Alfred Eisenstaedt, Peter Stackpole, and Carl Mydans — and of Henri Cartier-Bresson and Dorothea Lange on photojournalism and the photo essay is hard to measure. They and other between-the-wars photographers (such as Man Ray, Lászlo Moholy-Nagy, Edward Weston, and Ansel Adams) helped to give photography its identity and opened up the new art form so that the next generation could carry it into directions never imagined by the Pictorialists:

- ✔ Aaron Siskind and Minor White, inspired by Abstract Expressionism (see Chapter 23), created abstract photography.

- ✔ Bill Brandt, Jerry Uelsmann, and Lucas Samaras, inspired by Surrealism and Man Ray, created special-effect or fantasy photography, in which superimposition, composite images, and filters are used to create dreamlike and surreal images.

- ✔ Painters like David Hockney and Robert Rauschenberg combined photography and painting.

- ✔ Postmodern photographers merge photography with text and media messages and symbols and/or make pictures about pictures. For example, Cindy Sherman (see Chapter 26) photographs herself playing various stereotypical roles borrowed from cinema and advertising. Many of her works look like parodies of cinema-stills from '40s, '50s and '60s B-movies.

Chapter 26

The New World: Postmodern Art

· ·

In This Chapter

▶ Exploring Postmodern trends in architecture

▶ Recycling art history

▶ Navigating installation art

· ·

To be postmodern sounds oxymoronic. How can something exist *after* the modern, if modern is the present day? Wouldn't that put it in the future? The trick to making sense of the term *postmodern* is to understand that when artists and art historians discuss *Modernism,* they aren't talking about the present day or the here and now. (When they want to refer to the present, they use the term *contemporary.*) *Modernism* refers to a style and a period of art that stretches roughly from Cézanne and Gauguin in the 1890s (although some scholars track it back to Manet in the 1860s and others find its roots in Romanticism) to Donald Judd and the Minimalists of the 1960s and 1970s. During that time, Modernism dominated much of the art world; in architecture, Modernism was so widespread that it was dubbed the *International style* (see Chapter 23) — everybody was doing it. Some artists and architects still claim to be practicing Modernism even though most agree that it is no longer the dominant style. The new epoch is sometimes referred to as the Postmodern Age, suggesting that Postmodernism is not only an art movement, but also a major lifestyle shift.

In this chapter, I explore Postmodern architecture, then discuss Postmodern examples of painting, photography, digital, and multimedia art.

From Modern Pyramids to Titanium Twists: Postmodern Architecture

Modernism (and the International style in architecture) rejected tradition and embraced the innovations of industrial capitalism. Modernists placed great faith in technology and science, a view known as *positivism.* Architects like Le Corbusier (see Chapter 23) referred to houses as "machines for living" — and

they did so as positivists celebrating the precision and reliability of machines. In architecture, that meant structures made from the latest industrial materials, usually with crisp, clean lines (no ornament) and an obvious function (nothing was done just for show).

After World War II, Modernism and positivism got an even bigger boost as economic conditions improved for the middle class in many countries. Jacking up the standard of living on such a vast scale implied that the Machine Age was working. People came to expect new houses, automobiles, televisions, toasters, dishwashers, and all the other creature comforts the modern age could churn out.

While people bought more toasters and embraced technology, the art world celebrated the rise of abstract art and the idea that artistic beauty (or art for art's sake) transcends function (a thing's usefulness). Many of the heroes of modern painting, such as Pablo Picasso and Jackson Pollock, were renegades whose every swipe of the brush (or stick) was viewed as an authentic and original stroke of genius. The raw and unpremeditated look of their modernist art vouched for its truthfulness.

Postmodernism began in the late 1960s and early 1970s when artists started to doubt the truthfulness and originality of Modernism and all the values of masculinity, progress, and positivism associated with it. Postmodernism began innocently enough with architects in the 1960s and 1970s saying "enough is enough" to the cockiness of the International style, its rigid restrictions about ornament, and its utopian claims of creating better public housing. In fact, some of the Bauhaus-inspired public-housing projects, such as Minoru Yamasaki's Pruitt-Igoe Project in St. Louis, had to be torn down because high-rises appeared to bring out the worst in people. The mood was ripe for a more popular architecture that would bring back some of the personality, diversity, and history that Modernism had dumped.

Viva Las Vegas!

There's no better example of architectural diversity than the mishmash of buildings that line the strip in Las Vegas, Nevada. The closest thing Postmodernism has to a manifesto is the small book *Learning from Las Vegas* (1972), written by the husband-and-wife team of architects Robert Venturi and Denise Scott Brown. This book documents the strip in Las Vegas in order to celebrate and learn from the car culture, hamburger joints, casinos, and urban sprawl that characterize that city. For Venturi and Scott Brown, "the seemingly chaotic juxtaposition of honky-tonk elements expresses an intriguing kind of vitality and validity."

Postmodernism begins with this "messy vitality" and then explores the range of historic architectural forms that might better meet the needs of people and rev up the energy of any given space. There are no hard-and-fast stylistic rules akin to the steel-and-glass boxes of Modernism; Postmodern architecture has as many stylistic incarnations as there are kooky casinos in Vegas today. In fact, one Postmodern Disney hotel designed by Michael Graves in Florida assumes the shape of a giant swan, suggesting that architecture has turned into a form of sculpture.

Chestnut Hill: Case in point

Postmodern architecture has had a spirit of whimsy from the get-go. When Robert Venturi designed the Chestnut Hill House for his mother in Philadelphia, he set out to parody the routine elements of a suburban house, using ordinary materials. The facade is oversized like a stage set from an old Western town; yet its triangular pediment is split down the middle in Baroque fashion. Each side of the facade has five windows, but they are handled completely differently on each side in a way that showcases the various modern standards: four-square pattern window, long horizontal strip window, single-unit window. The chimney is supersized — except for the last few feet where it shrinks back to its normal dimensions.

The Chestnut Hill House doesn't look like a whacky funhouse from a distance — quite the contrary, it looks normal and suburban. But on close inspection, all the details are slightly off. You realize that someone has slyly undercut all the usual choices an architect would make. This "poking-fun-at" approach to design is part of a bigger postmodern trend: *self-referential* art making. Postmodern art includes lots of inside jokes and ironies that sometimes leave audiences and even house owners feeling like outsiders.

Philip Johnson and urban furniture

The skyscraper is pretty much a modern form of architecture — not one that has much reference to the past. The AT&T Headquarters Building in New York, designed by Philip Johnson (1906–2005) and John Burgee (1933–), is a pioneering exception that may rightly be called the first postmodern skyscraper.

Philip Johnson was an associate partner with Mies van der Rohe on the Seagram Building (an International style icon of architecture — see Chapter 23), so it's surprising that he would mix several historic styles in the AT&T Building. Its most famous feature is the broken pediment at the top that looks like a

scrolled bonnet on a highboy chest in the Chippendale furniture style. It's as if a giant dropped his fashionable chest of drawers on the top floor of a Midtown Manhattan skyscraper. The Chippendale style includes tall legs, and Johnson's building "stands" with tall legs (columns) at its base. This piece of urban furniture is actually a complex mix of styles. Its lower facade with a central oculus above a *loggia* (or colonnade) emulates the Pazzi Chapel, one of the masterpieces of Italian Renaissance architecture. Inside, a groin-vaulted space recalls the Romanesque period. The tower cuts an elegant and witty profile next to its boxy neighbors in New York's skyline.

The prismatic architecture of I. M. Pei

Another late 20th-century convert to Postmodernism is the Chinese-born American I. M. Pei (1917–). Pei is known for his great modernist buildings such as the John F. Kennedy Library on Columbia Point, Massachusetts, and the East Building of the National Gallery of Art, Washington D.C. But when former French President François Mitterrand chose Pei to expand the Louvre in 1983, the architect began to explore how to give a modern building a historical look without simply imitating an outdated style. The Louvre is a series of royal palaces built over a 13th-century castle. Pei realized he couldn't just add on a Modernist rectilinear entrance to the world's greatest museum — it would look like a subway stop surrounded by ornate Renaissance and Baroque buildings. Instead, he reached back to the Ancient Egyptian form, the pyramid, updating it by using transparent glass instead of stone (see Figure 26-1).

Figure 26-1: I. M. Pei's Pyramide, Le Grande Louvre, is meant to be a bridge between old-school and new-school architecture.

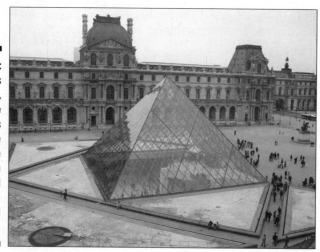

John Garton

Few recent projects have ignited such heated debate as Pei's Pyramide, Le Grand Louvre. Critics feared anything "new" would disrupt the architectural harmony achieved over several centuries. Others objected to a foreigner reshaping the heart of French culture.

Pei pushed the limits of contemporary technology to come up with his solution for the museum's entrance and underground expansion. In the main entrance pyramid, diamond- and triangular-shaped panes are bound together by a web of steel girders and thin cables. For the strong, ultralight joinings or "nodes" that hold the tension structure in place, Pei turned to a Massachusetts-based company that made the rigging for the America's Cup yachts. A specially manufactured colorless glass preserves the view of the historic palace both inside and outside the entrance, and a series of reflecting pools gives the impression that the structure floats upon water.

The transparency and lightness of Pei's 79-foot central pyramid and the two smaller flanking pyramids is the *exact opposite* of the dense stone Pyramids of Giza (see Chapter 6).

Pei's expansion of the Louvre includes a sprawling, two-level complex of shops, meeting places, and exhibition spaces. These changes make the Louvre the largest museum in the world, with nearly 1.4 million square feet of space. Though geometric, precise, and modern in its detailing, Pei's project is Postmodern in the way it breaks with the International style to reinvent a monumental form from ancient times.

Deconstructivist architecture of Peter Eisenman, Frank Gehry, and Zaha Hadid

When many people hear the term *deconstruction*, they think of a wreaking ball and knocking down a building. But that isn't what deconstructionist (or deconstructivist) architects mean when they use the term. For them, *deconstruction* means getting fancy and philosophical about their trade.

Deconstruction is a type of philosophy and a way of reading literature developed by the French intellectual Jacques Derrida. Among other things, deconstructivists argue that no literary work has an absolute meaning — everything's open to interpretation. For example, if an author describes a situation as "dark," the deconstructionist won't assume that "dark" is negative. He will analyze the passage without that preconception.

The goal of deconstructivists is to break down literary passages or architectural problems and analyze them without taking anything for granted. For

example, in architecture we assume that roofs should slant to spill off rain. A deconstructionist roof might twist and turn and appear to do somersaults like the one at Bilbao, designed by Frank Gehry — yet in spite of that, rain still rolls off of it. By clearing away the clutter of preconceptions, the deconstructivist architect is able to find highly original ways to solve old problems.

Peter Eisenman (1932–)

In his designs, the deconstructivist Peter Eisenman often breaks the rules by uniting unrelated elements (incongruous building parts) and by adding structures that have a symbolic rather than a practical purpose.

The Wexner Center for the Visual and Performing Arts at Ohio State University in Columbus, Ohio, designed by Eisenman, is a showcase of deconstructed spaces and unrelated elements. The crenellated redbrick tower near the entrance looks like a medieval castle that's been chopped in half by the architect. It's literally split down the middle.

Crenellations are teethlike notches on the top of a tower, also known as battlements. In the Middle Ages, archers hid behind the notches and shot their arrows between them.

Between the two halves of the tower, a grid of windows allows you to "see through" the structure into the courtyard beyond. The crenellations are echoed in other castlelike sections of the building, making the Wexner Center look like a medieval fortress superimposed on a Modernist glass box. The dungeons-and-dragons appearance is intended as a tribute to the castlelike Armory building that previously stood on the sight. (It was destroyed by a fire in 1958.)

In a nearby part of the building, the architect sliced a playful scoop out of the brickwork and filled it in with another window grid. An even more bizarre visual spoof is the large, grid-shaped awning made of square, white steel pipes that projects over the entrance. The trouble with this awning is that it doesn't protect you from the weather. The grid spaces are empty! What's the point of that? The mock awning has a symbolic rather than a functional purpose, which you can contemplate while you soak under it in the rain. In Eisenman's words, the square white pipes create a "metaphoric microcosm of the urban grid." The Ohio State campus grid and the surrounding city grid don't mesh; they are 12.5 degrees askew. Eisenman aligns them symbolically with his mock awning (which is lined up with the spine or backbone of the building itself) to indicate that all parts of a city should get along, not fight each other at 12.5-degree angles!

Frank Gehry (1929–)

A less intellectualized form of deconstruction is practiced by one of the most popular contemporary architects, the Canadian-born Frank Gehry. Gehry

seems to follow his instincts more than his intellect. His own house built in Los Angeles in 1978 has a devil-may-care haphazardness about it. The walls and roof slope at odd angles and the materials are ultracheap: corrugated metal siding, plywood, and chain-link fencing. It looks like the kind of house a builder might construct if he were drunk! But for the past two decades Gehry's deconstructivist works have been large buildings made from expensive materials.

All the wacky curves of Gehry's museums, concert halls, and university buildings have required special methods of architectural practice to allow for their load testing and construction. His firm pioneered the use of a computer-modeling software called CATIA, previously only used in industry. A modified version of that software helps compute the best loads and geometries for Gehry's unusual intersections and sculptural forms, calculating for the engineers and builders what types of material and structure will make the building hold up under the forces of nature.

Frank Gehry's Guggenheim Museum, Bilbao (completed in 1997), looks vaguely like a ship (see Figure 26-2), dominating the skyline of the Spanish industrial port of Bilbao. The giant, steel-framed museum is clad in sheets of titanium that reflect the weather and lighting conditions — bringing the environment onboard! In that sense, you never see the same building twice. Its curved surfaces bend and sway, even as the massing of the building gives it a bulky solidity. In this and later works, Gehry's buildings seem to erase all boundaries between architecture and sculpture. The building is a shape or a thing first, and then a building. Against the gridlike regularity of most cities, Gehry's designs seem like living organisms with silvery skins.

Figure 26-2:
Frank Gehry's streamlined Guggenheim Bilbao Museum is his crowning achievement of deconstructivist architecture.

Courtesy of Spanish National Tourist Office

Gehry's first European structure was the Vitra Design Museum in Weil am Rhein, Germany (1989). That museum was unveiled at the same time that the Vitra Company (furniture designers) commissioned Zaha Hadid (see the following section) to build her famous firehouse next door, creating a sort of deconstructivist mecca in southwestern Germany.

Zaha Hadid (1950–)

The Iraqi-born Zaha Hadid is a deconstructivist architect whose biggest inspiration seems to be Russian Suprematism, especially the artist Kazimir Malevich (see Chapter 23). Hadid is also an active painter and her designs look like dark Malevich compositions that have exploded into the 21st century.

Her Vitra Fire Station in Weil am Rhein is among her most famous works. It juts out in multiple sharp angles, as if the reinforced concrete had stopped the motion of an explosion. The building's long, pointed plains and sharp intersections provide a metaphorical sense of speed for the firemen. The conventions of architecture have been deconstructed to the point that there are no gutters, pipes, or cladding on this building — only the precise angularity of concrete slabs and cantilevers. Never the most functional of fire stations, the building has been converted into a showroom for Vitra's chair collection.

Making It or Faking It? Postmodern Photography and Painting

Today many Postmodern artists express doubts about progress, post-industrial capitalism, and grand arts movements. The themes of Postmodern artists such as photographer Cindy Sherman and painter Gerhard Richter (both discussed in this section) are usually personal and self-critical. Both artists often look ironically at the past, and occasionally treat art history as a grab bag of styles and images to be rummaged through. Like other Postmodernists, Sherman and Richter thrive on remixing things and creating hybrids that remind viewers of the originals while adding something distinctly contemporary.

The pop singer Madonna is sometimes labeled Postmodern for the way she continually reinvents her persona with every tour. Can anyone say what the "true" Madonna is like? A morphed image and the meanings it creates are more significant and "true" to Postmodernists than claiming to understand

the essence of the original. They believe modern life is in flux, everything blends and blurs. Nothing is stable. There are no absolutes. Both Cindy Sherman and Gerhard Richter change hats as often as Madonna. In the case of Sherman, the real person seems to disappear behind all the disguises.

In the following sections, I cover the art of the Postmodern photographer Cindy Sherman and the Postmodern painter Gerhard Richter.

Cindy Sherman: Morphing herself

Since 1977, photographer Cindy Sherman (1954–) has caught the world's attention by photographing herself in all sorts of campy costumes, makeup, and wigs. She endlessly reinvents herself as a kind of generic "everywoman," but often in roles assumed by women in 1950s and 1960s cinema, porn movies, or Old Masters portraits (portraits by great painters from the Renaissance through the 18th century).

In her series of 69 photos, the "Untitled Film Stills" (shot between 1977 and 1980), Sherman adopts stereotypical female roles from popular '50s and '60s film culture: the blonde-bombshell librarian, the wanton white-trash house-wife, the sexy prairie princess, and so on. Sherman's shots are so convincing that they look like actual B-movie stills. She meticulously re-creates the costumes, attitude, and period look, down to the wallpaper and lampshades. So what's the point? Is she trying to bring back the '50s or are these "remakes" a subtle commentary on our view of women, then and now? If so, how does Sherman signal the viewer that the photos are parodies?

In "Untitled Film Still #6, 1977" (see Figure 26-3), Sherman assumes a Debbie Reynolds/Tuesday Weld look and curls seductively on a bed in white panties and a black bra. Her porcelain-doll face hints that the scene is a put-on. Also, the camera practically plasters Sherman onto the wallpaper like a pin-up girl. Other than that, the imitation seems like the real thing.

After admiring herself in her black hand mirror, the woman glances up into the leering eyes of an out-of-the-frame voyeur, who, judging by the woman's reaction, is about to pounce. Her facial expression and pose are frightened, vulnerable, and inviting, all at the same time — just the right cocktail of "oh-no" and "oh-yes" to titillate '50s and early '60s film audiences without red-flagging the Hays Office (Hollywood censors). The pose and look are so steamy that you know the camera is about to cut.

Figure 26-3:
In Cindy
Sherman's
"Untitled
Film Still #6,
1977" the
photog-
rapher
poses as a
B-movie sex
kitten curled
on her bed
under the
gaze of an
unseen
voyeur.

Courtesy the artist and Metro Pictures

Gerhard Richter: Reading between the layers

The widespread use of photo-manipulating software such as Photoshop means that most photography has lost its reputation for telling the truth. People now routinely suspect that even news photography has been modified to some degree. As many Postmodern artists predicted decades ago, the *simulacrum* (fake version of a thing) would become more powerful and useful than the authentic object — like plastic flowers and artificial Christmas trees.

One painter whose brushstrokes have hovered between the simulated and the real is the German-born Gerhard Richter (1932–). Richter began by creating photo paintings from black-and-white photographs — not to imitate them, but because the ordinariness of, say, a family snapshot made it a neutral starting point on which he could build layers of paint. Instead of a "reality" composed by the artist, the photos (many of them taken from books and newspapers) offered a more objective snapshot of life. Also, painting over photos gave Richter's art a hand-me-down look, implying that reality is always recycled. The layers he builds also help indicate this view.

Typically, Richter blurs images — both the base image and the new images. He said, "I blur things to make everything equally important and equally unimportant." Blurring images also suggests that the boundaries of people and places are imprecise and open to interpretation.

Even as he adds layers, Richter scraps away some of the new paint to let the underlayers peak through. In this way, he shows that the old doesn't disappear, it just gets reworked.

Despite this borrowing and revising, Richter created a style of large abstract works that are all his own. His *Abstract Painting (750-1)* of 1991, for example, is a large canvas filled with brilliant colors that have at times been applied or dragged across the surface with a squeegee. Dappled color patterns emerge as the paint fills in some areas but leaves holes in others (revealing the past and signaling that the rest of the painting is a revision of it). This effect becomes increasingly complex as he builds up more and more layers of paint. The result is what you might call a *palimpsest* (a manuscript that has been written in once, then scraped down and written over a second time — some of the old words tend to peek through). Think of old weathered billboards in which multiple slogans start to appear. The difference with Richter's painted archaeology is that all the surfaces are pure color/paint and the intermingling of old and new has a purpose.

For more details about Richter's art and technique, see Chapter 29.

Installation Art and Earth Art

An *installation* is an environment that the viewer navigates or somehow interacts with. Sometimes installations are set up in galleries and sometimes they confront viewers in public spaces. Usually, they consist of many elements and can include sound, video, paintings, sculpture, commercial objects, and anything else the artist wants to weld to his artificial environment. Although installation art is temporary, it tends to interact with the viewer more aggressively than a painting on the wall.

In the following sections, I examine the work of four installation artists: Judy Chicago, the team of Christo and Jeanne-Claude, and earth artist Robert Smithson.

Judy Chicago: A dinner table you can't sit down at

Feminism is a chapter of art history that began to gain mainstream attention in the late 1960s and early 1970s. When Linda Nochlin, a leading feminist art historian, wrote her famous 1971 essay "Why Have There Been No Great Women Artists?", it struck a chord with female artists who recognized the unfair treatment they were receiving in a male-dominated art market. Even the subject matter and values of much of the leading art seemed to cater to

an alpha-male view of the world. Would there be different interpretations of traditional subjects if women were making the art? Artists such as Mary Kelly, Suzanne Lacey, Sylvia Sleigh, and Adrian Piper began exploring these issues. In 1971, at the California Institute of Arts, Judy Chicago and Miriam Schapiro formed the world's first Feminist Art Program.

A famous example of installation art addressing feminist issues is Judy Chicago's *The Dinner Party* (1979). Chicago's installation features an elegant triangular dinner table (the triangle has long been associated with femininity) set for 39 famous female guests — some historic, some mythical. None of the guests shows up because all the historical ones are dead, which is part of the poignancy and message of the installation. Many great women never enjoyed the recognition they deserved. Chicago inscribed the porcelain floor under the table with the names of 999 other famous women in gold. The number 3, often considered a mystical number, factors into 39 thirteen times. Thus, 13 great women sit on each side of the table, as 13 men gathered at the Last Supper.

Here the women face one another and the notion of "head of the table," usually associated with male domination, is abolished. The historic guests include the pharaoh Hatshepsut (whose name and monuments were often suppressed by later generations of male pharaohs), the Greek lyric poet Sappho, Empress Theodora (see Chapter 9), Queen Eleanor of Aquitaine, Hildegard von Bingen (the great medieval mystic, writer, and composer), Christine de Pizan, Artemesia Gentileschi (see Chapter 14), Susan B. Anthony, Emily Dickinson, Virginia Woolf, and Georgia O'Keeffe. Each woman's place is designated by a ceramic plate, chalice, and place mat on which her name is inscribed. The place mats are made with various needlework techniques (embroidery, needlepoint, and so on) that reflect the era in which each woman lived.

It's a wrap: Christo and Jeanne-Claude

American writer Max Eastman said for an object to be considered art, it must be so beautiful that we don't want to use it (see Chapter 23). The Bulgarian-born Christo Javacheff (1935–), known simply as Christo, and his wife Jeanne-Claude Denat de Guillebon (1935–) have a similar aesthetic. If you shut off an object's function by concealing it behind fabric or some other wrapping material, the aesthetics of the thing (cloaked and disguised) step into the limelight. For example, Christo might wrap a milk bottle so you can't drink from it or a suitcase so it's impossible to open. With its function suppressed, the contours and essential form of the dressed-up milk bottle or suitcase become apparent.

Christo and his partner Jeanne-Claude started wrapping tin cans and magazines with canvas and fabric and eventually graduated to wrapping buildings

and landscapes. In some ways, wrapping a building is like putting a picture frame around it that shouts "Look at me — I'm art." Christo's "frames" call attention to spaces, places, and things that otherwise go unnoticed or barely noticed. A Christo-wrapped building stops being its everyday self and becomes something to enjoy aesthetically — until the wrapping comes off.

Christo and Jeanne-Claude's largest works include *Wrapped Coast — One Million Square Feet, Little Bay, Sydney, Australia,* in which the duo and a team of 130 assistants wrapped a mile of Australian coastline; *Running Fence, Sonoma and Marin Counties, California, 1972–76,* where Christo and Jeanne-Claude circumscribed an area with about 24 miles of white nylon; and *Surrounded Islands, Biscayne Bay, Greater Miami, Florida, 1980–83,* in which the duo wound pink fabric around 11 islands, making each one appear to float in a pink pool surrounded by the sea.

Although Christo and Jeanne-Claude don't always wrap, they almost always use fabric. In *The Umbrellas, Joint Project for Japan and U.S.A. 1984–1991,* they altered the landscape in two countries simultaneously by dressing them in 3,100 colorful umbrellas. On October 9, 1991, 1,340 umbrellas turned a Japanese valley 75 miles north of Tokyo into a kind of tent city made of bright blue umbrellas that harmonized with the surrounding greenish-blue mountain peaks. Simultaneously, in California, 1,760 umbrellas transformed a valley 60 miles north of Los Angeles into a playful inland beach.

Robert Smithson and earth art: Can you dig it?

Robert Smithson's (1938–1973) *earthworks* (on-site sculptures from natural elements extracted from the surrounding environment) weren't built to last — they were meant to fall apart. Smithson's most famous work, *Spiral Jetty* (1969–1970), was built on ten acres of Great Salt Lake coast in Utah. He constructed the 1,500-foot spiral from earth, rock, and salt — all on-site materials. One reason he chose this location is because the saltwater tides would eventually carry away his sculpture like a kid's sand castle. However, after being submerged for 29 years, *Spiral Jetty* reemerged in 1999 following a drought that lowered the lake's water level. Smithson chose the spiral shape because it appears in both seashells and galaxies. The spiral also suggests both infinity and eternity (the antidote to decay). The resurrection of *Spiral Jetty* highlights that symbolism, perhaps more than Smithson ever planned on.

What's the point of a sculpture that doesn't last? One of Smithson's goals is to give us a fast-motion model of the decay of a civilization or a civilization's monuments. In the case of Greek and Roman ruins, we witness the decay from only one point in time, our own. Smithson speeds up deterioration, enabling the viewer to see the entire process. Usually, he records his work with photos because his installations are often constructed in remote locations.

British-born sculptor and former Kent State University art professor Brinsley Tyrrell and his students invited Smithson to Kent State from 1969 to 1970 to build an earthwork on campus. According to Tyrrell, Smithson wanted to "tip a truckload of mud down a hill and photograph it while it flowed. Well, in January mud won't flow downhill in Ohio." Smithson decided to return to New York, but Tyrrell asked him if there was something else he'd like to try. "He said he'd always wanted to bury a building," Tyrrell recalls. With Tyrrell's assistance, Smithson obtained permission from KSU to bury an old farm shed on university property. So he rented a backhoe and, with the assistance of Tyrrell and KSU students, dumped 20 loads of dirt on the woodshed until the spine of the structure cracked. That creative-destructive act triggered the decay of Smithson's *Partially Buried Woodshed*. Nature would do the rest.

"In the evening we sat down," Tyrrell recalls, "and I asked Smithson what it was he wanted to happen, now that we'd done it. He said he wanted the woodshed 'to acquire its own history, not just be bulldozed over.'"

One of the messages of Smithson's work is that decay is inevitable and can have aesthetic value. There is something poetic and nostalgic about a Roman ruin or van Gogh's famous depiction of withered sunflowers.

Whether the destruction and death that followed on the Kent State campus was inevitable is another question. On May 4, 1970, a contingent of Ohio National Guardsmen (who came onto the campus with loaded weapons) opened fire on student antiwar demonstrators, killing four and wounding nine. Shortly afterward, someone painted "May 4 Kent '70" on Smithson's structure in large white letters. *Partially Buried Woodshed* became the unofficial memorial for the dead and wounded students. In other words, it began to acquire its own history.

Soon letters poured in to local newspapers demanding that the woodshed be dismantled. People viewed it as an eyesore rather than art and perhaps as a reminder of something they wanted to forget. *Partially Buried Woodshed* absorbed that history, too. In 1975, an arsonist's fire bomb burned away half of the controversial building. *Partially Buried Woodshed* was diminished, but its history kept growing. The university then planted trees around the crumbling shed to protect and conceal it, adding another layer of history to it. In February 1984, the site disappeared, except for a few pieces of concrete foundation; the university apparently bulldozed it into oblivion.

Perhaps more than any of his other works, *Partially Buried Woodshed* met Smithson's goal of "acquiring its own history." Even though only a few slabs of foundation concrete remain — and a few preserved fragments like the one in Figure 26-4 — Smithson's earthwork continues to acquire history. It is now considered a *landmark* of conceptual art.

Figure 26-4:
Robert
Smithson's
*Partially
Buried
Woodshed,*
created on
the Kent
State
University
campus,
became a
magnet of
local
history.

Jesse Bryant Wilder

Glow-in-the-Dark Bunnies and Living, Genetic Art

Even as the mechanical age seems to be subsiding, a new biomorphic age is announcing itself with the mapping of the human genome. Movies such as *Jurassic Park* fantasize about how close we are to reversing the linear notion of time and the evolution of species. In that movie, dinosaurs are brought back to life using DNA trapped inside amber. Why? Because the scientists have discovered how and the results would make for an interesting theme park! As crazy as that nightmare may seem, individuals and multinational corporations have been cloning and genetically engineering at a surprising rate. Some artists want to expose these practices and others want to use similar processes to make aesthetic objects. Will this be a nightmare, or will the artists, like great artists of the past, reveal things that we didn't know about our era?

The divisions between art and the fields of science or medicine have become blurred in unusual ways. The performance artist Orlan, for example, makes videotapes of herself submitting to a series of cosmetic surgeries that bring her actual appearance into conformity with a Photoshopped image she composed from pictures of Old Masters paintings by Leonardo, Botticelli, and others.

Another performance artist, Stelarc, has prosthetic devices affixed (sometimes surgically) to allow him certain super- or cyber-human capabilities. For example, in 2000 he constructed a "manipulator" that extends his arm to "primate proportions." He also developed a computerized Extra Ear that functions as an Internet antenna.

But many artists practicing in this sphere are out to raise awareness about the "art" of biotechnology and the processes that make it a trillion-dollar industry. For example, the Critical Art Ensemble, a collaborative group started in 1987, brings its art activism to audiences by a combination of restaging events in the history of biotechnology and displaying actual bacteria, genetically altered material, or similar samples in a shocking way. Their recent *Germs of Infection* (2005) actually distributed *Serratia marcescens,* a harmless bacteria that simulates anthrax, into the air ducts of a Berlin gallery and then concluded by scientific testing that the space was "a suitable site for an anthrax attack." No one was harmed during the test; it was done to draw attention to a similar test that was conducted at the Pentagon in 1945 and led to a proliferation of germ-warfare programs. The artists' intention was to use fear to educate people about a time when those panic buttons were pushed in a non-art context and people made the wrong choices.

Nothing seems more God-like or fearful than *transgenic engineering,* the formation of new combinations of genes from one or more organisms that are then reintroduced into a living organism. You might say that this is where Postmodernism meets science. It was once believed that species' boundaries were for the most part impenetrable. However, with the various genome projects, we now know that genes of differing species can be easily spliced in endless combinations with no clear limitations (like cultivating cranapples or other hybrid fruits). The consequences are of course unknown.

The Brazilian-born artist Edoardo Kac has created an infamous work of art meant to draw the public's attention to transgenic engineering: the glow-in-the-dark bunny. The bunny's name is Alba. She was created in a laboratory in Jouy-en-Josas, France, by splicing in the genetic material from a glow-in-the-dark jellyfish. Alba looks like a normal rabbit, but under blue light she glows fluorescent green! Kac's hope was to create an installation in which he and his family would live with Alba. They would occasionally be either videotaped or placed behind a protective glass that allowed visitors to observe the whole family in their "natural" habitat. Think of a cross between a history museum diorama and the reality TV show *Big Brother.* Kac's idea borders on such controversial cruelty to animals that, under pressure, the lab has never released Alba to the artist for exhibition. Nonetheless, transgenic engineering is one of the many alarming developments of a Postmodern art obsessed with replication and simulation.

Part VI
The Part of Tens

The 5th Wave — By Rich Tennant

@RICHTENNANT

"No, my 5-year-old painted the landscape. The other one is a valuable example of Neo-Urban Impressionism."

In this part . . .

I recommend ways to extend your knowledge of art and art history. The only way to see most of the art in this book up-close-and-personal is to go to art museums. I list the ten best and give you a glimpse of their collections.

Who better to explain art and architecture than artists and architects with a knack for writing? (Not everybody can write you know!) In this part, I recommend ten of the best books about art written by artists, from Leonardo da Vinci to Friedensreich Hundertwasser. In many ways, these books are works of art, too!

I end my tour of great art by looking at brushstrokes — the ten most exciting and revolutionary painting techniques in history.

Chapter 27

Ten Must-See Art Museums

. .

In This Chapter

▶ Touring the world's greatest art museums

▶ Glimpsing the coolest collections

. .

*I*f you want to compress as much art site-seeing as possible into a handful of museum treks, then the museums listed here are the places to hit. I selected them because they offer more great art per square foot than anywhere else on the planet.

The Louvre (Paris)

Touring the Louvre is a hike through acres of art. Sometimes the walls are almost *too* loaded with images — you can't take it all in.

The Louvre, arguably the world's greatest museum, boasts a dazzling treasure trove of masterpieces. The world's most famous painting, the *Mona Lisa* (see Chapter 11), dominates one room; four other Leonardo da Vinci paintings, including the original *The Virgin of the Rocks* (see the color section), hang nearby, like afterthoughts. The museum also owns some of the most famous statues ever carved: Michelangelo's *Dying Slave* and *Rebellious Slave*, and the Hellenistic masterpieces *Nike of Samothrace* and the *Venus de Milo* (see Chapter 7 for both).

If you like mummies, the Louvre has a stash that could fill a necropolis. Its Egyptian collection is probably the greatest and largest in the world thanks to Napoleon's habit of looting art from the countries he defeated.

The Uffizi (Florence)

The Uffizi is Renaissance heaven. The building was designed by Giorgio Vasari (see Chapter 28). The Uffizi housed the mega-collection of the Medici family (Florence's ruling family) for centuries. Sandro Botticelli's two greatest masterpieces — *The Birth of Venus* and *Primavera* (see the color section) — hang here. The Uffizi also owns Michelangelo's *Holy Family with Mary Magdalen;* Raphael's *Madonna with a Goldfinch;* Titian's *Venus of Urbino* (see Chapter 12); Caravaggio's *Bacchus;* works by Giovanni Bellini, Giorgione, Agnolo Bronzino, Filippo Lippi, Paolo Uccello, Masaccio, Peter Paul Rubens, Albrecht Dürer, Lucas Cranach the Elder, and Rembrandt; as well as da Vinci's unfinished *Adoration of the Magi.*

The Vatican Museums (Rome)

The Vatican Museums share 13 acres with the pope and his court. The museum complex includes the Sistine Chapel Ceiling, painted by Michelangelo; the Cappella di Nicholas V, decorated by Fra Angelico; the Stanze de Raffaello, painted by Raphael; and the Stanze della Segnatura, where Raphael's greatest fresco *The School of Athens* (see Chapter 11) sprawls over a wall and where he painted *The Disputa* (featured on the front cover of this book). The Vatican Museums also include the Pinacoteca (Picture Gallery), which features works by Giotto di Bondone, Fra Angelico, Leonardo da Vinci, Filippo Lippi, and Raphael. The museums own some of the most celebrated statues of the Greco-Roman world including *Apollo Belvedere* and *Laocoön and His Sons* (see Chapter 7).

The National Gallery (London)

London's brilliant National Gallery features paintings from 1250 to 1900. Among the great works are Jan van Eyck's famous *Arnolfini Wedding* (see Chapter 12) and *Man in a Red Turban,* Michelangelo's unfinished *Entombment,* Leonardo da Vinci's second version of *The Virgin of the Rocks,* Raphael's *Pope Julius II,* and Caravaggio's super *Supper at Emmaus.* It also displays works by Diego Velázquez, Rembrandt, J. M. W. Turner, and Johannes Vermeer. And it has a stellar collection of Impressionist and Post-Impressionist works, including Georges-Pierre Seurat's *Bathers at Asnieres* and Vincent van Gogh's *Sunflowers.*

The Metropolitan Museum of Art (New York City)

Hands down, the Met is the greatest museum in the Western Hemisphere. It houses an astounding, wide-ranging collection of Egyptian, Mesopotamian, Ancient Greek, Roman, Byzantine, Islamic, African, European, and American art. Its Far Eastern collection is one of the greatest outside of China and Japan. The Met's holdings include 37 Monets, 21 Cézannes, and 5 Vermeers. It recently acquired Duccio's *Madonna and Child* for $45 million.

The Met's medieval collection housed in the Cloisters rivals the Musée de Cluny (a.k.a. Musée National du Moyen Age) in Paris. Don't miss it if you're in New York.

The Prado (Madrid)

The Prado holds the Spanish Royal collections. Its specialty is 14th- to 19th-century art. The collection boasts great works by Diego Velázquez, José Ribera, Bartolomé Estéban Murillo, El Greco, Francisco Goya, Titian, Raphael, Peter Paul Rubens, Caravaggio, Paolo Veronese, and Rembrandt, as well as Durer's *Self-Portrait at Age 26* (see Chapter 12), Hieronymus Bosch's *The Garden of Earthly Delights* (see the color section), and Rogier van der Weyden's masterpiece *Descent from the Cross* (see the color section).

The Hermitage (St. Petersburg)

The Hermitage houses the stupendous collection of the czars of Russia, started by Catherine the Great in 1764. The holdings include Leonardo da Vinci's radiant *Madonna Litta,* 2 Raphaels, 8 Titians, 40 Rubens, and 40 Rembrandts. The Hermitage is second only to the Louvre in its collection of French paintings, with works by Nicolas Poussin, Claude Lorraine, Antoine Watteau, Jean Auguste Dominique Ingres, Eugène Delacroix, Jean-Baptiste-Camille Corot, and Gustave Courbet, as well as an impressive Impressionist and Post-Impressionist collection.

The Rijksmuseum (Amsterdam)

The Rijksmuseum is the greatest Dutch Museum. Rembrandt's famous *Night Watch* is here, as is his *The Jewish Bride* and *The Denial of St. Peter.* The holdings also include Frans Hals's *The Merry Drinker* and four Vermeers, including *The Love Letter* and *The Kitchen Maid.*

British Museum (London)

The British Museum is stuffed with artistic loot, snatched from Britain's colonies during the 300-year-long British Empire. If the Elgin Marbles were the only thing the British Museum owned, the museum would still be on this list. The marbles were designed and possibly sculpted by Phidias, the greatest sculptor of classical Greece. You can gaze at the Elgin masterpieces for hours and still not get bored — the variety seems endless. The marbles dominate several vast rooms.

Of course, the British Museum owns much more that Lord Elgin's booty. It also managed to confiscate the Rosetta Stone (see Chapter 6) from the French who discovered it during Napoleon's expedition in Egypt. The museum's Egyptian holdings are vast and its collection of Roman statues would even wow a Caesar.

The Kunsthistorisches (Vienna)

The Kunsthistorisches Museum (which means "Historical Art Museum") is the greatest museum in Central Europe. The Marie de' Medici Room, with six paintings by Rubens, celebrates the marriage of Marie de' Medici to King Henry IV of France. Other collection highlights are Pieter Bruegel the Elder's *The Hunters in the Snow,* Rogier van der Weyden's *Triptych Crucifixion,* Johannes Vermeer's *Allegory of the Art of Painting,* Parmigianino's magnificent *Portrait in a Convex Mirror,* Titian's *Isabella d'Este,* and Andrea Mantegna's *St. Sebastian.* There are also paintings by Giuseppe Arcimboldo, Albrecht Dürer, Jan van Eyck, Giorgione, Caravaggio, and Hans Holbein the Younger.

Chapter 28

Ten Great Books by Ten Great Artists

In This Chapter

▶ Identifying great artists who are also great writers
▶ Reading an artist's mind — and his book

Most writing on art is by people who are not artists: thus all the misconceptions.

— Eugène Delacroix

Not many great visual artists are also great writers. But some are. The ten books in this chapter are all written by famous artists. Reading their words and looking at their visual art gives you a broader perspective of their artwork and a better understanding of its meanings.

On Painting, by Leonardo da Vinci

You could call Leonardo da Vinci's *On Painting* a book about the *science* of art. Leonardo liked to mix disciplines even more than he liked to mix paints. So *On Painting* is both an art book and a science book. If you use both sides of your brain regularly like da Vinci (you're not only a technical person but a creative one), then *On Painting* may be the book for you. Besides, climbing inside a complicated mind like Leonardo's and letting your brain gears mesh with his is super mental aerobics. It's like jogging alongside an Olympic runner. Some of the Olympian's star habits are liable to rub off — if you can keep up.

Lives of the Most Eminent Painters, Sculptors, and Architects, by Giorgio Vasari

Giorgio Vasari's book is a goldmine of information about Renaissance art and artists. He covers about 31 painters, sculptors, and architects, including Giotto, Lorenzo Ghiberti, Masaccio, Filippo Brunelleschi, Donatello, Fra Angelico, Filippo Lippi, Giovanni Bellini, Sandro Botticelli, Leonardo da Vinci, Michelangelo, Raphael, and Titian (all artists I discuss in this book). Vasari's writing is rife with colorful anecdotes about artists, some of whom he knew personally — Michelangelo and Titian were both pals of Vasari's.

Complete Poems and Selected Letters of Michelangelo

Michelangelo's poems and letters give insight into the man and help you understand his painting and sculpture more fully. Although Michelangelo isn't known as a great poet, many of his poems are quite good. Hundreds of them are love poems, the majority quietly homoerotic. Many of the poems he wrote late in life are about suffering.

The Journal of Eugène Delacroix

Delacroix's *Journal* takes readers on an inspiring voyage through the mind of a great artist. The *Journal* is part biography, part self-exploration, part art criticism, and part philosophy. Delacroix also writes about his friendship with Frédéric Chopin and George Sand, his romantic desires and fears, and his passion for some of his models. The *Journal* is full of subtle perceptions about life, art, and the creative process.

Van Gogh's Letters

Vincent van Gogh's letters to his brother Theo are among the greatest letters ever written by an artist, and they are as fresh today as when they were first

written. In these intimate letters, van Gogh explains many of his painting choices, composition decisions, influences, and sources of inspiration. He also explores life perceptively and honestly.

Rodin on Art, by Paul Gsell

Rodin on Art is an interview with the great sculptor Auguste Rodin. Rodin's words are as eloquent and potent as his art. Profound and often surprising insights on art gush from him as if he were a fountain of artsy wisdom.

Der Blaue Reiter (The Blue Rider) Almanac, edited by Wassily Kandinsky and Franz Marc

This visionary book of essays explains the goals of one of the two great German Expressionist movements, Der Blaue Reiter (The Blue Rider). Kandinsky, the leader of Der Blaue Reiter, believed colors, lines, and shapes were analogous to melodies and rhythms in music. He strove to paint color harmonies and color symphonies, which he believed would uplift people's souls, cleansing them of materialism. *Der Blaue Reiter Almanac,* which started out as a series of pamphlets before evolving into a book, is the program for this spiritual purification through a new art.

Der Blaue Reiter Almanac is interdisciplinary; it includes short essays, paintings, musical scores, and a play. Kandinsky not only integrated painting and music, but also brought artists of all stripes (writers, actors, musicians, painters) into the movement. Even the famous composer Arnold Schoenberg contributed a brilliant article on the relationship between music and language.

Concerning the Spiritual in Art, by Wassily Kandinsky

This book is a challenging, but very worthwhile, read. It helps you understand some of the impulses of modern art. More importantly, it explains the

spiritual role that Kandinsky, like many artists, assigned to art. Kandinsky believed that people respond to color in the same way they respond to music, especially if the colors are arranged like a musical score with patterns and kaleidoscopic variations. He believed his color art could awaken a sleeping spiritual dimension that lies in all of us. Kandinsky published this book the same year he and Franz Marc printed *Der Blaue Reiter Almanac* (see the preceding section).

Kandinsky sought a new form of art that would instant message the average Joe and Jill, an art driven not by money hunger or a desire to shock, but by a yearning to touch and awaken people spiritually, a longing to sing with colors that transcend form and the material world that form represents. Pretty complex stuff!

The Diary of Frida Kahlo: An Intimate Self-Portrait

Frida Kahlo's diary takes readers on a poetic journey through her tormented mind. The diary is full of love poems to Diego Rivera, her husband and muse, who frequently left her for other women but always returned. In the poems, she uses the language of painting (color and geometric and organic shapes) to convey the same kind of emotions and ideas that she expresses in her art. The diary is also full of sketches and watercolors whose images and meanings often meld with those of her poems.

Hundertwasser Architecture: For a More Human Architecture in Harmony with Nature, by Friedensreich Hundertwasser

Friedensreich Hundertwasser, an Austrian Fantastic Realist, declared war on the straight line. Why? Because, there are no perfectly straight lines in nature, according to Hundertwasser. Applying this idea to architecture, Hundertwasser created an organic architecture with wavelike walls and floors and rooftop gardens — all done up in Playskool colors. Hundertwasser believed that modern-day architecture is detached from nature, just sort of slapped onto our environment. He wanted to build structures that look like they grew out of nature. This richly illustrated book explains Hundertwasser's interesting theories.

Chapter 29

Ten Brushstrokes That Shook the World

Although many painters sign their canvases, a painter's brushstroke is his definitive signature. Some signatures are showy, and others are almost invisible. Connoisseurs can identify artists by the way they handle a brush. In this chapter, I tell you about the brushstrokes that changed the face of painting.

The Man Who Mainstreamed Oil Paint: Jan van Eyck

Before Flemish painter Jan van Eyck, most artists painted with *tempera* — a mixture of colored powder (pigment) and egg yolk or some other glutinous substance. Tempera had a few distinct disadvantages:

✔ Because egg yolk dries quickly, artists had to *paint* quickly.

✔ Tempera colors don't blend easily — artists had to use tricks to make the colors appear to blend.

✔ The brushstrokes show up in tempera, and that's not always the effect the artist is looking for.

✔ The finish has a dull, or *matte,* look; to give their paintings a sheen surface, artists had to glaze them.

Some painters experimented with mixing oil with tempera, but the results weren't encouraging. Then came Jan van Eyck. He discovered the right blend of oil and pigment and astounded the art world with the smooth finish of his paintings. The brushstrokes were virtually invisible. To his contemporaries, van Eyck's paintings looked as though they were conjured by magic rather than created through art. The surface sheen was so smooth that when van Eyck included a background mirror — as he did in *The Arnolfini Wedding* (see Chapter 12) — people felt they could see their reflection in it.

Because van Eyck figured out the right oil-pigment blend, people dubbed him the "Father of Oil Painting." But he didn't invent oil painting — he simply made it work.

The new style soon spread through Holland and Flanders, into France, and eventually to Italy. The first Italian artists to master oil painting were Antonello da Messina and Giovanni Bellini (see Chapter 12).

What's That Smoke? Leonardo Da Vinci

One of the ways Leonardo da Vinci made *Mona Lisa*'s face pulsate with life was by rounding out her cheeks, jowls, and forehead naturalistically (see Chapter 11). If you look at a drawing of a sphere, you'll see how he did it. To turn a flat circle into a round sphere, an artist uses shading. The sphere is drawn lightly in front and gradually gets darker toward the back to create the appearance of volume.

Leonardo did the same thing, more or less, with colors. He painted layers of translucent (almost see-through) colors on top of each other. This enabled him to smoothly blend flesh tones so that they gradually grew darker or lighter or pinker as he rounded out a surface. (The darker areas have more layers.) The border where two colors bleed into each other, on Mona Lisa's left cheek for example, has a blurry or smoky look, instead of a sharp edge. Leonardo used the word *sfumato* to describe this "smoky" effect. (The word *sfumato* is a variation of the Italian word *fumare,* which means "to smoke.") Andrea del Sarto, Giorgione, and others learned sfumato from studying Leonardo's work.

Lost and Found in Rembrandt's Shadows

Rembrandt dimmed the lights in his paintings, making the backgrounds seem mysterious, secretive, and deep. This gloom affects the light, making it more precious, like torchlight in a cave or your last match. The light on his characters' faces — often a golden, glowing radiance — has a homey, firelight feel that you can almost warm your hands by. This candlelight look helps to give

his paintings their humanity, their sense of warm compassion. The limited palette of earth tones that he used enhances this humanity and the down-to-earth look of his figures.

Rembrandt's experiments with dark and light are famous. So is his brushwork. As his style matured, his paintings got thicker. He spread on paint with a palette knife in layers like a cake decorator icing a cake. This technique is called *impasto*. Titian had moved in the cake-decorator direction 50 years earlier. But Rembrandt took the style further. Up close, facial features are almost unrecognizable. But step back and they tighten into focus. The thickness makes them look more real by giving the paintings added volume. On the faces of old people in his paintings, you feel as though you can see the layers of life beneath the skin's surface (like the strata of ancient rock formations).

Jan van Eyck hid his brushstrokes; Rembrandt flaunted his with bold flourishes. You can feel the delight he took in sweeping his brush across the canvas. This technique gives his paintings personality — which was revolutionary in art at the time.

Does the Guy Need Glasses? Monet and Impressionism

Claude Monet worked *en plein air* (outside) and captured atmospheric effects and color differences in light. He did this by dabbing spots of color on his canvases that blend when viewed from a distance. But because they're still dabs of color, they create a shimmering effect — like sunlight sparkling on water.

Monet studied the way light scatters, or the way a woman's blue dress tints the things around it with a soft blue light. Instead of a face or dress, Monet painted the patches of color and light that make up the face or dress. As he worked, the color patches grew into larger clumps of color, forming a hand, someone's hat, or the flickering water of a lily pond. The end product was a freer looking painting. People and objects appear sketchy as if they don't quite fit into their forms. In some paintings, the figures seem to be on the verge of dissolving into the landscape (see Monet's *Springtime* in the color section).

Pinpointing Seurat's Style

Georges-Pierre Seurat painted light shattering on objects, like broken pieces of glass — in a stylized way. Instead of painting patches of color (like Monet), Seurat painted particles — dots. Today, people might say he "digitized" his

images, made paintings from thousands of colored pixels. Artist historians call his unique style *Pointillism*. Seurat preferred the term *divisionism*.

Why go through the hassle of making a large picture out of tiny dots? Seurat studied the science of color and applied it to his work. He knew that side-by-side hues colorize each other. A red napkin lying on a yellow tablecloth throws some of its redness on the tablecloth. Similarly, some of the yellow splashes onto the red napkin.

Seurat learned something less obvious, too: Interacting colors don't merely cast color shadows on each other. Each color also throws off another, unexpected color, its complement from the opposite side of the wheel. So the red napkin casts not only a red shadow, but also a green one (green is the complement of red). The yellow tablecloth projects a hint of its complement, purple. So you see traces of yellow and purple on the red napkin, and splashes of red and green on the yellow tablecloth! Seurat mingled his dots to emphasize these effects and make the colors he used seem more vibrant in the viewer's eye. But the effect didn't quite work because his dots are spaced too far apart to cast color shadows on each other (see Seurat's *The Circus* in Chapter 20). But the effect they did produce is still almost magical.

The Frenzied Brush: Van Gogh

The forms in Vincent van Gogh's paintings don't blur into each other as in Monet paintings, yet a single, pervasive energy connects them, blending them "behind the scenes."

Van Gogh believed in a universal life force, and that's what he painted in a variety of manifestations. Sometimes he seems to be chasing this energy with his brush. Other times he captures it with thick, whirling brushstrokes or with quick slaps of color that look like painted rain (see *The Sower* in the color section). His paintings have an apocalyptic feel; forms seem on the verge of breaking down and merging into a turbulent sea of pure energy. Van Gogh accomplished this with his dynamic brushstrokes and with explosive, dazzling colors that at the same time are rustic (see Chapter 20).

Paint It Blue: Picasso

Pablo Picasso may be the most experimental artist of all time. He never settled on a style for long. He passed through styles like fashions or phases. He grew through a Blue Period — when everything he touched turned blue — a

Rose Period, a Cubist phase, and on and on. Picasso never let himself sink into sameness. He never stopped growing.

But behind all the change runs a solitary thread: reduction. Picasso reduced everything to its simplest underlying forms. He often stripped away beauty, flesh and limbs, sometimes moving closer to pure geometry. He might paint 14 versions of a bull. The first one looks like a bull you wouldn't want to tangle with; the last one like something you could hang your coat on. Yet the reduction still has the essential geometric ingredients of a Spanish *toro*.

Picasso could draw well, and he enjoyed mixing that skill with spirited brushwork. Even in some of his early works, he let paint drip on the canvas as if the brush and paint had lives of their own. He was the flashy bad boy of painting technique who drew outside the lines and scrawled his signature on the table when the teacher *was* looking. He toyed with the rules to see what he could tease out of them and use to shape his next style.

Painting Musical Colors: Kandinsky

Wassily Kandinsky didn't just paint *outside* the lines, he *eliminated* the lines, turning his back on form to focus on color. He believed that pure color — especially the color blue — was a springboard for spiritual awakening. Kandinsky felt that by freeing color from form, he could free man from his obsession with material things. Form was just the first "material" thing to toss out the window — the rest would follow, or so he imagined. Like his Russian friend Kazimir Malevich, Kandinsky was one of the first completely abstract painters, a pioneer who liberated painting from form.

Kandinsky used broad swathes of color, often smudging the edges where colors meet and harmonize. He replaced realistic form with geometric shapes. Without real-world forms to bottle up color and keep things separate or compartmentalized, his shapes could freely interact with and influence each other.

Paint-Throwing Pollock

Jackson Pollock liked to throw paint — at his canvases. He didn't need a brush — though he often used one, but the bristles almost never touched his painting. Instead, he let paint drip off the tip, or he used the brush to flick and fling paint. Afterward, he would slash and swirl the paint puddles with a stick. His best efforts look like confetti frozen in flight or firework finales (see

Temple of Hera (Paestum), `www.utexas.edu/courses/cc302k/Greece/Greece_images/0001110213.jpg`

Temple of Portunus, `www.eternalchaos.com/Rome/Portunus.jpg`

The Temptation of St. Anthony, Matthias Grünewald, `www.abcgallery.com/G/grunewald/grunewald23.html`

The Third Class Carriage, Honoré Daumier, `www.abcgallery.com/D/daumier/daumier82.html`

The 30-Day Fax Painting, Friedensreich Hundertwasser, `www.artchive.com/artchive/H/hundertwasser/hundertwasser_fax.jpg.html`

Thomas Jefferson, Jean-Antoine Houdon, `www.wga.hu`

The Tribute Money, Masaccio, `www.abcgallery.com/M/masaccio/masaccio7.html`

Triumph of Death, Pieter Bruegel the Elder, `www.wga.hu`

Three Goddesses, `http://daphne.palomar.edu/mhudelson/WorksofArt/05Greek/0114.jpg`

The Tub, Edgar Degas, `http://cgfa.sunsite.dk/degas/p-degas27.htm`

The Two Fridas, Frida Kahlo, `www.weta.org/images/press/Frida%20Kahlo/2fridas.jpg`

Untitled (1969), Donald Judd, `http://hirshhorn.si.edu/collection/search.asp?Artist=Judd+Donald&hasImage=1`

Untitled #205, Cindy Sherman, `www.broadartfoundation.org/collection/sherman.html`

Untitled (Forest), Hans (Jean) Arp, `http://z.about.com/d/arthistory/1/7/J/N/dada_zurich_01.jpg`

Untitled (Violet, Black, Orange, Yellow on White and Red), Mark Rothko, `www.guggenheimcollection.org/site/artist_works_138_0.html`

Vertumnus and Pomona, Camille Claudel, `www.mujerpalabra.net/conoce_a/images/camille_cacountala.jpg`

Pollock's *Untitled* in Chapter 23). Other works remind me of spilled boxes of thread. All his paintings prophetically predicted the wildness and randomness of the 1960s. (Pollock died in a car crash in 1956, the year Elvis Presley released "Hound Dog.")

Pollock's art — Abstract Expressionism — was not only about *what* he painted, but *how* he painted. Instead of mixing colors on a palette, he mixed paint on his canvases. The act of painting became a critical part of his art (a precursor of performance art). The finished paintings mirror his movements and energy as he whirled and dashed around his canvases, spilling, dripping, splattering, and swirling paint. His whole-body approach is called *action painting.* (Today we might dub it "aerobic painting!") The brush or stick, the flying paint, and his body merge into a single unit — an extended paintbrush.

To Pollock, messiness mattered. He wanted the loose, paint-splattered-all-over-his-pants look on his canvases. But it was a carefully composed messiness that he called "harmony."

Squeegee Painting and Richter

Gerhard Richter, the only artist on this list who's still alive, started out painting from photographs. He wasn't the first to do that: 1960s Photorealists used photos in place of models. (Actually, there's more to Photorealism than that — see Chapter 24.) But Richter wasn't content to just copy photos. He viewed the photograph as a neutral background he could build on. He didn't want to base his painting on the subject of the photo. For Richter, the real subject was the paint, the application of paint in all its fuzzy, squishy, thick, and thin possibilities.

During the late 1960s, Richter more or less abandoned color, painting a series of gray works that explore the textures of paint and the emotions and ideas that different textures evoke. Since then, he's gone back to color. Sometimes he starts with a photo, and sometimes the background image is unrecognizable — just thick layers of paint.

Richter often uses a squeegee as a paintbrush. This gives many of his paintings an oil-slick look. If you've never seen one, picture a few cans of paint thrown on a windshield and smeared with the wipers. Of course, there's more to it than that. The smear is Richter's favorite "brushstroke."

His second favorite brushstroke is the smudge. Richter doesn't just smear and smudge a painting once. He paints layer upon layer of smears and smudges. You can think of each layer as a civilization that's dying as he

paints it. When he's finished, the artwork has transformed into an archeological site of layered civilizations. The viewer's job: Excavate the painting.

Also, Richter's paintings chronicle their own creation. Although he's constantly improving the work, his revisions don't replace his flaws — they exist with them. Nothing disappears completely. It's kind of like shooting a documentary of a movie as it's being made. You include the raw footage, the burps and bumps, the cuts and retakes. It's part of the history of the film, the underlying reality.

Appendix

Online Resources

•••

*T*he Web Gallery of Art (www.wga.hu) includes the work for most famous artists from about 1100 to 1850. The site offers high-resolution images, and you have the option of blowing them up to 200 percent, which enables you to see detail quite well.

You can find images of many artists from Giotto onwards at Olga's Gallery (www.abcgallery.com). One of the things I like about this site is that it features lots of works by each artist and presents the works chronologically. However, not every artist discussed in this book is included in the gallery.

A site that has every artist you can think of (though not all their work) is Artcyclopedia (www.artcyclopedia.com). At this site, you can search by artist or artwork.

The Abduction of Rebecca (1846), Eugène Delacroix, www.abcgallery.com/D/delacroix/delacroix52.html

Abstract Painting (750-1), Gerhard Richter, www.clevelandart.org (**Note:** Click on "Collections," then "By Artist.")

Adam and Eve, Giuseppe Arcimboldo, www.abcgallery.com/A/arcimboldo/arcimboldo15.html

Adam and Eve Under the Tree of Knowledge, Ernst Fuchs, www.ernstfuchs-zentrum.com/c17e.html

Adele Bloch-Bauer I, Gustav Klimt, www.artchive.com/artchive/K/klimt/klimt_bloch-bauer1.jpg.html

Agnew Clinic, Thomas Eakins, www.the-athenaeum.org/art/display_image.php?id=20785

Akhenaten (potbellied statue), http://metamedia.stanford.edu/imagebin/akhenaten,%20bodily%20features.jpg

Akkadian Ruler, http://home.psu.ac.th/~punya.t/Meso/M5.jpg

Alhambra Muqarnas, www.baynardscastle.com/seville/200-164.jpg

The Apostle (from St. Sernin Cathedral), www.artlex.com/ArtLex/r/images/romanes_sernin.apostl.lg.gif

Argument in Limoges Market Place, Kenneth Bates, www.clevelandart.org (*Note:* Click on "Collections," then "By Artist.")

At the Inn of Mother Anthony, Pierre-Auguste Renoir, www.abcgallery.com/R/renoir/renoir4.html

At the Moulin Rouge, Henri Toulouse-Lautrec, www.artic.edu/artaccess/AA_Impressionist/pages/IMP_11_lg.shtml

AT&T Headquarters Building, Philip Johnson, www.bluffton.edu/~sullivanm/johnsonburgee/att.html

Aurora, Guercino, www.wga.hu (*Note:* See page 1.)

Avicenna, Frank Stella, www.artfacts.net/exhibpics/14797.jpg

Banner of Las Navas de Tolosa, www.legadoandalusi.com/legado/contenido/rutas/1024/HIB18361.jpg

The Bathers, Pierre-Auguste Renoir, www.impressionism.ru/images/Renoir/bathers.jpg

Beata Beatrix, Dante Gabriel Rossetti, www.abcgallery.com/R/rossetti/rossetti26.html

Berlin Wall, Henri Cartier-Bresson, www.angeltowns2.net/litterae/fotografia/cartier_bresson_berlin_wall.jpg

The Biglin Brothers Racing, Thomas Eakins, http://eakins0001.tripod.com/Eakins_The_Biglin_Brothers_Racing.jpg

Bird-Headed Man with Bison and Rhinoceros, www.tronchin.com/Art1A/lecture2_files/image012.jpg

The Birth of Venus, Sandro Botticelli, www.virtualuffizi.com/uffizi/img/878.jpg (*Note:* For an enlarged version, go to www.wga.hu, and look under Botticelli, allegoric paintings,1480s.)

The Blinding of Polyphemus and Gorgons (Oriental vase), www.utexas.edu/courses/introtogreece/lect10/img8polyphvse.html

The Blinding of Samson, Rembrandt, www.wga.hu (***Note:*** See "Biblical paintings," page 1.)

Blindman's Bluff, Jean-Honoré Fragonard, www.nga.gov/cgi-bin/pimage?45832+0+0

The Bodmar Oak, Fontainebleau, Claude Monet, www.artchive.com/artchive/m/monet/bodmer_oak.jpg

Book of Kells, St. Matthew page, www.snake.net/people/paul/kells/image/kells2

Bride of the Wind, Oskar Kokoschka, http://cgfa.sunsite.dk/k/p-kokoschka.htm

Broadway Boogie Woogie, Piet Mondrian, www.ibiblio.org/wm/paint/auth/mondrian/broadway.jpg

The Card Players, Fernand Léger, www.math.dartmouth.edu or www.abstractmodern.com

Carnac Menhir Alignment, www.loccarnac.info/index_fichiers/carnac%20menhirs.jpg

Catacomb of Sts. Pietro and Marcellino (Rome), www.saranae.com/Image/catacomb_pietro_m.jpg

Çatalhöyük, www.geocities.com/resats/Pictures/catalhoyuk.jpg

Chartres Cathedral, Jean-Baptiste-Camille Corot, www.abcgallery.com/C/corot/corot9.html

Chasing Butterflies, Berthe Morisot, www.abcgallery.com/M/morisot/morisot8.html

Chestnut Hill House, Robert Venturi, www.cultuurnetwerk.org/bronnen bundels/1992/h1992_57.jpg

Christ Before Pilate, Ernst Fuchs, www.ernstfuchs-zentrum.com/a9e.html

Christ in the House of His Parents, John Everett Millais, www.abcgallery.com/M/millais/millais19.html

Christ's Entry into Brussels in 1889, James Ensor, `www.paletaworld.org/Results.asp` (***Note:*** Click on "by work" and then type in the title.)

Colosseum, Rome, `www.artchive.com/artchive/r/roman/roman_colosseum.jpg`

Combat of the Giaour and the Pasha, Eugène Delacroix, `www.wga.hu` (***Note:*** See "Paintings between 1831–1839.")

Composition with Large Blue Plane, Red, Black, Yellow, and Gray, Piet Mondrian, `www.artchive.com/artchive/M/mondrian/mondrian_blue_plane.jpg.html`

Construction through a Plane, Naum Gabo, `www.nationalgalleries.org/collections/media/2/GMA_4405.jpg`

Constructivist Head No. 1, Naum Gabo, `www.staedelmuseum.de/index.php?id=400`

Contrast of Forms, Fernand Léger, `www.guggenheimcollection.org/site/artist_work_lg_87_2.html`

Corpus Christi in Bruges, Erich Heckel, `www.paletaworld.org/Results.asp` (***Note:*** Click on "by work" and then type in the title.)

Cupid a Captive, François Boucher, `www.wallacecollection.org` (***Note:*** Click on "The Collection," and then search for "Cupid a Captive.")

Cupid and Psyche (a.k.a. *Amor and Psyche*), Antoine Canova, `www.wga.hu` (***Note:*** See "Sculptures until 1799.")

Dance at Bougival, Pierre-Auguste Renoir, `www.abcgallery.com/R/renoir/renoir.html`

David, Gian Lorenzo Bernini, `www.galleriaborghese.it/borghese/en/edavid.htm`

David and Bathsheba, Ernst Fuchs, `www.ernstfuchs-zentrum.com/d5e.html`

Dead Christ, Andrea Mantegna, `www.wga.hu` (***Note:*** See "Paintings after 1471.")

Death of Sardanapalus, Eugène Delacroix, `www.abcgallery.com/D/delacroix/delacroix39.html`

Dinner Party, Judy Chicago, www.judychicago.com (**Note:** Click on "Gallery.")

Dionysius, Barnett Newman, www.nga.gov/cgi-bin/pinfo?Object=69321+0+none

Dipylon Krater (Geometric Period), www.accd.edu/sac/vat/arthistory/arts1303/Greek17.jpg

Diskobolus (Discus Thrower), Roman copy after a bronze original by Myron, www.aeria.phil.uni-erlangen.de/photo_html/plastik/maennlich/bewegt/diskobol/diskobol.html

The Drinkers (a.k.a. *The Triumph of Bacchus*), Diego Velázquez, www.abcgallery.com/V/velazquez/velazquez17.html (**Note:** See "Paintings between 1621 and 1630.")

Duomo (Florence Cathedral), Filippo Brunelleschi, http://ddlecs1.free.fr/Images/site%20italie/duomo%20florence.JPG

Durham Cathedral (exterior), http://vrcoll.fa.pitt.edu/medart/image/England/durham/Cathedral/Exerior/Durham-cath-ext-088-s.jpg

Durham Cathedral (interior), http://vrcoll.fa.pitt.edu/medart/image/England/durham/Cathedral/Interior/durham-interior.html

The Dying Trumpeter, http://academics.uww.edu/wota/Imagebank/054.jpg

The Ecstasy of St. Francis, Francisco de Zurbarán, www.abcgallery.com/Z/zurbaran/zurbaran9.html

"Etude de chêne," Gustave Le Gray, http://expositions.bnf.fr/legray/grand/048.htm

Farnese Gallery, Annibale Carracci, www.wga.hu (**Note:** See "Ceiling frescoes in the Palazzo Farnese, Rome.")

Feast of the Gods, Giovanni Bellini, www.wga.hu (**Note:** See "Paintings after 1509.")

Fifth Seal of the Apocalypse, El Greco, www.abcgallery.com/E/elgreco/elgreco62.html

The Flight into Egypt, Giotto, www.wga.hu (***Note:*** See "Frescoes in Arena Chapel, Scenes from the Life of Christ: No.1–5.")

Foot and Hand, Roy Lichtenstein, www.andipamodern.com (***Note:*** Click on Lichtenstein and scroll down.)

"Fort Peck Dam," Margaret Bourke-White, www.gallerym.com/work.cfm?ID=90 (***Note:*** Click on "Photographers," and then "Bourke-White.")

"Gandhi," Henri Cartier-Bresson, http://todayspictures.slate.com/20070131/

Gargantua, Honoré Daumier, www.abcgallery.com/D/daumier/daumier88.html

Ghent Altarpiece, Jan van Eyck, www.wga.hu (***Note:*** See "The Ghent Altarpiece.")

Gotham News, Willem de Kooning, www.albrightknox.org/ArtStart/Kooning.html

Hagia Sophia (exterior), www.princeton.edu/~asce/const_95const.html

Hammurabi's Stele (Code of Laws), http://employees.oneonta.edu/farberas/arth/Images/ARTH200/politics/hammurabi.jpg

Hatshepsut Funerary Temple, Luxor, www.2travel2egypt.com/sightseeing/images/hatshepsut.jpg

Hatshepsut Sphinx, www.metmuseum.org (***Note:*** Search for "Hatshepsut Sphinx.")

Holy Family with Mary Magdalen, El Greco, www.abcgallery.com/E/elgreco/elgreco73.html

Horse Dreaming, Franz Marc, http://cgfa.sunsite.dk/marc/p-marc7.htm

Houses at L'Estaque, Georges Braque, www.artchive.com/artchive/B/braque/housesle.jpg.html

The Hunters in the Snow, Pieter Bruegel, www.abcgallery.com/B/bruegel/bruegel79.html

Impression — Sunrise, Claude Monet, www.abcgallery.com/M/monet/
monet36.html

The Isenheim Altarpiece, Matthias Grünewald, www.wga.hu (Note: See "First
view of the Isenheim Altarpiece," and then *The Crucifixion.*)

Ishtar Gate, www.smb.spk-berlin.de/vam/vg/img/vamblg.jpg

James, Chuck Close, www.barbarakrakowgallery.com/contentmgr/
showdetails.php/id/3306

Joseph the Carpenter (a.k.a. *Christ in the Carpenter's Shop),* Georges de La
Tour, www.wga.hu (***Note:*** See "Paintings (Page 2).")

Joseph's Bloody Coat Brought to Jacob, Diego Velázquez, www.abcgallery.
com/V/velazquez/velazquez17.html

Just What Is It That Makes Today's Home So Different, So Appealing?, Richard
Hamilton, www.georgetown.edu/faculty/irvinem/CCTP738/
hamilton-home-appealing-2.jpg

Justinian mosaic (San Vitale, Ravenna), http://traumwerk.stanford.
edu/philolog/Justinian.jpg

Kaisersaal in Würzburg, Germany, Balthasar Neumann, www.artres.com
(***Note:*** Search for "Kaisersaal.")

The Kiss, Auguste Rodin, www.artchive.com/artchive/R/rodin/kiss.
jpg.html

Knidian Aphrodite, copy after an original by Praxiteles, www.livius.org/
a/1/greece/praxiteles_aphrodite_cnidus.jpg

Koran Cover, www.asia.si.edu/exhibitions/online/islamic/
images/F1930.55.450.jpg

Kouros, www.fll.vt.edu/Classics/NaxianKouros.jpg

La Strada Entra Nella Casa (The Street Enters the House), Umberto Boccioni,
www.sprengel-museum.de/v1/englisch/02munds/boccioni/ub_a.jpg

Lady and the Unicorn Tapestries, "Touch," www.musee-moyenage.fr/ang/
pages/page_id18368_u112.htm

Lady Governors of the Old Men's Home at Haarlem (a.k.a. *Regentesses of the Old Men's Almshouse*), Frans Hals, www.wga.hu (***Note:*** See "Paintings after 1658.")

Lady Sarah Bunbury Sacrificing to the Graces, Sir Joshua Reynolds, www.abcgallery.com/R/reynolds/reynolds236.html

Lamassus, Citadel of Sargon II, www.sandrashaw.com/images/AH1L05Lamassu2.jpg

Landscape Near Martigues, Maurice de Vlaminck, www.tate.org.uk (***Note:*** Search on the artist's name.)

The Last Supper, Andrea del Castagno, www.abcgallery.com/C/castagno/castagno6.html

Laurentian Library, Michelangelo, www.abcgallery.com/M/michelangelo/michelangelo66.html

The Lawyer, Giuseppe Arcimboldo, www.abcgallery.com/A/arcimboldo/arcimboldo10.html

The Librarian, Giuseppe Arcimboldo, www.abcgallery.com/A/arcimboldo/arcimboldo9.html

The Lion Hunt, Eugène Delacroix, www.abcgallery.com/D/delacroix/delacroix41.html

The Little Blue Horses, Franz Marc, http://cgfa.sunsite.dk/marc/p-marc9.htm

The Liver Is the Cock's Comb, Arshile Gorky, www.albrightknox.org/Akcart/images/Gorky.jpg

Love in the Italian Theater (a.k.a. *The Italian Theater*), Jean-Antoine Watteau, www.wga.hu (***Note:*** See "Paintings, page 1.")

Lovers in a Park, François Boucher, www.timkenmuseum.org/1-french-boucher.html

Lucretia, Artemisia Gentileschi, www.artemisia-gentileschi.com/lucretia.html

Luncheon on the Grass (a.k.a. *Le Déjeuner sur l'Herbe*), Édouard Manet, www.abcgallery.com/M/manet/manet6.html

The Lute Player, Caravaggio, www.abcgallery.com/C/caravaggio/
caravaggio14.html

The Lute Player, Orazio Gentileschi, www.wga.hu

Madonna Enthroned (a.k.a. *Madonna in Majesty*), Cimabue, www.wga.hu
(*Note:* See "Paintings of the Madonna.")

Madonna with Child (a.k.a. *Madonna*), Orazio Gentileschi, www.wga.hu

Madonna with a Goldfinch, Raphael, www.abcgallery.com/R/raphael/
raphael22.html

Madonna of the Rose Garlands (a.k.a. *Feast of the Rose Garlands*), Albrecht
Dürer, www.wga.hu (*Note:* See "Second Italian journey; paintings 1505-1506.")

The Martyrdom of St. Bartholomew, Jusepe de Ribera, www.nga.gov/
cgi-bin/pimage?70829+0+0

Menkaure and his Wife (Egyptian Pharaoh and his Queen), www.artchive.
com/ftp_site.htm (*Note:* Look under "Ancient Art," and click on
"Egyptian," and then "Fourth Dynasty King Menkaure and a Queen.")

"Mexico," Henri Cartier-Bresson, www.soulcatcherstudio.com/
exhibitions/bresson/index.htm

Mr. and Mrs. Andrews, Thomas Gainsborough, www.wga.hu

Monk by the Sea, Caspar David Friedrich, www.wga.hu/index1.html
(*Note:* Go to Caspar David Friedrich and then "Paintings before 1811.")

Morning: Dance of the Nymphs, Jean-Baptiste-Camille Corot, www.
abcgallery.com/C/corot/corot51.html

Mosque of Mutawakkil (Samarra, Iraq), www.arthistory.upenn.edu/
smr04/101910/Slide10.9.jpg

Mountains at Collioure, André Derain, www.rosings.com/derain.jpg

The Musicians, Caravaggio, www.abcgallery.com/C/caravaggio/
caravaggio13.html

My Dress Hangs There, Frida Kahlo, www.abcgallery.com/K/kahlo/
kahlo32.html

Nefertiti Bust, http://lexicorient.com/e.o/ill/nefertiti.jpg

The Nightmare, Henry Fuseli, `http://cgfa.sunsite.dk/f/p-fuseli4.htm`

The Nude Maja, Francisco Goya, `www.abcgallery.com/G/goya/goya52.html`

Oath of the Horatii, Jacques-Louis David, `www.wga.hu` (**Note:** See "Paintings between 1784 and 1792.")

Octopus Vase (Minoan), `www.shc.ed.ac.uk/images/octopushlinks.jpg`

The Orgy, William Hogarth, `www.wga.hu`

Palazzo Te, Giulio Romano, `www.wga.hu` (**Note:** Look under "Giulio Romano" not "Romano.")

"Pepper No.30," Edward Weston, `www.masters-of-photography.com`

Pietà, Michelangelo, `www.wga.hu` (**Note:** Look under "Sculptures," then "Representations of the Pietà.")

Pietà Rondanini, Michelangelo, `www.wga.hu` (**Note:** Look under "Sculptures," then "Representations of the Pietà.")

Pont du Gard, Nimes, `http://oak.cats.ohiou.edu/~uhalde/353A/Aqueduct_PontDuGard_Nimes.jpg`

Portrait of Ambroise Vollard, Pablo Picasso, `www.abcgallery.com/P/picasso/picasso190.html`

Portrait of Mrs. Currey: Sketch of Mr. Cassatt, Mary Cassatt, `www.garyhendershott.com/marycassatt-currycassatt.html`

The Potato Eaters, Vincent van Gogh, `www.abcgallery.com/V/vangogh/vangogh8.html`

Proun 99, El Lissitzky, `www.ibiblio.org/eldritch/el/pix/pn99.jpg`

Pyramids of Giza, `www.shunya.net/Pictures/Egypt/Memphis/PyramidsGiza1.jpg`

Raising of the Cross, Peter Paul Rubens, `www.wga.hu` (**Note:** See "Altarpieces in Antwerp Cathedral.")

Rameses Temple at Abu Simbel, `www.utexas.edu/courses/classicalarch/images1/AbuRamIID19.jpg`

Reclining Couple Sarcophagus, Cerveteri (Etruscan), `www.lanecc.edu/ artad/ArtHistoryProgram/images3/9-4.jpg`

Red Cross Train Passing a Village, Gino Severini, `http://siteimages. guggenheim.org/gpc_work_large_142.jpg`

Red Square: Painterly Realism of a Peasant Woman in Two Dimensions, Kazimir Malevich, `www.ibiblio.org/wm/paint/auth/malevich/sup/ malevich.peasant-woman.jpg`

The Road from Chailly, Fontainebleau, Claude Monet, `www.artofmonet.com/ images/Large/56_Rd_to_Chailly.JPG`

"Road of Chailly, Fontainebleau," Gustave Le Gray, `www.getty.edu/art/ gettyguide/artObjectDetails?artobj=68430`

The Rocky Mountains, Lander's Peak, Albert Bierstadt, `www.the-athenaeum. org/art/display_image.php?id=22694`

Room of the Giants (a.k.a. *The Fall of the Giants*), Giulio Romano, `www.wga.hu` (***Note:*** Look under "Giulio Romano" not "Romano.")

Rosetta Stone, `www.uh.edu/engines/rosettacasting.jpg`

St. Bartholomew with Flayed Skin in *The Last Judgment,* Michelangelo, `www. abcgallery.com/M/michelangelo/michelangelo55.html`

St. George and the Dragon, Peter Paul Rubens, `www.wga.hu` (***Note:*** See "Paintings before 1616.")

St. George and the Dragon, Tintoretto, `www.nationalgallery.org.uk` (***Note:*** Search for "Tintoretto.")

St. Jerome, Jusepe de Ribera, `www.wga.hu` (***Note:*** See "Paintings up to 1636.")

St. Mark's Basilica (Venice, Italy), exterior, `www.chato.cl/2004/viajes/ 7/San_Marco.jpg`

St. Mark's Basilica (Venice, Italy), interior, `http://cache.eb.com/eb/ image?id=20210`

St. Peter's Baldacchino, by Gian Lorenzo Bernini, `www.stpetersbasilica. org/Altars/PapalAltar/Baldacchino-fw.jpg`

St. Peter's Colonnade, the Vatican, Gian Lorenzo Bernini, `www.ruf.rice.edu/`
`~fellows/hart206/images/bernini_piazza.jpg`

St. Sernin, Toulouse, `www.bc.edu/bc_org/avp/cas/fnart/arch/`
`romanesque/toulouse/sernin03.jpg`

"Salute of Innocence," Dorothea Lange, `www.loc.gov/exhibits/wcf/`
`wcf0013.html`

San Giorgio Maggiore, Andrea Palladio, `www.nd.edu/~tschlere/visam/`
`visart_history/images/palladio.jpg`

San Lorenzo, Filippo Brunelleschi, `http://cv.uoc.es/~991_04_005_01_`
`web/fitxer/sanlorenzo.gif`

Savage Tales (a.k.a. *Barbarous Tales*), Paul Gauguin, `www.abcgallery.com/`
`G/gauguin/gauguin81.html`

Savoy House (a.k.a. Villa Savoye), Le Corbusier, `www.bc.edu/bc_org/avp/`
`cas/fnart/Corbu.html`

Scene from New Comedy, (Pompeii Mosaic), `http://sights.seindal.dk/`
`photo/9306,s1090f.html`

Seagram Building, from the series *Urban Landscapes 1,* Richard Estes, `www.`
`famsf.org` (***Note:*** Click on "My Gallery," then "Artists.")

Self-Portrait in a Convex Mirror, Parmigianino, `www.wga.hu`

Self-Portrait Pulling Cheek, Egon Schiele, `www.artchive.com/artchive/`
`S/schiele/schiele_cheek.jpg.html`

Senusret III, `http://nefertiti.iwebland.com/portraiture/12d/`
`senusret_iii_12d-met.jpg`

Shop Block Bauhaus Building (Dessau, Germany), Walter Gropius, `http://`
`you-are-here.com/europe/bauhaus_dessau.jpg`

Siena Cathedral (exterior), `www.lasocietaitaliana.org/bfv/`
`CathedralinSiena.JPG`

Siena Cathedral (interior), `http://opensg.vrsource.org/trac/wiki/`
`Gallery/Siena`

Sistine Chapel Ceiling, Michelangelo, www.wga.hu (***Note:*** Look under "Frescoes in the Sistine Chapel," then "The ceiling.")

Skara Brae, www.longpassages.org/images/Scotland_Skara_Brae_house.jpg

The Slave Ship, J. M. W. Turner, www.ibiblio.org/wm/paint/auth/turner/i/slave-ship.jpg

The Sleep of Reason Produces Monsters, Francisco Goya, www.abcgallery.com/G/goya/goya135.html

The Sower, Jean Francois Millet, www.mfa.org (Note: Click on "Collections," then "Collection Search," and search for *The Sower.*)

Sphinx, http://guardians.net/egypt/sphinx/images/sphinx-southeast-2001.jpg

Spiral Jetty, Robert Smithson, www.robertsmithson.com (***Note:*** Click on "Earthworks.")

"Spring Shower," Alfred Stieglitz, www.eastman.org/fm/stieglitz/htmlsrc/index.html

Statuettes from Abu Temple, www.lanecc.edu/artad/ArtHistory Program/2-5AbuStatu.htm

Step Pyramid, www.meekwanzaakit.com/Step%20Pyramid.jpg

Still Life with Chair Caning, Pablo Picasso, www.abcgallery.com/P/picasso/picasso78.html

Stonehenge, www.mythicalireland.com/ancientsites/stonehenge/stonehenge-xmw-1152.jpg

Summer Night, Winslow Homer, www.the-athenaeum.org/art/display_image.php?id=1404

Taj Mahal, www.xtec.es/~aguiu1/calaix/070tajmahal.htm

Tatlin's Tower, Vladimir Tatlin, www.stenderdesign.com/Images/WTC/tatlin-tower.jpg

The Tempest, Giorgioni, www.wga.hu

Vespasian (9th Roman Emperor), www.utexas.edu/courses/romanciv/
Romancivimages16/vespasian.jpg

Virgin of Vladimir, www.rollins.edu/Foreign_Lang/Russian/vlad.jpg

The Vision After the Sermon (Jacob Wrestling with the Angel), Paul Gauguin,
www.the-athenaeum.org/art/display_image.php?id=5100

Vitra Fire Station, Zaha Hadid, http://image.blog.livedoor.jp/
modernarchitecture/imgs/5/5/552e14aa.jpg

The Wanderer Above the Mists (a.k.a. *The Wanderer Above the Sea of Fog*),
Caspar David Friedrich, www.artchive.com/artchive/F/friedrich/
sea_of_fog.jpg.html

The Wedding Dance, **Pieter Bruegel the Elder,** www.dia.org (***Note:*** Click on
"Collection" and search for *Wedding Dance*.)

Wexner Center, Peter Eisenmann, www.bluffton.edu/~sullivanm/ohio/
columbus/wexner/eisenman.html

What the Water Gave Me, **Frida Kahlo,** www.abcgallery.com/K/kahlo/
kahlo38.html

"Winter Sunrise from Lone Pine," Ansel Adams, www.masters-of-
photography.com (***Note:*** Click on "Ansel Adams.")

Woman I, **Willem de Kooning,** www.moma.org (***Note:*** Click on "Collections,"
then "Artists," and then "Kooning.")

Woman of Willendorf, http://witcombe.sbc.edu/willendorf/images/
willendorf-large.jpg

The Yellow Cow, **Franz Marc,** http://hs.riverdale.k12.or.us/
~dthompso/art/marc/gallery

Young Man with a Skull (Vanitas), **Frans Hals,** www.abcgallery.com/H/hals/
hals29.html

Ziggurat of King Urnammu of Ur, www.eyeconart.net/history/ancient/
mesop/ziggurat.jpg

Index

• Numerics •

The 30-Day Fax Painting (Hundertwasser), 345, 412

• A •

Abbey Church of St. Denis, 137–139, 141
The Abduction of Rebecca (Delacroix), 247, 399
Abraham, 43–44
Abstract Expressionism movement, 13, 31, 334–337
Abstract Painting (750-1) (Richter), 375, 399
Abu Temple statuettes, 47–48, 411
academy exhibitions, 254
Accademia degli Incamminati art school, 200
action painting, 13, 336, 396
Actionen (Beuys), 350
activist art
 Critical Art Ensemble, 380
 photography, 13
Adam and Eve (Arcimboldo), 195, 399
Adam and Eve Under the Tree of Knowledge (Ernst Fuchs), 399
Adams, Ansel, 359, 413
Adamson, Robert, 355
Adele Bloch-Bauer I (Klimt), 301, 399
aerial perspective, 161
The Age of Bronze (Rodin), 282
Agnew Clinic (Eakins), 259, 399
Akhenaten (potbellied statue), 399
Akkadian art, 51
Akkadian Ruler, 51, 400
Alba, the glow-in-the-dark bunny, 380

Alhambra, 120–121
alla prima (at once) technique, 265
allegorical stories, 148
Allegory of the Triumph of Venus (Bronzino), 191–193
Amarna style, 66–67
Amiens Cathedral, 139
analogous colors, 295
Analytic Cubism movement, 306–307
ancestor worship, 92
ancient art, 9–10
Ancient Greek art period
 Archaic period, 24, 75–76
 architecture, 83–85
 Classical period, 24, 76–78
 politics, 16, 24
 sculpture, 75–81
 vase painting, 81–83
Aphrodite (Praxiteles), 80–81
The Apostle (from St. Sernin Cathedral), 134, 400
aqueducts, 98, 408
Archer, Frederick Scott, 354
architecture
 Ancient Egypt, 61–63
 Ancient Greek, 16, 83–85
 Art Nouveau, 286–288
 Baroque, 11, 204–206, 214
 Byzantine, 109–110
 Constructivism, 316–317
 deconstruction, 369–372
 Etruscan, 89–90
 Fantastic Realism, 344–345
 Gothic, 136–140
 Islamic, 118–121
 Italian Gothic, 143

architecture *(continued)*
 Mannerism, 197–198
 megaliths, 40–41
 menhirs, 41
 Middle Ages, 10–11
 Modernist, 330–334
 New Stone Age, 40–42
 post-and-lintel system, 40–41
 Postmodern, 366–372
 Renaissance, 153, 179–180
 Rococo, 219–220
 Roman, 17, 98–101
 Romanesque, 130–133
 Sumer, 45
 ziggurats, 45–46
Arcimboldo, Giuseppe, 194–195, 399, 406
Arena Chapel fresco series (Giotto), 147
Argument in Limoges Market Place
 (Kenneth Bates), 400
The Arnolfini Wedding (van Eyck),
 181–182, 392
Arp, Hans, 323, 412
art movements. *See movements by name*
art museums
 British Museum, 386
 Hermitage, 385
 Kunsthistorisches Museum, 386
 Louvre, 383
 Metropolitan Museum of Art, 385
 National Gallery, 384
 Prado, 385
 Rijksmuseum, 386
 Uffizi, 384
 Vatican Museums, 384
Art Nouveau (New Art) movement, 285–288
art periods. *See periods by name*
Artcyclopedia Web site, 399
Arts and Crafts movement, 28, 262
The Assumption of the Virgin (Titian), 176
Assyrian art, 52–53

At the Ball (Morisot), 273
At the Inn of Mother Anthony (Renoir),
 269, 400
At the Moulin Rouge (Toulouse-Lautrec),
 277, 400
AT&T Headquarters Building (Johnson),
 367–368, 400
Augustus of Primaporta, 93–94
Aurora (Guercino), 200, 400
Austrian Expressionism movement,
 300–302
author, contacting, 6
automatic writing, 324
Autun Cathedral, 133
Avicenna (Stella), 347, 400

• B •

balance, 18
Ball, Hugo, 319–320
Banner of Las Navas de Tolosa, 121, 400
Barbieri, Giovanni Francesco, 200
Barbizon School, 255–256
Baroque art period
 architecture, 204–206, 214
 Catholic Church, 11, 27, 199–200
 ceiling frescoes, 200
 Counter-Reformation, 11, 27, 199–200
 painters, 200–203, 207–217
 Protestant church, 27, 207
 religious art, 16, 27, 200
 sculpture, 203–204
 themes of, 200
Basilica of Ste-Madeleine Cathedral of
 Vezelay, 133–134
Bates, Kenneth, 350–351, 400
The Bathers (Fragonard), 222
The Bathers (Renoir), 270, 400
Bauhaus, 332
Bayeux Tapestry, 20, 127–130

Beata Beatrix (Rossetti), 260, 400

Belgian style *(le style Belge)*, 286

Bellini, Gentile, 172

Bellini, Giovanni, 172–173, 392, 403

Bellini, Jacopo, 173

Benday dots, 342

Berlin Wall (Cartier-Bresson), 358–359, 400

Bernini, Gian Lorenzo, 196, 203–205, 402, 405

bestiaries, 126

Beuys, Joseph, 349–350, 352

Bierstadt, Albert, 257–258, 409

The Biglin Brothers Racing (Eakins), 259, 400

The Binders (Millet), 256

biomorphic forms, 335

biotechnology, 379–380

Bird-Headed Man with Bison and Rhinoceros cave painting, 38, 400

The Birth of Venus (Botticelli), 157–158, 400

Black Magic (Magritte), 327

"Black Paintings" of Goya, 249

Blake, William, 241–242

The Blinding of Polyphemus and Gorgons (Oriental vase), 82, 401

The Blinding of Samson (Rembrandt), 210, 401

Blindman's Bluff (Fragonard), 219, 401

Blue Dancers (Degas), 271

Blue Period (Picasso), 304, 394–395

The Blue Rider (Der Blaue Reiter) Almanac (Kandinsky and Marc), 298, 389–390

The Blue Rider (Der Blaue Reiter) movement, 29, 295, 298–300

Boccioni, Umberto, 310–311

The Bodmer Oak, Fontainebleau (Monet), 355, 401

book curses, 125

Book of Durrow, 125

Book of Kells, 125–126, 401

Books of Hours, 126

Books of Secrets, 126

Books of the Dead, 69

Bosch, Hieronymus, 184–185

Botticelli, Sandro, 18, 157–158, 400

Boucher, François
 Cupid a Captive, 222, 402
 Diana Leaving Her Bath, 219
 Hercules and Omphale, 219
 Lovers in a Park, 219, 406

The Boulevard (Severini), 312

Bourke-White, Margaret, 361–363, 404

Brady, Matthew, 356

Braque, Georges, 304, 306–308, 404

Brecht, George, 349

Breton, André, 324

Bride of the Wind (Kokoschka), 302, 401

The Bridge (Die Brücke) movement, 29, 295–298

British Museum, 386

Broadway Boogie Woogie (Mondrian), 318, 401

Bronzino, Agnolo, 191–193

Bruegel the Elder, Pieter, 186–187, 404, 412–413

Brunelleschi, Filippo, 152–154, 403, 410

brushstrokes
 action painting, 13, 336, 396
 colors, 395
 impasto, 393
 Impressionism, 12, 393
 Pointillism, 275–276, 394
 reduction, 395
 sfumato, 161, 174, 392
 smear, 396
 smudge, 396–397
 tempera, 391–392

buon fresco technique, 165

Burgee, John, 367

The Burial of Count Orgaz (El Greco), 196

Byzantine art period, 11, 25, 105–115

• C •

Cabaret Voltaire, 319–320
Calling of Saint Matthew (Caravaggio),
 20, 201–202, 210
calotype, 354
Camera Work magazine, 322, 357
Campin, Robert, 183
Canon (Polykleitos), 78
canon of proportions, 61
Canova, Antonio, 237, 402
The Caprices (Goya), 248
Caravaggio
 Calling of Saint Matthew, 20, 201–202, 210
 cellar lighting, 201
 The Lute Player, 202, 407
 The Musicians, 202, 407
The Card Players (Léger), 308–309, 401
Carnac Menhir Alignment, 401
Carolingian Renaissance, 127
Carolingian script, 127
Carracci, Annibale, 200, 403
Cartier-Bresson, Henri, 357–359, 400, 407
Casa Batlló, 287–288
Casa Milà, 287
Cassatt, Mary, 271–272, 408
Castagno, Andrea del, 155, 406
Catacomb of Sts. Pietro and Marcellino
 (Rome), 401
Çatalhöyük, 40, 401
Cathedral of Chartres, 139, 141–142
Catholic Church
 Baroque art period, 11, 27, 199–200
 Counter-Reformation, 11, 199–200
 Reformation, 199
cave paintings, 9, 35–38
ceiling frescoes, 200
cellar lighting, 201
Cennini, Cennino, 146
Cézanne, Paul, 284–285
chance, 320
Charioteer, 77–78

Chartres Cathedral (Corot), 257, 401
Chartres Cathedral, 139, 141–142
Chasing Butterflies (Morisot), 272, 401
Chestnut Hill House (Venturi), 367, 401
chiaroscuro, 162, 209
Chicago, Judy, 375–376, 403
Children of War (Someroski), 351
Christ Before Pilate (Fuchs), 343, 401
*Christ Enthroned and the Apostles in the
 Heavenly Jerusalem,* 107–108
Christ in the House of His Parents (Millais),
 261, 401
Christ Risen (Rubens), 208–209
Christianity
 Early Christian art works, 107–108
 Medieval art period, 26, 123
Christo, 376–377
Christ's Entry into Brussels in 1889 (Ensor),
 284, 402
Church of Holy Wisdom (Hagia Sophia),
 109–110
Cimabue, 144–146, 407
The Circus (Seurat), 276
classicism, 229
Claudel, Camille, 281, 283, 412
Cloisonnism, 278–279
Close, Chuck, 348–349, 405
collages, 307
Color Field movement, 345–346
colors
 analogous colors, 295
 brushstrokes, 395
 Cloisonnism, 278–279
 complementary colors, 295
 Fauvism, 292
 Pre-Raphaelite Brotherhood, 260
 Tachism, 265
Colosseum (Rome), 100–101, 402
Combat of the Giaour and the Pasha
 (Delacroix), 247, 402
Communist Manifesto (Marx), 256
complementary colors, 295

Complete Poems and Selected Letters of Michelangelo (Michelangelo), 388

Composition Number VI (Kandinsky), 299

Composition with Large Blue Plane, Red, Black, Yellow and Gray (Mondrian), 318, 402

Conceptual Art movement, 13, 32, 352

Concerning the Spiritual in Art (Kandinsky), 298–299, 389–390

Construction Through a Plane (Gabo), 318, 402

Constructivism movement, 30–31, 315–318

Constructivist Head No. 1 (Gabo), 317–318, 402

contacting the author, 6

contrapposto, 78

contrast, 19

Contrast of Forms (Léger), 402

Corot, Jean-Baptiste-Camille, 252, 257, 401, 407

Corpus Christi in Bruges (Heckel), 298, 402

Council of Trent, 177, 199–200

Counter-Reformation, 11, 27, 177, 199–200

Courbet, Gustave, 251–253, 255

Creation mosaics, 114

The Creation of Adam (Michelangelo), 160, 167

crisis of Impressionism, 269–271

Critical Art Ensemble, 380

Crusades, 134–135

Cubism movement, 13, 29–30, 303–309

Cupid a Captive (Boucher), 222, 402

Cupid and Psyche (Canova), 237, 402

● *D* ●

da Messina, Antonello, 392

da Vinci, Leonardo
 inventions, 160–161
 The Last Supper, 18, 163–165
 Mona Lisa, 20, 162–163, 392
 On Painting, 387
 sfumato, 162, 392

symbolism, 164
 techniques of, 161–162
 The Virgin of the Rocks, 161–162

Dada movement, 13, 30, 319–323

Daguerre, Louis, 354

daguerreotype, 354

Dalí, Salvador, 325–327

Dance at Bougival (Renoir), 270, 402

Dance at the Moulin de la Galette (Renoir), 269

Daumier, Honoré, 252, 254, 404, 412

David (Bernini), 203, 402

David (Donatello), 158–159

David (Michelangelo), 166, 203

David, Jacques-Louis
 The Death of Marat, 233–234
 The Oath of the Horatii, 231–232, 408

David and Bathsheba (Fuchs), 402

de Kooning, Willem, 337, 404, 413

De Stijl movement, 30–31, 318

Dead Christ (Mantegna), 173–174, 402

The Death of Casagemas and *Evocation: The Burial of Casagemas* (Picasso), 304

The Death of Marat (David), 233–234

Death of Sardanapalus (Delacroix), 245–247, 251, 402

The Decisive Moment (Cartier-Bresson), 358

deconstruction, 369–372

"A Defense of Poetry" (Shelley), 240

Degas, Edgar, 270–271, 412

Delacroix, Eugène
 The Abduction of Rebecca, 247, 399
 Combat of the Giaour and the Pasha, 247, 402
 Death of Sardanapalus, 245–247, 251, 402
 Journal, 388
 Liberty Leading the People, 17, 245–246
 The Lion Hunt, 247, 406
 The Massacre at Chios, 240

Deposition (van der Weyden), 183

Der Blaue Reiter (The Blue Rider) Almanac (Kandinsky and Marc), 389–390

Der Blaue Reiter (The Blue Rider) movement, 29, 295, 298–300

Derain, André, 293–294, 407

Derrida, Jacques, 369

Descent from the Cross (Pontormo), 190–191

design, 17–19

Diana Leaving Her Bath (Boucher), 219

didactic art, 229

Diderot, 232

Die Brücke (The Bridge) movement, 29, 295–298

The Dinner Party (Chicago), 376, 403

Dionysius (Newman), 346, 403

Dipylon Krater, 82, 403

Diskobolus (Myron), 78

Diskobolus (Roman copy), 403

divine right of kings, 16

Divisionism, 275–276, 394

documentary photography, 355–356

Domenichino, 200

Donatello, 158–159

Dormition Shroud (Uveges and the Eikona Workshop), 116–117

Doryphoros (Polykleitos), 19, 78–79

Drerup, Karl, 350

The Drinkers (The Triumph of Bacchus) (Velázquez), 403

drip technique, 336

drolleries, 126

The Drunkards (Los Borrachos) (Velázquez), 216

Ducal Palace frescoes (Mantegna), 197

Duccio, 146–147

Duchamp, Marcel, 321–322

Dulle Giet (Mad Meg) (Bruegel the Elder), 187

Duomo of Florence, 153, 403

Dürer, Albrecht, 174–175, 407

Durham Cathedral, 131–132, 403

The Dying Trumpeter, 86, 88, 403

• E •

Eakins, Thomas, 258–259, 399–400

Early Christian art works, 107–108

Early Renaissance, 151–159

earth art, 375, 377–379

Earth Herself (Kahlo), 330

Eastman, George, 354

Ecstasy of Saint Theresa (Bernini), 196, 203–204

Ecstasy of St. Francis (Zurbarán), 216, 403

Eddy, Don, 348

Egyptian art period

 Amarna style, 66–67

 architecture, 61–63

 Books of the Dead, 69

 Egyptian style, 60–61

 Great Sphinx, 63

 historical periods, 56–57

 Ka statues, 64

 mummies, 55–57, 63–64

 mummy slaves, 68

 Palette of Narmer, 57–61

 pyramid texts, 69–70

 Pyramids of Giza, 61–63, 408

 Rameses's temples, 70

 religious themes, 16, 24

 Rosetta Stone, 63

 Senusret III bust, 65

 tombs, 24, 63–68

Egyptian style, 60–61

Eikona Workshop, 116–117

Eisenman, Peter, 370

El Greco, 195–197, 403–404

Emile (Rousseau), 278

emphasis, 19

en plein air

 Expressionism, 296

 Impressionism, 263–264

 Realism, 12, 255

enameling, 350–351

End of Summer (Monet), 267

Enlightenment, 229–230

Ensor, James, 283–284

Ernst, Max, 324–325

Essay on Painting (Diderot), 232

Estes, Richard, 348, 410

Etruscan art period, 25, 89–90

"Etude de chêne (Study of Oak), Fontainebleau" (Le Gray), 355, 403

exhibitions, 254

Expressionism movement, 13, 29, 291, 295–302

Eye-Slit-House (Hundertwasser), 344

• F •

Fall of Phaeton (Rubens), 208

fall of Rome, 102

The Fall of the Rebel Angels (Bruegel), 187

Falling Water (Wright), 331

Fantastic Realism movement, 343–345

Farnese Gallery (Carracci), 200, 403

Fauvism movement, 13, 29, 291–294

The Feast in the House of Levi (Veronese), 177–178

Feast of the Gods (Bellini), 173, 403

feminist art, 32, 375

Fertile Crescent, 44

feudalism, 136

Ficino, Marcilio, 157

Fifth Seal of the Apocalypse (Vision of St. John) (El Greco), 196, 403

Fischer von Erlach, Johann Bernhard, 206

The Fishermen and Women of the Firth of Forth (Adamson and Hill), 355

Flack, Audrey, 348

The Flight into Egypt (Giotto), 148, 404

Flora fresco, 96–97

Flowers (Symphony of Colors) (Vlaminck), 294

Fluxus artists, 349–350, 352

focal point, 20

Foot and Hand (Lichtenstein), 342, 404

"Fort Peck Dam" (Bourke-White), 362, 404

Fountain, by R. Mutt (Duchamp), 322

Fra Angelico, 156

Fragonard, Jean-Honoré
 The Bathers, 222
 Blindman's Bluff, 219, 401
 The Swing, 222–223

Franco-Prussian War, 255

Frankenstein (Shelley), 240

Free International University for Creativity and Interdisciplinary Research, 350

French Revolution, 232

frescoes, 200

Friedrich, Caspar David, 243, 407, 413

From Cubism and Futurism to Suprematism (Malevich), 314

frottage, 324–325

Fuchs, Ernst, 343, 399, 401–402

Fuseli, John Henry, 242, 408

Futurism movement, 13, 30, 303, 309–312

• G •

Gabo, Naum, 315–318, 402

Gainsborough, Thomas, 224–225, 407

Galileo, 229–230

Gallé, Émile, 286

"Gandhi" (Bourke-White), 404

"Gandhi with His Nieces" (Bourke-White), 362–363

The Garden of Earthly Delights (Bosch), 184–185

Gargantua (Daumier), 252, 404

The Gates of Hell (Rodin), 282–283

Gaudí, Antoni, 287–288

Gauguin, Paul, 277–279, 410, 413

Gehry, Frank, 370–372

genre pittoresque (picturesque style), 219

Gentileschi, Artemisia, 202–203, 406

Gentileschi, Orazio, 202, 407

Gericault, Théodore, 243–245

German Expressionism movement, 13, 29, 291, 295–300

Germs of Infection (Critical Art Ensemble), 380

Ghent Altarpiece (or Adoration of the Mystic Lamb) (van Eyck), 180–181, 404

Ghiberti, Lorenzo, 152

Gilgamesh (Sumerian epic poem), 44–45, 49

Gilles and Four Other Characters from the Commedia dell'Arte (Watteau), 221

Giorgione, 174, 412

Giotto, 147–148, 152, 404

Girl with a Pearl Earring (Vermeer), 212

The Gleaners (Millet), 256

glow-in-the-dark bunny, 380

Gorky, Arshile, 334–335

Gotham News (de Kooning), 337, 404

Gothic style
 architecture, 136–140
 Greek manner, 144–148
 Italian Gothic, 143
 sculpture, 141–142
 stained-glass windows, 140–141

Goya, Francisco, 247–249, 408, 411

grattage, 324–325

The Great Odalisque (Ingres), 234–235, 245, 266

Great Sphinx, 55, 61, 63, 411

Greek manner, 144–148

Gropius, Walter, 332, 410

grotesqueries, 126

Group f/64, 359

Grünewald, Matthias, 186, 405, 412

Gsell, Paul *(Rodin on Art)*, 389

Guercino, 200, 400

Guggenheim Museum, Bilbao, 371

Guimard, Hector, 286

Gypsy Girl (Hals), 211

• H •

Hadid, Zaha, 372, 413

Hagia Sophia (Church of Holy Wisdom), 109–110, 404

Hals, Frans, 20, 211, 405, 413

Hamilton, Richard, 340, 405

Hammurabi's Stele (Code of Laws), 51–52, 404

Hanging Gardens of Babylon, 54

Hansen, Al, 349

Hardouin-Mansart, Jules, 214

A Harlot's Progress (Hogarth), 224

"The Harvest of Death" (O'Sullivan), 356

Hatshepsut Funerary Temple, Luxor, 65–66, 404

Hatshepsut Sphinx, 404

Haystack (Monet), 267

Haystack at Sunset (Monet), 267

Heckel, Erich, 298, 402

heliography, 354

Hellenistic art period, 24, 86–88

herbals, 126

Hercules and Omphale (Boucher), 219

Hercules Slaying the Nemean Lion with Aiolos and Athena (Psiax), 82–83

Hermes and the Infant Dionysus (Praxiteles), 80–81

Hermitage, 385

Hiberno-Saxon manuscript illumination, 124–125

Higgins, Dick, 349

High Renaissance, 26, 159–170, 189

Hill, David Octavius, 355

Hogarth, William, 224–225, 408

The Holy Family on the Steps (Poussin), 20, 213

Holy Family with Mary Magdalen (El Greco), 196, 404

Homer, Winslow, 258, 411

Horse Dreaming (Marc), 300, 404

Horta, Victor, 286
Houdon, Jean-Antoine, 237, 412
Houses at L'Estaque (Braque), 304, 404
How to Explain Pictures to a Dead Hare
 (Beuys), 352
Hudson River school, 259
Hugo, Victor, 240
humanism, 16, 184–187
The Hunchback of Notre-Dame (Hugo), 240
Hundertwasser, Friedensreich, 344–345,
 390, 412
*Hundertwasser Architecture: For a More
 Human Architecture in Harmony with
 Nature* (Hundertwasser), 390
Hundertwasser Haus, 344–345
Hunt, William Holman, 259
The Hunters in the Snow (Bruegel), 187, 404
Hylas Mosaic, 97

• *I* •

icon painting, 25, 115–117
Iconoclasm Controversy, 109, 115–116
The Iliad, 74
illuminated manuscripts, 124–126
illuminated printing, 241
impasto, 393
Impression — Sunrise (Monet),
 264, 267, 405
Impressionism movement
 brushstrokes, 12, 393
 crisis of Impressionism, 269–271
 en plein air, 263–264
 lighting effects, 267
 painters, 264–273
 popularity of, 12, 263
 themes of, 28–29
Industrial Revolution, 11–12, 28
Ingres, Jean Auguste Dominique
 The Great Odalisque, 234–235, 245, 266
 opinions about Romantic art, 245

installation art, 375–377
International style, 365
The Isenheim Altarpiece (Grünewald),
 186, 405
Ishtar Gate, 53, 405
Islamic art period, 26, 117–121
Italian Gothic style, 143
Ivanhoe (Scott), 247

• *J* •

James (Close), 349, 405
Jeanne-Claude, 376–377
Jesuits, 199
Joanna of Aragon (Raphael), 197
Johnson, Philip, 367–368, 400
Joseph the Carpenter (La Tour), 214, 405
Joseph's Bloody Coat Brought to Jacob
 (Velázquez), 216, 405
Journal (Delacroix), 388
The Joy of Life (Matisse), 18, 292–293
Judd, Donald, 347, 412
Judith Slays Holofernes (Gentileschi), 203
*Just What Is It That Makes Today's Home So
 Different, So Appealing?* (Hamilton),
 340, 405
Justinian mosaic (San Vitale, Ravenna),
 111–113, 405

• *K* •

Ka statues, 64
Kac, Edoardo, 380
Kahlo, Frida, 328–330, 390, 407, 412
Kaisersaal, 219, 223, 405
Kandinsky, Wassily
 Composition Number VI, 299
 Concerning the Spiritual in Art, 298–299,
 389–390
 *Der Blaue Reiter (The Blue Rider)
 Almanac,* 298, 389–390

Kandinsky, Wassily *(continued)*
 Der Blaue Reiter (The Blue Rider)
 movement, 298–299
 painting style, 395
Kant, Immanuel, 229–230
Karlskirche (St. Charles Church), 206–207
kinetic art, 317
King Ashurnasirpal II Killing Lions, 53
Kirchner, Ernst Ludwig, 297
The Kiss (Lichtenstein), 342
The Kiss (Rodin), 281, 283, 405
The Kiss of Judas (Giotto), 147–148
Klimt, Gustav, 300–301, 399
Knidian Aphrodite (Praxiteles), 80–81, 405
Kokoschka, Oskar, 302, 401
Koran Cover, 121, 405
kores statues, 75
kouros statues, 75–76, 405
Kritios Boy, 75–77
Kunsthistorisches Museum, 386

• **L** •

La Sagrada de Familia, 287–288
*La Strada Entra Nella Casa (The Street
 Enters the House)* (Boccioni), 310, 406
La Tour, Georges de, 213–214, 405
La Vie (Picasso), 304–305
The Lady and the Unicorn tapestries,
 149–150, 405
*Lady Governors of the Old Men's Home at
 Haarlem* (Hals), 211, 405
*Lady Sarah Bunbury Sacrificing to the
 Graces* (Reynolds), 226, 406
Lamassus, Citadel of Sargon II, 406
Landscape Near Martigues (Vlaminck),
 294, 406
Lanfranco, Giovanni, 200
Lange, Dorothea, 360–361, 410
Laocoön and His Sons, 86–88

Las Meninas (The Maids of Honor)
 (Velázquez), 216–217
Last Judgment reliefs, 133–134
The Last Supper (Castagno), 155, 406
The Last Supper (da Vinci), 18, 163–165
Lastman, Pieter, 209
Late Gothic art period, 180–183
Laurentian Library (Michelangelo), 198,
 406
T e Lawyer (Arcimboldo), 194, 406
Le Brun, Charles, 214
Le Corbusier, 333–334, 410
Le Gray, Gustave, 355, 403, 409
Le Nôtre, André, 214
le style Belge (Belgian style), 286
Le Vau, Louis, 214
Learning from Las Vegas (Venturi and Scott
 Brown), 366
Léger, Fernand, 308–309, 401–402
Les Demoiselles d'Avignon (Picasso),
 305–306
Les Misérables (Hugo), 240
Les XX (The Twenty) movement, 283–284
Liberty Leading the People (Delacroix),
 17, 245–246
The Librarian (Arcimboldo), 195, 406
Lichtenstein, Roy, 342, 404
Life (Picasso), 304–305
lighting effects
 alla prima (at once) technique, 265
 cellar lighting, 201
 chiaroscuro, 162, 209
 Hudson River school, 259
 Impressionism, 267
 tenebrism, 201
Lindisfarne Gospels, 125
linear perspective, 154
The Lion Hunt (Delacroix), 247, 406
Lippi, Fra Filippo, 156–157
Lissitzky, El, 315–316, 408
The Little Blue Horses (Marc), 300, 406

The Liver Is the Cock's Comb (Gorky), 335, 406

Lives of the Most Eminent Painters, Sculptors, and Architects (Vasari), 388

Locke, John, 230

Lord Byron, 240, 246–247

Los Borrachos (The Drunkards) (Velázquez), 216

Louvre, 383

Love in the Italian Theater (Watteau), 220, 406

Lovers in a Park (Boucher), 219, 406

Lucretia (Gentileschi), 203, 406

Luminists, 259

Luncheon on the Grass (Manet), 19, 266, 406

The Lute Player (Caravaggio), 202, 407

The Lute Player (Gentileschi), 202, 407

Lysippos, 80

• *M* •

Machine Age, 316, 318

machines à habiter, 333

Maciunas, George, 349

Maderno, Carlo, 204–205

Madonna (American pop singer), 372–373

Madonna and Child with the Birth of the Virgin (Lippi), 156–157

Madonna Enthroned (Cimabue), 144–145, 407

Madonna Enthroned (Duccio), 146–147

Madonna in Majesty (Cimabue), 146

Madonna of the Rose Garlands (Dürer), 174, 407

Madonna with a Goldfinch (Raphael), 168, 407

Madonna with Child (Gentileschi), 202, 407

Madonna with the Long Neck (Parmigianino), 193–194

The Magnetic Fields (Soupault), 324

Magritte, René, 327

The Maids of Honor (Las Meninas) (Velázquez), 216–217

Maison Carrée, 98, 100

Malevich, Kazimir, 314–315, 395, 409

Man Ray, 322

Manet, Édouard, 19, 264–267, 406

Manetho, 56

Mannerism movement, 16, 26–27, 189–198

Mantegna, Andrea, 173–174, 197, 402

manuscript illumination, 124–126

Marc, Franz
 Der Blaue Reiter (The Blue Rider) Almanac, 298, 389–390
 Der Blaue Reiter (The Blue Rider) movement, 298–300
 Horse Dreaming, 300, 404
 The Little Blue Horses, 300, 406
 The Yellow Cow, 300, 413

Marilyn Diptych (Warhol), 341

Marinetti, Filippo Tommaso, 309–310

Marriage of Venus and Mars, 96

Martin, Agnes, 347

The Martyrdom of St. Bartholomew (Ribera), 215, 407

Marx, Karl, 256

Masaccio, 155, 412

The Massacre at Chios (Delacroix), 240

Matisse, Henri, 18, 292–293

meaning of art, 19–20

Medea Krater, 83

Medieval art period
 Bayeux Tapestry, 127–130
 Christianity, 26
 dates of, 123
 Gothic style, 136–148
 illuminated manuscripts, 124–126
 Romanesque style, 130–135
 stained-glass windows, 140–141
 tapestries, 148–150

megaliths, 40–41

menhirs, 41

Menkaure and his Wife (Egyptian Pharaoh and his Queen), 407

Merode Altarpiece (Campin), 183

Mesopotamia, 44

Mesopotamian art period, 16, 23

Metropolitan Museum of Art, 385

"Mexico" (Cartier-Bresson), 358, 407

Michelangelo

 Complete Poems and Selected Letters of Michelangelo, 388

 The Creation of Adam, 160, 167

 David, 166, 203

 Laurentian Library, 198, 406

 Pietà, 166, 408

 Pietà Rondanini, 190, 408

 Saint Bartholomew with Flayed Skin in *The Last Judgment,* 409

 Sistine Chapel Ceiling, 165, 167, 411

 techniques of, 165

Middle Ages, 10–11, 16

"Migrant Mother, Nipomo, California" (Lange), 360–361

Millais, John Everett, 259, 261, 401

Millet, Jean-François, 252, 255–256, 411

Minimalist movement, 347

Minoan art period, 24, 72–74

The Mocking of Christ (Fra Angelico), 156

Modernism movement, 32, 365–366

Modernist architecture, 330–334

Mona Lisa (da Vinci), 20, 162–163, 392

Monastery of Melk, 206

Mondrian, Piet, 318, 401–402

Monet, Claude

 The Bodmer Oak, Fontainebleau, 355, 401

 End of Summer, 267

 Haystack, 267

 Haystack at Sunset, 267

 Impression — Sunrise, 264, 267, 405

 Morning, 267

 Near Giverny, 267

 painting technique, 267, 393

 The Road to Chailly, Fontainebleau, 355, 409

 Springtime, 268

Monk by the Sea (Friedrich), 243, 407

Mont Sainte-Victoire (Cézanne), 284–285

The Monument to Balzac (Rodin), 281–282

The Monument to the Burghers of Calais (Rodin), 281

Monument to the Third International, 316–317

Morisot, Berthe, 271–273, 401

Morning (Monet), 267

Morning: Dance of the Nymphs (Corot), 257, 407

Morris, William (founder of the Arts and Crafts movement), 262

mosaics, 25, 97, 111–114

Mosque of Córdoba, 118–120

Mosque of Mutawakkil, 118, 407

Mountains at Collioure (Derain), 294, 407

movements. *See movements by name*

Mr. and Mrs. Andrews (Gainsborough), 225, 407

mummies, 55–57, 63–64

mummy slaves, 68

Munch, Edvard, 291

museums

 British Museum, 386

 Hermitage, 385

 Kunsthistorisches Museum, 386

 Louvre, 383

 Metropolitan Museum of Art, 385

 National Gallery, 384

 Prado, 385

 Rijksmuseum, 386

 Uffizi, 384

 Vatican Museums, 384

The Musicians (Caravaggio), 202, 407

My Dress Hangs There (Kahlo), 329, 407

Mycenaean culture, 74

Myron, 78

• N •

National Gallery, 384
Near Giverny (Monet), 267
Nefertiti Bust, 407
Neoclassicism art period, 11–12, 27, 229–236
Neolithic art period, 23, 39–42
Neo-Plasticism movement, 318
Neo-Platonic movement, 157
Never Again (Someroski), 351
New Art (Art Nouveau) movement, 285–288
New Babylon, 53–54
New Stone Age, 23, 39–42
New York Dada magazine, 322
Newman, Barnett, 345–346, 403
Nicéphore Niépce, Joseph, 354
The Nightmare (Fuseli), 242, 408
Nike of Samothrace, 86–87
noble savage, 241, 277–279
Nochlin, Linda, 375
Notre Dame, 139
Notre Dame du Haut (Le Corbusier), 333–334
Nude Descending a Staircase No. 2 (Duchamp), 321–322
The Nude Maja (Goya), 249, 408

• O •

The Oath of the Horatii (David), 231–232, 408
Octopus Vase (Minoan), 408
The Odyssey, 74
official academy exhibitions, 254
oil painting, 392
Old Stone Age, 23, 35–39
The Old Testament Trinity (Rublev), 116
Olga's Gallery Web site, 399
Olympia (Manet), 265–267
On Painting (da Vinci), 387
Ono, Yoko, 349–350

Ophelia (Millais), 261–262
Ordinator (Abbot Suger), 137
The Orgy (Hogarth), 224, 408
Orlan, 379
Orphism movement, 308
Orsini garden, 190
O'Sullivan, Timothy, 356

• P •

Paik, Nam June, 349
Palazzo Te (Romano), 197–198, 408
Paleolithic art period, 23, 35–39
Palette of Narmer, 57–61
Palladio, Andrea, 179–180, 410
Pantheon, 101
papier collé, 307
paranoiac-critical method, 326
Parmigianino, 193–194, 410
Parthenon, 80, 85
Partially Buried Woodshed (Smithson), 378–379
patrons, 17
pattern, 18
Pearlstein, Philip, 348
The Peasant Dance (Bruegel), 186–187
Pei, I.M., 368–369
pendentives, 110–111
"Pepper" (Weston), 359
"Pepper No. 30" (Weston), 408
performance art, 32, 349–350, 352, 379–380
periods. *See periods by name*
Persistence of Memory (Dalí), 326
personal vision, 17
Phidias, 78–80
Philosopher in Meditation (Rembrandt), 210
The Philosophy of Andy Warhol (Warhol), 340
photography
 activist art, 13
 art, 355–356
 calotype, 354

photography *(continued)*
 daguerreotype, 354
 documentary photography, 355–356
 Group f/64, 359
 heliography, 354
 history of, 353–354
 Photo-Secession movement, 356–357
 Pictorialism, 356–357
 Postmodernism movement, 364, 372–375
 roll film, 354
 Talbotype, 354
 techniques, 356
 wax-paper negative, 355
 wet-collodion process, 354
Photorealism movement, 13, 347–349
Photo-Secession movement, 356–357
Picasso, Pablo, 304–308, 394–395, 408, 411
Pictorialism, 356–357
picturesque style (genre pittoresque), 219
Pietà (Michelangelo), 166, 408
Pietà Rondanini (Michelangelo), 190, 408
Pisano, Giovanni, 143
Pisano, Nicola, 143
Pointillism, 275–276, 394
politics, 16–17, 252
Pollock, Jackson, 335–337, 395–396
Polykleitos, 19, 78–79
Pont du Gard, Nimes, 98, 408
Pontormo, 190–191
Pop Art movement, 31, 339–342
Portrait of Ambroise Vollard (Picasso),
 307, 408
Portrait of Giovanni Arnolfini and His Wife
 (van Eyck), 181–182, 392
Portrait of Marchesa Brigida Spinola Doria
 (Rubens), 208
Portrait of Mrs. Currey: Sketch of Mr. Cassatt
 (Cassatt), 272, 408
Portrait of Myself (Bourke-White), 362
Portraits of Distinguished Scotsmen
 (Adamson and Hill), 355

positivism, 365–366
post-and-lintel system, 40–41
Post-Impressionism movement
 painters, 275–281, 283–285
 Pointillism, 275–276, 394
 sculptors, 281–283
 themes of, 12, 29
Postmodernism movement
 architecture, 366–372
 biotechnology, 379–380
 earth art, 375, 377–379
 installation art, 375–377
 Learning from Las Vegas (Venturi and
 Scott Brown), 366
 Modernism movement, 32, 365–366
 photography, 364, 372–375
 sculpture, 377–379
 simulacrum, 374
 themes of, 14, 32, 365–366
 transgenic engineering, 380
The Potato Eaters (van Gogh), 280, 408
Poussin, Nicolas, 20, 213
*Practical Treatise of Photography on Paper
 and Glass* (Le Gray), 355
Prado, 385
Prandtauer, Jakob, 206
Praxiteles, 80–81
prehistoric art period, 23
Pre-Raphaelite Brotherhood, 28, 259–262
Primaticcio, Francesco, 198
Primavera (Botticelli), 18, 157–158
Protestant church, 27, 207
Proun 99 (Lissitzky), 315–316, 408
Puabi Lyre, 48–49, 82
Purism, 333
purpose of art, 15–17
Puteaux Group, 308
pyramid texts, 69–70
Pyramide, Le Grande Louvre, 368–369
Pyramids of Giza, 61–63, 408

• R •

Raft of the Medusa (Gericault), 244–245
Raising of the Cross (Rubens), 209, 408
A Rake's Progress (Hogarth), 224
Rameses Temple, 70, 409
Raphael, 168–170, 197, 407
readymades, 322
Realism movement
 Barbizon School, 255–256
 en plein air, 12, 255
 messages of, 12, 28, 251
 painters, 251–259
Realistic Manifesto (Gabo), 317
Reclining Couple Sarcophagus, Cerveteri
 (Etruscan), 409
Red Cross Train Passing a Village (Severini),
 312, 409
Red Houses (Heckel), 298
*Red Square: Painterly Realism of a Peasant
 Woman in Two Dimensions* (Malevich),
 314–315, 409
reduction, 395
Reformation, 199
Reign of Terror, 232
Reims Cathedral, 139
reliefs, 38
religious art
 Baroque, 16, 27, 200
 Egypt, 16
 Mannerism, 16
 Mesopotamia, 16
 Middle Ages, 10–11, 16
 Renaissance, 10, 16
 Roman Empire, 16
religious rituals, 16
reliquaries, 26
Rembrandt, 209–210, 392–393, 401
Renaissance art period
 architecture, 153, 179–180
 Counter-Reformation, 177–178
 Early Renaissance, 151–159
 High Renaissance, 26, 159–170, 189
 humanism, 16, 184–187
 Mannerism, 16, 26–27, 189–198
 painters, 172–179, 184–187
 Renaissance of the North, 184–187
 sculpture, 158–159, 166
 themes of, 11, 16, 151
 Venetian Renaissance, 171–180
Reni, Guido, 200
Renoir, Pierre-Auguste, 269–270, 400, 402
Return of the Hunters (Bruegel the Elder),
 187
Reynolds, Sir Joshua, 224–226, 241, 406
rhythm, 18
Ribera, Jusepe de, 215, 407, 409
Richter, Gerhard, 374–375, 396–397, 399
Richter, Hans, 319
Rijksmuseum, 386
rituals, 16
Rivera, Diego, 328, 390
"Road of Chailly, Fontainebleau" (Le Gray),
 355, 409
The Road to Chailly, Fontainebleau (Monet),
 355, 409
The Robing of the Bride (Ernst), 325
Robusti, Jacopo (Renaissance painter), 179
The Rocky Mountains, Lander's Peak
 (Bierstadt), 258, 409
Rococo art period, 27, 219–226
Rodchenko, Aleksander, 315–316
Rodin, Auguste, 281–283, 405
Rodin on Art (Gsell), 389
roll film, 354
Roman aqueducts, 98, 408
Roman arch, 99
Roman art period, 16–17, 25, 91–102
Roman realism, 92–97
Romanesque style
 architecture, 130–133
 sculpture, 133–135

Romano, Giulio, 197–198, 408–409
Romanticism art period
 Industrial Revolution, 12, 28
 messages of, 12, 28, 239–241
 painters, 241–250
Room of the Giants (Romano), 198, 409
Rose Period (Picasso), 395
Rosetta Stone, 63, 409
Rossetti, Dante Gabriel, 259–260, 400
Rothko, Mark, 345–346, 412
Rousseau, Jacques, 230, 240–241, 277–278
Royal Photographic Society in England, 355
Rubens, Peter Paul, 208–209, 408–409
Rublev, Andrei, 116
*Running Fence, Sonoma and Marin
 Counties, California, 1972–76* (Christo
 and Jeanne-Claude), 377
Ryman, Robert, 347

• S •

St. Bartholomew with Flayed Skin in *The
 Last Judgment* (Michelangelo), 409
Saint George and the Dragon (Rubens), 409
Saint George and the Dragon (Tintoretto),
 179, 409
Saint Margaret (Raphael), 197
Salon des Refusé, 254, 266
Salon of Paris, 254, 266–267
"Salute of Innocence" (Lange), 360, 410
San Giorgio Maggiore (Palladio), 180, 410
San Lorenzo (Brunelleschi), 153, 410
San Rocco in Glory (Tintoretto), 179
San Vitale mosaics, 111–113, 405
San Zaccaria Altarpiece (Bellini), 172
Savage Tales (Gauguin), 279, 410
Savoy House in Poissy-sur-Seine (Le
 Corbusier), 333, 410
Scene from New Comedy (Pompeii Mosaic),
 97, 111, 410

Schiele, Egon, 302, 410
The School of Athens (Raphael), 168–170
Scott, Sir Walter, 247
Scott Brown, Denise, 366
The Scream (Munch), 291
sculpture
 Abu Temple statuettes, 47–48, 411
 Ancient Greek, 76–81
 Baroque, 203–204
 Constructivism, 317–318
 earth art, 375, 377–379
 Futurist, 310–311
 Gothic, 141–142
 Greek, 75
 Hellenistic, 86–88
 Ka statues, 64
 kores statues, 75
 kouros statues, 75–76
 Minimalist, 347
 mummy slaves, 68
 Neoclassical, 236–237
 Post-Impressionist, 281–283
 Postmodern, 377–378
 reliefs, 38
 Renaissance, 158–159, 166
 Roman, 93–95
 Romanesque, 133–135
 Senusret III bust, 65
 statuettes, 38, 46–48
 Sumerian, 46–48
Seagram Building, 367
Seagram Building, from the series *Urban
 Landscapes 1,* (Estes), 348, 410
Secession movement, 300–301
Second of May, 1808 (Goya), 248
Self-Portrait at Age 26 (Dürer), 175
Self-Portrait in a Convex Mirror
 (Parmigianino), 193, 410
Self-Portrait Pulling Cheek (Schiele),
 302, 410

self-referential art making, 367

Senusret III, 65, 410

Serra, Richard, 347

Seurat, Georges-Pierre, 275–276, 393–394

severe style, 77

Severini, Gino, 311–312, 409

sfumato, 161, 174, 392

shamanistic ritual, 16

Shelley, Mary, 240

Shelley, Percy Bysshe, 240

Sherman, Cindy, 364, 373–374, 412

Shop Block Bauhaus Building (Gropius), 332, 410

Siena Cathedral, 143, 410–411

simulacrum, 374

Sistine Chapel Ceiling (Michelangelo), 165, 167, 411

Skara Brae, 40, 411

Skopas, 80

The Slave Ship (Turner), 250, 411

The Sleep of Reason Produces Monsters (Goya), 249, 411

smear brushstroke, 396

Smithson, Robert, 377–379, 411

smudge brushstroke, 396–397

The Social Contract (Rousseau), 240–241

Socialism, 252

Society of Jesus, 199

Someroski, James Melvin, 351

"Song to the Men of England" (Shelley), 240

Soupault, Philippe, 324

The Sower (Millet), 256, 411

The Sower (van Gogh), 281, 394

Spearbearer (Polykleitos), 19

Sphinx, 55, 61, 63, 411

Spiral Jetty (Smithson), 377, 411

"Spring Shower" (Stieglitz), 357, 411

Springtime (Monet), 268

St. Chapelle Cathedral, 139

St. Charles Church (Karlskirche), 206–207

St. Denis, 137–139, 141

St. George and the Dragon (Rubens), 208

St. Jerome (Ribera), 215, 409

St. Mark's Basilica, 114, 409

St. Peter's baldacchino (Bernini), 205, 410

St. Peter's Basilica, 205, 410

St. Peter's colonnade (Bernini), 205, 410

St. Sernin Cathedral, 130–131, 400, 410

Sta. Susanna, 204–205

stained-glass windows, 140–141

Standard of Ur, 49–51, 53

statuettes, 38, 46–48

Steichen, Edward, 356

Stelarc, 380

Stella, Frank, 347, 400

Step Pyramid, 61–62, 411

Stieglitz, Alfred, 356–357, 411

Still Life with Chair Caning (Picasso), 307, 411

The Stone Breakers (Courbert), 253

Stonehenge, 41–42, 411

Street, Berlin (Kirchner), 297

The Street Enters the House (La Strada Entra Nella Casa) (Boccioni), 310, 406

Suger, Abbot, 136–139

Sumer

 Akkadian art, 51

 architecture, 44–46

 Gilgamesh (Sumerian epic poem), 44–45, 49

 Hammurabi's Code, 51–52

 Puabi Lyre, 48–49

 sculpture, 46–48

 Standard of Ur, 49–51, 53

Summer (Arcimboldo), 194

Summer Night (Homer), 258, 411

Suprematism movement, 30–31, 313–315

Suprematist Painting, 1915 (Malevich), 315

Surrealism movement, 13, 30, 324–330

Surrealist Manifesto (Breton), 324

Surrounded Islands, Biscayne Bay, Greater Miami, Florida, 1980–83 (Christo and Jeanne-Claude), 377
Susanna and the Elders (Gentileschi), 203
The Swing (Fragonard), 222–223
symbolism, 20, 164
Symbolism movement, 278
sympathetic magic, 37
Synthetic Cubism movement, 307–308
Synthetism movement, 278

• T •

Tachism, 265
Taj Mahal, 122, 411
Talbot, William Fox, 354
Talbotype, 354
tapestries, 148–150
Tatlin, Vladimir (Tatlin's Tower), 315–317, 411
tempera, 391–392
The Tempest (Giorgione), 174, 412
Temple of Hera, 85, 412
Temple of Portunus, 98, 412
The Temptation of St. Anthony (Grünewald), 186, 412
tenebrism, 201
textiles
 Banner of Las Navas de Tolosa, 121
 Bayeux Tapestry, 127–130
Textures in Pink and Brown (Winter), 351
The Thinker (Rodin), 281–283
Third of May, 1808 (Goya), 248–249
The Third-Class Carriage (Daumier), 254, 412
The 30-Day Fax Painting (Hundertwasser), 345, 412
Thomas Jefferson (Houdon), 237, 412
Three Goddesses (Phidias), 80, 412
Tiepolo, Giovanni Battista (Italian painter), 223

Tiffany, Louis Comfort, 286
Tintern Abbey (Wordsworth), 240
Tintoretto, 179, 409
Titian, 175–177, 393
tombs
 Egyptian, 24, 63–68
 Etruscan, 90
The Toreador Fresco, 73–74
Toulouse-Lautrec, Henri de, 277, 400
Tower of Babel, 46
The Tragedy of Sardanapalus (Lord Byron), 246–247
Trajan's Column, 95
transgenic engineering, 380
The Tribute Money (Masaccio), 155, 412
The Triumph of Bacchus (The Drinkers) (Velázquez), 403
Triumph of Death (Bruegel), 187, 412
Triumphal Arch of Orange, 99
trompe l'oeil (tricks of the eye), 198
The Tub (Degas), 271, 412
Turner, J. M. W., 249–250, 411
The Twenty (Les XX) movement, 283–284
The Two Fridas (Kahlo), 329, 412
Tyrrell, Brinsley, 378

• U •

Uffizi, 384
The Umbrellas, Joint Project for Japan and U.S.A. 1984–1991 (Christo and Jeanne-Claude), 377
Unique Forms of Continuity in Space (Boccioni), 311
universal space, 314
Untitled (Forest) (Arp), 323, 412
Untitled (Judd), 347, 412
Untitled (Pollock), 336
Untitled (Violet, Black, Orange, Yellow on White and Red) (Rothko), 346, 412

Untitled Film Still #6, 1977 (Sherman), 373–374
Untitled #205 (Sherman), 412
Urban Landscapes 1 (Estes), 348
Uveges, Christine, 116–117

• *V* •

Van de Velde, Henry, 286
van der Rohe, Mies, 367
van der Weyden, Rogier, 183
van Doesburg, Theo, 318
van Eyck, Jan, 180–182, 391–392, 404
van Gogh, Vincent
 letters, 388–389
 painting style, 394
 personal vision, 17
 The Potato Eaters, 280, 408
 The Sower, 281, 394
Vasari, Giorgio *(Lives of the Most Eminent Painters, Sculptors, and Architects),* 388
vase painting, 81–83
Vatican Museums, 384
Velázquez, Diego, 216–217, 403, 405
Venetian Renaissance, 171–180
Venturi, Robert, 366–367, 401
Venus de Milo, 88
Venus of Urbino (Titian), 176–177
Venus of Willendorf statuette, 38–39
Vermeer, Johannes, 211–212
Veronese, Paolo, 177–178
Versailles, 214
Vertumnus and Pomona (Claudel), 283, 412
Vespasian (9th Roman Emperor), 94, 413
Vienna Secession movement, 300–301
View of Volterre (Corot), 257
Vigée-Le Brun, Élisabeth-Louise, 235–236
The Virgin of the Rocks (da Vinci), 161–162
Virgin of Vladimir, 116, 413

The Vision after the Sermon (Jacob Wrestling with the Angel) (Gauguin), 278, 413
visual narrative, 20
visual vocabularies, 15–16
Vitra Design Museum, 372
Vitra Fire Station (Hadid), 372, 413
Vlaminck, Maurice de, 294, 406
Voltaire, 230

• *W* •

The Wanderer Above the Mist (Friedrich), 243, 413
Warhol, Andy, 340–341
Watersnakes (Klimt), 301
Watteau, Antoine, 220–221, 406
wax-paper negative, 355
Web Gallery of Art, 399
The Wedding Dance (Bruegel), 186–187, 413
Weston, Edward, 359, 408
wet-collodion process, 354
Wexner Center (Eisenmann), 370, 413
What the Water Gave Me (Kahlo), 328–330
"White Angel Breadline, San Francisco" (Lange), 360
"Why Have There Been No Great Women Artists?" (Nochlin), 375
Winckelmann, Johann Joachim, 230–231
Winter, Edward, 350–351
"Winter Sunrise from Lone Pine" (Adams), 359, 413
Woman of Willendorf statuette, 38–39, 413
Woman I (de Kooning), 337, 413
Wordsworth, William, 240
World War I, 13, 30, 295, 318
World War II, 13
Wrapped Coast — One Million Square Feet, Little Bay, Sydney, Australia (Christo and Jeanne-Claude), 377
Wright, Frank Lloyd, 330–331

• *Y* •

The Yellow Cow (Marc), 300, 413
Yes Painting (Ono), 350
Young Communards in Prison (Courbet), 255
Young Man with a Jug of Beer (Hals), 211
Young Man with a Skull (Hals), 20, 211, 413

• *Z* •

Zampieri, Domenico, 200
ziggurat of King Urnammu of Ur, 45, 413
ziggurats, 45–46, 413
Zurbarán, Francisco de, 216, 403

BUSINESS, CAREERS & PERSONAL FINANCE

0-7645-9847-3

0-7645-2431-3

Also available:
- Business Plans Kit For Dummies
 0-7645-9794-9
- Economics For Dummies
 0-7645-5726-2
- Grant Writing For Dummies
 0-7645-8416-2
- Home Buying For Dummies
 0-7645-5331-3
- Managing For Dummies
 0-7645-1771-6
- Marketing For Dummies
 0-7645-5600-2

- Personal Finance For Dummies
 0-7645-2590-5*
- Resumes For Dummies
 0-7645-5471-9
- Selling For Dummies
 0-7645-5363-1
- Six Sigma For Dummies
 0-7645-6798-5
- Small Business Kit For Dummies
 0-7645-5984-2
- Starting an eBay Business For Dummies
 0-7645-6924-4
- Your Dream Career For Dummies
 0-7645-9795-7

HOME & BUSINESS COMPUTER BASICS

0-470-05432-8

0-471-75421-8

Also available:
- Cleaning Windows Vista For Dummies
 0-471-78293-9
- Excel 2007 For Dummies
 0-470-03737-7
- Mac OS X Tiger For Dummies
 0-7645-7675-5
- MacBook For Dummies
 0-470-04859-X
- Macs For Dummies
 0-470-04849-2
- Office 2007 For Dummies
 0-470-00923-3

- Outlook 2007 For Dummies
 0-470-03830-6
- PCs For Dummies
 0-7645-8958-X
- Salesforce.com For Dummies
 0-470-04893-X
- Upgrading & Fixing Laptops For Dummies
 0-7645-8959-8
- Word 2007 For Dummies
 0-470-03658-3
- Quicken 2007 For Dummies
 0-470-04600-7

FOOD, HOME, GARDEN, HOBBIES, MUSIC & PETS

0-7645-8404-9

0-7645-9904-6

Also available:
- Candy Making For Dummies
 0-7645-9734-5
- Card Games For Dummies
 0-7645-9910-0
- Crocheting For Dummies
 0-7645-4151-X
- Dog Training For Dummies
 0-7645-8418-9
- Healthy Carb Cookbook For Dummies
 0-7645-8476-6
- Home Maintenance For Dummies
 0-7645-5215-5

- Horses For Dummies
 0-7645-9797-3
- Jewelry Making & Beading For Dummies
 0-7645-2571-9
- Orchids For Dummies
 0-7645-6759-4
- Puppies For Dummies
 0-7645-5255-4
- Rock Guitar For Dummies
 0-7645-5356-9
- Sewing For Dummies
 0-7645-6847-7
- Singing For Dummies
 0-7645-2475-5

INTERNET & DIGITAL MEDIA

0-470-04529-9

0-470-04894-8

Also available:
- Blogging For Dummies
 0-471-77084-1
- Digital Photography For Dummies
 0-7645-9802-3
- Digital Photography All-in-One Desk Reference For Dummies
 0-470-03743-1
- Digital SLR Cameras and Photography For Dummies
 0-7645-9803-1
- eBay Business All-in-One Desk Reference For Dummies
 0-7645-8438-3
- HDTV For Dummies
 0-470-09673-X

- Home Entertainment PCs For Dummies
 0-470-05523-5
- MySpace For Dummies
 0-470-09529-6
- Search Engine Optimization For Dummies
 0-471-97998-8
- Skype For Dummies
 0-470-04891-3
- The Internet For Dummies
 0-7645-8996-2
- Wiring Your Digital Home For Dummies
 0-471-91830-X

*** Separate Canadian edition also available**
† Separate U.K. edition also available

Available wherever books are sold. For more information or to order direct: U.S. customers visit www.dummies.com or call 1-877-762-2974.
U.K. customers visit www.wileyeurope.com or call 0800 243407. Canadian customers visit www.wiley.ca or call 1-800-567-4797.

SPORTS, FITNESS, PARENTING, RELIGION & SPIRITUALITY

0-471-76871-5

0-7645-7841-3

Also available:
- Catholicism For Dummies
 0-7645-5391-7
- Exercise Balls For Dummies
 0-7645-5623-1
- Fitness For Dummies
 0-7645-7851-0
- Football For Dummies
 0-7645-3936-1
- Judaism For Dummies
 0-7645-5299-6
- Potty Training For Dummies
 0-7645-5417-4
- Buddhism For Dummies
 0-7645-5359-3

- Pregnancy For Dummies
 0-7645-4483-7 †
- Ten Minute Tone-Ups For Dummies
 0-7645-7207-5
- NASCAR For Dummies
 0-7645-7681-X
- Religion For Dummies
 0-7645-5264-3
- Soccer For Dummies
 0-7645-5229-5
- Women in the Bible For Dummies
 0-7645-8475-8

TRAVEL

0-7645-7749-2

0-7645-6945-7

Also available:
- Alaska For Dummies
 0-7645-7746-8
- Cruise Vacations For Dummies
 0-7645-6941-4
- England For Dummies
 0-7645-4276-1
- Europe For Dummies
 0-7645-7529-5
- Germany For Dummies
 0-7645-7823-5
- Hawaii For Dummies
 0-7645-7402-7

- Italy For Dummies
 0-7645-7386-1
- Las Vegas For Dummies
 0-7645-7382-9
- London For Dummies
 0-7645-4277-X
- Paris For Dummies
 0-7645-7630-5
- RV Vacations For Dummies
 0-7645-4442-X
- Walt Disney World & Orlando
 For Dummies
 0-7645-9660-8

GRAPHICS, DESIGN & WEB DEVELOPMENT

0-7645-8815-X

0-7645-9571-7

Also available:
- 3D Game Animation For Dummies
 0-7645-8789-7
- AutoCAD 2006 For Dummies
 0-7645-8925-3
- Building a Web Site For Dummies
 0-7645-7144-3
- Creating Web Pages For Dummies
 0-470-08030-2
- Creating Web Pages All-in-One Desk
 Reference For Dummies
 0-7645-4345-8
- Dreamweaver 8 For Dummies
 0-7645-9649-7

- InDesign CS2 For Dummies
 0-7645-9572-5
- Macromedia Flash 8 For Dummies
 0-7645-9691-8
- Photoshop CS2 and Digital
 Photography For Dummies
 0-7645-9580-6
- Photoshop Elements 4 For Dummies
 0-471-77483-9
- Syndicating Web Sites with RSS Feeds
 For Dummies
 0-7645-8848-6
- Yahoo! SiteBuilder For Dummies
 0-7645-9800-7

NETWORKING, SECURITY, PROGRAMMING & DATABASES

0-7645-7728-X

0-471-74940-0

Also available:
- Access 2007 For Dummies
 0-470-04612-0
- ASP.NET 2 For Dummies
 0-7645-7907-X
- C# 2005 For Dummies
 0-7645-9704-3
- Hacking For Dummies
 0-470-05235-X
- Hacking Wireless Networks
 For Dummies
 0-7645-9730-2
- Java For Dummies
 0-470-08716-1

- Microsoft SQL Server 2005 For Dummies
 0-7645-7755-7
- Networking All-in-One Desk Reference
 For Dummies
 0-7645-9939-9
- Preventing Identity Theft For Dummies
 0-7645-7336-5
- Telecom For Dummies
 0-471-77085-X
- Visual Studio 2005 All-in-One Desk
 Reference For Dummies
 0-7645-9775-2
- XML For Dummies
 0-7645-8845-1

HEALTH & SELF-HELP

0-7645-8450-2

0-7645-4149-8

Also available:
- Bipolar Disorder For Dummies
 0-7645-8451-0
- Chemotherapy and Radiation For Dummies
 0-7645-7832-4
- Controlling Cholesterol For Dummies
 0-7645-5440-9
- Diabetes For Dummies
 0-7645-6820-5* †
- Divorce For Dummies
 0-7645-8417-0 †

- Fibromyalgia For Dummies
 0-7645-5441-7
- Low-Calorie Dieting For Dummies
 0-7645-9905-4
- Meditation For Dummies
 0-471-77774-9
- Osteoporosis For Dummies
 0-7645-7621-6
- Overcoming Anxiety For Dummies
 0-7645-5447-6
- Reiki For Dummies
 0-7645-9907-0
- Stress Management For Dummies
 0-7645-5144-2

EDUCATION, HISTORY, REFERENCE & TEST PREPARATION

0-7645-8381-6

0-7645-9554-7

Also available:
- The ACT For Dummies
 0-7645-9652-7
- Algebra For Dummies
 0-7645-5325-9
- Algebra Workbook For Dummies
 0-7645-8467-7
- Astronomy For Dummies
 0-7645-8465-0
- Calculus For Dummies
 0-7645-2498-4
- Chemistry For Dummies
 0-7645-5430-1
- Forensics For Dummies
 0-7645-5580-4

- Freemasons For Dummies
 0-7645-9796-5
- French For Dummies
 0-7645-5193-0
- Geometry For Dummies
 0-7645-5324-0
- Organic Chemistry I For Dummies
 0-7645-6902-3
- The SAT I For Dummies
 0-7645-7193-1
- Spanish For Dummies
 0-7645-5194-9
- Statistics For Dummies
 0-7645-5423-9

Get smart @ dummies.com®

- **Find a full list of Dummies titles**
- **Look into loads of FREE on-site articles**
- **Sign up for FREE eTips e-mailed to you weekly**
- **See what other products carry the Dummies name**
- **Shop directly from the Dummies bookstore**
- **Enter to win new prizes every month!**

*** Separate Canadian edition also available**
† Separate U.K. edition also available

Available wherever books are sold. For more information or to order direct: U.S. customers visit www.dummies.com or call 1-877-762-2974.
U.K. customers visit www.wileyeurope.com or call 0800 243407. Canadian customers visit www.wiley.ca or call 1-800-567-4797.